Otto Benesch

COLLECTED WRITINGS

Volume I · Rembrandt

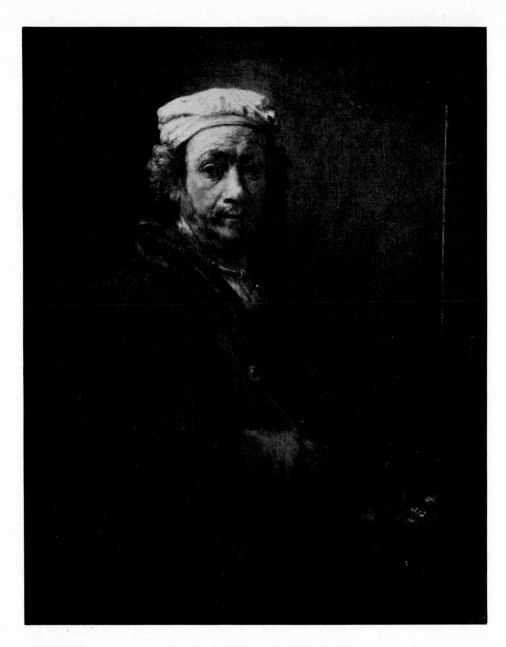

Rembrandt: *Self-Portrait*. Paris, Louvre.

Otto Benesch

COLLECTED WRITINGS

Volume I · Rembrandt

Edited by Eva Benesch

Phaidon

Essays originally printed in German have been
translated by Gillian Mullins

Phaidon Publishers Inc · New York

Distributors in the United States: Praeger Publishers Inc
111 Fourth Avenue · New York · N.Y. 10003

Library of Congress Catalog Card Number: 69-12787

21 5188 ISBN 0 7148 1365 6

Plates printed by Cavendish Press Ltd · Leicester
Text printed by Bell and Bain Ltd · Glasgow

8-30-95 Made in Great Britain

Contents

Introduction

"For the creative gift of an art historian, who in his nature has numerous affinities with the artist, is revealed in the originality of his intuition and not only in the logical-analytical precision of his mind."*

THIS sentence, written by Otto Benesch in 1923, may stand as a motto to the present edition. It characterizes his personality and his approach as a scholar throughout his life. These qualities, his never wavering character and, foremost, his infallible eye, were the guiding factors of his research, his connoisseur- and scholarship.

For more than forty years Otto Benesch contributed essays to numerous art journals. It seemed desirable to assemble and reprint these dispersed essays in an edition of his "Collected Writings" and thus to give, in his memory, a comprehensive picture of his contribution to the history of art. They are presented here, in four volumes, to scholars, students and to the general reader.

At the suggestion of the publishers, all the author's essays on Rembrandt appear in the first volume. Those originally printed in German have been translated; the others were originally written and printed in English. In the succeeding volumes, the essays will be presented in their original languages and grouped as follows:

Volume II: Netherlandish Art of the 15th and 16th Centuries; Flemish and Dutch Art of the 17th Century; Italian Art; French Art.

Volume III: German and Austrian Art of the 15th and 16th Centuries.

Volume IV: German and Austrian Baroque Art; The Art of the 19th and 20th Centuries; Museums and Collections; Monument Service; Theoretical Writings on the History of Art; Museology and Art Education; Musicology.

The publication forms a whole, though each volume will be a self-contained unit, with a general index in the last volume.

The arrangement of this edition is based on that of the chapters in the bibliography of the author's writings (*Verzeichnis seiner Schriften*, 1961). Essays on drawings (ibid., chapter XI), however, have been divided according to schools, and are placed as the last group in volumes II and III, and in their appropriate places in volume IV. In some rare instances this procedure has led to a change in the chronological sequence of the publication dates of the essays. Such breaks of chronology have been indicated by cross-references. Similarly, essays which appeared after the publication of the bibliography have been placed in the appropriate volume.

Two essays on Rembrandt's etchings, in part abbreviated, are included here, which resulted from the author's work on the artist's oeuvre in the Albertina. At that time the etchings were still divided between the collections of the Albertina and of the Imperial Library (Hofbibliothek), pasted into large bound volumes. By establishing the states of the prints according to the literature, the author also inserted states newly recognized by himself, and later added the more recent literature to the Rembrandt oeuvre in the Albertina up to the 1950s.

At the end of each essay its bibliographical source is quoted. All of the author's essays will be reprinted in this edition except some short articles written for special occasions and those which the author himself incorporated—on a larger scale— in his later treatises or books. In some instances a few essays have been abbreviated.

The essays not reprinted here, and related writings on the respective subjects, such as books, book reviews, exhibition catalogues, etc., are listed by title with their bibliographical sources in a special section of each volume. Thus all writings by Otto Benesch are either reprinted or quoted in this edition.

The author's text has been preserved in every respect and is here reprinted without changes. However, in order to refer to the latest state of research, more recent literature—by Otto Benesch as well as by other authors—dealing essentially with the themes and works of art under discussion, has been inserted in the text or in footnotes by the editor without an attempt at completeness. Changes of locations of works of art have also been inserted as far as they could be verified. In the captions to the illustrations only the present location appears.

All additions made by the editor, as well as cross-references within the volumes and to other volumes of this edition, have been placed in square brackets. However, catalogue numbers from standard publications on artists under discussion which appeared after the author's essays, have been added for easier identification. These are not distinguished from the author's text. Some misprints have been corrected without being specially marked.

A selected bibliography including abbreviations will appear in each volume. Because of limitations of space, this edition includes only a selection of illustrations from the original essays. Preference has been given to works of art discussed extensively—being key-notes in the text—and to those first published, such as new attributions and discoveries by the author. This applies also to reproductions chosen to illustrate some of the essays or book reviews which appear in abstracts by the editor. No special reference has been made to those illustrations which are not reprinted here.

A few new illustrations have been added in order to incorporate some of the author's more recent discoveries or to show noteworthy comparisons. The text to these insertions has also been enclosed in square brackets.

Photographs used for the reproductions come in the main from the author's

personal archives, others have been provided by museums, institutes and private owners.

Permission for reprinting the essays has courteously been granted without exception.

I should like to express my warmest thanks for the ready response and courtesy accorded me in museums, institutes and collections. Many of my husband's friends and colleagues have unreservedly lent their assistance. I am most grateful to all who have given scientific information or have put photographs at my disposal. Their names appear in a separate section in each volume.

The Graphische Sammlung Albertina and the Oesterreichische National-bibliothek, Vienna, grant me permission to use the facilities of their collections and libraries, for which I wish to record my special thanks.

Professor J. Q. Van Regteren Altena, a friend of old standing, provided essential scientific information for this volume, for which I express my most sincere thanks.

Above all I would like to extend my thanks to my collaborator, Dr. Martha Vennersten-Reinhardt, Stockholm, who has for several months put her manifold abilities at my disposal. Without her help and devotion it would have been im-possible to accomplish the preparatory work in such a comparatively short time.

Finally my thanks are due to Mr. H. I. Miller of the Phaidon Press, who agreed to undertake the publication of this edition and gave it the traditional care of the Press; further, to Mr. Ludwig Goldscheider for discussing with me various problems involved, and to Dr. I. Grafe for his untiring assistance.

A subsidy has been granted by an American Fine Arts Institution which prefers to remain anonymous.

Vienna, May 1968 Eva Benesch

* "Denn in der Ursprünglichkeit der In-tuition offenbart sich die schöpferische Begabung des in seinem Wesen mit dem Künstler vielfach sich berührenden Kunst-forschers und nicht nur in der logisch-analytischen Schärfe des Geistes." *Peter Paul Rubens, Sammlung der von R. Olden-bourg veröffentlichten oder zur Veröffent-lichung vorbereiteten Abhandlungen über den Meister,* edited by Wilhelm von Bode, Munich-Berlin, 1922. Reviewed by O. Benesch in *Die Graphischen Künste* XLVI (1923), Vienna. Mitteilungen, pp. 34–36.

Biography

Born Ebenfurth, Lower Austria, June 29, 1896.

Studied History of Art at the Faculty of Philosophy in the University of Vienna, Pupil of Max Dvořák.

Studied under Johnny Roosval at the University of Stockholm in 1920.

Ph.D. 1921 under Julius von Schlosser.

From 1920 an Assistant at the Gemäldegalerie of the Kunsthistorisches Museum.

1923 Assistant and later Curator at the Albertina.

1938 Dismissed by the National Socialist Government.

Emigration to France and England.

From 1940 in the United States. Lived in Cambridge, Massachusetts. Research Fellow at the Fogg Museum of Art, Harvard University; twice awarded a John Simon Guggenheim Fellowship, in 1945 and 1946; Member of the Institute for Advanced Study, Princeton 1945–6; teaching at Harvard University, Wellesley College, New York University.

1947 Recalled by the Austrian Government as Director of the Albertina; from 1948 also Professor at the University of Vienna.

Director emeritus of the Albertina from 1962.

President of the Austrian National Committee and Member of the Board of the International Council of Museums (ICOM); Member of the Board, later Honorary Member of the Comité International d'Histoire de l'Art (CIHA); President of the Austrian chapter of the Association Internationale des Critiques d'Art (AICA); Member of the Board of Directors of the Wiener Konzerthausgesellschaft.

Officer of the Légion d'Honneur; Knight of the Order of Oranje-Nassau, and of the Order Léopold II; Österreichisches Ehrenkreuz für Kunst und Wissenschaft I. Klasse.

Died from a heart attack, November 16, 1964.

Photo Fayer, Vienna

OTTO BENESCH

"From the Scholar's Workshop"

I consider it a rare stroke of good fortune which gave me Max Dvořák as a teacher and thus the opportunity of experiencing, in my youth, the guidance of a truly great intellect and man. Max Dvořák introduced me to the strict and pragmatic spirit which regards the history of art as a historical discipline, far removed from all aesthetic essayism. The sole foundation of this scientific method of approach is the view that the work of art is a statement and the literary evidence its meaningfully interpreted source. This school of thought was represented by Dvořák and Julius von Schlosser, following Franz Wickhoff and Alois Riegl. A few months after Dvořák's death, I graduated under Schlosser. The theme of my thesis, "Rembrandt's Development as a Draughtsman until 1634", was suggested by Dvořák, who was at the time giving seminars on Rembrandt's drawings. Dvořák emphasized the importance of close contact with the work of art as a primary source, and thus often held seminars with his pupils in the museums. Participation in these discussions gave me the first impetus for my main work, the corpus of Rembrandt drawings which appeared in London in six volumes from 1954 to 1957.

In 1920, even before I had graduated, I joined the Gemäldegalerie in the Kunsthistorisches Museum in Vienna as an assistant, and there the outstanding Rubens scholar, Gustav Glück, introduced me to practical connoisseurship, for which I was said to have a particular gift. My fondness for drawings led me to spend many hours in the Albertina and to benefit from Joseph Meder's extensive practical experience of drawings and graphic art. In 1923, Alfred Stix offered me an appointment at the Albertina, and apart from the years when the National Socialist Government was in power, I have remained there ever since.

In spite of my scientific orientation towards the concrete artistic fact, it was not in my nature to restrict myself to a limited, specialized area. In fact, I was saved from this by the breadth of my interests, also in other disciplines, which were encouraged by my professor's universal approach as well as by the universal character of the collections in which I was active. Beside my research on Rembrandt and Netherlandish art, there was another subject which had engrossed me since my student days, early German art, particularly the Danube School. As my investigations in this field had been fortunately accompanied by many new finds, I wrote a number of long and short treatises on the subject, among which I should like to mention those dealing with fifteenth-century Viennese painting, Jörg Breu and Lucas Cranach's years in Austria, and the rediscovery of Erhard Altdorfer as a painter. Three books also emerged from this work, *Oesterreichische Handzeichnungen des 15. und 16. Jahrhunderts* (1936), *Albrecht Altdorfer als Maler* (1939) and *Der Meister der Historia Friderici et Maximiliani* (1957). I found Italian and German

Baroque painting no less fascinating, and endeavoured to approach my central problem, Rembrandt, through the medium of his universal sphere of influence.

After five years, my research work in the Albertina resulted in the catalogue of Netherlandish drawings of the fifteenth and sixteenth centuries. This was followed by further work on catalogues, together with a programmatic compilation of the graphic collection and numerous catalogues for exhibitions in the Albertina. To me, painting, drawing and graphic art form a whole, each of them throwing light on the others. Max J. Friedländer's pioneer work of research in early Netherlandish and early German art I regarded as exemplary. I started my publishing activity in the *Mitteilungen der Gesellschaft für vervielfältigende Kunst* and the *Wiener Jahrbuch für Kunstgeschichte* already during my University studies. I followed these with publications, some of them as extensive as books, in the *Staedel-Jahrbuch*, the *Jahrbuch der Preussischen Kunstsammlungen*, the *Münchner Jahrbuch*, the *Wallraf-Richartz-Jahrbuch* and in other foreign professional journals.

From my earliest days I was most familiar with the art of the nineteenth century and contemporary art. I was brought up in artistic circles—Egon Schiele was a friend in my early youth; thus, it was from this point of view that I approached earlier art, and much of what I had learnt from my contact with living artists proved a key to the understanding of the art of the past. While, up to Dvořák's time, the Vienna School had concerned itself mainly with the history of the development of art, I realized that the main task confronting our discipline was to recognize the work of art as a world of its own.

In spite of an almost overwhelming variety of practical research projects, I did not lose the desire for theoretical summing up and passing on my findings academically. My links with the University had been broken by the death of my professor. In 1937, when I submitted my publications on Austrian art to the Board of the Technische Hochschule in Vienna, in order to obtain an academic post, the shadow of 1938 was already upon us, and I did not succeed. The fall of Austria in that year forced me to leave my native country and seek a new centre of activity in lands familiar to me only from my travels. In 1940, after two years spent in France, Holland and England, I accepted an invitation to go to the United States, where I remained until 1947, when I was recalled to Vienna by the Austrian Government, to take up the post of Director of the Albertina. I have also been teaching at Vienna University since 1948, when I became a professor.

But the sad lot of the refugee also had its brighter side. My unbroken association with Harvard University, where I was a Research Fellow at the Fogg Art Museum, enabled me to continue my work on Rembrandt in the research centre for drawings set up by Paul J. Sachs and, fortunately, despite all vicissitudes, I had managed to save my photographic material in its entirety.

Two consecutive Guggenheim Fellowships and two terms at the Institute for

Advanced Study in Princeton enabled me to devote the necessary concentration to my main research project and bring it to its conclusion. My years of emigration also gave me the opportunity of studying the treasures of Western museums and collections. I was also offered the long-desired chance of academic teaching, although not in my mother-tongue. Resisting the temptation to do as so many, even prominent, refugee scholars had done, and to put my experience at the service of the art market, I was determined, from the first, to choose teaching as a basis of living. I taught at Harvard University, New York University and Wellesley College. I also gave visiting lectures at Yale, Fordham, Princeton, Johns Hopkins, Wesleyan and Chicago Universities, Dumbarton Oaks, Smith and Vassar College and innumerable other academic institutions. The visiting lectures I had already given at the University of Cambridge, England, were a good preparation for this, at least from the linguistic point of view.

Teaching in America was deeply satisfying because of the liveliness and receptivity of the audiences. The general lack of knowledge of the art of Central Europe which existed at the time led me to make a speciality of this in courses and seminars. The result of my lectures were two publications in book form, one of which, *The Art of the Renaissance in Northern Europe* (Harvard University Press 1945; London 1965), is chiefly devoted to the problems of German art of the sixteenth century.

I am continuing my researches into Rembrandt, which were marked by a series of treatises and several books, after and beyond the completion of my newly-finished corpus. My return home to my old field of activity also inspired many new projects relating to the history of Netherlandish, French and German art, and I hope I will be able to bring these to a successful conclusion.

Otto Benesch

Acknowledgements

Grateful acknowledgements are made to the following scholars, private collectors and to the directors and staff of museums and institutes for valuable help in providing information and for permission to reproduce photographs of works of art in their collections.

AMSTERDAM: Rijksmuseum, Dr. A. F. E. van Schendel, Hoofddirecteur; Rijksprentenkabinet, Dr. K. G. Boon, Director, Miss L. C. J. Frerichs; University, Professor Dr. J. Q. Van Regteren Altena.

BARCELONA: Instituto Amatller de Arte Hispánico, Professor José Gudiol.

BERLIN-DAHLEM: Staatliche Museen, Gemäldegalerie, Prof. Dr. Robert Oertel, Director, Dr. Ernst Brochhagen, Konservator; Print Room, Prof. Dr. Hans Möhle, Director, Dr. Fedja Anzelewski, Oberkonservator.

BERNE: Mr. Eberhard Kornfeld.

BRAUNSCHWEIG: Herzog Anton Ulrich-Museum, Dr. Gert Adriani, Director.

BREMEN: Kunsthalle, Print Room, Dr. Christian v. Heusinger, Kustos.

BRUSSELS: Musées Royaux des Beaux-Arts, Monsieur Philippe Roberts-Jones, Conservateur en Chef.

BUDAPEST: Museum of Fine Arts, Dr. Klara Garas, Director.

CAMBRIDGE, MASSACHUSETTS: Professor Dr. Arthur Burkhard; School of Architecture, Harvard University, Prof. Dr. Eduard F. Sekler.

CLEVELAND, OHIO: The Cleveland Museum of Art, Dr. Sherman E. Lee, Director.

COLOGNE: Wallraf-Richartz-Museum, Prof. Dr. Gert von der Osten, Director General; Dr. Othmar Metzger, Kustos.

DRESDEN: Staatliche Kunstsammlungen, Gemäldegalerie, Dr. Henner Menz, Director; Print Room, Dr. Werner Schmidt, Director.

FLORENCE: Casa Buonarroti, Prof. Dr. Charles de Tolnay, Director.

FRANKFORT ON MAIN: Städelsches Kunstinstitut, Prof. Dr. Ernst Holzinger, Director; Dr. E. Heinemann, Konservator.

GRONINGEN: Rijksuniversiteit, Prof. Dr. Horst Gerson.

THE HAGUE: Rijksbureau voor Kunsthistorische Documentatie, Dr. S. J. Gudlaugsson, Director.

HEIDELBERG: University, Prof. Dr. Eduard Hüttinger.

KARLSRUHE: Staatliche Kunsthalle, Prof. Dr. Jan Lauts, Director.

KROMERIZ (Kremsier), CZECHOSLOVAKIA: Museum of Fine Arts, Dr. Karl Togner.

LONDON: British Museum, Department of Prints and Drawings, Mr. E. F. Croft-Murray, Keeper, Mr. J. A. Gere, Assistant Keeper, Mr. J. Rowlands, Assistant Keeper; National Gallery, Sir Philip Hendy, Director em., Mr. Martin Davies, Director; Buckingham Palace, Mr. Oliver Millar; The Warburg Institute, Professor Dr. Ernst H. Gombrich, Director, Dr. J. B. Trapp, Chief Librarian; Count Antoine Seilern; Mr. Philip Pouncey.

MADRID: Museo del Prado, Prof. Dr. Francisco J. Sánchez-Cantón, Director, Dr. A. E. Pérez-Sánchez, Conservador.

MOSCOW: University, Fine Arts Department, Dr. Michael Liebmann.

MUNICH: Staatliche Graphische Sammlung, Dr. Wolfgang Wegner, Oberkonservator.

NEW YORK: Metropolitan Museum of Art, Mr. James J. Rorimer, Director, Mr. Theodore Rousseau, Curator of Paintings, Dr. Claus Virch, Curator; The Pierpont Morgan Library, Miss Felice Stampfle, Curator; Professor János Scholz.

OLDENBURG: Landesmuseum, Dr. H. W. Keiser, Director.

PARIS: Musée du Louvre, Département des Peintures, Madame Sylvie Béguin, Conservateur, Cabinet des Dessins, Monsieur Maurice Sérullaz, Conservateur en Chef, Mlle Roseline Bacou, Conservateur; Bibliothèque Nationale, Monsieur Jean Adhémar, Conservateur en Chef; Institut Néerlandais, Monsieur Frits Lugt.

PRAGUE: National Gallery, Dr. Jan Krofta, Director em., Dr. Ladislav Kesner; Institut de la Théorie et d'Histoire de l'Art, Prof. Dr. Jaromir Neumann.

RALEIGH, NORTH CAROLINA: The North Carolina Museum of Art, Dr. Justus Bier, Director, Miss Nina Kasanof.

ROTTERDAM: Museum Boymans-Van Beuningen, Dr. J. C. Ebbinge-Wubben, Director; Department of Drawings, Dr. H. R. Hoetink, Keeper.

STOCKHOLM: Nationalmuseum, Prof. Dr. Carl Nordenfalk, Director; Print Room, Dr. F. D. Per Bjurström.

TORONTO: University, Fine Arts Department, Prof. Lee Johnson.

VADUZ: Sammlungen des Regierenden Fürsten von Liechtenstein, Dr. Gustav Wilhelm, Director.

VIENNA: Akademie der Bildenden Künste, Gemäldegalerie, Dr. Margarethe Poch-Kalous, Director, Dr. Heribert Hutter; Graphische Sammlung Albertina, Dr. Walter Koschatzky, Director, Dr. Alice Strobl, Kustos, E. Lünemann, Photographer; Kunsthistorisches Museum, Dr. Erich M. Auer, Director General, Gemäldegalerie, Dr. Friderike Klauner, Director, Dozent Dr. Günther Heinz; Österreichische Galerie, Prof. Dr. Fritz Novotny, Director, Dr. Hans Aurenhammer, Kustos; Österreichische Nationalbibliothek, Dr. Josef Stummvoll, Director General em., Dr. Rudolf Fiedler, Director General, Hofrat Dr. Karl Kammel, Hofrat Dr. Ernst Trenkler, Hofrat Dr. Franz Unterkircher; Historisches Museum der Stadt Wien, Dr. Franz Glück, Director em.; Niederösterreichisches Landesmuseum, Prof. Dr. Rupert Feuchtmüller.

WASHINGTON, D.C.: National Gallery of Art, Dr. John Walker, Director; Dr. Perry B. Cott, Chief Curator.

Selected Bibliography
including Abbreviations

B. (in reference to etchings): A. Bartsch, *Catalogue raisonné de toutes les estampes qui forment l'œuvre de Rembrandt . . .*, Vienna, 1797.

B-B.: G. Biörklund and O. H. Barnard, *Rembrandt's Etchings, True and False*, Stockholm–London–New York, 1955.

K. BAUCH: Kurt Bauch, *Rembrandt, Gemälde*, Berlin, 1966.

BENESCH (in reference to drawings): O. Benesch, *The Drawings of Rembrandt*, vols. I–VI, London, 1954–57.

BENESCH, *Rembrandt, Werk und Forschung*: O. Benesch, *Rembrandt, Werk und Forschung*, Vienna, 1935.

O. BENESCH, "Rembrandt Harmensz. van Rijn" in Thieme und Becker, *Allgemeines Lexikon der Bildenden Künstler*, vol. XXIX, Leipzig, 1935, pp. 259 ff.

O. BENESCH, *Rembrandt, Selected Drawings*, London and New York, 1947.

O. BENESCH, *Rembrandt as a Draughtsman*, London, 1960 (*Rembrandt als Zeichner*, London–Cologne, 1963).

BENESCH, *Meisterzeichnungen der Albertina*: O. Benesch, *Meisterzeichnungen der Albertina*, Salzburg, 1964. (Master Drawings in the Albertina, Greenwich, Conn.–London, 1967.)

BENESCH, *Verzeichnis seiner Schriften*: O. Benesch, *Verzeichnis seiner Schriften*, Zusammengestellt von Eva Benesch, mit einem Vorwort von J. Q. Van Regteren Altena, Berne, 1961.

E. BOCK–J. ROSENBERG: E. Bock und J. Rosenberg, *Staatliche Museen zu Berlin, Die Zeichnungen alter Meister, Die niederländischen Meister*, Berlin, 1930.

BODE: W. Bode, *Rembrandt, Beschreibendes Verzeichnis seiner Gemälde mit den heliographischen Nachbildungen*, vols. I–VIII, Paris, 1897–1905.

BREDIUS (in reference to paintings): A. Bredius, *The Paintings of Rembrandt*, Vienna, 1935; Second edition, Vienna–London, 1937; third edition, revised by H. Gerson, London, 1969.

BURL. MAG.: *The Burlington Magazine*, London, 1903, vol. 1 ff.

DG (in reference to paintings): C. Hofstede de Groot, *A Catalogue Raisonné of the Works of the Most Eminent Dutch Painters of the 17th Century*, vol. VI, London, 1916.

GAZ. d. B.-A.: *Gazette des Beaux-Arts*, Paris, 1859, vol. 1 ff.

GRAPH. KÜNSTE: *Die Graphischen Künste*, Vienna, 1879, vol. I ff.

H d G (in reference to drawings): C. Hofstede de Groot, *Die Handzeichnungen Rembrandts*, Haarlem, 1906.

HENKEL: M. D. Henkel, Catalogus van de Nederlandsche Teekeningen in het Rijksmuseum te Amsterdam, Vol. I, Rembrandt, s' Gravenhage, 1943.

HIND or H. (in reference to etchings): A. M. Hind, *A Catalogue of Rembrandt's Etchings*, London, 1923, vols. I, II.

C. HOFSTEDE DE GROOT: see dG and HdG.

HOLLSTEIN: F. W. H. Hollstein, *Dutch and Flemish Etchings, Engravings and Woodcuts*, vol. I ff., Amsterdam, 1949.

Jb. d. Kh. SLGEN: *Jahrbuch der Kunsthistorischen Sammlungen*, Vienna, 1883, vol. I ff.; Neue Folge, 1926, vol. I ff.

Jb. d. PREUSS. KUNSTSLGEN: *Jahrbuch der Preussischen Kunstsammlungen*, Berlin, 1880, vol. I ff.

Jb. f. KW.: *Jahrbuch für Kunstwissenschaft*, Leipzig, 1924, vol. I ff.

Kl. d. K.: *Klassiker der Kunst*, Stuttgart–Leipzig (Berlin–Leipzig).

LIPPMANN I–IV: *Original Drawings by Rembrandt*: I Series, Berlin 1888–92; II Series, The Hague 1898–1901 (F. Lippmann, continued by C. Hofstede de Groot); III Series; IV Series, The Hague 1903–11 (C. Hofstede de Groot).

LUGT, or L. (preceding numbers): Frits Lugt, *Les Marques de Collections de Dessins et d'Estampes*, Amsterdam, 1921; Supplément, The Hague, 1956.

LUGT, INV. GÉN. III: *Musée du Louvre, Inventaire Général des Dessins . . . École Hollandaise*, par Frits Lugt, vol. III, Rembrandt, Paris, 1933.

MITT. or MITTEILUNGEN d. GES. f. VERV. KUNST: *Mitteilungen der Gesellschaft für vervielfältigende Kunst, Beilage der Graphischen Künste*, Vienna.

MÜNCHNER Jb. d. BILD. KUNST: *Münchner Jahrbuch der Bildenden Kunst*, Munich, 1906, vol. I ff.

MÜNZ: L. Münz, *Rembrandt's Etchings*, Vols. I, II, *A Critical Catalogue of Rembrandt's Etchings*, London, 1952.

C. NEUMANN: *Aus der Werkstatt Rembrandts* (Heidelberger kunstgeschichtliche Abhandlungen 3), Heidelberg, 1918.

C. NEUMANN: *Rembrandt*, Munich, 1924, 4th ed., 2 vols.

OMD: *Old Master Drawings*, London, 1926, vol. I ff.

ONZE K.: *Onze Kunst*, Antwerp, 1902, vol. I ff.

OUD H.: *Oud Holland*, s'Gravenhage, 1883, vol. I ff.

REP. f. KW.: *Repertorium für Kunstwissenschaft*, Vienna (later Berlin), 1876, vol. I ff.

J. ROSENBERG: *Rembrandt*, Cambridge, Mass., 1948, 2 vols.; *Rembrandt, Life and Work*, London 1964, I vol. (revised edition).

ROVINSKI: D. A. Rovinski, *L'Oeuvre Gravé de Rembrandt*, St. Petersbourg, 1890, vol. I ff.

SEIDLITZ: W. v. Seidlitz, *Die Radierungen Rembrandts*, Leipzig, 1922.

THIEME–BECKER: U. Thieme und F. Becker, *Allgemeines Lexikon der Bildenden Künstler*, Leipzig, 1907, vol. I ff.

VALENTINER or VAL. (in reference to drawings): Wilhelm R. Valentiner, *Rembrandt/Des Meisters Handzeichnungen*, vols. I, 2, Klassiker der Kunst, vols. 31, 32, Stuttgart–Berlin.

W. R. VALENTINER: *Rembrandt, Des Meisters Gemälde*, Klassiker der Kunst, vol. II, 3rd edition, Stuttgart–Leipzig, 1909.

WILHELM R. VALENTINER: *Rembrandt, Wiedergefundene Gemälde*, Klassiker der Kunst, vol. 27, Berlin–Leipzig, 1923.

VASARI SOC.: *The Vasari Society for the Reproduction of Drawings by Old Masters*, Oxford, 1st series, 1905 ff.; 2nd series, 1920 ff.

VERZEICHNIS SEINER SCHRIFTEN: see O. Benesch, *Verzeichnis seiner Schriften* . . .

ZEITSCHR. f. BILD. KUNST: *Zeitschrift für Bildende Kunst*, Neue Folge, Leipzig, 1890, vol. I ff.

See also the *Bibliography* to Rembrandt in O. Benesch, *The Drawings of Rembrandt*, vol. I, pp. XV–XVIII, and XIX.

Miscellaneous Abbreviations

CAT.	-	Catalogue
COLL.	-	Collection
INV.	-	Inventory

Rembrandt and the Problems of Recent Research

I N his most recent work,[1] Carl Neumann broaches two important problems, both crucial for the present development of art-historical studies, and both more evident in the study of Rembrandt's art than anywhere else. These are the problems of methodology and of critical analysis. The first is dealt with in the chapters "Rembrandt as a Monumental Painter" and "Rembrandt and Artistic Tradition", and the second in "On the Criticism of the Drawings".

"Rembrandt as a Monumental Painter" is a discussion of a single work, *The Conspiracy of Julius Civilis* (Bredius 482; fig. 2) in the National Museum, Stockholm. This chapter expresses the views of a great movement which is sweeping through art history today, demanding a radical change in our attitude. This new movement rejects the dogmatic pragmatism of the past century in favour of a method which does not regard analysing the "chain of development" as the ultimate aim of art history. This movement represents a departure from the strictly evolutionary approach, which sets a coherent genealogy above the individual manifestation of human genius, values the chain more than the links and which discards a work of art as soon as its artistic and spiritual past, present and posterity have been elucidated. The art historian of this old school takes from each individual work only what he needs for his theoretical construction, that is, for a system based upon categories of his own formulation, without any connection with historical reality. For the disciple of the new methodology, however, each individual work is an inexhaustible wellspring; he will never drain it dry, never touch bedrock, and can never do more than try to plunge in deeper and deeper. At least, this is what happens in reality. As time goes on, of course, the art historian will come closer to his ideal aim of total disclosure, but he will never quite succeed. It is a continuous and ever-continuing task. This is because such a scholar does not see the individual work of art merely as a clue to the whole, as something which is devoid of interest as soon as the whole has been grasped and established; for him, each work he studies is an inexhaustible source of experience, the germ, motive power and purpose of all his theoretical work, the thing he endeavours to approach as closely as possible.

The demand for a new methodology has not yet received an unequivocal response, although various solutions have been put forward. For instance, in connection with Dilthey's descriptive psychology "Description and Analysis", Heidrich demanded the kind of analysis "which results automatically when art is considered within the context of the whole life of a nation, as part of the nation's fund of living, its creative ability".[2] An alternative solution can be found in a new historico-

philosophical approach to the history of art. But however much these solutions appear to diverge, they share the same ideal orientation: they both attribute a new importance to the individual historical fact, and to the work of art as an individual phenomenon, not merely as a link between historical abstractions and logically necessary chains of development.

Our present position results from the development of the historical humanities during the last few decades. The nineteenth-century pragmatists regarded the whole process of history as an endless fabric, woven from the closest of causal connections, and issuing from a single source, while, according to Riegl's system, all historical events have one deep-lying, common undercurrent which runs from the extreme objectivism of primitive art to the extreme subjectivism of the present day, and this was an early intimation of a grandiose historico-philosophical synthesis. Rickert, on the other hand, considers that the idiographic historical studies should concentrate on whatever is unique and transient.

Whenever we trace the course of a new historical idea and its causality, the way it bridges the gap between isolated events, we can observe that, after all, such ideas do have starting-points, and do emerge somewhere for the first time. In other words, their appearance is not necessarily explicable only on the basis of that causal necessity connecting the different phases. Their entrance into the world can be attended with as much puzzling mystery and irrationality as a unique event in history, and so may their departure, and this is the origin of our concept of development as a chain where every newly-evolving idea is a unique historical event. The more sharply we differentiate between the instruments of our historical researches, the more delicate the nuances of historical reality we learn to perceive, the more the sequences of development, which seemed, at first, to span long periods, will branch off into smaller, narrower and less general lines of development until, eventually, we will find the ideal, non-dimensional point, the historical event itself, in all its mystery, fortuitousness and inexplicable fatefulness. The new methodology tries to do justice to these aspects of historical existence, whether by analytical description and colourful animation as in Heidrich's work, or as in Georg Lukács' new metaphysical philosophy of history.[3] It is obvious how it has been logically derived from the pragmatic approach to history.

Neumann also attempts to do justice to the element of irrationality, to that which is inaccessible to deductive thought in the fabric of historical life, whether in the society as a whole, or in the individual case. As he puts it in his introduction, he has no desire to discuss "the development of artistic forms and their apparently independent life", nor the "development of any individual artist's career". "The course of the individual's life and art leads over hills and valleys", it is not a continuous and progressive line, but wavers, full of breaks and digressions. Neumann is convinced that there are moments of crisis and change which lead an artist to desert

his previous path, such as, for instance, produced Rembrandt's *Night Watch* (Bredius 410; fig. 9). The works of art that followed it were quite different. But before postulating such "breaks" in an artist's career, we must first ask what method of approach would put us in a position to recognize them as such and analyse them.

In Riegl's view,[4] *The Night Watch* was painted at the height of Rembrandt's pursuit of Baroque subordination in the group portrait, and he regards the works that followed it as a logical development; in other words, *The Night Watch* was a necessary step towards Rembrandt's ultimate achievement of an artistically quite different goal. Neumann, who sees an irrational vacillation at this point, regards Rembrandt's later art as "a kind of atonement for *The Night Watch*", which "treacherously bubbles forth all of Rembrandt's secret ambition, and, in his youth, he did not aim low". Neumann is not only applying here a value system so subjective that it views Romanism and Italian Baroque as something alien; he even assesses them negatively, together with everything in any way related to them. Indeed, he also considers that this gives him the right to postulate "changes" and "breaks" wherever the enigmatic and mysterious uniqueness of historical events emerges into the light. Thus, in his opinion, Rembrandt's career as an artist can be divided into two halves, the first of which was spent striving after goals that seem to have been alien to him. However, any other theory based on similarly subjective and qualitative arguments would be equally justified in placing the caesura at almost any other juncture.

At this point, the question arises whether we are justified in completely emancipating ourselves from evolutionary thinking, to the extent of removing its strictures from subjective value-judgements or from the categorizing of a theoretical system, whichever is relevant. In the second case, we would only achieve another system of aesthetics, and nothing methodologically new would have transpired; in the first, we would have to sacrifice every scientific and objective method. It is obvious that another approach must be found. Either the evolutionary approach must be made so sensitive that chains of events hitherto regarded as one unit can be revealed as complex sequences of inwardly incommensurable and unrelated events, connected only chronologically, not causally, or we must take the path of pure induction and try to analyse the essence and individuality of a work of art. The latter of these two methods would enable us to blaze a trail to a truly idiographic concept of art history and, furthermore, to a new philosophy of history where events are not forced to conform to a preconceived deductive system, but are combined to make a new, meaningful synthesis without jeopardizing their deep-lying independence and individuality. Neumann begins his discussion by analysing one work only, and the extent to which he has furthered our efforts to find a new method remains doubtful. In his opening paragraph, he relates the story of the painting he has chosen. For a long time its content was a subject of the most varied speculation, until De Roevers

discovered a document and linked it with a hitherto overlooked passage in Fokken's description of Amsterdam. The painting was then identified as *The Conspiracy of Julius Civilis* (Bredius 482; fig. 2), the work Rembrandt had painted in 1662 for the cycle of scenes from the wars of the Batavians and the Romans intended for the large gallery of the new City Hall in Amsterdam. However, as early as 1663, the painting had been taken down and replaced by a work by Juriaen Ovens. Neumann suggests, plausibly enough, that matters had come to a head between Rembrandt and the officials who had commissioned the work, because the latter were insisting on various alterations. Thus Neumann even tries to explain the revision of the painting as being due to its vicissitudes.

After these preliminary remarks, Neumann turns his attention to an analysis of the work itself, beginning with a comparison between it and another of Rembrandt's paintings, which has a similar composition, *The Syndics* (Bredius 415; fig. 1), executed at very much the same time. Neumann goes so far as to say that it is the "twin of *Julius Civilis*".[5]

There are, in fact, many points of comparison between the two paintings. For instance, if we compare *The Syndics* with the *Julius Civilis* in its original form, as it appears in the drawing in Munich (Benesch 1061; fig. 6), we can see that they not only have the same arrangement of a group of people around a table, but that they also share the peculiarity of having an empty space in the centre of the composition, in the main plane. In the *Julius Civilis*, this centre point is, paradoxically enough, a completely empty space to the right of the figure of Civilis, the point towards which the swords and goblets seem to be aiming. It is situated precisely in the middle axis of the space framed by the two lion statues. The central point of the pictorial plane of *The Syndics* is also an open space, that is, the gap between the two seated Syndics in the centre, with the servant in the background behind them.[6] Purely from the point of view of their arrangement in the pictorial plane, and disregarding their position in space, the figures of these three men form a low triangle which would dominate the painting, were it not for the figure of the standing Syndic. The plastically tangible culmination point of both compositions—in one, the standing Syndic, in the other, Julius Civilis himself—is slightly displaced to the left of the compositional centre, and is, in both cases, the only figure looking at the spectator and making contact with him.

Neumann speaks of the "magical power concentrated in Julius Civilis by the touch of so many hands, the gaze of so many eyes, and which surges back from him in a foaming wave". This description is not accurate, and makes it sound as if the protagonist were dominating the rest in an egoistic way. But if we follow the conspirators' lines of vision, we discover that they are not (with two exceptions) focusing on the figure of Civilis, but on the point where the swords cross. This is the ideal centre of the painting, a symbol of the enormous energies pent up in the

scene, energies, however, which are not being discharged in violent action and violent deeds, but whose potential can only be sensed in the deep, thoughtful watchfulness of the faces turned towards the blade. We can see here the suppressed movement of the old Rembrandt which replaced the lively activity of his youth. There is also a feeling of hesitation, of pause in a movement, of reluctance, which gives us a superbly clear sense of the spiritual process generating the movement. At the same time, this movement is frozen and we can see its past and its future, that is, the state of mind engendering it. In fact, it springs from a higher reality and not from the character of Julius Civilis, who meets the spectator with his gaze, and merely has the impersonal function of communicating this reality to the outside world.

The speaker in *The Syndics*, whose words are the ideal centre-point of the painting, has very much the same function. He does not overshadow his colleagues in an egoistic way, but acts as the interpreter of a matter of more than individual, that is, of mutual interest. He is the mediator of a reality which binds the rest of the figures in close, unspoken understanding, as inward as the calm objectivity of their gaze, levelled at the spectator, is outward. Riegl interprets this look as softened by benevolence.

In *The Syndics*, internal and external awareness are of equal importance, and equally weighted; indeed, they even interact. In other words, by providing a direct contrast, the external awareness intensifies the internal and makes us doubly conscious of it. Neumann grossly misunderstands this painting when he calls this external awareness a "novelistic device", and complains that it has only been brought in as a "spice" to "flavour the somewhat insipid task of painting a group portrait, and to enliven it with the superficial appeal of an integrated picture". In his opinion, colour played the main part in solving the problem.

Neumann is equally unclear about the inner unity of the *Julius Civilis*. For instance, he describes the group of three men in front of the table as a configuration which, "psychologically, adds little to the action", and attributes to them the purely formal role of providing "foreground support, to enhance the illusion of space". In reality, however, this group contributes enormously to the construction of the inner unity of the painting: it helps to intensify the solemn silence of the conspirators, and to illustrate their remoteness from the world and the fateful significance of their oaths. And how vividly Rembrandt conveys to us the feelings of these men, and their silent devotion, even though we cannot see their faces! One of the old Rembrandt's most effective devices was to impress the spectator all the more forcefully by concealing what he was trying to say. By averting the faces of his figures, or by causing them to petrify in those characteristic masks or dissolve into patches of light, Rembrandt conveyed a much more vivid sense of the profound emotions throbbing through them. There is a formal analogy to this technique in

Rembrandt's power to suggest space; the more he conceals it with optical planes, the more vividly he reveals its true depths.

Neumann's description of the strange old man at the right of the painting shows a similar insensitivity to the inner integrity of the scene: he interprets him as a representative of doddering, childish old-age, a figure tagged on to the solemn composition to heighten the illusion of reality, with no further function at all. "Why should there not also be, in this portrayal of a scene from life, a figure which has no 'role'? Rembrandt felt the same about these things as Shakespeare." Once again we meet that well-worn, but rarely tested comparison with the great dramatist; commentators often overlook the fact that Shakespeare, like Cervantes, was a representative of the age of Mannerism, and nothing could be more foreign to the compositions of this period than a device designed to enhance the illusion of real life by adding irrelevant objects to serve as a framework for the main action. In fact, this type of subjective illusionism was an achievement of the post-Shakespearean period. Rembrandt knew and used it during the 'thirties and early 'forties. So even though Shakespeare outgrew the limitations of his age, and developed far beyond the conventions of Mannerism, he was not moving towards an anachronistic anticipation of the trends which a later generation were to develop. His characters cannot be divided neatly into main and subsidiary parts, nor can we legitimately distinguish between main actions and the subsidiary actions which provide the illusionistic framework. Every scene and every action has equal importance, they run parallel and interact, thus providing the fabric of a huge polyphony more akin to the art of the elder Bruegel. Bruegel, a far better subject for comparison with Shakespeare than Rembrandt, lived at the beginning of the period to which the playwright belonged.

That use of illusion to heighten the reality of life which Neumann finds in *Julius Civilis* is just as alien to the art of the late Rembrandt. He, too, achieved a polyphony, but one that was different from that of Bruegel and Shakespeare. In Rembrandt's early period, his paintings had *one* main action forming the theme, and the subsidiary motifs accompanying it, in spite of their apparent divergence, only served to emphasize it. In the compositions of his old age, however, every figure, no matter how fragmentary, is of equal importance and is as passionate and inwardly willing an instrument of the event depicted. The only difference is that this polyphony is welded into one entity by the subjectivity of a dominant, all-pervading spiritual mood. Thus, when the classical columns and rectangles of Rembrandt's late compositions are submerged, with all their enigmatic, dark potential, deep into the unity of one prevailing spiritual mood, their polyphony becomes a grand homophony. This homophony produced by the complete submergence of an event more intimated in its spiritual potential than described in its outward processes, is what distinguishes the style of Rembrandt's late period from the polyphony of the

action in Shakespeare's plays. While these latter also form one great whole, they are bound together by omnipresent life, not by a subjective mental mood.

When he comes to pictures of "the Virgin, the Saints, St. Jerome and St. Francis which Rembrandt painted in Calvinist Holland", Neumann asks "what these Catholicizing manifestations mean", and comes to the conclusion that "we must content ourselves with finding no answer". In fact, the force that attracted the element of the miraculous—so alien to Protestantism—into Rembrandt's orbit, was equally alien to Roman Catholicism. It was not an event in Rembrandt's everyday life, but the extreme of psychic subjectivity which led him to these quiet figures of saints and men at prayer, rapt and worshipping, to these monks and nuns, whose inner spiritual life has set their features, framed in characteristic costumes, in an immovable mask of awe-inspiring expressiveness, and to the wonderful, Dostoyevskian head of a Russian pilgrim that Bode[7] published in 1917 (Bredius 284). Rembrandt's Catholicism is very unorthodox, and borders on the sectarian, like that of Grünewald.

In his introduction, Neumann stresses that he is not concerned with the "development of artistic forms" nor the "development of an individual artist's life", but with "penetrating into the development of a masterpiece", and at this point he turns to the history of *Julius Civilis*, and discusses the four sketches preserved in Munich. It would not have been unreasonable to expect a description of the genesis of the pictorial idea, and an outline of the progressive stages it went through in the artist's mind before completion, as illustrated in the drawings, but this is not done. After referring to a text in Tacitus (*Historiae* I, 59; IV, 13–15) to explain the content, Neumann proceeds directly to a discussion of the individual drawings, beginning with HdG 409, Benesch 1061 (fig. 6) the last preparatory sketch for the finished painting. Then he takes HdG 412, Benesch 1060 (fig. 4) the first sheet with a clear conception of the group of conspirators round the banquet table, and rounds off the discussion with HdG 410, Benesch 1059 (fig. 5) and HdG 411, Benesch 1058 (fig. 3) without mentioning the chronological relationship between the latter two, which is essential for any real insight into the origin of the work.

Drawings are, in some respects, rather like ancient documents and archives; for one thing, it is essential to read them correctly and then to put the right construction upon what has been read. But the ability to "read" old drawings correctly is a rare quality, and Hans Kauffmann has produced reasonable and convincing evidence that Neumann did not "read" the drawings in Munich with sufficient care.[8] But, to return to Neumann's final conclusion—that the painting was revised after being reduced in size—my opinion on this point is not based upon external historical factors, which do little to assist us here, but upon the evidence supplied by an interpretation of the works of art themselves and the sequence of ideas behind

them, judging purely from my knowledge of Rembrandt's late art. This evidence does not support Kauffmann's interpretation.

The first problem Rembrandt tackled was not the task of arranging the figures in a group, but their disposition within a large, overwhelming area of space. In the earliest of the drawings, Benesch 1058 (fig. 3),[9] he solved this by basing the composition upon a physically perceptible volume, as round and compact as a bell. We see through the curve of an arch into the room where the conspirators have gathered. It is presented in true Baroque fashion as a rotunda with a cupola supported on an arcade, and it has an enormous circular canopy hanging over the scene like a lid and enhancing the feeling of concentric rings of space, enclosed on all sides. This technique of making one volume stand out from the fluid space surrounding it by using a physical object to mark the boundary—in this case, a canopy which functions as the top of an immaterial, invisible, cylindrical drum, as fantastic and unreal as a halo, hovering above the scene—is a technique ultimately aimed at emphasizing the spiritual significance of the event, and is something Rembrandt learned from German art. I am thinking particularly of the Danube School, where such an enormous part is played by the wheel rotating in space, the circular form either bringing out the enclosed space, or pushing it back; we are reminded, for instance, of *Pilate washing his Hands* in Altdorfer's passion cycle, of the same painter's *Birth of the Virgin Mary in the Church*, or of his *Holy Family round the Font*, although, in this latter example, the rotating form manifests itself as an earth-bound, not as a floating form. We can also find these "wheels" in late Gothic German churches, as a manifestation of a free sense of space which is concentric, or revolving upon itself.

The group of figures is strangely displaced into the left half of the picture. There is one essential difference between this and all other versions (as Kauffmann observed): the entire group is placed in front of the table, which runs its whole length behind them. The figure of the man kneeling before Civilis does not appear again in the other drawings.

The treatment of space also gives us some clues to the chronological order of the drawings. For instance, the idea of a room with a cupola, broken up by arcades, is still foremost in Benesch 1060 (fig. 4), a drawing which has unfortunately not only been trimmed, but, as Kauffmann emphasizes, cut all round. There can, however, be no question of the figures in the uncut original having been located right at the edge of the sheet, in the immediate foreground, as Neumann supposes. But even Kauffmann's proposal that we should enlarge the 107 × 105 mm fragment to measure 175 × 160 mm and thus make the group the same size relative to the whole as the rest of the drawings, is impracticable. The arcades are what give us the scale, and the figures are larger in relation to them here than in any of the other drawings. In any case, if the sheet had originally been as large as Kauffmann thinks, we would

have difficulties in expanding the subject-matter to fill the extra space; the scene, as we know it from the other sheets, never consists of more than three visible arcades and the framing arch. In other words, we can take it as read that the group of figures in the above sheet had a larger dimension in proportion to the space than in any other of the drawings.

In Benesch 1060 the canopy has disappeared. The cupola (indicated by the curve of the penlines) arches over the group of figures which has now, for the first time, been put under the central arch. Two poles fixed to the columns project into the room in almost vertical foreshortening. There were once two lamps hanging from the ends, but Rembrandt covered them over with white. The group of figures has been clearly conceived, and is closer to the group in Benesch 1061, although there are striking differences between the individual figures and the way they are arranged. The table has already been pushed halfway into the group, and the shadowy silhouette of the tall young man acts as a screen against the light; however, his neighbour on the left, the man with the goblet, is still lacking. Another feature appearing for the first time is the broad curtain forming a kind of tent around the group to shield them from the eyes of the world.

Even though the symmetry of the rotunda is characteristic of Rembrandt's late style, the classicism of his old age, the whole idea of this rounded, plastic spatial volume is unsatisfactory. It is no longer the plasticity of its volume that gives us the sense of the room, but the optical surfaces of its limits, serving as a framework. In fact, the essence of this classicism is not tangible corporeality, but optical flatness. Thus, in the next sketch (Benesch 1059; fig. 5), he expanded the bell into a stage, open towards the spectator. Unlike Benesch 1058, the arch does not merely reveal one section of a larger spatial whole, nor does it have the effect of a repoussoir, banning the action into the distance. On the contrary, the arch now spans the sheet in a grand classical sweep, and frames both the pictorial surface and the content, which is subordinated in its actual, objective scale and not only in the subjective scale of diminishing distance. A broad, gently-rising stairway leads up to the banqueting room in calm horizontal lines. The steep diagonals of the lampposts have been moved to the edges as tent-poles. The rotunda has almost become a quadrilateral, the cupola, a cross-ribbed vault. And in the composition of the group, something very strange has appeared. The disposition of the figures is still somewhat uneven and scattered, and gives the impression that the artist has not yet achieved the crystal-clear grouping of the large drawing, Benesch 1061 (fig. 6), which was transferred to the painting without alteration; but whereas the table only reached halfway into the group in Benesch 1061 and Benesch 1060, in Benesch 1059, it has moved right across, and we can see an arrangement we already know from the revised version of the painting.

These facts have led Kauffmann to the following conclusion. He sees Benesch

1061 as the preparatory sheet destined for the officials who commissioned the painting, and suggests that Rembrandt became dissatisfied with the plan during the course of the work, and tried out various changes in Benesch 1058 and Benesch 1059. For example, he experimented with "a longer and higher table, a uniform stretch of wall above the heads of the group in the centre, and a canopy". He then incorporated these changes into the painting he had already begun, and this was the reason for the clearly-visible overpainting. These arbitrary changes led to conflict with the municipal authorities, who had the painting removed so that Rembrandt could restore it to its original, projected state. However, Rembrandt never actually did this; instead he kept the painting, and cut it down for financial reasons.

This interpretation is in complete opposition to Neumann's views, because he regards the amended version as a premeditated and well-considered revision, not merely a mutilation. Neumann believes that Rembrandt cropped the painting first, and then made the changes that then became necessary on compositional grounds, extending the table beyond the figures of Civilis and his neighbour on the right, and adding the man rising up at the lower edge of the canvas.

A little close study of Benesch 1061 will help to clarify the matter, because in this drawing, although the spatial composition is a direct development of Benesch 1059, and has the same large, flat classical arch, the room with the cupola has become the junction of a more comprehensive suite of rooms. This can be clearly seen in the pillar in the background on the right which supports a transverse arch forming a bridge with the edge of the room in the foreground. There are also a few, faint lines in the vaulting which hint at a kind of cupola on a pendentive. At the same time, the spectator's line of vision is no longer within the axis of symmetry, as in Benesch 1058, and Benesch 1060, but has been moved slightly to the left, a shift which was already evident in Benesch 1059, where the wide threshold was displaced to emphasize the fact that both the spectator and the main group of figures were not in line with this objective axis. In other words, there was a subjective element in the rhythm of the composition right from the start.[10]

Rembrandt retained this objectivity in Benesch 1061, using a rather shallow curve, but the two lions flanking the steps already show a shift in symmetry resulting from a subjective point of view. The lion on the left is seen full on, whereas the lion on the right is placed slightly aslant. Rembrandt then attempted to give added, objective justification to this subjective effect by placing the arch and its supporting pillar not beside, but slightly to the right of the lion, so that it separates it from the edge of the drawing, and by showing the arch extremely foreshortened. But this objective justification of the subjective shift in rhythm is only apparent. In fact, the arch in the background corresponding to the arch in the foreground has been included in the subjective focus and has also been shifted from its axial position, a supremely important feature of the spatial arrangement, faintly indicated in Benesch

1059, and now a fully evident and demonstrable fact. This displacement offers a better view of the adjacent room on the right, because the building no longer ends here, as in the other drawings, but continues in a series of further vaulted or domed bays also opening, like the banqueting chamber, on to the twilight grove. There is no longer the feeling of a central room, ending beyond the edge of the composition, but of a continuous suite of rooms like a Southern French domed basilica, where one bay opens towards the spectator, while its subjective tectonic dependency is subordinated to a subjective shift in rhythm.

Thus, what we have here is spatial subjectivity, but in the guise of a strictly classical plane-like composition, with an illusion of symmetry. This is a typical feature of the stylistic consistency of Rembrandt's late art, and the rhythm is syncopated in that strange way so characteristic of this period. In fact, although Rembrandt adopted in its entirety the method of composition we find in Southern Classicism, we rarely find any of his works arranged completely symmetrically around an axis. In most cases, he shifts the centre-point or its surrounding space slightly away from the central axis of the pictorial plane. But this gentle moving and displacing of lines that would otherwise have led to one another, or coincided, gives us, despite all the classical regularity of the composition, a feeling of looseness, of swinging and swaying forwards and back, a feeling that space is unstable. Unlike his Italian models, Rembrandt was not chiefly concerned with producing a compact arrangement of figures of such importance that all the spatial accessories served only to enhance it. Nor do we find in his works that unhampered rotation of free space in which, as in the art of the nineteenth century, every object dissolves into something subjective. In Rembrandt's art, the primary feature is, to adopt Riegl's phrase, the "formed space", a floating medium between form and space, a space that is neither an abstract concept nor concrete and natural.

One of the most miraculous things about Rembrandt's power of artistic expression in his later years, was his use of a syncopated rhythm to render the *a priori* quality of his formed space in strictly classical terms, employing mainly horizontal and vertical lines, and avoiding all spatial diagonals. There is also a corresponding syncopated rhythm of content in his works, but it is not possible to discuss this any further here.

The group of figures in the drawing Benesch 1061, is now enclosed within the zones of space running parallel to the surface of the picture, and it, too, has been kept as much as possible on a plane and in relief, although the treatment of the light and the projecting cube of the table give a strong sense of perspective. The sides of the arcade directly above the main group also give an indication of its dimensions and make it stand out. This group itself is welded together by a concave arc curving from the head of the man standing in front of the table on the right, down to the man with the bowl, through the point where the conspirators' hands

meet and up again to the outstretched arms of the two men on Civilis' right, ending at head height. This arc encloses the wedge of space, standing on its narrow end, which begins between Civilis and the ghostly, white-haired man on his left, and which is marked within the group itself, by the lines of the contour of the left side of Civilis' body, the bowl and the point of the sword, and outside the group, by the contour of a building, outside in the evening twilight, which has been cut off by the arch of the arcade. This wedge-shape is the real centre of the drawing and thus also the compositional focal-point of the whole pictorial surface.

The group of figures is superbly articulated and balanced; the two dark silhouettes on the right are offset by the two well-lit men standing very close together on the left, the central axis of the group and the arch above it correspond. The figure of Civilis towers up like a column, and we must think of the spectator's position relative to the drawing in terms of his kingly breadth; this is what we have come to see, he draws the eye, offers himself to our gaze, and is the outward symbol of the inward process. He is the representative of the outward unity, and he thus had to be given this lofty position, even though his person is not the actual centre of the content of the picture, since the real focus is the point in space where the symbols of the act of conspiracy meet.

It would only be possible to conceive of Rembrandt submitting this deeply thought-out composition to such radical changes as we see in Benesch 1058 and Benesch 1059, if these compositional sketches represented a closer approach to the artist's aim, as we can see it in Benesch 1061. But as far as the spatial arrangement is concerned, these drawings would imply a return to Benesch 1060, the version Kauffmann believes to be the first. In other words, a retrogressive step away from the infinite, flowing spaciousness of Benesch 1061, and the expansiveness which became more and more marked in Rembrandt's old age, towards an earlier stage in the development of the central canopy. Kauffmann also considers that Rembrandt actually included the canopy in the painting, and believes he can discern its edge, still unobliterated, in a softly-undulating fringed border so close to the top of the canvas that it touches Civilis' headgear. Quite apart from the fact that the canopy in the drawing is hanging higher up, in the painting this border can be seen clearly only between Civilis and the young man standing up, whereas if it were the edge of a canopy, it would have to ring round the entire group. It is also hidden in a dusky twilight, which would lead us to suppose that it is further away from the group than a canopy would be, if it were hanging directly over a well-lit table, and acting more as a reflector. In fact, the fringe is simply the edge of the curtain hanging behind the group in the gloom, and arranged in folds in the same way as it does in Benesch 1061 where it hangs at the back in the darkness and gives the effect of a neutral ground.

As further evidence for his placing of Benesch 1058 and Benesch 1059, Kauffmann

suggests that the figures in these drawings already have the right proportions in relation to the surrounding space, whereas in Benesch 1061, the group is too small. However, if we measure the groups, we find the same mathematical error in all three sheets. The diameter of the lunettes in the City Hall was about $5\frac{1}{2}$ metres, and the painting in Stockholm is about 3.09 metres wide, whereas, in the drawings, the ratio of the Stockholm group to the size of the picture is about 3 : 6 throughout. The only exception is the sheet Kauffmann considers to be the earliest, Benesch 1060, but this has been cut too much for us to come to any valid conclusions, although the figures are much bigger in relation to the architecture and the curtain, and might well have been proportioned with the area of the commissioned painting in mind. In this drawing, too, the curtain hangs from a cord only just above the conspirators' heads and falls down to a tasselled fringe, and this is the probable explanation of the traces of fringing in the painting. Presumably Rembrandt reverted to the proportions of this drawing when he commenced work on the final canvas, a supposition which is borne out by a glance at the original in the National Museum in Stockholm, where it has been given a mount indicating its previous dimensions.

If Rembrandt has really drawn Benesch 1059 *after* Benesch 1061 he would presumably have been interested in the articulation of the architecture, in addition to trying the effect of making the table run right the way across. But even if this comparatively minor detail had had such vital importance for the appearance of the whole that it warranted a complete, new sketch, surely Rembrandt would not have drawn the figures in such an ill-proportioned way. After all, if Kauffmann is correct in supposing that Benesch 1061 was executed prior to Benesch 1059, then Rembrandt had already worked the group out in considerable detail. In other words, we are being asked to believe that in Benesch 1059 he ripped the figures from their carefully planned positions and huddled them together in a way which indicates carelessness or hastiness, rather than a deliberate advance on the arrangement in Benesch 1061. But how would it help Rembrandt to try out a new basis for the group when he was completely distorting and displacing the figures? Surely it would be more like him to have covered over the light figures with a wash and thus have lengthened the table!

It is interesting to take a photograph of Benesch 1061, and try to reconstruct what Kauffmann considers to have been the final stage. The result is no enhancement or intensification of the composition; on the contrary, the meaning becomes less clear. The horizontal line of the edge of the table, when prolonged in this way, seems to traverse the sheet in tedious endlessness, spoiling the proud upswing of the crystalline structure of the group, and reducing it to the status of yet another horizontal line to join the monotonous gradations of the rising steps. At the same time, the balance between the group of men on Civilis' left and those in front of

the table is upset, and the latter is left isolated and apart, without a counter-balance. This effect is all the stronger if we mentally add, as we must, the man rising up above the edge of the painting, whom Kauffmann sees as a kneeling shield-bearer, and the whole group becomes so over-weighted that it seems to hang in the air. Thus the whole point of the composition is lost, and Civilis, who is so important as a towering sign-post, loses all significance.

Thus, we would have to think of the revised version of the painting, now in Stockholm, as a regression, rather than an advance, a picture without any meaning; and it would be difficult to see in it the original version of the painting. But, in fact, the reasons why Rembrandt lengthened the rectangle of the table to finish and complete the composition of the fragment were quite different. If we imagine the men in the left half as full-length figures again, the painting immediately falls apart into two unequal sections, the left side so over-weighted that any effect of unity is completely lost. In other words, Rembrandt's return to Benesch 1059 was a matter of necessity; he knew that he must create the effect of a frieze of figures supported on a mighty, rectangular podium, and thus reintegrate the group in a superb new totality.

As far as the man rising up in the foreground of the painting is concerned, I am unable to reach any definite opinion. When we see the original, it is immediately obvious that the floating, translucent tone of the surface of the table has been painted over the mighty figures on the left which shine through like phantoms, but the thick paint used for this man precludes any such assumption. It is equally difficult, however, to prove that he was present in the original version. Even if he had been kneeling on the steps, he would have pushed the calm, plane-like configuration of the group downwards and increased its vertical height, which would not have been to the advantage of the painting as a whole. In the present form of the composition, however, this figure plays a totally necessary role as an anchor for the newly-forged unity of the group.

Neumann's view that the arm of the man on Civilis' left and the "masterless" sword were added later is untenable, and there is no evidence for it in the painting itself.

Kauffmann also adduces the unerased traces of the hand on the right as evidence that "no brush touched the torso again". In fact, this hand originally belonged to the nearer of the two men on Civilis' right, who were not originally located in the same plane as the table, but, as we can see from the drawing, much further forward. What we can still see of the hand in the painting, today, cannot be recognized as such, unless we are deliberately looking for it. The structure of the brushstrokes at this point suggests a cloth lying on the edge of the table, and the play of the shadows emphasizes this interpretation. It is by no means just an object hanging in the air in front of the table, and we may reasonably presume that this area has been retouched.

Thus an approach proceeding mainly from the point of view of the development of the artist, as a whole, leads us back to Neumann's final conclusion. Indeed, this is the most important finding in his whole book, and also what gives it its high value, even if his interpretations are somewhat misleading in some other directions. Neumann does not have a clear conception of the development of the pictorial idea of *Julius Civilis*, nor has he thought his arguments out clearly enough. His findings lack a methodological grounding as regards the aims of Rembrandt's late art, as I have tried to explain them above. However, this does not affect the correctness of his theory, nor his invaluable achievement of having been the first to recognize and interpret the strange history of this painting.

The present version of *Julius Civilis* shows a noteworthy affinity to an earlier work by Rembrandt, which suggests that the *Civilis* might have been revised under its influence. Neumann points out that the etching *Christ disputing with the Doctors* (B. 64, Hind 277), of 1654, has one of its models in common with the painting. But in fact, the extensive compositional relationship is far more important than this rather dubious similarity. In the painting, there is a bold, steep diagonal stretching from the head of the standing youth down to the edge of the canvas where it rises again up to the tiara on Civilis' head, only to descend towards the edge of the painting on the left, following the figure of Civilis' neighbour. The same double pair of diagonals can be found in B. 64, Hind 277. In this case, the line flows down to the left from the head of the standing man, rises again in the figure of the young Jesus, culminating (though not as high as in the *Julius Civilis*) in the man with the broad, low hat and then descending again along one of the rear figures in the corner of the sheet. The line which runs down over the back of the standing youth in the *Julius Civilis* is repeated, in the etching, in the steep curves which unite the standing man with the man coming up the stairs on one side, and the seated old man on the other. Another similarity linking the two works is that between the plane of the tablecloth with the three heads appearing above it on the far right in the *Julius Civilis*, and the plane of a hanging drapery in the etching, which also has a frieze of heads emerging above it.

The method of composing in zigzags is characteristic of the old Rembrandt. In his late period, he loved to use diagonals which rise and fall throughout the painting and form steep triangles which stand alternatively on their apex or their base, the one providing the sides of the next. Each triangle fits into the next, or leads into the next, like interlocking gear wheels and, at the same time, empty and form-filled space alternates, so that there is a continuously changing interplay between space and form, form and space. The principle of reciprocity is only one of the secrets of Rembrandt's late art, but a very important one. He lays wedges of form and space on a plane like pieces of mosaic, and gives them substantially the same value, so that they fit into one another, and lead into one another, like strips of

ancient cuneiform decoration. The wedge-shapes of these patterns can be seen either as the pattern or the ground, in a continually fluctuating exchange and, in the same way, every spatial, atmospheric depth in Rembrandt's late works is condensed into an optical plane, and every space-distorting plane leads, and evaporates, into the spatial volume stretching back behind it into the distance. This technique is also what makes the forms in Rembrandt's last paintings appear to fluctuate and float, to submerge into the depths of space, despite all the classical discipline and rectangularity; indeed, because of these very things.[11]

The closing paragraphs of his first chapter are a good illustration of Neumann's antipathy towards Mannerism, the Italian seicento and particularly towards all classicism. For example, he contrasts the late Rembrandt and Van Campen's City Hall in Amsterdam, the building for which the *Julius Civilis* was painted, as if they were incompatible, "artistic antipodes". He calls the City Hall a "pompous Italianate gesture of the municipal authorities in Amsterdam", an "alien element, built with an eye fixed on Venice and Rome". "The notion of bringing Rembrandt and the City Hall together is a kind of art-historical farce."

One of the most important problems in the study of Rembrandt's art is the classicism of his old age, and even Neumann feels himself compelled to speak of a "shift towards an art essentially foreign to Rembrandt's nature". But he overlooks Riegl's suggested method of solving the problem, namely, to view classicism as if it were something which arose out of the innermost being of Rembrandt's art and the inevitability of his method of presentation. According to Neumann, the danger that Rembrandt's shift in direction might have had a chilling effect was averted by light and colour. In the chapter "Rembrandt and Artistic Tradition", he explains the problem by saying that "symmetrical composition, centralization and an architectonic structure were crutches borrowed from Italian art". In other words, they had helped Rembrandt surmount difficulties in composing, which was not his special ability. Neumann sees no feat of assimilation in this change, but merely "transition points in a moment of doubt and fumbling".

The classicism that began to appear throughout Dutch painting after the turn of the century was first manifested in Rembrandt's works, and we can already see clear evidence of it at the time of *The Night Watch*—the climax of his "Romanism" —in *Manoah's Offering* of 1641 (Bredius 509; fig. 202)[12] in which there are many features which anticipate the 'fifties; the figures are organized on one plane, enclosed within layers of space, and have compact contours whose lines flow away, leaving only the colourful, shimmering elevation of the bodies embedded in the spatial depths. The agitated movement of the 'thirties has been replaced by gestures of monumental composure and emotion, and the system of co-ordinates in the articulation of the background has been restricted to intersecting horizontal and vertical lines. But whereas, in the 'forties the classical principle of expansion on one

plane was used to intensify the spatial effect mainly in single figures, in Rembrandt's late period these principles came to govern the entire composition. By the use of rectangularity, the objects scattered throughout the composition were welded together in huge, block-shaped masses, and by the use of symmetry, they were grouped around a central axis. Every figure was inscribed within a rectangle and thus apparently cut off from its environment, although, in reality, all the more firmly rooted within it. At the same time, Rembrandt's method of composing in reciprocal triangles gave all the elements in his paintings the closest interrelationships, and the figure group, which he had loosened with floating chiaroscuro in the 'forties, now won a new significance. At this moment we may ask what were his grounds for reverting to the objectivity of the compact group and the symmetry of composition in relief.

The answer has nothing to do with the aims of Italian compositions which bear the same characteristics. In Rembrandt's paintings all solid forms are flattened into planes, but the planes are optical, not tactile, and are stretched across the space like thin membranes, shimmering as they veil the cubes and spatial volumes running back behind them into the distance. The more disciplined and controlled the composition, the more compact and impenetrable the surface appears, and the deeper it sinks into, and merges with, the depths of the space. At the same time, it is not the light and colour alone which paralyse the surface in this way, but rather the universal syncopation of the rhythm of the forms. The late Rembrandt's objectivity is not real, but only relative, and he was using it as a means to achieving a completely individual goal.

More important than this intensification of space, however, is the increased profundity of content Rembrandt achieved with his classicism. The self-contained quality of the figures and the composure of their silhouettes heighten the impression of vigorous inner activity, and the pose of those bodies, with their silent rapture, their shy, hesitating gestures and their apparent rigidity and immobility, only serves to accentuate the indescribable emotion in their souls. At this time, Rembrandt often constructed his figures as if they were made of square or rectangular blocks, and this makes them seem more cut off and apart from one another; but, in reality, this separation and co-ordination symbolizes an even deeper connection. Seen as a whole, these individual block-figures, arranged beside one another, are always united within one enormous, all-embracing block which forms, with other similar blocks, the foundation-stones of the composition, and they are equally united within a single framework of spiritual experience and mood. Preoccupied and introspective, their backs turned to the outside world, they are all borne along on the same wave of spiritual activity, welded together by the bond of their inner watchfulness.[13] And this mental communion is far more important than the unity of space.

In the last analysis, even Rembrandt uses space merely as a means of conveying the actual content of a picture, that is, the underlying spiritual values and the unity of mood which point to a great, universal, predestined relationship, and which exists at a higher level than the uniqueness of the event. Thus, here too, Rembrandt's objectivity was only relative and he employed classical methods only to attain a creative goal lying far beyond.

Rembrandt's classicism is, in many respects, similar to that of the old Titian. Titian's paintings show the same flattening of plastically rounded surfaces and the same compositional broadening in the optical plane. His solid forms also transform themselves into far-seen apparitions of colour, which detach themselves like great strange phantoms from the atmosphere surging up around them in optical contours. There, too, everything tangible and palpable vanishes and is replaced by the vibration of coloured planes in space, which give an enormously enhanced power of spiritual expression.

The fact that Rembrandt was familiar with the work of the Venetians, particularly Titian, must have been tremendously important to him in his late period. It was not a matter of "borrowing"[14] so much as of assimilating what the Venetians could give him in terms of essential artistic principles, the total effect of a work, and their method of translating an image from the mind, or from real life, into visual terms. By this time, Rembrandt was no longer concerned with individual motifs. The pictorial potency and the dynamic experience of colour manifested in the works of the great Venetian flowed into his works, irrespective of whether he had a particular example in mind as a "prototype". Thus, when works by Rembrandt or Titian are compared for evidence of a relationship, we should consider them, not as documentary evidence of a definite point of contact, but as typical instances, even symbols of the fact that a broad, general connection did exist.

The connection between the late Rembrandt and other Italian artists of the cinquecento is very similar. When Rembrandt made a pen copy of a work by one of Raphael's pupils,[15] he endeavoured to transpose the superb effect of the composition as a whole into his own, unique artistic vocabulary and to produce a completely new and original work of art; there was no question of his borrowing "crutches" from abroad in order to surmount his difficulties.

The motive behind Rembrandt's move towards Italian art in his old age was an autonomous urge towards a sweeping synthesis as the vehicle of spiritual significance and of increasing profundity in his themes. This aim lay well within the range of problems posed by his art and he would have reached it on his own, even if he had never seen the compositions of the Italians; the fact that he did study them represents no straying from the path, but is, rather, strong evidence of the mysterious power of his ability, as an artist, to adapt a classical composition and give it an entirely new meaning. Rembrandt took over the foreign invention, assimilated it,

without many alterations, into the world of his own imagery, but was able to adapt it and tone it down in his subjective mirror in such a way that it harmonized completely with his sphere of creativity. What he was seeking in Italian art was not definite supports for a definite side of his own creative work, but concepts and ideas to enrich his artistic vision; these he imbued with his spirit and transformed into the instruments of his imagination. Here we find revealed the omnipresence of spiritual experience, the universality of feeling which welds the figures in a scene by Rembrandt into one unit and links innumerable tales from the Old and New Testaments, Mythology and History into one great cycle, one great saga of everything that is supra-individual and foreordained. At the same time, the sum of everything creative that had been before was at his command, ready to give up its former meaning, take on a new guise and provide him with a new outlet for communicating the mysteries of his artistic language. The historical unity connecting the foreign works of art which entered his realm was of a spiritual nature, and bound them to the great kinship of all Rembrandt's creative work, to the unison of the spheres, and the harmony of the entire spiritual world.

The fact that Rembrandt actually took over and reinterpreted Italian compositions is thus of less importance than the fact that through his art their breadth and originality took on a new meaning. Indeed, it is precisely this mutual quality of breadth and originality which provided the real bridge between the two worlds and first attracted Rembrandt to Italian art, quite apart from his use of Italian works as guides and models. We also find this quality in works which have, at a superficial glance, no apparent connection with Italy, for the real relationship between Rembrandt and the Italians lies deep beneath the surface.

It is within this category of relationships that we should seek Rembrandt's connection with Titian's late work, because instances of direct derivation from named works can hardly be ascertained. The two artists were connected by kindred artistic principles, and such a relationship produces much deeper and richer affinities than the connection between prototype and adaptation.

Rembrandt proceeded to mark the breadth and originality he had derived from the late works of the artists of the cinquecento with a new stamp, transposing the qualities that were more formal in the originals, endowing them with the spiritual enchantment of his creativity and using them as vehicles for purely psychic values.

There can be no denying that one of our most difficult methodological problems is the task of understanding and describing these deep-lying relationships and influences with scholarly precision, especially where there is no concrete evidence of "prototypes". This is one of the art historian's most pressing problems; indeed, the newly oriented methodology has made the urgency acute. Neumann also touches upon this point in his book when he suggests the possibility of a new approach to the genetical method of explaining Rembrandt's late style.

The aging Rembrandt divided space and form into rectangles which he then reconstructed like pieces of stonework. Neumann, who believes that this was the point where "the plasticity of objects carved out of space touches the problem", wonders whether we could not speak of Michelangelo's art impinging upon Rembrandt's range of vision here. In both cases there is undoubtedly the same striking use of rectangular construction and the same method of fitting form within blocks. The late works of Michelangelo and his school also share Rembrandt's feeling for construction in layers of rectangles. Basically, this is a related artistic principle.

However, the likelihood of any relationship between the two artists is very small, since Rembrandt's use of the cubic block is very different from that of Michelangelo. In Michelangelo's sculptures there is an eternal conflict between the block and the figure, which tries to break loose, but is held captive by the power of the artist's imagination and thus fills the whole volume of the block with the counterpoint and contortions of writhing limbs. The result is the concept of a solid cubic volume tangibly enclosed on all sides. The third dimension is only present in so far as it is manifested by plastic form; the rest is vacuum. And every composition is a conglomeration of these cubic volumes.

In Rembrandt's works, on the other hand, "formed space" rather than the cubic block, is the starting point. The figures are condensed into blocks in space, and the squares and rectangles of which they are composed are cut out of the substance of space. Thus their isolation and enclosedness are only apparent. Indeed, it would be more accurate to say that the surface of the painting is divided into optical fields and compartments; what lies behind is not a series of plastically-defined, solid volumes, but a general pictorial concept of forms running back into the distance, not sculpturally precise, but fluctuating; in other words, spatial density. These blocks of space have nothing in common with Neumann's "plasticity of objects carved out of space", which is a concept that could possibly be applied, say, to the frescoes in the Cappella Paolina. In Rembrandt's paintings, units of space are divided into compartments with thin walls which are not tangible, alien entities, but points where the substance of space has gathered, or built up, and they offer no resistance to it. Nor are the figures confined, struggling within great blocks of stone; they detach themselves from the spatial field in peaceful and tranquil symmetry. Their inner will is in harmony, not in conflict, with the will that guides them and the power that disposes them in space. The inner will and the external power are both emanations of one and the same transcendental being.

In the case of Rembrandt, paradoxically enough, solid forms are only present to the extent that they are space, whereas in Michelangelo's works, space is only present when it is created by the cubic three-dimensionality of the solid form. Indeed, in every one of his larger compositions we can still feel seams where the blocks join. In Rembrandt's late, large-scale compositions, however, if the spectator

wants to become fully aware of all the various elements involved, he must pay great attention to the simple, straight lines of the contours, otherwise the figures may escape him and vanish into the innumerable optical blocks and rectangles of the space. This happens particularly when the chromatic power of the light makes the thin separating walls melt and suffuse all the forms in an undulating fluid (cf. the etching B. 89, Hind 237, *Christ appearing to the Disciples*).

Neumann's firm conviction, from the beginning, that Rembrandt's art was absolutely incompatible with that of Italy led him to give a hesitant, predominantly negative answer to his question. In time, this conviction became a dogma, and he simply closed his eyes to the fact that whole constellations of concepts from Italian art had entered Rembrandt's late style and had been submerged in the unfathomable depths, only to re-emerge as something completely new, thus giving us the most eloquent testimony to his artistic omnipotence. Indeed, he can only conceive of relationships between great artists in terms of "hints and recipes". "I have never found that a real artist can be influenced by another, except in matters of technique. The things an artist has to say are his alone. To a certain extent, the know-how can be learned, and this is the sense in which we should form a judgement about Rembrandt's contacts with Italian art."

The nineteenth-century pragmatists, when they were analysing historical continuity, laid great weight on "influences" and scrutinized both schools and individual instances of artistic development primarily to discover what they had derived from other artistic regions in a directly causal way. Thus a work of art was first and foremost the point of intersection of various influences, and all problems were considered solved once these influences had been traced back to their actual or supposed sources. But this approach only skims the surface of the problem; the migration of compositional schemes and individual motifs is not the whole answer and leaves us still very much in the dark about the peculiar, individual qualities of the phenomenon in question. We learn nothing about the deep-lying, independent, essential traits that first prepared the ground for outside influences, and points of contact, and causal relationships are made to seem like tricks of blind fortune or the results of external events. Pragmatic historians do not ask the why and wherefore of the outside influence because the answer can be found only in those individual peculiarities of a work which cannot be derived or transferred.

In every case where one artist has influenced another, the most important fact is not the forms in which the influence manifests itself, but the underlying significance. The mere existence of a connection proves nothing, although the art historian's researches cannot begin until it has been established, since it is his task to seek for more than superficial answers, and to track down its real essence. Adaptations and assimilations are only outward manifestations of those essential artistic values that flow from one work of art, or one circle of artists, to another. Indeed,

even the process of adaptation or exchange of essential characteristics can only take place when the independent, individual development of a movement, artist, or circle of artists, has reached a stage where it is accessible to, or even needs, stimuli from outside.

In the 'thirties, Rembrandt borrowed motifs of movement, counterpoints and figures from Italian art, and Neumann interprets this phenomenon as an expedient, explaining that Rembrandt, who had been trained on static models, used these motifs to overcome the problems of representing movement. Indeed, he goes so far as to suggest that Rembrandt's early relationship with Italy stopped at borrowing individual motifs of a "foreign vocabulary, rejected later on", and this is how the matter would appear to anyone who went far enough to discover that some adaptations had occurred. But we must probe more deeply to discover the quality which Italian art bestowed on Rembrandt—and of which the "borrowings" are only the outward sign.

Towards the middle of the 'thirties, Rembrandt's art underwent a change; he began to weld his forms together in grandiose compositions, with a rich variety of interrelationships, constructing each painting as a unit where nothing could be displaced without jeopardizing the whole. The same spirit is evident in his handling of the individual forms; and the boldness and confidence with which he captured his figures, in their dramatic mobility, was a completely new feature of his work. At this period, Rembrandt was no longer primarily concerned with reproducing the surface of objects, as in a still-life, but was already attempting to portray the construction of the moving form, its essence and core, the contours of its lines of force and the effect of its motor potential, expressed in broad, generalizing outlines. When working from the nude, he laid stress not on presenting a real, unique model, but on conveying the soft, painterly mellowness of a total phenomenon, bathed in light, and the contours of the figures roll down in swaying lines.

These are qualities which Rembrandt owed to his contacts with Italian art, and which could not have been acquired simply by adapting individual motifs. These qualities are essential, and can be traced in his art throughout the middle and second half of the 'thirties, even in works in which no direct connection with any particular Italian model can be found. To trace them is the real task of the art historian confronted with "adaptations" and "borrowings".

Rembrandt's relationship to the art of Antiquity[16] must be viewed in much the same way. Particularly in his late period, Rembrandt occasionally used ancient works of art in his work, the result being a strange transposition, a kind of free variation on the antique theme. For him the composure and characteristic detachment of these figures and heads certainly conveyed a mood, and they became means for portraying strange figures sunk within themselves and apparitions from another world, suffused with visionary power by the inner glow of a sublime spiritual life.

The *Homer* of 1663 (Bredius 483; fig. 187) is the most stirring example of this. However, when Rembrandt turned to Antiquity, he was not, as Neumann believes, seeking the painterly and the "unclassical" side of the Hellenistic–Roman Baroque, or its pronounced physiognomies. He did not "destroy the essentials of their form", by "stripping them of the beauty of the antique tradition". There can be no doubt that Rembrandt sensed the objective calm of the self-contained classical form and treated it as the tranquil reflection of a visionary mood.

This type of approach and contact between the essential natures of two otherwise alien realms of art can thus take place without the evidence of borrowed schemes and motifs. Their relationship cannot be proved by external means, but it un-doubtedly exists, and can be observed in the deep-lying kinship between their creative talents. Such are the links between the late Rembrandt and the late Titian. For instance, both use optically plane-like forms which evaporate in a visionary play of colour, and a chromatic dynamic that functions as the materialization of the most lofty spiritual values. It is not a question of the migration of certain individual motifs, but of an entire fabric of ideals flowing from one into the other, and the unravelling and formulating of this process will provide the art historians of the future with a most rewarding and important task.

The relationship between Rembrandt and the German artists of Dürer's age is of much the same kind. In this case, there is far less overt evidence of direct borrow-ing, but the relationships concerned are probably far more important because the ideas transmitted concern not only the problem of form but the primary elements of Rembrandt's art: the problem of space, the magic of a scene unfolding in the interplay of light and colour, and the spiritual content.

All the examples of historical continuity which we have discussed up to this point, whether they took place in the essential depths or at the level of day to day studio practice, were due to immediate causal connections. But there are also other kinds of historical continuity.

Achievements in the field of art are never entirely lost, since their effect con-tinues indefinitely. When they lose their immediate significance, they merely "go undergound" for a while and pursue some hidden course until they re-emerge and acquire new importance. In cases where this happens the re-appearance is never in the form of conscious imitation or direct influence; but the development of art has simply moved in a direction which brings it mysteriously close to the spirit of earlier epochs. No immediate contact between these epochs is necessary; the strange connection can arise autonomously, and without the stimulus of an outside influence.

Much of what links Rembrandt with Dürer and his contemporaries belongs to this category of historical continuity. The threads between the two periods are numerous, and not always unbroken. Where these threads are discontinuous we are

surprised to see an element from early German art appearing in Rembrandt's work, though we cannot pinpoint intermediaries or prove a direct inspiration. Nevertheless, despite the lack of unbroken causal chains, we must devote some study to these deep, essential relationships, although, even in cases where it is possible to trace the pragmatic chains, nothing can be gained by tracking them down to the last link. The routes by which elements from Dürer's age could have reached Rembrandt are so many and various, the possibilities of such a migration so infinite, that they could hardly be enumerated in one essay, let alone exhaustively analysed. The whole great realm of German art up to Elsheimer, and Netherlandish art from Lucas van Leyden onwards is intersected with pathways that mingle and branch off in every direction—and how many have been interrupted by the loss of the connecting links! Indeed, even in cases where we can follow the vicissitudes of one composition or motif from its source to its goal, we still know little or nothing about the deep, mysterious affinity between its original and final forms. The elements that were essential in their relationships were not transmitted to Rembrandt from the German artists by means of the "Little Masters". In the same way, when Rembrandt recreated Leonardo's *Last Supper*, which he had never seen, from an Italian engraving, his free version of 1635 (Berlin)[17] came much closer to the original than the dry, precise reproduction.

As I have pointed out before, it will be the task of the new art history, oriented more towards the history of ideas, to establish this kind of historical continuity on a scholarly basis, and, above all, to approach great relationships from a new point of view. It will be necessary to follow, not the detailed causal connections, but the superb panorama of ideas that binds spheres of art centuries apart; and this refined, more penetrating analysis will come much closer to the ideal aim of the historical humanities than the old pragmatism.

The discovery that deep connections exist in historical life, hidden from the eye of the pragmatist, leads us directly to a third type of continuity. In the development of art we occasionally observe phenomena which, though widely divided in time and place, have puzzling affinities and points of similarity explicable neither in terms of direct causal contacts, nor of connecting pathways temporarily hidden from our eyes. In other words, there is simply no possibility of indirect or direct causal relationship, although some relationship does exist. This is a problem which will have to be clarified by a future historico-philosophical orientation of the history of art.

Vienna, December 1919

"Rembrandt und die Fragen der neueren Forschung," *Wiener Jahrbuch für Kunstgeschichte* 1, Vienna, 1921/22, pp. 65–102.

A Drawing by Aert de Gelder

ALTHOUGH the drawing *David on his Death-Bed*, Chatsworth Settlement (fig. 7), is attributed in this essay to Aert de Gelder, the present abstract is included here because the author later revised his opinion and listed the drawing in his Corpus, *The Drawings of Rembrandt* vol. VI, p. 398, as Attribution 81.

In his comment to Benesch A 81, he took up the complex problem again and discussed it fully, including also examples of comparison such as Benesch 892 (fig. 198), 891, as well as Rembrandt's etching B. 41, H. 258, and the drawing by Samuel van Hoogstraten, *Bathsheba at David's Death-Bed*, Vienna, Albertina, Inv. 17592. For this reason the essay has not been reprinted in full. It is one of the author's earliest writings and demonstrates the problems he encountered in the initial stages of his research in clarifying Rembrandt's drawn oeuvre.

[See also *Collected Writings* II, "Govaert Flinck: Isaak segnet Jakob".]

The painting *Maria Annuntiata*, Stockholm, Count Hallwyl Collection (fig. 8) is attributed to Aert de Gelder.

"Eine Zeichnung von Aert de Gelder," *Die Graphischen Künste* XLV, Vienna, 1922, Mitt. Nrn. 2/3, pp. 37–43 and XLVI, Vienna, 1923, Mitt. Nr. 1, pp. 2–3.

Rembrandt's Development as a Draughtsman
A proposed methodological foundation for an analysis[1]

> Devotion makes the mind of the truly inspired historian into a universe reflecting the whole historical world. In this universe of moral forces the unique and singular has a quite other significance than in any realm of nature outside. Recognition of it is not the medium upon which it is based, it is indestructible and consonant with the highest things in our being.
>
> <div align="right">Dilthey, Introduction to the Humanities</div>

IN his treatise *The Group Portrait in Holland*,[2] Alois Riegl asserts that Rembrandt's development as an artist was an integral part of the total development of Dutch Baroque painting, as seen from the point of view of an artistic problem of typical significance. He regards events in history as stages in the progress of one great, predetermined course of evolution. In consequence, his analysis and interpretation of one chapter in Dutch painting are extended so as to become component parts of a great, developmental teleology. In his view this teleology embraces the entire spiritual being of the past, and is identical with that which spans the whole history of cognition from its dawn in the Orient until the present time.

According to this theory, the great, unique personality of Rembrandt was the incarnation of a higher, spiritual power, and his artistic achievements, however sublime and epoch-making, were nothing but the predetermined instrument of a superior historical dynamic.[3] In other words, the forces of historical necessity came to a supreme realization in the figure of Rembrandt, a realization that would most rapidly accelerate the development of Dutch Baroque painting as a whole. But, as even Riegl emphasizes, the qualities that distinguished Rembrandt from the mainstream that bore him along were, precisely, his particular epoch-making genius, the importance of the "turning-point" in his own artistic development and the fact that it was one personality in which everything predestined from the beginning was realized. In Riegl's view, Rembrandt was the only artist who fulfilled the inner demands of Dutch art, and achieved supreme external and internal unity by deliberately introducing the artistic principle of complete subordination. But it was due precisely to this paradoxical method of attaining what Riegl considered to be the specifically Dutch end-result of complete coordination of both elements—figure and space, sitter and spectator—that he out-stripped the intellectual capabilities of his contemporaries to such an extent that it brought him into conflict

with them, and even, as in the case of *The Night Watch* (Bredius 410; fig. 9) caused a breach between them and himself. In other words, even Riegl's historically conditioned Rembrandt is credited with being the reigning executant of historical necessity and with having an importance beyond the realm of the causally conditioned. But is there any real reason why Rembrandt's feat of satisfying the inner demands of Dutch art by introducing the heterogeneous should not be regarded as something new and original, as a breach in the dams obstructing the whole current of development, something he achieved by himself without assistance from anyone else ? If Rembrandt were not one of the links in Riegl's chain of development, the course of the development would have to be presumed to have taken a mighty, unexplained leap forward and to have lost its sense of direction—something that would not happen if any other artist, even Frans Hals, were excluded. Riegl also interprets Rembrandt's late art from the same point of view, suggesting that he continued to strive for a complete solution to the central problems of Dutch Baroque painting—the absolute homogeneity of internal and external unity—long after the contemporary world in general had lost interest in it and was seeking other goals. Thus his personality, unfathomable and insular as it was, is seen as having led him into a blind alley, while the mainstream of Dutch art passed him by. Of course, the old Rembrandt may very well have appeared outdated to the eyes of his younger contemporaries, but when we regard him from the historical point of view, and consider the historical–philosophical significance of his work, we can only see him as a man towering above the rest, growing beyond the confines of his time, and pointing towards the future. Thus, if even the strictly genetical interpretation conceals a germ of irrationality and fortuitousness, then it is only a short step to seeing the problem of Rembrandt as not necessarily identifiable with the problem of Holland. This view leaves the great artist room to be something enigmatic and inexplicable, or, at best, explicable in his historical–philosophical aspect, a man larger than his time and, particularly in his later period, the personality who shaped the destiny of art in Holland.

In spite of the classicism of Bologna and Rome, the fate of all Italian painting in the seicento was determined by one late Mannerist artist, Caravaggio. Indeed, in a broader sense, Caravaggio shaped the future of painting in every European country possessing a national art at the time, by providing the foundation for the various branches of Baroque. The whole of European art between 1600 and 1620, more or less, bears the stamp of his influence, and we can only compare the triumphant power of his creative personality with the revolutionary effect of Giotto and Michelangelo. But, while Caravaggio's work was most important for Baroque Italy—an event of unique significance and influence for both painting and drawing —it was not until later in the century, with the coming of Rubens and Rembrandt, that the fate of art in the Northern countries was decided. Both artists, admittedly,

also derived much from the Caravaggism of the early years of the century, but the seal they set on the art of their own countries and more or less the whole of Northern Europe was far more final than anything his influence left behind.

The process did not follow the same course in the Northern and Southern Netherlands. Rubens, the founder of the Northern Baroque, is actually very much a Mannerist, both in his work taken as a whole and in his period of activity; he died shortly before Rembrandt concluded the Mannerist–Baroque period of his youth, and embarked on new problems, which were to lead to the creative feats that turned the course of the Dutch Baroque. Except in the last ten years of his life, Rubens remained far more closely bound to the Italianate and Mannerist origins of his art than Rembrandt. This does not imply that Rubens' creative individuality and genius were in any way inferior. Indeed, his pioneer work was no less great or epoch-making than Rembrandt's, and he set his seal on the Baroque art of his native land, but his personality still seems to have been more firmly rooted in the situation in which he found himself. Rubens enhanced the significance of this situation to the utmost, and produced an œuvre of unique grandeur, but never reached out beyond traditional boundaries into the strange, mysterious realm of unknown regions.[4]

Rembrandt's position in Dutch art was quite different; for one thing, he appeared more isolated. Although he grew out of the Elsheimer–Caravaggesque tradition, by his time this style no longer played a major role in Dutch art, and was really only a relic of the Caravaggism that had been more prevalent before 1620. After this period, Caravaggism was superseded by new trends, particularly the strong Venetian elements in the Mannerism of Frans Hals, and was kept alive only within the narrow confines of one particular school, where it survived until the early years of classicism. Thus, in his early period Rembrandt does not appear a true representative of the inner aims of Dutch art. Unlike the Fleming, Rubens, who was a perfect representative of his national art, Rembrandt was only a comparatively late product of a minor movement, but this movement achieved unexpected significance through his art. It must also, of course, be admitted that he wrought enormous changes in this movement, and that some of its representatives, with whom he came in contact during his early years, later fell under his influence. At the same time, we will not find an explanation for the young Rembrandt's development in the Dutch Elsheimer–Caravaggesque style alone, any more than in other trends in Dutch art, for he was susceptible to foreign influences to an extent and in a manner that nothing in the development of Dutch art could have suggested and that was something completely new and unprecedented. One of Riegl's main points is that Rembrandt subjected himself to the Italian principle of subordination so completely that he came into conflict with the taste prevailing throughout Holland. But even the Italian Baroque does not provide the only key. The truth is that Callot's mannerism was no

less a decisive influence on Rembrandt's early work than the Caravaggism trans-
mitted by his master Lastman. There are also traces of Rubens and Bruegel as well
as of the Italians in his work. Indeed, there are many possible sources of
Rembrandt's art which have not yet been examined, or which have at the most been
vaguely indicated, such as the entire world of German art of the sixteenth century.

It is more difficult to determine what Rembrandt derived from far-distant, alien
sources than it is for any other artist, because the evidence of obvious influence
proves nothing. What he took from others, he took at a much deeper level, and it is
not necessarily evident on the surface. This is particularly true of Rembrandt's late
period, when his encounter with other worlds was much more serious, much deeper
and less explicit than ever before. Until now, researchers have only been able to
theorize vaguely on the subject, and their analyses have not been made more im-
pressive by the instances they have isolated of what they believed to be the unmis-
takable impact of foreign material. There can be no doubt that Rembrandt's vision
extended far beyond the limits of the general run of Dutch artists at the time, and
this is yet another proof of his uniqueness.

Rubens set his stamp on the art of his nation for all time by clothing its latent
aims in unique splendour. In spite of Van Dyck, late Baroque Classicism never
played as important a role in Flanders as it did in Holland, because the leading
Flemish artist dissociated himself from it,[5] while in Holland, classicism won enor-
mous importance, because her greatest living artist was also its founder. It is typical
of the situation that, whereas the sound of Rubens' language can be detected
everywhere in Flemish art, and whereas all seventeenth-century Flemish painting
is mainly a much enlarged school of Rubens, in Holland, Rembrandt's traits can
only be traced unequivocally in the paintings of his more intimate circle of pupils—
and that only so long as they are still under the immediate influence of his person-
ality. As soon as they left Rembrandt's studio, most of them began to be affected
by the spirit of the new classicism, which, seemingly, has very little in common
with Rembrandt's later style. Thus, the specific "Rembrandt style" played only a
very limited role in the physiognomy of Dutch art—yet another instance of how
the master was a man apart.

The whole problem can be stated briefly as follows: the classicism of the late
Rembrandt is neither essentially different from Dutch classicism in the second half
of the century, nor an offshoot of it, but its source of creative inspiration. From the
beginning of the 'forties, classicism became the leitmotiv of Rembrandt's creative
activity, and by 1650, it had come to full maturity, and revealed its universal signifi-
cance by producing a transformation throughout the whole of Dutch art. This
change did, of course, have an analogy in the new classical movement which swept
through all other artistically significant nations in Europe at that time, but the fact
remains that Rembrandt was preparing himself for it at a time when it had not even

begun to impinge upon the world. We must, therefore, regard the enormous stylistic change in Holland as Rembrandt's creative achievement. Rembrandt was the founder of Dutch Baroque Classicism, and thus determined the future course of all Dutch painting and drawing. He was the greatest of all masters of European Baroque Classicism.

Before classicism had been generally accepted in Holland, it was already making its influence felt among Rembrandt's immediate circle of pupils, though only as an internal force in his studio, as a result of the master's creative genius, not a merit on the part of the pupils. In fact, the deep and special principles of form in Rembrandt's classicism struck roots only in the more talented of his pupils; in them it remained active even after they left the studio community and acquired a new language of forms; in their work the master's achievement was not lost when his tutelage ceased, it was not confined to obviously "Rembrandtesque" qualities but lived on and even gained in depth and vitality. In this we see Rembrandt's art acting as a generative force, inspiring those independent, creative minds who were the real propagators of his work. One of the most important was Carel Fabritius, who kept his master's classicism alive even though, in his later period, he went very much his own way. Fabritius, in turn, inspired his pupil, Vermeer, who, although never a direct pupil of Rembrandt's, should be counted among the latter's most truly creative followers. In this sense, Vermeer is more a pupil of Rembrandt than Victors or Hoogstraten. As for the rest of Rembrandt's pupils, the majority merely reduced his world of forms to formulae, or transferred their allegiance to the Neo-classical movement which tended increasingly to look to France.

It therefore appears that we must seek the traces of Rembrandt's great, late style in regions beyond the circle of his school alone. Yet, wherever his profound, creative principle survived, in a few great spirits, hardly any of whom had been his direct pupils, it usually worked at a hidden level, and is not obvious to the eye. For instance, neither the classicism of the great genre painters Vermeer and Ter Borch nor the great landscape painters Ruisdael and Hobbema, nor the great architectural painter Emanuel de Witte are conceivable without the style created by Rembrandt. None of them were pupils of his, and yet all were deeply influenced by his achievements. Indeed, Aert de Gelder studied the master's work only after his death and yet became the most original heir of the "Rembrandt style".

However, the complete stylistic change that took place around 1650, even in its most far-reaching ramifications, is a direct result of Rembrandt's art.[6] In fact, even groups of artists far removed from Rembrandt in every respect came within his sphere of influence, although probably unaware of it, when they adopted the formal principles of his classicism, and in particular, his method of composing in a system of optical planes. This principle of using planes brought about a complete change in Dutch art after the mid-seventeenth century, although Rembrandt was probably

not the direct source of inspiration in every instance. But the new movement was sponsored by leading artists everywhere, and, for them, the Rembrandtesque principle was always alive—I am referring to Cappelle and Kalf as much as to the great masters of landscape and interiors—and through their influence, the movement spread in ever-widening circles until it eventually dominated all artistic activity in Holland, in the second half of the century.[7]

The great majority of minor and mediocre artists, however, did not grasp the true essence of the classical principles as Rembrandt had formulated them and this is evident from its fate. Instead of pursuing the path of calm and of increasing depth and clarification of pictorial representation so that it became a fitting vehicle of spiritual intensity and subjectivity, these artists turned away from Rembrandt's classicism and fell under the spell of French Classicism. Indeed, only the great masters of composition were able to heighten their objective means of expression while simultaneously intensifying the subjective significance. Lesser artists merely saw the means, not the aim, and adopted them wherever they found them ready-made in a suitable form, and ignored them wherever they had to be reformulated and given new significance through individual creative effort.[8] However, if Rembrandt had not paved the way, classicism, as a phase in Dutch art, would hardly have attained such importance.

One of the most puzzling historical facts about the late Rembrandt is his isolation within the artistic framework of his time and country. Riegl's interpretation is that the development of Dutch art overtook Rembrandt while he was engaged on the final solution of a problem that was already out of date. This is the logical consequence of Riegl's identification of the problem of Rembrandt with the problem of Holland. If, however, we reject this identification, we can see that, far from stagnating, the old Rembrandt, in the incomparable singularity of his mind, grew, inwardly, beyond the bounds of the great problem, without rupturing them externally. This problem, to which he provided a historical solution, was the problem of coordination. It seems to have been completely resolved in Rembrandt's late classicism; and the solution is only conceivable within the framework of a real baroque art, an art in which the subjective element has not yet gained complete mastery, but still works hand in hand with the objective. This, then, is the historical situation of Rembrandt's late style, as we see it in his treatment of problems of form; objects still have a certain objective validity. But the meaning of this art is not to be found in the historical situation alone. It is not until we look beyond the historical setting of this style that the true significance of its essential nature is revealed, a significance beyond history, an ultimate deepening of the psychic element, a complete spiritualization of all material objects. This style continued to grow far beyond both the near and the remote future during the centuries to come, and the point when its influence will eventually terminate cannot be foreseen, even

today. In fact, the influence of Rembrandt's style is still making an impact on work so far removed from him in time that the historical link seems more like a historico-philosphical connection. We can trace it, for example, in the work of Goya, Daumier, and even the late Cézanne.

The utmost emphasis on spiritualization, and the highest subjectivity: these are the essential principles of Rembrandt's art, and to observe how this art achieved expression within the limitations of its period is to witness one of the most fascinating and moving of historical dramas. For instance, unlike the artists of later times, Rembrandt was denied complete freedom of imagination, and, indeed, it cannot have lain within his nature, or he would have anticipated the achievements of a century and a half later. On the other hand, he did succeed in illuminating from within the classical discipline of his late compositions, in clarifying them to a spiritual translucency by means of the supernatural, incomprehensible power of the message conveyed by their content. This is the great, universal element in Rembrandt's art which towers above his time (though he, personally, never made the breakthrough) into infinity, and this is the explanation of the isolation and loneliness he suffered in his old age, as an artist and as a man. It is also the explanation of the deep creative significance of Rembrandt's personality, and also of the gulf that separated his classicism from that of his contemporaries.

Thus Rembrandt, the original creator of Dutch Classicism, remained, stylistically, at a stage which enabled him to pursue it to its ultimate fulfilment, while the development of art generally passed him by. Thus, his contemporaries, in their efforts to increase the objectivity of their means of representation, turned to French Classicism, and attempted to learn the language of increased subjectivity from the French method of fragmentation and reinterpretation. But their aim of objective means and subjective content was never achieved, because their cool, analytical intellectualism forced the content back within the confines of an even narrower objectivism, and, instead of becoming more subjective than Rembrandt's classicism, it became less so. Rembrandt himself, on the other hand, retained his attitude towards formal methods of rendering, and did not force the objectivity of his media like the later classicists, and the power of subjective inspiration he generated from the depths of his creative genius was so strong that it swept him beyond the bounds of his historical environment, and isolated him within the movement he himself had originated. In the profound subjectivity of his approach, and the transcendental message of his paintings, Rembrandt probes far deeper into the realm of pure spirituality than any other artist of modern times has been able to do. At the same time the essential, subjective content of his art is so limitless and so beyond comprehension that it could only have been accommodated within the system of spacious, universal forms we generally associate with classicism. The spiritual tension is too overwhelming to be fully realized in a perceptible form, we can only

sense it behind the quiet self-sufficiency of one of those characteristic "masks".
For this is the role of classicism in Rembrandt's art, the classicism he created for
himself, to be the vehicle of his intuitive spiritual world. This is also the reason why
his classicism retained its integrity and avoided the prevalent analytical reduction
and fragmentation; for it was his only means of capturing the things that moved
him, and setting them down in a visual form.[9] Thus, although the general trend of
development seemed to be passing Rembrandt by, in reality, it was he who was
growing beyond it. In his late period, his art was calm and self-sufficient, and no
longer needed to rebel and burst its bonds as in his youth, when he was more hide-
bound by tradition. The paintings he did at this period are rooted deep at a level
where the relative value of historical reality has been swept away and the absolute
value of creative reality prevails, and out of those depths Rembrandt's art rises,
great and powerful, stretching beyond the limits of time and human life, and
spreading, without restraint or restriction, throughout the realm of timelessness
and universal humanity.

This deeply subjective art does not indulge in contemplative self-observation to
such an extent that it reduces the ego to the level of an object, as the superficial,
subjectivist, late classicism tended to do, but it still attains the highest imaginable
degree of subjectivity. The creative power of the soul reaches so far into infinity
that it encompasses all human values, past and present, and in its depths, reflects
the combined radiance of everything that is great, eternal, and of timeless validity.
Hence, the image of *one* mind embraces the universe, and its subjectivity becomes
a force of objective, universal validity, because it contains the sum of all humanity's
most treasured values. In the last instance, complete subjectivity becomes a sublime
objectivity, making the soul expand, even to the point of immolation, until it
can contain all things. This is an objectivity which has nothing alien, supernatural
or superhuman about it, but is the projection into the vastness of eternity of one
man's creative depth. This personality presides, an omnipresent spirit, over the
development of the subjectivity of more recent times, like a supreme fulfilment,
and wherever ultimate problems of spiritual expression are being solved, we can
find the traces of its presence. Rembrandt is a force in the development of modern
intellectual life whose influence has never been appreciated at anything like its true
value. He reappears, not in obvious examples only, such as his eighteenth-century
German imitators, but wherever painters have adopted his compositions, his formal
details and pictorial effects, and strangely enough, his influence is often strongest
in the instances where his artistic principle alone emerges, usually in a completely
altered guise, because the connection has been formed at a deep, essential level.
Wherever an artist is striving to express hidden spiritual values and clothes the
ineffable in visual forms, and wherever the human soul has come to the utmost
limits of its capacity to portray material objects, this deep-lying affinity with

Rembrandt leads him towards calm, spacious forms, eroded by spiritual tension and hovering on the brink of disintegration. This is the point at which the pictorial space begins to fluctuate with the same mysterious tremors and cross-currents as in Rembrandt's late works, where this phenomenon is always associated with grandiose forms of typical, universal validity and mask-like faces whose composure conveys, all the more vividly, the spiritual experience taking place behind them. It is, in short, a phenomenon which always goes hand in hand with everything associated with the word "classicism".

The whole concept of modern classicism is a paradox, and in its profoundest and most forceful manifestations it always negates itself. Indeed, its real meaning is a negation of its outward appearance, which is all typicality, abbreviation and fusion, because it is, in reality, striving towards disintegration, dematerialization and a flight into the spiritual sphere. The classicism of the period around 1800, for example, was not so much a problem of form as of expression: and the problem of that epoch was how to transform the external form by means of a transfiguring, inward "message".

Such considerations make it easier to understand the isolation of Rembrandt's later years. In his youth, while he was still engrossed in the principle of formal configuration invented in Southern Italy, he had already developed beyond the artistic horizons of his native land, and he was even further in advance in his old age, when he created a new spiritual world of all-embracing, universal human significance. Just as the artistic problem of "Rembrandt" is international, and not merely identical with the problem of Dutch art, so "Rembrandt", as a total problem, extends beyond the realm of the arts and ascends into the sphere of universal spirit.[10]

However, any outline of the essential trends in Rembrandt's work would be incomplete, as Riegl had already emphasized,[11] without a discussion of material from the rich resources provided by his drawings. As the general development in art tended more and more towards subjectivity, this category of "monuments" increases in importance, because, more than any other it illustrates the supremacy of a fertile and constantly productive imagination. It is interesting to remember that drawing only came to major importance with the appearance of Rembrandt, who created a completely new concept of the art.

For Rembrandt, drawings were not, as for Rubens, the preliminary steps towards a painting, nor, as they were for the cinquecento, sketches for compositional ideas. Although he evidently regarded them as an artistic category of their own, at the same level, and as justifiable an outlet for creative energy as painting and graphic art, Rembrandt's drawings were rarely rounded off and finished like those of Dürer, Lucas van Leyden or the Mannerists, whose drawings are as complete as a painting. Nor were his drawings merely the means of mastering empirically observed forms

as the incarnation of objectively functioning natural forces, like those of the artists of the quattrocento. Nor was he mainly concerned, like most of his Dutch contemporaries, with capturing the truth of an optical impression, and reproducing a natural phenomenon, bathed in atmosphere. Certainly, Rembrandt drew innumerable studies from nature, but with a completely different purpose in mind, because drawing, to him, was first and foremost an outlet for his subjective, creative imagination. He regarded his artistic vision as being of primary importance, not in the sense of formal structure, as the embodiment of objective, artistic laws, but as the result of a mental or intuitive experience or of a revelation. It was the world of content that provided the deep-lying foundation of Rembrandt's art, not content in the sense of something which can be enclosed within a concrete, literary form, but subjective, spiritual experience, visionary intuition. In Rembrandt's art, every object is a spiritual experience, he creates each one anew out of his inner resources. His studies from nature are as permeated with the vitality of his productive imagination as the traditional themes he rediscovered and recreated; he transforms all objective events into inwardly mobile, ever-changing reflections of the subjective generative power of the mind.

For Rembrandt, a drawing was the foremost means of expressing the continuous flow and texture of his imagination, and, indeed, even from the point of view of their external appearance, drawings have nothing restricted or confined about them, nothing which is incapable of further development. In fact, it would be justifiable to claim that a drawing represents a new concept of finish, whereby any product of the artistic imagination can be seen to bear, at every stage, the stamp of inner completion, and is thus viable as an organism in its own right. Rembrandt was the first to see the potential of this new approach to "completion" and he originated a new concept of the drawing itself. In his work, the old distinctions between study, sketch and finished work no longer apply, because his works of art do not develop through the same sequence of stages as those of the cinquecento, and even where he did go through such a sequence, the "study" is not merely a preliminary step or stage in the gradual maturing of an idea. For Rembrandt, an artistic idea was something organically complete at every stage, right up to the point of ultimate "perfection", and yet, at the same time, something that could be extended infinitely. Even his "preliminary studies" and "sketches" have the importance of artistic entities, complete within themselves.

Rembrandt's original concept of drawing has dominated the whole development of art ever since, and has produced many radical changes. For instance, the technique of catching the spiritual essence of a theme in the mirror of a subjective vision, and the freedom to portray the deepest emotions in a "sketch", using the scantiest of means, is now no longer restricted to the drawing, but has made progressive inroads into graphic art up to the time of Goya, into painting, up to

Delacroix and Daumier, and finally brought a complete reappraisal of even these media.

The best method of outlining Rembrandt's development as a draughtsman is to analyse individual works. In this way, it is possible to capture the essence of a unique historical phenomenon, and also to grasp the underlying purpose of the process of development, the element of continuity associated with a historical personality.

This is an undertaking of some magnitude, however; but although it could hardly achieve its ultimate goal at first attempt, it might prepare the ground for dealing with the primary problem of any analysis of Rembrandt's work, the question of authenticity. From the methodological point of view, the problem of the chronology of Rembrandt's drawings must also be solved before there can be any satisfactory solution of the critical problems which will be valid for all known cases. The extent to which these latter have been dealt with is, of course, common knowledge. There is a large quantity of School work and apocryphal material among the drawings generally accepted as being by Rembrandt, and indeed, authentic works may only represent a fraction of the whole, but there are also many sheets which have been rejected through over-hasty criticism, as well as many which are still unknown. Admittedly, attempts at a critique are being made on many sides, but none have yet proved satisfactory, or capable of providing a methodological foundation.

It is hardly surprising that works by Rembrandt's pupils and imitators cannot fit into the organic, chronological structure of authentic works without incongruity, and that they often unite traits from several different stages of the master's development. Since Rembrandt's followers did not develop their language of form out of their own personal solution of the problems involved, but by copying models executed at different times in his life, discrepancies naturally tend to creep in. For instance, the work of a pupil active in Rembrandt's studio during the 'thirties or 'forties will be, comparatively, more consistent than the work of a pupil of his later period, who ran the danger of being inspired by a wider range of conflicting stages in the master's development. This, of course, did not always happen, since there were some strong personalities intellectually abreast of the master's late style, who adopted it *in toto*, without inconsistency. However, many of the apocryphal drawings executed after 1650, show elements of Rembrandt's style of drawing from the 'thirties and 'forties, and as a general rule, the greater the difference in age between master and follower or imitator, the more such inner inconsistencies appear, and they may even be found in conjunction with traits and elements from a later period to which the draughtsman belongs. This line of approach alone yields a large range of objective criteria for judging authenticity, but we might also find it helpful to keep the demands of the "science of methodology" in mind, "that, as in the comparison of handwriting in the study of ancient documents, we can extract

objective criteria out of the total material for any one period or group of monuments, without being affected by subjective impressions, criteria which vary according to the type of works of art in question. Establishing these criteria is the most important and ineluctable task for the criticism of monumental sources in art-historical research."[12]

If, however, the chronology of Rembrandt's work is to be used to furnish criteria of authenticity, it will have to be reliably accurate or, at least the essential elements in Rembrandt's development will have to be established. Unfortunately, as far as his drawings and their relationship with his other works are concerned, this is far from being the case. We still have not ascertained the salient features and factors in Rembrandt's development as a draughtsman and we do not even know the full repertoire of forms and methods of expression in his drawings at any one period. For instance, in his youth, Rembrandt used convoluted, sinuous baroque lines, sharply drawn, while in his middle period he favoured rich, "painterly" washes, and in his old age, optically broad, angular strokes. But since he often drew with broad strokes in his early period and with fine, swinging lines in his old age, these criteria, and thus the dating based upon them, are often unreliable.

On the other hand, Rembrandt's drawings provide us with another source of important clues, that is, not the external, technical characteristics of a sheet, but the inner, formal meaning and artistic content of the subject-matter; and these clues are decisive. In brief, it is no longer true to say that Rembrandt used one technique in his early period and another in his old age. Instead, we must begin to ask why he developed a certain technique, and what he was trying to express with it. This is the only way we will achieve a total picture of the most important factors in his work, and, incidentally, those which, alone, can give correct, objective vantage-points for an attempt at dating. In this way, we shall also be able to apply the various technical criteria in the correct way. Technique divorced from content is an empty concept, and no basis for a critical analysis. Rembrandt often changed his technique even within stylistically related groups of drawings, simply because he wanted to ring changes on a basic artistic theme.

It would be perfectly feasible to obtain a clear concept of Rembrandt's development as a draughtsman if we could also apply finer and more exact systems of analysis to the works themselves, in order to "read" their essential features. Indeed, modern research into the history of art has already developed such sensitive instruments of stylistic analysis in other fields that the prospects of success here are very good.

The first problem is to find a reliable point of departure, such as a small group of unquestionably authentic sheets either dated by Rembrandt himself, or whose dates can be established by documents. Such a group exists, but it is small, too small for our purposes, although it can be augmented with drawings that can be

dated from their relationship with dated, or fairly precisely datable, paintings and etchings. Unfortunately, there are very few sheets which can definitely be said to be direct, preparatory studies for other works. Rembrandt created a new concept of drawing, and his drawings do not conform to traditional patterns of draughtsmanship. According to this tradition, a "design" is a project for a certain work of art, while a "study" is preparatory to a particular part of it. The majority are either subjective observations or inner visions, ideas or thoughts, developed with the pen in mind, and hastily jotted down. One version of a theme evolved out of another; there was no amending or augmenting in order to bring the drawing closer to some preconceived project already in the artist's mind. He never made step by step designs like the Italians.

In many cases, such "studies" and "designs" form part of a common, genetic relationship which also included paintings and etchings. These relationships are not only general, and stylistic in nature, like those linking works done during a certain phase of development, or a group closely connected in style, but they are also concrete bonds uniting one work with another, woven by the conscious activity of a creative imagination. Rembrandt never planned or expanded his designs, he simply let his ideas develop and roam as free and unfettered as variations on a musical theme. Just as our concept of a philosophical idea is of something which is not merely fulfilled by the sum of its individual realisations, but which spreads over them, full of potential, and links them together, so in Rembrandt's works, one artistic idea often links various works together. These works are separate organisms in themselves, and yet are somehow closely connected in a higher, artistic unity.[13] Thus the genetic connection of Rembrandt's drawings to certain etchings and paintings is very tenuous, and putting a date to many of the drawings, correspondingly difficult. This is further complicated by the fact that long periods of time often intervene between the execution of a "preparatory" drawing and the painting or etching and in such cases dating can be attempted only with the utmost circumspection.[14]

There is, however, another possible method of establishing connections between Rembrandt's drawings and his other works which has been largely overlooked until now, but which is, perhaps, the most important method available; this is the establishment of concrete, stylistic relationships.[15] We shall be able to apply this method as soon as we have disentangled the various changes and developments in the forms of expression in his paintings and etchings. In order to do this, it will be necessary to ascertain and elucidate the essential elements in Rembrandt's style of presentation, his problems and the methods he employed to solve them, and finally, his technique, the crystallization of the processes in his imagination. It is reasonable to assume that what concerned Rembrandt at any one period, what he was trying to express in his paintings and etchings, must also have emerged in his drawings,

and we can thus approach them armed with experience derived from studying the former.[16] In other words, certain stylistic groups of paintings and etchings must have corresponding sheets among the drawings, and once we have distinguished them, a clear picture of Rembrandt's development as a draughtsman will gradually emerge.

It is, of course, obvious that only unquestionably authentic material can be used as a basis for analysing Rembrandt's development as a draughtsman. But if, on the one hand, there are an insufficient number of signed or dated sheets or acknowledged designs for known works, to provide the basis for the analysis and material must be adduced from a wider field; and if, on the other hand, an exact chronology has to furnish the criteria for an objective evaluation of authenticity, how are we to find the unimpeachable sheets we need to demonstrate the salient points of Rembrandt's development? This appears to be a vicious circle. The material we propose to authenticate by means of a chronology seems to be needed to formulate it in the first place. But, in fact, the problems exist less in the practical field, than in the realm of theoretical approach, which seeks to demonstrate its methodological structure.

A certain basic stock of undisputed drawings exists which must suffice for the construction of our preliminary concepts. But here, as in all other fields of historical research, the quantity of material available is less important than the skill of the scrutinizing eye, and a connoisseur's intuition is only a part of this. Indeed, even preliminary reviews of the material should be accompanied, at every step, by meticulous and stringent comparisons of forms, using only the most objective viewpoints and rejecting all related works obviously executed by another hand. In this way, we will be proceeding in a scholarly manner, even though the arguments may not carry the full weight and conviction of a chronological foundation. The fact that the material has been tested for authenticity is, of course, implicit in the analysis itself.

The material selected as authentic is next arranged in chronological order and used to reconstruct the course of development. Then, if the construction appears to be complete, and there are no inner discrepancies, and if it ties in with the results of our studies of the paintings and etchings, then the material can be considered to have stood the test. That is to say, anything that can be fitted into a meaningful, historically organic sequence has a claim to authenticity, anything that does not, can be rejected without further demur.

Even if it were ever possible to use all of Rembrandt's surviving drawings for our reconstruction, it would still be neither practicable, nor would it make sense, to set up an absolute chronology, nor indeed would this bring us any closer to the artist's mind. Problems and ideas in an artist's work do not follow one another in an orderly sequence but are entangled and intertwined. An artist may be still thinking about one idea while already engaged on another, or some new impulse may move

him and send one theme spinning on its way, while the rest progress at a more pedestrian pace. He may also resume an interrupted idea after a long interval of time. In fact, the precise chronological course of all these threads can only give us a fragmentary picture which does not reveal the nature of the whole. The individual human being and his activities are only a microcosm, mirroring, on a smaller scale, the situation of mankind in general. This is why only "interpretative" historical classifications and categorizations can concentrate the light diffused throughout the overwhelming profusion of phenomena and focus it, as in a burning-glass, in one illuminating ray.[17]

"Rembrandts zeichnerische Entwicklung," *Oesterreichische Rundschau* XIX (1923), Vienna, pp. 993–1013.

Rembrandt's The Falconer

In the early 1660's, the aging Rembrandt created a series of paintings representing pilgrims, saints, evangelists, monks and nuns. In these portraits, everything is inner resonance, a deep, mysterious harkening to an inner voice, which makes the features inscrutable, mask-like and enigmatic, betraying an indescribable spiritual tension. The figures are not incarnations of higher beings whose divine origin is manifested by the brilliance and blazing splendour of their appearance, as the masters of Italian Baroque would have represented them. Nor are they creatures of an imagination like El Greco's, functioning in a transcendental dream world far beyond the bounds of normal experience. In fact, they are real human beings whose humanity has been raised to such heights that they have shed any semblance of contingency and transcience and have almost become, through this process, the incarnation of the eternal forces of destiny. When Rembrandt paints a nun during this period, he represents her with the mortal, contingent qualities in her features so nearly extinguished by destiny, that she herself becomes an image of destiny: ghost-like, but not an alien, chill phantom, rather, spiritually close and akin to us, radiant with suppressed fervour.

This suppressed fervour burns in all the mature Rembrandt's figures. This is the time when he was portraying his own face looking as furrowed and weather-beaten as an old crater, in whose depths the mighty flames lie dormant. Fate has written the whole life of the man in his features, and we sink into his gaze, as into a boundless world, while his eyes shine with the fervour of a psychological strength capable of lifting itself above life, not by negation, but by glorifying it in a positive way.

We can read Rembrandt's whole life, from start to finish, in his late self-portraits, and the same is true of the features of the people he was using, at the time, for the lone and solitary subjects of his paintings. In these portraits and pictorial soliloquies, we also see the close of a life which has run full circle and has thus become a symbol of eternity. Indeed, the light of eternity breaks forth from behind the severe gravity of the mortal frame as the suppressed fervour of the colours erupts from behind the dark, optical planes of the space. Even in advanced old age, Rembrandt was still receiving commissions for portraits but he fulfilled these commissions as if he were painting them for himself alone, as if he were trying to come to terms with the mysterious realm of another human personality. The subjects of these portraits often look strangely like their creator. This is particularly true of portraits of people to whom the master was connected by more than the

bonds of a commission, and where we sense that the subject has somehow become an experience for the master himself, a kind of incarnation of his own spiritual potential. When this happened, the ensuing work was of a quality rarely encountered in the annals of artistic creation.

The Falconer (Bredius 319, fig; 11)[1] is a painting of this kind. The sitter is a man of mature years, with a wonderful psychological depth to his expression, rather like the Dostoyevskian type who plays such a role in Rembrandt's work during the 'fifties and 'sixties, and who also emerges in the figures of Russian pilgrims. Here are features moulded by a whole lifetime; they reflect both the depths and the heights, curiously intermingled and transfigured, not by being remote from life, but by illuminating it. The brightest light in the whole painting radiates from the face, which shines with an almost uncanny expressiveness, and makes it the focal point of the composition. All the man's psychological strength is concentrated in his large, dark, unfathomable eyes, emanating a magical power. These eyes look out from between wide-open lids, they miss nothing, because their penetrating gaze pierces every obstacle, and yet they remain at peace, and deep in self-contemplation.

Rembrandt has portrayed his subject as a falconer in the rich, romantic dress of the previous century. He is wearing a wide-brimmed, plumed hat on his majestic head, a broad collar with a magnificent embroidered edge round his shoulders, and the cross of some order hangs on a ribbon down to his belt. His half-length figure looms up like an apparition, out of the narrow corridor of space between the spectator and the dusky background. This background is filled with the misty, indistinct shapes of a horse and groom, so closely interwoven with the chiaroscuro of the space that they look like part of an old tapestry. Against these twilight colours, the falconer's head glows with redoubled luminosity. The solid forms have melted into atmosphere and, in contrast, the space has been solidified into optical planes which suggest vast, oppressive depth with far more intensity than any free spatial illusionism. This is the artistic principle of "formed space" —a term coined by Riegl.

Against this background, there is a varied play and counterplay of forms intersected by diagonals. The lines of the falcon, the ribbon, the falconer's hat and the servant cross the picture in one direction, the contour of the falconer's left shoulder, and the horse, in the other. The falconer's head is the pivot of the dynamics and movement in the picture, whose Baroque vigour has been refined by the classically formal arrangement of the planes. The atmosphere, almost physically perceptible, seems to compress the solid forms as if between sheets of glass, so that they look transparent, immaterial, almost disembodied. The same quality is produced by the wonderful painterly breadth with which the bird, the falconer's gloved hands, and his hat, have been set down. They look like translucent planes, rimmed with

phosphorescence as if the atmosphere were foaming up around them. This is an interpretation of material substance which transcends descriptive naturalism, and where the device of extreme heightening of reality serves as a key to the realm of the unreal.

The Falconer was painted about 1661/62, and is, spiritually, most closely related to the series of monks and men at prayer, but it also has connections with a *Self-portrait with the Bible*, painted in 1661, in which Rembrandt portrayed himself looking like a man lost in a dream (Bredius 59, collections of the Earl of Kinnaird [de Bruyn; now in the Rijksmuseum, Amsterdam]; fig. 169). The glowing plasticity of *The Falconer's* features, set off against the dark shadows, also reminds us of the *Portrait of a Man* in the Hermitage (Bredius 309), which was painted in the same year. The monumental impact of his presence, however, is more reminiscent of the *Portrait of a Young Man* (Bredius 312, collection of Count Wachtmeister, Wanas [now in the National Gallery, Washington]; fig. 117), and the demonic expressiveness of the brightly-lit face, reflecting the soul within, recalls the *Portrait of a Man* at Gutekunst[2] (Bredius 311 [now in St. Louis, City Art Museum]). Both of these latter paintings were executed in [1663] 1662.

Rembrandt used the same model again for a painting of a *Crusader* (Bredius 318),[3] and it is impossible not to wonder why he felt impelled to return, in the last decade of his life, to the sort of romantic, historic scene he had loved to paint in his youth. It was certainly not, as it was then, because of a desire to set off a strange, unusual subject against a display of exotic and picturesque drapery. Such devices would have been superfluous to the aging Rembrandt, who was only concerned with spiritual expression. Nor is the costume an arbitrary choice; the reason why he selected this rich attire for his sitter can undoubtedly be found in a deep-lying relationship with the personality of the model himself. The setting does not give the impression of theatricality as much as it conveys the feeling that here is a soul wandering in the past, searching for something it has lost, because it has withdrawn from the world, although it is still glowing with inner vitality. There is much of the "poor knight" in this enigmatic figure.

It is not only the setting which links *The Falconer* with a bygone era. The vigorous and confident way the man has been painted also creates a mental bridge between Holland of the seventeenth century and Reformation Germany. In this portrait, Rembrandt establishes contact, at an inner, essential level, with the adamantine peacefulness of Holbein's two portraits of falconers in the Hague [P. Ganz, cat. nos. 72 ("Robert Cheseman") and 121]. Possibly, this was the world that gave him the inspiration for his *Falconer*. It could be objected that Rembrandt may not have known the Holbein originals, which were in England during his lifetime, but there may well have been a deep-lying relationship between the two artists formed along hidden pathways to which we could not even obtain access today.

The theme of one of Rembrandt's best late drawings was inspired by the same constellation of ideas. It shows a *Lady Hawking* (Benesch 1183 recto; Dresden, Print Room, fig. 10), and was probably executed at much the same time as *The Falconer*, although probably a little later. The drawing provides the stylistic link between, on the one hand, the drawings which can be grouped round the *Syndics*, *Julius Civilis*, and *Homer* in the Hague, and on the other, the sheets *St. Peter at the Death-Bed of Tabitha* (HdG 229, Benesch 1068, fig. 207) and *Diana and Actaeon* (HdG 240, Benesch 1210).

The lady, whose horse is being led by a man on foot, is advancing towards us out of the picture followed, at a distance, by another man on horseback. The movement cuts almost vertically through the plane of the foreground. This is the ultimate in the suggestion of space in the plane. The bodies of the three people and their mounts are set in the fluid ether as if in a vertical sheet of water; the atmosphere has dissolved their physical substance and transformed it into a network of rays. The tangible part of their bodies has almost vanished, but if we concentrate on the confused maze of lines, the essential forms suddenly begin to stand out with the utmost clarity. The lines of stress created by the broad pen-strokes have soft resonant lines quivering round them and swinging away in counterpoint to the forms; hairline contours alternate with wide areas of dark flecks. The most intense concentration suddenly changes into weightless volatility.

This confrontation between antagonistic forces is one of the mysteries of Rembrandt's last great works of art. Silence conveys the underlying feeling, concealment reveals disturbing reality and actuality, violent movement manifests itself in calm, and calm emerges from movement which has come full circle. Form is frozen space, space is form loosened by the atmosphere. When heightened to the utmost, earthly things become unearthly, and when the supernatural is conjured up by total devotion, as if by sorcery, it appears in a palpable form. Life spreads its tentacles into the kingdom of death, and disintegrating bodies stream forth everlasting life.

"Rembrandt's Falkenjäger," *Wiener Jahrbuch für Kunstgeschichte* III, 1924/25, pp. 115–118.

The Rembrandt Drawings in the Museum of Fine Arts, Budapest

THE Museum of Fine Arts in Budapest possesses a number of drawings attributed to Rembrandt, which originally came from the Esterházy Collection. Hofstede de Groot accepted 26 of these in his catalogue of Rembrandt's drawings (Haarlem, 1906) and Térey[1] published them in his illustrated supplement to the great Lippmann–de Groot corpus. In the interim, however, our methods of critical analysis have made considerable advances, and without any implied disparagement of the pioneer work of these great connoisseurs, it has now become necessary to reject some of the sheets they included in what was, after all, the very first edition of the master's drawn œuvre. At the present time we have reached a point where we must disregard all such criteria as, for instance, personal taste, and accept drawings as genuine only if they fit into Rembrandt's pattern of development as a draughtsman, and if their connection with undisputed works can be established from every angle.[2]

In the following pages, I am proposing to review, briefly, those of the drawings in the Budapest Museum which we can justifiably claim to be by Rembrandt, and to make an attempt to fit them into the appropriate historical niche in the evolution of his art. The extent to which this can be done will be the measure of the correctness of the attribution.

The earliest work to come under scrutiny is the sheet of studies HdG 1380 (Benesch 47; fig. 12). This sheet, apparently a leaf from a small notebook, shows several sketches, in which the master has captured various impressions, just as the grey waves of everyday life washed them up at his feet. We see a blind beggar sitting by the edge of the road, rattling his clapper, as he cries out piteously to the passers-by and holds out his hat for alms. There is a small dog guarding him, its head hung down sorrowfully. Directly at the knee of this poor wretch, the half-length figure of a curly-headed scholar rises up, as if growing out of the ground; he is completely engrossed in sharpening his quill-pen. In actual fact, the drawing is so faint that we cannot identify his tool but we can easily guess at what he is doing from his attentive pose, and the preoccupied expression on his face. Above him, the half-length figures of two Orientals or Jews loom out of the space, deep in some weighty discussion.

This sheet could have been executed at either one of two points in time: about 1630, or shortly afterwards, or about 1637/8.[3] During these years we often find

the so-called "griffonnements" among Rembrandt's drawings and etchings. These are small sheets, showing a collection of figures, fragments of figures, or heads, all of which look like jottings, or fleeting impressions. These griffonnements have nothing in common with the varied abundance of most contemporary painters' sketchbooks, because, despite their apparent unconnectedness, all the various heads and small figures are linked together by an underlying bond of content: whether they are, as in the second half of the 'thirties, people listening to a sermon, or bystanders, startled by some event, exchanging opinions on it, or whether, as about 1630, they are connected by the mere fact of their common existence, of revolving in the same human sphere, and by the burdensome life they lead, so oppressive that it prevents all but the children from making more than a miserably apathetic, dull show of gaiety. It is precisely this underlying bond we notice in the above-mentioned sheet of studies. The figures seem to be a random enough assortment of people from inns, market-places and country roads, but they are all equally touched with the same unifying human warmth the master breathed into even the least of his creatures. There is not one of them who would not be missed; it is absolutely necessary that each one occupy the very spot where he has been placed.

The penlines of this airy little sheet are so very faded that it seems, at first, extremely difficult to give a precise dating from the artist's "handwriting" alone. However, we have already seen that the character of the content, and the mood of the sheet, point more to the period around 1630/31. The old man with the clapper clearly has brothers and sisters among the ragged figures of the etchings, the beggars decaying from age and poverty, creeping out wearily from behind banks of earth, exposing their wretchedness at the roadside, or standing together in wordless communication. On closer inspection, however, the delicate network of the lines gives clear signs of Rembrandt's style at the beginning of the decade. By the second half, he had already begun to build up a certain system in his draughtsmanship, though this, naturally, never became an end in itself, but responded as unceasingly to the rapid rate of his development as to the nuances of the problems of form and content posed by each individual case. This becomes easier to understand when we compare the Berlin study for St. John the Baptist preaching, HdG 85 (Benesch 140), probably made about 1637, with the sheet we are discussing. In the former, we find organization and discipline, in the latter, empirical probing and experiment. In the one, a self-confident concentration of the lines in the forms of a fully-developed artistic system, in the other, tentative essays, new methods of perception somewhat hesitantly loosening, and breaking through an older "language of style". By the end of the 'twenties, Rembrandt had achieved great mastery of expression in his drawings and the black and red chalk drawings of this period are the authoritative creations of a young artist aware of his strength.

They already show signs of Rembrandt's full intellectual power, although the forms are still reminiscent of an older world. The fact that the young Rembrandt's beggars and cripples were called works "in Callot's manner", was due not only to the similarity of the themes, because we find the same subjects among the work of other contemporary Dutch artists. The decisive factors are rather the glassy brittleness and the soft, undulating flow of the lines, which all point to Callot. Rembrandt rarely drew with a pen during his early years, finding the soft stroke of a piece of chalk, steeped in atmosphere, better suited to his purposes. But he still retained much of Callot's perception of line; the rise and fall of the strokes as they appear, for example, in the contours and folds of the beggar's cloak, give the figure a low relief as if it had been stamped out of a thin sheet of metal. This style of drawing is still rooted in the Mannerist calligraphy of Callot's manner—like the little dog, abstracted to an ornamental formula. But this calligraphy is already crumbling and falling apart. Undisciplined scribbles have begun to creep in, rebellious hooks, hatchings and crossing lines, fine and subtle enough, but disturbing the ornamental quality and seeking something different, a direct method of perceiving spiritual life. The piteous expression on the face of the old man, the concentrated look of the young scholar, and the way the voluble exchange between the two Orientals is set before us in a few airy strokes of the pen, actual and alive, this is the true, deeply inspired Rembrandt. It was not only his experiences of real life which brought about the transformation and dissolution of Callot's Mannerism in Rembrandt's drawings after 1630. The young artist was yearning for increased depth in his spiritual perception and it was this that led him to new sources of subject-matter and new methods of representation.

From the point of view of style, the sheet should be placed between the pen-sketch of *An Old Man in Meditation* (Lippmann III, 60b, listed as in the Walter Gay collection in Paris; Benesch 48, formerly Sir H. Oppenheimer), a companion-piece to the old men in red chalk of 1630/31, and the *St. Jerome kneeling in Prayer* (HdG 1176, Benesch 59) in Amsterdam, a study for the etching (B. 101, Hind 94) done in 1632.

The two views of a Dutch farmhouse (HdG 1393, Benesch 463, fig. 16; HdG 1394, Benesch 464), dating from about 1636, are among the master's most important landscape sheets. They are also of particular interest to us because they are the earliest extant, apart from a small silver point sketch of two small houses on the reverse of a sheet of studies of various heads (HdG 1023, Benesch 341), executed about 1636. The dating of the two views is indicated by comparison with a sheet (Benesch 324, Metropolitan Museum) showing a corpulent man sitting in front of the porch of a house overgrown with creepers, which, in its turn, is one of a group of drawings executed about the same time, such as HdG 129, Benesch 325 and HdG 832, Benesch 120. The technique of the sun-soaked foliage—the pen quavers

restlessly up and down without leaving the paper—and the character of the shadows in wash are very like the two views of a farmhouse.

The two landscape sheets are finished works of art, done for their own sake, and never intended to be anything more than drawings. They are thus in a category of their own, a category, let it be said, as important as paintings and etchings. Benesch 463 renders the whole complex of buildings at a glance, capturing them swiftly and suddenly, without the least hint of impressionism, but with that striking mobility and intensity in the pictorial experience which is, perhaps, the most striking characteristic of Baroque art. The leaf-fringed gables and the out-houses are still comparatively calm and compact. In the foreground, however, and towards the right, there ceases to be any descriptive refinement, and all the pent-up energy discharges in broad penstrokes. In this area description is, in fact, no longer the ultimate aim; the farm equipment, fence and tree are only providing outlets for a wild, irrepressible urge to convey a sense of movement. A diagonal plane suddenly shoots out from the midst of the broad, quivering hatchings in the fore-ground, towards the masses of foliage round the porch, and the large branches and wooden poles on the right form a vibrant close-up. They also have the effect of stage-scenery, or of a kind of springboard for our sense of the space which floods back from this point into the distance, to engulf the house, as it shines in the sun, beneath a web of tendrils. In fact, these broad foreground areas were certainly not Rembrandt's prime object when he began the sheet, nor even his point of departure, but eventually became the final result, the tempestuous final touches of a pen which started by dallying with loving details. The change in intention is also apparent in the treatment of the light. On the left, in the distance, everything is flooded with soft, even shimmering light, and light and dark seem to be growing out of, and melting into, each other. In the foreground, however, and on the right, there are extremely strong contrasts between dazzling light and deep shadowy masses, although the latter are not solid chunks of opaque heaviness, but are sprinkled with sparks of light. These are a necessary and intentional omission on the part of the brush, as it scurried across the paper, making the shadow into what we call, in a painting, chiaroscuro; that is, a dim haze, full of floating reflections.

The eruptive tumult of the above sheet could not be more different from its companion-piece, the tranquil Benesch 464, although the latter is no less great or significant. The contrast appears, outwardly, in the change of motif, and choice of pictorial detail. The artist is no longer gathering together the elements in broad, rapid strokes, but is deliberately restricting himself to one individual unit, the foliage over the door, and the small porch; the tall gable still towers above, but is no longer visible in its entirety. Admittedly the composition is fundamentally arranged around a diagonal, as in the previous drawing, indeed, any other form of com-position would be unthinkable for the Rembrandt of the 'thirties, but everything

is much quieter, more restrained and even more profound. Dense, transparent shadows lie under the porch, and on the walls facing away from the sun; floating transition passages flow out into the blazing light which falls, radiant and burning, on the wall of the gable and sparkles and shimmers as it plays on the luxuriant foliage of the climbing plants. Everything is still and deep; the lofty gable rises up with almost the grandeur of a mountain range, just beyond the compass of the picture space. Yet everything vibrates and pulses with life; the gnarled stems of the creepers twist and twine, their foliage foaming everywhere like waves, and the hot, glowing summer air weaves a diaphanous veil of light over the whole scene. Is it possible, in the case of two such sheets, done in the same impulse, perhaps within the space of a few hours, to decide which is the earlier, which the later? The *a priori* reasoning of the art historian would force him to abandon the attempt in instances when the related works cannot supply the answer on their internal evidence alone, without any superimposed "categorization". However, Benesch 463 shows the artist still in the process of coming to terms with his subject-matter. The bold sweep of the diagonals, the restless contrasts of light and shade, the brittle, stubborn, wilfulness of the way the line collides with, and breaks on, the contours of the tips of the branches, the roof ridges and the chimney stacks, and the whole attack and grasp of the motif throbs with the excitement of a preliminary skirmish. In Benesch 464, however, the concept is clearer, and has grown full and placid. The contrast has been toned down, but the artist's sense of the existence of the scene, as a whole, has been increased, the register is richer and more sonorous, the experience has been subjected to more of a working-through; in short, the mood has more to convey to us. This sheet can also produce internal evidence for being the later of the two, because the sun can be seen to have sunk into the peaceful post-meridian, and the shadows to have lengthened. It is also a more symbolic interpretation of an immediate artistic experience of the subject-matter. Whereas Benesch 463 reminds us of the dramatic tension of Rembrandt's historical paintings around the mid-decade, Benesch 464 foreshadows the later Rembrandt, growing more profound and serene. Thus his process of artistic creation seems to be regulated by the same rhythms, in the individual instance, as his life's work as a whole.

These two sheets are the first of a small group of landscape drawings, spanning the years from about 1636 to 1639, and executed before the continual stream of such drawings which began in the 'forties. Among this group we find such works as the *Landscape with a Herd of Cattle* (HdG 164, Benesch 465) in Berlin, done at about the same time as the Budapest sheets or only a little later, and related to them as closely by the character of the wash, and the drawing of the grass, as to the children's scenes of 1636/37 by the staffage. There is an edge of a forest (*Cottage with a Landing-place*, Benesch 470) of about 1637 [1636] in the Goethe Museum in

Weimar which closely follows the Berlin sheet, but is more mature and, in accordance with the artist's development at the time, more abstract. Finally, this group also includes the silverpoint sheet in Berlin, HdG 169, Benesch 466.

The period around 1638 was a time of crisis in Rembrandt's development as a draughtsman. Mental perception and analysis of reality had become the guiding principle of his work, and was replacing the abstract elements of Mannerism with the fruits of empirical observation. Now, suddenly, he came to a turning-point— it might even be called a retrogressive step—and Callot's style reasserted itself in his drawings. All at once, Rembrandt's proportions, which had begun to close up, were split open in a series of bold figures with fantastic plumed hats, and an urge for height. The obvious naturalism of his draughtsmanship, already fully developed, was torn asunder and scattered, almost by force, ripped into frayed tatters, broken into wild, jagged angles and hurried into breathtaking curves. The placid milieu of his drawings of women and children was transformed into the fantastic, schematic turmoil of theatrical ideas for compositions, and exotic masquerades. It seems almost as if Rembrandt wanted to smash the natural world he had attempted to win, and put in its place a set of values which, though powerfully expressive, are totally unreal. The best example of this change in style is the sheet in London *Joseph expounding the Prisoners' Dreams* (HdG 939, Benesch 423 verso; fig. 86); there is, on the recto, the preliminary study for the etching *The Artist drawing from a Model* (B. 192, Hind 231), a work usually, and erroneously, dated about 1650, but obviously belonging to the last years of the 'thirties. To the perceptive eye, however, it is no secret that this, on the face of it, abrupt change was foreshadowed in the growing tension of Rembrandt's work since 1637. At that time, his development was not, as used to be thought, influenced by a definite, progressive naturalism, but, rather, by constant wrestling with the problems of inner expressiveness and mental perception of the world. He, too, could stray from the narrow path of progressive mastering of natural phenomena when his true aims demanded.

The extent to which Rembrandt was really reviving Callot's style in these works is particularly well illustrated by a series of sheets showing men in fantastic costumes on horseback, now in the Boymans-Van Beuningen Museum in Rotterdam (HdG 1355, Benesch 151). Other examples of the same series can be found in the Bonnat (HdG 710, Benesch 360 verso)[4] and Hofstede de Groot (HdG 1278, Benesch 363 recto)[5] collections. Benesch 360 verso, shows several studies of a man on horseback, seen from the rear, peering into the distance; he appears again above, but on a smaller scale, this time with a companion. Taking them, for the moment, just as a complex of lines, this pair is very similar to the *Two Rowing Oarsmen* (HdG 1383, Benesch 361; fig. 20). In both drawings we see the same darting confusion of lines, an irregular network, frayed, and torn apart, with the same lattice-work of deliberate layers of hatching. As far as the details are concerned, these drawings

are even harder to decipher than those of the previous years, but the meaning, as a whole, whether movement streaming out from within, or mental tension, is conveyed far more strongly. The way the riders stare, wordless and motionless, into the distance, and the way the two oarsmen perform their task, silent and preoccupied, gives a picture of their whole sphere of life in a few, rapid lines. In this regard, the Budapest sheet is much closer to the naturalistic genre drawings of 1635/36 than Benesch 360 verso, where the abstraction is far more advanced. Rembrandt must have been particularly interested in the movement in this sheet, because he drew the left arm of the nearer oarsman twice, once bent, once outstretched. There is a sheet in Frankfort quite closely related to this small sketch (HdG 338, Benesch 84), showing a suppliant kneeling before an airy figure, indicated in swinging curves.

We will have to make a leap of nearly a decade before we reach the next sheet in the Budapest collection. During the period around 1646/47, Rembrandt was particularly absorbed in the problem of the nude, and he produced a series of important etchings and drawings, as well as returning to the Susanna theme in a painting (Bredius 516) in Berlin. The artist's interest in the nude, at this period, was not directed towards the swelling plasticity of the body, as in the 'thirties, nor the glorious faceted shimmer of light and colour of a volume displacing space, as in the 'fifties. At this time, he was studying the natural structure of the human body, in all the organic individuality of its inner form and outer appearance, and in its obvious relationship with the soft, atmospheric envelope of the space immediately surrounding it. The standing female nude (HdG 1388, Benesch 713; fig. 15) is one of the most important surviving documents of Rembrandt's artistic aims in this period, and, of all his nudes from the first half of the 'forties, most clearly foreshadows what was to come. Soft light plays around the figure, which is seen in profil perdu, standing against the dim shadow-cavern of an interior, and the broad, chalk hatchings cushioning the gleaming figure fall like driving rain.[6] This sheet is conceived on a larger scale, and more simply, than any of the rest of the group. The elastically soft contour flows down in delicate, frequently curving, parallel lines which vibrate, and are "optically" related to the background. Within this contour, however, the lines are reduced to a minimum: a light zigzag on the upper arm, a few rapid chalk-strokes on the back, buttocks, calves and bands wound round the column-like roundness of the legs. It is particularly interesting that the shadowy ground of the right contour is contrasted with the mass of light garments on the left; thus light is being allied with light, and dark with dark, an extremely heretical procedure to the eye of the academic draughtsman.

One of the most wonderful details is the soft coil of curves out of which the head has been woven. The horizontal line of the jaw has been drawn deliberately too high, so that the over-deep contour of the cheek overlaps it and re-echoes it after

the turn of the chin. Here, as in the body, we find that same delicate sweep and vibrancy which does not give the form a precise outline, but yet makes its supple plasticity seem to grow out of space all the more vividly.

The chronological position of the sheet will be easiest to determine if we compare it with the rest of Rembrandt's black chalk sheets from the second half of the 'forties. There are two other nudes among these sheets, one the preliminary study for the *Susanna* of 1647 in Berlin (HdG 46, Benesch 590) and the other a seated youth in the Bonnat collection (HdG 747, Benesch 711). The deft study for *Susanna*, rapid, though full of detail, has its roots in former years, but the youth is grander and more peaceful, and thus essentially nearer to the Budapest nude. For instance, the figure is set against the same shadowy background of dense hatching, and although the internal drawing is much richer than in Benesch 713, we find similar fine zigzags on the arms. The Budapest sheet is also undoubtedly the latest of the three; indeed, it is so tranquil, monumental and compact and the media so simple as to make us think forward to the 'fifties, were it not for the features already quoted for comparison, as, for instance, the drawing of the drapery on the right which can be exactly paralleled in sheets like HdG 709, Benesch 761 dating from the early 'forties. In fact Benesch 713 has its closest affinities with the black chalk studies of beggars and other figures from the end of the decade, which, in their monumental economy, are preparing the way for Rembrandt's maturity, and leading to the threshold of the new decade.

At much this time, that is, in 1647, Rembrandt executed one of his best etchings, representing *Jan Six at the Window* (B. 285, Hind 228). There is a superb pen study for it in the Six collection in Amsterdam (HdG 1235, Benesch 767). The Budapest portrait of a *Scholar at his Desk* (HdG 1373, Benesch 766; fig. 18) which has been wrongly linked with the *Coppenol* (Hind 300) is imbued with the same feeling and spirit as the sheet in Amsterdam, but is not as mature and powerful. The fine pointed loops, and the folds of the sleeves point back to the Dresden study (Benesch 536) for the *Susanna* in Berlin (Bredius 516), published by L. Burchard (*Jb. der Preuss. Kstslgen* 33), and some almost contemporary studies for paintings of 1645: HdG 683, Benesch 567, for the *Holy Family with Angels* in Leningrad (Bredius 570) and HdG 304, Benesch 762,[7] the study for the *Portrait of a Preacher* (Bredius 237), Carstanjen Bequest [Cologne]. But the structure of the lines would only have to be a shade denser and stronger to make this drawing very similar to *Jan Six*. Shortly before the close of the 'fifties, the structure of sinews and tendons in Rembrandt's drawings began to revolt and rebel again, beyond control, threatening to split apart. But this time, the resultant fluctuation in the pictorial space did not introduce a loosening up, but rather a new concentration. The linear energy started to build up in important areas, to a degree of intensity never encountered in Rembrandt's work before this time; in the drawing,

we can see this in the sharp, eye-catching outlines of the head, and in the hand—however hastily the sketch has been tossed off, we can still feel the grip of the fingers—and in the open book. At the upper right, there are some tall, powerful penstrokes,[8] and although it is not immediately clear whether they are meant to indicate scientific instruments or drapery, there can be no doubt that they are fulfilling their function of deepening space, and providing a broad sounding-board for the many discordant, scattered "voices" in the foreground. However, the richer and deeper Rembrandt's draughtsmanship grew, the less the lines stand for anything in particular. Not that they ever became a mere expressive flourish, or irrelevant ornament; Rembrandt's line always retained its fundamental significance as the seal of some object, or natural phenomenon in the utmost depths of its being, almost in the metaphysical essence of its reality. In consequence, we no longer enquire what a line stands for, in the everyday, pragmatic sense, because we sense the absolute necessity of its existing in this one spatial and spiritual position, and the absolute impossibility of any other alternative.

The next sheet (HdG 1375, Benesch 1078; fig. 14), brings us to the brink of the 'fifties. The subject is an old man in a patched, fur-trimmed coat with a high hat on his head, wearily feeling his way along the wall, like an old Tobit; he might well be one of those figures from the ghetto in Amsterdam, who seem to be so closely bound up with Rembrandt's artistic and human milieu. The sheet is rich and shimmering, drawn with a wealth of detail, as minute and exact as a miniature. The tattered cloth of the threadbare coat with its mosaic of patches is calmly and thoughtfully described and fine layers of brief parallel hatchings stream out from the contours, building up on the planes, indicating, here, a colour, there, a hovering half-shadow. Admittedly, wash has been applied fairly copiously, but it is not this alone which evokes the impression of a wealth of colour, despite the monochromatic media. Even the language of the lines themselves is expressive and colourful. The deep and yet gleaming tone of the outstretched sleeve has the wonderful look of dark velvet, and yet it has been rendered with only a few broad brush strokes. And this effect is made even more intense by the watery, atmospheric fluidity of the wash closing round the arm. The subtle line structure of this figure is closest to the *Prophet Elijah by the Brook Cherith* (HdG 81, Benesch 944) in Berlin, itself a drawing firmly anchored in the group of sheets dating from about 1651/52 [54/55] (HdG 62, 1426, 694, Benesch 945, 950, 910). As far as paintings are concerned, its nearest relatives are to be found among the portraits of old men, one of 1651, [formerly] in the Speck von Sternburg collection, Lützschena (Bode 377, KdK 368 [Leipzig, Museum der Bildenden Kunst, Inv. 1561, since 1945]) and the other, from 1652, in the Duke of Devonshire's collection, London (Bode 381, Bredius 267 [now London, National Gallery, New Acquisitions 1962, p. 71, Inv. 6274]).

During the 'fifties, Rembrandt's draughtsmanship went through a quick succession of changes, as we can see from the vast range of surviving mileposts (in total, about as many as from all the rest of the decades put together). As far as volume of output is concerned, he probably reached the height of his activity as a draughtsman during this decade. The more mature specimens of the group of sheets of about 1651/52 pave the way for a geometrical analysis of the human body, and in the immediately subsequent group, which includes the two old shepherds in Budapest (HdG 1376, Benesch 1087; fig. 19), we find intimations of the vertical ray-articulation of the middle of the decade. In this case, the result is not so much a "loosening up" of the human body, as an increase in the painterly structure by means of rich, dark layers of lines. There is also a large group of landscape drawings which must be placed at much the same time, most of which are farmhouses amid trees, with cubic blocks of buildings strewn among the monumental silhouettes of masses of foliage, while the light and atmosphere of an infinite open space plays round them. The Budapest collection also possesses an example from this group (HdG 1392, Benesch 1264; fig. 17).

Around 1653/54, Rembrandt went through a phase of reducing all his figures to articulated dolls; and about 1655 he was drawing nudes and making copies from Oriental miniatures.[9] In his historical compositions of the same time, the figures and groups of figures are articulated like sheaves of vertical rays, pulsing with the same dynamic force as the great, sweeping brushstrokes in his paintings. After a time, the rays were enclosed in contours again, the interior drawing grew ever more simple, and the figures began to develop into strange block-shaped constructions of cubes, three-dimensional rectangles and cylinders. We find human figures with this structural framework in *Christ Healing a Leper* (HdG 1270, Benesch 1026), the *Group of Orientals* (HdG 1462, Benesch 1133), and in the sheets most closely related in style to the sheet in Budapest, the *Two Men in Discussion* (HdG 1382, Benesch 1134; fig. 13).[10] In one respect, the latter surpasses all the rest: the lapidary strokes are set down with a somewhat dry brush, so that the torrent of lines often vibrates intermittently and fades away, and this makes the figures seem gloriously saturated with light and atmosphere, their bodies realistically solid, displacing space and sunk deep into the atmosphere despite all the frontality of their poses. Indeed, it is precisely this lapidary simplicity and frontality which heightens the impression of roundness and volume. These particular qualities may be compared with HdG 156, 270 and 1321, Benesch 1141, 1140 and 1208.

The most important of Rembrandt's drawings in Budapest is *Haman in Disgrace before Ahasuerus and Esther* (Benesch 1067; fig. 21), a sheet Dr. Simon Meller rescued from banishment to an inferior category. It is a late work from the 'sixties, a period when drawings are rare and the etching-needle was abandoned because he found it too precise and limiting. It was as if, in his old age, Rembrandt had realized

that colour was the most expressive and flexible medium for his art, and that the only way he could convey the visionary depth and power of his pictorial ideas was to clothe them in the ethereal glory of hovering planes and flecks of colour, shining and glowing from within, more often applied with spatula and finger than with a brush. During this period Rembrandt constructed his figures using the massive block shape of classicism, chromatically illuminated. This was not the classicism of absolute peace and objective compactness, but the classicism of supreme inward tension, combined with the urge to expand, spiritually, a discipline which, in order to avoid chaos and destruction, was compelled to turn to the faceted monumentality of simplified forms. This is the true meaning of Rembrandt's classicism, which is, at heart, a negation of all classical objectivity, and can be seen most clearly in its own dissolution, in the master's late works. By this time, it was already in the process of disintegrating, and everything swings and vibrates, the forms surging up in grandeur, as unreal as phantoms, and yet real to the core, all within one area of space. This space itself is more cosmic than earthly, no longer full of atmosphere, but containing a strange fluidity, which often flashes up to form structures, travelling as fast as cracks in a crystal, only to flee away as rapidly into incorporeality. The two supreme examples of this style are *St. Peter at the Death-Bed of Tabitha* (HdG 229, Benesch 1068; fig. 207) in Dresden and *Diana and Actaeon* (HdG 240, Benesch 1210).[11] The Budapest sheet is more closely related to the former.

The scene opens, broad as the panorama of a stage set with only the simplest props and scenery. In the centre, a table stands, placed asymmetrically, and block-shaped, like a huge, sacrificial altar, separating the three figures from one another, but yet holding them together. It is covered with a heavy cloth, falling to the ground, where it is heaped in thick, rounded folds. Ahasuerus' and Haman's seats are indicated only schematically in a series of swinging parallel lines. A few delicate folds, and the heavy border of drapery on the right edge of the picture indicate the vaulted roof of a gigantic tent. The stage must be as simple and as flat as this to provide the right setting for the emotional shock of the old Rembrandt's historical narratives. No sound escapes. Movement is restricted to the minimum. Outwardly, the three human beings are separate from one another, the only bond between them is their spiritual relationship, a bond now being strained to bursting point. Esther is the focus of the three; she has just uttered her accusation, and has fallen silent. She has been placed in the distance, so that she looks quite small, pushed back by the cube shape of the table. Her features show anxiety, and her face, under the high forehead with the pointed crown jutting up over it, is screwed up like that of a disappointed child. But it is she who has provoked the storm that is about to break. Ahasuerus has risen to his full majestic height, presenting himself frontally to the spectator, but with his mighty head turned towards Haman cowering

under this gaze of superhuman intensity. But this gaze is only a flash of light-ning compared to the disaster it presages: and the guilty man has heeded the warning, because he is already annihilated. To see how he collapses, and to see the helpless, half-pleading, half-defensive gesture of a man who, at the height of his power, suddenly realizes that his world is crashing about him—this is pro-foundly moving. In the mature Rembrandt's tragedies, things always happen wordlessly and soundlessly and without any of the commotion and thunder-claps of Rubens' paintings. Everything is tension, bated breath, and silence at the moment when the emotion is at its climax, a silence in which we can hear the heart beats growing louder and louder. This is the reason why the tragic element in Rembrandt's stories has far more human immediacy and gripping actuality than the most clamorous pathos can ever induce.

"Die Rembrandt-Zeichnungen des Budapester Museums der Schönen Künste," *Belvedere* 8, Vienna, 1925, pp. 119–129.

Rembrandt's Artistic Heritage[1]

T H E artistic heritage we derive from great masters exercises an influence on
posterity in two quite distinct ways. In the first instance, such a master
reacts upon his intimate or more remote circle by the very fact of his immediate
presence. Studio companions, or pupils, gather round him because they can see
the ideal fulfilment of their own artistic ambitions in his work. There are also
others who, without actually being pupils, still fall under the spell of a strong
creative personality, and are guided by it. In this way a great master can influence
the art of his entire nation, and even determine the future course of its development.
Finally, and in rarer cases, he can even influence the art of an epoch, by providing
a turning-point, a change in direction, the beginning of something new.

The second way these great masters can influence posterity is in the course of
time, and is the effect, over the centuries, of the outpouring of their creative
energy. This energy does not manifest itself, however, in archaic imitation, re-
gressive plagiarism or retrospection. Such phenomena do, of course, appear, but
they are only of secondary importance, superficial signs of the historical process
working at a much deeper level, and it is this process which heralds the reawakening
of the essential strength of a great master in the creative production of a later era.
Archaists and regressive imitators only revert to an old master, when the leading
artists of their day are showing them the way.

As I have said, the reawakening of the creative power latent in the work of a
great artist is a process that takes place at a deep level. It cannot always be recog-
nized at first glance, nor is it as eye-catching as the credo of the imitator. In fact,
the process is all the less obvious, the more enigmatic, cryptic and intangible the
effect of the work concerned, the less it can be grasped at the level of palpable,
concrete things, and the more it is rooted in the mental world of deep, inward,
spiritual relationships. Such a process can only be perceived by an eye which has
not been conditioned by the dogma of traditional formulas of style, and which
does not come to a halt after a superficial glance, but attempts to penetrate further
into the essential nature of the work of art. In fact, the best way of learning to
recognize this process is to approach historical facts with a mind full of sympathy
for the artistic aims and products of our own times, and with the awareness that,
like all spiritual values, artistic values are eternal, above the vicissitudes of time,
and have not only a permanent validity, but a permanent influence.

The following brief attempt at demonstrating the extent of the artistic heritage
we have derived from Rembrandt is not intended to be more than a selection of the

wealth of complex material available. Nor do I propose to analyse each factor and phenomenon that appears, since it is more important to recognize and explain the basic characteristics as well as the influence of Rembrandt's art. With the help of a few salient examples, we shall be able to shed light on a large section of painting and graphic art since the seventeenth century, because its nucleus and focal point is the art of Rembrandt, the greatest artist of modern times.

The word "style" is brief, and does not convey much. However, it is the term we generally use to describe the total creative output of an artist, his personal mode of expression, and all those values, whether easily perceptible, or too subtle to be expressed in verbal concepts, which make up the living fabric of his work. In Rembrandt's case, his circle of pupils received his style as a prism receives light; each one accepted his talent and put it to whatever use he could. Often, it seemed more like crumbs falling from the tables of the rich, but occasionally a strong, independent character emerged, who grasped the master's message at the right level, and created something new and individual in the same spirit.

Rembrandt taught several generations of pupils, and their work changed according to the phase their master was going through at the time. When Rembrandt was working with his contemporary and studio companion, Jan Lievens, he was still enjoying the pleasures of work shared in common, and the same spirit inspired them both. On the occasions when Lievens achieved a good piece of work, such as the *Raising of Lazarus* (B. 3, Hollstein 7; fig. 22), this was not only because he was inspired by the more talented Rembrandt,[2] but a sincere proof of his own creative power. Lievens does not march behind Rembrandt, but beside him.

Soon after Rembrandt moved to Amsterdam, at the beginning of the 'thirties, a great number of students entered his studio, and the calibre of their artistic talent can be judged from the fact that some of their best works pass, or once passed, for works by their master. For instance, J. A. Backer from Harlingen, one of Rembrandt's first pupils, painted a portrait of Elisabeth Jacobsdr. Bas, widow of Admiral Swartenhont (fig. 23), which is so "Rembrandt-like" that until only a short while ago, many critics were convinced it was by the master, despite all the stylistic similarities with known paintings by Backer (fig. 24).[3] The portrait is distinguished by a tranquil, pragmatic opulence, and a certain metallic rigidity, the same style Rembrandt used for portraits during his period of real success in Amsterdam, but filtered through the personal temperament of his pupil. Instead of Rembrandt's rich, painterly upsurge, there is a conscious slowing down, a strict self-limitation to a plain black, and a deep fur-brown that make a sharp, puritanical contrast with the colours of the linen cuffs and ruff, and the flesh. Instead of Rembrandt's modelling which is soft but shows a deep grasp of the structure of the form, we find only angular contours and linear, indented hollows. Instead of the free, untrammelled monumentality of Rembrandt's way of seeing

the human being, Backer seems to cut himself off in Protestant bourgeois conformity, and to muster his fellow creature with self-effacing taciturnity. In his paintings, Rembrandt's melting, all-enveloping chiaroscuro gives way to sharp contrasts and antagonism between light and shadow, and his vigorous outlines seem to be crumpled and creased—but not without gains in the realm of expression. For what Backer's portrait has lost in artistic and human impact, it gains in harsh realism and logic; it is a stern, inexorable statement of the facts, with none of Rembrandt's idealization.

In contrast to the realism of Backer, Ferdinand Bol took over Rembrandt's delicate mellowness of tone, and the dream-like fairy-tale atmosphere of his narrative work. Bol had a decidedly lyrical bent. He veils his portraits in the dreamy romanticism of a filmy chiaroscuro out of which the colours seem to bloom in a soft shimmer. Some of the most beautiful pictures he painted are Biblical legends, such as his representation of *Jacob's Dream* (fig. 27): the young patriarch has fallen asleep amidst the undergrowth, his face as round and boyish as a wandering scholar. A shaft of soft light is falling from the heights of heaven onto the dark earth beneath, illuminating the shining dream-figures of the celestial messengers. A tall, winged angel, slim as a wand, is approaching Jacob; he is not a real living being, but a vision, the fantastic reflection of the mental chiaroscuro of the sleeping man. Even his well-formed features betray his origin in a legendary world beyond, far away from the present world of the completely mortal dreamer.

The third noteworthy pupil from Rembrandt's early period in Amsterdam is Govaert Flinck, the shrewdest psychologist of them all, but as far as painterly technique is concerned, no equal to Bol. Flinck never simply reproduced a stock scene or personage; he always endowed his characters with distinct, personal traits, bringing out their mental attitude in an almost literary way. When he painted *Hagar dismissed by Abraham* (Moltke 2), for instance, Flinck demonstrated the personalities of the participants and their state of mind at the distressing moment of leave-taking. Abraham's patriarchal features are full of grief and sorrowful resignation and gentle, kindly pity; the young Hagar expresses her sorrow with upturned eyes and the gesture of her hands, and the little child sobs. Flinck also used the same approach in his portraits of individual people; there is something like a flicker of the quiet pathos of suppressed sorrow in the face of the *Young Officer,*[4] Bredius 204, formerly Vienna, the Prince of Liechtenstein, [then New York, A. W. Erickson, now Mrs. H. Anda-Bührle, Zurich; fig. 25], while his large shining eyes seek those of the spectator in an almost over-animated way, as if he were under great mental stress. In this case the inner life of Rembrandt's models, who are never psychologically analyzed but simply transfigured, has been transformed into outward gesture.

The above pupils produced important, or at least competent paintings, as long

as they were still working in Rembrandt's studio, or were still under the direct influence of his personality. In other words, his great example enabled them to take flights they would never have been capable of making by themselves. But with increasing distance from the master, and with independence, their strength began to fail them, and their late works, which conform rigidly to the mainstream of the fashionable classicism, soon rapidly lost quality. This is more or less true of all Rembrandt's pupils except the few who had exceptionally high creative potential.

Carel Fabritius was one of these few, really gifted artists (K. E. Schuurmann, *Carel Fabritius*, Amsterdam s.a.), and he and his pupil, Vermeer, were the highlights of the Delft School. Fabritius was Rembrandt's pupil during the early part of the 'forties, just at a moment when Rembrandt's art was on the brink of a change which would put him at a far remove from the Rembrandt who taught Backer, Bol and Flinck. Instead of the dramatic emphasis of narrative painting, and the self-confident, heightened baroque realism of his portraits, Rembrandt's art now acquired a calm and introverted aspect. Nothing can make this clearer than to compare *The Night Watch* (Bredius 410; fig. 9) of 1642, which reverts to the 'thirties in style, and *Manoah's Offering* (Bredius 509, Dresden; fig. 202), painted in 1641, which anticipates the 'fifties. In other words, Rembrandt was on the threshold of the decade in which he was to develop a sublime mastery of chiaroscuro and colourful, magical light, and to quell the tumult of his movement, and steep it in the contemplativeness of Biblical tales and the calm of meditative people.

This new spirit in Rembrandt's work found a worthy disciple in Carel Fabritius. His *Beheading of John the Baptist*[5] (Rijksmuseum, Amsterdam) was probably painted while he was still in Rembrandt's studio, although the composition seems to bear a closer resemblance to the latter's style of the 'thirties, with its large-scale figures, and its baroque opulence. However, the gleaming, rich colour and soft, blended modelling in the figures and their garments, points exclusively to the new decade, and the local colour, steeped in atmosphere, is very striking. Perhaps the new trend is most apparent when we look the figures in the face. These are neither opulent baroque types, nor the powerfully accentuated character heads of the 'thirties; their eyes and features convey a new, psychological refinement, and this spiritual fluid seems to penetrate their bodies from within, and purify them. Consider, for instance, the fine, inspired head of the woman casting a glance full of pity at the saint's severed head. The new achievements in Rembrandt's studio were certainly not in the technical field alone.

This new painterly quality showed great advances in emphasis and refinement, as we can see from Fabritius' magnificent *Self-Portrait* (fig. 26) in the Boymans-van Beuningen Museum in Rotterdam, a picture in which the personality of the model has already won through to a full expression of its individuality. This portrait

is "Rembrandtesque" in the fullest, and best, sense of the word. Whereas Fabritius' *Abraham de Notte*,[6] painted in 1640, in the Rijksmuseum, Amsterdam, despite its new depth and intensity of colour, was still redolent of the older style of portrait painting derived from Mannerism, with his *Self-Portrait* he passed beyond the stage where Rembrandt was his intermediary, and found himself for the first time. The light, downy web of chiaroscuro, filmy, and soaked in atmosphere, sets off the material objects in the painting with astonishing intensity. But skill in rendering material objects was not all he learned. The most important element in this work is the underlying, psychological theme, which gives the defiant, saturnine, dourly appealing head of this Dutchman stability and a background at the spiritual level, just as the wonderful grey of the wall, the wellspring of all the colours, sets it off in the technical sense.

In the meantime, Rembrandt's art was pursuing its own course in grandeur and solitude. Few were capable of keeping pace. The power of his painting grew with the increase in depth and concentration he achieved, the inner, spiritual stresses heightened by the new outward calm, and their intensity, glorification and penetration endowing everything with a tranquil, solemn existence of its own. All the forms are big and peaceful, like the cubes and rectangles turning their flat surfaces to the spectator, and giving him the impression of retreating into the depths, an uncanny sense of being woven into space itself. Anyone looking at Rembrandt's late paintings must become involved in these magnetic currents; physically, and mentally, they suck him into the visionary depths with irresistible strength.

The emotional tension of Rembrandt's art at this period was something none of his pupils could equal; indeed the master himself was the only man mature enough to sustain it. The forms born in his gigantic world were also designed to furnish it, so any pupil not content to remain merely an imitator, but wishing to develop his own individual gifts, was compelled to try and adapt them to his own more modest sphere. Fabritius was one of the more successful adaptors, and his *Watch* (fig. 28), painted in 1654, is a good example of the result.[7] A simple and realistic painting, it seems far removed from Rembrandt's visionary world. In the soft, diffuse light of a quiet summer afternoon, an arquebusier is seen, sitting dozing near an old arched gateway, full of homely nooks and crannies. The only thing which seems alert and mobile in the whole picture is his watchdog. Everything is so simple and intimate—yet it has been visualized on a grand scale. This piece of "reality" has been, so to speak, sponsored by the broad surface rhythms and chiaroscuro of Rembrandt's late art, and endowed with monumentality. The great, calm paintings of Vermeer van Delft also took this as their point of departure, the relationship with Rembrandt is extremely close, but not so much in appearance, as in the essential depths.

Another of Rembrandt's pupils in his later years was Nicolaes Maes, who was studying under the master at the beginning of the 'fifties. Maes' *Mathematician* in the Cassel Gallery is, however, a much more imitative work than Fabritius' paintings because the former was obviously carried away by his admiration for Rembrandt's style of the 'fifties. The *Mathematician* has Rembrandt's large-scale forms, his transparent, glowing mellowness of colour and the tranquil, spiritualized quality of his mature single figures. As for the technical quality, it is outstanding, and this painting is still usually accepted among Rembrandt's oeuvre,[8] although when it is compared with Rembrandt's scholars and evangelists it falls down, precisely because of the brilliant, studied imitativeness. The figure, for example, has none of Rembrandt's deep-lying, powerful, mobile grasp of form; Maes' lyrical temperament and tendency towards genre is obvious in both the soft, formal and chromatic consistency and the retiring pensiveness of the expression. There is no mistaking the future painter of lace-makers, women at prayer, and mothers suckling their babies, for this was the modest niche Maes eventually found.

Another interesting pupil, this time from the 'forties, was Barent Fabritius, influenced not only by Rembrandt, but also by Carel Fabritius, who may have been his brother. Barent Fabritius' historical paintings are told in a simple and straightforward manner, content being more important to him than problems of technique. He had found his method of expression ready-made in Rembrandt's studio, and although he was in brilliant command of it at the beginning, it gradually began to petrify in the asceticism of his Biblical stories. In their strange combination of realism and expressive line, these narrative paintings are reminiscent of the works of the Spanish Church painters (fig. 29).[9]

Gerbrand van den Eeckhout is the prime example of one of Rembrandt's pupils whose work remained frozen at the disciple stage, and never progressed beyond the merely superficial, coldly academic gesture. He too was an artist whose best works were painted during his period as a pupil and although his *Solomon's Idolatry* of 1654 (fig. 31) is worlds away from the work Rembrandt was doing at the time, it was still executed under his aegis. The character of the composition, the figures, the treatment of the objects and even the conception and the rendering of the content are all ultimately due to Rembrandt. But once Eeckhout had to stand on his own feet, all his power ebbed away, reduced to a formula; it developed into that cool, modish classicism which dominated Dutch art at the time.

This seems to be a good moment to interpose a few words about the position of Rembrandt and his circle in contemporary Dutch art. To start with, it was completely different from the position of that other great antipode of Northern Baroque art, Rubens. In fact, all Flemish Baroque painting is merely an extension of the school of Rubens and his influence can be sensed everywhere, because although it is also a powerful intellectual experience, his art manifested itself in

large forms, moving monumentally. It is as much an art of form as an art of the spirit, and form becomes common property much more easily than purely intellectual qualities. Thus, it is only too comprehensible that Rembrandt and his school formed an oasis in the midst of Baroque Holland, and that miles of barren desert separated the spiritualizer of the Joden Breestraat with his esoteric circle of pupils, from the painters of official portraits, landscapes, still-lifes and animals.

Despite this fundamental incompatability, Rembrandt had a much deeper, and more lasting effect on his native art than appears at first sight, and this brings us to the problem of the Dutch classicism of the middle of the decade. Indeed, however paradoxical it may sound, Rembrandt was the real inspiration and pioneer of this movement. The new monumental style which appeared after 1650—the method of composition using surfaces and simple, large-scale forms, indicating the depth of infinite space by the rhythms of the light and the magic of the colour—can only be attributed to the influence of Rembrandt's creative personality. At any rate, he initiated this "classicism" (which is by no means identical with academic formalism), and he did so as early as 1640, a decade before the beginning of the "movement" as a whole. *The aim of this classicism is to increase the simplicity, profundity and calm, while heightening the inner mood and emotional expressiveness.* It is as apparent in the peace of Ruisdael's woodland scenes as in the intense solemnity of Emanuel de Witte's church interiors. We can see it in the intimate monumentality of the tranquil interiors of Vermeer and Pieter de Hooch, as in the clear nobility of Willem Kalf's still lifes; in the unadorned dignity of Ter Borch's portraits, in Cuyp's golden summer pasturelands, Philips Koninck's vast plains and the infinite celestial horizons of Cappelle's seascapes. *In this way, Rembrandt determined the destiny of the art of his native land.*

The classical movement paved the way for an academic, modish formalism, and for the French influence, which, towards the end of the century, increasingly took the lead. In fact, these were merely two symptoms of a current which ran much deeper, and consequently persisted long after the movement itself had been dead for some time. It was one of the most tragic features of Rembrandt's destiny that he was fated to grow more and more isolated within the intellectual vacuum and formalistic superficiality of the movement he had himself originated, until he eventually ended his days as "old-fashioned" and, for the most part, alone, and forgotten by his contemporaries although, in fact, it was the stately, transcendental paintings of his old age which showed how far he towered above his time, and even anticipated some of the great developments of the centuries to come (Bredius 60; fig. 55). If we understand Rembrandt's classicism in this way, we can interpret the artistic activity it generated.

Very few of Rembrandt's immediate circle of pupils were capable of doing justice to the real depths of meaning in his classicism. Bound to superficialities,

they lost their sense of the underlying principles when they took leave of their master, and fell prey to the outward trappings of the movement. Carel Fabritius was possibly the only pupil who, until his premature death, kept faith, in spirit, with his master, if only because he developed away from him, and retained his own creative individuality. Otherwise, the most faithful guardians of Rembrandt's artistic heritage were usually men who were never part of his circle. But any further investigation of this problem would be beyond the scope of this interpretation, because it would involve describing the entire history of Dutch painting in the second half of the seventeenth century. Thus I shall conclude by mentioning one more of Rembrandt's pupils, a strange late-comer, Aert de Gelder, who, apart from Fabritius, was the most original and inspired of the master's pupils. De Gelder was Rembrandt's only pupil in his later years, and although only half-grown, he spent his apprenticeship in the master's studio, and steeped himself ineradicably in Rembrandt's mature style. From his first to his last painting, far into the eighteenth century, his style was consistently influenced by the latter's genius (fig. 30).

The first country we enter, after leaving the confines of Rembrandt's native land, is Germany, and indeed there are many points of contact between the natures of the Dutch and the North Germans. These are easiest to trace in the years after the beginning of the new period of art, when Lower Germany seems to have come under the influence of the Dutch. In other words, it is hardly surprising to find Juriaen Ovens and Christoph Paudiss from Lower Saxony among Rembrandt's pupils. The Germans were interested in quite different aspects of his work. The kind of baroque art being developed in the Netherlands and in Italy was still unknown in seventeenth-century Germany, a land still under the spell of its own great 16th century, its late medieval past and more deeply affected by Mannerism, the Neo-gothic revival, than any other of the countries in Europe who have a claim to a national art. This is why Rembrandt's baroque period, his classical style, remained a closed book to his German pupils, while his early work, so redolent of Mannerism, Callot and the Dutch painters of the turn of the century, must have been a revelation for them.

Paudiss' entire creative production from beginning to end, shows the influence of Rembrandt's early paintings. Paudiss died in 1667, while holding the post of Court painter to the Dukes of Bavaria in Freising and, although himself a Protestant, many of the huge and imaginative altar-pieces he painted were housed in the private Catholic chapels of their castles. Paudiss derived his exotic figures, and the medieval romanticism of their Mannerist drapery, from the early Rembrandt, and his pale, cool palette, dominated by faded bluish and greenish tones originating in a grey, with yellowish or russet reflections and misty crescendos and diminuendos of light, comes from the same source. Although Paudiss never achieved the robust

strength and monumentality of Rembrandt's early work, he was a highly cultivated artist, capable of giving his paintings a touch of refinement which, though individual, is still almost tainted or hysterical. This quality is strangely at odds with the monumental forms of his figures, and they often look waxen and ghostly (fig. 32) [National Gallery, Prague, formerly in the Nostitz Collection, 1958, cat. no. 448].

In Johann Matthias Weyer's superb *Conversion of Saul* (Braunschweig; fig. 33) we see the wildness and theatricality of the early Rembrandt translated into the German idiom. Expressiveness, inner turmoil, imaginativeness—it is hard to find words to describe the turbulence of this painting. Yet the wildest bizarreness, the most grotesque discrepancies between the figures and the shrillest disharmonies in the composition are just what this artist needed to render the passionate flurry and urgency of his tale. In the painting, Christ appears high up in the sky like a tiny, fleeting cloud, but his presence has the impact of a hand-grenade. Men and beasts scatter in terror, and Saul falls backwards to the ground; a standard-bearer soars upwards on his rearing horse, forming the apex of the steep, pyramidal composition, a wierd archer with shaggy, tousled hair flees from the unknown terror, grooms are soothing startled horses, and there are riders galloping away down the distant hillsides, already half-hidden in the mist. The play of the light is equally agitated and flickers over the whole scene, erratic and irrational. This work is much closer, in concept, to the dramas of the early Rembrandt than Paudiss' paintings and contains far more of the former's spirit, though distorted and charged with the Gothic urgency of German Mannerism. Weyer's wild, bearded men are forerunners of the figures of Maulbertsch. In fact, "Saul" is not derived only from Rembrandt; Leonard Bramer and Benjamin Cuyp also influenced it, and there are traces of everything the early Dutch Baroque produced in the way of fantastic, expressive values.[10] Indeed, the entire seventeenth-century "Rembrandt-esque school" in Germany was dominated by exaggerated effects and fantasy. But we should not think of this style as in any way second-hand; it was something the German artists working in Holland brought home with them, their own version of Dutch art, and it flourished, uninterrupted, in Germany until far into the period of eighteenth-century Baroque.

Germany was not the only country to fall under the influence of Rembrandt; Italy did likewise, although it was his etchings that aroused the special admiration of the artists of the seicento, as Dürer's copper-plate engravings had done in the cinquecento, and they were soon imitated. As early as the mid-century, Giovanni Benedetto Castiglione was producing etchings in Rembrandt's style. Castiglione, a Genoan, in the spirit of the Bassani, painted gay, lively animal pictures with titles taken from the Old Testament; he was addicted to Roman forms and the Flemish technique. It is not only his scenes from the scriptures and his romantic ghost-

stories which come straight from Rembrandt's repertoire, complete with dim valuting full of chiaroscuro, sheltering roman-classical figures; he even used Rembrandt's early self-portraits and character-types as prototypes, as well as the series of orientals by Jan Lievens retouched by Rembrandt. Thus, among his sheets, we find typically Lievens orientals, side by side with portraits of Rembrandt himself, depicted as an outlandish monster, a werewolf of an artist, straight from the caverns of Northern mythology (fig. 35). But if the motif was Rembrandtesque the technique and the spirit of the "handwriting" were too. It is strangely moving to see how these heads are built up out of a vibrating web of airy etching lines, because however picturesque, they are Italian in form and compactness, and they seem to grow out of the solidity of the Italian feeling, and drift into the phantasmagoric.

But Rembrandt was never as strong a leaven to Italian Baroque as he was to German Baroque art. Apart from Venice, where he held complete sway in the eighteenth century, artists who came under his influence were the exception: exceptions, that is, in that they were mostly men who were already attracted by the introspection and the dark forces of expression in Northern Baroque, which meant that, later on, our own Catholic church-painters would gain great importance.

One of the most important of these Italian followers was Guiseppe Maria Crespi, a Bolognese who flourished during the late seicento and the first half of the settecento. His cycle of Holy Sacraments in the gallery in Dresden breathes the whole dark fervour of true Baroque church painting, transfigured by light from another world beyond. Crespi's *Last Sacrament* (fig. 38) shows us a dimly-lit, bare cell, where a dying monk lies on the hard cushions, his only furniture, a skull and crucifix on a miserable straw chair. But a shaft of shimmering light falls down on this dark cell, illuminating both the sorrowing monks at their task, and the monk's dumb, scanty possessions, like a message from another world. This light pours down on the domed heads, furrowed brows, folded hands, on habit, skull and sacramental ewer; it gives a high lustre to the white surplice of the priest reading the Prayers for the Dying and plays round the brothers absorbed in their devotions. It is as if a shaft of light straight from Rembrandt were transfiguring the last moments of this pious Italian monk.

Crespi handed on what he had learned from Rembrandt to his pupil, Giovanni Battista Piazzetta, a Venetian, born in 1682, and thus created the foundations for the Venetian followers. Piazzetta also did etchings inspired by Rembrandt, but, more important still, his whole creative production seems to be permeated with Rembrandt's fluidity, even where he shows himself to be an out and out Venetian Baroque artist as well. Piazzetta derived his style from another artist as well, Jan Liss, who came from Holland and was very active in Venice at the start of the

seventeenth century, and his *Supper at Emmaus* (fig. 39)[11] shows traces of the influence of both, though reworked into a vital, deeply felt, personal statement. Piazzetta took his mastery of paint and the blazing flare of his form and line from Liss, and Rembrandt furnished him with his spiritual tension, his expressive, supercharged reality, and his light which transfigures everything by picking out one salient detail from the shadows; a haggard profile, a hand raised in astonishment, hollow eyes upturned towards the radiance. The *Supper at Emmaus* throbs with inner ecstasy; earthly things recede and beckon us into the world beyond. Form is no longer, as is usual in Italian art, present for its own sake, but merely provides a bridge into the spiritual world.

There are other examples of his paintings where Piazzetta's forms are extremely concrete, and monumentally massive, as, for instance, in his *Apostle Jacob, being put into Chains* (Venice, S. Staë, R. Pallucchini, ibid., p. 12, pl. 1), but even here, where he shows himself to be thoroughly Italian, formal organization of the material is not his chief aim. He shifts the weighty masses into positions where they are so daringly foreshortened, breaks the flow of curves with such expressive angles, and so vigorously tears the compact organization apart with light that completely new aspects emerge, extending far beyond everything that is merely formal and material. We can sense, at once, that Piazzetta was the source of Maulbertsch's creative inspiration.

The unreality of Piazzetta's sombre chiaroscuro church paintings became real again in the free spatial depths of Giovanni Battista Tiepolo's great frescoes, which glow with dazzling atmosphere. What Piazzetta heightened and distorted for the sake of effect became joyous, confident life, full of sparkle. The gay fresco-painter, who even made his religious themes gleam with profane splendour might seem to be the direct opposite of Piazzetta, who gave even his genre subjects a note of religious ecstasy. But, in fact, Tiepolo followed in Piazzetta's footsteps, took over his portion of Rembrandt's heritage, and, as a personality who dominated and shaped his time, made it common property among the Venetians of the settecento. For the sake of argument, I am disregarding the series of Rembrandt-esque portrait heads Giovanni Domenico Tiepolo etched after inventions by Giovanni Battista, because these are only part of a general contemporary fashion for doing things in Rembrandt's manner. What is more important to my theme is the significance the picturesque aspect of Rembrandt's world began to have for Tiepolo. It is oddly moving to see Rembrandt's exotic orientals, with their enormous cloaks, furrowed faces, primaeval beards and giant turbans in the daytime realm of Tiepolo's miraculous light and colour, amidst gnarled, Altdorfer fir trees, hung with saxifrage. But he differs from Piazzetta in one fundamental way; it is the pictorial, not the spiritual, content which binds him to Rembrandt.

Tiepolo's *Scherzi di Fantasia* (fig. 34)[12] are among his best works. These

whimsical, colourful dreams have been improvized rapidly and spiritedly onto the page with an airy etching-needle. They show effects of shimmering light that are probably the closest Tiepolo ever came to Rembrandt, and in turn, the themes themselves foreshadow Goya's gigantic *Caprichos* and *Sueños*.

As I have already pointed out, the direct Rembrandt tradition of the seventeenth century was carried over to the Baroque of the eighteenth by German artists. But the eighteenth century also staged its own Rembrandt revival, and the new movement swept through almost every nation in Europe. At last, Rembrandt was winning world-wide acclaim; everywhere, people were following in his footsteps and modelling their art on his. In Germany, where it was perhaps most widespread, this movement was inspired by two sources, the direct Rembrandt tradition, and the indirect, through Venetian painting, and it was the combination of the two which paved the way for a Renaissance-like return to the fountain-head itself, that is, to Rembrandt and his Dutch contemporaries.

It will be interesting to trace these two sources of Rembrandt's influence in the world of German and Austrian artists in the eighteenth century. The greatest, and spiritually, the most kindred follower of Piazzetta, north of the Alps, was Franz Anton Maulbertsch, the Suabian from Lake Constance, working in Vienna. It would be mistaken to link Maulbertsch with Tiepolo, as is so often done, because the former had already discovered his own definitive style before there was any question of Tiepolo's influence having extended beyond the Alps. In fact, his only connections with Tiepolo are some common sources, and certain similarities due to the fact that they were contemporaries. In every other sense, they tread quite different paths. Maulbertsch's religious fervour and flaming ecstasy is undoubtedly most closely related to the art of Piazzetta. This is particularly obvious in his early works, but even in his middle period, especially in his frescoes in the Kremsier (Kromeriz) Lehensaal, of about 1758/60, we still see traces of Piazzetta's influence. But the sketches for Kremsier and Schwechat have a glowing radiance, and a transparency of colour that far transcend anything Italian painting ever produced. The standard, and the janissaries, with the dark silhouette of St. Jacob looming up in front of them, are not so much lit from outside as shining from within. And if we consider one of his mature works, such as *St. Narcissus*[13] of about 1770, where the spirit of Piazzetta seems to flare up anew, we have to concede that the burning ardour and fervent yearning for the other world in these Northern church paintings also leaves the Italians far behind. The saint is being whirled up into heaven, like a fluttering flag, in the turmoil of his ecstatic devotion. His arms fly away from his body, like an epileptic's. Everything breaks up into rays, and seems to disintegrate in the flickering light.

This transcendental fluidity in the light and these figures distorted and contorted for the sake of the effect are more than just Venetian. They are completely in the

unreal, fantastic spirit of the early Rembrandt and his circle and since we cannot assume that Maulbertsch made any direct contact with the well-spring, we must presume that he made such contact with the German Rembrandtists of the seventeenth century. But there are two small paintings from his mature period which definitely suggest direct contact, *Joseph telling his Dreams* (fig. 43) and *Esther and Hathach*.[14] The first is a free adaptation of Rembrandt's etching B. 37, Hind 160, refined and made airy by the atmosphere of late Austrian Baroque, the second is a free creation in Rembrandt's manner with only a passing reference to his work. Neither is imitative; both are independent, new works of art; both seem to conjure up the spirit of a bygone age.

While Maulbertsch united Rembrandt and Venetian Baroque with the ecstatic fervour of the Late Gothic art of the lands bordering on the Alps, seeking, above all, the former's dramatic values, his contemporary, Martin Johann Schmidt, concentrated on reviving the magic of Rembrandt's chiaroscuro, and raising it to new splendour by making it the vehicle of inner moods. In the works of Schmidt, a devout church painter from Krems, sometimes called Kremser-Schmidt, the expressive force does not consist so much in the individual details as in the transcendental aspect of the whole. The simple story of the marriage of St. Joseph, the carpenter, with the young Mary (fig. 42), for instance, becomes a fairy tale of shimmering light.[15]

Schmidt was also influenced by the Italians, especially the Neapolitans Luca Giordano and Solimena, and the Venetian Gasparo Diziani. In every case, however, he succeeded in dissolving their elements of form in Rembrandt's chiaroscuro, and weaving the whole into the latter's enchanted mood. The fact that he also occasionally took up the etching-needle and pen to imitate Rembrandt is of secondary importance in comparison.

The Austrian religious painters scanned Rembrandt's works for the secret of his lively expression and inner atmosphere, but apart from a few exceptions, there was nothing imitative about their pictures. This was not the case in Germany where there were only two artists who could compare with the Austrians in originality, the Suabian father and son, Johannes and Januarius Zick. Johannes Zick himself described Piazzetta and Rembrandt as his masters, and indeed, the Rembrandtesque element in his paintings has a distinct Venetian flavour. Januarius was more successful as he received a wide, cosmopolitan education, first under his father, and then from the Venetians, from Watteau's work and the Parisians', and from Mengs and the Romans. Whereas his *David and Abisai*, painted in 1752, when he was in his twenties, shows him still completely under the Rembrandtesque influence of his father, the companion piece *Saul with the Witch of Endor* (fig. 36),[16] painted in the same year, shows a strong individual streak of fantasy in mood and effect. *Saul with the Witch of Endor* takes place in the eerie

half-light of a flaming torch; the spirit of Samuel, summoned up by the no less eerie witch, is rising out of the tomb and the warriors fall to their knees before him, while bats, owls, and lizards flit and glide through the iridescent night air.

We must not forget that it was not always Rembrandt himself who passed on the "Rembrandtesque"; he was part of a collective concept which included the artists of his circle, as well as followers of other nationalities. For instance, the Rembrandtist Germans of the seventeenth century follow straight on the porcelain-smooth realism of Denner and Seyboldt; but even the artists in the area of the Main and the Rhine, the Seekatz family group and their circle, gained inspiration from the same collective concept.

There was one group of artists, however, who harked back to Rembrandt himself. They were completely imitative and cannot be compared with either the Austrians or Suabians in creative inventiveness. The chief representative of this group is the Saxon Court painter, Christian Wilhelm Ernst Dietrich, and in his *Presentation in the Temple* of 1759 (fig. 37), he goes so far as to base the entire inspiration completely on Rembrandt, and, as if this were not enough, to take several figures, line for line, out of the "Hundred Guilder Print" as well as other works. It is shown here engraved by another Rembrandtist, Georg Friedrich Schmidt (Le Blanc III, p. 458, 164). The mood of the painting as a whole, however, is typically German, full of domesticity and bourgeois intimacy, and so far removed from anything remotely monumental or exotic, that it anticipates another Saxon, living a century later, who also took only the mundane poetry of living-rooms and nurseries from Dutch art: Ludwig Richter.

Although the German nation produced a larger contingent of artists in the Rembrandt renascence of the eighteenth century than any other, few had any real creative gift. In fact, it was only the Austrians, Maulbertsch and Schmidt (figs. 44 and 45) who could be called talented, and who kept the experience of "Rembrandt" alive in their work until the end of their period of activity.

At this point, I should like to turn to another nation which gained increasing importance in the realm of art during the eighteenth century, and emerged as the leader of Europe in the nineteenth: France.

There was far less painting obviously in the Rembrandt style in France than in Italy and Germany. What influence Rembrandt had, was effective at a lower level, deep in the cultural subconscious and thus there are fewer striking surface manifestations of it. Not that the French painters apprehended Rembrandt at a more essential level than the Germans or the Italians; on the contrary. With one exception, French eighteenth-century artists had less feeling for his values of content; but their development, as a whole, cannot be conceived without his influence. He was the true turning-point of modern art, and the foundation for all that followed. The example of French art gives us a particularly good illustration of the

misguidedness of measuring the historical consequences of an artist's influences only in terms of renaissance-like revivals, and regressive imitation. A personality like Rembrandt is capable of providing a constant source of energy, enough to feed the following generations for years to come, although it may do so imperceptibly, beneath the surface and along hidden pathways. Indeed, we will probably find phenomena discussed in the following survey that one would not immediately connect with Rembrandt, or his artistic heritage; but I trust that the results of my argument will provide a satisfactory explanation.

Eighteenth-century France inherited the artistic culture of the Baroque Netherlands. This Northern Baroque art had two great antipodes, Rembrandt and Rubens, the well-springs of two great streams of influence which can be traced throughout French eighteenth- and nineteenth-century painting. There is no point in considering any further what Rubens meant for the artists from Watteau to Delacroix, but it is still most interesting to observe how Rubens' stream of influence is often strongly infiltrated by that issuing from the opposite pole, and eventually intermingles with it and is engulfed. These two sources of influence and their interaction can be distinctly observed in the following distinguished examples.

Antoine Watteau was a painter from the Flemish region of Northern France, who appeared in Paris at a time when the conflict between the academic, classical school and the disciples of Rubens had been decided in favour of the latter. Watteau himself, as his early paintings show, based himself completely on the Flemish, but he also enlivened the tradition of Rubens with the delicate, penetrating spirit of the French tradition whose chief representative, one century earlier, was Jacques Callot. This inspired conciseness of form enabled him to blend precise observations of reality with the day-dreaming of an artistic imagination soaring far above the mundane. Watteau can paint both elegant, discreetly realistic, genre pictures, and dream-like fairy-tales of colour, the airborne fantasies of his romantic parklands. He can also combine them, so that life becomes a game, the game becomes life, and the comedies enacted on the dream stage of nature become *Fata Morgana*, a visionary world. We see one of these colourful reflections of life in the paintings *Love on the French Stage* and *Love on the Italian Stage*, painted during the period before the *Embarquement* (H. Adhémar, Watteau, Paris 1950), between 1710 and 1716. The "French" comedy is being played in the airy radiance of the glad day, and the shimmer of the elegant and splendid silken costumes is like a last, delicate flicker from Rubens' *Garden of Love*. The "Italian" comedy, in contrast, is a Rembrandtesque night-piece, with flickering torch-light falling on exotic masks, several different conflicting sources of light and a group of brightly-lit figures silhouetted against dark surroundings.

Watteau also stripped his parks of the sensual voluptuousness present in those of Rubens, and dipped them in misty chiaroscuro so that they look as unreal and

dream-like as the distant vistas in Rembrandt's early paintings of legends (*Les Jardins de St. Cloud*, Prado; H. Adhémar 135). Indeed, they even take us back to Jacques Callot, particularly his veiled, wash drawings, a comparison which makes us realize all the more forcibly how much the young Rembrandt owed to that artist.

As Watteau increased in maturity, the Rembrandtesque dissolution, the dream-like spiritualization and dematerialization of the Flemish forms and colours in his pictures became more and more marked. For example, a very late painting, such as the *Judgement of Paris*, Louvre (H. Adhémar 150) could almost be seen as fore-shadowing Johann Martin Schmidt's mythological pictures, because all the forms are subject to an ethereal swinging and vibrating that is full of atmosphere. Here, too, the spirit of Rembrandt is at work, but imperceptibly, because there is no question of plagiarism or imitation.

Watteau was the forerunner of a long line of painters whose work spanned the whole eighteenth century, among them Lancret, Chantreau, Pater, de Troy, Boucher, Baudouin and Fragonard. Naturally, his image became somewhat blurred in their work, as more and more Venetian and, above all, Roman elements infiltrated the French–Flemish core; but he still remained the prime mover of their development. Watteau himself was far from "Rembrandtizing", or working in the Rembrandt manner. Jean Honoré Fragonard was active at a time when an interest in historical retrospection was beginning to be widespread. This was also the moment when the Rembrandt renascence began in France.

If there is any one original, new and masterly creation that can be attributed to this renascence, it is Fragonard's *The Pasha* [Private Collection; G. Wildenstein, *The Paintings of Fragonard*, London 1960, cat. 339; fig. 41]. This erotic painting is as grandiose in form as the Roman paintings, delicate and French in its artistic quality, and as vivid as a legend, due to the magic of Rembrandt's chiaroscuro. The pasha lies sprawled on the cushions like an idol, bathed in light from above, which sets off his form against the twilight of the surrounding space, and gently illuminates even the dark corners. Perhaps no other artist since the seventeenth century has mastered the art of using chiaroscuro to suggest depth in quite the same way; and when we examine Fragonard's brilliant brush and wash drawings, his links with Rembrandt become even more striking. Since Rembrandt's time, no other painter has been able to emulate those sparkling light grounds, and the reciprocal heightening of values by the lighting. The dusky tunnel of Fragonard's *The Shady Avenue* (Metropolitan Museum of Art, New York; G. Wildenstein, cat. 350), extends into an infinite distance, as if leading into a far-off magical land which radiates light. And light, in a wonderful gamut of nuances, sheds its silvery beams through the crowns of the gigantic trees, towering up like airy castles. In fact, since the days of Rembrandt and his Dutch followers, no other artist had even approached the problems of such a motif.

The influence of the Dutch tradition on the French is also revealed by the French interest in drawings done for their own sake, and not merely as preparatory studies and sketches. One of the most gifted of these French draughtsmen was Gabriel de St. Aubin, and his superb sheet *Illumination of the Gallery at Versailles* (E. Dacier, *Gabriel de St. Aubin* II, Paris 1931, 615) shows how much he had derived from Rembrandt's painterly genius.

It has become almost a platitude to say that Jean Baptiste Siméon Chardin was the preserver of the Dutch tradition in France. Elements of the Dutch influence were still persisting in the eighteenth century in many forms, and it is thus scarcely odd to find an artist painting still-lifes and intimate interiors like Kalf, Vermeer, Pieter de Hooch and Ter Borch. Indeed, Chardin was not the only painter to choose such subjects; he was, rather, part of a historical trend of development directly opposed, in its contemplative pragmatism, to the decorative exuberance derived from Rubens. Chardin, the most gifted painter France ever produced, was, despite all his influence on the general development, an outsider. His calm, uncomplicated art achieved monumental heights way beyond the Dutch painters "in his field" who preceded him, and makes him a worthy and spiritually related descendant of Rembrandt. Chardin did not, however, deliberately concern himself with painting in Rembrandt's style, except in one isolated instance, his portrait of a friend, dressed in the costume of an oriental scholar and posed in the same Faustian study as Rembrandt's philosophers, presumably the *Portrait of the Painter Aved* (A. Dayot—J. Guiffrey, *J. B. Siméon Chardin*, Paris s.a., cat. 103, and G. Wildenstein, *Chardin*, Paris 1933 [London 1963]). Nor did Chardin achieve Rembrandtesque effects of chiaroscuro with mystic spatial depths, like so many of his contemporaries. His was an art of simple facts, stated with a straightforwardness, naturalness and feeling which can only be compared with the work of the mature Rembrandt.

We have already discussed Rembrandt's mature style, the period when his art was enclosed within itself, peaceful, full of flat surfaces and massive, with no urge for bold, spatial constructions and chiaroscuro effects, an art in which everything united to concentrate in the soundless language of the soul. *This, the mature Rembrandt's classicism of the 'fifties, this introspective art, where the large, still forms are only there to communicate emotions, awoke to new life in the paintings of Chardin.* Such a reawakening could never have been caused by historical influences, nor historical retrospection; it could only have come about because of a spiritual kinship. Rembrandt and Chardin are an excellent example of the way artistic values can be revived, quite independently of any unbroken causal relationships.

When Chardin painted a group of apples with an orange-tree, a copper kettle beside a dead hare, he was constructing his compositions with the same monumental peacefulness we find in Rembrandt's landscapes, and even, to anticipate a

little, in Cézanne's powerful *natures mortes*. And when Chardin portrays children playing, or saying grace, the whole picture is full of the gentle devotion that so endears Rembrandt's idylls to us. However, merely to analyse the "Rembrandt-esque" content of Chardin's work is hardly satisfactory, and I should like to discuss a few concrete examples.

Confronted with the portrait of the poet Sedaine (Dayot–Guiffrey, op. cit., cat. 106), we are immediately reminded of Rembrandt's early self-portraits, where he painted himself in a broad slouch hat, casting a shaft of shadow over the upper half of his face. The other baroque features the painting has in common with the self-portraits are the sense of a section of space, and the arrangement of the composition as a sloping triangle, boldly crowned by the diagonal of the artist's hat. But this structural arrangement has nothing to do with the early Rembrandt's undulating baroque. Here, everything is grand and simple, the fist clutching the hammer, the breast and shoulder, the head, soft and colourful, but firmly modelled, separated from the light background by a dark contour which, like Rembrandt's contours, makes the objects look as if they were sinking into the atmosphere. This is the evidence which proves the essential kinship between the two artists.

We can also see the close relationship between the old Chardin and Rembrandt when we compare the seventy-six-year-old Frenchman's *Self-portrait* (Dayot–Guiffrey, op. cit., cat. 61; fig 46) with one of Rembrandt's late self-portraits (Bode 433, Bredius 55; National Gallery, London). The former, a quiet old man, perhaps somewhat odd or ludicrous in appearance, looks out at the world from the peaceful, soundless kingdom of his art with kindly sympathy and attentiveness. The mature Rembrandt, calm and collected, also looks out at the world from his inner realm with sorrowful, forgiving comprehension.

Rembrandt achieved the block-like massiveness of his forms purely by painterly expedients, concentrating the colour in dense, and yet atmospherically saturated, blocks and rectangles. At the same time this whole edifice of solid and yet floating masses of colour is sunk into the depths of space. Thus a reciprocal relationship arises; the solid form becomes concentrated space, and space becomes dissolved, colourful form. Chardin's little painting *Pierrot catching Goldfish* [Glasgow, Burrell Collection, Wildenstein 306] shows how completely he grasped Rembrandt's secret. The simple figure is visualized with such size and massiveness, and the architectonics of the chiaroscuro are completely clear. What an enormous difference there is between this picture and the usual contemporary French conversation pieces with their air of elegant frivolity. Here Pierrot is seen as a pale, moonstruck dreamer, tormented by hunger, who is fishing for his ideals in order to grill them. Chardin was the first artist to sense the real tragedy of Pierrot's situation.

The true inner ties between the two masters become most evident, perhaps, in the superb chalk drawing by Chardin in the National Museum in Stockholm,

La Vinaigrette (Dayot–Guiffrey, op. cit., cat. 247; fig. 40). Chardin has grasped the essential inner being of this group and pared away every superficial detail, so that only a phantom of reality remains. But this phantom not only contains all the trappings of reality, but rises above and beyond it to visionary grandeur. This is true heightened realism such as the mature Rembrandt achieved.

At this point, I should like to close our discussion of French art, for the present, and turn to the central personality in art from 1800 to the present, the greatest phenomenon in art since Rembrandt: Francisco José de Goya.

Goya already had a long life and a long career behind him when he painted the works most often associated with his name today. His origins were in the tradition of Spanish church painting; he had painted frescoes and also, at one time, worked for the Royal Gobelins factory, but this style of painting began to lose favour in Spain. Mengs and his academic classicism had become masters of the day, and his followers looked askance at artists who still clung to the old baroque manner. Indeed, even Tiepolo, who painted his superb frescoes in the Royal Palace in Madrid at this time, was already out of the mainstream. Nevertheless, his work had a strong impact on Goya; and his Venetian Baroque influence united with Spanish Baroque to provide the great source of inspiration which started him on his long career. We have become accustomed to regarding Goya as the antithesis of everything classical, as the baroque artist who smashed the tin gods of classicism and created a great, new art, alone and supreme, but this is only partly correct. In fact, Goya was the absolute antagonist of classicism, if by classicism we mean the solemn, academic tedium and rhetorical drapery of a Mengs or a Canova. But if we consider, for a moment, the chief creative personalities of the Neo-classical period, we immediately think of Kant the philosopher, Goya the painter, Jean Paul the poet and Beethoven the composer. Certainly none of these can be neatly reconciled with the contemporary concept of classicism. On the other hand, it would be almost contradictory to state that the great men of a period were inwardly unrelated to it, and stood in rebellious, secluded opposition to it. Evidently, we must seek the meaning of classicism along other roads than that of superficial academic formalism.

The key to the problem undoubtedly lies in that earlier period when the question of classicism had become urgent in much the same way, the time of the late Rembrandt. I should like to emphasize here that this is not a matter of playing with clever analogies and interpretations, and that the historical and spiritual processes referred to are actual and real, and can be understood with the help of scholarly concepts. Rembrandt was the first to grasp the problem in all its significance and to make use of classicism to achieve the greatest depths of intensity and expressive power. As far as his late work is concerned, classicism is one phase of an art which concentrates primarily on the spiritual; but such is its enormously

heightened urge for emotional outlet that, in order not to disintegrate into chaotic shapelessness, it seeks physical forms that are extremely concise and block-like, simple and lapidary. This is the reason for the enigmatic mask-like character of the late Rembrandt's portrait faces; the spiritual element seems to have been captured on the canvas at the very last moment before it disintegrated into the universe, like a wraith. But these strange figures, with their simple, flat forms, seem to vibrate with colour from within, and shine with the unbounded, spiritual fervour that buoys them up.

It now remains to investigate whether there are any traces of this kind of classicism to be found around 1800.

Goya said that his masters were, after Nature, Velázquez and Rembrandt, and the fact that he was a true descendent of Rembrandt, not only in his art, but in his whole philosophy, is obvious when we look at his *Self-Portrait*, painted in 1815 (fig. 47)[17] when he was sixty-nine. Here are strong, deeply human features which have been moulded by a lifetime of pain and passion, but which show that the creator and shaper has triumphed over all the vicissitudes of time. These eyes have the same look as Rembrandt's self-portraits of the 'sixties. Suffering and resignation are expressed in their depths, as well as infinite love, sympathy with all creation, and spiritual unity with the universe.

Goya lived the life of his times as a complete human being, and his attitude towards his fellow-men was as real and whole. Murder and sudden death were commonplace at that time in a Spain devastated by the Napoleonic wars, and all the horrors of death, and the sufferings of those pursued by a malignant fate entered deep into the artist, and a great artistic edifice developed out of his emotional response. When he witnessed the execution of some street fighters, the *Third of May, 1808*,[18] unlike Manet, he did not turn the scene into an artistic display of cultivated forms and colours. For Goya, the content, the action, were all; he was only concerned with expressing the despair of human beings in the face of an inexorable doom; the way one man flings himself into the jaws of death and another breaks down in prayer, while the rest lose control of themselves, stare at the impending horror, or hide their faces in their hands. And the eyes Goya has given them, and those faces, verging on madness—enough to bring chaos to the soul, and thus to the work, of the watching artist. But here we must admire Goya's enormous power of representation, the way he controls the impending, inner, emotional chaos in massive, block-like forms, contrasting the pitiful huddle of condemned men with the inexorable silhouettes of the soldiers, the one desirous of sinking into the earth or vanishing into the dark night air, the other abstract and anonymous as fate itself. Observe, too, how the dead lie about the ground, setting the sombre, oppressive atmosphere of the scene, how the schematically lit outlines of the hill and the distant town weigh heavily on the whole, how everything is compressed,

block-like, massive and compact, and the way the masses are lit by a beam from a great lantern so that they look ghostly, translucent and floating, for this is the true spirit of the late Rembrandt.

Again, like Rembrandt in his old age, Goya expresses more by concealment and silence than by direct comment. There is an etching, on much the same subject as the painting described above, in his series *Desastres de la Guerra*, executed from 1810 onwards (see J. Hofmann, "Francisco de Goya", *Katalog seines graphischen Werkes*, Vienna 1907), a cycle of themes that recalls Callot and his *Misères de la Guerre*, two centuries before. The etching (Hofmann 170) is also gripping and direct and has been inscribed with the words: "No se puede mirar" ("One cannot bear to watch it"). It shows a group of women, children and defenceless men about to be bayonetted by the soldiers, of whom only the bayonet-tips are visible. The figures that appeal most forcibly to our emotions, like the mother and her children, are covering their faces, and it is precisely this suggestive silence which makes us so poignantly aware of the reality of their tragedy. In his late period, Rembrandt also frequently compressed his figures into cubic shapes, crowding them together in clumps, with their faces veiled or turned away, and this enclosedness, and veiled silence, makes the person's inner emotions ring out of his whole figure. The same applies to the beggars, cripples, prisoners and lunatics Goya so often drew; when he shows their faces, they are frequently as mask-like as those in the late Rembrandt's portraits.

And what a superb composition! The group of figures is arranged in a striking trapezium, and there is a classical archway curving over it, dark, extremely solemn, and yet deep in space. This configuration re-echoes the same mighty syncopations that resound in Beethoven's symphonic works, composed at much the same time. Goya has built up light and darkness in a masterly fabric, like Gilly's architectural fantasies, without a trace of nebulous chiaroscuro. Everything is clear, translucent and plastic, not with the firm malleability of the human body, but spatially plastic, radiant and fluorescent, sunk deep in the fluid atmosphere; and, in the distance, there are only schematic silhouettes, as transparent as glass. Goya achieved this masterly colourfulness in black and white by means of his peculiar etching technique; using a dense warp of fine parallel lines without any crosshatchings to produce this swinging, vibrating effect. Indeed, it hardly need be said that this method of composition, this way of building with light and shadow, and this ethereal, fluid language of the etching-needle is a brilliant revival, and continuation, of the work of Rembrandt.

Goya's drawing technique is also very close to that of Rembrandt. He had the same gift for saying much with the minimum of means, as we can see in two of his sketches in the Prado, sheets 7 and 50 of the *Desastres* [Museo del Prado, Los Dibujos de Goya . . . por F. Sánchez Cantón, Madrid, 1954, I, 84, 111]. Goya

presents us with the whole tragedy of this scene in a few luminous lines; as the dead mother is being borne away, her little daughter runs after her, sobbing bitterly. The child is sketched in with only a few strokes but they express the whole help-less misery of the forlorn little creature. In the second sketch, we see a woman climbing a mountain of corpses to fire a cannon. She is the only person left alive, and the silhouette of the cannon looms up behind her as classically large and simple as a phantom. The whole story is described with grandeur and simplicity, and is full of heroism and deep humanity. We can trace the same attitude towards the world and life in Beethoven's "Eroica" symphony, composed only a few years earlier.

Goya did his first great cycle of etchings, the *Caprichos*, at the end of the 'nineties, and just as the *Desastres* are linked to Callot by their range of themes, so the *Caprichos* are connected with Tiepolo's *Scherzi di fantasia* (see T. Pignatti, op. cit.). But what was, for Tiepolo, merely the whim of a decorative imagination, became, in Goya's mind, deep, human insight, a mirror held up to mortal frailty by an ironical hand. Sheet 13 (Hofmann 13) of this series, with the monks at their vespers, shows that this work, too, owes something to the mighty figure of Rembrandt.

Like Rembrandt, Goya's attitude to men and to life witnessed a strong ethical will. Art was not an end in itself for him, but rather a means of moulding life, and this is the true interpretation of the subtle irony and visionary prophesying in his great allegorical works which appeared directly after the *Desastres*. This latter series was a spirited indictment of murder officially condoned under the name of war; sheet 69 (Hofmann 213; fig. 48) shows a dusky background of infinite space, sparkling with phosphorescent light, and with phantoms fluttering through it, against which a corpse is writing the closing page of the history of the world— the single word "Nada" (Nothing). This supreme sheet can only be compared with Jean Paul's "Rede des toten Christus vom Weltgebäude herab, dass kein Gott sei."

In his old age Goya's works grew more and more visionary, chaotic and cryptic; he withdrew to a lonely house in the country which he decorated with paintings. One of these shows Saturn devouring his children [now Prado], and is a painting of unbelievably telling, ghostly fantasy, where our horror is only lifted by the power of a technique that matches the late works of Rembrandt. As in many of his later portraits, Goya was anticipating Daumier here. But yet these paintings do not have one trace of romanticism; to the end of his days, Goya remained a classicist like Beethoven, and in his late self-portraits, even came to look more and more like that composer. Attempts have been made to solve the mystery of the content of Goya's late works in a literary, programmatic way, and when this produced no result, many were content to see them merely as figments of a boundless, subjective artistic imagination, without any significance, comparable to Goethe's poetic

subjectivism. But this does not help us get to the bottom of the *Sueños*, the "dreams" (Goya's original title of the series, later called *Proverbios*). In fact, Goya's late works only appear to get more and more enigmatic and chaotic, only threaten to disintegrate in the universe, like Beethoven's last compositions. In truth, their chaos has a deep, significant, cosmic shape. It is not expressed in literary content, nor in poetic fantasies, but in a moral awareness that God has created the Universe with all its heavens and all its hells, an awareness that extracts the last vestige of spiritual vitality from a world of ruin and decay.

This is the real message of the classicism of the period around 1800, and this is what we should bear in mind when we call Goya, Beethoven and Jean Paul "classical artists". The fact that there was another secondary classicism existing at the same time, the anachronistic classicism of the academics and literati, should give no trouble to anyone who is aware of the true interpretation of the word.

With the figure of Goya, we have reached another turning-point in the history of modern painting. Although completely isolated during his period, he has meant an inestimable amount to the generations that followed him, and will continue to do so in the future. For he represents the rallying-point, in one mortal man, of all the immortal energies radiating out from Rembrandt; and not only this, he also raised them to a new, vital potentiality and transmitted them, recharged, to posterity.

I intend to omit English art from this discussion because Rembrandt's art was interesting to the English only from the point of view of technique except, perhaps, for a few of Constable's landscapes, and they did not form any relationship with his deeper levels of content. I shall thus continue my interrupted consideration of French painting by following the Rubens line of tradition which pursued its course via Géricault the classicist, and Delacroix the romantic. In Delacroix' eyes, Rubens was the "Homer of painting", but when he attempted to translate the latter's robust vitality into his own medium, it became a spiritualized fire, an inner, self-immolating ecstasy. Delacroix' paintings reverberate, flare and smoke with light and shadow. The colours gleam like molten jewels and the lines flicker and vibrate with the urge to express. In fact, what is happening here, is that Rubens is being permeated with Rembrandt's introspection and the material substance in these paintings is being illuminated through and through and transfigured with ecstasy. Delacroix is full of the Romantic's yearning for another world. He undoubtedly experienced the colours of this earth with exceptional vividness, but for him, they were a part of a conflagration whose flames soar up towards another world, glowing through the earthly substance as they do so, and illuminating it almost to the point of annihilation. The *Assassination of the Bishop of Liège* (Louvre; fig. 49)[19] for example, is staged in a lofty, Gothic hall, full of people, and lit, mysteriously, with candles and smoking torches. There is much more of Rembrandt here than of Rubens! We have only to recall *The Wedding of Samson* (Bredius 507) and *The Conspiracy of*

Julius Civilis (fig. 2). Delacroix himself wrote in his diary that the day would come when the world would realize that Rembrandt was a greater painter than Raphael. Another of Delacroix' paintings which is strongly reminiscent of Rembrandt's work is his *Head of an Old Nun* (formerly in the Chéramy collection).[20] The old woman is swathed in the kerchiefs and veils of her order like a mummy, but looks as if she is about to burst her bonds, such is the glowing intensity of the spiritual life eloquent in her dark eyes. This portrait is very like the old woman Rembrandt often painted about 1654, thought to be the wife of his brother (Bredius 381, Hermitage, Leningrad).

The other line of tradition, that issuing from the Holland of Rembrandt's time, also found a worthy representative: the great Corot. Corot's *St. Sebastian* (Louvre; fig. 50),[21] constructed out of a network of apparently haphazard spots of colour, which are actually very carefully placed, is painted in a wonderfully clear, plastic chiaroscuro and gives us a distinct proof of his artistic and spiritual relationship to Rembrandt's later works, such as *Christ at the Column* (Bredius 591; Wallraf-Richartz Museum, formerly in the Carstanjen collection).

The two last great artists, who unite both traditions in a new harmony, are Daumier and Cézanne, and in their work, Rubens dissolves into Rembrandt.

In the expressive, far-reaching fantasy of his line, Daumier has taken much from the Romantics, and without the French inheritance of Italian and Flemish Baroque and without Géricault and Delacroix, the flaring swing and grotesque hypertrophy of the forms in his drawings would be unthinkable. But Daumier's technique also has a massive volume and power seen before only in Goya's works and, even earlier, in Rembrandt's. Again, Daumier's basically baroque approach, and the fluidity of his fantasy, often recalls the Venetians; we are particularly reminded of Tintoretto, for instance, when the writhing flashes of self-illuminated figures emerge, like ghosts, from the surrounding gloom. But in Daumier's pictures, the purpose of these forms, beauty for its own sake, is entirely secondary to the moral struggle for expression. This is the reawakening of Rembrandt's tormented soul, his Titanic combat with his material, transformed into chiaroscuro by Daumier in works such as the *Sculptor* [now in the Phillips Memorial Gallery, Washington; J. Adhémar, *Honoré Daumier*, 1954, no. 131]. Daumier knew nothing of the aging Rembrandt's peace and tranquility; instead he churned the latter's deep spirituality into a new baroque turmoil quite as bold as that of Rembrandt's youth.

Paul Cézanne brought concentration to block-like massiveness, and finally resolved it in even deeper quiet and restfulness. Cézanne's work is the logical conclusion to Chardin, as the baroque artists found their conclusion in Daumier. Cézanne's still-lifes emanate the same solemn peace and grandeur as those of Chardin although his early works, as, for example, the *Self-Portrait* of 1864 (fig. 51), were based upon Daumier (Moscow, Museum of Modern Western Art; L. Venturi,

Cézanne, Paris 1936, no. 81, 1865–66; B. Dorival, *Cézanne*, Paris 1948, no. 6). But, in fact, Cézanne only adopted the struggling massivity of Daumier's painting. His portrait head, which has been built up with a spatula, like a huge edifice of coloured tiles, is not only in technique, but also in spirit, exactly like Rembrandt's painting in his later years. And Cézanne himself was active at a time when Rembrandt's humanism was coming to its most recent great literary flowering in the novels of Dostoyevsky.

The artists I have mentioned are some of Rembrandt's true creative disciples, working in his spirit, independent of the historical form his paintings took. To hark back to an outdated historical form can only lead to a wistful, nostalgic atavism like that of the Dutch painter Jozef Israëls, in whose pictures only the costumes are contemporary, while the atmospheric chiaroscuro is derived completely from the seventeenth century. Such anachronism as this could never be the effect of Rembrandt's creative tradition—a fact another Dutchman, van Gogh, must have sensed when he painted his paraphrase of the *Raising of Lazarus* (fig. 52).[22] In this picture, he discarded all historical retrospection and translated Rembrandt's paintings directly into his own glowing, burning dynamism of line and colour; the most it has in common with Rembrandt is the spiritual poignancy and pathos of the scene, but it lacks all the confident massiveness and natural grandeur of Rembrandt's figures.

Rembrandt's late art did not discard nature or make it disintegrate into Mannerism, but allowed it to stand on its own right, deepened and transfigured by means of the spiritual experience of the painting. This inward-looking, clarified naturalism can be seen again in the work of several important artists working at the present day. I should like to mention two of them.

When Lovis Corinth represents the Saviour (fig. 54) sinking under the weight of the cross, with a throng of excited people seething around him, he pares away everything superficial from the natural objects, without removing their essential depths. In consequence, the outward forms become phantom-like, while the inner forms register with increased intensity.[23]

Herbert Bœckl's *Self-Portrait* is also distinguished by a most powerful spiritual intensity (Oesterreichische Galerie, Vienna; fig. 53). He also strives, to the utmost, to grasp the innermost spiritual structure of his material and paints it with directness and naïveté, showing, not the outward appearance, but the deep-lying psychical reality. The result is a tremendous concentration; Bœckl's paintings illuminate nature by penetrating into the unfathomable depths of things without ever destroying them. An artist able to control these spiritual tensions needs a grandeur and power in his compositional technique that few can muster. In fact, the path of any man who attempts to render ultimate reality without possessing the maturity and depth of a Rembrandt or a Goya will be beset with torment and

strife. Artistic creation of this standard is an elemental fight for life, a conflict with life itself, because once an artist has had a truly deep insight, he can no longer endure life if he does not achieve liberation through a satisfying artistic expression. This makes the occasional triumphs in the constant conflict all the more powerful and poignant. It is a hundred years since Théodore Géricault took up arms and yet, in Bœckl's work today, the same life-process is running its course, although the circumstances are quite different, and the heroic pathos of the classicist has been replaced by the introspection we already know from the late Rembrandt's philosophy of life.

In this connection, the following passage by Max Dvořák comes to mind:
"Everything art created during the periods of culture which are both known to history and connected with one another, was never completely lost, but belonged, from then onward, to the substance of the whole following sequence of evolution, although continually taking on a new significance. This is as true of isolated motifs as of general trends and solutions. They often seem to vanish or fade away, only to be revived, centuries later, without anyone having had recourse to their period of origin, and incorporated into a new development, much as the ancient legends which have been preserved by popular tradition or in some other way are being resuscitated in modern poetry."

As a result of this analysis, we have established that Rembrandt was a power behind, not only the trends in art, but also the entire intellectual life of modern times, and that the effect of his influence is as vital today as it was during his lifetime, and has no foreseeable term.

"Rembrandts Vermächtnis," *Belvedere* 5, Vienna, 1924, pp. 148–176.

Rembrandt Drawings in the Graphische Sammlung, Munich

THE collection of drawings associated with Rembrandt in the Graphische Sammlung in Munich are divided into two groups. The first (comprising in all three volumes) contains all the sheets Hofstede de Groot accepted in his catalogue raisonné; the second (in two volumes) contains the museum's large collection of works by the school of Rembrandt and some followers. In a postscript to the catalogue,[1] Hofstede de Groot himself describes what pitfalls there are for the art historian in this collection, which was formerly in the possession of the Comtes Palatins du Rhin. His own particular difficulty was the fact that many of the drawings, which would otherwise have presented no grounds for doubt, are signed, falsely, with Rembrandt's full name, in the same medium as was used in the sheet itself. I shall take up this point where relevant in the following paragraphs.

In any case, the rich resources of this old collection have by no means been exhausted from the critical point of view, and the purpose of my article is to bring a few drawings in particular to the general notice. Although they have been designated doubtful, or even rejected by the worthy founder of our modern school of research into Rembrandt's drawings, they fully deserve to be considered among the ranks of authentic works. Indeed, they are all the more important, because many are preparatory drawings for known paintings by the artist, and thus can throw new light on the chronology of his drawings, an aspect of his work which is still very obscure.

Very few studies for compositions from Rembrandt's earliest period are known, merely the *Raising of the Cross* (HdG 1362, Benesch 6), dating from the end of the 'twenties, the *Entombment of Christ* of 1630 (HdG 891, Benesch 17) in London, and the study (HdG 1423, Benesch 83) for *The Raising of the Cross*, of 1633, in Munich. However, there is also another sheet from this group among the rejected drawings; a preparatory drawing (Benesch 13, fig. 59) for the lost *Baptism of the Eunuch*, which is known to us only through copies (fig. 60) and through Vliet's etching of 1631 (fig. 61). The composition of this vanished painting towers up, rising steeply above us, a pattern already familiar from Rembrandt's historical paintings executed between 1628/30. The universal, baroque flow of movement increasing in a crescendo, which pervaded his development during the 'thirties, had not yet affected the orientation, which remained solidly unilateral. Admittedly, Rembrandt's compositions at this period were powerful and bold, but they "move" in one direction only; that is, upwards. Although he restricted the individual life of

his figures to definite limits and confined them within dull, heavy contours like all the rest of the Dutch followers of Caravaggio, in this one direction, he recognized no bounds, and even subordinated everything else to it. This upward movement dominates in steep diagonals and slender pyramid shapes, as in *The Presentation in the Temple* (Bredius 535) in Hamburg, *Samson and Delilah* of 1628 (Bredius 489), *The Tribute Money* of 1629 (Bredius 536 [now Ottawa, National Gallery of Canada]), *The Raising of Lazarus* (Bredius 538) and *The Entombment* (HdG 891, Benesch 17). During these years, Rembrandt liked to pile his figures and other elements of the composition one above the other, so that they reach up into the sky in flamboyant diagonals, like a vertical tower, and he even occasionally isolated one figure, and made it loom up in the same way. This tendency towards vertical height also emerges in passages where the composition looks as though it had been going to develop in a completely different direction. In Benesch 6, the steep ladder of figures sweeps up above the sharp diagonal of the cross to culminate in the man with the plumed hat; in the horizontal composition of *Judas returning the Pieces of Silver* (Bredius, third edition, 539A, fig. 62 [now Mulgrave Castle, Yorks., Normanby Collection; see comment to Benesch 8]) the steep upward slope commences with the kneeling man and ends with the tall hat of the priest.

The Baptism of the Eunuch (192 × 211 mm, Benesch 13; fig. 59) is one of Rembrandt's boldest and most grandiose early "tower" compositions. The kneeling Moor, the apostle and the rider high up on his horse, have been integrated into one vertical triangle, shooting up through the picture. This drawing is so closely related to the above-mentioned works, that it must not only be by Rembrandt, but also dated around the end of the 'twenties, or at the latest, 1630. To judge from the style, which places it between Benesch 6 and Benesch 17, 1629 seems more likely, at least, as far as the compositional idea is concerned. It was executed in black chalk, and is one of Rembrandt's best early sketches. The whole composition is a mighty turmoil of daring, swinging lines, which sing through the air in sharp curves, tie themselves into confused tangles, bend double and suddenly snap, and cover the whole surface of the paper with a broad shimmer. Indeed, the mere dynamism of the "handwriting", and even the network of lines, convey a pitch of excitement and emotion that far transcends the more calligraphic guise of Benesch 6, and bring the sheet closer to Benesch 17. On the other hand, the supple flow of line, and the sweeping, swinging curves of the main group take us back to the sense of form in the great, black chalk studies of beggars and apostles HdG 1184, 1186, 1185, 233 (Benesch 30, 32, 31, 12), itself the result of Rembrandt's contact with Jacques Callot's draughtsmanship. The hooks in the lines and the sudden black of the shadow strokes have the same origins. For example, the way the figures' heads sit on top of their torsos like tiny angular lozenges shows that the drawing is much closer to Benesch 6 than to Benesch 17, where the skulls have

been drawn with more regard for their plastic structure. The sweeping movement of the chalk lines seems to penetrate not only man and beast, but plants and earth as well. This dramatic tint, flaring and undulating over the picture surface, is reminiscent of previous decades when ornamental linear patterns were used to describe form. Reminiscent because what had previously had a purely decorative function became, in Rembrandt's work, a highly expressive medium for rendering reality, the inner, spiritual reality of Rembrandt's imagination.

The drawing is not a line for line preparation for the painting, as we know it from copies, and from the etching, but rather a bold, preliminary sketch which still varies from the final version in some important points. For one thing, the drawing is not vertical in format, but horizontal, although the main group of figures is very like the painting, and the germs of a steep tower formation are already perceptible. But here, too, there are divergences. In the drawing, the kneeling man and the apostle are bending towards one another, the latter raising his right hand, whereas, in the painting, Philip has lifted his left hand in the act of baptizing, and this gives the group a greater extreme of foreshortening, so that it falls more in line with the strict upward movement. Again, instead of being folded, and held down towards the earth, the eunuch's hands in the drawing are pulled in towards his body. One of the chief differences, however, is in the relationship between the rider and the baptismal group; in the drawing, his dimensions are much larger, he rises up like a gigantic statue, and is placed to the side of the main movement of the picture, so that the movement starting in the eunuch and the apostle is not transmitted upwards through his body, but through the head and neck of the horse. In other words, the whole group has not yet been united in one upsurging line; the rider is still on his own, rearing up like a tower, flaring heavenward like a fantastic beacon, his head enthroned on his torso like a ceremonial mask. As a whole, the picture has not yet been concentrated in a universal vertical movement as in the painting, where even the horse joins in the steep rise by providing a diagonal across the picture, and also by being half-way up the hummock—an idea not nearly so clearly expressed in the drawing. Admittedly, the intention was probably in Rembrandt's mind, but perhaps the thought was not yet completely ripe; there is the same rise in terrain, and it reaches the same height, but the central knoll is a new development.

Presumably, we may assume from this that the upward movement in the final version evolved only gradually out of the preliminary idea for the main figure group. In the drawing, the elements are also much more widely dispersed, and the figures look smaller in relation to the size of the pictorial surface as a whole. This is a point where a comparison between the surviving copies can be most enlightening. In Vliet's etching, there is more space surrounding the figures, and everything is freer and less compact than in the oil painting, formerly in Oldenburg [now

New York, private collection][2] which seems to be more constricted by the vertical movement. The arrangement of the figures in the etching is also closer to the drawing, so it is reasonable to regard it as truer to the lost original than the painting, and to presume that the painter exaggerated the urge for height. In other words, when painting the final version, Rembrandt decided to concentrate the elements; the chariot, which stands fair and square beside the main group in the drawing, was pushed behind the rider, and the luxuriant undergrowth in the right-hand corner crept nearer the figures, engulfing the light-coloured open space beneath the body of the chariot, and thus shifting the main group into the axis of the painting. His most important change, however, was in the arrangement of the composition as a whole. In the drawing, the tree-grown slope rises up behind the cart and dies away on the left in that typically Elsheimer-like diagonal we know so well from Lastman's *Baptism of the Eunuch*,[3] painted in 1608, in Berlin. In his final version, however, Rembrandt managed to free himself from the academic precepts of a generation he had far outgrown, replacing them with the bold new types of composition only he could have created.

The sheet we have been discussing is an excellent illustration of the visionary flights of thought and the sheer unexpectedness of all Rembrandt's early compositional drawings. Everything the older generation had discovered or evolved in the way of non-rational, transcendental methods of representation flared up in these studies in a last blaze of emotional expression, only to be snuffed out by the penetrating blast of a new reality. As they extracted its final consequences, Rembrandt's early works shattered Mannerism. The young artist was flinging the doors of the citadel open from within. Now the waves of a new world of empirical observation and direct artistic experience could break in and wash the old, worn-out formulas away.

In the drawing of *The Baptism of the Eunuch*, the bold group of figures soars up into the sky like a flame. The chalk strokes probe and jerk up and down on the surface, but out of this seemingly confused maze of lines, a presentiment of the whole spiritual reality of the scene rises up with compelling power: the real meaning of this shapeless caravan which has called a halt in this river valley, and the reason why the beasts and their grooms are standing still and watching. We sense, without seeing it, the watchful wondering of the shadows emerging here and there amidst the rain of shimmering strokes. We also sense the presence of Rembrandt himself, in his full grandeur and accomplishment, and this is what makes this early memorial to his genius so particularly valuable to us; it undoubtedly surpasses the lost painting in directness and impact.

Around the turn of the decade, Rembrandt's new attitude to the world around him began to affect his work, although this did not mean that new themes were introduced into his art. The studies of old men in red and black chalk he drew

between 1630 and 1631 are completely individual, naturalistic, and realistic in every detail, and completely in line with everything that had gone before. The only innovation is the new spirit these well-worn themes have acquired. The old men are not only individualized and characterized from the external point of view, but also, whatever their attitude, pose and mood, Rembrandt has observed and rendered them with equal directness, and has given them the true "breath of life". The draughtsmanship still shows many traces of Rembrandt's earlier sense of line; the "handwriting" is alternately full of hooks and undulations, both derived from Callot's style of draughtsmanship. HdG 997, Benesch 37 and HdG 1322, Benesch 40 are good examples of the first trait, and the red chalk study (Benesch 38; fig. 57), for the etching B. 325, Hind 27, of 1630 (fig. 56), is the best example of the latter; it is in the Stockholm Print Room, as a work by Claude Mellan. A soft, gently undulating rhythm pulses through the whole sheet, making the hair and beard curl gently, sending fine, curved tucks rippling down the clothing, crinkling the contours of the sleeves, and knotting the old man's bony hands. It is this lower part in particular which is the most vivid reminder of Rembrandt's links with Callot; and yet the total result is something completely new and different. The homogeneous light which seems to bathe the shimmering figure, the grandeur and composure with which it has been visualized, the rich variety of tones in the gradations of shadow, the earnestness and feeling speaking out of those eyes, deep-set, and overshadowed by the forehead and, indeed, even the peace and intensity of the whole composition, all add up to a new method of portraying human beings. At one bound, Rembrandt has outstripped his forerunners in Utrecht and Amsterdam, and his contemporaries. The study is fresher and has more impact on us than the etching; it probably came between *St. Jerome resting his Hands on a Skull* (Hdg 191, Benesch 19) [formerly] in Bremen and the *Bust of an old Bearded man* (HdG 624, Benesch 39) in the Louvre, because it has the former's technique and "handwriting" and the latter's rich play of light. The hooked, brittle method of drawing was more suited to the problems posed by Rembrandt's new naturalism than the undulating method; it enabled him to take a firm grasp on natural forms and to emphasize individuality, and there are clearer traces of it in the new empirical style of the studies of old men. Not that the former disappeared, as we can see from the drawing in Stockholm, and also from a study for a *Raising of the Cross* (HdG 1423, Benesch 83) and from a small, red chalk study of Saskia (HdG 623, Benesch 429), a drawing especially closely related to the Stockholm sheet in its floating airiness.

Towards the middle of the 1630s, Rembrandt's draughtmanship became more and more a process of assimilating the environment, and none of the things he saw around him, nor any of the events of everyday life were too small or insignificant for him to record. From 1634 onwards, a whole crowd of such themes invades his

sphere of interest. There is a series of drawings from this group in the Munich collection, one of them drawn on the verso of one of the countless Rembrandt forgeries of the eighteenth century (Inv. 1763).[4] The sketch is executed in rapid, bold strokes and shows a recumbent woman and a woman asleep in bed (Benesch 288; fig. 58). The lines of the recumbent figure are angular and brittle, but yet describe the loose, relaxed pose of a resting body with consummate simplicity and naturalness, completely mastering the difficulties of extreme foreshortening. A figure like this seems to be the quintessence of everything Rembrandt was striving for around the turn, and at the beginning, of the decade. His artistic language of forms has been completely and utterly translated into "life"; there are no further traces of linear ornament for its own sake, a problem Rembrandt had overcome in earlier years; every tiny stroke "means" something, portrays something that has really grown, or is the emanation of a living being. And as the uninhibited lines dance around, a tumbled bed appears, with a sick woman huddled among the pillows, deep in sleep. The woman's strong, somewhat gross, profile has been sketched in with a few short hooks and wedge shapes, each feature is firmly in its place, has form and volume, and what is even more essential, conveys the feeling of deep sleep, a stupor which streams forth from the closed eyelids and the gaping mouth. Nothing could be further removed from pompous ornament than the way the arms have been "poured" round the body, with the hands lying limp, captive to a dream, and the same is true of the foreshortened woman, who could so easily have become a Mannerist inverted cone, or swastika shape.

Descriptive naturalism has always been an element in the structure of Netherlandish Mannerism. But spiritualized, interpretative naturalism was something completely new, and this was where Rembrandt made his absolute break with the past, his moment of reappraisal, the final result of which was classical Dutch painting.

Benesch 288 provides a good opportunity for a brief review of the whole group under discussion. The two studies most closely related to it are of a sleeping girl "Saskia", Benesch 289 from the former Fairfax Murray Coll., no. 180 [the Pierpont Morgan Library], but the most important in the whole group is the study of a woman, ill in bed (HdG 418, Benesch 405, "Saskia"). Benesch 288 is also closely linked with a series of sketches of recumbent women, HdG 995, 934, no. 1199 de Grez Coll., Brussels [Musée des Beaux-Arts], 255, 706 (Benesch 281, 286, 287, 255, 284) and the woman in bed, HdG 773, Benesch, 283. The two sheets HdG 417, Benesch 256 and HdG 1359, Benesch 285 also belong here; in both cases the original Rembrandt core, a recumbent figure, has been given a background, the first, cushions, blankets and draped curtains, the second, a landscape. The additions were drawn by a clumsy eighteenth-century hand. Another sheet which has affinities with the group, especially HdG 418, Benesch 405, if only on thematic

grounds, is the sketch in Weimar, HdG 527, Benesch 425, a less detailed, more rapid version of a scene which appears in a richer and more detailed form in the F. Lugt collection (Benesch 426). Closely connected with these two sheets is a study (Benesch 410) in Hofstede de Groot's collection [now Groningen, Museum] (not in the catalogue) where the sick woman is lying to the right, as well as HdG 1299, Benesch 404. Another magnificent sheet from the Hofstede de Groot collection [Groningen] (not in the catalogue) shows a woman in bed (Benesch 282), whose right arm has been drawn twice; the drawing in general has many similarities to HdG 417, Benesch 256. The same motif of a woman lying in bed appears on the verso of a sleeping child (HdG 1190, Benesch 379) in the Print Room in Amsterdam, although here her hands are folded. It has been drawn in airy red chalk, and thus provides the connecting link with HdG 1454, Benesch 308 and HdG 1457, Benesch 375 in the Albertina; HdG 1190, Benesch 379 recto, however, is most closely connected in style with HdG 1292, Benesch A 2. In this case the chronological and artistic links are working backwards in time, because HdG 1292, Benesch A 2 takes us back to the silverpoint portrait of Saskia, in Berlin, dated 1633 (HdG 99, Benesch 427). The whole "griffonnements" group, which has yielded, comparatively, so many surviving sheets, and which spans the years 1634–36, actually begins around 1633, with HdG 133, 141, 157 and 159 (Benesch 203, 223, 218 and 219). The two views of the group of women at the door of a house, seen once from outside (HdG 1194, Benesch 407) and once from inside (HdG 739, Benesch 406) can also be dated by means of HdG 1190, Benesch 379, and there is another similar motif [now Bredius Museum]: two women and a man at the door of a house (Benesch 408). Sheets like HdG 738, Benesch 275 and Benesch 313, *Nurse going Downstairs* (*Saskia Carrying Rumbartus Downstairs*, formerly Fairfax Murray Collection [The Pierpont Morgan Library])[5] lead on to the most mature members of this series, such as HdG 140, 877 and 1455, Benesch 401, 113 recto and 276, which can only have been executed, at the earliest, in 1635/36.

There are only two known instances in Rembrandt's work where several studies showing variations of a finished composition have survived; the etching B. 50, Hind 279 and the *Julius Civilis* (Bredius 482 [see pp. 1–24; fig. 2]). Such cases are particularly valuable because they show us how an idea developed and matured in Rembrandt's mind. The Munich Graphische Sammlung can provide two more instances of the same process.

Rembrandt by no means discarded the idea of the Baptism of the Eunuch. In 1636 he followed the lost painting with a large-scale landscape (Bredius 439),[6] where the story only provides actors for a drama in chiaroscuro, with an elaborate display of rugged scenery. There followed, in 1641, an etching (B. 98, Hind 182), in complete contrast to the paintings, where Rembrandt has refrained from any of the fantastic melodrama achieved in the 1630 painting, by means of the

perpendicular composition, and in the 1636 work, through his use of colour. It is a simple description of the event, as it took place, without any psychological emphasis, and without any dramatic movement; indeed, we can already sense the quiet authority of Rembrandt's religious idylls of the 'forties. The little company has come to a halt in a bright, welcoming summer landscape, and the incongruous baptism is being performed quietly and inconspicuously.

When Rembrandt next returned to the theme, an enormous span of time, compared with his rapid development, had elapsed. The equilibrium and quiet pragmatism of the 'forties were followed by a period of new dramatic tension, but it was no longer manifested, as in the 'thirties, in outward movement. During this phase, the theatricality in his works emerged as a new intensity in his methods of representation. Inner crescendos of excitement now reduced the outward physical garb, the visible appearance of an event, to a series of brilliant intimations conveying the sense of reality with double the force, or to a rapid outline of the essential features of the narrative and its location. During this time, that is, between 1653 and 1655, Rembrandt developed a style of drawing where events and scenes set in what seem to be completely peaceful landscapes, are humming with inner tumult, and where the figures are reduced to the minimum and look like jointed dolls. In spite of the similarities with Rembrandt's work of two decades earlier, the situation is now quite different. At the beginning of the 'thirties, Rembrandt was having to struggle to fill the hollow abstractions of Mannerism with living substance, whereas, by the 'fifties, abstraction no longer played any part in his art. On the contrary, everything was condensed, all the rich, free life and naturalism was pared down to the essential; the living fact was empirically perceived, and translated into core spiritual intensity. This new development in his work could never have been a product of Rembrandt's historical and artistic background, even if he had turned the old formulas upside down and disavowed them; it is a sign of the primary, and unprecedented expression of a completely original creative gift.

The last painting of *The Baptism of the Eunuch* falls in this period, but we do not know whether it was ever executed. At any rate, the Munich Graphische Sammlung possesses two studies for it (Inv. 1659 and 1660, Benesch 967 and 968; figs. 63 and 64). These studies can be accurately dated by the intimate stylistic connections of Benesch 967 with the study (HdG 84, Benesch 956; fig. 183) for *Quintus Fabius Maximus at Suessa* of 1655, in Berlin. In fact, it is only necessary to put the two sheets side by side to see that the riders and horses are almost identical, especially in the hook-shaped abbreviation of the latters' heads. Nor should there be any need for further proof that both sheets are by Rembrandt. To mention only a few more examples, the narrative drawings HdG 27, 89 and 687 (Benesch 966, 960 and 969) and the landscapes HdG 177, Benesch 1341 and HdG 1046, Benesch 1324 show how firmly these sheets are rooted in the 1653 group.

Benesch 967 represents another rich scene, a woodland valley rustling with trees, a fortress raising its massive towers on the distant hill. Like *The Rest on the Flight into Egypt* (Bredius 576) of 1647, in Dublin, it reminds us of Elsheimer. But why did the mature Rembrandt return to a landscape setting for the story, when he had already deliberately rejected it in the final version of his earlier representation of the subject? In adopting this familiar setting the mature Rembrandt did not think of himself as bowing to tradition but, rather, as making a free artistic choice. We should not envisage this as the persistence of an old historical link; it was a free revival of an old idea, but under such radically altered conditions, and on such different spiritual terms, that it was not so much a revival as a completely new creation. With increasing maturity, Rembrandt's work became ever more intense and concentrated and, to match his development, the simple, enclosed forms of Elsheimer's scenery had to take on a new meaning. What was, for the German, realistic compactness and weight, became for Rembrandt, floating layers of planes and simple, grand silhouettes that unfold and evaporate in the atmosphere to such an extent that they seem almost hollow, and only become visible to all because the "fluid" substance around them builds up around their edges and forms optical contours. In his mature works, the simple form gives a sense of floating freely, and this is even clearer in his drawings than in his paintings. Thus, in our sheets, the Elsheimer stage-setting has developed into a flickering, vibrant slice of the universe; and we can perceive the extent of the infinite landscape whose shining undulations sweep through the pictorial space from all sides. In contrast to the previous versions of the theme, everything has grown peaceful. The scene has been moved back to become a vista, as if the spectator were seeing it from the other side of the river. At first the wooded valley was quiet and unpeopled; then the small procession of travellers appeared, and now the scene we have read about in the Bible is taking place but the impression is so new and immediate that this might be any incidental event in the quiet landscape the distant observer cannot quite make out. Indeed, the baptism seems to be developing out of the atmosphere of the whole picture, and it is this inner spiritual affinity with Elsheimer which means more than any formal relationship between the two artists. In other words, the link between them is a fundamentally original and spontaneous one, arising out of similar psychological viewpoints and, without it, no formal contact could ever have been made in the first place.

Using Elsheimer as his contact, Rembrandt has conjured up the spirit of the masters of the Danube School out of the previous century, although without our having to think in terms of a direct connection between the two artists. There is evidence enough to show that the age of Dürer was again and again revived in Rembrandt's works in the 'fifties, though not so much, as before, in isolated motifs, as in the spirit and the mood of his compositions—for instance, the drawing

recently published by G. Falck,[7] a magnificent conception, of a *Visitation* (Benesch 1019; fig. 134).

Benesch 967 is sketched out in brief, powerful, but intermittent penstrokes; where there are hair-line strokes, they are only the onset or dying away of an area of intensity or blackness. It is a draughtsman's shorthand with rhythmic intervals, but these rhythms have nothing abstract or remote about them; they seem to be flowing out of nature herself. But it would be no less misguided to try to see any impressionism in this style of drawing. These essential lines and strokes are not abbreviations of a fleeting glance, they are not atmospheric intervals, but the spiritual quintessence of an experience rooted deep in nature—even if it has been seen with the inner eye alone. These dark, optical lines are not luminous effects, they are heart and veins of a reality; they have an enormous power of cohesion, because they make the surrounding white space join in the rhythm, and thus maintain a vital, physical fullness.

In the second drawing, Inv. 1660, Benesch 968, Rembrandt has placed the main group of figures nearer the foreground. This group looks unexpectedly large, as if it were appearing to the far-off spectator in visionary grandeur, or as if he were looking through a telescope, whereas the landscape, on the other hand, recedes into the distance in a series of tempestuous dots and dashes. The scene has been magnified, but the telescope is more mental than physical. The objects being viewed through it are not more solid or more detailed. The parts where the ink ran and formed dark patches in the earlier version have been deftly sketched out here, dissolved in a bold, radiating dematerialization, and thus placed beyond rational experience, although remaining utterly true to life. However, the spiritual intensification has caused the material elements to levitate: everything begins to float and, while remaining absolutely still, to revolve soundlessly in space—the waiting chariot, the rider, who has a double as if he were being reflected, transcendentally, by the atmosphere, and the group by the stream. Just as Rembrandt has concentrated the darkness in the centre of this sheet, and loosened the edges correspondingly, so has he simplified and concentrated the composition, and made it lighter and more airborne. The servant carrying his master's cloak has approached nearer the scene of the baptism, and forms a group with the apostle, the Eunuch and the "double" rider who arches over the scene. Here, too, the movement has an upward direction, no longer in a steep, early baroque diagonal, but in a solemn vertical line. The rider looks as if he were perched on a high pedestal. We can also see the ceremonious stratification of planes typical of the 'fifties, a feature which came to its fullest fruition in the *Ecce Homo* (B. 76, Hind 271).

The cluster of figures and the distant vistas that make Benesch 967 look rather like a toy farm have vanished. There is no procession of people emerging from the

dip in the ground behind the knoll. The event has become more private, the narrative more serious.

The false "Rembrandt" signature that made Hofstede de Groot query, and even reject, certain sheets, appears in the bottom right hand corner of Benesch 968. We can assume that these signatures, which appear over and over again on sheets in the Munich collection, were written by one and the same person. It is not a seventeenth-century hand, but rather a rough attempt at turning the familiar signature from Rembrandt's paintings and etchings into a handwritten one. The forger has "signed" false and authentic sheets alike, but close scrutiny reveals that the colour of the ink he used always differs from the colour of the medium of the drawing. Apart from the crudeness of the lettering, however, the forger was not unskilled at his task; he more than once hit on a shade of ink that, at least at first glance, looks very much the same as the drawing, and he sometimes even added a few scribbles to the drawing in his ink to make it more plausible. In Benesch 968, the signature is also present, but written in a greyish tone of sepia which clearly differs from the blackish-brown of Rembrandt's original bistre; but sepia also appears in the drawing. On the other hand, every flick of the pen in Rembrandt's hand, however rapid, had a definite meaning, and was placed in position with deliberate, unwavering accuracy, whereas the sepia scribbles which appear above the signature in the form of a 10 with a stroke through it and on the right, below the horses' heads, in a rough concertina slope are senseless. It seems likely that the signatures were intended to give the sheets more credibility, and thus a higher value or, what is more probable, a large quantity of false, or forged Rembrandts were planted among the authentic ones.

The study for *Potiphar's Wife accusing Joseph* (Benesch 958 recto; fig. 71), of about 1654/55, bears the same forged signature. This is probably the reason why Hofstede de Groot designated it as doubtful, although he accepted it as no. 365 in his catalogue. There are two versions of the painting, one [formerly] in Leningrad, [now in the National Gallery of Art, Washington] (Bredius 523; fig. 69) and the other in Berlin (Bredius 524; fig. 70). The drawing, which served as the basis for both, gives us an important insight into the master's method of procedure. In the study, Joseph appears on the far side of the bed, as in the painting now in Washington, his head bent, his eyes downcast, his arms folded. However, at the foot of the bed, in the front, there is another shape painted in strong, broad brushstrokes, and looking very much like a figure kneeling, with forearms propped on the bed. Originally, indeed, there was a figure there, and the proof of this is the sketch on the other side of the sheet (Benesch 958 verso), where the same outline has been drawn again and is, quite clearly and plainly, a kneeling figure. It obviously represents Joseph, who must have originally been placed at the foot of the bed, shattered and annihilated by the enormity of feminine malice. He must

have knelt there, struck dumb, not unlike the penitent David in B. 41, Hind 258, letting the flood of lies engulf him. It is obvious that this figure must originally have been intended for Joseph, because Potiphar's wife is gesturing towards it with her right hand, and not towards the man standing in the background on the other side of the bed. Rembrandt evidently did not find his first solution satisfactory, and when he rearranged the composition, he succeeded in blending the kneeling figure into the bedstead, by drawing and shading over it, so that the body looked like a bed-post, with heavy coverlets hanging over it and dragging on the floor, and the head became a cap in the hand of Joseph standing humbly by. The version in Washington shows that this alteration was adopted during work on the painting, or after it had ceased. There we can also see a covered bedpost which cannot completely conceal its origins in a kneeling figure seen from the rear. Where the head used to be, there is a shadowy patch, masked by Joseph's cap, and the finger of Potiphar's wife points clearly enough to the hidden bedpost, and not to the young man on the other side of her bed; evidently Rembrandt decided not to change her hand. I am not familiar with the painting in the original, but from a study of photographs, I am of the opinion that these corrections could be still traced today. [8]

In the second version of the painting, Rembrandt naturally reduced the strange scarecrow of a bedpost to more normal dimensions, and the hand of Potiphar's wife is also gesturing quite clearly across the bed. The main revision of the pictorial idea was carried out during, or after, the first version of the painting, now in Washington, and the drawing served as a basis for planning the proposed changes. But even the later alterations to the Berlin version were tried out on the drawing. At first the woman was sitting quietly with her legs uncrossed; but later Rembrandt reworked this pose with broad strokes, drawing in another with the right leg crossed over the left. In some features the Berlin painting represents a reversion to the drawing, while the painting in Washington tends to diverge from it; for example, in the distance between the man and woman, and the wide space behind the overhanging canopy (although it is possible that the canvas has been cut at the upper edge). The fact that the Washington painting has had the date altered from 1654 to 1655 might also be taken as an indication that the major changes were performed after the first version had been considered, at least temporarily, complete.

The type of line used in the drawing is broad and powerful, the dark, optical contours are sketched in with a reed-pen, in mighty strokes, as thick as beams—intense streams of power. They have broad, shimmering shadows woven round them, submerging them in even deeper gloom. The few remaining bright passages sparkle, giving a marvellous impression of fluid colour, radiant and glowing from within, although Rembrandt has used nothing more than his draughtsman's tools. Even more astonishing is the skill with which he has reached the heights of spiritual

expression while using only the minimum means of representation; and, in this, the drawing could almost be said to surpass the paintings. These "jointed dolls" are full of inner life, the woman's hypocritically pained expression is concentrated into a single, dark horizontal line, the man's dumbfounded, hurt astonishment into one small circular eye, and the youth's downcast humility and pious resignation have been produced in three or four strokes; this shows the most sublime mastery of pictorial representation of inner life.

We can also admire the same quality in a small sheet executed about the same time, or only a little later, an *Entombment* (Inv. 1629, Benesch 972; fig. 72). This drawing was undoubtedly larger at one time, but has been cut and given a framing line. In style, it is closest to the study for *The Anatomy Lesson of Dr. Joan Deijman* of 1656 (HdG 1238, Benesch 1175), where the figures are also reduced to the same geometrical shapes, cylinders, cones and spheres. We can find the same style in the studies for compositions HdG 1551, 17, 33, 1546 and 791 (Benesch 936, 955, 502a, 975 and 974), all of which belong to the same group and the same period. The *Entombment* is also connected closely with the *Death of Sapphira*—wife of Ananias—(Benesch 1016 [now Paris, Louvre, W. Gay Bequest] Lippmann-HdG III, 61). Rembrandt was led towards this unusual method of portraying the human figure, that is, reducing it to almost constructional forms, by his ever increasing urge for spiritual expression. The simpler and more lapidary he made his figures, the better he was able to convey their spiritual voices, and the more he muted the psychological details, the more he encouraged the soul to speak. Because isolated effects were disappearing, the whole figure had to be the vehicle of expression. We see this happening in the small *Entombment*, in Mary's weary body stumbling along, racked with unbearable, and therefore inexpressible grief. Although she is supported by her companions, she is trying to hold herself erect, with her last ounce of strength. And how moving these companions themselves are, with their air of numbed, grief-stricken reverence, their pity both for her, and for themselves, in their mutual loss. Yet these expressive figures have heads that are only circles with one or two short lines in them. The coffin-bearers, too, are equally moving, as they struggle down the uneven steps with their precious burden—and how grave the expression on the face of the centre coffin-bearer, as he turns towards the man in the front. The burial-ground is in a grotto, and we are ourselves inside it, watching the whole scene unroll from the entrance.

In 1654 Rembrandt etched a *Descent from the Cross by Torch-Light* (Hind 280). In the same or the next year he etched an *Entombment* (B. 86, Hind 281). The small drawing of *The Entombment* in Munich is related to the latter in spirit, and the composition shows strong links with the composition of the etching, although in mirror-image.

The Munich Graphische Sammlung also has three superb studies for the composition *The Adoration of the Magi* (Bredius 592; fig. 68) of 1657, in Buckingham Palace. Hofstede de Groot listed one of them in his catalogue as dubious (no. 380, Benesch 1030; fig. 66), and rejected the other two. However these works are all undoubtedly by the same hand; if one falls, the other two must also and, in fact, there is no reason to question these magnificent reed-pen drawings. They are extremely closely related in style to Rembrandt's studies for compositions from the late 'fifties and early 'sixties, for instance, the studies for the etching B. 50, Hind 279 (HdG 734, Benesch 1033, and Benesch 1032, [formerly] in the collection of Dr. Beets, Amsterdam,[9] [now in the Boymans-van Beuningen Museum, Rotterdam]), and, finally, the sketches for the *Julius Civilis*. In his later years, Rembrandt developed a very personal type of "shorthand" for his compositional studies, a style which was completely different from his ordinary style of drawing, and this enables us to group together sheets that are authentic, though separated by many years. He evolved this "shorthand" out of the "jointed doll" technique of the first half and middle of the 'fifties, and by its means was able to produce one or more of these figures, loaded with suggestive tension, in a few brief strokes and dabs of the pen. Naturally, it is also perfectly possible to trace the changes in Rembrandt's draughtsmanship through these compositional sketches, but the stages are less markedly different, and thus more difficult to recognize.

The fact that we possess three studies, none of which is exactly like the painting in every detail, makes this group as important to our knowledge of Rembrandt's method of thinking as the group of preparatory drawings associated with the *Julius Civilis*. As in the latter case, we can presume, from the first, that the version most far removed from the painting is the earliest, in this instance, Inv. 1626, Benesch 1029 (fig. 65). The format of the picture is square and has not yet been elongated into a rectangle, and thus the whole scene is still broad, low and diffuse, without any of the ceremonious, calm, vertical movement acquired later. The main group of figures appears more or less as they are in the final version, but there are a few salient differences. The two kneeling servants of the aged Magus are further away from him, and the standing servant is in a different position. The train of followers is much more modest, the camel with the umbrella is small and the baggage-cart less conspicuous. The most marked difference is at the right edge where a small horse is trotting briskly towards the right over the columns of the huge archway framing the scene. Instead of compactness and emotional depth, the drawing is a centrifugal, disorganized medley, not yet filled out and conscious in every component part, still tentative. In the centre there is a confused, shadowy throng (white body-colour has been used copiously for corrections), and the edges of the drawing are often empty, while the upper left-hand corner has not been dealt with at all. The "handwriting" is full of curves, like the earliest of the *Civilis* draw-

ings (HdG 411, Benesch 1058), covered over with a shimmer of dark layers of strokes in an attempt to give the effect of space and depth. In the first instance, Rembrandt visualized the central group in reverse, as we can see from a jotting on the verso, showing the Madonna and the kneeling Magi in brief outline. This drawing was executed in blackish-brown bistre on brownish-grey paper, and the brownish-violet ink of the forged signature has also been used to draw the outermost line framing it.

In the next study in the sequence (Inv. 1706, Benesch 1030; fig. 66), Rembrandt has grasped all the colourful splendour of his subject in one stroke. The sheet fluoresces. It has been drawn with a rather broad reed-pen which occasionally omits part of a line and leaves only brittle strands on the paper, giving the impression that the drawing has waves of inner force constantly surging through it, as if it were fluid, despite all the monumental grandeur of form, and as if it were vibrating with colour, although the scene is extremely tranquil and solemn. Areas of drawing and areas of blank space set one another off as in late classical high relief, and the sheet seems to oscillate with innumerable fluctuating currents. Even though it is completely monochrome, it seems to glow and scintillate with colour. It is also interesting to observe how heavy and massive the parallels are as they march up in tiers towards the vast arch framing the scene, and sweep around and up towards the thatched roof of the straw hut, how full the cluster of people with inner life, how dignified and suggestive the silhouette of the camel with the umbrellas as it rears up against the background to complete the composition. This is undoubtedly the most important drawing of the three, because here Rembrandt has captured the essence of his future painting, and in most details, the two are identical. Of course, there are a multitude of small differences; instead of two men kneeling behind the old Magus, there is a small boy with a dog, some figures in the space where formerly there was a horse trotting, and a man is being led in by another boy. But already the composition has begun to be more closely knit and concentrated. The third Magus, newly dismounted from his horse, approaches ceremoniously, as if he were hovering above the group around the crib.

The third and last drawing (Inv. 1426, Benesch 1031; fig. 67) is thus the final reckoning before the painted version. It reverts to the first version in several details: the humble obeisance of the old Magus, with the column-like figure of the incense-burner towering above his head, and the servants kneeling behind him. The incense-burner is one of the "Russians" Rembrandt was painting at the time, and here he is finally given the function of apex and uniting force of the whole group. On the right, two men from the Magi's suite are approaching, one of them swinging a censer on a long chain. The other appears in the painting with a tiara on his head as the third Magus, while the dignified man with a turban remains in the darkness of the background. The space to the right of the camel has been filled with the

retinue; there are towers on the distant hills and the celestial shaft of light streams down from the Christmas Star onto the little Child. At last Rembrandt had solved the problem of distributing the weight. The group with the incense burner balances the group of worshippers, and as the "Russian" Magus provides the apex for a pyramid here, so the Magus with the turban provides the apex of the whole composition. Again, he himself is enclosed within the arch formed by the camel's hump, which repeats, like an echo, the function of the figure in the composition, that is, as the apex of a pyramid. Even the two men approaching from the right are united in a triangle by the diagonals that swing away from them. In spite of all the strictness of the grouping on the horizontal axis, there is tremendous freedom in the arrangement of the elements in space and, in fact, the late Rembrandt only used this technique to heighten the inner tension, and prevent disintegration. There is a frieze of half-length figures behind the standing King, which does not appear in the painting. Joseph appears in the shadowy darkness of the hut as a profile figure, whereas, in the painting, he has turned towards the spectator. Finally in the painting, Rembrandt also brought the composition down lower, removed the foreground, and vaulted the space in the upper half of the picture so that it looks as lofty and dark as the interior of a cathedral.

The lines framing all the drawings are by a later hand. In Benesch 1030 it is easy to distinguish the violet tone of the later ink from the original, and the same is true in Benesch 1031 where the original ink was brown bistre with white body-colour on the Child and the standing King. Here, the false signature was originally written in sepia, and several additions made to the drawing in the area over the signature in the same medium, for instance the zigzag hatchings below the men on the left. However, since the pale grey sepia stood out revealingly from the original ink, the forger went over it in places with brown, and the signature thus appears to have been written twice.

The last of the sheets in Munich I should like to mention is a small work, but a supreme example of the simplicity and grandeur of Rembrandt's draughtsmanship in his old age; it is a *Lamentation for Christ* (Inv. 1454, Benesch 1049; fig. 73). This last stage in the development of Rembrandt's draughtsmanship can be traced from about the turn of the 'fifties and 'sixties, and one of the first examples of it is the Munich *Christ and the Adulteress* (HdG 383, Benesch 1047) on the reverse of a funeral announcement dated May 14th, 1659. The clarity and precision Rembrandt had achieved in his figure drawing during the late 'fifties, seems to be falling apart here, but the disintegration is only apparent, because the lines soon unite again to form heavy, massive, statuesque contours. One of the most imposing representatives of this late group is HdG 1556, Benesch 1044; and the same group of figures, Mary with her dead Son in her lap, appears on the reverse of Benesch 1049. In this version, the dead body is lying stretched out more on the floor, and the Mother

is bending lower over him; the group reminds us directly and forcibly of early sixteenth-century German art. Although the close connections of this drawing with the sheet in Stockholm are immediately obvious, the recto shows, in spite of the optical breadth of the line, a softer, undulating character, such as we see in the contemporary, but much more finely drawn, *Christ with His Apostles and the Woman who had an Issue of Blood* in the Albertina (HdG 1416, Benesch 1052; fig. 74). Further support for the authenticity of the Munich sheet can be found in the *Liberation of St. Peter* in Dresden (HdG 262, Benesch 1062) and *A Child Being Taught to Walk* in the British Museum (Benesch 1169).[10]

The men have put down the body, wrapped in linen, and have laid it across the women's laps. One of the men is still standing, bending forward, with the shroud clasped in his hand. Only one face has been clearly finished, although only a few lines have been used, the face of Christ. The whole anguish of the passion can be read in these features, for all their composure, and the infinite weariness of someone who has suffered to the end. In contrast to the unforgettable expression of the dead Christ's face, everything that is alive seems dumb and lifeless. The mourners' faces are frozen into inarticulated, mask-like surfaces, their bodies motionless, their heads fused into cubic structures; everyone is holding his breath as if spellbound by the still, weary face of the dead Christ. They have become as motionless and lifeless as sticks and stones. The dead Christ is more alive than the living.

Rembrandt's late style of draughtsmanship reached the heights of monumentality with *Jeroboam's Son* (*St. Peter at the Death-bed of Tabitha*, HdG 229, Benesch 1068; fig. 207). *Haman in Disgrace before Ahasuerus and Esther* (Benesch 1067; fig. 21)[11] in the Museum in Budapest is already half-way towards the spiritualized style of drawing, almost on the point of dissolution, which we find in the mighty *Diana and Actaeon* (HdG 240, Benesch 1210).

It is with the utmost caution that I should also like to add here a small *Study for a Beheading of St. John* (Benesch A 14, 78 × 70 mm) very much in Rembrandt's style of 1637, and *Orientals in Discussion* (*Oriental talking to an Old Musician*, Benesch 719, 112 × 86 mm), which is like his drawings of 1647. These may both be original drawings, but the first is much too badly preserved and has been too much drawn over, for any final decision to be reached, and the latter was given a grey-brown wash in the eighteenth century.

G. Falck has also found a sheet by Renesse, corrected by Rembrandt *The Incredulity of St. Thomas* (Benesch 1375).

As far as the rest of the sheets in the Munich collection are concerned, Hofstede de Groot's original negative judgement has been completely confirmed.

Postscript to the above article

[In this postscript the author appends the following references he had not quoted in the above article, and records the opinions of the authors on some of the drawings discussed:

F. Saxl, *Rep. f. Kw.* 31 (1908), pp. 531 ff.
E. Michel, *Rembrandt*, Paris, 1893, p. 579.
W. Bode, *Zur Geschichte der holländischen Malerei*, 1883, p. 374.

He also attributes another sheet in Munich to Rembrandt: *Peasant Cart in Full Drive*, Schmidt 150, Benesch 469.]

"Rembrandt—Relicta aus der Münchner Graphischen Sammlung," *Die Graphischen Künste* XLVIII, Vienna 1925, Mitteilungen pp. 25–39; and idem XLIX, Vienna 1926, Mitteilungen p. 10. [Abstract.]

New States in Prints by Mocetto, Nicoletto da Modena, Lucas van Leyden and Rembrandt[1]

I.

Girolamo Mocetto, *St. John the Baptist* (Bartsch XIII, p. 219, 5; Hind, p. 464, 8).[2]

H IND mentions only the print from the Hofbibliothek, but, as a whole, the print of the Albertina gives a more favourable impression. It is warmer and deeper in tone, not only because of the richer colour of the ink and the yellowish paper, but also because of the clearer and more compact plastic quality and the greater relief of the figure. The print from the Hofbibliothek looks much flatter and only the dark shaded parts are deeply incised, while the half-shadows are grey and shallow, and do not give the figure any proper plasticity. The difference is particularly obvious in the upper half of the Baptist's body, but the landscape and the interior drawing of the trees and hills have also become greyer and thinner—the characteristic look of a plate worn by use. This contrasts strongly with the deeper shadows, which seem to have grown heavier and more dense, to an extent that could not be attributed to reworking on the plate alone, and close scrutiny of these deeper shadows shows that we are dealing with two different states. The layer of shadow between the Baptist's bare leg and the contour of his long cloak is produced, in the Albertina print, by a row of irregular fine vertical lines with short horizontal and diagonal strokes running across them: on the right foot and the folds of the cloak the latter often occur in extremely fine, delicate groups which give an excellent effect of solidity to the curved form. These fine layers of horizontal and diagonal lines have either vanished or grown patchy and sparse in the Hofbibliothek print, while the hollows of shadow are shown by strong, regular vertical lines. The hatching on the dark hem of the cloak on the right in I, looks coincidental, undisciplined and empirical, while in II, the layers of cross-hatching are firm, vigorous and regular.

Also, in the latter impression, there is a firm sheaf of vertical lines in the shadowy hollow to the left of the Baptist, whereas I only gives the impression of a patch of darkness. In II, the curve of the Baptist's left shoulder is accompanied by a new layer of oblique lines inclined towards the right which covers the part of the hair in shadow with a new layer of vertical lines. Also in the layers of shading on the curves of the scroll, much has been changed.[3]

Nicoletto da Modena, *The Adoration of the Shepherds* (Bartsch XIII, p. 256, 4;
Hind, p. 434, 40).

Both prints are mentioned in Hind. The sheet from the Hofbibliothek is the
earlier one. The Albertina print was taken from the plate when it had been more
strongly worn and also partially reworked in the layers of shading on the archi-
tecture. At the same time, the engraver made a few striking changes: he hatched the
diamond-shaped pattern of the pavement in front of the group of kneeling shep-
herds with a layer of diagonal lines in I, and a horizontal layer in II.[4] The partly
obscured arch of the edifice on the right has, in I, a lunette surrounded by scroll-
work, and through the lower part we can catch a glimpse of distant vaulting.
In II, both these features have been erased and replaced by homogeneous hori-
zontal hatchings. The inner contour of the large arch is shaded with a new layer
of diagonal lines which lengthens the shadow of the column so that it reaches up
under the arch.

II.

Lucas van Leyden, *Fortitudo* (B. 132).[5]

A clear and silvery early impression from the Hofbibliothek (formerly Mariette)
bears the inscription "Vortitudo"; the phonetic similarity between F and V in
Dutch is responsible for the spelling mistake. In the stronger, but less attractive,
print in the Albertina, the V has been changed to an F.

III.

Rembrandt.

Rovinski's[6] observations are decidedly more accurate than those of von Seidlitz,[7]
and the series of states he established are completely justified, although von
Seidlitz eliminates them from his lists. I should like to quote three examples which
can be verified by comparison with sheets in the Albertina.

The first state of *Rembrandt with Staring Eyes* (B. 320, Hind 32, Münz 11 II) with
rough edges, which Rovinski established on the basis of the sheet in the old
Albertina, can be fully confirmed now that we can compare it with the second state
from the Hofbibliothek.

All Rovinski's states of the *Self-Portrait with a Sash* (B. 17, Hind 108, Münz 18)
can be confirmed by comparison with sheets in the Albertina.

Rovinski's sixth state of the small *Coppenol* (B. 282, Hind 269, Münz 80) actually
shows a return to the dark circle erased from IV; the print of the sixth state in the
Albertina shows, as clearly as V, the traces of the erased triptych.

The only justification for eliminating any of Rovinski's established states would
be a reappraisal of the originals he used as the foundation for his catalogue, and

we must be equally circumspect in describing the states and distinguishing the characteristics of each. Rovinski's descriptions are unfailingly precise, and any move to replace his distinguishing marks by new ones, as happened in the Seidlitz–Singer catalogue in the case of state III of the *Gold-weigher* (B. 281, Hind 167, Münz 259) must be accompanied by an examination of the originals, not merely of the reproductions in Rovinski's catalogue. For instance, in the case mentioned above, the "new layer of transverse lines on the right of the bronze snake" simply does not exist, but is the consequence of the background of the picture being printed more strongly. As we know from the Albertina prints of the second and third states, this can also happen in reverse.

In cases like these, where we have to make final decisions about states of prints, we are compelled over and over again to return to Rovinski's corpus, since the cursory descriptions in Hind's catalogue, however much he has added to our knowledge by having observed a whole series of new states, do not suffice for our needs . . .

In the following paragraphs, I am proposing to review the sheets in the Albertina. As I have already pointed out in another place,[8] such a reassessment would not be, in Rembrandt's case, a matter of antiquarian hair-splitting, but a search for factors that can give us real insight into his method of procedure and into the development of his conceptual powers. It is just as important for our knowledge of his work to be able to distinguish between two states where the artist himself has done the revising as, for instance, to be able to identify the two men behind the parapet on the left of the *"Hundred Guilder Print"* as apostles from Leonardo's *Last Supper*.

The Angel leaving Tobias and his Family (B. 43, Hind 185, Münz 179)[9]

There are, altogether, five states of this etching, and it is extremely difficult to arrange them in order. The chronological sequence has been given wrongly in all existing catalogues without exception.

I. The knot on Tobias' girdle is white,[10] the hatching on the hood of the kneeling woman indicated, as a preliminary measure, by very faint dry-point strokes, and the triangular area under her right arm is shaded only with a double layer of hatching (Albertina [Inv. 1926/72], Rovinski repr. 146; fig. 75). The reproduction in Rovinski shows an uninterrupted fringe of diagonal hatchings on the upper left hand edge of the plate, while in the Albertina sheet, as in all other examples known to me, the fringe is broken by the outermost vertical hatchings of the lintel of the window. Without seeing the original, I cannot say whether this is due to reworking, touching-up on the reproduction, or a state prior to the sheet in the Albertina.

II. The knot is hatched. Strong layers of hatching on the hood. The triangular area has been given a third layer of hatching. Albertina ([Inv. 1926/73], Rovinski repr. 145) and Rovinski repr. 144. (Rovinski has confused the chronological relationship between the two states which Claussin had already correctly arranged.)

III. New, copious layers of hatching on the clouds and the robe of the angel in the upper right corner. Albertina [Inv. 1926/71].

IV. The light triangular area of ground in the left hand lower corner has been given a fringe of brief strokes (Rovinski repr. 147).

V. The print reworked by Watelet (Rovinski repr. 148).

From III on additions like the hatchings of the knot, the thick layer of hatchings on the hood and the third layer on the triangular area of the robe begin to grow fainter, and the prints seem to look gradually more like I. (Possibly this is what led Rovinski, who did not know III, to confuse I and II.) However, traces of the worn-away additions are still clearly visible.

Christ disputing with the Doctors. Small plate (B. 66, Hind 20, Münz 190)

The Albertina [Inv. 1926/265] has a faint but clear impression where two more heads with turbans, drawn in delicate dry-point, appear in the background, on the right and left of the group of three scholars that feature in III. These heads disappear later on.

Christ driving the Money-Changers from the Temple (B. 69, Hind 126, Münz 206; fig. 77)

The Albertina possesses two prints of the second state where the chandelier hanging in the archway has been eliminated, though not from the plate itself, since it still appears in III. In both of these cases, it looks as if the chandelier has been removed by covering the plate. Rembrandt made several experiments on these sheets, giving them a grey wash to achieve a particular lighting effect. Christ's halo blazes out in the gloom, and at the end of the dark, vaulted aisle the entrance yawns, full of daylight; since Rembrandt was chiefly concerned with emphasizing these two sources of light, he decided to remove the dark lamp, which would have spoilt the effect. In one of the two prints [Inv. 1926/271] the chandelier has been removed more successfully than on the other [Inv. 1926/270]. The Albertina has several sheets which Rembrandt almost made into monotypes by giving a special treatment to plate or print; I shall discuss these sheets as a group at some later date.

The Raising of Lazarus. The larger plate (B. 73, Hind 96, Münz 192)

Seidlitz–Singer give as VI the "woman with the startled man on the right, who had a round face and a short, straight nose in the earlier states, but who has now acquired an oval face and a snub nose as well as showing less bare forehead than before", and as VII the "startled man behind her wearing a cap".

A sheet in the Albertina ([Inv. 1926/141]; fig. 76) shows Mary's head before the alterations, but the man behind her is already wearing a barret. We should thus exchange VI and VII.

The Ship of Fortune (B. 111, Hind 106, Münz 256)
The distinctive sign of the third state of the bound edition (with the text on the reverse) is the horizontal slipped stroke across the flag. This already appears in a print from the Albertina which originated before the bound edition.

Beggar Man and Beggar Woman in Discussion (B. 165, Hind 13, Münz 110)
The slipped stroke on the man's cap is only known to appear in the first state where the edges have not been cleaned. The Albertina has a print of the cleaned plate from which the slipped stroke has not yet been obliterated.

The Flute-Player (*L'Espiègle*) (B. 188, Hind 200, Münz 264)
In the fourth state, the head on the right of the shepherd's staff has disappeared. The Albertina has another print where the pupils of the flute-player's eyes have been effaced from the plate [Inv. 1926/324].

Jan Antonides van der Linden (B. 264, Hind 268, Münz 81)
Rovinski gives a sequence of seven states. The baluster on the lower left has been reworked in Rovinski VI in such a way as to articulate the structure of the piers. Rovinski would not have been able to see this distinctly on his print. But it can be seen very clearly in a sheet of the Albertina [Inv. 1926/419] which has, in addition, on the blank white space below the etching, the following inscription in faint lead pencil, as a guide for the engraver:

"Joh: Anth: van der Linden
Professor en Doctor
in de
Medecynen"

Since this alteration does not appear in Rovinski VII (which has been inaccurately described by Seidlitz–Singer, the white cuff not having been worked over, but being dark only because the ink was left on the plate), the sheet is certainly an example of Rovinski V which has been badly printed and is grey. [Münz accepts this sequence of states, but is mistaken in believing that Benesch has reproduced IV instead of VI.]

Samuel Manasseh ben Israel (B. 269, Hind 146, Münz 56)
The Albertina has a particularly clearly printed example of a state prior to the known ones. The diagonal layer of hatching in the cheek, inclined towards the right, does not yet touch the ear [Inv. 1926/426].

Faust (B. 270, Hind 260, Münz 275)

A more saturated, deeper and ridged print in the Albertina, bearing the distinctive marks of III, shows a new change absent from other prints of III: the lower half of the shaft of light streaming towards Faust from the apparition of the macrocosm has been made darker by thickening and strengthening the rays, and the beam now falls into two zones, a lighter and a darker [Inv. 1926/431].

Jan Asselyn (B. 277, Hind 227, Münz 71)

I shows a clear horizontal seam running between the four pegs on the easel. This horizontal line has been obliterated from an excellent, deeply coloured print of the Albertina, and at the same time, the artist has begun to remove the easel—this is the reason for the many scratches on the area to the left of the hat [Inv. 1926/451].

Rembrandt with Cap pulled forward (B. 319, Hind 58, Münz 16)

The plate was reduced in size, as is proved by a print in the Albertina, before the shadow behind the right shoulder was removed; the result is a new state between II and III [Inv. 1926/512].

"Neue Plattenzustände bei Mocetto, Nicoletto da Modena, Lucas van Leyden und Rembrandt," *Die Graphischen Künste* XLIX (1926), Mitteilungen pp.5–9.

On the Problem of New States in Prints by Lucas van Leyden and Rembrandt[1]

Hans Kauffmann has recently published a critical review[2] of an essay I contributed to this journal (see pp. 101–106), and I should like to take this opportunity to answer a few of his points.

On Lucas van Leyden B. 132: "O. Benesch described a 'new' state of the *Fortitudo* engraving by Lucas van Leyden ("Vortitudo" instead of "Fortitudo") on the basis of the print in the Albertina in Vienna. According to Bartsch and Le Blanc the change in spelling was first noticed as early as 1884, by Evrard".

When working on his catalogue, Bartsch only had one *old* print to hand, the sheet from the Hofbibliothek with "Vortitudo" on it. Dutuit also only had a print of the same state, and he too noted down "Vortitudo". Evrard's remarks on the sheet were as follows: "Dans le 2ᵉ état, on a corrigé et écrit avec un F au lieu d'un V suivi du chiffre 7, ce qui semble prouver que cette pièce est la dernière de cette suite". This second state, as described by Evrard, is an impression from the later *numbered* series which he had followed by a third one from the series with the inscription "Martini Petri". These "states" were naturally familiar to Bartsch as well as to Dutuit, but they did not consider them to be actual states any more than we would judge an Alvin–Beaumont print of a Rembrandt plate to be such. Le Blanc simply noted "Fortitudo", and we can no longer tell whether he was looking at an old print or at a new one from the numbered series. The print in the Albertina is an *old* one, taken *before the numbering*, and since it shows the change from V to F there is every justification in calling it a second state, particularly as the correction was most probably made by the artist himself.

This state is not, however, the same as Evrard's II. The situation is probably much the same as in the case of Dürer's engraving of Adam and Eve, described by Meder: the artist himself corrected a mistake in the inscription. It is the artist's own intervention which was the reason for my interest, not merely the fact of a "change in orthography". Collectors and curators can now concentrate their attention on prints with "V" as being early impressions of higher quality and probably rare—this practical solution is probably the only one in an otherwise extremely unimportant matter.[3] As far as I know, the fact that the *old* prints of B. 132 appear in two states has not been mentioned anywhere previously in the literature . . .

On Rembrandt

"The rest of the notes apply to B. 69 (not a new state of the plate, but a print previously noted and reworked); B. 111, 165, 188, 264 (Benesch does not seem to realize that in state VII the whole plate has been reworked); B. 270, 277 (Benesch's observations cannot be verified on the Berlin example of the first state); B. 319."

On B. 69: Bartsch says in his catalogue, 1797, "On trouve quelquefois des

épreuves avec des supercheries. Il y en a une par exemple, qui est sans lustre; le possesseur de la planche ayant couvert cette partie lors de l'impression avec un papier blanc. Dans une autre épreuve on a substitué une partie du rocher de la résurrection du Lazare du Nro. 72, à la place de l'arcade qui est a gauche."

Rovinski remarks in his catalogue 1890: "Il existe des épreuves falsifiées de cette estampe; 1, le lustre est remplacé par un paysage du petit Lazare, Bartsch Nr. 72; chez Verstolk Nr. 186 (Brit. Mus., Amsterd.); et 2 avec le dedans de l'arcade tout à fait clair; le lustre est caché; travaillée à la manière noire; Verstolk Nr. 187, Vente Webster 33 fr."

These facts were accepted in toto in the Seidlitz–Singer catalogue, without any reappraisal of the originals.

Even the most fleeting glance could hardly extract, from my discussion of B. 69, the idea that I was attempting to describe a state newly discovered by myself. Anybody who has a print of B. 69 in its usual form and compares it with the print I reproduced could scarcely remain unaware of the difference in appearance of the two prints. This can be clearly seen in the bound volume from the Albertina where normal prints of B. 69 were followed by the questionable and "reworked" prints. What I was really concerned with showing was that these sheets with the empty archway were *old* prints, *made by Rembrandt himself*, a fact that was self-evident. Bartsch, who probably based his notes on these sheets had not yet included Basan's print which Rovinski established as III. For him, II was the last, and he felt fully justified in considering the possibility of forgery in the case of the two questionable sheets, thus overlooking the fact—which is not very surprising from the tone of the sheets—that the real forgery of B. 69 with the landscape and the supposed forgery with the empty archway were not made in the same state of the plate. The Albertina print of the forgery with the landscape was produced *at the same time*, or *after* Basan's print by which time the plate was worn and had been partially reworked with the needle.[4] It is possible that Basan made the experiment himself. However, the prints with the empty archway were taken from the *perfectly intact* plate of state II, except for the difference I have described which was achieved with a temporary *application of shellac*. These were certainly good, old prints from Rembrandt's time, a fact that is borne out by the old paper with the crown water-mark, a mark that appears as early as the sixteenth century, whereas the forgery with the landscape has been printed on bluish, late eighteenth-century paper, artificially coloured in a sepia bath. The idea that Rembrandt himself made the former can be deduced from the character of the changes themselves, which have an *artistic aim*, whereas the forgery with the landscape is meaningless. There is also a print in the Albertina which shows that Rembrandt set to work to achieve this effect in a logical manner. In this print, the chandelier still remains, but as in the sheets without it, wash has been added to produce masses of chiaroscuro, and

the left hand lower corner has been deepened to a velvet-black surface like mezzotint by particularly grainy printing and ink left on the plate. Here, there can scarcely be any question of later reworking.

Rovinski obviously did not know the forgery in the Albertina [Inv. 1930/384] and the Albertina prints without the chandelier [Inv. 1926/271, 270], so presumably they were either elsewhere in the Collection or temporarily absent, although the inventories show them to be items of long standing. As far as the forgery with the landscape is concerned, Rovinski knew only the prints in London and Amsterdam, and, as for the print without the chandelier, one print on the market; otherwise, since his method was to mention all examples he had really seen, he certainly would have included the Albertina sheets. Thus, even today, we cannot determine whether Verstolk No. 187 was an old print with monotype variations or a forgery from the Basan plate in imitation of the old copies without the chandelier; indeed, this is as conceivable, and even as likely, as that it was one of the forgeries with the landscape. Rovinski's work was extremely exact in every way, and we can trust him to have recognized the marks of Basan's plate, especially since he himself had noted them, even on a sheet that had been given a tonal wash.

On B. 264: to avoid misunderstandings, let me emphasize at once that my differentiation between states in the case of this sheet is based upon Rovinski, *not* Seidlitz–Singer. Seidlitz–Singer says "Rovinski's division of III has not been confirmed", but a mere glance at the Albertina print [Inv. 1926/417] indicates the opposite. In consequence, I have used Rovinski's establishment of states in my revised arrangement of the Albertina sheets. Indeed, my argument was intended to show that the sheet Rovinski published as VII was only a badly printed impression of V, because it does not exhibit the real distinguishing mark of V and VI, which Rovinski could not observe on his print: the clear articulation of the shafts and capitals on the piers of the balusters. Rovinski's only criteria for state VII are strong wear of the plate (an impression smudged prints of even perfect plates can often give) and strengthening of the "tailles and contretailles" covering the "place claire (grattée)" at the right edge. These latter actually appear as early as the fifth state, but have remained clear only in the impression Rov. 686 in the British Museum where the plate was only lightly inked. My critic also says he has discovered a reworking (on the basis of what original?), "misinterpreted" by me, of the whole plate in the seventh state, which would mean a new state *after* Rovinski VI; or was his remark inspired by Hind's definition of Rovinski VII ("generally reworked with fine shading") or perhaps it refers to Seidlitz–Singer VII (*Die Englischen Neudrucke des XIX Jahrhunderts*)?

On B. 277: There are two impressions of this in the Berlin Print Room. The first is a print on vellum (fig. 79) completely consonant with the currently accepted form of state I, as can be ascertained from reproductions in Rovinski (fig. 738 after

the Paris print) and Graul (*Meister der Graphik,* vol. VIII, fig. 228, from the print in Dresden). I find it regrettable that Kauffmann cannot confirm my observations, that is, the evidence I adduced as a criterion for state I: the line running horizontally between the four pegs of the easel parallel to the edge of the picture, which can also be seen in the reproduction. The second sheet has been described by Seidlitz as follows: "An impression of the worn out state I worked over by Rembrandt in red chalk, ink and Indian ink (formerly in the collections of A. von Beckerath and Edw. Cheney) and dated in another hand in ink: 1651" (fig. 78). Jakob Rosenberg,[5] to whom I owe closer information and the photographic material, informs me that the second of these two prints is a skilful copy of the new state II, which I am illustrating here to facilitate comparison ([Albertina Inv. 1926/451]; fig. 80). This old copy proves that the second state was known, and sought after, even during the master's lifetime. In my essay I gave the opinion that the "scratches" which seem to follow the contour of the hat point to preliminary attempts to erase the easel . . .

 Criticisms on these questions is fruitful only when it is based upon practical experience of the material in hand and the sort of knowledge collectors, or people working with a collection gather over the years. It cannot be delivered *ex cathedra* . . .

"Zur Frage der Plattenzustände bei Lucas van Leyden und Rembrandt," *Die Graphischen Künste* L (1927), Mitteilungen pp. 19–22. [Abbreviated]

A Copy of Rembrandt's 'Petite Tombe'

Now that I have encountered a second copy of this sheet on the art market, I should like to take the opportunity of publishing it. The original has no different states, merely differences in impressions,[1] some being saturated and grainy, and others, made after the grain was worn, registering as a more or less uniform grey. The copy is so similar to these latter impressions that it could easily deceive a hasty glance or an eye not fully accustomed to Rembrandt, particularly if there were no originals or faithful facsimiles available for comparison. The copy has been printed on old paper which further complicates matters. At the same time, it was not made as a photo-mechanical reproduction, but is an exact line for line etching copying every detail and thus gives much more the impression of a late, grey print from the original plate. In fact, the copy was probably produced from a tracing, and the resulting unavoidable, slight inaccuracies have so changed and coarsened the expressions of the faces that the sheet must seem suspicious, even before we start comparing details. The changes are most obvious in the face of Christ, and in the head of the man who is propping his left arm and leg on the "tomb"; Christ's face has lost all inspiration and He stares in front of Himself with a vacant air, while the listener's chin has grown too long, altering the proportions of the skull, and changing his whole character. A comparison of details reveals even more discrepancies, most noticeably in the hatched, shaded parts, where less attention was paid; for example, the left edge of the protruding part of the wall, where the man with a turban is leaning. As a later addition to the original, Rembrandt made the man prop his left arm against the low wall, a correction which can only be seen as such in the late impressions, since in the early prints it is still completely covered by the preliminary graining. The copyist has observed this addition, and included it in his version in striking clarity. I am convinced that the copy[2] was made with the intent of deceiving (fig. 81).

"Eine Kopie nach Rembrandts 'Petite Tombe'," *Die Graphischen Künste* LII (1929), Mitteilungen p. 49.

Rembrandt's Last Drawing of Himself

U NTIL now, the last known drawing in which Rembrandt recorded his own features was the sheet HdG 994, Benesch 1171, executed about 1655, and showing the artist full-length, in studio attire. In 1927, however, I discovered a small pen sketch[1] (Benesch 1177; fig. 82) on the art market in Vienna, a study for the head of the *Self-Portrait* in the Louvre (Bode 434, Bredius 53; frontispiece), which was subsequently acquired by the Albertina. This drawing measures 84 × 71 mm. and, in the eighteenth century, was mounted on a sheet of paper bearing the inscription "Portrait de Rembrandt par lui mesme". There is no discernible water-mark.

The powerful penwork is original, but the light bistre and grey sepia washes were applied in the eighteenth century with reference to the painting. Today the portrait head seems to emerge from a grey mist, and the brightest light falls on the cap, the only area where the light ground paper appears unaltered. This reworking makes the sheet reminiscent of drawings by the school which grew up under the influence of Rembrandt's early style and makes it look, at a fleeting glance, rather strange. This effect is heightened by the fact that the retoucher soaked the paper in so much sepia that, in some places, it has disintegrated and coagulated into lumps, particularly between the head and the penline marking the edge of the easel. However, if we ignore the retouching and mentally detach the purely structural part of the drawing (which has fortunately remained completely intact) from the differently-coloured shading,[2] a powerful original work by Rembrandt emerges, executed in the pen technique characteristic of the turn of the 'fifties and 'sixties.

The particular importance of this sheet is due to its chronological position between the bold oil sketch in Aix (Bode 432, Bredius 58; fig. 83) and the finished painting, because it establishes a genetic link between them. For instance, it resembles the sketch in Aix in having the collar turned up to frame the mighty cranium; the expression in the eyes, which bore into those of the spectator, and the bold sweep of the right eyebrow, are also similar. Indeed, the expression has something demoniacal and spell-binding about it. In the oil sketch, the deeply shadowed eye sockets seem to gape like pit shafts whereas, in the drawing, there are just a few dabs applied with a single stroke of the pen. The eyes look as if they could engulf us, draw us down into the depths, almost as if the paper had holes in it, whereas, in the finished painting, the expression is quite different and the eyes have an air of calm resignation, almost of transfiguration, as they gaze past the spectator into the far distance.

In the drawing, the face is modelled only by the shadows made by the light which falls steeply from some source considerably above the head, as in the study in Aix. On the other hand, the mouth area is more like the painting in the Louvre, where the shaft of light falls more diagonally, from the side. The hair is also dressed in the same manner, and the headgear is the same as in the painting. That Rembrandt already had the final composition in mind is indicated in the drawing by a broad pen-line at the right hand edge—the easel.

The drawing has been executed with a broad reed-pen in blackish-brown bistre and the lines and dots from which the mighty architecture of the head has been constructed are positioned with supreme confidence. Everything is set out in the simplest, and most lapidary way, and yet this small sheet yields a profusion, a wealth of forms. Rembrandt's brittle pen does not draw complete lines but, because the paper is rough, occasionally jumps a little, breaking the lines. This is what gives the drawing the colourful radiance and fluorescence characteristic of his late style.

At this point, we must ask whether the sheet can be related to other known sheets from the period around 1660, without discrepancies, and whether its authenticity can also be confirmed from the historical and developmental point of view.

There exist quite a number of drawings by Rembrandt from about 1658/60, where we encounter structures of broad and double lines, done with a brittle pen: for example, *The Raising of the Cross* (Benesch 1036, published by J. Rosenberg), the *Woman with a pissing Child* in Dresden (HdG 270, Benesch 1140), the studies of cripples in Berlin (HdG 156, Benesch 1141) and, above all, the *Entombment* after an Italian composition (HdG 1321, Benesch 1208, Haarlem). (Rembrandt had handled the same composition once before [about six years earlier] in a sheet in the Berlin Print Room; HdG 76, Benesch 1209). I should also like to add another related example, the study (Benesch 1032) for the etching B. 50, Hind 279 in Dr. Beets' collection in Amsterdam (Vasari Society VIII 26), where the *vibrato* of the penlines, although they construct forms of adamantine solidity, is particularly striking. This drawing is of a crystalline translucency.[3]

All these sheets belong, artistically, to the 'fifties complex. As far as technical structure is concerned, the self-portrait we are discussing is connected with this group, but spiritually, it foreshadows the 'sixties, during the early years of which we find the completed painting. The studies most closely related to it, in the spiritual sense, are those for *The Syndics* (HdG 101, Benesch 1178 in Berlin and HdG 1180, Benesch 1179 in Amsterdam) and particularly the sheet in H. E. Ten Cate's collection in Almelo (Benesch 1180, J. H. J. Mellaert, *Dutch Drawings of the Seventeenth Century*, plate 7)[4]. But, as far as the sheer mastery is concerned, and the way Rembrandt has used the minimum of suggestive lines and dots to conjure up a head of visionary spirituality, I can think of no better subject for comparison than

The Presentation in the Temple (HdG 1241, Benesch 1057; fig. 154) he drew in Dr. Jacobus Heyblock's album in 1661. The heads surge up, solemn and majestic, for all the small size of the sheet, out of a flickering play of dark and light flecks of bistre and apparently unconnected lines, with a compelling, spellbinding expression in their eyes. Simeon is deep in self-contemplation, his eyes seem dimmed, yet the radiance of intense inner activity shines forth from the dark sockets. In fact, this fore-shadows works from the years 1662/63, the *Lady Hawking* (HdG 260, Benesch 1183, Dresden; fig. 10)[5] and *Homer* in Stockholm (Benesch 1066, J. Kruse, v, 4), a sheet which makes a forceful impact despite the irritating later reworking.

"Rembrandts spätestes gezeichnetes Selbstbildnis," *Die Graphischen Künste* LV, Vienna 1932, Mitteilungen pp. 30–31.

Unknown and Wrongly Attributed Drawings
by Rembrandt

For a knowledge of the drawn œuvres of great masters not yet finally classified from the critical point of view, every unknown work can be just as important as the reinstatement of sheets that have been known, but not yet recognized. Sheets in this latter category have sometimes been published under other names, or as copies, and often they can be shown to have a rightful position in a specific group of works by the master when new material comes to light. Then they no longer appear to be alien entities, resisting all attempts at classification. Some such instances in the case of drawings by Rembrandt may be discussed here.

In the Kunsthalle in Hamburg there is an exquisite portrait drawing of a Dutch lady, full-length, seated in a big armchair, leaning back in an idle, relaxed attitude and turning an expectant gaze towards the spectator (Inv. 21.732, Benesch 428, *Saskia*; fig. 84). The white of her cuffs and her deep collar stands out against the sombre hue of the flowing, formal gown in which she is enveloped. The figure has been set down on the paper in pithy, broad strokes with hard black chalk and there is a masterly contrast between the sombre heaviness of the material, and the gleaming, translucent weightlessness of hands and head. In the near background a table, with the cloth slipping off it, provides a lighter shadow. To both right and left, a faint duskiness, rising to shoulder level, seems to cradle the figure in the atmospheric depths of space; the thinner and sharper shading on the left, indicating a wall, is a later addition. The same is true of the rounded corners, which have been added, and the chalk line of the margin. The sheet has, at some time, been under pressure when wet, and there are some cracks on it, vertical ones on the dress, and horizontal cracks by the underarms, but, otherwise, it is in excellent condition.

Although this sheet has been catalogued under the name of Bol, I am convinced that it is a work by Rembrandt, originating in 1633.[1] The idea of a figure filling a folding chair appeared for the first time in his group of studies of old men, drawn in red chalk, during the years 1630/31.[2] The sheet which yields the most interesting comparisons with the Hamburg portrait is a late-comer to the group, a drawing dated 1633 and fully signed, the *Study for Lot Drunk* in the Städelsches Kunstinstitut, Frankfort (HdG 324, Benesch 82). Both these sheets have the same richness, the same polyphony and the same contrast between the intense, completely solid darkness of the clothing, and the head and hands, which seem to float in the air in sheer weightlessness. In both cases, too, the garments are composed of a maze of lines, organically intermeshed, intersecting and heaping up in brittle,

splintering layers.[3] But above all, we should compare the treatment of the two hands hanging limply down. How superbly the artist has conveyed the frail boniness of the old man, whereas the young woman's hand, however relaxed, is still firm, round and supple! Who else but Rembrandt would have been capable of such mastery? Certainly not Bol, whose drawings are unmistakably less detailed and more superficial. We can "support" the Hamburg sheet with various other drawings too, particularly the study of an old woman dozing (HdG 243, Benesch 196), now in the Dresden Print Room, which obviously dates from the same year. This sheet has been drawn more hastily, and with less care, than the two described above; the lines of hatching seem to pour down the page in a rapid stream, but at the point where they begin to grow angular, and more dense, as, for instance, towards the underarms, we can immediately recognize the same structure of a dress heaped up round a figure. There is also a pen drawing in the Albertina showing the same principles of form, HdG 1448, Benesch 195—possibly after the same model as HdG 243, Benesch 196. The only example of a Rembrandt portrait drawing which has survived and which is finished to the same degree as a painting is a sheet executed in the following year, *Portrait of a Man in an Armchair* (HdG 1063, Benesch 433). This also shows clothing made of material with the same rigid, stone-like quality. Finally this group also includes a red chalk sketch after Saskia (HdG 623, Benesch 429), drawn in the same year, and related, in its undulating line, to the study for the *Raising of the Cross* in the Albertina (HdG 1423, Benesch 83). Saskia's pose is like a mirror-image of the sheet in Hamburg; it almost seems as if the same rounded face were looking at us, framed by the same delicate tufts of veiling. In spite of her formal garb, the model in the Hamburg portrait is still very young and could very well be Saskia. When Rembrandt painted older women in similar poses, as, for instance, the wife of Johannes Elison (Bode 110, Bredius 347 [now Boston, Museum of Fine Arts]), the result was always more ceremonious and dignified, and also a little stiffer.[4]

During the years 1634 and 1635 Rembrandt came to grips with the reality he was becoming aware of and experiencing afresh. The result was one of his richest productions of drawings: in addition to the copious studies of everyday life he did at this period, we also find a scattering of sketches for historical and mythological compositions, reflections of the heightened, ecstatic world of his baroque paintings and etchings of religious and antique themes. By 1636 these sketches were coming even thicker and faster and by 1637 this enormous production betrayed the pathos of a new struggle to render the supernatural. Rembrandt's studies from nature were now pulsating with the same excitement as his large-scale compositions, and, indeed, were being done with the latter in view, and less often for their own sake. The year 1636 marks a real turning point in Rembrandt's approach to style and composition. This is the year when Rembrandt's approach to form reached the

peak of Caravaggesque baroque heaviness and fullness, the year of *Samson* (Bredius 499, 501), the time when Rembrandt returned to his style of a decade earlier, but now with a very different purpose in mind.

The story of Samson, the Nazarite hero, supplied Rembrandt with an excellent subject for his urgent and vigorous world of forms. Samson shakes his fist at locked doors, yet falls a victim in his tragic conflict with a deceitful world; but he manages to engulf his enemies in the process. He is a kind of personification of Rembrandt's own dynamic strength, for Rembrandt, too, even at the height of his worldly success, gained no sense of fulfilment from the sweets of conquest. Unlike the more fortunate Fleming, Rubens, he never freed himself from the feeling that he must ram his head against the wall. It almost seems as if his sympathy with the tragic figure of Samson were due to a premonition of the years to come.

There is a small pen sketch in the Museum in Dijon which should be dated to the same year as *Samson* (HdG 577, Benesch 127; fig. 85),[5] showing the first stages of Samson's tragic fall, as Rembrandt had already rendered it once before in the painting of 1628 in Berlin (Bredius 489). The unsuspecting hero has dozed off in his mistress' arms, and she is cutting off his abundant locks of hair. The only difference is that the Berlin painting shows her turning away towards the hero's captors as they creep up, anxious and frightened, while in the Dijon drawing, she is already engaged in her treacherous task. The latter group has been tossed off swiftly and fleetingly, almost like a pen test, but its suggestive power is incomparable. Samson has sunk back, exhausted, in his mistress' lap; his right arm is supported on her knee, and projects beyond it with the hand hanging down limply. His massive limbs are relaxed—the hurrying pen maps out their angular contours. Delilah, on the other hand, is shown totally concentrated on what she is doing, and this is expressed in her whole figure. Her face consists of only a few straight lines, but the destructive cunning in her expression could scarcely be intensified. Even her left hand, wielding the scissors, itself becomes a pair of scissors, a double-bladed weapon, snipping its way towards her lover's head. The pen works as hastily as the treacherous woman's hand, and concludes its narrative work with a few zigzags to indicate space and make the shadows which complete the atmospheric integration of the group.

This drawing is not only firmly anchored in Rembrandt's œuvre by its subject-matter, but earns its position equally well by its form. Two pen drawings, both to be dated about 1636, are most closely related to it: *Jacob's Dream* (HdG 25, Benesch 125), in the Berlin Print Room, and *Lot and his Daughters* (HdG 528, Benesch 128) from Goethe's collection in Weimar. In the former, the face of Jacob, sunk back in sleep, has grown sharp and haggard, and its bone structure juts out like that of Samson; in the latter, the comparison should be made between the cunning and persuasiveness on the faces of Lot's daughters, drawn with a few

penstrokes and the face of Delilah. The zigzag lines also have the same function, providing spatial shading, and, at the same time, giving the whole scene an air of feverish expectancy.

The year 1637 also stands out as a climax in Rembrandt's development as a draughtsman, and in his struggle to achieve values of dramatic expression. Satiated by his close scrutiny of reality, he now tossed off one bold study after another: mostly Biblical or imaginative creations surpassing, if possible, those of the two previous years by their tense energy and audacity. However, these drawings are not as rich in naturalistic detail and observation as the narrative historical sketches of 1635, since their expressive power is apparently derived from the richness of the line. It would be no implication that his creative powers were failing to say that Rembrandt was now reviving his memories of Callot—the greatest French draughtsman of the time and a man who had an enormous influence on the young artist—though in a completely personal sense of form. On the contrary, this is perhaps the first time that Rembrandt was able to progress beyond the "true to life" naturalism to which he was so dedicated in 1634 and 1635. For instance, a hand now becomes a claw. A contour which would have been simply rounded off before, is now splintered into fragments. A straightforward network of lines becomes a maze. This does not mean that Rembrandt's drawing was "further from nature" than before; on the contrary. From one point of view, it was actually closer to nature, because the inner, vital rhythm was warmer and more controlled, and, in the process of its becoming so, much of the more irrelevant detail that used to be present could, and indeed had to be eliminated. One of the most striking examples of this is the verso of HdG 939 (Benesch 423 verso), the preparatory drawing for the etching *The Artist drawing from a Model* (B. 192, Hind 231): *Joseph expounding the Prisoners' Dreams* (fig. 86).[6] The whole effect of this scene cannot be attributed merely to its boldness, its unexpectedness or its fantastic excitement—the silhouette of the butler with his tuft of plumes upright on his head fairly leaps out of the page—but to what is far more important, those elements which make the story as impressive and memorable as possible. Joseph's arm accompanies his words. The artist has sketched it twice. The second time, the arm is raised like a great paw threatening the chief baker who reaches out into space with his arms, horror-struck as he learns of his coming death sentence.

There is another good example of this style of draughtsmanship [formerly] in the collection of Dr. A. Feldmann, Brno, a pen and bistre drawing showing *The Liberation of St. Peter* (142 × 126 mm, Benesch 170; fig. 87).[7] The apostle is leaning against the heavy block of stone to which he has been chained, and we can see the solid, round links of the chain. Behind him, there is another chain anchored to the wall, but hanging free, and the guard is resting his right leg on it—we can see where it cuts into the leg of his wide trousers—with his foot on the block of stone. He has

propped his arm on the end of a stick or club, and has dozed off. A few lines indicate the spatial extent of the dungeon, fading away into the gloom, and some lances seem to be leaning against the wall on the left. Soundlessly, and without warning, an angel has materialized in these calm surroundings. Unlike Italian paintings it is not possible to see here precisely how and where he entered. He is simply there, all of a sudden, huge and close, almost frightening; and the apostle, awakening from a troubled sleep, sees him. The old man's waking, and the way he raises his head, expresses the whole "spiritual situation" in the most concise way. It is a moment of change; an awakening from an uneasy, despairing twilight to a glimmer of hope. St. Peter is allowing his left arm to be raised gently, while his right lifts of its own accord. We can almost hear the silence and the dream-like furtiveness of this act of liberation. Everything is so still that we can understand why the guard was not roused, whereas in all the other contemporary baroque presentations of the scene there is so much commotion going on, that we can only assume that the guards were dead drunk.

The London and Brno sheets appear to form part of a very closely knit group which includes the two drawings in Stockholm, *Christ calling Matthew as Apostle* (HdG 1565, Benesch 144) and the wildly dramatic scene on the reverse of HdG 1608 (Benesch 351 verso); the subject of the latter has not yet been deciphered, but it is possibly The Massacre of the Innocents. Movement, and the radiating explosiveness of mental and physical forces that flare up in space are everything in these brilliant improvisations.

On the obverse of HdG 1608 (Benesch 351 recto), there are five figure studies which belong more to the world of fantasy than to that of real life. The sheet belongs to a larger group of works closely related in style, and done at much the same time and of which I should like to mention the studies for the *Sermon of John the Baptist* (HdG 158, Benesch 141). Benesch 141, in its turn, is related to HdG 85, Benesch 140, a study, as Hans Kauffmann established, for the same painting, and to HdG 833, Benesch 142, as well as to the "Callot Riders" (HdG 710, Benesch 360 verso), the *Studies of Men on Horseback* (HdG 1355, Benesch 151), and a group of exotic Oriental riders which I saw in Mr. Julius Boehler's gallery in Munich in 1926 (Benesch 364). One of the characteristics of these sheets is scattered, straggling looseness of form, a feature we also find in the study sheet for the *Mater Dolorosa* from the Hofstede de Groot Collection (Cat. Boerner 178, Benesch 152) which even bears an inscription by Rembrandt himself. This "study from life", a free creation of Rembrandt's imagination, represents the final stage in the composition. The same applies to a sheet in the Pierpont Morgan Library (F. Murray I, 211, "Ascribed to P. Koninck", Benesch 145; fig. 89), which is extremely similar to the above group of sheets, and, like the *Mater Dolorosa* sheet, also reveals traces of Rembrandt's own handwriting.[8] This last drawing is

somewhat difficult to interpret, as there seems to be no apparent connection between the two figures on the right beneath the inscription and the composition as a whole, although the two figures on the left, the bowman, humbly and hesitatingly approaching the Oriental prince, form a definite unit. The reference is possibly to some narrative we have not yet recognized, but the mystery may be solved when the inscription has been deciphered, or by a chance finding of an appropriate text in the Bible.

Without forfeiting any vigour or strength, the sheets Rembrandt was executing about the end of the decade are obviously clarified and show a definite consolidation. Rembrandt's line remained as sweeping, baroque and descriptive as before but he achieved greater articulation of the objects he set down, their attitudes were more confidently grasped and rendered with greater simplicity. He no longer felt it necessary to slash the contours, because the curves now gliding along their well-defined tracks gather up and concentrate the forces that used to wander away into space and evaporate. Even the structure of individual figures becomes simpler, more translucent, with outlines sometimes as clear as those of a sculpture. This new trend is clearly exemplified in a small group of closely related drawings, the first of which is *Manoah's Offering* in Berlin (HdG 31, Benesch 180),[9] a drawing created with the simplest means. How transparent is this web of lines! Every confident line concentrates the form spread round it like a sinew. The composition looks as if it had been "X-rayed"—an artistic principle Rembrandt was never again to abandon, and which, after being more or less dominant for a while, came to its full glory in his maturity. Another equally valuable illustration of this quality is to be seen in the sheet HdG 137, Benesch 178 (Berlin) which has not yet been deciphered, but which shows a wounded warrior, falling back into the arms of his comrades. The outlines of this figure are extremely firm and clear, with an emphasis on their geometric structure, and when we compare it with Rembrandt's first approach, in the *Samson* in Dijon, it is obvious how far he has progressed.

The third sheet belonging to this group is a scene from the story of Joseph [formerly] in Dr. A. Feldmann's collection in Brno (Benesch 181; fig. 88).[10] It shows Joseph being hauled out of a semi-circular well, surrounded by a parapet open to the spectator. Jacob's other sons are crowding round; one of them, on this side of the well, a powerful, sinewy fellow, seen from the rear, and another on the other side, kneeling on the parapet, are pulling the youth out of the depths with ropes. The others, with shepherd's crooks, are looking on, leaning on the parapet, or chatting with the foreign merchants. Thick bushes surround the spot, and branch-tips hang down over the well. The whole event is narrated clearly and vividly, and the sheet is alive with the warm breath of a real story set in a Biblical landscape. In spite of the enormous variety of figures and activities, there is no confusion, and we can follow each thread perfectly clearly. The most interesting feature of this sheet

is the man on the left, leaning on the parapet. Although this figure must have been drawn about 1639, it is sculpturally lucid and solid, and directly foreshadows Rembrandt's "classicism" of the 'fifties. The shepherd stands there, massive and dignified, almost as if he had stepped down from a classical relief.

Finally, at the close of this group and almost into the beginning of the new decade we find the first compositional sketch for the "Hundred Guilder Print" (HdG 56, Benesch 188). It must have been done about 1640, and shows Rembrandt's first crowd scene fully articulated even into the furthest corners of the composition.

One of Rembrandt's best black chalk drawings is in the de Grez collection [Musée des Beaux-Arts, Brussels] listed as "Gerbrand van den Eeckhout" (Kat. 1200, Ploos van Amstel Collection, Benesch 737; fig. 93). This collection is exhaustingly extensive, and a fund of unsung masterpieces, as I discovered while spending many hours looking through it with J. Q. van Regteren Altena. It was during this fascinating occupation, that he first drew my attention to the above-mentioned chalk drawing, suggesting that it might be Rembrandt's work. I fell in with this view all the more quickly because, at first glance, I thought I recognized the sheet as a study from life for the superb *Preciosa* (B. 120, Hind 184; fig. 92).[11] J. Six had already produced historical evidence for linking the etching with a stage version of Cervantes' story of the same title, published in Amsterdam in 1643 and stylistic evidence confirms the historical evidence. Black chalk was one of Rembrandt's favourite drawing materials in the 'forties, mainly because the soft, colourful and shimmering light effects it produces were particularly suited to his pictorial aims at the time. *Preciosa* is also easy to place among the chalk sheets of the first half of the century, if we look through a series of them. The first of these are sheets like the *Portrait of a Lady in a Turban* (HdG 709, Benesch 761, Bonnat Collection [now Musée, Bayonne]) and *Two Jews in Discussion* (HdG 1326, Benesch 665, Haarlem, Teyler Museum) dated to about 1641/42. *Preciosa*, however, is particularly distinguished by its rich light effects; the old woman's left contour melts away completely into the shimmering atmosphere, and the layers of diagonal hatchings, drawn from left to right, position the pair in the chromatic plane, and make them look as if they had been woven into a glistening veil. The vibrancy of the black chalk places the Brussels sheet close to Benesch 761, because of its illusion of colour. The gipsy girl stands out against the light colour of the old woman, who gazes amicably into the sun-soaked haze, almost as if she were being transfigured by the light. The soft curving lines, crossed by subtle hatchings, of Benesch 665, dissolve into the atmosphere in the same way.

Another excellent subject for comparison with *Preciosa* is a study from life, in Dresden, for the *Portrait of an old Woman* in the Hermitage (Bredius 361), painted in 1643. This drawing (HdG 306, Benesch 684 [now London, Count Antoine Seilern, cat. III, 191]) must have been executed at about 1643, like *Preciosa*,

and it has much of the same strength, illusion of colour, and all-pervading spiritual refinement. The only difference between them is the scale. The small, black chalk drawing (HdG 247, Benesch 692) of an old man in Dresden belongs in the same context. The shimmering figure of a girl of 1645 (HdG 308, Benesch 700) from the Friedrich August Collection [now London, Count Antoine Seilern, cat. III, 192] —the study from life for Bredius 368—marks the beginning of a new phase of black chalk drawings. The best example of this new group is the *Susanna* in Berlin (HdG 46, Benesch 590), the study from life for Bredius 516.

How does the drawing of *Preciosa* compare with the final etching? The former is, of course, a mirror-image of the latter, with the old woman walking on Preciosa's right in a more remote plane and slightly in advance of her. In the etching, on the other hand, the pair have been slightly rotated in space, and Preciosa, who is now in advance, and carefully clearing the way for the old woman, is turning back towards her in such a way that she faces the spectator. In the drawing, Preciosa, dark-skinned and foreign-looking, is helping her stepmother along with care and modest respect, but in the etching the old woman has dispensed with the supporting arm slipped under her own. Preciosa is wearing almost the same costume in both versions, and the same two-stringed necklace, but in the etching, she has lost her exotic swarthiness and becomes simply a dark-eyed Southerner. At the same time, the two figures' more vigorous movements are accompanied by an increase in the scenery as a whole. They are no longer merely making their way through a light-haze; they are now enclosed in a piece of landscape, warm with the shadow of ancient trees.

Can we call the drawing in Brussels a pure study from life? It is perfectly possible that it originated in an impression from nature, but it was certainly put together as a piece of narrative. These two women are not just figures noted down at random, but characters in a story; a story whose warm, poetic feeling comes to complete fulfilment in the final etching.

It is remarkable how many copies after Indian miniatures Rembrandt made around the middle of the 'fifties (Benesch 1187–1206; see fig. 240).[12] It used to be thought that these copies were connected with his bankruptcy in 1656, and that he had made copies of the miniatures in his possession so that he would be able to remember them after his property had been sequestered and he had been forced to part with them. It is also remarkable, not only that he made these free adaptations at all, but that the style of the miniatures themselves had, as Sarre observed,[13] a lasting effect on some of Rembrandt's own graphic work and painting. Undoubt-edly there must be an underlying artistic reason for this phenomenon, and indeed, we do not have to search further than Rembrandt's production of drawings between 1653 and 1655. During this period his formula for the human form became increasingly simple and lapidary, and eventually confined itself to the basic,

essential elements of structure. The figures had become geometric, although not for reasons of formal qualities, as in Italian Mannerism, but because Rembrandt's attempts to portray the workings of the human spirit had come upon this system of rendition. Thus, any details which would distract attention from the spiritual process were discarded. All that remained was the human figure in its simplest form, though no less expressive than the play of emotion shown in the faces. Indeed, the contour of the human figure as a whole became almost more important as an organ of expression than the face. The silhouette took on a particular importance, and the result was inevitably the "optical flatness" which probably provided Rembrandt with the source of his new, suggestive representation of corporeality. This would explain Rembrandt's interest in the Indian miniature with its flatness and emphasis on contour, and it becomes evident that their appeal is no less easy to fit in with the development of his personality than the strong bonds with Titian and the Venetian classical artists that emerged in his maturity. One of the best examples of this group of copies is *Emperor Akbar* (229 × 179 mm, Benesch 1192 [Indian Prince, probably Emperor Jahangir]; fig. 91), acquired some years ago by the Albertina from Frits Lugt. The rich shimmer of the light effects in this drawing provides excellent proof of Rembrandt's masterly ability to convey the sense of colour through monochrome media. For the ground, he chose the matt, silken gleam of warm, light-brown Japanese paper, and with a fine, pointed pen, sketched in the stern figure in profile with folded arms, supported on the pommel of a sword. The young Emperor's head is surmounted by a turban already familiar to us from the drawing in London, HdG 930, Benesch 1190; it is exquisite, wound in low ornamental coils, and decorated with a heron's feather clasp. The final chromatic touches have been applied with airy brushwork. There are darker tones clinging to the puttees and sash, and light, clear half-tones hovering among the folds of the white linen kaftan, mark the aiguillettes and model the turban. They have also been used to indicate the delicate amber tones of the translucent skin. A suspicion of white body colour causes lights to flicker here and there, and there is a scarcely visible trace of reddish ochre on the crossband. Rembrandt has translated the motley splendour of the original into a scale of extremely finely graded nuances of tone, and has produced a masterpiece of imitation, a poetic reinterpretation.

Around the figure, he has painted in a wash of space-creating shadows with a broad brush, but not merely as a dark ground to set off the light silhouette, as in HdG 1122, Benesch 1199. The shadow does not start directly at the edge of the penline contours; instead, the light shines out over them while the darkness, in its turn, encroaches, in places, upon the light (as at the lower edge of the hem). Light and shadow thus seem to have grown together in an organic whole, the one generating the other. The light figure attracts the darkness with magnetic force, and holds it like an enveloping garment. The shadows gradually lighten in a radiant

vision of the Emperor's person, and there is a pale corona of light playing around his princely head, like St. Elmo's fire.

By about 1656, Rembrandt had completed the process of making his drawn human figures geometrical, and in his next group of sheets, he reduced his newly won stability and precision to a system of radiating lines of force and energy that come into violent collision, while always retaining their rhythmic swing. *The Dismissal of Hagar* in Berlin (HdG 20, Benesch A73) is an important example of this group, and so is an *Ecce Homo* (Rosenberg pointed out the connection in the Berlin Catalogue), formerly in the Artaria collection (Benesch A120), *Judah and Tamar* (HdG 789, Benesch A113, P. Mathey, [F. Koenigs]), the *Rest on the Flight into Egypt* (HdG 879, Benesch A94, London) and, finally, *Hagar in the Desert* (Benesch A74, Berlin; fig. 94). I do not share Rosenberg's doubts about this last. We see the same style, raised to monumentality, in *Christ washing the Disciples' Feet* (HdG 607, Benesch A110, Louvre) and the superb *Dismissal of Hagar* (Benesch 1008) in the Pierpont Morgan Library. In these drawings, outlines, drawn with sculptural monumentality, are filled with rhythmically swinging lines of force. Rembrandt has achieved a superb new "relief" style—the plane-like relief of rectangles of form sunk into space—and the best example of the result is the oblong etching *Ecce Homo* (B. 76, Hind 271). Rembrandt's form, in all its newly found weight and compactness, began inwardly to float and radiate, although the edges still hold firm. This can be seen, as it occurs in drawings, in another sheet the Albertina obtained from Frits Lugt, *Two Women on their way to Church* (Benesch 1167; fig. 90), executed about 1657. This sketch has been drawn with a broad reed-pen dipped into warm bistre (the grey line framing the sheet was added later by another hand). The sheet is certainly more than a simple study from life, probably a historical anecdote, in fact, although we do not yet have any means of identifying it. The women are wearing medieval costumes, the smaller of the two being decked out in Burgundian head-gear, the taller holding a Gothic bookbag in her left hand. Unlike the 'thirties, when Rembrandt chose models for his historical paintings from among his contemporaries, so obviously full of the enjoyment of life, the figures from previous centuries who appear in his works at this period seem like visions, as historically accurate in dress as if they had been summoned up from the past, completely unchanged. In addition to heroes from Indian manuscripts, we also find classical and medieval figures from Rembrandt's own national history. Leah, from *Jacob blessing his Grandchildren* (Bredius 525; fig. 120), looks as if she had just stepped down from an old Netherlandish tomb slab; she has the same scent of the past about her as a whole group of such figures, including the two women from the drawing in the Albertina. These two figures in their stately garments are constructed basically around a rectangular block-shape, like the crowd of onlookers in the *Ecce Homo* (Hind 271). The spread-out quadrilateral of the woman on the

right, who is in strict profile almost like an Egyptian relief, is a strict frontal view in the case of the woman on the left. In the foreshortening, the latter's feet have become like heavy lumps, but they still give the precisely correct effect of form and dimension, and really carry the heavy body. The woman has paused in her progress for a moment—and the way she has shifted her weight from the moving leg to the supporting leg has been described with scarcely a displacement of the line. Her figure has been outlined with an unwavering hand and is as angular as a sculpture stepping out of a block of stone. There is some variation in the strength of the strokes; sometimes the line is broad and dense, at others it forks to form parallels, and fades away in fine hairlines at right-angles to the artist's moving hand. The tonal planes may flow into one another, or the brittle, dry pen may only hint at forms, which seem to dissolve in the light, as shadowy as a reflection in water. They are agitated and fluctuating, not with the mobility of some fluid substance, but rather like a crystal which stays solid and immovable in spite of the changing play of light. At this period, Rembrandt was also intensely preoccupied with the kind of religious themes favoured by late medieval ecclesiastical art. It has been observed that *The Tribute Money* (Bredius 536), for instance, was obviously inspired by *The Marriage of the Virgin* from Dürer's *Life of the Virgin*, and *The Visitation* from the same series of woodcuts could well have inspired Rembrandt's own interpretation of the theme, a quick sketch for a composition, but conceived on a grand scale, in the Louvre (Benesch 1019; fig. 134).[14]

There is a large sheet in the collection of drawings in the Kunsthalle in Hamburg (no. 22833) bearing on one side a water-colour landscape by Roelant Roghman and on the other an extremely expressive study of a wood, drawn in blackish-brown bistre with a reed-pen, undoubtedly a work by Rembrandt from his late period (Benesch A89 [expresses some doubts]; fig. 95). A faint, pencilled "Rembrant fecit", probably dating from the beginning of the last century, shows that the true authorship was assumed at one time. The drawing shows a cart-track winding gently into the distance, through a wooded landscape following the line of the dells. In the foreground, the ruts made by the wheels curve round, close to us, and large. Immediately beyond them is the distant prospect and the artist has intensified the spatial tension by bringing the distance points close together on the surface of the paper. Half-way along, a mighty tree-trunk springs out of the ground like the column of water from an artesian well, forking at the top and branching off gently into slim twigs. The trunk has been given a shadowy wash with a broad brush, and has become a disembodied silhouette, standing out darkly against the clearing, but also throwing a shadow across the track. On the other side of the path there is a group of trees standing on the top of a mound, as light as a plant in a dream. The pen flings out branches and foliage, describing curves and loops, and becomes dry at the top, so that the line looks porous, light and airy. The edge of the wood, in the background, is composed

of the same species of tree, one of which, much further away, by the entrance
to the wood, and obviously drawn under the same impetus, stands out stronger and
darker than the tree in the front plane, thus making it even more dream-like in its
lightness. The trees are disembodied, like palms and plane-trees silhouetted against
the night sky by the flash of fireworks, or like underwater plants which unfold their
feathery fronds in a realm of silence. The movement continues on the right. For short
stretches, the brush suspends a dusky curtain of wash shadow, then the delicate,
porous panicles on the trunks bristle up again, arching to form a grotto stretching
into the distance, like the hall of an Alhambra, only to die away, like an echo out
of earshot. There are traces of an alien hand in the drawing. Someone other than
Rembrandt is responsible for the dry, sharp, trembling penlines running parallel
to the left-hand rut, the hints at clumps of grass where the track enters the woods,
and the weak tufts of foliage to the left of the tree in shadow. These additions may,
perhaps, be by Roghman, who did the water-colour landscape on the reverse of
the sheet.

There are very few landscape drawings from Rembrandt's later period, the last
numerous group having been executed about 1653/54. The best example of this
group is the *Large Tree by a Dike* (HdG 785, Benesch 1331), and in general they
show the highest degree of stability and a heightening of the natural impression
into the typical. After 1655, we find only a few isolated examples, and in these the
landscape becomes a dream image again, translated in a visionary way, even when
rendering an impression from nature, but without any recourse to the fantasies of
the 'thirties. These features appear in the *House beside a Road* (HdG 1517, Benesch
1366), formerly in the Dr. M. Strauss Collection in Vienna, now in the collection
of Frits Lugt. If we follow along the porous contour of the lighter branch-tip on
the right, we can see a flowing line abounding with the same feeling as the tree
shapes in the Hamburg drawing. This can also be observed in *Cottages beneath high
Trees* (HdG 171, Benesch 1367) in Berlin, dating from towards 1660, which has been
tossed off boldly with an unruly pen; it is a sheet flooded with sunlight, scoured by
the wind. On this side of the turn of Rembrandt's last decade, we find the *Road
leading through a Forest* (Benesch 1368) in the H. Oppenheimer collection (Vasari
Society VIII, 25; [now Print Room, Amsterdam]) and the *Farmhouse surrounded
by Trees* (HdG 759, Benesch under A89) in the Bonnat Collection, now Louvre, a
group of buildings that are dissolving into light and air like clouds. The landscape
is reduced to its original elemental forces, the movement of light and air, organic
activity and growth. The trees shoot out of the earth like the soil thrown up by a
falling shell, and the tree-tops are piled up like glorious, shining cumulus clouds.
At this point Rembrandt was standing at the last outpost of figurative landscape art.
One step more, and material form would have ceased to exist altogether. This, the
most powerful expression of organic growth and activity—only landscape kept this

quality in the art of the old Rembrandt, when his groups of figures had long become crystallized—connects the Hamburg sheet with the examples I have mentioned. It may be presumed to have been executed about 1657/58.

"Unbekanntes und Verkanntes von Rembrandt," *Wallraf-Richartz-Jahrbuch,* N.F. II/III, Frankfurt, 1933/34, pp. 295–309.

Portrait of a Woman from Rembrandt's Early Period in Amsterdam

THE early years of Rembrandt's period of activity in Amsterdam are characterized by a particularly large number of commissioned portraits. In fact, these commissions were probably the reason why the young artist from Leiden decided to settle in the city. He was probably visiting Amsterdam frequently for sittings during the second half of the year 1631, and by the time he had accepted the ambitious task of painting Professor Tulp's anatomy lesson, he was more or less an inhabitant.

It is easy to trace the influence of the grand manner of Amsterdam portrait painting in Rembrandt's works between 1632–33, although they still retain vestiges of the delicate mellowness and transparent glow of his Leiden style. But it was not until 1633 and 1634 that he approached most nearly the official Amsterdam style and, at the same time, reached the zenith of his success as a society portrait painter. In these works, the bourgeois citizens of Amsterdam appear full- or half-length, and occasionally these lively faces, in bust only, gaze at us out of an oval format—a shape derived from Mannerism. One of the masterpieces of this period is the head of Margaretha van Bilderbeecq (Bredius 339), dated 1633, in Frankfort; this is a superb specimen of the shrewd, worldly-wise Dutch patrician's wife. In 1634, however, an element of change began to be noticeable in Rembrandt's portraits due, primarily, to his preoccupation with historical themes which demanded large-scale figures and compositions that are monumentally crowded and condensed. It was also at this time that Rembrandt renewed his interest in Caravaggio, although he did so far more directly than before, no longer taking the roundabout route via the Utrecht school and Lastman, his master, who had been influenced by Elsheimer. The resulting increase in volume and compressed energy in the composition of the figures also made itself apparent in the construction of Rembrandt's single figures, the most frequent subject of portrait painting at the time.

The portrait of an old woman in the National Gallery (Bredius 343), dated 1634, is a good example of these changes. This wonderful head, full of individuality, split up by a multiplicity of eloquent, character-revealing folds and wrinkles, is built up with new vigour and majesty. The very way the figure is arranged within the frame underlines these new qualities. One could almost think that some trace of the language of form Rembrandt used in his earliest days in Leiden were coming to the surface, although, admittedly, under the new banner of a heightened, "baroque" feeling for life.

The head of a woman from a private collection in Vienna (fig. 96)[1], here published for the first time, is another example of the same trend. The face is comfortably rounded, and its fullness emphasized by the closeness of the edges of the frame. It is possible that the oak panel it is painted on was once oval, and thus larger (today it measures 445 × 360 mm), which would also explain the lack of a signature. The sitter, a pleasant-looking, grave woman, is turned slightly towards the right, and has turned her head outward, towards the spectator, her dark grey eyes fixing him full in the face. There is something of Margaretha van Bilderbeecq's enjoyment of life in her expression, but it is transformed, in this instance, by the monumental manner we find in Rembrandt's paintings between 1634 and 1635. The fact that he has been able to raise the round-cheeked plumpness of this burgher's wife to heights of grandeur is due to Rembrandt's own undeniable genius. Even when painting an "objective" portrait, he presents us with a race of men all his own and utterly alien to the faces which appear in other contemporary portraits.

The woman's head is superbly modelled in light and shadow, and set against a dark grey background. The flesh, faintly yellow with whitish lights playing on it, is threaded through with olive-green shadows. The cheeks are tinted by a light, rosy pink verging on carmine and violet. The rest of the figure is painted in the Amsterdam portrait style; the cap and ruff, delicately drawn and sculpturally moulded in a white which runs through a gamut of airy greys, are set off against a deep black dress.[2]

"Ein Frauenbildnis aus Rembrandts früher Amsterdamer Zeit," *Pantheon* XIII, Munich, 1934, pp. 92–94.

The Dutch Landscape in Rembrandt's Period

On the occasion of the exhibition in the Albertina, Vienna, 1936

O NE of the peculiar qualities of seventeenth-century Dutch landscape art
is its tendency to seem almost timeless because it is so strongly imbued with
values still positively relevant today.[1] This is not only due to the fact that it reflects
the unalterable face of Nature and is thus raised above the transitory changes of,
for instance, human costume, style and fashion. The life rhythms of the artists them-
selves are also responsible, and the way they speak to us in fresh, frank voices that
seem to belong to today or yesterday, not as if three hundred years had passed since
their homeland had been wrested from the Spaniard and the sea in bitter strife.
We can wander through the brightly coloured world of the polders with Hendrik
Avercamp, let our gaze range over the sweeping pasture-lands with Jan van de
Velde, visit, with Esaias van de Velde, the peaceful, gleaming village of Spaerwou
or, with Cornelis Hendriksz Vroom, the majestic alleys of trees by the meadows;
we may even follow the pensive Hercules Seghers into the apocalyptic barrenness
of his mountains, or into the vast, overwhelming spatial expanses of his lowland
paintings. In every case, a note reaches us which could just as well have rung
out from Van Gogh's drawings of Brabant and Arles, or from Munch's rocky
Northern solitudes. It is not only the power and grandeur of the whole spatial
architecture, nor the infinitely delicate equipoise—studied and worked out in
depth, despite all the simplicity and modesty of the scene from Nature—which
gives such an unbelievably "modern", contemporary effect. This is due also to the
artistic "handwriting", the bold, linear stenographs and clusters of dots pinning
the forms and vibrant colour-surfaces to the paper. The seventeenth-century
Dutch artists also anticipated our way of feeling in their attitude towards the works
of man and his architecture. In one of W. Buytewech's small etchings, for example,
the sense of line reminds us of the treasures of the Far East: when he sets a haunted
castle, or the ruins of an abbey, into a deserted landscape, he imbues them with a
sense of the past, a familiar and homely past, the history of our forefathers.

This is the moment at which the feeling for bygone days and historical monu-
ments was really born and it flourished then even more than in the nineteenth
century, its supposed heyday. On Ruisdael's sheets, castle Egmont op de Hoof
crumbles away amidst a teeming, verdant Nature, like a fallen warrior or a pre-
historic burial mound. The same is true of Hobbema's ancient water-mills, full of
mysterious life, the handiwork of man which has gradually become part of Nature
and is being absorbed by her.

The most personal works ever created in the realm of landscape art, and also those which most firmly retain the character of a monologue, are Rembrandt's drawings and etchings, although it took him some time to grow into the task. Towards the end of his early period, Rembrandt executed a group of freely invented compositions which have been called dramas in paint, because they are so full of conflict between opposing masses of light and darkness, and because the superbly controlled antagonism between the forms seems to be so completely anthropomorphic. At much the same time, he began to draw in his sketchbook the occasional edge of a wood, row of trees or a farmyard tucked away among the furrows, as if he were irresistibly attracted by the sheer simplicity of the motif. These sheets which Rembrandt sketched while wandering through the countryside become increasingly plentiful until—about mid-century when Dutch Classicism was at its height—they dominated his drawn oeuvre in a copious flow. We follow Rembrandt on his walks through Amsterdam, out beyond the ramparts towards Amstelveen and Diemen, up the Amstel to his favourite spots. We accompany him on his journeys through old provincial towns, where he notes down gateways, towers, canals and views over the hills. Rembrandt used this profusion of sheets to form a basis for the supreme achievement of his landscape art: his etchings, which he rendered with as much vitality and impact as impressions from life, though they are, in fact, products of his mighty architectonic imagination. They are timeless, in the heightened sense of eternal [see fig. 97].

Innumerable generations of pupils passed through Rembrandt's studio, each taking what he had to give and using it in his own way. Lievens and Eeckhout took the clumps of trees foaming in the wind and sparkling in the light. Doomer, the gloom of rain-clouded skies, Koninck, the cosmic vastness of his open spaces.

At this moment, the wonderful, unique world of Dutch seventeenth-century landscapes is being displayed in the exhibition rooms of the Albertina. This is so far the most outstanding loan exhibition showing, besides the museum's own collection, drawings from the Rijksmuseum in Amsterdam and from Dutch private collections. It has also been augmented by Rembrandt drawings from the Print Room of the Akademie der Bildenden Künste, Vienna. One of the most laudable functions of such selected exhibitions is to show the public a different landscape from their own, a setting geographically distant, but closely related on the emotional plane.

Last year, Holland welcomed a loan exhibition of the Rembrandt drawings from the Albertina; now it is our turn to celebrate the return visit as a most agreeable and festive occasion.

"Die holländische Landschaft im Zeitalter Rembrandts," *Profil*, 4. Jg., Vienna 1936, pp. 244–46.

Rembrandt, Seated Figure of Diana

Basel, Dr. Tobias Christ [now Private Collection]
Pen and brush in bistre. 183 × 263 mm
Benesch 116

UNDER the influence of Italian example, Rembrandt, about 1635, was giving his subject pictures, and among them his representations of Biblical scenes, a strongly dramatic character. By means of skilful chiaroscuro, modelled on the example of Caravaggio, he contrived to throw his figures into strong relief; and his compositions, whether constructed of a few, large-scale figures, or closely packed with a multitude of smaller ones, were one and all endowed with a super-abundance of movement. Mythological and secular subjects are no exception. To the year 1635 belong the Dresden *Ganymede* (Bredius 471) and a picture in the possession of Prince Salm-Salm (Schloss Anholt, Bredius 472), representing *Diana and Actaeon*. For both of these, studies are preserved in the Dresden Print Room, viz. HdG 241 (Benesch 92), for the former, and, for the group including Callisto in the latter picture, HdG 263 (Benesch 93). They are studies of composition in which the artist was concerned with the rendering of movement vehemently conceived. In the pictures, however, there is also a wealth of careful detail, by which each figure is minutely modelled and wrought to a finish. For this phase, too, in the performance of a pictorial task, Rembrandt must presumably have prepared himself by the execution of preliminary studies: while a sketch depicting transient movement can be born of an artist's imaginative and creative resources, it needs the careful meditation of reality to achieve finish in a picture.

What constitutes the particular charm and interest of the present *Diana* (fig. 98) is that we have here precisely such a drawing from a living model—an example of that type of literal study which Rembrandt required for his mythological pictures of the 'thirties. We are shown a plump and rather homely young woman, clad in the chiton and buskins of antiquity, a crescent moon adorning her hair, armed with a spear and girt with a bow and quiver, and posed, so accoutred, in a corner of the artist's studio where the incidence of a strong side-light plainly models her form and features. The face, one will observe, is not unlike Saskia's under the familiar guise of Flora. By means of literal renderings of nature such as this, Rembrandt was able gradually to possess himself of the wealth of naturalistic detail which was essential in order for him to attain the effect of reality in his pictures. Even the two hounds which form part of the group were clearly drawn from life. Light and shade are strongly contrasted; the delicate tracery of the pen alternates with shadows

broadly applied with the brush and smeared with the tip of the finger. These passages correspond closely with the Caravaggesque chiaroscuro that is so much in evidence in the master's painting. They serve at once to unite the figure group with the space around it, to lessen its appearance as a studio pose, and to imbed it in the atmosphere of an imaginary forest, an abbreviated indication of which is to be found in the immense tree-trunk which rises behind the figure of Diana. The tree casts a heavy shadow behind itself in the background, and to this, in the foreground, the shadow of the couchant dog responds. Thus composed, the sketch acquires a completely organic and pictorial unity which, as is always the case with Rembrandt, removes it far beyond the casual and improvised appearance of a mere study from the model. One might readily imagine that a sketch somewhat of this kind could have been drawn by Rembrandt before he started to paint the miniature group of Diana with her dogs, bathing in the twilight of the forest, in the National Gallery picture (Bredius 473). But of course a direct transposition, without alteration or correction, would be altogether contrary to Rembrandt's artistic practice.

The drawing shows, as one may readily perceive, an abundance of analogies to authenticated works by the master—analogies which serve to fix it convincingly in the general complex of his work. The hounds are very similar to the one in HdG 1387 (Benesch 411) at Budapest, a drawing of 1635 which gives a charming representation of everyday life. Of the same year is the powerful study of a woman in bed HdG 773 (Benesch 283, probably Saskia), in the Petit Palais, which shows us the same searching modelling under the incidence of strong light. From early in 1636 date two drawings with a similar plastic value of light and shade, viz., the Berlin "*Jewish Bride*", Hdg 129 (Benesch 325), and the Louvre *Oriental*, HdG 731 (Benesch 158). Finally, I will mention Lippman 148b (Benesch 324), formerly in the Seymour–Haden Collection [now The Metropolitan Museum of Art, New York], which represents an elderly man seated peacefully at the door of his house. This drawing shows a particularly close relationship to the present one (Benesch 116), not only in its actual penmanship, but generally in the homely note of its interpretation.

Old Master Drawings XIII, No. 51, London, 1938, pp. 45, 46.

BE—L

An Early Group Portrait Drawing by Rembrandt [1]

Among the Rembrandt drawings of the Bonnat Bequest in the Museum of Bayonne is one very impressive sheet representing a group of persons seated around a table by candle-light (fig. 99). This drawing has been reproduced in Lippmann's corpus on plate 151 of the first series and quoted in Hofstede de Groot's critical catalogue as no. 682 (Benesch 52). In spite of its quality, it has received little consideration. It has not been reproduced in any one of the numerous selections of Rembrandt drawings nor included by Valentiner in the "Genreszenen" part of his valuable volumes of the *Klassiker der Kunst*. The reason for its neglect seems to be doubt about the authenticity of this unusual drawing.

In any case, this drawing is an excellent specimen of the Caravaggesque light effect which was so appreciated by a certain section of Dutch painting in the earlier 17th Century. It is one of the most brilliant examples, too. The draughtsman used the brush almost exclusively in making this sketch. There are only a few sharp traces, in the face and the left hand of the seated woman at the left, which could have been done with a pen. But it is possible that they too were done with a skilfully handled brush pointed in liquid bistre, the same tool used elsewhere in such a rhapsodic manner to build up heavy masses of shadows and bright surfaces of light.

The composition consists of three figures, the one at the right covering the source of light and appearing only as a dark silhouette. It is used as a screen. The stream of light floods the woman at the left, who seems to be protecting her eyes from the glare. The young man on the other side of the table between these two figures is also within the circle of light, but his slightly turned face is obscured by half-shadows which nevertheless contain light. The contrasts of dark and light in this figure are not so striking; it seems to be more enveloped in the glare of the unseen light which is expressed only by the touched surface of the paper. The two latter figures sit against a wall on which they cast blotches of shadow. But these shadows are not as intensive as those which model the figures in the foreground; they float in reflections of the omnipresent light. In this way the idea of a hard and firm limit of space is avoided and the group seems as though sheltered in a globe of light within the floating indefiniteness of shadowy space.

I think the chief reason for the omission of this effective drawing from among Rembrandt's works is the difficulty of dating it. Its masterly handling leads one to attribute it to a somewhat later date in Rembrandt's artistic development, although not before the earlier years of his residence in Amsterdam. But there arises the difficulty of placing it plausibly in the chronological order of his works. Everywhere

it presents contradictions. Rembrandt shows in his career as a draughtsman an orderly development, not only of artistic ideas but of means of artistic representation and realization. And in the clear sequence of his efforts as a draughtsman from 1632 onward there seems to be no place for this primitive outburst of visionary realism. No wonder that doubts are the consequence of such reflections.

We must, however, raise the question whether it might not be possible to avoid these difficulties by another dating of the drawing. If it is not the product of a highly developed and organized style of drawing such as Rembrandt shows already in his first years at Amsterdam, may it be the result of a youthful genius' moment of inspiration?

The designer has obviously been captivated by a fascinating impression drawn from real life: this group of persons in ghostly, flaring light, concentrating on the same feeling, the same circle of thoughts. He threw his sketch on the paper with hurrying brush strokes without deliberate, reflective application of artistic means. In addition to the hasty technique the subject also has a bearing upon the date. The drawing has in most cases been wrongly described. In the Lippmann corpus it is called *Group of Chess Players*; in Hofstede de Groot's catalogue *The Holy Family (Presentation of Christ)*. Only the photographer Giraudon in entitling a negative called it correctly *The Reading (La Leçon)*. There is no doubt about it; the shadowlike person at the right holds an open book in her hands and is reading while the others are listening. The woman at the left follows the reading deep in thought, half closing her eyes, secluding herself from the outer world and concentrating on the meaning of the sentences. The young man is not so deeply absorbed in his thoughts. He is not only a silent listener but an attentive observer of the outer world as well. He not only hears the momentous words, but he *sees* too, and is fascinated by a visual impression.

I should like to discuss the works of Rembrandt which are in close relation to the Bonnat drawing. As a pupil of Lastman, Rembrandt was strongly influenced by Caravaggio's followers in Utrecht, and cultivated in his youthful work not only the heavy forms but also the sharp contrasts of shadow and light familiar to all followers of Caravaggio. May I call attention to a painting as generally neglected as the Bonnat drawing. It is a small genre-painting in the National Gallery of Ireland in Dublin, which, in spite of its old attribution to Rembrandt, was once wrongly attributed to Gerard Dou. It has now been restored, I understand, to its real author. This painting of a game of *La Main Chaude* (fig. 100) in a dark room lighted by a candle or oil-lamp, is so close in style and manner of painting to the *Foot Operation* (Bredius 422), signed and dated 1628, in the [Haab-]Escher Collection at Kilchberg, Zurich, that there can be no doubt it is a work not only of the same period but of the same year. Clumsy and somewhat naive in its handling, it has considerable quality. The white-washed walls, decorated with "Rembrandt paintings" and an old map,

emerging with a half-illuminated column from the half-light, achieve remarkably the effect of porous, crumbling materials. The scene is the same as in Gerard Dou's painting of *Rembrandt in his Studio at Leiden* [formerly] in Sir Herbert Cook's Collection at Richmond [Kl.d.K. xxiv, G. Dou (W. Martin), 1913, p. 57]. Of special charm is the group in the left corner, watching the curious ceremony of the game, which fills with its musical accompaniment the centre of the composition. The whole scene recalls the Callot etchings representing artificial light effects, which is one more motive in support of Rembrandt's authorship. The charming group in the left-hand corner is so close to the Bonnat drawing that it is not difficult to recognize the same artistic imagination. The figures are grouped in the same way around a table bearing a candle, which is hidden by the figure seated next to the spectator. This person too is visible only as a dark silhouette, giving the effect of a screen. The strange parabolic shape of this silhouette, derived from the stylistic feeling of late Northern Mannerism, is once again significant of Rembrandt during his activity in his native town of Leiden.

The young Rembrandt liked the effect of space provided by dark silhouette figures in the foreground. We find them often in his early paintings and in his drawings as well. May I refer here to the reverse side of a Rembrandt drawing in the Koenigs Collection at Rotterdam [now Museum Boymans-Van Beuningen], the *Raising of the Cross* (HdG 1362; Benesch 6 verso; fig. 101). With different material, black chalk, but handled in the same rapid rhythm, Rembrandt seems there to attempt details of a composition very similar to the figures of the Bonnat drawing.

The stylistic comparison of figures drawn in grey chalk with those washed in with more or less heavy shades of bistre and ink is obviously rather difficult. But chalk drawings are not the only ones which allow a comparison. There are also bistre drawings containing sufficient brushwork to make comparison in some degree easier. I should like to begin with the *Self-Portrait* in the De Bruyn Collection at Spiez ([now Amsterdam, Rijksprentenkabinet], Benesch 54; fig. 104). The features are drawn with the pen. Its brittle traces combine curved and straight lines, and give a sort of sculptural modelling to the sturdy round head. This pen technique was characteristic of the period about 1628/29 and occurs also in some of the earliest beggar studies, showing the influence of Callot's technique of sharp brittle pen drawing on the first years of Rembrandt's graphic development. The wild tuft of hair, the body and the shadow cast behind it on a wall or in space, are done with a brush. This impetuous modelling is so much like the brushwork in the Bonnat drawing that it is hardly possible to recognize in the latter another hand than Rembrandt's.

The *Self-Portrait* of the young Rembrandt in the Print Room of the British Museum (Benesch 53; fig. 103), is somewhat earlier than that from the De Bruyn

Collection. It is farther from a decided graphical system than the other and may be dated about 1627/28. The young artist is still struggling to attain graphic expression. He endeavours to draw what he *sees*, to render these clumsy features staring at him from the looking glass, in an entirely empirical manner. For clearer accentuation he used different materials and different tools. He drew the face, the curls on the forehead, and the collar with pen and grey ink. These dark, strong traces are surrounded by a more transparent brushwork with olive-brown bistre to indicate the mass of the hair, the modelling shadows and the bust. The difference in colour of the two materials gives a very delicate effect and proves the young artist's sensitivity to colour. Unlike the De Bruyn *Self-Portrait*, this has in common with the Bonnat drawing the effect of artificial light. The person is plainly not represented in the diffused light of day but by night in the sharp light of a low candle. He seems to appear before the footlights of a stage. The loosely-washed brushwork of this drawing models the body with the simplified contrast of shadow and artificial light in the same manner as in the Bonnat drawing.

Another example of portrait drawing by candle-light is the *Portrait of Rembrandt's Mother* in the Stroelin Collection at Lausanne ([now Paris, Private collection], Benesch 55; fig. 102). The drawing shows an old woman with the majestic air of a prophetess in the sharp side-light falling from a low candle or lamp at the right. The same footlight effect as in the preceding drawing is to be seen in the shadow of the chin, slanting upwards to the left, and in the upper outline of the headcloth suddenly darkening in sharp relief. Once again the accentuating penstroke is mixed at the left with hasty brushstrokes, where the well-cut plasticity of the head disappears in the gloomy shadows of space faintly lighted by reflections.

A comparison of these two drawings with the Bonnat drawing well confirms Rembrandt as the author of the latter. Its mastery is not incompatible with the young Rembrandt's artistic ability. It may be recalled that Rembrandt's first etchings after a living model, the portraits of his mother, are already of the highest perfection attainable with the etching needle. It is no more impossible to acknowledge the Bonnat drawing as a work of the 22-year-old master than the etchings dated 1628 (Hind 1 and 2). Although the Bonnat drawing is somewhat superior to the simple portrait drawings in liberty and spontaneity of handling, it shows the same sharp lines and rushing shadows, combined with forms of an emphasized realism in flaring light.

The small painting representing a group of singers in the Van Aalst Collection at Hoevelaken (Bredius 421; fig. 105; see also fig. 106),[2] makes clear how by about the year 1626 Rembrandt already occupied himself with the problem of composing a group of persons concentrating on a common spiritual act and of making it stand out in all its luminosity from the background of darkness. It is a real continuation of Gherardo della Notte's paintings. The Italian triangle composition exists in the

Bonnat drawing too, but it is hidden and dispersed in space, plastic bodies, and floating shadows.

However, the conception of the drawing is not derived completely from the practice of the Caravaggesque painters. Their artistic abstraction becomes in Rembrandt's works an intuition of reality. The group of singers is still an abstraction, but the candle-light drawings are ingenious perceptions. The evening hours were for the Dutch artists the time to practise their draughtsmanship and graphic arts. This is illustrated in Rembrandt's etching, *An Artist Drawing from a Cast at Candle-Light* (B. 130, Hind 191). The unfinished etching, *The Artist Drawing from a Model* (B. 192, Hind 231), shows in the completed portion of the vaults the mysterious play of shadows and half-lights in a painter's studio at a late hour. We learn from Constantijn Huyghens' reference how restless and devoted to his artistic workmanship the young Rembrandt was, even to the point of being careless of his health. The long hours of the Dutch winter also had to be used for artistic practice. Pen and brush, bistre and ink were the best instruments. It is an old academic practice to arrange drawing lessons in the evening hours after painting from the model. And Rembrandt in his domestic academy in the miller's house at Leiden, where the features of mother, father, sister, brother and his own face were the chief models, accepted the custom. So the origin of these drawings is not solely the stylistic influence of the painters of night and cellar subjects, although the natural premise was in both cases the same.

We know that in a large number of early genre and portrait paintings and drawings Rembrandt used the members of his own family as models. Parents, brother and sister occur no less frequently than his own features. They formed a part of his historical and religious compositions as well. It is characteristic of Rembrandt that he filled his works with people of his own imagination. Even the models of his portraits are changed into spiritual entities, not always corresponding with their external appearance. This imagination was, more than that of any other artist, formed by the people surrounding him in his earliest youth, by the members of his family. That is the case in the Bonnat drawing as well. It may be proved that it represents an evening scene in his home by a comparison with the singular group painting of Rembrandt's family, lately published by Vitale Bloch (Bredius, third edition, 632; fig. 107).[3] It seems to be somewhat earlier than the Bonnat drawing and may have been painted in the year 1626. Rembrandt's father is playing the violoncello, he himself the harp, his sister Lisbeth is singing from a large music book on her knees, and the mother is listening. It is not difficult to recognize some of these persons in the Bonnat drawing. Rembrandt's sister wears a strange head-dress having the shape of a horn, a cross between a doge's hat and a Burgundian cap, on the top of which a veil is fastened. This head-dress covered by the veil is also worn by the person reading from a large book in the Bonnat drawing. Although we

cannot recognize her because of her shadow-like appearance, we may guess that it is Rembrandt's sister Lisbeth. That the young man observing attentively is Rembrandt himself, who saw the whole scene in a looking-glass and took the opportunity to draw it, may be easily recognized from the picture, in which he has given himself the same task of forming the top of the pyramidal composition. I should like to suggest that the young man in the group of singers (Bredius 421) who holds the same position might be a variation of Rembrandt's image of himself. To recognize the artist's mother in the pensive listening woman would be obvious. She has the sharp features which correspond with her numerous portraits. But here a difficulty arises. Rembrandt's mother never wore this dress with the kind of large lace collar and lace cuffs which became fashionable about 1630. We always see her wearing her fur jacket and furbelowed corsage. That may have been a house dress. But when she went out she certainly wore the stiff millstone collar, fashionable about 1600 in the time of the Spaniards, which was worn about 1630 only by elderly ladies and by Mennonites. That this woman is the young Saskia, as my friend Professor Van Regteren Altena has suggested, does not seem probable because the portraits drawn by her bridegroom about 1633 show very young features, soft and round-cheeked, not as sharp and elderly as the woman in the Bonnat drawing. The question, therefore, remains open. Which member of Rembrandt's family, consisting of seven brothers and sisters in 1622, is to be recognized in her?

In any case, Rembrandt seems to have received his inspiration from the daily life of his family, as he often did in later years. More than any other artist, he is in the deepest sense rooted in the reality of life, out of which he created his most sublime works of imagination.

The Art Quarterly III, Detroit, Winter 1940, pp. 2–14.

The Rembrandt Paintings in the National Gallery of Art

IN the history of painting and collecting Holland holds a unique place, as the seventeenth century was not only the great period of her artistic activity but also that of her world-wide economic domination. During this time Dutch trade carried Dutch painting throughout the world. From the seventeenth century on Dutch pictures formed the main part of the international art trade. Dutch paintings were the first which came from Europe to the North American colonies and the first also which were executed on North American soil. We meet them in overwhelming majority in the great aristocratic collections of the Baroque in the Northern European countries, and often they were the pride of some prominent Italian collector also, as for instance, of Conte Ruffo of Messina, who was one of Rembrandt's last patrons.

The democratic character of Dutch art in itself appealed to the bourgeois amateur, hence Dutch paintings or imitations of them decorated such middle class homes as that of Goethe's father. What made Dutch paintings attractive to collectors in former centuries was their subjects, even more than their pictorial quality. In the nineteenth century this was changed by the influence of French artists who established pictorial quality as the main value. Influenced by the tendencies of contemporary painting, art collectors began more and more to concentrate on the *point of pictorial quality*. Pictorial quality is the basic feature of the collecting of Dutch painting in America during the later nineteenth and in the twentieth centuries. This is the reason why works by Rembrandt came to this country in such large numbers that it is now hardly possible to study this master thoroughly without a knowledge of his works in the United States.

The main strength of the Dutch section in the National Gallery is its series of paintings by Rembrandt. Recognition of the fact that paintings by Rembrandt gathered in one room and undisturbed even by important neighbours enhance each other and achieve a solemn and mysterious totality, led to the shaping of the Rembrandt Room.[1] I do not hesitate to call this room, with its panelling of stained oak and its careful setting of select masterpieces in splendid daylight, one of the best modern museum achievements. It contains nine works by the master, each of which is given large breathing space to develop its individuality. With one exception, all belong to the category of the portrait or of the monologue figure, as do most of the Rembrandts which have left European collections during recent decades. Accordingly, works of the artist's mature and late periods prevail over those of the earlier years. It may be useful to reconsider the problems and questions connected

with their position in Rembrandt's *oeuvre*, as some new light on facts and dates may be obtained.

The earliest of these nine Rembrandt paintings is the *Portrait of an Oriental* (dG 351, Bredius 180; fig. 109). The half-length figure of a bearded man faces the onlooker. It is built up in a simple pyramidal composition, while a turban enhances the shape of the dominating head. The attitude of the man—the right hand grasping the belt, the left resting on a stick—would suggest that he is standing upright; but some shifting in the body's balance, expressed mainly in the contour, does not exclude a sitting posture. The left shoulder comes to the fore, the right goes back into space, breaking through the plane of the simple silhouette in a way typical of the Baroque. A beam of light falls diagonally from the upper left corner, shaping the yellowish-red face which is moulded with broad summarizing brush strokes bare of details. The painter's interest was concentrated upon the turban's shimmering coils of violet, blue, yellow, and silvery-white silk. The reflection of this head lights up, slightly, the rest of the body which was purposely left in the dark. The paint covers a ground of cool yellowish-grey, harmonizing beautifully with the black design of the sleeve. The dark olive-grey of the mantle frames the dusky wine-red velvet of the tunic. A ruby increases the luster of the gold chain. The hands look as though they are covered with gloves, so dark is their clay-like hue, a feature which occurs also in the half-length figure of an *Oriental* at Munich, dated 1633 (dG 348, Bredius 178).

Rembrandt imagined the world of the Bible as a richly coloured Orient reaching his own doorstep, for he never travelled. His Dutch predecessors, Lastman and Pynas, the Caravaggio and Elsheimer followers, had already led the way. But Rembrandt was not satisfied with an abstract invention: he wanted to see his heroes in reality. Figures of Turks were not unfamiliar to the quays of seventeenth-century Amsterdam. In the Portuguese Synagogues and the surrounding little houses of the Seminary, Jewish antiquity was still alive. Rembrandt drew and painted figures like this from living models. They are not among his most highly-appreciated works but they exhale a certain rough power. The three-quarter length figure of an *Oriental* in the Metropolitan Museum, dated 1632 (dG 349, Bredius 169), and the half-length figure of *The High Priest Aaron* in the Devonshire Collection, Chatsworth (dated 1633, not 1635 as is usually indicated; dG 346, Bredius 179)[2] still show the devout modelling of the paint characteristic of Rembrandt's earliest years. Then a new trend starts toward the grand and Baroque, a trend which discards earlier achievements. It is clearly visible in a group of drawings done about 1633/34. Figures like those reproduced here (Benesch 214, 215, the latter published for the first time; figs. 110, 111) were used by Rembrandt not only for portraits but also for Biblical paintings. The drawing in the De Grez Collection in Brussels seems to prepare for the *Belshazzar* (Bredius 497; Knowsley House, Earl of Derby

[now London, National Gallery]). The new grand style was attained in paintings of Orientals done in 1635 (dG 353, Bredius 206, Brussels, D. A. J. Kessler [now Amsterdam, Rijksmuseum]) and 1637 (dG 344, Bredius 210, Heemstede, Frau von Pannwitz [now Rijksinspecteur voer Roerende Monumenten, The Hague, property of the Government of the Netherlands]). We may, therefore, tentatively date the Washington picture around 1634, the year of the *Jewish Scholar* in the F. Nostitz Collection, Prague (dG 236, Bredius 432 [now Prague, National Gallery]).

Next in order of time follows the *Polish Nobleman* (dG 271, Bredius 211; fig. 108). The painting is signed and dated 1637. Figures from the Slavic East appealed to Rembrandt no less than those from the Orient. The young artist was attracted by the picturesque dress of Polish warriors; the mature man portrayed an officer of the Lysowski regiment in *The Polish Rider* of the Frick Collection (Bredius 279). Polish figures first appear in his graphic work about 1631. The little *Figure of an old Pole* in black chalk (Benesch 44; Lugano, Wendland Collection; fig. 112), still reminiscent of the beggar studies of the late 1620s, was soon followed by two etchings (B. 142, Hind 40, dated 1631; and B. 141, Hind 98). Polish dress occurs here and there, either in portraits (including self-portraits) or in supernumeraries like the little groom in the etching of *The Good Samaritan* (1633; Hind 101).

After the climax of a ponderous and ostentatious Baroque about 1635, Rembrandt turned back in the following years to medieval refinement and intimacy, to Late Gothic and mannerist fantasy. This means a certain increase of the fantastic element on the one hand, and the forming of a thorough psychological realism on the other. Character studies of all kinds were accumulated in highly refined and detailed pen drawings, ready for use in depicting the sermons of saints and other similar events. At this time Rembrandt painted the portrait of the *Polish Nobleman* in Washington. How general, almost abstract, the Orientals seem in comparison with this lively, animated figure which "speaks" not only in its total expression but in every little detail and ornament, in every little flame of light and flourish of shade! It is the progress from an indifferent mask to a personality full of restlessness and nervous tension. How much more tense is the grasp of the hand, how curved the indented outlines! The colour scale is built up on the contrast of warm and cool: the red of the coat, the fiery layer under the brown fur, the reddish gold of the chain contrast with the bluish hues in the fur, in the baton and in the greenish-grey foil of the crumbling wall.

The Portrait of an Old Lady with a Prayer-Book (dG 876, Bredius 362; fig. 116)[3] shows a figure full of the rigidity, constraint and severity of Holland's Calvinist society. She is enclosed in her black silk dress and white millstone collar as if in armour. The outlines are unusually straight. Spatial indications are kept to a minimum. The lady is turned slightly to the left but the contour is almost symmetrical.

The recession of the planes is indicated only by the sharp foreshortening of the arm-chair. These features point to a stage of Rembrandt's development later than 1643, as the date has heretofore been read. A similar subject of 1643, the *Old Woman with the Bible*, Hermitage, Leningrad (dG 319, Bredius 361) shows a flowing softness of style enveloped in modulations of lights and shadows, which is foreign to the present picture. So the assumption based on a recent cleaning, that the date may have been 1647, gains likelihood. The portrait may be better compared with the portrait of *Adriaentje Hollaer*, the wife of the painter Sorgh, which Rembrandt did in 1647 (dG 865, Bredius 370). Even there the shape of the hand is much softer and lacks the wooden stiffness; but the person portrayed is considerably younger. And the expression of the face of this old lady is so immensely human that the onlooker becomes reconciled with the idea of its being a work by Rembrandt.

With the figure of *A Girl with a Broom* (dG 299, Bredius 378; fig. 113), which is signed and dated 165(1), we enter Rembrandt's mature period. People working about the house were favoured subjects of the painters of Rembrandt's native city Leiden. The emphasis was there laid on the activity as such, on the moral value and religious dignity of everyday work. Rembrandt was more interested in the human side of the subject and the genre painting became a portrait. This little girl was surely a maid in the artist's household. Six years before he had portrayed a charming little creature of the same sort in a picture in the Dulwich College Gallery, London (dG 327, Bredius 368; dated 1645). Now it was Hendrickje who had advanced to the rank of *huisvrouw* and needed a helper in the artist's housekeeping.[4] So the girl in the red bodice came upon the stage. The artist portrayed her twice. In the Stockholm portrait of the same year (dG 330, Bredius 377) she leans thoughtfully upon a window ledge. The burning scarlet-red of her dress, standing out from the pitch-dark background, becomes indelibly fixed upon the onlooker's memory. Rembrandt prepared for this picture in a drawing in the Dresden Print Room (HdG 253, Benesch 1170; fig. 114). In the Washington picture, she holds a broom firmly clasped in her arm as she leans over the wooden parapet of one of those open fountains, such as used to be found in the courtyards of Dutch houses. A bucket and a metal basin complete the still-life. In both paintings she looks earnestly at the onlooker as if she were puzzled by the activity of the man with the brush.

The paint is of a miraculous substantiality. The white of the dress, in spite of being slightly tinted by a greyish-golden hue, has a shining splendour framing the fiery red of the bodice. Reddish and greenish hues mingle in the face beneath the reddish hair. The shadowy surroundings re-echo the values of red, green, and gold in a warm glow.

The only Biblical subject among the Rembrandt paintings in the National Gallery is *Potiphar's Wife accusing Joseph* (dG 18, Bredius 523; fig. 69 [see p. 93]),

signed and dated 1655. About 1655 Rembrandt studied Persian and Indian miniature paintings assiduously, copying them in highly ingenious and original pen drawings. The influence of these studies is noticeable in the Biblical paintings of these years. Potiphar is a figure who has stepped out of one of those miniatures. He keeps in the shadows out of which the golden damask of his garment shines mysteriously. He leans silently over the shoulder of his wife listening to her report. The radiating salmon colour of her robe concentrates most of the light. The light bluish and greyish white zone of the bed linen separates her from Joseph's figure in golden yellow. The young man, resigned to his fate, endures the slander silently. In spite of the calm there reigns an immense tension between the three people. The foreground is again covered by shadow, out of which glows the deep red of Joseph's mantle to which the woman points as proof of her false accusation.

The Kaiser Friedrich Museum [Staatliche Museen], Berlin, possesses another, slightly smaller version of the same composition, also dated 1655. (dG 17, Bredius 524; fig. 70). The divergence from the Washington picture is considerable. The woman points to Joseph himself and keeps his mantle under her feet. She looks more excited, Joseph more pathetic. Luxury of garments and furniture have increased. The dark space above the figures widens.

Which version is the earlier? There is no doubt that the Washington version surpasses that of Berlin in depth of psychical expression. But the Berlin version seems to be a step further in pictorial refinement, so we may regard it as the later.[5]

The old Rembrandt accepted very few orders for female portraits. Those which he did accept resulted in works of masterly concentration and clarification like the *Portrait of a Young Woman holding a Pink* (dG 878, Bredius 390 [signed and dated 1656]; fig. 115). About the middle of the 'fifties, Rembrandt approached most closely the classic art of the Venetian cinquecento, especially that of Titian. In portraiture he reached the utmost simplicity. The value of the plane is restored; all breaking through of the picture plane is discarded. The figure is built up in a clear pyramid, symmetrically arranged, only slightly shifted in space. On the other hand, this does not mean that the power of space is diminished. On the contrary, it is increased as the quiet planes suggest much more intensely the volume of the body disappearing into atmospheric space behind it. This is achieved by masterly painting. In this portrait every shape is immovably fixed but free from coercion in a silent harmony. How compactly and softly the hands are modelled in their negligent attitude! The colour scale, too, is as simple as possible, based on black, white, red, and yellow. A dark glowing red appears in the flower and in a strip of cloth peeping out from the sleeves and intermingled with golden embroidery in the tablecloth. Both colours dominate the beautiful apple still-life. The direction and restraint of statement make the human character speak with an incomparable intensity. Works of the kind became the basis of classical Dutch art.

The years around 1660 are especially rich in self-portraits. The master seems to have wished to hold his own in a time of economic and social distress. The unbroken power of his artistic spirit triumphed over the reverses of life. He appears in Olympian grandeur in the *Self-Portrait* of 1658 in the Frick Collection (Bredius 50; signed and dated 1658). The Washington *Self-Portrait* of 1659 (dG 554, Bredius 51; fig. 118) and the Louvre *Self-Portrait* of 1660 (dG 569, Bredius 53; frontispiece) show how an unextinguished fire of mind glows through a declining physique. The figure in the Washington portrait, turned to the left, completely fills the frame without becoming heavy, as it is modelled with infinite softness in a dark velvety grey. Paint applied in vibrating spots over the hidden glow of a bolus ground suggests the material of a fur. The contrast between cool and warm tones prevails. The shape of the reddish-brown hands is blurred in shadow; the face shines in radiant pink with spots and lights in red, ochre, and pale yellow, lined with a foil of grey. The contrast to this warmth gives a blue hue to the black of the cap and the icy grey of the hair. The gaze of the eyes, grey like a moss agate, is impenetrably deep. The painter scratched golden lights into the cloudy mass of hair with the stick of the brush. The function of the brushwork for drawing is most obvious. The modelling of form is not only the result of the colour values but also of the surface of paint. This is in harmony with the relief-like character of the composition—the background closes like a relief ground around the figure—which suggests depth of space better than all the Baroque diagonals ever could.

The classic grandeur of Rembrandt's mature style coincides with the movement of Classicism which Holland shared with the countries of Western Europe during the second half of the seventeenth century. This brought about the strongly architectonic character of his compositions which sometimes have distinctly classical features. The outstanding example is the large historical painting of *The Conspiracy of Julius Civilis* (Bredius 482; fig. 2 [see pp. 1–24]) which must have fitted very well into the classical architecture of Van Campen's newly-built City Hall of Amsterdam. We meet with such features also in the portrait of *A Young Man Seated at a Table* (dG 784, Bredius 312; fig. 117), signed and dated 1663, one of Rembrandt's works with a strongly emphasized architectonic character. The shape of the head can be circumscribed by a blunt cone (not dissimilar to that which sometimes occurs in Cézanne) and is repeated by the hat. So Rembrandt achieves the marvellous climax of the mountain-like towering of this figure. The figure stands out as an imposing architectural form against the background of a solid wall, which is not recognizable as material but is effective in its function of closing the space. A classical blind window is cut into this wall, increasing the figure's character of relief-like enclosure between planes and fastening it almost mathematically into an architectonic framework that reminds us of Poussin. At the same time it looks like a door leading into the beyond, yet a door that is walled up. The figure seems

almost to have been painted on gold ground: the face seems to shine from the reflection of evening light. The head is drawn carefully with glazing paint. The broadly-washing brush sketched the planes of the hands first and shaped them afterwards by setting in dark intervals and shadows.

The death of the Roman virgin Lucretia dishonoured by Tarquinius was one of the chief moral subjects of the Renaissance and Baroque. It was treated either as a dramatic mass scene or as a cold intellectual display of anatomical knowledge (as for instance by Dürer). Rembrandt took up the subject in his last years and brought out all the deep human qualities it contains. He made it the lonely struggle of a wounded soul, in all its frightful tension, choosing between shame and death. So he made the subject in the painting in the National Gallery (dG 218, Bredius 484; signed and dated 1664; fig. 119) a monologue figure—the main content of his late art. Lucretia lifts the dagger, her face takes the expression of a dying person and her left hand is raised as if feeling the way into the dark region before her. The most substantial thing in the picture is the golden embroidery of the garment —face and hands are those of a somnambulist, fading, seen as in a dream.

We are at a point in Rembrandt's development where the immense architectonic firmness of the classical period begins to dissolve. The dissolution has gone even farther here than in the *Jewish Bride* (Bredius 416) in the Rijksmuseum, proving that it is an earlier work. The old varnish, beneath which this painting is marvellously preserved, however, accentuates the general gold tone too much. A cleaning will reveal beautiful shining whites. Rembrandt used for a ground a sort of rough sackcloth, sometimes brushing the paint over it with a half-dry brush, attaining in this way the immaterialization of the medium which he achieved in his drawings with the reed pen on coarse paper.

Two years later Rembrandt took up this theme once again in the painting in the Institute of Art at Minneapolis (dG 220, Bredius 485; signed and dated 1666). There Lucretia grasps a bell rope, arousing servants and kinsfolk after having applied the deadly stroke to herself. Her attitude seems to be petrified under the weight of fate.

We do not know how many of Rembrandt's master-works will emerge unharmed from the chaos of Europe. It is a heartening thought that this country has by its recent collecting succeeded in assembling so many within its borders, safeguarding this precious heritage for posterity.

Rembrandt and the Gothic Tradition[1]

O NE of the main reasons for Rembrandt's unusual position in the art of Holland was his universal interest in the art and culture of foreign countries and of the past. Rembrandt showed a deep understanding of the modes of artistic expression not only of periods near to him but also of remote ones, which is very unusual for a Dutch artist of the 17th Century. Although Dutch art, due to the economic expansion of the country, was spread over the whole globe, it gave mainly a faithful representation of the native world. The mental realm of Rembrandt's art was different.

Universality of mind does not surprise us in Rubens. He was a scholar, because of his education and environment, and enjoyed the intellectual background of international European culture through his travels and connections. But universality of mind surprises us in Rembrandt, the Hollander who never crossed the frontiers of his country, and whose personal isolation increased in his late years. Although Rembrandt, too, received the rudiments of humanistic education in his youth, he, unlike Rubens, acquired universality less in the intellectual and literary way, than in the intuitive and visual. Ideas were conveyed to Rembrandt mainly through his eyes, and these eyes were more sensitive to the secrets of artistic form than any others.

Rembrandt could have gained his knowledge of historical forms of art in three different ways. First, he was a very broad-minded collector. His collection embraced works of art from the classical world to the Far East. He collected old masters as eagerly as contemporaries. The artists of the Gothic era and the Renaissance were as familiar to him as Rubens and Callot, Brouwer and Seghers.

Secondly, the flow of art through Holland was the strongest in Europe at the time of Rembrandt. Amsterdam was practically the centre of the international art trade where works of all regions and periods could be seen. Rembrandt was an "habitué" of the sale halls and shops of the dealers. He was considered an expert whose opinion was requested in cases of doubtful attribution. Many wealthy Hollanders were collectors like Rembrandt himself who could study their treasures in their houses.

Thirdly, Rembrandt could see many remains of past centuries in his own country. The majority of Old Dutch churches belong to the Romanesque and Gothic periods. Although Calvinism had deprived them of most of their paintings and sculptures, there remained enough at portals, in capitals, bosses and choir stalls, to stimulate an artist's imagination. Catholic enclaves like Utrecht had preserved much of their medieval art. Rembrandt was interested in the medieval monuments

of his country, as a little drawing of the Church of St. Mary in Utrecht (Benesch 1303, [now Fogg Art Museum, Cambridge, Massachusetts])[2] proves. Many of the old paintings, altarpieces, and cast and carved statues, which were banished from the churches, had found refuge in city halls, charitable foundations, schools and orphanages. Figurative decor in profane buildings remained intact. The traditional sense of the Dutch, who were fond of the past, even cherished those old mementos.

These were the sources Rembrandt could draw from. Historians of art have often studied his intimate relation to Italian Renaissance art. He was not only inspired in his own works by the great masters of the Renaissance at different periods of his development, but, with the maturing of his art, he acquired also an inner affinity to them which makes his style seem more closely related to the elevated style of the masters of the cinquecento, of Leonardo, Raphael and Titian, than to that of his contemporaries. One of the finest interpreters of Rembrandt's art, F. Schmidt-Degener, even called him "the last of the great Renaissance masters".[3]

Rembrandt's relation to medieval art has not yet been as systematically investigated as his relation to Renaissance art. The points of contact there are not so obvious. Yet Rembrandt's vast interest in the past, his predilection for the old, because it is venerable, mysterious, and filled with a meditative mood, certainly did not exclude an interest in the era which had shaped the essential cultural features of his own people, and which was still alive in so many relics around him.

It was again Schmidt-Degener who first drew attention to the fact that Rembrandt, in one of his most solemn and beautiful paintings of religious history, *Jacob blessing his Grandchildren*, of 1656 (Bredius 525; fig. 120)[4] was inspired by one figure from a series of Gothic bronzes which were designed by Jan van Eyck and cast by Jacques de Gérines (fig. 121).[5] These bronzes, now in the Rijksmuseum in Amsterdam, once surrounded as mourners the tomb of Philippe de Mâle in St. Pierre at Lille.[6] Later, they were donated by Philippe the Good to the community of Amsterdam and kept in the City Hall where Rembrandt could have studied them. They represent Dukes and Duchesses of Burgundy and the Netherlands, medieval rulers of the country. It is quite obvious that Rembrandt used the figure of Jacobea of Bavaria, humble and devout in her attitude in spite of the elaborate pomp of her Gothic court costume, for Joseph's wife Asnath. Asnath, filled with silent emotion, is present at the moving ceremony when the blind patriarch blesses his grandsons. Rembrandt not only accepted the general attitude, but even details of the costume, as, for example, the Burgundian headgear. He translated the shapely and delicately cut bronze form into his inimitable art of colour, making the dark grey and gold of the figure respond to that chord of blue and yellow which began to ascend so gloriously in the paintings of the masters of Delft. There is a

soft weaving atmosphere around Asnath, embedding her in the sublime colour symphony of the whole and imbuing her at the same time with that sacred and thoughtful mood which, like the chiaroscuro, unites the figures in a Rembrandt painting. The essential factor is what Rembrandt made from this figure, what kind of spiritual accent it lends to his picture. He used the medieval remoteness and dignity of the model to express the mythical distance of a royal figure of Old Egypt which played such a great part in the history of the chosen people. The medieval was to Rembrandt something shrouded in mystery and sanctified by time. This case is a point of obvious and demonstrable contact between Rembrandt and medieval art. If we deal with the problem, we shall have to base our conclusions first of all on such cases. As Rembrandt was no imitator, but a creative transformer, it has to be anticipated that such cases are extremely rare, even rarer than the cases of direct influence of certain Renaissance models. Suspected sources of inspiration will have to be tested through a consideration of what works of art were available and within Rembrandt's reach.

This does not mean that we shall thereby exhaust all possibilities of medieval elements in Rembrandt's art. As Rembrandt was a creative transformer, the source of inspiration may often be very veiled and hidden in his work. In these cases it will be difficult to point to a specific work as a source. The source may be suggested rather than unequivocally identified. We shall have to be satisfied with giving an example instead of putting the finger on the one work which was decisive. Here and there in Rembrandt's work, we shall discover features which are medieval in mood, character and expressive meaning. We can try to explain them by showing analogies in medieval art. But the way in which they entered Rembrandt's art may elude our investigation. Those medieval features may have been handed down to Rembrandt through much more recent sources. The medieval tradition was alive in the North much longer than in the South. In the early 16th Century, it interfered with the rise of the Renaissance, especially in the Netherlands. It experienced a revival shortly before 1600.

Iconographic relics of the Middle Ages in Rembrandt's art were investigated by a Dutch scholar, Jonkheer van Rijckevorsel, who, for this purpose, also made use of works of the beginning of the Northern Renaissance, for instance in the case of Rembrandt's magnificent drawing *The Agony in the Garden* (Benesch 899, Hamburg), a work of the 1650's. The angel has brought the chalice of suffering to the Saviour and the soldiers approach in the background, as we see it in Dürer's woodcut of the Large Passion (B. 6, Meder 115).[7]

We could extend such iconographic comparisons to the field of allegory. The old medieval idea of the Dance of Death was visualized by Dürer in his engraving *The Promenade* (B. 94, Meder 206) where death lies in ambush for an amorous couple behind the tree. This engraving certainly gave Rembrandt the idea for his

etching *Death appearing to a Wedded Couple from an Open Grave* (B. 109, Hind 165).

But we have to go beyond iconographic features in order to understand how deeply Rembrandt was linked with the medieval tradition. We also have to examine resemblance of form.

It is most appropriate that we investigate for this purpose the art of the regions, examples of which could easily have come to the knowledge of Rembrandt. These will be first of all the Low Countries, and the neighbouring or affiliated provinces of France and Germany. In the field of the graphic arts we also have to include Upper Germany, as Rembrandt's collection was very rich in prints by German masters. We have to extend the time limits as far down as the medieval feeling of form prevailed, that is into the beginning of the 16th Century.

A striking example is offered by a leaf of sketches of the late 1630s which represents *Mary Mourning beneath the Cross* (Benesch 152; fig. 122), drawn with the pen, and several other mourners, drawn with red chalk.[8] The 1630s are usually called the "Baroque" period in Rembrandt's development, yet we find little of the pathetic lamentation and surging movement of a Holy Virgin by Rubens, or one of his pupils, in this Mater Dolorosa who shrouds herself tightly in her mantle and rises to heaven like a Gothic pillar, one soaring note of grief and pain. The silhouette is angular, and even the penlines point in sharp angles to heaven. The whole expresses grief which strives beyond itself and is sublimated into devotion. Rembrandt indicated the expressive meaning of this figure by a sentence which he wrote on the leaf: "A devout treasure that is kept in one's heart for the consolation of her compassionate soul".[9] Here represented is the Holy Mother listening to the last words of Her Son on the Cross. The feeling which the figure conveys is essentially medieval. It is not difficult to recognize in her the mourning Mary who forms a part of the sculptural groups representing the Crucifixion placed high up under the triumphal arches of the Gothic cathedrals, or in the surrounding cemeteries. A figure [formerly] in the Museum of Cleveland, a work of the Southern Netherlands or the North of France, may stand as an example for many others: Mary congealed into a column from immeasurable pain burning in her heart. From the original plastic imagination, this concept entered the pictorial. So we see the mourning Mary pressed in the crowd of the mourners around the dead Christ[10] in the grandiose fragment of a glue water-colour painting on canvas by Hugo van der Goes (Berlin, Staatliche Museen). There she crosses her arms in the same attitude we see in Rembrandt's drawing, as if she would contain an excess of grief in her breast. Rembrandt harks back to Gothic pointedness even in the sharp, abbreviated cut of the features. Medieval grandeur flames up once again at the dawn of the new era in the art of Quentin Massys, a master who was also represented in Rembrandt's collection. In the painting [formerly in Vienna, Liechtenstein Gallery],[11]

he placed the Holy Virgin, as part of the Crucifixion group, before a vast expanse of scenery, as sternly secluded in her grief as in the mantle which separates her from the beauty of the world. It is the same spiritual accent which Rembrandt's figure incorporates.

Rembrandt drew this sketch at a time when he was striving ardently for expressive values: in the late 1630s. This striving for expressiveness eclipsed the problems of naturalistic motion which had occupied Rembrandt in the preceding years. Rembrandt now consciously took up types and forms of medieval art. Another sketch of this kind is a little pen drawing in the Museum Fodor, Amsterdam (Benesch 153; fig. 123), which represents the half-length of one of the Marys present at the Lamentation for Christ.[12] She is of a type similar to the Mater Dolorosa. Her haggard features are overshadowed by the mantle drawn over her head. This tight framing of the face, this clenching of the silhouette, doubles the expressive potential. She wrings her hands in a gesture of despair. We see the "medieval" antecedent of this mourning woman in the left part of Rogier van der Weyden's *Lamentation for Christ* in the Hague.[13] Overpowered by grief, she loses her self-control. The lips of the aching mouth part, just as in Rembrandt's drawing.

This conception of the mourning Mary continued to occupy Rembrandt's imagination until his latest period. About 1641, he etched a half-length of *The Holy Virgin* (B. 85, Hind 193; fig. 124), appearing behind a parapet on which the instruments of Christ's martyrdom are displayed. She offers them as if it were for pious adoration, while she raises the right hand in an attitude of defence, accusation and compassion. As her look wanders to the right, we supplement her figure in our thoughts with a half-length of the Man of Sorrows, a representation very frequent in late Gothic Dutch painting up to the 16th Century. In a lost diptych by Lucas van Leyden, known from several old copies, half-length representations of the Man of Sorrows and the mourning Mary were combined in this way.[14] The parapet with the instruments of Christ's martyrdom seems to have a special meaning. In late medieval French and Netherlandish sculptured groups of the Entombment of Christ, Mary and the Holy Women emerge behind the sarcophagus, holding the crown of thorns, the nails and the ointment jar, or placing them on the edge of the tomb. So we see them in the *Entombment* group of Semuren-Auxois.[15] Another work of the same kind is the *Entombment* in the Church of St. Michel at Dijon (fig. 125),[16] where the figures even appear in half-lengths, making the similarity with Rembrandt's etching still more striking. The French works may stand as examples for a type which was in the Netherlands as common as it was in France.

Like most medieval motives in the art of Rembrandt, this one also reached its climax in the late phase. In 1661, the year when Rembrandt painted a whole series of saintly figures in half-lengths, he created the magnificent figure of *The Mourning Virgin* in the Musée des Vosges, Epinal (Bredius 397; fig. 126). Veil and head-cloth

encase the face with such severity, that the picture is often called *Portrait of a Nun*. All outer softness and motion is congealed into an inflexible pattern which imprisons the figure like armour. It is the idea that the rigid structure should contain emotion which is so great that it threatens to disrupt the consistency of form. The feeling of this figure glows out of the darkness of the night which spreads over her, as do the colours in the shining parts of the garment. This glow has a strength that seems to come from inside the painting; the folds of the veil stream like rays of light down to the hands. The mask-like seclusion of the face increases the spiritual intensity. It is a conception of ghost-like grandeur.

The late Rembrandt made use of the medieval restraint of form to increase inner expressiveness. Works of Late Gothic art must have been in his mind when he created this extraordinary painting. Figures of the *Holy Virgin* from Crucifixion groups again offer themselves for comparison. A Dutch example of the late 15th Century in the Museum of Utrecht (fig. 127), coincides remarkably with Rembrandt's work in its general attitude.[17] Such a wood carving could easily have come before Rembrandt's eyes. The almost weird grandeur of expression in the painting makes us think of German works of the great era. Some came to the Netherlands. I would like to compare a group in the Church of St. Nicolas at Liège, carved by an artist from the Middle-Rhine at the beginning of the 16th Century.[18] The heroic rigidity of the German work affiliates it with the austere gloom of Rembrandt's painting. This reminds us of the fact that Rembrandt had many works by Old German masters in his collection, among others engravings by Martin Schongauer. We may imagine that a figure like Mary in *The Crucifixion* (B. 24, Lehrs 13) found a deep response in the master, especially as it continued a version treated by the Old Netherlandish painters.

While the Mater Dolorosa appears in the works by Rembrandt discussed above in symbolic timelessness, she becomes an exponent of the highest dramatic tension in some drawings which represent *The Lamentation for Christ*. It is remarkable how Rembrandt, in order to show glowing devotion and private religious feeling, took up again ideas formulated by Gothic painting. The most obvious points of comparison are offered in paintings by Rogier van der Weyden representing the same subject. The drawing in Berlin (Benesch 100 recto)[19] where Mary, in a wild outburst of grief, covers the face of the dead with kisses, takes up the version which we see in Rogier van der Weyden's altar in the Cathedral of Granada[20] (also in the Berlin replica).[21] This drawing was done about the middle of the 1630s, the climax of dramatic motion in Rembrandt's art. The drawing in the Wessenberg Museum, Constance (Benesch 883; fig. 129),[22] belongs to the mature period of the master (beginning of the 1650s). The nervous split of lines is replaced by quiet concentration. The groups are more closed. Mary's mourning loses its cramped, distorted frenzy, but increases in loving intensity. There is no doubt that Rembrandt

received inspiration from a composition which we see in Rogier's painting [formerly] in the Collection of the Earl of Powis, London (fig. 128).[23]

To the group of drawings from the end of the 1630s, connected with the Passion of the Lord, belongs an *Agony in the Garden* (formerly in the C. Hofstede de Groot Collection, Benesch 173; fig. 132).[24] The Apostles, who have fallen into deep sleep, are stretched in the foreground like plates of rock. The silhouette of Christ, turned towards the invisible angel, towers steeply up in the background. Several drawings and etchings of this subject by Rembrandt exist, but they all follow a familiar Baroque or Renaissance type of composition, and none shows so strong a Gothic accent as this figure of Christ. The Apostles, embedded into clefts of the terrain, go back to the engravings of *The Passion of Christ* by Dürer (B. 4, Meder 4) which Rembrandt had in his collection; St. Peter and the prostrate Apostle are easily recognized, in the reverse direction. Yet how different is Rembrandt's steep, pointed silhouette of Christ from the widely open, pathetic Renaissance pose of Dürer's Christ! We see clearly how Rembrandt tends to "medievalize" his figure. It is in character much more closely related to the *Christ* of Dürer's Late Gothic forerunner Schongauer (B. 9, Lehrs 19), also represented in Rembrandt's collection. There, we see this steep, fervent soaring in prayer. Yet we do not have to turn to German art to find closely-related examples. We can find many of them in Netherlandish sculpture of the 15th Century, for instance the group carved in stone in the Church of St. Peter in Louvain (fig. 131). Rembrandt's penstroke adopted, at the end of the 1630s, a particular harshness and angularity which lends his figures the character of roughly-framed sculptures. This makes the Christ in his drawing so similar to that in the sculpture, even in details such as folds of drapery.

As I mentioned before, the Gothic grammar of forms was so deeply rooted in the national temper of the Netherlanders that it was not at all eliminated by the beginning of the Renaissance; on the contrary, it blended in different ways with Renaissance forms, without changing the basic Gothic feeling. At the beginning of the 16th Century, we can observe this phenomenon in the works of the Dutch masters of the Schools of Leiden and Amsterdam, the very places of Rembrandt's activity. Jacob Cornelisz van Amsterdam enveloped the figures of his religious woodcuts in waves of exuberant drapery, knowing well the monumental and expressive value of those banked up masses of cloth from sculptures of the time of Claus Sluter. His woodcut of *The Agony in the Garden* in the series of the Large Passion (B. 2, Hollstein 68)[25] exhibits this expressive value as much as Rembrandt's drawing does.

Cornelis Engelbrechtsen of Leiden, the master of Lucas van Leyden, made use of the great flowing, comprehensive silhouette in the way of medieval art to underline the expressive content of a figure. Thus, in the figure of *Christ taking*

Leave of His Mother (Amsterdam, Rijksmuseum)[26] everything is subordinated to the great expressive accent of the curve which flows down His back and bends His whole body into one mighty arch, indicating the overflowing affection and loving sympathy of the Saviour for His mother. The same means were adopted by Rembrandt in his etching *The Return of the Prodigal Son* (B. 91, Hind 147), to visualize the same feeling of the father towards his son. Again it was the use of the draped lay figure in a particular way which achieved the desired effect.

I wish to return to Rembrandt's use of a figure draped in medieval style, and shaped after a medieval model. We saw in the case of Asnath in the Cassel painting (fig. 120) that such a figure served Rembrandt in his maturity to give an air of solemnity, of remoteness and elevation to a work. So he used medieval types of figures or compositions pre-eminently for religious subjects or scenes; yet occasionally they also entered Rembrandt's worldly portrait paintings. His knowledge of the Van Eyck bronzes may have fostered his imagination in creating such figures, yet we also have to assume other sources.

The Albertina possesses a beautiful late pen drawing by the master (Benesch 1167; fig. 90),[27] done about the time of the Cassel painting. It represents two women conversing with each other on the road. Their dresses are medieval. The taller and older one is reminiscent of the Mater Dolorosa in the way her head is covered with a veil. The younger one wears a costume very much like that of Asnath, with the characteristic Burgundian headgear. It would be hard to guess the meaning of this group if we were not aided by an engraving by the Westphalian master Israhel van Meckenem, mentioned among the artists collected by Rembrandt. Meckenem's prints offer a valuable repository of Gothic costumes and habits. The engraving (Lehrs 499; fig. 130) shows a couple on their way to church carrying a rosary and a prayer-book in a medieval book bag which consists of the parchment of the binding extended beyond the covers. Now we understand the meaning of the objects which the two women in Rembrandt's drawing hold in their hands. It is not probable that Rembrandt had a Biblical theme in mind when he made this drawing. Presumably he wanted to create only a genre scene of olden times as he saw them in Meckenem's prints: two women going to church.

It was a matter of course that figures of this type, inspired by works of Gothic sculpture, painting or engraving, developed into religious representations. As Asnath was inspired by the Van Eyck bronzes, so was Mary in a drawing of *The Betrothal of the Virgin* (Benesch C 81) which we know from a copy by a pupil (Washington, D.C., National Gallery, Widener Collection).[28] Mary appears there as a noble lady in Burgundian court costume, like Jacobea of Bavaria or the lady at the right. The woodcut in Dürer's *Life of the Virgin* (B. 82, Meder 194) gave rise to the composition of this drawing.[29] Rembrandt exchanged Dürer's figure of the Virgin for one familiar to him from native medieval art. It is interesting to notice

how Rembrandt was often more fascinated by the medieval elements in Dürer's art than by the Renaissance elements because to him they embodied the greater expressive values. From the composition of this drawing developed the painting *The Tribute Money* (1655; Bredius 586). Rembrandt's figures look much more bound and archaic than those of Dürer and give the impression of cathedral sculptures of the 13th and 14th Centuries.

On the reverse of a pupil's drawing in the Louvre occur two fugitive projects for a *Visitation* by Rembrandt (Benesch 1019; fig. 134).[30] They are full of solemnity and sublimity, proving the master's ability to conjure up a great idea even in the most accidental sketch. The pious devotion of Elizabeth, the humbleness and dignity of the Handmaid of the Lord are indicated in an unmistakable fashion. Again, we could assume a woodcut in Dürer's *Life of the Virgin* (B. 84, Meder 196) as a source of inspiration for such a group, all the more as the same woodcut had promoted the painting of the subject which Rembrandt did in 1640 (Bredius 562). Yet if we compare Rembrandt's drawing with Dürer's print, we notice that the feeling of sanctity is much stronger in the former. The radiant landscape and the majestic pose of the women in Dürer's print speak more strongly than the awe with which an impending miracle fills two pious souls. This awe was expressed much better by an anonymous Dutch master of the 15th Century in the shy and constrained gestures of his group which is closer to Rembrandt's work not only in spirit, but also in formal character.[31]

Rembrandt even recast the whole idea of the painting of 1640 in a magnificent late drawing of the second half of the 1650s (Benesch 1018; fig. 135), contemporary with the previously shown sketch. It forms part of the Walter Gay Bequest in the Louvre and is hitherto unpublished. The main compositional elements are the same in both works, yet Rembrandt has immensely increased the mood of sanctity, of religious foreboding, in the late drawing. All elements of Baroque stage-craft are discarded. The figures are rather heavy, blocky, and approach High Medieval sculpture more than Late Gothic. The columns become those of a Romanesque porch. The devotion of Elizabeth, filled with awe, is still more obvious in her deep genuflexion. As the Lord elevates those who humiliate themselves, she is the one transfigured by a ray of light falling from heaven.

In Rembrandt's late works, the boundaries between religious and profane art fluctuate. As he used elements of medieval art in order to enhance the expressive solemnity of religious representations, so he filled living persons whom he portrayed with the mood of the past, transporting them into a sphere of poetic elevation. In a most subtly and spiritedly painted *Portrait* of 1655 (Bredius 388, Stockholm; fig. 133), he represented an old lady in the Gothic dress which we know from religious characters. The costume is familiar from the Van Eyck bronzes. Thus, Rembrandt conjured up the memory of the old burghesses of

Flanders as Jan van Eyck and the Master of Flémalle portrayed them: tightly wrapped in their voluminous headgear, hands folded as if they were sitting in church.

The favourite sport of medieval aristocratic society was hawking. In tapestries, book illuminations, panels and drawings, we meet the knights and noble ladies who were devoted to it. In a silver-point drawing, a follower of Jan van Eyck portrayed a man in Burgundian dress with a hawk on his arm.[32] Rembrandt had a "tronie," a portrait by Van Eyck in his collection. In one of his most tremendous portraits of the 1660s, the aged master represented a contemporary as a falconer in archaic costume (fig. 11).[33] The pale face shines out of the sombre splendour of a bygone world, the world of chivalry and knightly games, now fallen to dust. He is a knight errant, belonging to an imaginary No-Man's Land.

A contemporary drawing in the Print Room of Dresden is a project for a life-sized hunting scene, where a lady rides out hawking (fig. 10).[34] She is a last descendant of the noble ladies who ride out to hunt in the calendar pages of the prayer-book of the Duc de Berry, painted by Paul van Limburg. If Rembrandt's painting had been executed, it would have been one of his most imposing creations. The master cherished the flavour of the world of the past.

In this last period, when Rembrandt concentrated increasingly on the single human figure as the bearer of a tremendous freight of thoughts, he painted many saintly persons, not only Christ and the apostles, but also nameless monks and hermits, praying or meditating. They are embodiments of religious attitudes or moods, often without a definite iconographic meaning. One of the most beautiful is the *Reading Monk* of 1661 (Bredius 307; Helsinki). A cowl envelops his head—his features sink into anonymity, only slightly illuminated by the reflexion of the page. He is the embodiment of religious meditation. In his anonymity, he approaches closely the mourners that in France and the Netherlands surround the tombs of princes, such as Philippe the Bold and the Duc de Berry. Those works by followers of Claus Sluter embody the mood of grief, of meditation, of devotion. The men are shrouded in complete anonymity, yet the eloquence of these silent, draped figures is so great that we understand their language better than the weeping of the putti on Baroque tombs. Through hiding and concealing, they reveal all the better—a principle valid also in the art of the late Rembrandt.

A subject and composition very popular in the Middle Ages, yet almost forgotten in the era of Rembrandt, was that of the pious knight St. Martin who shares his cloak with a beggar. A painter of the school of Haarlem, a follower of Geertgen tot Sint Jans, represented the Saint as a nobleman,[35] leaving the gates of a city on a graciously ambling horse; he turns round towards the poor man who receives the gift. The twists of figures and horse are typical of the Late Gothic style. Rembrandt, in a monumental drawing of about 1660 (Benesch 1051; Musée

Communal, Besançon),[36] interpreted the Saint as a hardened warrior clad completely in steel. We do not know how Rembrandt acquired his knowledge of armour and weapons of the 13th and 14th centuries, yet he gave them to his Saint who wears a basinet, the helmet of the High Middle Ages. St. Martin halts for a moment on the road, forming, together with the beggar, a massively towering structure which has in its weightiness and simplicity more in common with High Gothic than with Late Gothic works.

We could enlarge upon Rembrandt's relation to medieval art on the basis of many more examples from his late period. For instance, his grandest etching, the *Three Crosses* of 1653 (B. 78, Hind 270), renders the whole Calvary with a variegated crowd thronging around the crosses and milling on the hill. In this way, the Northern masters of the first half of the 15th century interpreted the Crucifixion as an epic mass scene. The altar wing in the Metropolitan Museum, New York, attributed by some scholars to Hubert van Eyck, by others to an early Dutch master, may serve as an example.[37]

In conclusion, I wish to touch upon the work of Rembrandt which is perhaps most thoroughly imbued with a solemn medieval spirit: The *Adoration of the Magi* of 1657 (Buckingham Palace, Bredius 592; fig. 68). Darkness lies over the scene. It is not the darkness of a particular hour, but rather the darkness which reigns unceasingly in the high naves of a cathedral. A ray of light, streaming down almost vertically, illuminates the main group. Its austere ceremoniousness is striking. The old king genuflects deeply before the Infant Saviour. His humbleness is made still more manifest by the two chamberlains who follow Him and worship in reverent distance. Their parallel figures counterbalance the enthroned Virgin. Restraint and parallelism are familiar features in Old Dutch art. In Geertgen tot Sint Jans' painting in the Oskar Reinhart Collection in Winterthur, Switzerland,[38] two of the Magi kneel down like brothers before the Virgin who does not move out of her stiff reserve. This reserve becomes in Rembrandt's painting the expression of religious awe and sanctification. The lack of outer movement conceals spiritual emotion. The Virgin looks like an idol in her mystical remoteness. The Eastern figure of the Moorish King with the burning censer crowns the adoration group like a tower. The third king, wearing the crown of an orthodox dignitary, approaches with a gesture of surprise and awe. Schmidt-Degener thought that this figure was inspired by that of the Emperor in Van Eyck's series of bronzes. Yet his majesty and solemnity are more closely related to the Biblical kings at portals of the High Middle Ages. In their archaic restraint, the figures are as if enclosed between imaginary picture planes. The space in which they move seems to be no earthly one. It is related rather to the ideal space of Byzantine mosaics, as is the mystic sparkle of colours in the painting. It is not impossible that Rembrandt saw Byzantine or Russian icons. Yet such relations evade the proof of an apparent

influence because they are too deeply hidden in the essentials of the work of art.

I hope that even this fragmentary demonstration may give an idea of how much the medieval world, the world of the cathedrals and their art, meant to Rembrandt. It was deeply anchored in his artistic consciousness. He was strongly attracted by its austerity and mysteriousness. In 1640 Rembrandt drew a series of English cathedrals, among them a *View of the Cathedral of St. Albans* (Benesch 785; fig. 136).[39] They do not prove that Rembrandt visited England, as was wrongly assumed, because Rembrandt did not sketch them from reality. Yet they prove how much those solemn and monumental creations of the human genius occupied his imagination, not only filling the dream world of his paintings, but also imbuing many of his most sublime creations with their spirit.

January 6, 1945.

"Melanges Henri Focillon," *Gazette des Beaux-Arts* xxvi, July–December 1944, published in New York, 1947, pp. 285–304.

Rembrandt's Artistic Heritage—From Goya to Cézanne

REMBRANDT, mainly in his late period, established a new idea of artistic completion, which was previously unknown in Western art. The master, who in his youth had begun with highly finished and technically elaborated paintings, ended with a broad, improvising and rhapsodic style which puzzled many a contemporary, and angered the theorists of sleek academicism which became increasingly fashionable in the days of the old Rembrandt. Streams of liquid gold and fire run through his late paintings. The colour is roughly patched on his canvases with the knife, the finger, or a linen pad, so that they seemed incomplete to the master's contemporaries. Yet Rembrandt himself declared that a painting was complete when the intended artistic purpose of its creator was obtained, without regard to its outer perfection. Rembrandt had first developed this new idea of completion in his drawings; in his late years, he applied it increasingly to his paintings. Almost no one understood him in his time, yet in the 19th century understanding of what we call "the true Rembrandt" was growing. Rembrandt experienced another revival in the 19th century, different from that of the 18th century which was mainly interested in his picturesque early periods. This revival, however, is more concerned with the essential achievements of his art than with its outer aspect. The great modern painters opened the way for it; Goya took the lead.

Spain, which had ceased to be a centre of creative artistic production, became the meeting place of foreigners in the 18th century. In the 1760s, the old Tiepolo inflamed his decorative genius to its last glory in the ceiling frescoes of the Royal Palace in Madrid. At the same time, Anton Raphael Mengs, the apostle of the Neo-classicist creed to which the famous archaeologist, Winckelmann, had given his blessing, developed his activity as a court painter. These opposing trends found their precipitate in the art of the Spanish painters. Goya, with his great innate painter's instinct, was quite naturally drawn more into the sphere of the Italian Baroque painters. Although he was not entirely unaffected by Mengs' excellent portrait paintings, Goya, with his naturalism and pictorialism, detached himself from the Neo-classicism of the academics. He gave expression to the heritage of the Italian Baroque masters Crespi, Piazzetta, and Tiepolo in his huge ceiling and altar paintings for Spanish cathedrals. In 1771 he had himself been in Northern Italy. His innate inclination towards pictorial and expressive values was too strong for him not to have come into the Italian sphere of influence. His position may be compared to that of the Austrian church painters to whom he shows astounding parallels in his religious works. Together with the Italian pictorial tradition, Goya

also received the tradition of Rembrandt's dramatic and expressive chiaroscuro. This comes distinctly to the fore in the altar painting, the *Seizure of Christ*, painted in 1788 for the Sacristy of the Cathedral of Toledo (fig. 137).[1] The manner in which the emotional, distorted faces of the bailiffs—evoked like a host of monsters from darkness through screened torch-light—surround Christ's figure, reveals the true Goya whom we know from his nightmarish visions. His brushwork has a sketchy lightness, but at the same time it has an unfailing sureness of touch which distinguishes him strongly from the smooth perfection of the academic Neo-classicists.

This consideration might lead us to the conclusion that Goya was opposed to the general artistic tendency of his time, that he moved on a side-line which had nothing in common with the art of about 1800, and that he anticipated tendencies which came to a final break-through in the Romantic era. We would be correct in our assumption, if we simplified the problem to the extent of regarding the Classicism of between 1770 and 1810 as of one kind, that is, the academic. For instance: the *Parnassus*[2] by Mengs seems indeed to be separated by an abyss from all that Goya stands for. Clearness of line, polished surfaces, glossy colouring, intellectual arrangement, complete absence of chiaroscuro and of any sign of emotion, are its main features. As great as was Mengs' fame in the Neo-classical era, historical justice would rather call Goya the greater, and therefore the truer, artistic representative of his time. We do not consider the linear smoothness of Méhul and Cherubini as the most faithful musical expression of the spirit of the time, but rather the colourful block-like momentum of Beethoven. In poetry, we have, besides the crystal-clear world of Goethe, the colossal and fantastic visions of Jean Paul and William Blake, who are equally representative of the time. Which of these two tendencies is the true meaning, the common denominator of that enigmatic era of Neo-classicism?

To look back into the 17th century may further our understanding. In that period also, the restrained and intellectual classicism of Poussin parallels the art of the old Rembrandt, which presents classical tendencies in its own way. A theme of classical history, *The Conspiracy of Julius Civilis* of 1661 (Bredius 482; fig. 2)[3] confronts us with a group of figures welded together into cyclopean blocks which resemble those in Goya's late works as, for instance, in the murals from his country house. All Baroque diagonals crossing space, all picturesque eruptions of silhouette, have been abandoned. The forms are blunted, tightened, compact, spread out in a relief of classical simplicity; and yet they retain their tremendous realism. These block-like forms are fluorescent from an inner light, which makes their cyclopean architecture vibrate with inner tension. An immense eruptive force seems controlled by these tremendous blunted silhouettes, which are saturated with atmosphere and are of an extraordinary spatial suggestiveness. We see similar features in Goya, as for instance, in his *Siege of a Rock*, at the Metropolitan Museum, New York.

We can now understand what Goya meant when he said in his later years that nature, Velázquez, and Rembrandt were his masters. While in his youth he was inspired by the Baroque and Rococo tendencies of Italian and French art, in his maturity he increasingly approached the classical style of the late Rembrandt. This approach was caused by the necessity of Goya's own inner development, and not a result of outside influence.[4] This kind of relation to Rembrandt was decisive for all great artists after Goya, into whose genealogy Rembrandt enters.

The spiritual meaning of this kind of classical art, which can merge with the most startling realism, may also reveal to us something of the ideological structure of the era of Goya, into which the French Revolution and the Napoleonic Wars fell. That era was charged with eruptive energies, which the colossal social and political concepts attempted to unify and to master.

We notice that Goya gradually adopted Rembrandt's concept of artistic completion. His works up to 1800 do not reject the usual characteristics of 18th-century art. In 1797, he painted circular porticoes with allegories of different activities in the state, for the palace of the prime minister Godoy.[5] In taste, they are not too far from Mengs' academic Neo-classicism. The preparatory sketches for these porticoes are much freer and more pictorial in style—as for instance, the one symbolizing *Commerce* in the Van Beuren Collection, New York. A merchant in his office is bent over the accounts, bathed in a stream of Rembrandtesque light which flows through a window and glides slightly over the figures of the clerks in the shadowy depths of the hall. The little picture is charming in its light-effect, but not essentially different from Fragonard.[6] [See Fig. 147.]

Since 1793 fantastic and demoniac subjects, which previously were admitted only into the framework of religious painting and its traditional iconography, began to appear as proper content of pictorial or graphic representation. Goya suffered a severe illness in 1792 which deprived him of his hearing. In a letter to Yriarte dated January 1794, he wrote that in order to occupy his fantasy, mortified by the illness, he had embarked on paintings in which caprice and invention had no limit (as for instance the *Lunatic Asylum*, Vienna, Kunsthistorisches Museum).[7]

From 1793 to 1798, Goya worked on a series of etchings entitled *Los Caprichos*[8] in which he followed the traces of Tiepolo's *Capricci* and *Scherzi di Fantasia*.[9] The purpose of the series is a moralizing one, to scourge aberrations in human society, monsters produced by the sleep of reason. Yet Goya recognized the sleeping reason within himself, and one sometimes gets the feeling that the artist, who was now isolated and enclosed in the world of his imagination, tried to exorcise the evil spirits by drawing and painting them. The *Caprichos* are masterpieces in the handling of the etching needle. Figures are seen not as combinations of lines, but as masses in hazy space. Often they are condensations of atmosphere like the phantom spying behind the monks who enjoy their drinking with the words: "Nobody has

seen us." The phantom is a vibrating colour surface without any confining outline at all. This technique harks back to Tiepolo and Rembrandt. The addition of mezzotint creates a half-tone which permits the sparing out of spotlights evoking faint reflections in the half-dark. This is still that kind of effect Rembrandt created by the incidence of light, which is familiar in the 18th century.

How different is the treatment of light in a mature etching of the cycle *Disasters of War*, on which Goya worked from 1810 to 1820. This can be clearly seen in the introductory print entitled *Sad Presentiments of What is Going to Happen* (fig. 140). A terrified man kneels in the darkened space, and extends his arms in a deprecating gesture. His pale figure is surrounded by indistinct spectres roaring through the gloomy air. The figure seems to shine by its own light, and even the darkness glistens from sparks. Goya could dispense with the drenching medium of mezzotint because the oscillating rhythm of the lines sufficed to create the illusion of light. Rembrandt proceeded likewise in his etchings after 1650.

Subjects which Goya treated in the *Caprichos* in a sarcastic and satirical way later grew to weird grandeur. An example is given by a life-sized painting in Lille representing two old *Majas* who compare their former likeness with their image in the looking-glass. The substance of laces, silks and jewellery glows in a phosphorescent light while Chronos, the God of time, glides over the old coquettes on soundless wings woven from light; he is ready to sweep them into nonexistence with his broom.

As much in the mode of Rembrandt as the pictorial means of this and other paintings with similar themes may be, their content is foreign to Rembrandt. Rembrandt never made the sarcastic, diabolic and inhuman subjects of his deeply human art. Nightmares were foreign to him. Goya acquired a country house which he adorned about 1815 with wall paintings of his own choosing. People called it *La Quinta del Sordo*. There, not responsible to any patron, he unleashed the full vehemence of his grandiose fantasy. These wall decorations in oil are the most representative paintings of Goya's last, the so-called "dark period". In this period, he made extensive use of black—that deep saturated black which he always liked for the design of his brush-work—set into wonderful greys or contrasted with creamy whites. It is the black which later in the century inspired Manet so strongly. Here, it forms the deep night of cosmic space out of which the spectres, the offsprings of the painter's fantasy, glow in broad, phosphorescent brushstrokes. *Two Old Witches* (fig. 141) lap their soup; their mask-like faces resemble death-skulls. All earthly relations cease in this realm. We may imagine that these spectres are mountain-sized.

An old hermit looms up in the darkness. An evil spirit behind him tries to tempt him by persuasion. The scene brings to our mind the diableries of Hieronymus Bosch which Goya could see in Madrid and in the Escorial.

Although the content of these fantastic, immensely expressive paintings is foreign to Rembrandt, they are related to his very late paintings in many ways. The brushwork is of the most daring breadth. The colour is mainly applied with knife, finger and pads of cloth. It glows out of the darkness with a phosphorescent quality. In general, the deep gold tone of Rembrandt deviates from Goya's tonality which tends towards grey and pitch-black. Yet in paintings of the 1660s Rembrandt also sometimes made the figures shine out of nearly black darkness in a ghost-like way. The figures are comprehended in massive, clumsy silhouettes but have a phantom-like quality, and seem to be condensations of atmospheric space. The inspiration which Goya received from the broad brushwork of Velázquez, can already be noticed in the tapestry cartoons. He did not take up the broad brushwork which makes us think of the late works of Rembrandt before his own late period. Like the late Rembrandt, Goya was furthered in this regard by his activity as a draughtsman.

Like Rembrandt, Goya was a most assiduous draughtsman, observing and noting down the reality of life around him. More than one thousand drawings by him are preserved, most of which are executed with soft chalks or brush. Although in many of them Goya prepared his fantastic inventions, still more deal with real human life—life in all its sadness, cruelty and unbelievable grotesqueness, rivalling the boldest inventions of an artist's fantasy. Actually, we cannot draw a strict line of demarcation between reality and fantasy in Goya's drawings. Their human tone, apart from all technical similarities, all atmospheric and luminous qualities, unites them with Rembrandt's drawings. This becomes particularly evident in Goya's *Study of a Beggar*, Metropolitan Museum of Art.

Goya witnessed the most horrible reality during the years of the Napoleonic invasion as well as the famine and epidemics which followed it. No one has ever delineated the *Disasters of War* in such a breathtaking way as he in his series of etchings. In the *Desastres de la Guerra* Goya is not only the chronicler of the most incredible realities, but also the admonisher and prophet, the voice in the desert. This political work is not only his greatest, but also his most human one. He speaks in the name of tortured mankind. In one of the philosophical, concluding prints he represents a half-decayed corpse rising from the tomb and writing the single word "*Nada*" (fig. 48)—Nothing—a comment on the turmoil which vanishes into cosmic space like a host of gleaming spectres [see p. 78].

In works of generally human content, such as scenes from real life, portraits and religious representations of his last years, Goya's spiritual affinity to Rembrandt comes most to the fore. Goya's religious paintings of the "dark period" are doubtless his deepest. They reveal that, in spite of his scepticism with regard to the world, there dwelt in the old master a deeply faithful soul. In 1820, he painted for the church of St. Anthony the *Last Communion of St. Joseph of Calasanz* (fig. 138),[10]

the saintly educator, the patron of children. He kneels in the nave of a cathedral plunged into deep night, out of which crowds of little schoolboys shimmer. Light from the beyond transfigures him and the celebrating priest who offers him the host. The Saint closes his eyes and the features of the dying man assume the expression of a deep inner peace and happiness.

In these last years Goya painted *Saint Peter* and *Saint Paul*[11] in half-lengths— two of his greatest masterpieces. Their similarity to the apostle figures which the old Rembrandt painted in the 1660s is striking, both in technique and in spirit. *Saint Peter* appears like a huge pyramidal block, like a rock or a mountain, yet is of the utmost pictorial lightness of texture. The broad brushstrokes glimmer on the dark ground which shines through the lavender blue and yellow of the garments, the reddish skin and white hair. As in Rembrandt's saints, the human content prevails. Saint Peter, after having denied the Lord, is represented in a state of contrition and deep remorse. The old man, with tears in his eyes, folds his hands pityingly. The awkwardness and ruggedness of this proletarian saint make him twice as moving and expressive in his naïve faithfulness and devotion. *Saint Paul* (fig. 139) is his worthy companion, a monumental block whose inner modelling is fused with the most tender pictorial unity. His clumsy grasp of the sword, his trustful look towards heaven, prove his sincere will to stand for the Lord's cause.

As in the case of Rembrandt, these characters are true images of the master. Goya's own naïveté, awkwardness and creative genius are mirrored in them. As Rembrandt freed his pictorial technique from all fetters, so did he lay bare the human character without any mask of social convention. One of the most stirring *Self-Portraits* of the old Rembrandt (Bredius 61; Wallraf-Richartz Museum, Cologne) was thrown on the canvas in a *furioso* of creative impulse which neglects all accepted notions of painting: Rembrandt pausing in his work, and laughing a silent laugh at the vanity of the world, because he knows what matters in reality. In a similar grandiose improvisation, the old Goya represented himself at work (Vienna), cunningly laughing at his image in the looking-glass and at the world which looks at his portrait—a laugh full of wisdom and divine humour about the *Corral de Locos*, the mad-house of the world.

When the seventy-four year old Goya arrived in Bordeaux as a political refugee from the reactionary oppression in Spain, he stayed only a few days in the city which was to become his last home, and continued his journey to Paris, eager to see the world. He arrived in Paris in time to see the memorable exhibition of 1824 in the Salon—that show which brought the works of the great English painters, mainly Constable, before the French public for the first time and made a deep impression on French artists. We know its effect on Delacroix, who exhibited his *Massacre de Scio* in the same show. There, Goya could have seen one of Constable's

views of the English countryside which raise a modest motive to true monumentality, as for instance the *Windmill*, National Gallery, London,[12] that so imposingly crowns the hill under a sky covered with drifting storm clouds. He may have felt that Constable's broad open brushwork was related to his own, and that these landscapes were the only ones since Rembrandt which revealed a cosmic feeling similar to that revealed by the great Hollander. Constable was the only English artist to whom Rembrandt was not only a model for technical improvement, but also a source of deep inspiration. The ambitious William Turner intended to create a counterpart (formerly Sir Herbert Cook Collection, Richmond, England)[13] of Rembrandt's *Windmill* in the Widener Collection.[14] Although he consciously emulated Rembrandt's magic light, he lagged far behind the naive grandeur of Constable's vision of nature which unconsciously came much nearer to Rembrandt's powerful concentration.

Eugène Delacroix, the greatest and most universal intellect among the French painters represented in the show of 1824, was a deep admirer of Rembrandt. The paragraphs on Rembrandt in his *Journal*, essays and letters are among the most revealing 19th-century writings on Rembrandt. Delacroix was also an admirer of Goya, whose works he copied in sketches.

Delacroix formulated Rembrandt's new idea of artistic completion in clear sentences. He wrote the following with the heading "First Thought" in his draft for a *Dictionnaire des Beaux-Arts*: "The first outlines through which an able master indicates his thoughts contain the germ of everything significant that the work will offer. Raphael, Rembrandt, Poussin—I mention these particularly because they are brilliant above all in the quality of thought in their studies—make a few rapid strokes on paper, and it seems that there is not one of them but has its importance. For intelligent eyes, the life of the work is already to be seen everywhere, and nothing in the development of this theme, in appearance so vague, will depart in the least from the artist's conception: it has scarcely opened to the light, and already it is complete" (25th January, 1857).

His own drawings demonstrate that this theoretical insight grew out of his artistic practice. An ingenious drawing of a classical subject *Odysseus Recognized by his Old Nurse* (Louvre) shows the flaming up of the first idea in a completeness akin to Rembrandt.

Time and again Delacroix preached that the artist should omit secondary things and concentrate on the essential. Rembrandt was to him the unsurpassed model in this respect. Delacroix, the great admirer of Raphael, mentions the latter's method of drawing the figures of a historical composition as nudes in the preparatory work and continues: "I am very sure that if Rembrandt had held himself down to this studio practice, he would neither have that power of pantomime nor that power over effects which makes his scenes so genuinely the expression of nature. Perhaps

it will be discovered that Rembrandt is a far greater painter than Raphael" (6th June, 1851).

"Perhaps that elevation that Raphael has in the lines, in the majesty of each one of his figures, is to be found again in Rembrandt's mysterious conception of his subjects, in the deep naturalness of expression and of gestures. Although one may prefer the majestic emphasis of Raphael, which perhaps belongs to the grandeur of certain subjects, one might affirm, without causing oneself to be stoned by men of taste, that the great Dutchman was more natively a painter than the studious pupil of Perugino."

The Assassination of the Bishop of Liège 1829 (fig. 49) may serve as an illustration of what Delacroix meant by power of pantomime and power over effects. A high, deep and gloomy Gothic hall illuminated by the glow of candles on a festive banquet table is filled with the roaring turmoil of the soldiery of Guillaume de la Marck. The composition is "unclear" in the same way as an early work by Rembrandt, filled with the flickering struggle of dark and light. But how convincingly did Delacroix render the seething uproar.

In his mature works, Delacroix showed an even deeper understanding of Rembrandt's principles than in his early ones. The influence of Rembrandt on particular works becomes quite evident. Rembrandt's etching of *The Raising of Lazarus* inspired Delacroix in 1850 to do a painting (fig. 143) of the same subject.[15] The chiaroscuro has now gained much more of that unifying and diaphanous character, that expression of mood which Delacroix called "the limitlessness of reverie and attitude". The painting reveals that he himself had attained "the deep naturalness of expression and of gestures" which he admired so much in Rembrandt. From the Romantic pathos of the *Bishop of Liège*, Delacroix had proceeded to the divine lightness of his late style, where everything is expressed with the greatest ease, charm and intensity, where the lights become liquid jewels and the shadows a golden glow.

Delacroix turned from his idol Rubens to Rembrandt. Paintings of religious subjects, especially, show the increasing spiritualization of Delacroix' late style in its approach to Rembrandt (*Agony in the Garden*, Pastel, 1847).[16] Delacroix was not religious in the same sense as Goya, yet his soul was deeply moved by the miraculous and sublime.

The most inward paraphrasing of a Rembrandt subject ever painted by Delacroix is *The Supper at Emmaus* (fig. 142) of 1853.[17] Delacroix greatly admired the Venetian masters, especially Veronese and Tintoretto. The composition and setting of this painting were evidently inspired by the Venetians. We recognize the chord of intense red and greenish-blue characteristic of Veronese. Christ's halo flares up in the hall darkened by a curtain. This recalls the visionary light of Tintoretto. Yet this strong dramatic accent is softened by the deep mood which pervades the

scene with the growth of dusk. The evening gloom which made the travellers seek shelter, pervades the old timbered hall. In it the miracle acquires that silent mystical poetry which is apparent in Rembrandt's *Emmaus* picture in the Louvre (Bredius 597) and in his etchings. Delacroix described it as follows: "Rembrandt makes flare up before your eyes the lightening which strikes the disciples at the moment when the divine Master transfigures himself breaking the bread" (25th January, 1857).

Delacroix said that Rembrandt had more of the ideal than David. He wrote that Rembrandt when he painted a beggar in his rags, acted in the same way as Phidias when he modelled Zeus and Pallas. Delacroix contrasted Rembrandt with "beauty" as it was promoted by the school of Ingres. He recognized the inner beauty of Rembrandt's world which may appear in ugly and repellent features. Delacroix' friend Baudelaire wrote the following verses:

> *"Rembrandt sad hospital that a murmuring fills*
> *Where one tall Crucifix hangs on the walls*
> *Where every tear-drowned prayer some woe distils*
> *And one cold wintry ray obliquely falls."*

<div align="right">(LES PHARES)</div>

Honoré Daumier and Delacroix were almost contemporaries, and yet they belong to two quite different worlds. The romantic spiritualist, who saw everything in the enhanced light of poetry, contrasts with the realist who depicts the life of the little people in their narrow world, the hard lot of the poor and oppressed, of labourers and outcasts of society. The court of justice, the slums of old Paris, the railroad, the political arena, the theatre, the fair—these are the stages of Daumier's dramas. He was the first to find a striking formula for human beings as an anonymous mass, as social beings who act impulsively and in the frenzy of passion. The time which brought a revival of Baroque tendencies, may explain the chiaroscuro, and the wavy and flaming rhythm which Delacroix' and Daumier's pictures have in common. The artists knew and appreciated each other. Yet Daumier came from lithography, from the drudgery of cartooning from which he could free himself for only a short while to indulge in the beloved activity of painting. A sculptor's genius was hidden in him, and he endowed his realistic subjects with a Michelangelesque grandeur.

Apart from related features due to style and time, Delacroix' and Daumier's paintings have one thing in common: the notion of painting as something growing, developing and revealing the artist's struggle with the problem. Delacroix wrote of Titian and Rembrandt: "Titian probably did not know how he would finish a painting. Rembrandt often must have been in the same situation. His tremendous

raptures are less a result of his intention than of his successive attempts." The brushwork remains open like a drawing. It is Rembrandt's idea of the completion of the apparently incomplete, which Goya inherited from him and handed down to the great modern painters. It allows a concentration on the essential points as was never attained before. One of Daumier's most grandiose canvases *The Uprising*,[18] would not have come about without this achievement. All spiritual energy is concentrated in the man in the centre acting like a sleep-walker, as the foremost exponent of the electrified mass of people behind him. He is sketched with the brush in thick flaming outlines, like a rapid spontaneous drawing. The faces around him vanish into anonymity. Further completion would have extinguished the white heat of emotion.

Another equally great work is the *Ecce homo* (1850; fig. 144) in Essen.[19] The mob rages and cries: "We want Barabbas". One thick stroke outlines here a head, there a hand, yet we *feel* the seething furor of the mass of people. The protagonists are shown as silhouettes, blurred by a veil of atmospheric space. Yet how sublime is the figure of the sufferer in its simplicity, how eloquent the gesture of Pilate, the unmoved physical brutality of the giant jailer! With a minimum of means a maximum of expression is attained. This is truly in the spirit of Rembrandt!

Daumier could not have come to this utter simplification without the experience of the draughtsman who knew well how to group the masses in light and dark with crayon and brush to attain that abstraction which is a preliminary to monumental art without being a detriment to striking realism.

This great sculptor in black and white, in light and shade knew how to create a figure as an atmospheric phantom, as a condensation of light, as Rembrandt and Goya did before him. *The Sculptor*, Phillips Gallery, Washington D.C., is the most ingenious improvisation of this kind. Greyish spectral light renders concrete in the darkness of the studio the figures of the artist and his critic who contemplates a plastic group. Outer description of reality has been kept to a minimum but the spiritual content—silent scrutiny of a work of art—is more eloquent than ever.

If modern artists found the way back to Rembrandt, it was mostly the outcome of a deep inner urge, rising with the artist's own problems. This was the case with Vincent van Gogh. The expressive values, achieved by Delacroix and Daumier, rose to new power after the era of Impressionism which was devoted more to the problems of rendering optical sensations than content. Post-Impressionist art rediscovered the importance of spiritual content. Pictorial refinements were readily thrown overboard if they were meaningless. Van Gogh strove for expression of the human content in painting. So Rembrandt, the greatest figure of his national ancestry, came to new life in his artistic conscience. In the last two years of his troublesome life, Van Gogh frequently copied Delacroix, Daumier and Millet. His copies are free paraphrases—completely new creations. Two of them he dedicated

to Rembrandt. The *Vision of an Angel* (fig. 146)[20] was copied after a painting by Aert de Gelder then considered a work of the late Rembrandt.[21] Van Gogh was attracted by the way in which the figure is woven out of light. He changed the glory of oscillating rays into a mystical pattern resembling the fire ball of the sun which rolls over the hills of his flaming landscapes. The angel's face has the deeply human traits which Van Gogh observed in the faces of poor people.

He wrote to his brother Theo, in May 1890 (*Letters*, German Edition, Berlin 1914, no. 613), from St. Rémy: "On the other side of this, I have scribbled a sketch after a painting I have done of three figures which are in the background of the etching *Lazarus* (Hind 96): the dead man and his two sisters. The cave and the corpse are white yellow violet. The woman who removes the handkerchief from the face of the resurrected man has a green dress and orange hair; the other, black hair and a gown of striped green pink; behind a countryside of blue hills, a yellow sunrise." Van Gogh melted the visible world down in the furnace of his imagination in order to create a new cosmos—a cosmos which stood as a promise before his wrestling soul. He broke down before he could enter the Promised Land. Here, he translated Rembrandt's chiaroscuro into the burning colours of his vision. The flaming rhythms of Delacroix and Daumier became a conflagration in his work, to which he devoted himself with religious zeal.

As Goya started the 19th century, so Paul Cézanne concluded it. The greatest French painter of the 19th century laid the foundation of the 20th. No path seems to lead from the deeply mystical, emotional world of Rembrandt to the hermetic grandeur of Cézanne's form. Yet, just as Rembrandt finally succeeded in synthesizing his emotions into a great, universally valid form, so the tremendous logic of Cézanne, the admirer of Poussin, seems in his last works to vibrate with an inner tension and to break up, so that something immensely human comes to the fore. This is mainly the case in the last portraits, like the *Vieux à la Casquette* (Venturi 717; fig. 145).[22] The deep blackish blues of the late Cézanne's palette have no relation to Rembrandt; but the great synthetic form, full of inner vibrancy, and an almost terrifying presence of the human, is very closely related to Rembrandt's last portraits. In these last works there returns something of the sombre, chaotic grandeur of the works of Cézanne's youth, which were much indebted to Delacroix and Daumier. At the time when he and Zola were in college, Cézanne worshipped Rembrandt.

A human life is too short a stretch of time to embrace all artistic, cultural and human reactions, which a gigantic oeuvre like that of Rembrandt is bound to evoke. We therefore see the drama of Rembrandt's life extend itself into the centuries to come: initial acknowledgment, growing precaution, prejudice, refusal, even neglect, derision and hatred, and finally, triumph—Rembrandt, like a tremendous star, the influence of which outmatches all others, seems to hover above the history

of Western painting and drawing during the last three centuries, and to evoke in turn all the evil and friendly forces which threatened and fostered his own life. Thus he becomes a symbol for the idea of creative artistic genius in this era. The spiritual vigour of his work is as much alive today as it was in his own century, and we could not forsee its end without forseeing, too, the decline of our artistic culture.

[This is a later version in English in two parts of *Rembrandts Vermächtnis* (pp. 57–82) which is based on a manuscript for two lectures given in the Phillips Memorial Gallery, Washington, D.C. in the winter of 1945. Part I (published in *Gazette des Beaux-Arts* XXXIII, New York, May 1948, pp. 281–300), although somewhat changed, repeats the German text in its general line of thought. Thus it is not reprinted here. Part II (ibid LVI, Paris, July 1960, pp. 101–116) has been enlarged and revised by the author; a few illustrations have been added here.]

Rembrandt as a Draughtsman

[This essay is a summary of previous writings on Rembrandt's drawings and was later more fully developed and published by the author as the introductory essay to *Rembrandt as a Draughtsman* (London, 1960). It is therefore not reprinted here.]

"Rembrandt als Zeichner," *Mitteilungen der Gesellschaft für vergleichende Kunstforschung in Wien*, I. Jg., Vienna, 1948, pp. 7–8.

An Unknown Rembrandt Painting of the Leiden Period

O N the occasion of a visit to the Musée des Beaux-Arts, Tours, in the autumn of 1952, my colleague Boris Lossky, the Director of the museum, drew my attention to a small wood panel which had recently been cleaned and which, in his opinion, showed close affinity to the works of Rembrandt's Leiden circle.[1] My surprise was all the greater when I was faced with an entirely unknown, genuine early Rembrandt of the highest quality, which showed the handwriting of the young master in every stroke of the brush.

The picture in question is painted on an oak panel, measuring 37 by 36 cm. It bears the initial 'H R' in capitals in the lower right corner and represents *The Flight into Egypt* (Bauch 43, Bredius, third edition, 532A; fig. 148). We see the Holy Family stumbling along through the darkness of the night, with Mary seated on the mule, which is cautiously guided by St. Joseph. The group moves out of the picture, striding towards the lower right hand corner. The diagonal of this movement is emphasized by the pose of the mule whose bent neck and head point in the same direction. To counterbalance this, the painter has enhanced the monumentality of the composition by placing the figure of Mary high up and directly above the figure of St. Joseph. This compositional device is characteristic of the young Rembrandt. We meet it in various paintings of the early period: in the *Balaam* of 1626, Bredius 487 (the riders above the irate prophet), in the *Simeon in the Temple*, Bredius 535 (the figure of Hannah above Mary and Simeon), and the compositions of two lost early paintings which are preserved in etchings by van Vliet: *The Baptism of the Eunuch* (B. 12; fig. 61)[2] and *Lot and his Daughters* (B. 1).

St. Joseph is walking barefoot. He wears a wide-brimmed straw hat, the wavy silhouette of which is a Mannerist touch, reminiscent of certain pastoral figures of Bloemaert which, in their turn, are connected with Mannerists of Antwerp and Brussels such as Jodocus van Winghe. Here is one more hint of Rembrandt's connexion with the school of Utrecht. St. Joseph's coat, made of thick woollen cloth, is painted in a greyish-pink colour with a suggestion of red copper; a yellow patch is fastened to his right shoulder. Mary is wrapped up in a coat of bluish-grey and wears a turban, which gives her the aspect of a sibyl. The travellers' luggage is heaped onto the back of the mule; we notice among it the carpenter's tools : a drill and a saw.

The paint, although carefully modelled, is applied thickly and has a pasty quality, which causes minute cavities and furrows—the "tracks" between the brush strokes meandering over the gesso ground. The coloured surfaces have a

porous quality, which betrays the skilled etcher and draughtsman, who seems to have been affected by the technique of Seghers' paintings. We notice this peculiar surface quality particularly in the textiles, but it appears also in Joseph's right hand. The draughtsman is at work everywhere and the connexions with well-known works of the early Rembrandt are numerous. The mule may be compared with the ass in the *Balaam* and the carpenter's baggage with that of the prophet. Even a walking-stick is drawn in both paintings in the same way. The heavy leaves of a gourd fill one corner of the foreground in both paintings, although they appear in the *Flight* only as a shadowy silhouette against the moonlit path. Similar plants may also be seen in *The Baptism of the Eunuch*.

Even in works on a small scale, the young Rembrandt proved himself an artist with the gift of monumental conception. It has already been pointed out that the composition, with its emphasis upon a towering vertical, has a monumental quality. The same proves true of every detail. The young Rembrandt preferred to risk a certain clumsiness rather than deny his gift for monumentality. Every detail reveals an emphasis on plasticity. St. Joseph's naked legs tread the ground like columns. One may compare his right foot with that of Delilah in *Samson and Delilah* of 1628 in Berlin, Staatliche Museen, Bredius 489 (Bauch 4). The modelling of the mule's legs is coarse and clumsy like that of the horses in *David showing the Head of Goliath* of 1627, Bredius 488 [Basel, Kunstmuseum]. The doll-like child with its incandescent halo is closely related to that in the *Simeon* in Hamburg, Bredius 535.

Connexions with Rembrandt's drawings and etchings of the Leiden period are also evident. St. Joseph is related to the large figures of beggars and tramps which Rembrandt liked to sketch in black chalk around 1628–9. Compare in particular the *Man with a Leather Bag* in the Rijksprentenkabinet (Henkel 3, Benesch 31). At the same time as he made these sketches, Rembrandt produced a large sketchy etching of *The Flight into Egypt* (B. 54, Hind 17) in which he used one of these beggar studies for the figure of St. Joseph (compare a drawing in the Louvre, Lugt 1159, Benesch 14). Compared with the panel, the etching shows a more advanced stage of naturalism. The painting is still more primitive, more bound to the Lastman and Pynas tradition, and contains more Mannerist elements. This points to 1627 as the probable year of origin.

The newly-discovered painting is a most valuable contribution to the problem of the early Rembrandt's "Caravaggism". It represents a night scene, the artist's earliest open-air *notturno* so far known. The group is flooded with moonlight as the tonality indicates: a monochrome silvery-grey modifies the intensity of strong local colours in the garments, toning down the colour scale to that of a *grisaille*. Yet this is no atmospheric moonlight pervading all the forms; it is sharply canalized like a searchlight and allows the group to stand out in sharp contrast to the impenetrable

darkness of its surroundings. This is the canalized light of Caravaggio and his followers which Rembrandt usually applied to scenes in interiors only. Thus the figures hold sway over the surrounding space, a feature which diminishes in the master's later development. In contrast, one may compare *The Flight into Egypt* of 1634, discovered a few years ago (Bauch 61, Bredius, third edition, 552A, fig. 149),[3] where the figures are much more submerged in the nocturnal scenery. Here they stand out from it as a compositional unity. Although the scenery seems to be conceived as a forest by night, where the travellers enter the sudden light of a clearing, no naturalistic details specify the character of the surroundings, which are as dark as a cave. Thus, the effect of light is immensely expressive, almost fantastic. Fantastic and bizarre is also the deep shadow cast by the group upon the ground; this makes us think of La Tour and Callot. In spite of the obvious role of Caravaggism, as the source of this kind of illumination, it will be difficult to find anything among the works of the Italian and Dutch precursors of Rembrandt which could be described as a step leading up to it. It is true that we know early paintings of Bloemaert in which the figures flicker like torches out of darkness, but they do not suffice to explain a stylistic phenomenon like the treatment of light in this painting. The bizarre and expressive note in it points indeed to French art as has been mentioned before. Callot, who strongly influenced Rembrandt as a draughtsman about this time, and who himself underwent the influence of Caravaggism, seems not entirely irrelevant to this problem.[4] In his night scenes we meet with a similar violent contrast of dark and light, a similar abstract and generalized conception of darkness.

In Rembrandt's painting of 1634, all this has changed. The homely light of a lantern held by Mary and lighting up her motherly face, is struggling with the hazy light of the moon hiding behind a thin veil of clouds. The lantern, in spite of its reddish reflections upon the leaves of the trees nearby, cannot entirely prevent the moon's mysterious spell from pervading the atmosphere of the entire forest. The spell of nature, as Rembrandt, in the meanwhile, had experienced it in the works of Elsheimer and Altdorfer, has replaced the one-sided intensity and concentration upon the "real" of his earliest youth.

The Burlington Magazine XCVI, 1954, pp. 134, 135 and fig. 1 on p. 132.

'Caravaggism' in the Drawings of Rembrandt

R EMBRANDT is regarded as one of the followers of Caravaggio. Without Rembrandt the picture of "Caravaggism" in seventeenth-century Europe would not be complete. The art of the Italian master has been considered the main force active in so many realistic endeavours of the Baroque era. Its decisive role in the painting of the Netherlands became the subject of many scholarly studies. Neither Rubens nor Elsheimer, neither Van Dyck nor Jordaens, neither Frans Hals nor Vermeer were exceptions, so that Caravaggism seems indeed to have been the dominating artistic movement in seventeenth-century Europe, which found its limits not entirely even at the exclusive realm of Classicism.

We shall not touch upon the question of to what extent the creative genius of a single man may become the main source of a great international movement. By comparing those times with the artistic situation of today, we may arrive at the conclusion that international artistic ideas and symptoms arise independently in different places and in connection with different personalities. In the historical distance, the achievement will be connected with one single, outstanding name which, as if it were a symbol, comprehends all those related endeavours in the most striking and convincing manner. This may have been the situation in the Netherlands where we find "Caravaggists" already at the time of the early Caravaggio and even before—I mention only the names of Arnout Mytens and Abraham Bloemaert.

It is in this sense that we may be permitted to speak of "Caravaggism" with regard to Rembrandt. It is beyond any doubt that Rembrandt in his very beginnings was deeply rooted in the Caravaggist movement. Caravaggism gained importance for him in its two most distinct Dutch manifestations: first, in the followers of Elsheimer, second, in the School of Utrecht. Rembrandt's masters Pieter Lastman and Jan Pynas belonged to the former, whereas the latter gained considerable influence upon him through its works. Both were symptoms of the Italianate movement in Dutch art and they had already surpassed their culmination points when Rembrandt entered the field. By then, they were eclipsed by the new Dutch naturalism, which in landscape, portrait and genre developed a true picture of the native country and of Dutch reality. At the end of the 'twenties, they grew somewhat out of fashion and formed a more or less isolated sidetrack in Dutch painting, a situation changed very little by the admission of the Caravaggesque style to the court in The Hague.

The distinctive marks of Caravaggism, as far as they have been determined by scholarly investigation, may be grouped according to the following points:

1st general realistic tendency which becomes most obvious in subject-matter;
2nd compositional principles, types of composition, and types of figures;
3rd treatment of light.

They are most obvious in painting and were treated at large by Arthur von
Schneider in his treatise *Caravaggio und die Niederländer*, devoted mainly to Dutch
painters. Yet "Caravaggism" in the art of the seventeenth century meant more than
a temporary stylistic influence, a fashion or mode of painting. It was almost a new
way of feeling, a new attitude of the artistic mind, a kind of "künstlerische Weltan-
schauung", which became apparent in qualities of structure, of formal and spiritual
articulation, to the same extent as in the above mentioned more general features.
Those qualities are of a more intimate nature and reach to the very core of artistic
creation. They have not yet been analysed, because elaborate paintings offer less
suitable substrata for observations of that kind than do drawings, the products of
the most immediate artistic expression. Whereas the elements of Caravaggism were
often observed in Rembrandt's paintings, they have so far not been investigated in
his drawings. It is my intention to do this in a series of significant examples.
Therewith, our attention should be devoted not only to the more general features
such as realistic aspect and subject-matter, composition, types and chiaroscuro,
but also to qualities more difficult to grasp, qualities of a semantic character,
significant for graphic works of art.

One of Rembrandt's earliest paintings in the Caravaggesque style, dated 1628,
represents *Two Philosophers disputing* (Bredius 423; fig. 151). The subject is typical
of the Utrecht School. Pairs of contrasting male characters, usually entitled
"Democritus and Heraclitus"—the laughing and the weeping philosopher—occur
frequently, as for instance in the paintings of Terbrugghen in the Museum of
Utrecht. Not the beautiful and typical, but the characteristic and significant of the
decay of old age was stressed by the artist. The figures are heavy and clumsy.
Almost the same care was applied to the old volumes of withering, crumbling
vellum which complement the wrinkled men as in the paintings of Stomer and
Serodine. It is a picture of definitely realistic character. The painter became
engrossed by details. The composition has been patched up from single elements
to which weight and emphasis were given. The elements of the composition in
themselves are almost more impressive and monumental than their unison. They
do not tend towards dissolution and interrelation, but towards seclusion in heavily
rolling contours. This becomes most obvious in the philosopher seen from the back
who fills the left corner like a massive block fitting particularly into that place.
This figure is a typical Caravaggist set piece which also plays its part in the
luministic composition. Since *The Calling of St. Matthew* in S. Luigi de' Francesi,
Cappella Contarelli, Rome, the sharp lateral incidence of light had been basic for

the new art. It creates a zone of light in which the opposite figure and the folios are bathed, whereas the corner figure functions as a dark screen lit up in parts only, pushing back the centre of light.

The single elements of this composition were carefully elaborated on the basis of drawings after the general arrangement had been settled. One of them, destined for the figure seen from the back, is preserved in the Berlin Print Room (Benesch 7; fig. 150) and conveys to us an excellent idea of the studies preparatory to the Caravaggesque paintings of Rembrandt's youth. It remains an open question whether Rembrandt made the present drawing especially for the purpose of using it for the painting or whether he used an already existing study for the picture. The man's pose remains the same, but less prominence was given in the painting to the heavy drapery thrown over the back of the chair. Rembrandt lent the most vigorous effect to it in the drawing. We feel the heavy material of the woollen cloth, its weight, its space-filling substantiality. It makes the figure as compact as a block. The foreshortening also serves the impression of compactness; it eliminates projections of a silhouette which would break up the uninterrupted outline. The meaning of foreshortening in the paintings of Caravaggio and his follower Saraceni, from whom Elsheimer and Terbrugghen had taken it, involves not only the penetration into depth of space but also the creation of a compact volume. The drawing is intended to evoke reality and substance to the highest degree. Paint in Caravaggesque pictures was handled toughly and draggingly; heavy pigments were considerately moulded, so that the grip of reality could not be lost. The linear texture of Rembrandt's drawings is the equivalent of that kind of brushwork. It consists of a tight network of lines in black and red chalk—the combination favoured alike by Italian and Dutch Mannerists, by Caravaggio's sponsor Cavaliere d'Arpino as well as by Goltzius.

About 1626, Rembrandt painted a series of genre paintings representing the "Five Senses" under the guise of the domestic life of simple people and peasants. Two of them, Sound (Bredius 421; fig. 105) and Touch (Bredius, third edition, 421 A; fig. 106) have been preserved in the Van Aalst Collection in Hoevelaken.[1] They represent a group of singers and an operation by a quack. They are typical Caravaggesque candlelight scenes, as Rembrandt could have seen them among the works of Honthorst. In the following years, Rembrandt took up scenes of this kind repeatedly, showed them in even daylight and stripped them of their Caravaggesque character. I mention the Foot Operation, a smaller painting in the Escher Collection in Zurich (Bredius 422) and a large drawing of the same subject in the Uffizi at Florence (Benesch 51). One may feel inclined to call "Caravaggesque" the crude reality itself of these subjects, but this would be incorrect because we are facing here a genuine Netherlandish tradition which harks back to the masters of the sixteenth century and which we meet in Rembrandt's time, with

particular emphasis upon the folklore in the illustrations of Adriaen Pietersz van de Venne. The same applies to Rembrandt's stirring etchings and drawings of beggars during his Leiden period: types and scenes from life, experienced in a cruel reality, and surpassing the merely picturesque effect which those themes acquired in the majority of the works of the Caravaggists. If they contain any Caravaggesque elements they were transmitted to Rembrandt only indirectly through the medium of Callot who, in several candlelight scenes, proved to be a master of Caravaggesque composition. The great influence which Callot exerted upon Rembrandt not only in subject-matter, but also in style and method of drawing, interferes so strongly with his genuine Caravaggism that in analysing the works this influence has to be distinguished from it carefully. Wherever we find an inclination for rational formula and flourish in Rembrandt's most realistic early drawings, we follow the traces of Callot. We have to distinguish between them and that naive and immediate struggle for reality which is the meaning of genuinely Caravaggesque drawings.

There is no doubt that a Caravaggesque painting like *Sound* meant to Rembrandt an abstraction in composition of figures and light. Yet this abstraction, inspired by foreign examples, was realized through models and observations taken from the artist's immediate surroundings, as I have demonstrated in a communication delivered at the London Congress of the History of Art in 1939.[2] The head of an old woman seen in the sharp light of a lamp or candle placed upon a table, was a favourite topic of Gherardo della Notte and of the Bloemaerts. Rembrandt brought it to fullest realization by applying it to the venerable features of his old mother in a wonderful drawing, monumental in spite of its small size, in the Stroelin Collection at Lausanne ([now Paris, private collection], Benesch 55; fig. 102). He enhanced the impressive aspect of the old woman through a cloth which he threw over her head, thus lending her the solemn appearance of the prophetess Hanna. How Rembrandt dealt with the problem of representing this effect in a drawing is demonstrated by his purely empirical procedure. Harsh and obstinate penlines— short, as if they were chopped off—mark the main traces of the face. The side in shadow is covered with a tight net of hatches intersecting at a narrow angle, similar to that we saw in the seated philosopher. Yet some small intervals are left open and appear to be gleaming reflections. After the intense moulding of this centre portion, the work was finished by counter-balancing long sweeping penlines indicating the drapery at the illuminated side, and bold broad pen- and brush-strokes, indicating the relief at the shadowy side. The broadest penstrokes are almost engraved into the paper. The brush is a softer tool and its strokes touch the paper more loosely, so that breathing intervals of light break up the darkness. This perfect range of accents and means of visualization was developed by intuitively transposing reality into a system of graphic representation which remained purely empirical.

We see how the coercion exerted by teachers and surroundings to materialize Caravaggesque items and ideas for paintings, led Rembrandt to the development of a new freedom and immediacy in drawing, hitherto unknown. May I show some results of this process which becomes distinctly visible towards the end of the Leiden period and at the beginning of the Amsterdam period. From 1630 to 1633 Rembrandt made careful drawings of old men seated in half-length, three-quarter-length or full-length, either looking thoughtfully at the spectator or enveloped in their own contemplation. We find some of them inscribed with the dates 1630, 1631 and 1633. Old age with its wrinkles and marks of time, with its loosely growing hair and bodily decay was a favourite subject of the Caravaggists, Italian and Northern alike. It was a strong contrast to the smooth and typified ideals of Mannerism, an antidote against its construed types and platonic synthetizations. In the works of the Utrecht School, we meet time and again with character studies of old men. The idea of the "picturesque" model, taught in the academies and drawing schools up to the past century, originated in the Caravaggist era, because only the irregular, close to nature, was considered as worthy of being painted. Between 1630 and 1633, Rembrandt specialized in studies after such models, which he drew mostly with red chalk, sometimes with black chalk, or a mixture of both. He was not satisfied with the mere statement of a picturesque appearance as were his forerunners and his contemporary Guercino in his early works. Rembrandt's spirit, always searching for deeper layers of content, experienced these models as saintly figures of the Old and New Testaments: Job, Jacob, Tobias, Jeremiah, St. Paul and St. Jerome. Since 1628, Rembrandt's freedom in handling his tool had tremendously increased. Whereas in the earlier drawings he had not yet freed himself entirely from the slow and hesitant modelling of his Caravaggesque forerunners, he had gained by now a flowing totality of vision which placed him all at once ahead of all the adherents of the new Italian realism in the North. The results, as seen in the drawing of a *Seated Old Man* of 1630 (Benesch 37 [Washington, National Gallery]), are already autonomous and independent elaborations of the Caravaggesque impulse. We recognize them for instance in Italy in the early works of Guercino. Like Guercino, Rembrandt found the way to the Venetians through Caravaggism. If we are reminded of Bassano and Tintoretto in front of such drawings, it is not at all certain whether these artists were already known to Rembrandt at that early date, but they certainly were half a decade later. Gradually he prepared himself to accept the influence of the great Renaissance masters. The wild groping in the strongly built-up figure, the softly waving linear texture in the head together with the lucid red of the medium give the effect of being thoroughly bathed in an all-pervading light. The concentrated searchlight effect is gone, as well as the antiquated attitude of Rembrandt's scholastic predecessors.

We notice the same progress in Rembrandt's brush drawings as for instance in *The Reading*, Bonnat Collection, Bayonne (Benesch 52; fig. 99).[3] I reported on this drawing in particular at the occasion of the London Congress in 1939. The drawing represents a Caravaggesque lamp- or candlelight scene, yet not as a premeditated compositional abstraction, but rather as the ingenious perception of a momentary situation in the artist's home. The models are Saskia, Rembrandt's sister Lisbeth, and perhaps Rembrandt himself, if we assume the use of two mirrors reflecting each other. The drawing must have originated about 1632 to 1633. Rembrandt's sister, reading from a book, screens the source of light, just as we see this in two earlier paintings: "*La Main Chaude*" in the National Gallery at Dublin (fig. 100)[4] and *The Supper at Emmaus* in the Musée Jacquemart-André in Paris (Bredius 539). In contrast to all the previous attempts in Caravaggio's style, this one renders an impression which shows the Caravaggesque elements at the point of utmost dissolution. The Italianate triangular composition still subsists on the surface, but it is entirely dissolved and loosely scattered in space. The drawing is executed with the brush, except for a few penstrokes in Saskia's face and hand. The heavy solids, carefully built up in contrasting zones of light and shade four years earlier, are turned into an uproar of flickering blotches applied with the hurrying brush. Such a vision had to be seized in one moment because in the next one it would have been gone. But the figures shining up in the light, emanate in this turmoil all the more convincingly their tremendous effect of palpable presence, whereas the silhouette figure appears as a condensation of space filled with the struggle of dark and light. We see how the endeavour of Caravaggism to convey to us an utmost feeling of reality was substantiated by Rembrandt in his own characteristic manner, by making use of Caravaggesque precepts and devices, yet changing them into an entirely new idiom. Thus Caravaggism was the point of departure for the achievement of his own aims, and the meaning and importance which Caravaggism held for Rembrandt becomes apparent. It will be proved by further investigation.

Once Rembrandt had attained this state of creative freedom, he was no longer dependent upon that close and detailed study of a model when executing a Biblical painting as had been the case during his Leiden period. On the contrary, he may have started from an already existing picture with the goal of creating a majestic drawing as a work of art in itself. This is the case of the *Lot Drunk* of 1633 in the Staedel Institute, Frankfort-on-Main (Benesch 82) which Rembrandt signed and dated fully, thus declaring it a completed artistic creation. The drawing is, so to say, the conclusion of the early studies of old men. The model assumed a similar pose in a painting done several years earlier during the Leiden period. The painting no longer exists, yet is known to us from an etching by Van Vliet (Bartsch 1). The pose, however, is looser and completely relaxed in the drawing. This gives freedom to the work of the chalk, suggestive of different materials such as fur, thick felt,

various cloths, silvery hair, shiny skin, the whole of this wonderful human still-life flooded by sunlight. At this point, the comparison with an Italian drawing may be permitted: the only one which has been attributed to Caravaggio himself with considerable good reason (Elizabeth Hajos, *Old Master Drawings* III, p. 27). It represents an old man pondering over a book, in an attire and pose which remind us strongly of St. Matthew in the first version of the altar-piece for the Contarelli Chapel. The reverse side shows the same figure in a different pose. Although it remains a hypothesis, the assumption that the drawing was intended for the first version of St. Matthew cannot be disregarded. The contour is heavy and bulging, yet open and respiring. The outlines swing and make one sense the atmosphere. This feeling of atmosphere is increased by some vigorous patches of bistre, applied with the brush. The work nearest to it with regard to linear texture is Caravaggio's original etching of 1603, representing *The Denial of St. Peter*.[5] There we find in the shadowy parts the same tight hatches crossing each other at narrow angles. This drawing, considerably earlier than Rembrandt's drawings, has something which anticipates them strongly. The manner of cross-hatching may remind us of the *Seated Philosopher*, the groping curves of the *Old Man with a Book* of 1630; the hands, as well as the vigorous zigzag lines on the reverse side, make us think of Lot. The extreme rarity of drawings by Caravaggio in Rembrandt's time makes it impossible to assume that he could have seen any of them. Yet this case proves that Rembrandt arrived through his own efforts at a style of chalk drawing which came closer to Caravaggio than that of any other immediate follower. St. Matthew placed beside Lot reveals an astounding affinity in general aspects and character. The *ungues leonum* come to the fore in both.

Drawings which are neither studies from nature nor preparations for a composition, but ends in themselves, gained increasing importance in the œuvre of Rembrandt. So, in the next year, we see him accomplishing one of his largest sheets, *Jesus and His Disciples* (Haarlem, Teyler Museum; Benesch 89; fig. 153). It is also fully signed and dated. Technically, it is a combination of black and red chalk, bistre and India ink and gouaches in different shades—whitish and yellowish —so that the effect is definitely that of a painting, as for instance that of *The Incredulity of St. Thomas* (Bredius 552) [Moscow, Pushkin], of the same year. Both works demonstrate the freedom and the mastery which Rembrandt had acquired in handling imagination according to the style of Caravaggio. Both are night scenes, representing the apostles in a group surrounding the Saviour Who floods them with the light of His halo. Thus, they are moulded out of darkness and those nearest to the spectator function as shadowy screens, as stepping stones which deepen the spatial composition. It develops horizontally in the drawing. Master and pupils have assembled in the open air, in a garden, at a late hour. Branches of trees and a fence are indicated in the semi-darkness. St. John, being tired, is overwhelmed by

sleep, whereas another apostle yawns stealthily. Yet the old men listen attentively and piously. The massive and solid, the heavy and ponderous features of the new realism appear most strongly in the figures of the foreground, but are produced with a baroque brio, a waving and rolling of the surface which was unknown to the works of the 1620s. The dynamism which we noticed in the play of various light and shadows in *The Reading* now seizes whole bodies as substantial as the quietly seated philosophers. A changed bearing and behaviour become perceptible, which dramatize intensely the composition. In contrast to the dark masses, Christ rises steeply and flames up vertically like an immaterial spirit. A surging and heaving move through the entire composition. We find ourselves on the threshold of a new phase of Rembrandt's style.

This stylistic phase is characterized by a powerfully moved *Baroque*, full of drama and emotional conflict. It reaches a culmination point in the years 1635 and 1636. We have an utterance by Rembrandt himself to define his artistic endeavour during those years: he mentioned in a letter that he had, in his *Raising of Christ*, "die meeste ende die natuereelste beweechgelickheyt geopserveert". He created large compositions from vigorously growing figures. To the already existing inner monumentality of his work was now added the outer monumental appearance, consisting of large canvases and life-sized groups. He liked to represent moments of dramatic climax and peripeteia. The *dramatis personae* act in a fraction of a second. The angel in the painting at the Hermitage (Bredius 498) snatches Abraham's arm so violently, that the terrified patriarch drops the knife which is shown hovering in the air. For such violence of movement, Rembrandt found no forerunners in Dutch art which is inclined to be impassive and calm. He turned again to Italian art, not to mediators, but to the sources themselves. Through the logic of his own development, he had reached a point where the essence of Italian art became a new inspirational force to him. Amsterdam as the centre of the European art market gave him the opportunity to become acquainted with original paintings, prints and drawings; he had already started a collection of his own. He now discovered the Italian masters of the High and Late Renaissance. It is well known how he transformed Leonardo's *Cenacola* in his own drawings. He could have studied such vigour of movement in the works of the Venetians from Titian to Tintoretto and in those of the painters of the Emilia from Correggio to Lelio Orsi which were represented in his large print collection. With regard to movement, Tintoretto had already exerted a tremendous influence on Rubens whose works were, of course, familiar to Rembrandt. Yet Rembrandt, under the impact of these new experiences, neither could nor wanted to free himself from the Caravaggism of his early years. On the contrary, Caravaggism became important to him in a new and thoroughly different way.

Schemes of motion, as Rembrandt could find them in the works of the cinque-

cento masters, did not provide a complete fulfilment of his desire. He could not stop at the convincing expression of movement after he had striven successfully for a new intensified reality, an effort in which he had been strongly supported by the Caravaggesque realism. Only a new attitude towards the old Caravaggesque problems, which supplemented the battle for "beweechgelickheyt", could be of any help to him. Although dramatic movement was not foreign to Caravaggio, if we think of *The Martyrdom of St. Matthew* and of the early *Conversion of Saul* in the Galleria Balbi at Genova (no. 13),[6] the movements of his figures appear as if they were fixed in the air and the bodies held in suspension by devices. *The Conversion of Saul* through its general compositional arrangement challenges in particular a comparison with Rembrandt's *Sacrifice of Abraham*. Rembrandt seems to have known the composition through an engraving which apparently showed it in the reverse direction. Thus realism and the newly gained freedom and grandeur of invention had to be merged with each other.

This was the main idea of Rembrandt's paintings in 1635 and 1636. He increased the might of the bodies and spanned them narrowly into the frame which they threatened to shatter with their bulging masses. It is less the obvious picturesque aspect of the composition which now recalls Caravaggio, but rather the tight plasticity and the material vigour of huge bodies in dramatic conflict. To Caravaggio's tremendous pictorial substantiality, Rembrandt added the movement which he acquired from the Venetian painters and from Correggio and his followers (he was an admirer of Lelio Orsi as a draughtsman). Rembrandt prepared Bredius 498 in a drawing which is in the British Museum (Benesch 90). In a sketch-like manner, it endeavours to evoke the effect of a completed painting. Rembrandt was not satisfied with the conveyance of his imagination by graphic means alone, but was eager to evoke for himself the impression which the finished picture was supposed to give. Therefore a rich scale of washes has been added to the work of red and black chalk, creating a suggestive chiaroscuro in the corners and in the background. This group of figures participates in the chiaroscuro, in order to show its close connection with space. On the other hand, this interweaving of the figures with the play of light and shadow strongly increases their plasticity in a purely pictorial way which is one of the chief aims of Caravaggism. This becomes particularly evident in the radiant body of Isaac. How did Rembrandt solve the problem of movement in this sketch? Mainly by putting his red chalk pencil into motion and by making it curve and circle around those sections of space which were supposed to be filled by the solids of the figures. It is the same kind of groping movement, though much more systematic and impressive, which we noticed already in the body of the seated old man in the National Gallery, Washington. It is interesting to observe how Rembrandt in this drawing adhered more strongly to an earlier phase of his style of composition which, for instance, is represented in the *Lot* (Benesch 82) and in the

Baptism of the Eunuch (Benesch 13; fig. 59) of the Leiden period. The figures are towering up vertically whereas a zone of free space gapes around them. Visualization of the depth of space was more important to Rembrandt in the preparatory drawing than in the finished painting. The half-length of the angel for instance stands out from the surface in the same, somewhat awkward manner as the Lord and the angel in *The Conversion of Saul*, Balbi Gallery. In the finished painting the size of the figures is increased and they are spread across the surface in a majestic half-circle; in the drawing, the angel bends forward from a loft of clouds.

Even more than in the carefully drawn preparatory sketch for *The Sacrifice of Abraham*, the dramatic and realistic emphasis which Rembrandt gave at this time to his figures, appears in quick improvisations filled with a wild grandeur and the hot breath of the momentary event. They belong to Rembrandt's most intimate and personal creations and are the outcome of his continuous imagination. They were not necessarily meant to be preparations for paintings or etchings, although they already contained their elements.

Caravaggio's realism possesses something of the quality which was commonly attributed to the art of Michelangelo by his contemporaries: the *terribile*. The *terribile* is the overwhelmingly great and impressive which terrifies the spectator. In Caravaggio's art, the breathtaking nearness to life was added to it, and in Rembrandt's art the catastrophic suddenness of appearance. In the *Study for Jacob lamenting*, Berlin, Print Room (Benesch 95; fig. 152), the act of showing the coat is almost unrecognizable, because everything is concentrated upon the impact of the figures. A figure arises in front of Jacob, almost inhuman, without any articulate indication of details, like a bogy or phantom. It is bent forward with a threatening insistence which makes it grow out of all proportion and which dehumanizes it entirely. It is an unsurpassable sign for the feeling: fright. In order to distinguish it from its surroundings and to increase its anonymous strangeness, Rembrandt washed it with the brush and made it function as a shadowy screen against the light, a device which he frequently used in his earlier Caravaggesque compositions. This device was here transformed into a feature of psychical expression. The psychical impact upon Jacob is so strong that it almost turns the heavy man over in his chair. The figure of Jacob is executed in detail, particularly in the face whose features, distorted by the shock, become coarse and ugly. In order to vivify the story, Rembrandt described on purpose every realistic detail. The figure's attitude of horror was tried out once again on a slightly smaller scale and was applied to a beardless man, as this attitude was to Rembrandt of main importance. The figure is strongly illuminated as if by a searchlight and it throws a strong, yet flickering shadow. The structure of the penlines is in a kind of disorder. They are scratchy, split and reiterated and look almost like stalks of straw. What do they mean? They intend to demonstrate the weightiness of the bodies which in the

pulsating movement are dissolving into fibres. They also intend to demonstrate the speed of this process. This structure of penwork is characteristic of Rembrandt's drawings of the middle of the 'thirties and forms a safe clue to their time of origin. We have to keep this in mind in dealing with problems of chronology.

Rembrandt's drawings in chalk are becoming increasingly rare. He now prefers the pen because it opposes stronger resistance and through its recalcitrant character, it frustrates the play of easy flourishes. It gives to the linework an expressive articulation and its occasional harshness, even crudeness, is just in accordance with Rembrandt's artistic intention at the time. Thus, he also preferred the pen for projects of paintings. One of them is the preparatory drawing to *The Rape of Ganymede* of 1635 (Benesch 92, Dresden, Print Room). This painting has at times been considered a caricature and a blasphemy of the classical subject, a painted joke. This is not correct. Although Rembrandt might have been inspired by a harmless scene in his own home—his crying son Rumbartus being carried off by his mother from his playmates, as it can be seen in a well-known drawing in the Berlin Print Room (Benesch 401)[7]—the humorous observation of daily life as shown in that study turned to bitter earnestness in the painting (Bredius 471). The terrifying expression of utter anxiety is increased by the realistic heaviness of the body which is carried away by the eagle. This heaviness is almost over-emphasized in the preparatory drawing where penlines are scratched into the paper, and heavy washes concentrate in the body of the boy whereas the rest evaporates in a flurry of dancing lines and hints of shadows; it conveys to us almost a visualization of the feeling of being lifted into the air and loosing ground. There is no doubt that Rembrandt succeeded much better in the drawing in evoking this feeling, as he gave there much more eloquent expression to the terror in the boy's distorted features and to the dangerousness of the huge bird of prey. In order to increase the impression of turmoil, he inserted into the vanishing depth two figures, shooting and gesticulating violently.

Not only compositional ideas but also the style and the diction of these drawings are dynamic. They materialize so to say from linear vibrations. The outlines swing incessantly. This gives increased weight and substance to the bodies and is, therefore, in line with the aims characteristic of Caravaggism. It no longer impedes the description of relevant details, as we noticed in the *Jacob Lamenting*. It is therefore no wonder that we see Rembrandt, about 1635, returning to subjects significant for his beginnings, from 1626 to 1628: candlelight studies, warriors in fancy dress, genre scenes with people making music, playing games, carousing, smoking and sporting. We also recognize such scenes in the grand style paintings: the most popular among them is his *Self-Portrait with Saskia* (Bredius 30). They occur in quite a series of drawings, *Tric-Trac Players*, Venice, Academy (Benesch 398). Two players in sixteenth-century costumes with plumed hats are eagerly

bent over the draught-board. The ancestors of this group are the money-changers of Caravaggio's *Calling of St. Matthew*. In the background, a sporting couple and a smoker turn up. We see here an ensemble which is familiar to us from the paintings of Manfredi and Stomer, Valentin and Tournier, Honthorst and Terbrugghen, but it has been increased to huge, terrific shapes. The *terribile* turns into caricature in the grimaces of the couple. Back and thighs of the standing player form a tremendous, swelling curve. Even in genre representations, Rembrandt strives for the monumental. A single figure is monumentalized in the *Scribe sharpening his Quill by Candle-Light* at Weimar (Benesch 263) a variation of the theme of the *Money-Changer* (Bredius 420) which Rembrandt had treated already in a painting of 1627. The tense expression in the ugly features is described with minute care, whereas the garment dissolves into a loosely swerving net of stalk-like lines. What looks like a cushion or shadowy bunch of cloths in the left corner, seems to have originally been the back of another version of the same figure which afterwards was cut off by Rembrandt. The gradation of shadows is treated with extreme subtlety by lighter and darker washes. A very charming *Musica* in the pure Utrecht style, is in the collection of Mr. Gathorne-Hardy (Benesch 399; fig. 155). The musical theme, already treated by Rembrandt in a family portrait of 1626 [see fig. 107], receives here a psychological sublimation which only Rembrandt was able to achieve. Two of the four men listen quietly and attentively to the flute solo; the singer stops and reads the score. It is remarkable what eloquence of articulation is achieved by the system of swerving penlines. In an almost magic way, the attitudes of hands, limbs and bodies are suggested and clarified through this apparent disorder of lines. An incredible subtlety of telling details is reached in the heads of the two flute-players, which surpasses in expressive significance everything that Rembrandt had formerly achieved. In contrast to this, the man seated on the edge of the table is sketched roughly and coarsely, and is summarized in an almost geometrical manner. In this way, the necessary variation and tension between the different parts of the composition was accomplished. Psychologically, the abridged figure is no less eloquent than the others. Its geometrical structure foreshadows a new step in Rembrandt's development which came to a full realization in the second half of the 'thirties: the geometrization of the human figure so as to organize its newly-acquired plastic quality and bring it to crystallization. Thus, the apparent disorder of lines tends towards a permanent settling of substance and form. A half-length figure of a *Man in a plumed Hat with a Halberd* formerly in the Victor Koch Collection, London (Benesch 362), slightly earlier than the *Musicians*— about 1636/37—clearly shows this tendency towards cubic crystallization. The accentuation changes from the curving to the angular. It is accompanied by an increased psychological concentration. The little man has an almost weird aliveness. The theme is typically Caravaggesque and it also occurs in one of the incunabula of

mezzotint engraving by Prince Ruprecht von der Pfalz [dated 1658, Wurzbach 8]. About 1634/35, Rembrandt also cultivated in his paintings the typical Caravaggesque figure composition in half- or three-quarter-lengths, mostly in connection with historical or mythological subjects. The earliest example is the *Sophonisba* of 1634 in Madrid (Bredius 468; fig. 177).[8] Caravaggio had taken this type of composition from the painters of Brescia and Venice, as it permitted him to give the figures, just in the narrow format, special weight and prominence. Almost the entire Italian and Northern seicento accepted it and developed it further. So did Rembrandt at about the middle of the 'thirties. I mention *Belshazzar* (Bredius 497), *Samson threatening his Father-in-Law* (Bredius 499), and furthermore, classical deities such as *Minerva* (Bredius 469) and *Flora* (Bredius 102). It was usually Saskia who served him as a model for the female figures and, of course, drawings had to precede the paintings. One example of this is in the collection of Captain Edward Speelman, London; it shows *Saskia* in three-quarter length (Benesch 292a), holding a sceptre or staff in her hands similar to the painting in the National Gallery (Bredius 103), dated 1635. To this year we must also assign the date of the drawing. Saskia is standing beside a table with a still-life of opened books, not unlike the one before which *Minerva* is seated in another painting of 1635. Yet in a final correction, he drew vigorously over its dark cloth the outlines of the figure, which at the beginning was overlapped by the table. So the table is eliminated and the figure alone dominates the picture space. It is drawn from nature. The face is carefully and minutely modelled with the quill-pen, in a rhythm which we know from the heads of the musicians. Yet Rembrandt wanted to try out a painting. He therefore provided the figure with a dark background which he drew with wildly and perfunctorily sketched lines of the reed-pen, the favoured instrument of his late years. With this same tool the broad and vigorous lines had to be applied to the body if power and substance should be its qualities. Furthermore, the rich scale of washes plunges the entire drawing into a dramatic chiaroscuro. The light falls upon the figure from above and from behind so that the face remains in the shadow, whereas hair and shoulders gleam up in the light. Lighting lines are scratched with a stylo into the dark cover of the table—a technical device which nearly has the value of an original signature. Most surprising is the effect of the broad reed-penlines which anticipate works of a much later period. From the woman emanates a mysterious and almost eerie majesty: the terrifying, which causes the great and strange expression of so many a work of the middle of this decade.

The impression of grandeur and highest substantiality is commonly attributed to the work of Rembrandt's maturity and old age. Whenever this esthetic impression was taken as a basis for the dating of undated drawings, without considering their particular structure, errors easily occurred. I wish to discuss two such cases. It may

certainly be true that Rembrandt achieved those qualities to the highest degree in his late works, but this does not mean that they were without importance to him in earlier phases of his development, as for instance at the height of his baroque Caravaggism about 1635/36. Indeed, drawings originated then which were wrongly attributed to Rembrandt's late period. One of them is a study after a male model, a *Young Man pulling a Rope* in the Rijksprentenkabinet (Benesch 311), which Hofstede de Groot dated at about 1658, because this drawing was used for a painting which had the misread date of 1658: *The Flagellation of Christ* in the Museum of Darmstadt (Bredius 593). Consequently, Valentiner dated the drawing at about 1658. The painting, however, cannot help date the drawing because it is a work by a pupil, which, in some features, is reminiscent of Barent Fabritius. What was encouraging for the late dating of the drawing is the tremendous vigour of its broad execution which recalls indeed some nude studies of the late 'fifties. Reed-pen was used for the summary outlines, which detach the figure strongly from the surrounding white surface, yet at the same time connect it intensely with the atmospheric space. Bold washes applied with the brush lend the figure a colourful modelling and anchor it in space by casting a shadow upon the ground. But in examining the drawing closely, we notice that the head of the boy was first subtly drawn with the quill-pen—his profile as well as his hair—and that the fibrous texture of those lines clearly points to the years 1635/36. It was only during the further elaboration of the drawing that Rembrandt continued with the reed and also vigorously remodelled the boy's hair. The highest imaginable pictorial substantiality was achieved in this way. And so we recognize the aim which actually induced the great painter-etcher and draughtsman to take up the principles of Caravaggism. The other example is the *Self-Portrait* in the collection of Dr. Hamilton Rice [now Lehman Collection], New York (Benesch 434). The pen—apparently reed-pen in parts, as in the *Saskia* of the Speelman Collection (Benesch 292a)—has worked here with such boldness that Valentiner dated the drawing about 1657, which is contradicted by the young and lean shape of the face, which lacks the square-shaped features of the aging Rembrandt. This work of the pen was supplemented by equally bold brushwork. Concerning structure, this drawing stands next to the *Saskia* and also to the *Boy pulling a Rope*; it originated about 1636.

Is it justified to speak here still of "Caravaggism"? Not in the sense of a temporary mode, a style or fashion of painting or drawing. Here Rembrandt is quite his own self and opens a new way instead of following one trodden by others. The gloomy grandeur of expression is so unique that it can indeed be compared to that of the late self-portraits. Yet, if we understand Caravaggism to be an artistic principle, that is to say, a union of highest pictorial quality with the utmost quality of corporeal and psychical realization—which make the portrayed object indeed palpably present in body and soul—then we may speak of Caravaggism in its true

sense. This *terribile*, however, was only within the reach of a great painter and spirit, namely of Caravaggio himself and after him of Rembrandt.

It is significant that by the complete and unparalleled fulfilment of this great task in his late years Rembrandt was brought back to the compositional formula of Caravaggism: the composition in half-lengths, filled with dramatic tension. *The Denial of St. Peter* in Amsterdam (Bredius 594), the final version of the *Julius Civilis* (Bredius 482; fig. 2) are again Caravaggesque "candlelight scenes". But how changed is their spirit now! How very remote from rolling pathos and baroque ostentation every gesture has become! Everything is transformed into the tension of the inner realm of the soul. We also find among Rembrandt's drawings a most moving example of this type of half-length composition: the drawing in the memorial-book of Dr. Jacobus Heyblock, minister of the Dutch Church, which Rembrandt made on March 30, 1661. It represents *The Presentation in the Temple* (Benesch 1057; fig. 154, The Hague, Royal Library). Mary, St. Joseph and the kneeling Simeon are shown in half-lengths, framed, as if seen through a narrow window. This frame, however, which makes the figures visible only as a cutting, does not increase their material weight, as it would have done in the 'thirties. It just moves them nearer to the spectator and brings them quite close to him, as if he were an immediate bystander of the intimate scene. Matter dissolves into palpitating light. Dark and bright are no longer contrasts, because both are vibrations of a radiance metaphysical rather than physical, which appears to end all corporeal limitations. Thus, the *inner reality*, the presence of the soul, begins to speak with an eloquence and intensity transcending all realism which the visual arts in Caravaggio's century were ever able to achieve.

Extrait des Actes du XVII^me *Congrès international d'Histoire de l'Art*, The Hague, 1955, pp. 385–404. [The lecture had been given in Amsterdam in 1954.]

Worldly and Religious Portraits in Rembrandt's Late Art

PORTRAITS form two-thirds of Rembrandt's painted oeuvre: we have, therefore, every reason to call Rembrandt one of the foremost representatives of a branch of art in which the Dutch were rightly looked upon as outstanding. Skill in portrait painting enabled the young Rembrandt to move from his birthplace, Leiden, with its provincial school of painting, to establish himself in Amsterdam, a centre of artistic activity and international trade. Portrait painting formed the foundation of his early fame. In the art of the old Rembrandt, the Rembrandt of the 1660s, who had abandoned the graphic arts and produced comparatively few drawings, portrait painting acquired a dominating position.

In spite of this, Rembrandt was never considered primarily a portrait painter in the sense in which the term is applied to his great contemporary Frans Hals. Other and by far inferior painters were more successful in producing what the seventeenth-century public expected in a good likeness. Documents even give evidence of complaints by dissatisfied patrons. The contributions of the members of the rifle company whom Rembrandt portrayed in *The Night Watch* (Bredius 410; fig. 9)[1] had to be apportioned because those whose faces are visible only in part were not expected to pay the same share as those who appear in stately full-length. In a similar situation a Bartholomaeus van der Helst or a Govaert Flinck knew how to place all their sitters in the limelight. The old writers tell us of Rembrandt's imperiousness in disregarding the wishes of his customers.

Rembrandt had a different conception of portraiture from that of his contemporaries. The average Dutchman expected from a portrait, first of all, a striking outer likeness of the man portrayed, with some indication of his social rank and standing. Yet Rembrandt was first of all interested in his inner being, in his mind and soul. He evoked from man what he read into him. He projected his own mental and human qualities into his models, assimilating them to himself and his spiritual world. No wonder that under those circumstances the outer likeness was sometimes bound to suffer. On the other hand, while an ordinary seventeenth-century portrait, the sitter and the history of which are unknown, means little to us beyond its major or minor pictorial qualities, each portrait by Rembrandt opens a new world, deeply appealing, mysterious, and at the same time intimately familiar to us.

This is due to the generally human qualities of Rembrandt's portrait art. Such portraiture was bound to be more personal and independent of the wishes of a patron than was customary. It became a revelation of the artist no less than of his sitters. It was to its creator an artistic problem, self-chosen, as deep and personal

as any religious subject; his attitude toward the mystery of a human soul was as devout as toward the Holy Writ in which he was so deeply absorbed.

These qualities of Rembrandt's portrait art, which we are nowadays inclined to rank above all others, grew with maturity. The last phase of his art, which expresses a whole universe simply by rendering the image of man, without employing the rich and differentiated means of complex composition, shows this deliberate and autonomous portraiture at its height. As the human figure, and particularly the human face, then sufficed to Rembrandt to convey everything, even the mysteries of religion and of history, there arose an affinity between portrait and religious character which is unique in art. Rembrandt dared to portray the saintly figures of the Bible as if they were living characters, people whom he encountered in real life. Never before was the representation of a Biblical character attempted in terms of a simple human portrait; and very few dared to follow Rembrandt on this dangerous path.

This idiosyncratic relation between the spheres of the worldly and the religious in an artistic problem becomes clear in the following examples. Many of the portraits painted by Rembrandt are "free portraits", creations to which the master was inspired by the interest the sitter evoked in him. In catalogues and descriptions they are mostly called "studies". The word "study" implies something preliminary or intermediate, not the final achievement of an aim. It would be wrong to attribute this quality to these representations by Rembrandt of men deeply lost in their thoughts, like apostles, prophets, penitents or religious thinkers: they are accomplishments in themselves. Giving satisfactory artistic expression to the contemplative mood which they exhale, Rembrandt regarded his task as fulfilled. Indeed, no other artist could have visualized so masterfully that dark, inscrutable, dimly and and mysteriously-lit realm of thought out of which they emerge. Rembrandt certainly did not think of addressing the public in portraying these men, but was following an inner urge. One such subject shows the characteristics of the Slavic race: protruding cheekbones, a broad saddle-nose, deeply imbedded eyes. The strong, bony, square face is framed by a dark beard. He appears in half-length in a portrait in the museum in Berlin [Bredius 284, Staatliche Museen]. A slanting ray of light moulds the strong relief of the face, leaving the eyes in shadow, revealing the deep furrows which carve the forehead and the cheeks. The eyes are filled with a deep and dark melancholy, a feeling of loneliness and homelessness, of repentance for an unknown guilt. W. Bode suggested that the sitter was a Russian pilgrim; trains of them crossed Europe and may also have reached Holland. Indeed, a figure of this kind, charged with all the woes of the human race, reminds us strongly of religious characters in the epics by Dostoyevsky and Gorki.

The same man appears in sacred splendour as a Moorish King in *The Adoration of the Magi* in Buckingham Palace (Bredius 592; fig. 68), painted in 1657.[2] The

strangeness and secretiveness of this character from a remote world offered themselves to Rembrandt as qualities of the Holy King who had travelled far to greet the Infant Saviour. Rembrandt used the same model also for another religious picture, *David playing the Harp before Saul* (Mauritshuis, The Hague; Bredius 526).

There that Russian face, full of silent self-accusation, remorse and contrition, appears in the very role for which it seems to be created: as King Saul, awakening for a moment from mental aberration, filled with deep despair and contrition because the Lord had abandoned him. The splendour of his royal state, shining forth in gold brocade, purple and fiery jewels, enhances by contrast the misery of a lost man who sobs secretly into the velvet folds of the curtain.

In the same year, 1657, Rembrandt painted the *Portrait of a Man with a Long Stick* in the Louvre (Bredius 286; fig. 157). His attire is timeless, kept in neutral tones. A round biretta frames the head with its long tresses like a dark halo. The face shines a tender pale pink out of the brownish-grey shadows, subtly and firmly modelled. It is full of a nobility which soars above the meanness of life, but also of a grievous resignation and detachment. The staff in his hand seems to indicate an Ahasueric wanderer, an eternal traveller over the earth, searching for something which he knows he never will find. We also read in this face an expression of the homeless and errant, although less of fanatical religiosity than of a philosophical resignation, token of the stoicism which tinged so strongly the spiritual elite of the seventeenth century.

The year 1657, which was one of greatest distress and darkness in the master's life, is marked by other outstanding works which illuminate our problem. Experiencing in his own life how human fortune and happiness vanish like sand running through the fingers, Rembrandt's mind turned increasingly towards men who had given up all the happiness of life to attain higher spiritual aims. The heroes and martyrs of religion, who suffered persecution and death for their conviction, became to him objects worthy of artistic glorification. We notice an almost ardent desire to portray the apostles and followers of Christ. But since Rembrandt, in spite of the soaring and visionary power of his art, was so deeply rooted in nature that none of his ideas took shape without inspiration from reality, the images of the saints which he formed in his mind incorporated the faces of those pilgrims, religious scholars and the outcasts of bourgeois life whom he seems to collect as Leonardo da Vinci collected the strange deformities of nature. So from this year we have two of the grandest representations of apostles, both in the United States. Perhaps he planned a cycle (like another cycle to be discussed later) which progressed only as far as these two, which are, however, two of his most sublime creations.

St. Bartholomew (San Diego, Calif., Bredius 613; fig. 159) emerges from

darkness into golden light which transfigures his pale face. We recognize again the Russian pilgrim of the painting in Berlin. He is seated in an armchair in which the heavy yet indistinct mass of his cloak, of a warm, almost glowing brown, forms a weighty pedestal for the figure. The greyish steel blade of the knife flashes in the reddish hand. This hand is formed in a great and expressive way, which concentrates on the essential. In Rembrandt's paintings hands are as eloquent as faces. The ray of light which evokes the figure from the darkness grows upward in intensity to flame out finally on the head. A hidden glow answers, like an echo, from behind the contour of the apostle's left arm. Suffering, gladly endured for a higher purpose, marks the apostle's features. All the psychical tension animating this face is concentrated on one detail as in a focus; the wavy dark brow above the apostle's right eye, formed by the underlying dark ground which has been left uncovered in this particular place. It reveals pain, yet pain which deepens the human quality shining forth with still greater warmth and brightness.

While this confessor holds his own against a world which afflicts him with suffering, the *Apostle Paul*, now in the National Gallery in Washington (Bredius 612; fig. 158), is an introspective thinker. As in the two portraits discussed at the beginning, we see in these two figures of St. Bartholomew and St. Paul the contrast between the life of struggle and the contemplative life. The venerable head of St. Paul is all thought. His giant sword still recalls his past as a fighter, but now it leans quietly against the wall, a symbol of the Cross and a herald of the Saint's future martyrdom. It fits into the monumental framework of the stones of the wall which encompass the Saint in simple horizontals and verticals, a rhythm corresponding to the repose of the figure. The relation between load and support becomes as distinct as in an architectural structure. The conflicting forces so violently emphasized in Rembrandt's early works have steadied down to this quiet balance, a reflection of the apostle's meditating spirit. The left hand supporting the head, which is heavily fraught with thought, and the relaxed right hand which holds the pen, mirror this relation.

As a painting this work is a perfect example of Rembrandt's reduction of multi-colouredness to a basic chord of black, red, yellow, and white, the same as that used by the old Titian. Red in a hue of subdued cinnabar glows in the apostle's jerkin; it is framed by a gown woven from blackish-grey and gold. The ochre tones, suggesting gold, shine elsewhere, too, through the texture of grey. Notwithstanding the firmness of the result, all these pigments are applied by a broad brush with an extreme lightness of touch which reminds us of the liquid, diaphanous texture of Rembrandt's pen drawings at this time: look at the folds of the cloak, at the leaves of the manuscript. This lightness grows to unearthly luminosity in the face, which shines forth like the apparition of the spirit to Dr. Faust in the famous etching (Hind 260). Indeed, this is St. Paul as we know him from the letters to the

Corinthians: erudite, like an ancient philosopher, harbouring the flame of Christendom. "For though I preach the Gospel, I have nothing to glory of: for necessity is laid upon me; yet, woe is unto me, if I preach not the Gospel. . . . For though I be free from all men, yet have I made myself servant unto all, that I might gain the more" [I Corinthians 9, vv. 16, 19].

We may imagine what a response these words must have found in the soul of the old Rembrandt with his idea of artistic freedom and inner urge. We shall see later how far his self-identification with Pauline thought went.

Another point becomes clear in this masterwork: the contrast between pagan and Christian is extinguished in the sphere of highest spirituality and deepest humanity. Just as the figure of the blind, old Homer occupied Rembrandt's mind during all his later years and blends frequently with the image of St. Peter, this St. Paul is essentially related to the concept of the pagan philosopher *Aristotle* (Bredius 478 [now New York, Metropolitan Museum]) who, in a painting of 1653, places his hand on a bust of Homer, pondering deeply. They are men of the same mental ground.

The model which Rembrandt used for the *Aristotle* appears in two portraits. One of them is the so-called *Rabbi* in the National Gallery in London (Bredius 283; fig. 156), dated 165[7]. The head shines in that golden hue which we know from St. Bartholomew, framed by the black of an archaic biretta and gown. There is nothing to justify the title of Rabbi, for the same man appears in 1661, in a portrait of the Hermitage, Leningrad (Bredius 309), in that timeless, or rather medieval attire in which the old Rembrandt liked to vest the sitters of his "free portraits". The head is now modelled in an almost weird reality and majesty. It exhales a deep melancholy, marked by past passion yet now slackened, like a burned-out volcano. It expresses in the highest degree that loneliness and human exclusiveness which marks Rembrandt's late paintings: man, sublime in his victory over all vanities of life, shining like a star in the blackness of the universe. I feel inclined to assume that it is the same model which Rembrandt used for St. Paul in the painting of the National Gallery, Washington.

From these examples we can see how Rembrandt brought worldly and religious portraiture increasingly nearer to each other, and this not only in cases where the use of the same model offered a point of outer, material contact. The late Rembrandt imbued even the commissioned portrait with a spirituality which elevated it to the sphere of the religious attitude. I should like to mention, as the most magnificent examples of this, the so-called *Auctioneer* of the Altman Collection in the Metropolitan Museum (Bredius 294; fig. 160), the portrait of a middle-aged man holding a pamphlet, with the date 1658. Perhaps he was an art collector, like Rembrandt's wealthy pupil Govaert Flinck, or a humanist. A Roman bust stands beside him in the half-darkness on a table, in its secrecy giving the impression of

one of the funeral portraits of El Fayum. The man wears a long wig and lace cuffs of the latest fashion, yet this costume becomes as unsubstantial as the classicistic setting of the background with column and curtain because of the tremendous spiritual power which the portrait exhales. The sitter seems to belong more to the beyond than to this world. The painting is a symphony of grey and withering gold. Streams of old gold rush down over the dark greyish-brown of the garment; the laces turn into scum, light grey like the foam of the sea. All-over material design dissolves into hazy, ghost-like indefinitness. Out of this shadowy world, heaving in half-light, materialize the head and the right hand. They are of a very light brownish hue, like old ivory, their pallor emphasized by the velvety black of the biretta and the dark grey of the leaves. We feel the bony substance of the skull and the skeleton of the hand penetrating underneath the tender vellum of the skin.

With this almost mysterious penetration of substance, the painter X-rayed, so to say, the organic form. Nothing of its anatomic correctness was omitted or distorted, but it is divested of all coarse materiality; it is spiritualized to a degree unsurpassed in painting. We are met by a look of abysmal melancholy from large, dark, deeply-sunken eyes, yet also a look of grief sublimated into *spiritual nobility*. This was the quality which the man Rembrandt proved so strongly in the dismal days of 1657, and which he saw also in his models. It is also the foremost sign of Rembrandt's religious portraits.

The worldly portrait is capable of encroaching upon the religious portrait almost unnoticeably. We see this in an example taken from Rembrandt's family circle. The moonlight-like pallor and spiritualization of the New York portrait returns in some of the later portraits of Rembrandt's son Titus. The most expressive of his proper portraits is that of 1660 (Paris, Louvre, Bredius 126; fig. 162). The keynote of the painting is bluish- and greenish-black. Only an inkling of moonlight-like blue dawns in the depth. The gold tone of the garment succumbs to the darkness. In almost terrifying intensity the face emerges from the different chords of black. Its pink hue turns white, or becomes a pale bony yellow. Again, as in the portrait in the Altman Collection, Metropolitan Museum, we feel the structure of the skull. The eyes of this face are of a pungent black, like coals. The black-white contrast is still further enhanced by the fiery gold and red of the sparkling locks. The touch of the brush is, if possible, still lighter than in the 1650s, in parts almost a spray or drizzle of colour. This increases the spell-bound character of this face, whose withering pallor is foiled, and in parts even corroded, by the blackness. The bottomless eyes meet us with a hypnotizing gaze.

Rembrandt had the ability to capture something of the fate of his models in his portraits. We can read in the features of Titus' last portraits that the young man's doom was sealed. Consumption raged among Rembrandt's kindred like an

epidemic. If the shadows of death fell on a face, Rembrandt knew how to give it still greater expression, to make it humanly still more attractive. One of his most moving and deeply human portraits is the last one of *Hendrickje* (Bredius 118), Rembrandt's second wife, done in the same year, 1660, one or two years before the sitter's death. This painting is full of a transfigured richness and opulence. Its warm glow has nothing of the Titianesque substantiality of the middle of the 1650s. It is more like a veiled firework, a drizzle of deep fiery brown, black, bluish-grey, gold and salmon colour. The painter seems to caress the forms rather than to grasp them firmly, yet, from this hazy spray, they materialize with no less accuracy, only in a much softer key. The master has concentrated all love and goodness of heart in the face. This is Hendrickje, who in her testament of 1661 "friendly asks Rembrandt to assume guardianship over her little daughter," and who appointed her stepson Titus as the heir of her own child. Yet her eyes have the same inscrutable depth as Titus', and some spots of hectic red on the cheeks forbode an early end as much as the spotty greyish shadows which grow through the tender flesh.

Rembrandt transfigured death and decay by lighting the glow of soul and spirit. The weirdness of Titus' sickly physique is sublimated into religious glorification in his portrait as a saintly monk in the Rijksmuseum, Amsterdam, 1660 (Bredius 306; fig. 163). He wears the cowl of a Franciscan friar, the reddish-brown of which is developed as a contrast, and at the same time as a complement, to the subdued olive of the vegetation. The foliage surrounds him like a friendly shelter, with twigs softly sprouting into the light. An immensely tender crescendo of light evokes the figure from its deep and sonorous bed of shadows into the marble-like pallor of the face, which is also chiselled like a precious marble sculpture. That aura of dreamy and magic light, like cool, bluish moonlight which we noticed previously, seems to emanate from the features. This face is full of an immense peace and inner happiness, like St. Francis absorbed in the spell of nature whom Rembrandt represented in a late etching (Hind 292). It is an introspective face like those of St. Paul and the thinkers, yet not the face of a religious intellectual, rather of a mystic who has become lost to the world in an abyss of inner serenity.

With this work we re-enter the religious sphere. It brings us to the most astounding cycle of half-lengths of Christian saints ever created by Rembrandt. Cycles of the images of the apostles were common in the Catholic countries, in Italy, Spain and Flanders, during the Baroque period. Rubens, about 1603, created such a cycle where the apostles were idealized as majestic men whose eminence of spirit is demonstrated by superior beauty and vigour of body. They are ideal men in every sense of the word, men whose ancestors we find in the works of Raphael and Michelangelo. Rembrandt's apostles are far from that: they are poor, rugged men, born sceptics who have been turned into fanatic believers by the

miraculous experiences of their lives. They are figures from real life. Rembrandt seems to have left this cycle incomplete also. Seven apostles are known; five of them bear the date 1661. Rembrandt seems to have intended to merge the cycle of the apostles with the evangelists. Therefore we meet with figures like St. Luke and St. Paul who did not belong to the Biblical group of the apostles.

St. Matthew in the Louvre, 1661 (Bredius 614; fig. 165), illustrates most strikingly the calling of these men, as Rembrandt understood it. In the act of writing the saint ceases, to listen to a voice speaking to him. What happened to the publican bent over accounts and piles of money when suddenly the voice of the Lord called to him happens again. Rembrandt, in a most ingenious way, transported the history of St. Matthew's life into the representation of a man who is suddenly awakened through a higher spiritual message. He is dumbfounded and filled with awe. He raises his rugged old hand and places it on his breast as if the voice would sound there in his innermost soul. He does not see the friendly vision of a beautiful angel, stepping behind him, touching him lightly on the shoulder and speaking the message softly into his ear.

Light and colour were used by Rembrandt magnificently to express the difference between these two beings. The face of the apostle glows in a warm brownish-red beneath a cap of smoky silver, as if it were sunburned; grey and white are intermingled with fiery commas in his beard. A still darker red glows in his hands, set off from the dark grey of the Saint's robe which is inflamed to a deep gold tone where the light falls upon it. The brushwork is particularly significant. It shows no smoothing of flat areas and planes with the palette knife, but a continuous vibrato of brushstrokes, flecks and scratches with the brush stick, nervous and utterly alive. *It has the highly drawing-like and improvisatory character of the late Rembrandt's brushwork in its full splendour.* The painting arises under our eyes. We witness its coming into being. Much softer and more ethereal is the pictorial structure of the angel, a dreamy vision from the beyond, full of poetry. The strong accents of physical life, which we notice in the apostle, vanish. A half-shadow of greenish-gold spreads over the face, and the subdued gold and red of the locks dissolve as in clouds. This painting, a symphony of gold, grey, pink and brick-red, also testifies to the importance of the colour scheme of the late Rembrandt, which permits an unlimited polyphony, if handled by a master.

The angel in this picture, again, is a proof of the closeness of worldly and religious portraiture in Rembrandt's art. It is Rembrandt's son Titus represented in a visionary and poetic mood, which distinguishes the portrait in the Kunsthistorisches Museum, Vienna (Bredius 122; fig. 164). Here Titus reads aloud from a book, his lips half opened, while a transfiguring ray of light touches his face slantingly.

St. Bartholomew in the A. R. Boughton Knight Collection, Downtown Castle (Bredius 615; fig. 161, [now J. P. Getty, Sutton Place, Surrey]) is a harsh and

crude figure, not appealing in outer aspect. As he stands there ostentatiously clasping his knife, he reminds one more of a butcher than of a man ennobled by thought. But the spirit may also overshadow simple people of a low or crude profession, as it has happened to this clumsy man who grasps his chin thoughtfully, reflecting upon the great miracle which has come into his life. The brushwork is as much alive as in the *St. Matthew*, like a drawing. It weaves a texture of flickering lights and bluish-grey shadow commas, lending an incredible depth to all shadow accents in the picture, particularly to the eyes.

The figure of *St. James the Elder* in the Stephen C. Clark Collection, New York (Bredius 617),[3] is represented as a pilgrim deeply absorbed in prayer. He is also a man who forgets the world around him in silent colloquy with his God. His profile, his attitude with folded hands are of a sublime simplicity which seems to object to all formal principles of the Baroque. He reminds us rather of a donor in a Gothic panel painting. His face is sealed, betraying nothing but mystic absorption in prayer. The figure in its grey pilgrim coat tends to fade away in poverty and humbleness. Yet the hands speak most eloquently; the master seems to have concentrated in them the mystical depth of devotion with which he invested this character. He placed them parallel to the picture surface, avoiding all demonstration of space. Nevertheless, you feel that each of the praying hands floats in a different layer of space, softly intercrossing each other, substantiated by a modelling in dim light of infinite tenderness.

A variation of the man praying was painted by Rembrandt in another picture of the same year, [formerly] in the Harrach Gallery, Vienna (Bredius 616; fig. 166).[4] It shows a rugged old man in a hairy gown, folding his hands, murmuring prayers. He blinds himself to the outer world in order to contemplate only the light which shines within himself. This is not the portrait of a definite person, nor of a character of religious history. It is the portrait of a religious attitude, the portrait of humbleness, contrition and glowing devotion itself, the rendition of a state of soul, behind which the personal significance vanishes into anonymity.

We return to the cycle of the apostles and evangelists. A most valuable recent addition to the cycle is the *Apostle Simon*, acquired, after its discovery, by the Ruzicka Foundation in Zurich [now Kunsthaus, Zurich].[5] Simon Zelotes bends over the instrument of his martyrdom as if he were a carpenter resting during his work. The face of this poor craftsman is transfigured by sublime thoughts which lift him above the strain and hardship of his daily work. The colour scale approaches closely the painting of *St. Bartholomew*, striking in the violet-pinkish hue of the hands. The deep ochre tone of the mantle clears up in the shining face as in an aureole. The painting in the Boston Museum of Fine Arts (Bredius 619) shows a strange figure, an Arabian scholar, wearing the headgear and cloak of a sheik. He writes at the desk in front of him, and by this activity is characterized as an evan-

gelist. Rembrandt was fond of the implements of exotic life and culture and collected them. We know of his interest in Indian miniatures. He was able to evoke the flavour of past and of foreign cultures better and more faithfully than any of his contemporaries. Although Rembrandt provided the Saint with no attribute, we may assume from his characterization that he is St. Luke, who was a physician and scholar from Antioch in Syria. The Saint is tightly wrapped in his costume, like a mummy in its shroud, so that only the face peers out. It is a blank, mask-like face, revealing as little of psychology as some faces by Vermeer. But the delicacy of its handling—and here Rembrandt made most subtle use of the palette knife—lends it a diaphanous quality, illuminated by an inner light. So St. Luke does not fall behind the others in spiritualization. The light greys in the turban, the chord of copper-red and dark grey in the gown forecast the eighteenth century, to which this colour refinement was handed down by Rembrandt's last pupil Aert de Gelder.

The gown is piled up in heavy, angular rhythms, reminiscent of draperies in the Netherlandish Gothic woodcuts of the fifteenth century. It may be mentioned that the idea of a Netherlandish late Gothic or early Renaissance portrait, as presented in works by Massys and Mostaert, also dominates one of the most daring pieces of painting ever achieved by Rembrandt. I am thinking of the half-length of an *Evangelist* in the Boymans Museum, Rotterdam (Bredius 618) in which perhaps we see St. John. This kind of painting must have seemed to Rembrandt's contemporaries something completely enigmatic. Here the master spoke entirely to himself, with little hope of being understood by anybody in Holland. Rembrandt used all registers of his magical colour without any restraint. Streams of colour break loose and the picture reminds one of an agglomeration of liquid gold and jewels. It is almost completely worked with the palette knife, yet without any smoothing of the pigment. The old Rembrandt did not care for what was considered among his contemporaries as the completion of a painting. He said a painting was finished when the artist had achieved his purpose.

The ground of the painting is rather dark: a deep golden blackish-brown. Rembrandt spread layers of reddish-gold and fiery ruby in an irregular manner over this ground so that the dark foil breaks through everywhere and seems to corrode the glowing colour. As if they were threatened by speedy decay the bright colours glow in a last intensity. The scarlet of the biretta drowns everything. The face appears as a shining mask, eaten away by shadows. The religious feeling, which Rembrandt expressed in the other paintings of this cycle through depth of interpretation, is here conveyed by a mystical indulgence in colour. Colour in this state is no longer a factor of naturalism and pictorialism; it is rather a metaphysical principle which may signify the deepest mysteries of life and religion.

We turn now to the image of Christ. The Saviour usually formed a part of the cycle of the apostles. The traditional canon of beauty was modified only slightly

toward naturalism by other Baroque masters like Van Dyck. For Rembrandt, the idea of Christ was so deeply rooted in the idea of the Son of Man that he would embody it only in the most appealing and deeply human features that he found in real life. He did not attempt to portray the features of the Saviour before 1648, the year in which his art took its decisive turn to the late style. About this time he discovered a model who came close to his idea of Christ's features, and inspired by his discovery painted quite a few portraits of him, both small and large. One of these is a small panel in the Bredius Museum in The Hague (Bredius 620) where the kind face, full of forgiveness, looks out from a frame of ebony-black tresses. The model may have been a young Jew of the Amsterdam community in which Rembrandt lived, one of the Marranos who came from Spain and Portugal. His noble, warm sympathetic features were certainly deepened and spiritualized by Rembrandt, who doubtless had the intention of creating portraits of Jesus.

This character entered Rembrandt's representations of religious history, too. The face of Christ in the *Emmaus* picture of 1648 in the Louvre (Bredius 578) shows his features in visionary ecstasy. Christ as the friend of the sick and poor in the *Hundred Guilder Print*, Hind 236, also bears a close resemblance to him.

The most monumental painting based on this model is the life-sized half-length figure of *Christ* in the L. F. Hyde Collection (Bredius 628, Bauch 229; fig. 167). It is also the most mature and must belong to the period of 1650. It displays an iridescent richness of the palette, unknown to Rembrandt before this time, colour transitions from blackish-violet and brick-red to bluish-grey with masses of dark and light. Quietly the gentle face shines above them in a pale ivory tone.

After the 1650s this type disappeared. In the prolific year 1661 Rembrandt painted the *Portrait of a Young Jew* (Van Horne Collection, Montreal, Bredius 300; fig. 168). He is seen full face with head bent slightly towards the spectator. He wears the little cap of the orthodox Jew; perhaps he was a young scholar of the theological seminary. He has the pale complexion of the Jews of Eastern origin and seems to come from a far and foreign world—a point to evoke the painter's ardent interest.

This model inspired Rembrandt's representations of Christ done in the 1660s. In front of them we no longer can speak of *portraits* of Christ, because the Saviour is idealized, not according to a conventional type but according to the mental image which Rembrandt himself formed of the creator of the Christian doctrine. The *Christ* of the Bache Collection in the Metropolitan Museum (Bredius 629; fig. 170) glows in red and gold. It is Christ the teacher in the Synagogue, wearing a black headcloth, standing beside a heavy column with an inscribed tablet. His face is a radiant hazy pink and his reddish hair turns into pure gold. The figure conveys the feeling of the magical and strange. Not only is Christ's garment that of a traveller from a distant Eastern land but his type is also foreign, aloof, belonging

to another world, which is always to Rembrandt the world of the Spirit. (Unconsciously this Christ approaches the type of Byzantine mosaics and murals.) The painting formed part of our apostle series.

The Risen Christ in the painting at Munich, 1661 (Bredius 630) is the Son of Man, Who has passed through suffering and death but is now removed far beyond the pains of this earth. A dim halo floats above His head. The livid colouring with the deep grey and brownish shadows demonstrates that this Man has gone through the darkness of the tomb and of hell; but they now resound only as faint echoes in Him. And so resounds only a faint echo of the various types of Christ which Rembrandt studied from living men. It is the image of a transfigured spirit in whom the deep humanity, intrinsic in all the characters of Rembrandt, dwells as a spiritual essence.

The question arises how the old Rembrandt, the Rembrandt of the 1660s, with this intense faculty of spiritualizing and transfiguring his subjects, dealt with the problem of the commissioned portrait. Insurmountable difficulties seem to arise between a patron's demand for a faithful portrait and the artist's imperious demand to see the world with *his own eyes*. Yet these obstacles fade away if a common platform can be found, as it was found by Rembrandt and his patrons. From the latter of course it demands also a high degree of intelligence. This common platform was the human quality. The old Rembrandt's deep respect for the human soul restrained him from arbitrary interpretations and induced in him a certain objectivity which an intelligent patron could appreciate. Such was a wealthy merchant from Dordrecht, Jan Jacobsz Trip (Bredius 314, London, National Gallery), who certainly agreed with the master when he represented him in ghost-like solemnity, like one of the old religious heroes and thinkers, his waxen face shining above gold brocade which sparkles with the subdued glow of mosaics. We have normal bourgeois portraits of the sitter and his wife by J. G. Cuyp and Nicolaes Maes, yet Rembrandt, who portrayed Margareta Trip twice (Bredius 394, 395 [now both London, National Gallery]), succeeded in sounding a human note in these likenesses which must have deeply satisfied the sitters. We thus understand the predominant role which the portrait played in Rembrandt's last period.

Yet when Rembrandt displayed all the riches of his art of colour, when he gave the very utmost in a profusion of burning and glowing tones, when colour reached a mystical intensity, then he usually transcended the customary meaning of the art of portraiture and touched the sphere of the religious. This is the case in the so-called *Jewish Bride* (Bredius 416), one of the most glorious creations of the old Rembrandt, the iconographical meaning of which is still an enigma.

In 1659 Rembrandt painted a little portrait of a man with hollow cheeks and deeply sunken eyes (Bache Collection, Metropolitan Museum, Bredius 296). The

model was not a healthy and vigorous type, but was, rather one of those consumptive figures that the late Rembrandt liked to portray because they enabled him to demonstrate the beauty of the soul outliving the decay of the body. Bluish-grey shadows underline the pale brownish face and make it immensely expressive. Yet its expressiveness would not be complete without the glorious purple-red of the garment which gives the little painting an emphasis like that of a flourish of trumpets.

Rembrandt increased this glory of colour half a decade later and removed the model into the sphere of the religious. As F. Schmidt-Degener recognized, he is the husband of *The Jewish Bride*. His stature is enhanced; loving kindness embellishes his features. The couple's meaning has often been discussed. Their rich archaic garments remind one of the Orient. Jacob and Rachel, Tobias and Sarah, have been suggested.[6] Perhaps merely a double portrait was intended, yet in that elevated sense with which Rembrandt endowed the representation of man in his last years. As man and woman stand in their burning and glowing garments before a deserted garden which vanishes into the deep golden-brown of an old tapestry, as he places his hand with an almost sacred solemnity on her breast, they seem to fulfil a Biblical fate. The human in these transfigured portraits is of such universal importance that the living characters, contemporaries of Rembrandt, were transformed into timeless heroes of the Old Covenant, symbols of eternal religious values. The colour is an integral part of the mystical legend. Radiant red in the woman and shining golden-yellow in the man form the basic chord which is supplemented by the iridescent play of silvery-olive, greyish-green and salmon-pink. Glowing colour as the means of the highest pictorial realization and utmost spirtualization is Rembrandt's last word in painting.

We return to the apostle series. The question was often asked, why Rembrandt, the artist of a Protestant country, showed almost Catholic leanings in his late paintings of saints, monks, hermits and pilgrims. The truth is that the meaning which they embody can be called neither Catholic nor Protestant. These figures have nothing to do with confessional distinctions. They are simply Christian, as simple, deep and human as Christian faith is. As the great figures of the pagan past blended in Rembrandt's world with the pioneers of Christianity, so also did those of the Old Covenant. *A deep humanity is their common link.* It unites them with the people in Rembrandt's surroundings as Rembrandt saw them and, finally, with the painter as he saw himself. One of his deepest and most grandiose self-portraits is that of 1661 in which the master represented himself as the *Apostle Paul* (Bredius 59; fig. 169, [Amsterdam, Rijksmuseum]). It forms part of the cycle which we discussed.

The figure of the master is bathed in the most tender and visionary half-light which Rembrandt ever displayed in a painting. Like moonlight, it dawns in a greyish-blue shimmer above the shoulder and drizzles over the leaves of the book.

The face glows up, blending yellow and orange tints with greyish shadows; the curls shimmer in silver under the turban, which seems to be woven from coloured light.

Rembrandt, the old fighter, saw himself as the apostle who wrote to the Corinthians : "And though I have the gift of prophecy, and understand all mysteries, and all knowledge; and though I have all faith, so that I could remove mountains, and have not charity, I am nothing" [1 Corinthians 13, v. 3]. Profound wisdom lies in his questioning eyes turned towards us, while a faint smile plays around his lips, a smile not only of resignation, but also of deep loving understanding.

In *The Jewish Bride* and this *Self-Portrait* Rembrandt found perhaps the most accomplished solution to the problem of fusing worldly and religious portraiture into one great unity.

The Art Quarterly XIX, Detroit, Winter 1956, pp. 334–355.

The Rembrandt Exhibition in Warsaw

THE exhibition "Rembrandt and his Circle" at the National Museum in Warsaw was the second of several large-scale events held to celebrate the 350th anniversary of Rembrandt's birth. The arduous and highly responsible task of organizing the exhibition was performed by Professor Stanislaw Lorentz with the collaboration of Professors Julius Starzynski and Michal Walicki.

The exhibition was dedicated to Rembrandt's circle of pupils as much as to the master himself. Anyone who has ever been concerned with this field will know how many awkward problems are still waiting to be solved, but these three Polish art historians have shirked none of them. The proof is the catalogue,[1] which is presented in two volumes, one for the paintings (compiled by Dr. Jan Bialostocki and Mgr. Janina Michalkowa) and the other for the drawings and etchings (compiled by Stanislawa Sawicka and Maria Mrozinska). The designations of authorship and the attributions are evidently the result of careful and cautious research and are extensively documented with references to the literature.

As for the presentation of the exhibition, it is outstanding. Not only does it give a remarkable impression of integration, but it is arranged organically, individual works that throw light upon one another being hung close together. In this way, the organizers were able to illustrate tentative ideas about some of the works which they would not have been rash enough to state in the catalogue.

Poland plays an important part in the history of the collecting of Dutch art[2] because it once possessed rich treasures from the works of Rembrandt and his school. But no visitor can properly understand this until he enters the gallery of photographs of paintings that used to be in Poland, one of the foremost being the superb *Polish Rider* (Bredius 279) in the Frick Collection, New York. To the astonishingly large stream of visitors flowing through the exhibition, this gallery must have seemed like a memorial to their national past. Another gallery, where one could sit, was showing photographs of Rembrandt's most important paintings and this was of enormous pedagogical value. Indeed, the real success of the exhibition was pre-eminently at a pedagogical level; it made many valuable contributions to scholarly research. The knowledge we gained there about the school of Rembrandt is beyond price, and it is astonishing how many treasures from this school Poland still possesses today—and how many surprises!

The group of works by Rembrandt himself was small but impressive; the picture which surpassed all others in quality was the magnificent *Stormy Landscape with the Good Samaritan* (Bredius 442; cat. no. 16) painted in 1638, from the

Czartoryski collection, Cracow, now in the National Museum, Warsaw. This painting is exceptionally beautiful and very well preserved, a superb example of the grandeur and nobility of Rembrandt's power of imagination in his landscapes. On the right there is an avenue of trees, like the twilight interior of a church nave, contrasting with the low-lying ground near the river which is as bright as if illuminated by a flash of lightning. The Good Samaritan is making his way through this avenue with the wounded man, and the indifference of their fellow human beings is shown by a huntsman, aiming at a sitting bird with his gun, and a couple of passersby, gaping, but unmoved. On closer inspection, this stretch of land proves to be full of shepherds, grazing cattle, fishermen, and a coach (similar to the Munich drawing, Benesch 469), as minutely detailed and microscopically precise as the detail in a Van Eyck panel. However, these details fade away in the streams of green and pale-golden light flooding the valley which are, themselves, overhung by the lowering gloom of the distant mountains and the stormy sky. Here is the spirit of Hercules Seghers' work, presented with a graphic intensity which seems to follow directly the works of the masters of the Danube school. The wooded area is as lively a microcosm as only Altdorfer had achieved before Rembrandt.

Among various paintings from the collection of the National Museum of Warsaw there was a male portrait of 1634, identified as Maerten Day [Soolmans] (Bredius 195; cat. no. 14). This identification, though not impossible, is not entirely satisfactory. The painting is typical of Rembrandt's work during the period of his greatest success, when he was painting the portraits of Amsterdam society, and doing so in a manner elevated, by his magical treatment of light, far beyond the usual formal naturalism of this sociologically limited genre. The painting is extremely well-preserved and the treatment of the material elements masterly, although the dominant impression is one of character and feeling. A recent X-ray examination shows that Rembrandt executed the portrait originally without the hat—a common feature of his graphic work and his oils because he liked to enhance the prominence of the sitter by the silhouette of some form of headgear. The self-portrait in the round format (dG 379, Bauch A 28; cat. no. 12) is also from the Museum's own collection. Bauch considered it to be a copy and Bredius did not accept it in his corpus. In technique, this small panel (the circular format, often used by the early Hals, appears nowhere else in Rembrandt's work) has much the same structural form as Rembrandt's very early paintings of about 1626–28, and the technique of drawing with the handle of the brush is also a feature of the same period. There is, however, a certain tentativeness which makes it easy to understand why Bauch thought the portrait was an early studio copy.

The majestic *Scholar in his Study* (Bredius 432, Nostitz Coll.; cat. no. 15) and the fragment of an *Annunciation* (cat. no. 17; fig. 173), discovered by Vincenc Kramar,

both came from Prague. The latter shows only the figure of the young Virgin, alone, surprised while reading; presumably the angel was lost in the same fire which consumed the rest of the painting; at least this is what the badly damaged edges of the canvas would lead one to believe. What is left, however, is miraculously beautiful, and makes it seem incredible that this painting had been completely ignored hitherto, except for Kramar's reproduction in a local Prague journal. This "Mary" is undoubtedly part of a work dating from the beginning of the 'fifties, and has many parallels in Rembrandt's drawings; although paintings from these years are rare because Rembrandt was devoting himself mainly to drawing and graphic art. Nevertheless, the painting is completely up to the standard of spiritual content and pictorial conception displayed in, for instance, the Braunschweig *Christ appearing to the Magdalen* (Bredius 583). In its monumental conception, the figure is reminiscent of the classical artists of the High Renaissance, and even anticipates Rembrandt's own work in the middle 'fifties, particularly the lower part, which flashes out from behind the dark red cloak in a golden, creamy colour. The face, too, is remarkable; none of Rembrandt's pupils would have been capable of producing such a profound expression.

The promised contributions from the Hermitage in Leningrad did not arrive, but Budapest sent their *Joseph's Dream* (dG 86), which is based on the drawing HdG 52, Benesch 879 in Berlin. The drawing is undoubtedly by Rembrandt, but the painting is far less convincing. Parts are powerful enough for Rembrandt (the angel and the animals in the twilight background), but the figures of the Holy Family are, by comparison, completely inferior. Obviously, Rembrandt left this canvas incomplete, and one of his pupils turned it into a finished painting.

One of the greatest surprises waiting for scholars in the field of Dutch art were the works by the generation who taught Rembrandt, and those older artists who were part of the environment of his early years: for example, Lastman's *Adoration of the Magi* of 1606 (cat. no. 5; fig. 172) from the National Gallery in Prague (Narodni Galerie, 1955, no. 330). This is a very important work, almost unknown in the literature, dating from Lastman's early period and strongly influenced by the Italian school. There is a particularly striking relationship between Lastman, Elsheimer and the early *Epiphany* by Rubens in Christopher Norris' collection. Indeed, we may conclude that the Northern artists in Rome at that time kept together in an integrated group, and only split up and went their several ways later on. Lastman's *Ahasuerus' Anger against Haman* (cat. no. 6) is another magnificent work dating from the second decade of the century, which was first brought to general notice by Walicki. This painting is full of pathos and forceful realism which help us to understand why Lastman made such a great impression on Rembrandt. The subject is superbly drawn, and the colour strong and expressive (vivid gentian blue, golden brown and scarlet). Another painting, ascribed to

Lastman, but not by him, is *Saul Threatening David* (cat. no. 7).[3] In fact it is by a remarkable early "Rembrandt-ist" whose hand can also be traced in a sheet of studies preserved in the Louvre (Lugt 1325). This painter was probably also active as a graphic artist, but I found no further grounds for my previous idea that he might have been Rottermond.

The best of the works by Moeyaert in the exhibition is his *Jacob weeping over Joseph's blood-stained Coat* (cat. no. 9), painted in 1624, from the museum in Lodz. The painting is Caravaggesque in style, with clear colours, dating from a time before Rembrandt appeared on the scene, and still containing all the qualities of Elsheimer's Roman tradition. After he came within Rembrandt's sphere of influence, Moeyaert's work gradually declined, as can be seen in his *Raising of Lazarus* (cat. no. 8) from the Warsaw museum, and, finally, in his *Parable of the Unworthy Wedding Guest* (cat. no. 10), from the Rijksmuseum. The strange painting by Tengnagel *Lot fleeing from Sodom* (cat. no. 11; National Museum, Warsaw), however, preserves all the spontaneous vitality of Elsheimer's style.

There was also a painting by Elsheimer himself in the exhibition, a landscape with a round temple, contributed by the Prague Gallery. Bramer was represented by a few strongly expressive works, one of the most striking being the *Raising of Lazarus* from the Prague Gallery (cat. no. 2), a painting related in spirit to the early work of Lievens.

Rembrandt's studio companion and friend of his youth, Lievens, was represented by two powerful early Caravaggesque works from the Warsaw Museum, the *Boy blowing on a Fire* (*A Smoker*, cat. no. 48) and the *Boy lighting a Torch* (cat. no. 49), apparently two of a series of the "Five Senses". His *Head of an Old Man* (cat. no. 51), recently acquired by the Museum, is one of a sequence of works executed under the direct influence of Rembrandt's early studies of Apostles and Prophets. A later work representing a pair of mythological lovers is marked with a question-mark in the catalogue (cat. no. 53), but is, however, a typical "Venetianizing" Lievens from his post-Flemish period, very much like his portrait of a gentleman (cat. no. 54) from the Wawel Museum in Cracow.

By far the most interesting, and indeed the most astonishing, work in the exhibition was the *Raising of Lazarus* (cat. no. 38; fig. 171) by Carel Fabritius, an altarpiece from the classical Aleksandra church where it had always been attributed to Dietricy, until cleaning revealed the signature. In fact the painting was completely unknown until Starzynski published it. The same scholar has also recently produced some interesting X-ray studies which are now awaiting publication. In its turbulent pathos, the composition of *Lazarus* is reminiscent of Rembrandt's etchings, paintings and drawings on the same theme, executed about the beginning of the 'thirties, but the semi-circular garland shape suggests that Fabritius had seen Rembrandt's recast version of the same theme in the drawing in Rotterdam

(Benesch 518) of 1641/42. It seems likely that the painting was executed in the early 'forties, as Schuurman suggested, that is, during the time when Fabritius was working in Rembrandt's studio. Otherwise, if it were not for the signature, no one would have been bold enough to attribute this painting to him because of the enormous discrepancy between its fiery chromatic scale, and glowing tones of red, yellow and orange, and the cool, Delft scale we normally associate with Fabritius, between this tempestuousness and the tranquil, still-life mood of his later works. The only feature that might make us think forward to the Fabritius to come is the technique, which centres around the optical spot, the paint being laid on loosely, in broad flakes. There are also certain areas of cool grey, bluish and greenish tones (for example, in Lazarus) which scarcely show amidst the glow of the rest of the colours. Fabritius' brother Barent seems to have served as model for the young man beside Christ, and, a real surprise, there is a portrait of Rembrandt just above the tomb. Starzynski's X-ray photographs show that there was a completely different head, an Oriental, originally in this position, so presumably Fabritius added his master's portrait during the course of the work.

This painting is an extremely important key to a better understanding of the school of Rembrandt. For one thing, it solves the problem of the magnificent *Diana and Endymion* in the Liechtenstein Gallery (Vaduz; [Moltke 92]), where we find the same loose brush-work and the contrast between warm reds and oranges and cool bluish and greenish tones. The artist has even used the same model for Diana as for Lazarus' younger sister. It also shows that the *Beheading of John the Baptist* (cat. no. 39) from the Rijksmuseum and hung, in Warsaw, on the same wall as the *Raising of Lazarus* is not, as it was thought to be, an early work by Carel,[4] but harks back, in its strong emphasis on the linear and the graphic, to Rembrandt's style of the late 'thirties. The figure of Salome can also be paralleled by a whole series of Rembrandt's drawings of female figures in costume of the same period. Finally, the head of a Jew appearing on the right of the executioner is the same model as the portrait Bredius 253, said to be dated 1648, but also, to judge from the style, a school work of the late 'thirties.

The exhibition also contained four works by Rembrandt's Leiden pupil, Dou: the portraits from the Palais Lazienki, and the *Philosopher* (cat. no. 32) from the Czartoryski Gallery in Cracow and, most beautiful and earliest of all, *Rembrandt's Mother praying* (Martin p. 43; cat. no. 30). Rembrandt's first pupil in Amsterdam, Backer, was represented by the delightful portrait of Rembrandt's sister (cat. no. 13) from the Warsaw Museum. This work was attributed to Rembrandt (?), in the catalogue, on the grounds of the date and signature "Rembrandt 1633", but, in fact, the pupil's more subdued artistic temperament is clearly evident, particularly when the painting is compared with his portrait of a boy from the Wawel museum (cat. no. 20), a painting in the flowing Flemish style. There is a portrait in Tours,

which Bauch claims to be the original of the Warsaw painting (comment to cat. no. 13), but comparison of the two shows that the latter is superior in quality, and thus that the version in Tours is more likely to be the copy.

There was also a series of early and later paintings by Bol which gave us the opportunity of assessing his span of development. One of the most significant was the portrait of a woman (cat. no. 25) from the Palais Lazienki, a replica of which was accepted in Bauch's catalogue of Backer's oeuvre,[5] as number 194. At first glance, the stylistic similarity with *Elisabeth Jacobsdr. Bas* (Bauch, Backer 137; fig. 23) is staggering, and the name Backer immediately springs to mind. But the Warsaw portrait is unmistakably signed "F. Bol", which indicates the need for renewed investigation into the ancient controversy about the authorship of the *Bas*. Bredius, for example, always favoured Bol, and, in any case, the signature looks convincing enough. Even on closer study, the technique of the composition is typical of Bol throughout.

Flinck was represented by a portrait of a young man in flowing, knightly garb (Moltke 246; cat. no. 40), dated 1637, and lent by the Wawel museum in Cracow. The painting is as characteristic as it is excellent; it confirms my suggestion that the *Portrait of an Officer* (Bredius 204; fig. 25)[6] and its companion piece (Bredius 352) should be attributed to him. There was also a drawing by Flinck in the graphic section, a charming, signed family group from his early period (cat. no. 56). This drawing is particularly important for any critical assessment of Flinck's early drawings in view of the recent vogue for ascribing to him, somewhat arbitrarily, many chalk drawings actually done by Rembrandt during the 'thirties.

One other of Rembrandt's first generation of pupils in Amsterdam represented in the exhibition was Jan Victors, and there were no fewer than five characteristic works by him. *Jacob blessing the Sons of Joseph* (cat. no. 62), from the Warsaw Museum, uses a theme taken from a composition by Rembrandt, so far known only from copies. Two of these are in the Print Room at the Rijksmuseum (Benesch C 23 and Henkel 94) and a third is in the Grassi Collection. Recently, however, the original drawing (Benesch Addenda 7), has turned up in the Houthakker collection. Rembrandt obviously gave this sheet to several of his pupils to copy, Victors being one of them.

The extent of the early Rembrandt's sphere of influence, and his effect on his more remote contemporaries, was demonstrated by works by Salomon Koninck, Jacob Willemsz. de Wet and Benjamin Gerritsz. Cuyp. The Schwerin Gallery had lent Koninck's *David playing the Harp before Saul* and *Joseph interpreting Pharaoh's Dream* (cat. nos. 46 and 45) and the *Zacharias in the Temple* (Bredius 542; cat. no. 47) was also tentatively attributed to the same painter, although Hofstede de Groot put the name of Lievens to it. In fact, the Schwerin painting gives the effect of being more condensed in the composition, and more convincing. I am

persuaded that the drawing in the Louvre (Lugt 1254) is not a copy at all, but a preliminary study for it. In any case, from the stylistic point of view, it looks like Lievens' work.

The next generation of Rembrandt's pupils was represented by three works by Gerbrand van den Eeckhout, from Warsaw and Prague. The delightful *Jacob's Dream* (cat. no. 37) incorporates a new version of the theme of the angel's ladder current among the pupils in Rembrandt's studio about the beginning of the 'forties. The same motif also appears in Rembrandt's own sketches from the first half of this decade (Benesch 555, 557 and 558). The Eeckhout and Fabritius generation also yielded a magnificent portrait of a man, from the Prague National Gallery, Nostitz Collection (cat. no. 55; fig. 32), painted in 1661 by the Saxon, Christoph Paudiss.[7] In this painting, Paudiss is still drawing on Rembrandt's early style, but the ghostly, opaque quality of his technique has already moved half-way towards Aert de Gelder. Two of the latter artist's paintings from his Passion sequence (cat. nos. 42 and 43) were on show (Munich, Pinakothek, Inv. 6284, 6337).

Renesse, a pupil from the late group, is seldom seen as a painter, but could be studied here in an entrancing genre composition, executed in 1653, *Satyr with Peasants* (cat. no. 57; fig. 174). This subject had previously been handled by Rembrandt in a drawing (Benesch A 31, Chicago) during the 'forties, but the effect of the light is typically Renesse. It makes the figures look as if they were disembodied, floating or hovering in space. The source of the light is the fire in the centre of the composition. In the catalogue, the wonderful rectangular painting of a woman ("Bathsheba"?) at her toilet before a mirror (cat. no. 58), from the museum in Poznan is also attributed to Renesse, but in my opinion it is by one of the pupils of the late 'thirties, or about 1640. For instance, the composition has been influenced by Rembrandt's *Sophonisba* of 1634 (Bredius 468; fig. 177).[8] The technique is painstaking, with an emphasis on the linear; greenish, golden tones predominate. The face, which is of compelling beauty and spirituality, has been painted to look translucent, and it may indeed have been this quality which lead the compiler to Renesse, although in every other aspect there is nothing to indicate his authorship. However, beyond the fact that the painting has been executed by an artist of talent and intelligence, no more definite conclusion can be reached at the present time.

Another of the surprises was a beautiful portrait of a woman by Gijsbert Sybilla (cat. no. 59), painted in 1650. This is a new facet of the Burgomaster of Weesp. It shows him no longer as a mere dilettante, but as an accomplished painter who had come within Rembrandt's orbit, and who was clearly influenced by the master's works during the late 'thirties. The evocative painting of *Vertumnus and Pomona* (cat. no. 70) is very probably by Drost.

If the emphasis was on the School of Rembrandt in the paintings section, in the

section on graphic art and drawings it was the master himself who took the lead. The Museum and the University Library had both contributed to make an imposing display of Rembrandt's graphic oeuvre, complemented by works by the most important of his pupils. Poland's inheritance of drawings by Rembrandt has been drawn from three superb collections dating from as far back as the eighteenth century; the Royal collection, founded by Stanislaus August Poniatowski, Count Potocki's collection, which he gave to the University of Warsaw, and the collection of Prince Lubomirski which is housed in its own museum in Lwów. The Rembrandt drawings in the latter collection were hidden by a Polish patriot during the Second World War and returned to the Museum authorities on the occasion of the exhibition. They now form part of the Ossolineum in Breslau.

It is with profound regret that I must deny myself the opportunity of discussing the exhibition of drawings in detail but, in fact, they are mostly included in my Corpus. The attributions in the catalogue have been made with an emphasis on caution and restraint. However, the question-mark put beside the beautiful interior (cat. no. 8; Benesch 644, *Old Tobit*) can confidently be eliminated, and the excellent studies of beggars (Benesch 739 and 740; cat. no. 88 and 89) are also undoubtedly Rembrandt's work. In my opinion, the *Judgment of Solomon* (cat. no. 64) ascribed there to "Philips Koninck?" is an early work by Eeckhout, and the study of the woman in Biblical costume (cat. no. 112) and the *Annunciation* (cat. no. 108) are by Bol. *John the Baptist's Sermon* (cat. no. 107) is a copy of an original in the École des Beaux-Arts in Paris (Lugt 498). The *Christ and the two Disciples on their Way to Emmaus* (Benesch 1383; cat. no. 100) is catalogued as a copy after Rembrandt but is, in fact, the original, and the drawing in Berlin (Val. 522) is the copy. This is a piece of work by a pupil, extensively reworked by Rembrandt, an instructive case, like *Job, his Wife and Friends* (Benesch 1379) in Stockholm. The *Old Scholar* (cat. no. 57) is by the same hand as the expressive study of a sleeping woman in the Boymans–Van Beuningen Museum in Rotterdam (Benesch A 19). It thus provides a new step forward on the way to defining the profile of yet another one of Rembrandts pupils.

This exhibition provided an inestimable fund of new information for all those professionally concerned with the school of Rembrandt, and its success was due not only to the generosity of the Prague Gallery, but also, in a large measure, to loans from the Fodor Museum and the Rijksmuseum in Amsterdam, the Gallery in Schwerin, and the Pinakothek in Munich.

"Die Rembrandtausstellung in Warschau," *Kunstchronik*, 9. Jg., Nuremberg 1956, pp. 189–204.

Rembrandt and Ancient History

THE humanistic heritage of the Renaissance, with its interest in classical antiquity, gives to the era of the Baroque one of its most outstanding features.[1] Renaissance and Baroque share in common much of their classical subject matter. The aspect of antiquity which the Baroque era gives is, however, not so much the revelation of a new world as it is a splendid, decorative performance, richly provided with the ingenious devices which a great theatrical art could offer. Could any stronger contrast be imagined than that offered by the realistic and deeply human art of Rembrandt? In consequence thereof, the majority of the art historians, among them the master's famous biographer Carl Neumann, reach the conclusion that Rembrandt did not pay more than the usual tribute to antiquity in subject-matter commonly demanded by the artist's time and his environment, and remained in his innermost soul foreign to the essentials of Classicism. He even appears to have made of antiquity a kind of travesty, with no attempt to hide his native Dutch naturalism behind a classical façade, as some of his mythological pictures apparently prove.

With the beginning of the Baroque, a new historical consciousness arose in the Western world. The historical tragedies of Shakespeare testify to this as much as do the historical paintings of contemporary artists. Nor was this trend alien to Rembrandt's art. He took a strong interest in it. His attitude to the problem of historical painting illuminates the master's position in his century: what he has in common with it; in what respects he differs from it. It was mainly from ancient history that he derived his subjects.

Although far from being a scholarly archaeologist, as Rubens was in some ways, Rembrandt was not unlettered. His parents, simple but worthy burghers, had him destined for a scholarly career, and he received the education in ancient languages which seventeenth-century Holland offered to an upcoming scholar. At the age of fourteen he was enrolled at the university of his native city Leiden, although he soon discontinued his studies.[2] In any case, he must have learned to read the ancient historians: Livy, Tacitus, Valerius Maximus, and Plutarch, and the figures depicted by them must have entered his imaginative consciousness. It is questionable whether at an advanced age he still was able to read the sources—his library contained only Josephus Flavius' *Antiquities of the Jews*—yet learned friends were always able to help him with translation and interpretation. In any case, Rembrandt was as familiar with the great figures of ancient cultural and political history as any of his Dutch contemporaries. They play a considerable part in his work. The way

he saw them—differently in different periods of his career, nonetheless with strongly marked and persistent features—will be revealing for Rembrandt himself.

The year 1626, the first for which we have preserved authentic works by the artist, is inscribed on a large painting of Roman history in the museum of Utrecht (loan, J. J. M. Chabot, Bredius 460; fig. 175).[3] To eyes accustomed to archaeological correctness it offers a strange aspect. This assemblage of heavy figures in wooden attitudes, wearing costumes and armours partly Oriental, partly early sixteenth century, partly contemporary, partly fantastic, has nothing to do with a neo-classical notion of antiquity. The figures are supplemented by a huge still-life of weapons as if they were piled up in a studio corner. Everything is displayed in full daylight, without the mysterious chiaroscuro which the master developed in the following years.

In spite of their stiff poses, the figures reveal a strong inner tension. They stare fixedly at one another; their motions suspended in a moment of fateful importance. These picturesque knights and martial ruffians perform a scene described by Livy: Lucius Junius Brutus pronounces the sentence of death upon his sons Titus and Tiberius, who participated in the conspiracy of the Tarquinii.[4] Livy, after describing the stage, a Tiber island with temples and porticos, which Rembrandt did not omit, gives the scene as follows:

> When the chattels of the princes had been pillaged, sentence was pro-nounced and punishment inflicted on the traitors—a punishment the more conspicuous because the office of consul imposed upon a father the duty of exacting the penalty from his sons, and he who ought to have been spared even the sight of their suffering, was the very man whom fortune appointed to enforce it. Bound to the stake stood youths of the highest birth. But the rest were ignored as if they had been of the rabble: the consul's sons drew all eyes upon themselves. Men pitied them for their punishment not more than for the crime by which they had deserved that punishment . . .

Rembrandt was intent on illustrating this report as dramatically as possible. We see the kneeling sons, the apprehension in their faces, the inexorable severity in the imposing figure of the consul, dressed in a pompous robe of greenish-blue and gold, the amazement and pity of the bystanders. The face of the young Rem-brandt himself gazes at us with wide-open eyes from behind the sceptre of the consul. The spoils of the Tarquinii are heaped up in the foreground, and the cluster of spectators around a column reminds one of the "stake" mentioned by Livy.

The youth and inexperience of the artist is revealed by the lack of skill in com-position. Inflexible as posts, the figures stand in each other's way. The colours

are harshly opposed. Everything is studied from the model. Realism to the utmost degree was the purpose of the young artist, with no regard for archaeological correctness. The cohort in the background looks like a picket of harquebusiers from the Spanish War. Gothic round churches and bell towers rise as pagan temples, just as guns thunder in Shakespeare's *Coriolanus*.

Did Rembrandt not know of any other models? Certainly; yet the very old of the classical past came most alive for him in the old things with which he could surround himself, which he could touch with his hands. Thus, the spirit of dramatization out of the experience of reality, which is significant for all creations of Rembrandt, is noticeable at the very beginning of his career.

Rembrandt also pondered over this tragic subject in later years. About 1640, when he etched the *Decapitation of St. John* (Hind 171), he made several drawings of scenes of beheading like the one in the British Museum (Benesch 479; fig. 176). They illustrate Livy's text (Livy II, 4, 5) on the execution: "The culprits were stripped, scourged with rods, and beheaded, while through it all men gazed at the expression on the father's face."

Rembrandt had learned by now to avoid exaggerated realism and to concentrate on the essential. The delicate, searching penlines indicate with admirable certainty the importance of every group and figure. The body lying on the ground is most strongly accentuated, the expression of death in the pointed features stirringly rendered. The other figures seem to tremble in a haze of light, which absorbs the continuity of their outlines, yet the psychical continuity of the narration is wonderfully maintained: despair marks the features of one of the condemned; his tied hands seem to pronounce a last hopeless claim for pity. Although we do not see the awe-stricken faces of the court-martial, their deep emotion is reflected even in the executioner's.

The 1630s, the first decade of Rembrandt's life in Amsterdam, were the period of his greatest outer success, in which he conformed as much to the taste of his surroundings as he contributed to the forming of this taste, the period in which he developed a notion of antiquity truly Baroque in the commonly accepted sense. Baroque in this sense means motion, dynamism, bold movement of sizable bodies in space, a blending of the real with the extraordinary, surprising, stupendous and superhuman. It enabled Rembrandt to keep his realism, gained in the wake of Caravaggio and his followers, even to increase it, and at the same time to fulfil all demands for bravura and ostentation made by the ruling taste. So far, his representations of ancient subjects did not contradict the custom of the times. It is true that Rembrandt's inborn naturalism now gave his subjects a forceful note, which was not always in accordance with the reverence scholastic humanism paid to them. Classicists might have been upset by the boorish aspect which he gave to Emperor Augustus in an etching of 1633 (Hind 106), destined to illustrate a

canto of Herckmans' poem *The Praise of Navigation*. It is an allegory of the peaceful government of the Emperor, who dismounts from his now useless battle horse, furthers trade by turning heavy men-of-war into light merchantmen, maintains law and order in his empire, and orders the closing of the temple of the double-headed god Janus. It is a very powerful and Baroque, at the same time a very rustic and Dutch, notion of antiquity, quite appropriate to the spirit of the rebellious *Geusen* and Protestant seafarers. Rembrandt's illustration was surely understood in this sense, and appreciated.[5]

He knew how the portraits of Roman emperors looked. In the time of his rising prosperity, which gave him the opportunity of satisfying his passion for art collecting, he acquired a series of ancient busts, originals, copies and casts, which he assembled in a large room of his house, the so-called *Kunst Caemer*, a kind of museum of antiquities. The inventory taken in 1656 mentions Augustus, Caligula, Marcus Aurelius, Galba, Otho, Agrippa, Vitellius, Vespasianus, Nero, Faustina, Gaius Silius, Brutus, and some other unnamed busts. They testify to Rembrandt's deep interest in the ancient world. He studied those portraits, as he studied features of living persons, and occasionally made pen sketches of them. One, in the Library at Turin (Benesch 452) renders an Emperor's bust in a rather general way, quickly jotted down on paper; even thus, it proves the strong appeal which the severe and haughty features had for the artist. The edged penstrokes excellently frame the cubic shape of the solid marble and its rigid traits. The profile bust in the Berlin Print Room (Benesch 770; fig. 178)[6] was drawn from Rembrandt's Galba bust. The characteristics are emphasized with Rembrandt's intensity, the realism of Roman portrait art increased by the draughtsman's vision. The bony structure of the skull, over which the skin is tightened like parchment, is most eloquent. The upper cranium bulges. The haggard old man has the profile of a bird of prey. Rembrandt concentrated here on the expressiveness of the character, while in the previous sketch he gave more prominence to the sculptural values. The drawing illustrates how Rembrandt's realism always becomes finally a vehicle of expression. The bust of emperor or philosopher, an almost tedious element of Baroque decoration, acquires life under Rembrandt's pen. Both drawings were done around 1640, a time when Rembrandt strove for exaggerated accents of sculpturesque rigidity and expression.

The Baroque Rembrandt of the 1630s understood the representation of history mainly as the drastic reality of heavy, bulging, bolstered forms with wavy, compact outlines, imposing in appearance and exotic in adjustment. He favoured the compositions in half-length introduced by Caravaggio. The figures emerge into a bright spotlight from a gloomy background. The spectator is moved close to the subject, with whose fate he is supposed to sympathize. The magnificent strange Eastern costumes enhance the extraordinary, the remoteness in time. With this

Oriental splendour Rembrandt endowed not only his Biblical heroes and heroines but also his Romans. A painting in the Prado, dated 1634 (Bredius 468; fig. 177), represents the tragedy of Sophonisba, daughter of Hasdrubal, as Livy recounts it. She had been the wife of the Numidian prince Syphax, who forsook the Romans. Overpowered by his rival Masinissa, he was not only deprived of his rulership but also of his wife Sophonisba, whom Masinissa married hurriedly. Scipio, fearing that a Carthaginian wife might have an adverse influence on the Roman ally, made serious reproaches to Masinissa and claimed Sophonisba as a prisoner of the Romans. Masinissa withdrew into his innermost chamber where the attendants heard him lament. Finally, he sent a servant to his wife with a cup of poison that she might escape humiliation by the Romans.

Rembrandt introduced into his painting the gloom of the royal chambers and made Sophonisba stand out from it in sharp light. A bust of her royal father looms mournfully in the background. Sophonisba, a stately blond woman who resembles Saskia in the disguise of an ancient deity, or Delilah, is shown in the last moment before her death, heart sick and hesitating, yet she will bravely accept the cup with the words: "I accept this nuptial gift, not unwelcome to me if my husband cannot bestow any better. Tell him that I would have died happier had I not married on my burial day."

Roman history had a particular importance for the Dutch nation. Neo-Stoicism, the dominating trend in contemporary philosophy, gave prominence to ethical and moral values: constancy, simplicity, industriousness, severity, incorruptibility, equanimity and justice. The Netherlanders saw those virtues embodied to the highest degree in the figures of Roman history, who served as models for Republican Holland. Public buildings were adorned with representations of Roman scenes in order to spur the patriotism of contemporaries. The democratic Hollanders in their brave struggle for the freedom of their country compared themselves with the heroes of Republican Rome. A story quite to their taste was that of General Manius Curius Dentatus, agrarian reformer, about whose simplicity and incorruptibility Valerius Maximus (IV, 3, 5) reports. The Samnites sent ambassadors carrying precious vessels and treasures in order to bribe him. They found the General before the fireplace, roasting turnips and eating from a wooden plate. He refused their gifts with the words:

> You ministers of a highly superfluous, not to say incapable embassy, tell the Samnites that Manius Curius prefers to command wealthy people rather than be wealthy himself; return those gifts which are as much devised for the corruption of men as they are precious, and remember that I can be neither defeated by steel nor corrupted by money.

About 1633 Rembrandt made a spirited sketch of this scene (Warsaw, University Library, Benesch 86; fig. 179). The Roman General is seated before a Dutch fireplace and angrily refuses the chains and vessels offered to him by the ambassadors. Heavy washes model the wavy line-work of the pen. Falling curtains create a setting redolent of pathos. The actors appear in strange Eastern garments, garments of Turks, Poles, Russians, rather than of Romans. It is the picturesque idea of antiquity which the mannerist Baroque of the early Rembrandt cherished. This will change very thoroughly in later years.

We now skip over a time interval of almost two decades in order to see how Rembrandt represented ancient history at the end of the 1640s. We mentioned above how much the Bible and ancient history blend in Rembrandt's fantasy. A drawing in the museum of Groningen (Benesch 596; fig. 181) was considered a scene from the Bible until Dr. Valentiner recognized it as an illustration of the tragic story of Marcius Coriolanus as recounted by Livy and Plutarch.[7]

Coriolanus is a half-legendary figure. The Roman, who received his surname from the conquest of a city of the Volsci, is quoted as an example of how overbearing pride and stubbornness can bring about the fall of a man whose noble character predestined him for a better fate. His attempt during a time of famine to wrest away the institution of the Tribunate from the people was answered by his public condemnation and expulsion. Thirsting for revenge, he joined the hostile people of the Volsci and led their army victoriously against his native city of Rome. He had already approached the Cluilian trenches. He had turned back an embassy of Senators as well as the High Priests who came to beg for peace. Finally, Coriolanus' old mother, Veturia, his wife Volumnia, and her children were sent to ask mercy for the city, and they succeeded.

Rembrandt still kept the Oriental attire for his Romans, men and women, yet all fantastic Baroque elements have gone. Rembrandt was very fond of landscape at this time and frequently sketched in the open. Thus, he closely interwove this story with the surroundings. We see the ramparts and trenches of the fortified camp, on the left an outpost with guards at a tent. The loosely sketched and washed scenery, full of air and light, has much in common with the simple and quiet Dutch landscape of downs and copses, as Rembrandt experienced it. His way of composing has become more natural. Thus, he gave the history more persuasive power. The group of officers and women seems to have met by chance at this corner. They stop, stand quietly, full of anxious tension, the old supplicating mother in front of the others. Livy (II, 40) describes this scene as follows:

> Then one of his friends, led by Veturia's conspicuous sadness to single her out from amongst the other women, as she stood between her son's wife and his babies, said: "unless my eyes deceive me, your mother is here and

your wife and children." Coriolanus started up like a madman from his
seat, and running to meet his mother would have embraced her, but her
entreaties turned to anger, and she said: "suffer me to learn, before I
accept your embrace, whether I have come to an enemy or to a son;
whether I am a captive or a mother in your camp . . ."

Rembrandt has shown all this simply and convincingly. The human content
prevails over the extraordinary and fantastic.

We see this also in a particularly stirring drawing (Berlin, Print Room; Benesch
1053; fig. 180), which treats the subject of Belisarius, the General of the Byzantine
Emperor Justinian, as an example of the ingratitude of mighty rulers. A novel was
spun around the figure of Belisarius, going back to the tenth century. After he had
defeated the Persians, Visigoths, Ostrogoths and Vandals his enemies brought
about his downfall. He was deprived of his sight and as an old man was forced to
beg in the street. Rembrandt represented him receiving alms from women who
pity him. The drawing is framed in thick lines of the reed-pen, powerful, straight-
forward. How stirring is the expression in the blind old face! Rembrandt has
rendered the *inner seeing* of those whose eyes are blind to the outer world.

The quality of Rembrandt's drawing stands out if we compare it with a Neo-
classical version of the same subject, painted by Jacques Louis David in 1781.[8]
It is an excellent work in the wake of Poussin's severe style, yet how melodramatic
it looks if placed beside Rembrandt's drawing, which is so much more striking.
Rembrandt inscribed it with the words which Belisarius speaks: "Have pity on
the poor Belisarius who was once in great esteem because of his brave deeds and is
now deprived of his sight through the jealousy of his rivals."

With the discarding of the Baroque style, with the reduction to the basically
human, Rembrandt was able to approach historical truth and correctness better
than all his contemporaries, who were hampered by that convention. This becomes
evident in the historical paintings of his maturity.

In the 1650s, a grand token of the civic pride of the Amsterdamers arose:
the new City Hall, a work of the ingenious architect Jacob van Campen. It was
said to be the eighth wonder of the world. The wealth and taste of all the city
contributed to this outstanding achievement by the Dutch republic of merchants.
The ideal model followed was the seat of another great republic of merchants:
Venice. Thus, van Campen's architecture was kept in a sumptuous Palladian
style with weighty classical forms in shining white marble, while the interior was
to display the spell of colours, as do the canvases by Titian, Veronese and Tintoretto
in the Ducal Palace. A unique possibility was given to the city government to
create a lasting document of Holland's great art of painting. The historical painters
were summoned, among them several outstanding pupils of Rembrandt: Quellinus,

Bronckhorst, Jordaens, Govaert Flinck, Ferdinand Bol, Jan Lievens, and others. The subjects were prescribed scenes from Roman history, examples of Stoic virtues and patriotism which were supposed to stand before the eyes of generations of officials working in the building. The *Incorruptibility of Manius Curius Dentatus* and the *Fearlessness of Caius Fabricius Luscinus* were painted; and in the Burgo-master's room the story of Quintus Fabius Maximus was planned to hang above the chimney place to remind the head of the government of his dignity and the respect due to his office.

Livy (xxiv, 44) and Valerius Maximus (ii, 2) recount the subject as follows: "Quintus Fabius Maximus, with the surname Cunctator, came as ambassador to his son, the Consul, into the Camp at Suessa. When he arrived, his son came to meet him in the full state of his dignity, accompanied by eleven lictors. The lictors, perhaps from reverence for the great Cunctator, failed to call out the usual command to dismount at the approach of the Consul. The old man, noticing this, remained angrily seated in his saddle. Then the son gave the lictors the order to call out the usual command. The father dismounted immediately from his horse, saying: "I have not disdained thy high command, my son, yet I wished to ex-perience whether thou knowest to act as a Consul."

Rembrandt was the artist who received the commission to paint this subject.[9] He was then no longer a favourite of the public, yet a famous master with influential friends like Jan Six, who may have induced the councillors to give him a share in the decoration of the building. Rembrandt solved his task in a way which was as new as it was surprising.

He shows the scene as a mass scene, overshadowed by the sombre, threatening walls of Suessa. There is a crowd of heavily armed legions. The cavalry streams out of the gate, down the mount. The smallness of the riders increases the size of the buildings. Space expands in tremendous depth. Up the hill in the foreground the crowd throngs and the protagonists appear, not as isolated individuals but as exponents of the grandeur and majesty of Roman military and political power. The young Fabius Maximus shimmers in steel and gold brocade on a white horse. The father emerges modestly into grey half-light, yet immense dignity radiates from his worthy old face. Rembrandt brought out wonderfully the contrast between outer and inner greatness. The Consul is accompanied by all the insignia of his authority: vexilla, eagles and manipular insignia rise behind him. The lictors walk in front. A tremendous earnestness, a gloomy majesty, fill the painting. Its rhythm is vertical and rectangular. We see this clearly in a little preparatory sketch, a first flashing up of the idea (Berlin, Print Room, Benesch 956 recto; fig. 183). There, the figures are reduced to an almost geometrical simplicity; the little "scratch", as the Dutch call such a drawing, is the only drawing we know for the large canvas. The mature Rembrandt used this style of drawing to make

up his mind about a composition. It served his purpose perfectly; he never needed elaborate detail studies, as the Italians and Rubens used. The execution was left to *prima vista* work on the canvas, so certain was the master of the decisiveness of his inner vision. There are no longer any Baroque swings and complicated curves. The rhythm of this many-voiced choir is rather simple—every figure is circumscribed by a few straight lines. It gives a droning sound like the ponderous tread of the legions. The colour increases this impression: dark steel, iron-grey and brownish-gold prevail in a harmonious unison, accompanied by the dusky red of the vexilla. When light sparkles up, it has a strange intensity and seems to break out, to shine forth from inside the objects.

It is astounding how closely Rembrandt approached historical truth in this painting, how much he grasped of the spirit of Old Rome. There is an archaeological correctness which proves that Rembrandt, who never travelled to Italy, must have drawn from reliable sources. Whatever they were, he did not depend on the sources alone. No artist was better equipped with archaeological material than Rubens, yet if we compare his painting of *Decius Mus* (fig. 182),[10] who tells the standard bearers his dream, we notice how the Flemish master, by introducing his Baroque *portamento*, his decorative and optimistic colouring, achieved something very different from the mood of world-conquering Rome. To conjure up *this* mood, requires a power of divination which Rembrandt possessed to a higher degree than anybody else. His picture of Old Rome exhales an almost medieval somberness; nevertheless, it shows the true Old Rome, the Rome of soldiers and engineers, out of which the medieval world rose.

In these ways Rembrandt's contemporaries could hardly follow him any longer. His painting was refused by the patrons. It contradicted too strongly the demand for a colourful and decorative antiquity which Rembrandt's own former pupils were more apt to give. In 1656 it was replaced by a painting of the same subject done by Rembrandt's friend and former companion Jan Lievens. It shines with bright colours like a Venetian master; it follows in composition the Flemish painters and displays an operatic mixture of ancient and Renaissance costumes. Last but not least, it makes better use of the space allotted to it above the fireplace, so that the patrons were much more pleased with it. Rembrandt's masterpiece fell into oblivion.

About this time, the middle of the 1650s, Rembrandt planned to paint some further subjects of Roman history. This is evidenced by several drawings which are apparently projects for paintings. I have mentioned how Rembrandt customarily abbreviated forms and figures in his compositional sketches to almost geometrical diagrams. Spheres, cylinders, rhombs make up the main elements. A strong tectonic balance prevails; verticals and horizontals are the main structural lines. The composition in almost every one of Rembrandt's works about the

middle of the 1650s is a tectonic structure of rectangular blocks, yet this comes out most clearly in drawings, like the one in the Boymans-van Beuningen Museum (Benesch 1034; fig. 184) representing Coriolanus receiving the deputies of the Roman Senate. It is amazing how Rembrandt, even in this abstract geometrical form, brought out the psychological tension, which increases tremendously in his late works. The pride and inflexibility of Coriolanus, the humbleness and submissiveness of the delegates, are strikingly expressed.

We have two drawings for *The Meeting Between Antiochus and Popilius Lenas*. Antiochus Epiphanes, King of Syria, an ally of Rome, fought a successful war against Egypt. He had already come in sight of the walls of Alexandria when Rome, concerned about his victory, decided to forbid him to advance further. When the Roman ambassadors arrived, Antiochus went to meet them and extended his right hand to Popilius. Yet Popilius first handed him the letter of the Senate and advised him to read it. The king, after reading, replied that he would consult with his counsellors. Then Popilius drew with a staff a circle around Antiochus and said: "Before you step out of this circle, give the reply which I have to report to the Senate." The king, confused by the sternness of this order, hesitated for a moment, then he said: "I shall do what the Senate decides." Now, Popilius accepted his right hand and greeted him as a friend (Livy XLV, 12).

Rembrandt's first sketch (Benesch 1014; Rennes, Musée Municipal) shows the figures only, in clear, diaphanous pen lines. The second sketch (Benesch 1015, [Estate of W. R. Valentiner]) renders the whole setting, the surrounding army and the city in the background. While the first drawing radiates with light, delicate floating layers of wash saturate the second with colour and atmosphere. Rembrandt's increase in tectonic firmness meant no decrease in his colouristic and pictorial achievements. The simplified mode of these drawings is very appropriate to the stern spirit of the Roman story. The ambassador's circle, too, is an emanation of Rome's art of state building and appealed certainly to Rembrandt's sense of the fundamental and constructive.

Ancient history as subject matter, with a stately display of figures thronging around great protagonists, occupied Rembrandt's creative fantasy until his very last period. It should be noted that the representation of such items was not always the outcome of official commissions. Rembrandt apparently chose them of his own free will because they fascinated him. Thus, he planned about 1659–1660 to paint a large scene from the Life of Pyrrhus, as narrated by Plutarch in chapter LIX: the surrender of the town of Aegae in Macedonia. An imposing drawing (Benesch 1045a; fig. 185), donated by Eric Rose in 1943 to the British Museum, gives evidence of this plan. It shows Pyrrhus, wearing the helmet described by Plutarch, amidst the troops of his camp, while the defeated enemies kneel before him. The army of elephants appears above the kneeling men in a threatening

mass. Weighty men on horseback and warriors frame the scene at the left. The style of the drawing closely approaches the *Ark of Noah* (Benesch 1045) which the Art Institute of Chicago acquired recently from the Stroelin Collection. The composition takes up anew the idea of an earlier version of about 1640, a reflection of which can be seen in a pupil's drawing in Munich (Benesch ad 1045a and see A 45). Rembrandt has monumentalized it, so that the drawing indeed heralds the majesty of the *Julius Civilis* (Bredius 482; fig. 2).

The classical phase of Rembrandt's art, which coincides with his maturity in the 1650s, is marked by a congenial affinity with the great masters of the Renaissance such as Titian and Raphael. His art of composition modified the Baroque through classical principles. A wave of classical regeneration surged through many parts of the Western world about this time. The new City Hall is as much a symptom of it as the buildings of Inigo Jones in England. If Rembrandt had been made the leading master for the decoration of the City Hall, his monumental style could have created a unity with the architecture which would have made it indeed the "eighth wonder of the world", as the Amsterdamers liked to call it. This glorious opportunity was miserably neglected.

Although Holland's great poet Joost van den Vondel wrote a poem for the inauguration of the City Hall in 1655, describing it then as complete in all its splendour, the walls stood at that time no higher than the second floor. The work continued for years. The courtyards are surrounded by an imposing gallery with two storeys of windows, a majestic flight of space, which offered at the angles huge panels of wall for pictorial decoration. The plan was to fill these empty surfaces with large paintings representing the story of *Julius Civilis*.[11]

Julius Civilis was the leader of the Batavians, the ancestors of the Dutch nation, during their uprising against Roman rule at the time of Vespasian. His story was narrated by Tacitus in the fourth book of the *Historiae*. Julius Civilis was of royal blood and a native commander of the Batavian auxiliaries. When the foreign rule grew too oppressive, he organized a sedition which extended also into both Germania and Gallia, and caused the Romans great trouble. He first assembled the native chieftains in a sacred wood called *Schakerbosch* under the pretext of a festive celebration. By night, when wine and gaiety had inflamed their spirits, he gave a rousing speech and bound the assembly by a solemn oath. The rebels made a surprise attack on the Roman camp on the Rhine and then won victories at Castra Vetera and Bona. Although the Dutch of the seventeenth century looked up to the frugal and severe Romans of the Republic as models, there was still more reason for them to celebrate a native hero because he had fought against Imperial Rome as the Dutch had fought against Imperial Spain.

When the visit of Amalia of Solms was announced for August 1659, the walls in the gallery still stood bare and without decoration. A former pupil of Rembrandt's,

Govaert Flinck, a wealthy and distinguished man, helped in this embarrassing situation. Within two days he had filled four of the empty walls with large water-colour paintings on paper, an accomplishment which evoked the delight of the councillors to such a degree that he received the final commission to paint the whole story of Julius Civilis in a series of twelve large oils.

Flinck, who had been a pupil of Rembrandt's in the 1630s, had long since turned away from the style of the master and changed over to the elegant and fashionable classicism of a moderate Baroque. His sketch of the scene of the *Conspiracy in the Sacred Wood* [Moltke D 36][12] shows an easy, flowing mastery of composition in the manner of the Italian and Flemish Baroque painters, yet lacks all depth. We understand that these works appealed to the official taste. They were never executed because Flinck died in February 1660. The four scenes which he had drafted in the watercolour cartoons were allotted to three other painters: Jacob Jordaens received two, while Lievens and Rembrandt were awarded one each. Rembrandt's task was to depict the *Conspiracy in the Sacred Wood*.

This painting was Rembrandt's greatest work, not only in actual size but perhaps also in absolute artistic importance. It comes down to us as a fragment which is now in the National Museum in Stockholm. Its history is a tragedy which reveals better than anything else the chasm which had opened between Rembrandt and his environment.

As usual, Rembrandt does not seem to have made very many preparatory sketches. A fortunate chance has preserved four of them in Munich (Graphische Sammlung, Benesch 1058–1061; figs. 3–6), giving us some idea of the way in which Rembrandt evolved his concept.[13] His creative fantasy was continually producing, and incessantly reshaping and remodelling his inventions.

Rembrandt decided to place the scene of conspiracy in an interior, harmonizing its organization with the architecture which the painting had to adorn. The panel of the wall is closed in a rounded arch. Rembrandt interpreted its shape as a large vaulted opening giving access to a domed hall, which opened on all sides through similar arches out into the nocturnal forest. This solemn room with its immense massive walls looks exactly like the interior of a circular Roman building, an example of which Rembrandt had never seen in reality.

The earliest sketch (Benesch 1058) deals mainly with the architecture; the figures are mere accessories to the space, the circular quality of which Rembrandt emphasized by a huge canopy hovering over the middle. This drawing is followed by a little "scratch", jotted down for the artist's use only (Benesch 1059), to test the relationship between the figure groups and the space which is already in a tremendous vault. The following drawing (Benesch 1060) is only a fragment; it deals with the figure group as the spiritual pivot and shows Julius Civilis in the center raising his sword, upon which the companions give the oath. The group is

illuminated, and screened by a kind of tent against the surroundings, in which we notice trees and a watch tower in the dusk.

The fourth drawing (Benesch 1061)[14] renders the figure group, with few changes, as it appears in the completed painting. We may assume that it was a project submitted to the patrons for their approval. A solemn flight of low stairs, flanked by huge stone lions resembling Hittite sculptures, leads up to the banquet table which occupies the centre of the room. Large aboriginal vessels stand about. The main group flairs up in the bright light from the lamps or candles on the table. Onlookers surround it at some distance, hidden from the outside by a large curtain. Reflections from the table light the upper half of the curtain and extend also into the vaults. Although it is a night scene, the whole, with the shadows lit up everywhere by reflections, has an unusual, dream-like luminosity. It must have given an impression of overwhelming grandeur and majesty.

In this shape Rembrandt's painting was in the place destined for it in the first half of the year 1662. But the councillors were not easily satisfied. It happened with the decoration for the City Hall that a painter's work was returned to him for changes requested by the authorities. In the contract with Rembrandt such a possibility was stipulated, and indeed, he did receive his canvas back for some alterations. Yet Rembrandt was always reluctant and unwilling in such cases. The elector of Cologne came to visit the City Hall at the end of the year and Rembrandt's space, just above the entrance into the consultation room of the Burgomaster, was still empty. So another former Rembrandt pupil, the German Juriaen Ovens, received the order to turn Flinck's old watercolour cartoon hurriedly into an oil. The result pleased the councillors exceedingly, and it remained forever in its place. Rembrandt's chef-d'oeuvre was never returned to the City Hall.

The tragedy of the *Julius Civilis* commission continued. Rembrandt, burdened with a large, unsaleable canvas, tried to save what he could from it. He cut out the main group and made a new unit of it. He continued the cloth-covered table across the figures of Civilis and the old priest on his right and introduced in front a new figure emerging from the dusk as if from a bottomless depth. He welded the whole together in a block of tremendous grandeur and tightness, at the same time giving it a plane-like quality and a mysterious, transfigured lightness. The scene, with all its overwhelming reality, is as remote as the vision of a dream. The centre of importance is shifted to the left. There, Civilis towers up like a mountain, crowned with a tiara in yellow and blue, the model of which Rembrandt took from Pisanello. He gave it also to one of the riders in the etching of *The Three Crosses* (Hind 270) which he completely reworked about this time. Civilis was one-eyed, like the god Wotan, and his single eye hypnotizes the onlooker, as do Rembrandt's own eyes in some of his late self-portraits. Civilis has just described how the Batavians were treated as slaves instead of as allies by the Romans, how the prefects pillaged the

country, and how recruitment and forced labour separated children from parents, brothers from brothers. He holds his broadsword, and the others extend theirs to cross with it, stretching arms and raising beakers to the solemn oath. Silence reigns at this moment. Gestures and movements are heavy and clumsy, like those of peasants or primitive tribesmen. The very old, the aboriginal of a primitive culture is conjured up. Rembrandt knew that he had to represent Dutchmen and not Romans. His imagination had to intercede. There are archaic medieval and Renaissance features in the clothing and in the crafts-work. The composition revives the Caravaggesque table and candle-light group which had been in vogue half a century before. These anachronisms are irrelevant in view of the unique and convincing power which the whole picture radiates. The eyes are hollowed like dark pits into the solids of the skulls. Thus, Rembrandt achieved an eerie intensity of spiritual expression, which is most obvious in the old man at Civilis' left.

The paint is brushed with tremendous strokes on the canvas. Bricks of colour are built up with the palette knife. The colour scale is very light and glitters like an opal; it must have fit wonderfully in the cool, white surroundings of the architecture. All heavy substance becomes immaterial, spirit-like in the magic of light.

How great Rembrandt's power of divination and realization of ancient figures was, is confirmed by another case. An Italian Maecenas, Don Antonio Ruffo of Messina, ordered from Rembrandt for his library a portrait of Aristotle. As a result Rembrandt painted in 1653 the magnificent ideal portrait of the philosopher in the guise of a medieval magician as if he were the embodiment of the medieval scholastic philosophy which was based on Aristotle's system (Bredius 478 [New York, Metropolitan Museum]).[15] Rembrandt owned several busts of Greek poets, among them a copy or cast of the famous Hellenistic bust of Homer, best known from the version in the museum of Naples. Aristotle holds a silent dialogue with this image of Homer, who reaches far back into a mythical age, remote even from Aristotle's time.

One decade later the same patron ordered from Rembrandt the portraits of Homer himself and that of Aristotle's pupil Alexander the Great, whom Strabo had called "Philhomeros". Rembrandt represented the blind poet dictating to pupils, as his own sketch submitted to the patron shows. The *Alexander* has been lost, yet the *Homer* comes to us in the stirring fragment in Stockholm (Benesch 1066; fig. 186).

While in the *Aristotle* the transfiguring glory of colour and light prevails, the *Homer* (Bredius 483; fig. 187) is a work of almost breath-taking veracity. It is not the descriptive, outer realism which we saw in the *Brutus* painting (Bredius 460), yet it has an inner, spiritual realism which vivifies the stone face of the blind seer from within and fills it with eerie life. Homer scans verses. His sightless eyes reveal

his visionary inner sight, like those of Belisarius. He is alone in his world; we do not mind the absence of the scribe, who was lost when the canvas was trimmed down at a later date. The colour is incrusted in thick layers, like melted gold or congealed lava. The patron misunderstood this technique and returned the painting as "incomplete". Rembrandt replied in an angry letter that there seemed to be few connoisseurs in Messina. His furious brush reworked the picture, hardly improving the matter for the Sicilian nobleman. Rembrandt's divination went beyond the capacity of his time. He, who had never seen an early Greek original, brought into this work something of the golden masks found in the tombs of the Minoan kings.

The *Conspiracy of Julius Civilis* was Rembrandt's last large figure composition. The outer world ceased to exist for the lonely old master, only the realm of the human soul remained. Silent monologue figures are the main content of his latest pictures. The struggle which every human has to fight through within himself is the late Rembrandt's means towards representing tragedy in history. The monologic character, already so strong in the Aristotle, Alexander and Homer trilogy, dominates completely Rembrandt's last versions of the tragedy of *Lucretia*.

The story of Lucretia, as recounted by Livy, initiates the revolution against the Tarquinii and the beginning of the Roman republic. The royal prince Tarquinius Sextus had forced the noble Lucretia to be subject to his pleasure by threatening to kill her beside a slave, that the shame of adultery might fall on her memory. After the deed she sent for her husband Conlatinus and her father, and incriminated Tarquinius, closing with the words: "It is for you to determine what is due to him; for my own part, though I acquit myself of the sin, I do not absolve myself from punishment; not in time to come shall ever unchaste woman live through the example of Lucretia." Then, she pierced her heart with a dagger which she had hidden in her garment.

The death of Lucretia was one of the chief moral subjects of Renaissance art. It was treated either as a dramatic group scene with assisting actors, or as a cold display of the mastery of the nude, as by Dürer (Munich, Pinakothek) in one of his most intellectual paintings. Rembrandt brought out only the deep human content of the subject. He made it the lonely struggle of a wounded soul choosing between shame and death. In the painting in the National Gallery in Washington, dated 1664 (Bredius 484; fig. 119)[16], Lucretia lifts the dagger, while her face takes on the expression of a dying person, and her left hand is raised as if feeling her way into the dark region before her. She wears a garment of marvellous gold brocade; it is no ancient costume but, rather, one of those rich dresses, partly Renaissance, partly Oriental, such as that worn by the Jewish Bride (Bredius 416)[17] in the famous Amsterdam picture. It does not affect us as an anachronism because the figure is beyond time and its changing styles. The sparkling miracle of this dress is of an

almost plastic reality. Lucretia's face is of a fading, diaphanous tenderness, transfigured by a soft melancholy—she dwells already in the beyond.

Two years later, in 1666, Rembrandt painted the *Lucretia* in the Minneapolis Institute of Arts (Bredius 485)[18]: dark, gloomy, of a cruel decisiveness. Tears rise in her eyes; she seems to suppress a sob. She pulls a glittering bell rope after having stabbed herself, as if dying in loneliness she would arouse her kinsfolk only at the last moment. The straight verticals and horizontals of her dress, which break in edges applied with the stroking palette knife, give visible expression to the rigidity of her attitude, the inflexibility of her will, although her soul is tense to the breaking point. The tragedy lies in the character, and is freed from the outer event.

Rembrandt was only a painter, etcher and draughtsman, yet in his naïve and creative way he was a genius of unusual universality, a universality which surpassed the reach of most of his contemporaries. Historical feeling and understanding was one of the marked features of this universality. Hence, it was a matter of course that it comprehended also the art and culture of classical antiquity. Rembrandt's attitude towards it was highly personal and independent, due to his creative originality, yet his approach was perhaps closer and more concerned with the essential of the classic than that of any other artist of the seventeenth century. This is affirmed by a series of works of incomparable depth and everlasting beauty.[19]

The Art Quarterly XXII, Detroit, Winter 1959, pp. 309–333.

Schütz and Rembrandt

UNTIL a few years ago, our idea of the outward appearance of Heinrich Schütz was based exclusively on a painting by Christoph Spetner in the University Library in Leipzig (fig. 188). This portrait shows the composer full face, half-length, turning slightly towards the right, his eyes fixed on the spectator. In his right hand, which is raised, he is holding a scroll of paper with music written on it. The pale tones of head and hand are set off against his plain, black doublet by the white of the collar and cuffs, and a gold memorial medallion gleams on his breast.

Christoph Spetner (1617–1699), who painted this portrait of Schütz, was not an important artist, but merely one of the local Leipzig painters who turned out decorative panels for the churches of St. Nicholas and St. Thomas and painted portraits of Superintendents and City Councillors. (A fragment of his signature can be found in the upper right hand corner of the picture.) He may have obtained the important commission of painting the famous Sagittarius through the intervention of Schütz' son-in-law, Dr. Christoph Pincker, Burgomaster of Leipzig. However, even though Spetner's art never rose above a competent mediocrity, in this instance, he carried out his task well and unpretentiously. He produced a faithful likeness and all the sitter's facial characteristics stand out quite clearly.

The painting shows Schütz at the age of about 65, by which time he had already composed the superb "Musicalia ad Chorum Sacrum" of 1648, dedicated to the councillors and city of Leipzig, and the choir of St. Thomas' School.[1] The first thing that strikes us is the remarkable height of the cranial structure of this sensitive, intellectually refined head. The composer's thin, slightly curved nose runs up into an enormously high forehead, and the lofty arches of his eyebrows are echoed in the equally sweeping curves of the tiers of furrows on his brow. This lends his countenance a hint of tragedy, just as the expression in his eyes has something unusually grave about it, a tendency to melancholy, perhaps.

Schütz' heavy eyelids also join in the lofty, sweeping movement, while the eyesockets beneath the strong, broad arches are deeply hollowed out. Diagonal creases run from the inner corners of his eyes towards the cheeks and tend to heighten the expression of stern resignation, while, in contrast to the vertical lines of the upper half of his face, the upper lip and chin are rather short and enclose a wide mouth. The only feature which restates the vertical note is Schütz' long, waxed beard, which is brushed downwards, whereas the moustache and imperial on the lower lip tend to accentuate the width of the mouth. This type of beard was fashionable in the early 1630s.

228

In spite of the modestness of the portrait, it clearly reveals the profound, religious gravity and high intellectual superiority of the sitter, and this impression of a serious and strong character is heightened by the expressive modelling of his bony hand.

Spetner's portrait provided the model for an engraving by Christian Romstet used, after Schütz' death, to illustrate the text of a memorial sermon by Martin Geyer (fig. 189). Like the Dutch engravers and painters, Romstet transformed the rectangular format of the painting into an oval shape, like a window, with the following inscription written on the frame: "Herr Heinrich Schütz, Churfürstl. Durchl. zu Sachsen in die LVII Jahr ältester Capellmeister, seines Alters LXXXVII Jahr" (Master Heinrich Schütz, Senior Director of the Chapel of the Elector of Saxony for LVII years, in the LXXXVII year of his life). The device at the lower edge of the engraving was copied from the corona on Schütz' memorial plaque in the entrance hall of the old Frauenkirche in Dresden. It is obvious from the engraving that the artist was endeavouring to emphasize the traits of extreme old age which do not appear in the portrait, but he evidently did this using the abstract, without looking closely at the original canvas.

We know what Schütz looked like in his old age, because Georg Schünemann recently discovered an oil miniature of him (fig. 190) in a private collection in Brandenburg and acquired it for the National Library in Berlin.[2] This is probably the most important contribution ever made to the iconography of Schütz. The composer is shown standing upright, holding a sheet of notes, leaning on that *sine qua non* of classicist portraiture, a column. He is wearing the costume of a conductor of the Dresden Court Orchestra, with which he was actively engaged until his dying day, although he usually lived in his home town of Weissenfels and only came to Dresden for the occasional festive event. The copperplate engraving by David Conrad which embellishes the Dresden Song Book by Christoph Bernhard (1676),[3] also shows him surrounded by his choir and wearing the same costume, including the gold medallion of the Spetner portrait.[4] The inscription on the miniature, "Henricus Sagittarius MDCLXX", confirms that it is a portrait of the composer at the age of eighty-five, but despite the ravages of the years, the ardour of his creative mind still shines out with undiminished vigour and almost disturbing eloquence.

Although unquestionably of a higher artistic quality than the Spetner portrait, the miniature's almost uncanny expressive power is undoubtedly due, in the first place, to the unique qualities of the sitter himself. At this time, Schütz was engaged on a work of gigantic scale, a setting for the 119th psalm with a double chorus, followed by the 100th psalm and a Magnificat in German, what was to be, in fact, his "swan-song". The features of Schütz' face are so out of the ordinary and so unmistakable that we can recognize traits from the Spetner portrait at first glance, though deepened and made more striking by old age.

These two portraits give us a clear idea of the appearance of the old Schütz. But what did he look like when he was younger? Bruno Maerker has provided an astonishing answer to this question when endeavouring to identify Rembrandt's *Portrait of a Musician* in the Corcoran Gallery of Art in Washington (Bredius 174; fig. 191) as Schütz at the age of 48.

This painting is signed and dated 1633 and it appears in the earliest catalogue of Rembrandt's canvases, Smith's catalogue, as no. 481. Bode accepted it in the supplementary volume to his corpus published by himself and Hofstede de Groot as no. XV, and in Hofstede de Groot's own catalogue it bears the number 760. Valentiner also reproduced the original, which once disappeared for a long time, in volume 27 of "Klassiker der Kunst", *Rembrandt, Wiedergefundene Gemälde* as plate 29. In Bredius' edition of Rembrandt's paintings it appears as no. 174. In all these cases, the painting has been described as the *Portrait of a Musician* because the sitter is holding in his left hand a scroll of paper with notes written on it.

The sitter is seen as a bust, his body turned slightly to the right; he is wearing one of the dark doublets fashionable at the time with a wide, pleated ruff. Rembrandt has positioned the figure skilfully in space, setting the silhouette off against a background filled with dim chiaroscuro in a very impressive way, the chiaroscuro being lightest on the right, in the vicinity of the signature, and darkest immediately below, where the left shoulder casts a shadow. The sitter's wide-brimmed hat throws a shadow over his brow, but the pensive eyes are in bright light, and so is the mouth, the right cheek and the chin, while the left cheek, with the shadow of the fine, curved nose falling on it, still remains in portentious chiaroscuro. The most intense light of all falls on the ruff. In this portrait, Rembrandt has exhibited his consummate mastery of the art of modelling a human face in chiaroscuro.

The date of the portrait, 1633, was a time when Rembrandt's fame, though still local, was steadily spreading. Art lovers in Holland were beginning to take notice of him, and he was about to become one of Amsterdam society's most favoured portrait-painters. At the time, he was mainly occupied with this kind of painting. However, although all bourgeois Holland is paraded before our eyes on his canvases, intellectuals rarely crop up among his models, the only exceptions being the doctors in *The Anatomy Lesson of Dr. Tulp* (Bredius 403) and the two brothers Maurits and Constantijn Huyghens (Bredius 161, 162). Nevertheless, even without attempting to identify the musician in the portrait, he is obviously a man of intellect, indeed, an intellectual of the highest rank.

The first person to try and identify the Washington portrait was A. de Hevesy,[5] who thought he could recognize Nicholas Lanier, Master of the King's Musick to Charles I of England. In fact, Lanier was himself a skilful painter, and has left us his facial characteristics in a superb self-portrait, now in the Examination

Schools in Oxford, and any resemblance to the musician in Rembrandt's portrait is so slight that Hevesy's suggestion has been universally rejected.[6]

To an impartial eye, Maerker's attempt at identification is most convincing. The *Musician* has the same high cranium as Schütz in his portraits, the same high, arching brows, thick eyelids embedded in deeply hollowed-out sockets and the same wrinkles near the nostrils and below the eyes. He also has the same contemplative eyes with their almost mournful, resigned expression, and the style of the beard is also identical to a degree beyond mere conformity to the current fashion. The lower lip projects slightly in the same way, and the fact that the mouth is softer and more youthful in the Washington portrait is hardly surprising in view of the difference in age between the two models. Indeed, there was only one feature that gave Maerker any doubts about his identification, and that was the corners of the mouth, which turn up, as if in a faint smile, in the Washington portrait, not down, in disappointment, as in Spetner's painting. However, in the miniature, where Schütz' expression is more positive, because it has been transfixed by extreme old age, the mouth has a definite upward lift.[7] We may conclude that the painter of the miniature did more justice to Schütz' mental powers than the humble Spetner, and that this is why it so strikingly resembles the model in Rembrandt's portrait, despite the greater lapse of time.

Schütz was a man of the world, much-travelled, accustomed to court life because he had served there so long, and thus more comparable with Rubens than Rembrandt. It is just such a man who gazes out of the portrait in Washington.

Maerker has also suggested how his discovery fits in with the known facts of Schütz' life. Since Rembrandt never set foot outside Holland, Schütz would have had to have spent the year 1633 abroad—and this is precisely what he did do.

The ravages of the Thirty Years' War had brought the once flourishing musical activity at the court in Dresden to a virtual halt, and Schütz therefore grasped at an invitation from King Christian IV of Denmark to attend the court in Copenhagen, which also included leave to take a holiday after his work in Dresden, and he decided to combine his visit with a long tour of the North. As early as the 6th of February 1633, he was writing to the Elector of Saxony's officer, Friedrich Lebzelter, in Hamburg: ". . . have most humbly emboldened myself with my most gracious Lord to solicit his most gracious leave to depart for about a year so that I may travel in Lower Saxony (regions I have never seen) and anywhere else I may decide." This reference to Lower Saxony should not be understood only in the modern sense of the term, that is, the North-West area of Germany, but also as including Denmark, as is clearly evident from Schütz' second request to the Elector for leave, dated February 9th. As Maerker points out, the expression "Lower Saxony" (Niedersachsen) was synonymous with "Lower Germany"

(Nederduytschland) and "Netherlands" (Nederland) in contemporary phraseology and thus also included Holland.

Thus, before he moved to Copenhagen, which he did not reach until December, Schütz spent several months in Hamburg, apparently making several shorter journeys from there. "Lower Saxony", at that time, was a region where music was more widely cultivated than anywhere else in the whole of the North, particularly organ music, and this culture centred around Amsterdam, the city where the great Jan Pieterszoon Sweelinck reigned supreme. Sweelinck had so many German pupils that he was called the "German organist-maker", among them some close personal friends of Schütz, such as Praetorius and Scheidt. At this time, the Sweelinck tradition was still so much alive in Amsterdam that a visit from nearby Hamburg by Schütz needs no further explanation.

At this time Schütz was at the height of his career, and his name internationally known. Yet, even in Rembrandt's portrait, his deeply spiritualized features show that he had already been scarred by suffering, possibly by the death of his wife in his youth; he never married again. In addition, Schütz' departure from Dresden, where his talent had unfolded so magnificently, was, in reality, flight from a Germany devastated by war.

However convincing Maerker's identification of the portrait in Washington is to the eye, his theory must remain hypothetical so long as the basic historical evidence is lacking. How did Schütz come upon Rembrandt, a painter still unknown outside Holland? We must also ask ourselves whether there is any evidence of the two men having had friends or acquaintances in common. Such evidence does exist, and is given below.

In 1616, the Elector of Saxony's official tax-collector, Burchard Grossmann, came near to losing his life and, being a great music-lover, he decided to celebrate his happy deliverance by commissioning a musical *ex voto*. As an allusion to the year of the event he had the 116th psalm of David, a prayer of thanksgiving for delivery from mortal danger, set to music by sixteen composers, including Praetorius, Schein and Schütz. Schütz was eminently suited to this task: the text is dramatically colourful; and the verse, "The sorrows of death compassed me, and the pains of hell got hold upon me; I found trouble and sorrow", inspired him to paint a musical picture of the fall of the damned in descending sixteenths, alternating in all five parts of the score. Schütz' setting is a gripping musical counterpart to *The Fall of the Damned* by Rubens (Munich, Pinakothek), painted at exactly the same time, since Schütz did not receive the commission until 1619. The idea that this verse was the spiritual focal point of the psalm must also have been in the patron's mind when he had the copperplate engraving made for the title page of the publication (fig. 192)[8] in 1623, because the lower half represents the flaming abyss of hell, full of demons, and the upper, the joys of Heaven in the shape of an

angelic orchestra. The engraving is archaic in conception, and owes much to Mannerists like Hans von Aachen and Bartholomaeus Spranger, who were still active at the court of Rudolph II in Prague at the end of the sixteenth century. In this, it contrasts markedly with the tremendous progressiveness of Schütz, who based his music on Gabrieli and the Venetians. Publication of the work was delayed by the vicissitudes of war.

In the preface to the text, the patron and Maecenas of the work movingly bewails the decay of musical culture in Germany, using as his metaphor a theme frequently painted by Rembrandt, the spear of Saul poised to pierce the music-making David.

In the seventeenth century autograph albums were very much in vogue. As "Album amicorum", people submitted them to eminent acquaintances, hoping for literary or artistic contributions, or took them on their travels, and asked for tokens of remembrance from the personalities they visited. For instance, the late, already famous, Rembrandt drew *Homer on Parnassus reciting Verses* (Benesch 913) in the album of his friend Jan Six in 1652, and in 1661, *The Presentation of Christ in the Temple* (Benesch 1057) in the autograph book of Pastor Dr. Jacobus Heyblock. So far as we know, from the material that has been preserved, Rembrandt only undertook one more contribution of this kind, and that was in the album of Burchard Grossmann the Younger, who visited him in the summer of 1634.

The subject of this third drawing is the small, half-length figure of an elderly man, evidently a learned Jew, such as Rembrandt was painting at the period (HdG 1240, Benesch 257, fig. 193). The sitter is gazing out of the plane of the picture as if out of a window, with an eloquent expression on his face, and is giving the owner of the album, as a pious admonition on his journey through life, the verse the artist wrote on the same page: "Een vroom gemoet acht eer voor goet" (A devout mind sets honour above worldly goods).

The fact that these two men should have met at all is very surprising. Rembrandt is the only artist among the 144 entries on Burchard Grossmann's son's autograph album, which hardly indicates an interest in art and besides, in those days, Rembrandt was only 28 years old and his fame very much a local matter. He would scarcely have been in the position to receive visits from foreigners unless they were recommended to him by mutual friends or acquaintances; and this must have been the case here, for he would not have drawn a careful little sketch with a motto in the album of a complete stranger who was merely passing through Holland on an "educational tour". So we may conclude that the elder Burchard Grossmann had already been in Holland and, if we are to accept the implications of the Washington portrait, that Grossmann's friend, Heinrich Schütz, had also visited Rembrandt and had his portrait painted.

The entry in the younger Grossmann's album thus gives new significance to

Maerker's theory. We now know that Rembrandt had connections with Schütz' circle of friends in Germany, and thus the notion that the Washington portrait does, in fact, portray the musician it so closely resembles becomes more and more likely.

This contribution to the iconography of Schütz is offered as a modest tribute to our friend who is celebrating his jubilee. His own fruitful combination of two branches of research, the history of art and the history of music, has been the source of so many valuable discoveries about the portrait iconography of the great musicians.

"Schütz und Rembrandt," *Festschrift Otto Erich Deutsch zum 80. Geburtstag,* Cassel, 1963, pp. 12–19.

On the Development of a Composition by Rembrandt
A Contribution to the History of his Artistic Thinking

D URING a recent visit to the Budapest Print Room, Dr. Ivan Fenyö, the Keeper, drew my attention to a drawing from this extremely rich collection which had caught his experienced eye. The drawing, hitherto overlooked, bore all the marks of a Rembrandt and close scrutiny of it swiftly brought me to the conclusion that we were indeed dealing with an indisputable, original work by the master. The sheet, which is drawn in the most delicate quill-penlines, measures 137 × 183 mm and represents the *Angel taking Leave of Tobias and his Family* (fig. 195).[1] It is of particular importance because it belongs to a sequence of works by Rembrandt dedicated to this theme and thus provides a significant contribution to the question of the unfolding and development of a pictorial idea which, as always in Rembrandt's case, gives some measure of insight into his artistic thinking.

This sequence of works begins with the dramatic painting of 1637, in the Louvre (Bredius 503; fig. 194). The drawing[2] shares the same principal actors: old Tobit, sinking to the ground overwhelmed by the celestial vision and the three other members of the family, dazzled and terrified by the shining light, holding up their hands partly to shield themselves, partly in prayer. The scene is set on the front steps of the Patriarch's house. Tobias, merely intimated by the lightest essential physical outlines, is standing behind Tobit. He is seen from the front, but he is turning his head away towards the left while holding up his left hand to shield himself against the blaze of light. The two women are standing slightly higher up. Sarah, still wearing her broad-brimmed travelling-hat, is seen from the back, starting back from the dazzling apparition and holding up her hands to shield herself, while in the case of Hannah, standing just behind Sarah, fright and shock have transformed themselves into prayer and the old woman's hands are lifted in an automatic gesture. This gesture of prayer was assigned to Sarah in the painting of 1637, but in a complete form, whereas, in the drawing, we see only the beginnings, the rudiments of the movement, and it is all the more effective. The little dog, Tobias' faithful companion on his journeying, is not absent here either. Apart from the figure of old Tobit, it is about the most clearly drawn thing on the sheet, while all the rest remain the faintest of indications. The figure of the angel is missing completely, but we can assume that there may have been some indication of it on the drawing which has been cut at the top. The crown of the arch over the door on the right has fallen a victim to this cut, and so has the continuation of two lines on the left which were intended to herald an apparition in the air.

The artist paid particular attention to the figure of Tobit casting himself to the ground, sketching it in twice. The first draught shows him, just in the act of flinging himself forward, outlined as lightly as the others with the quill-pen. Over this, the artist has drawn the figure again with the stronger strokes of a reed-pen; now it is thrown further forward, the torso supported on the arms, the hands folded in worship.[3] At the same time the artist used his reed-pen to go over the head, neck and forepaws of the dog, thus giving it, with the exception of Tobit, the strongest accents in the composition.

In order to understand the sheet fully, in its conception and reworking, we must compare it with Rembrandt's other renderings of the same theme.

The Louvre painting was followed by the etching of 1641 (B. 43, Hind 185; fig. 75). Here the composition has been reorganized into a horizontal format, though oriented in the same direction as the painting, from left to right. Thus, the drawing on the copper plate and any preparatory sketches must have been oriented from right to left like the Budapest drawing. The dramatic concentration of the Louvre painting has been expanded here into a broad, narrative form. Beside the principal personages, there is a large supporting cast—servants with pack animals, servants carrying things, maids appearing at the door and window, full of curiosity—and this robs the scene of much of the dramatic concentration of the painting. The emotions of the principal figures are also less intense; the miraculous recedes and genre supervenes. The dog is now behaving with the utmost indifference whereas, in the painting in the Louvre, both man and dog are equally dismayed. There can be no doubt that when Rembrandt was executing this etching he was still under the influence of the comfortable, narrative style he was using in the previous year when he depicted the encounter between Mary and Elizabeth (Bredius 562, Detroit, Institute of Art).

Rembrandt himself must have felt that he was devitalizing something he had already achieved in the astonishing Louvre painting because the pictorial idea had not yet come to fulfilment and gave him no peace. At the end of the 'forties he returned to it afresh and recast it in a vertical format which seemed to be more in keeping with the subject's singularity and unearthliness, and the result is the drawing Sir Karl Parker acquired for the Ashmolean Museum in Oxford (Benesch 638a; fig. 196). This drawing was done about 1649–50 and is important as a key to the Budapest sheet which it predates by only a short time.

The Oxford drawing is based on the etching. It has been fairly carefully executed and the use of wash makes it more like a finished picture. Things that are only hinted at in the Budapest sketch are fully drawn in here. Sarah and Hannah appear almost line for line as in the Budapest drawing, standing before the door of the house, and there is also a maidservant emerging in the doorway, full of astonishment. The dog, too, is already standing in the same place and the capital of the

arch over the door is indicated with a flourish, just as in the Budapest sheet. The sudden gesture of Hannah lifting her hands was at first emphasized by a stick she was letting fall, but this was later obliterated with white body-colour and a kneeling figure superimposed. It is seen from the back, holding a precious dish, and should presumably be identified as Tobias, although both costume and attitude are more indicative of a servant. On the left of this figure, the stick hangs in the air, and it is now old Tobit who lets it drop. In the background on the left there is another man, who has probably been leading the pack-mule. He is raising his arm in fright and grabbing at the dropped reins with a reflex movement. Far above him, the angel is vanishing in a stream of light with only his legs still visible.

The grouping compels us to ask who is throwing himself to the ground in the Budapest drawing. I identified him above as Tobit, by analogy with Heemskerck's woodcut and the painting in the Louvre, but he might also, in view of the Oxford drawing, be Tobias; any final decision is precluded by the sketchiness of the figures. The precious vessels in the Oxford drawing and their storage chest—offerings to the travelling companion in thanks for his services—have been taken over from the etching. As we will see, Rembrandt also developed this motif further.

In the Oxford drawing, Rembrandt was trying to find a new way of approaching the pictorial idea behind the composition and he also wanted to tone down the profane, genre note of the etching so that he could concentrate on the strangeness and miraculousness of the occurrence. In a certain sense, he was returning to the mood of the painting in the Louvre, and he reorganized the composition once again into a vertical format to heighten the distinction between the angel soaring up into a higher sphere and the stricken mortals left below. Rembrandt was at first only partially successful. Too much descriptive detail encumbers the scene in this naturalistic version; there is too much attention to minutiae, which distracts us from the spiritual event. In the Budapest drawing, which follows closely the Oxford sheet, he made a second attempt at sketching the scene, but this time he discarded everything extraneous, and concentrated only on essentials in order to emphasize the terror, the participants' sudden awakening to the fact of the miracle, and he achieved this with a directness, simplicity and urgency of which only the late Rembrandt was capable. Both man and beast seem to have had their earthly substance and shape extinguished by the unearthly light: only a few lines are left, trembling with emotion, but they say all there is to say. Man *and* beast—for the dog is an essential part of the scene. Though uninterested, in the etching, and, in the Oxford drawing, merely alert, like a watchdog pricking up its ears, here it bursts all bounds. Rembrandt depicted a dog in extreme excitement on only two other occasions; the etchings *The Triumph of Mordecai* (B. 40, Hind 172) and *The Blind Tobit* of 1651 (B. 42, Hind 252; fig. 197). In the latter the dog is Tobias' travelling companion and has run ahead of the returning men, rushing through the

open door, the first to greet the old man, in a fever of joy at seeing him again. The blind man, sitting in his armchair by the fire, recognizes its bark and realizes: "Here they are!" In joyful excitement, he springs up from his chair, knocking over Hannah's spinning-wheel, and missing the open door as he tries to fumble his way out towards his son. Only Rembrandt in his late works could have achieved such a moving portrayal of human helplessness coupled with infinite dignity and tenderness.

The little dog in the etching is evidently the same as in the Budapest drawing, but in mirror image, and this brings us within reach of a probable date for the drawing: about 1651. If we also examine this conclusion with an eye to style, we discover that the composition most closely connected to it in draughtsmanship is *Isaac blessing Jacob* at Chatsworth (Benesch 891; fig. 198), the date of which can be fixed at around 1651/52 which for several reasons interested readers will find in my corpus. Thus the attribution also holds from the stylistic point of view.

The diagonal line of the dish propped against the coffer in the Budapest drawing foreshadows a motif Rembrandt was to develop further. It recurs in 1652 in a small drawing in Munich which has been somewhat disfigured by touching-up; *Hagar and Ishmael in the Desert* (Benesch 894; fig. 199). Here, the oblique circle appears in the form of a travelling-hat leaning against a bottle. This still-life motif, dish and pitcher, returns, in conjunction with the chest, in two versions of the *Angel leaving Tobias and his Family* which at the present time are known to be the latest, and in which the compositional idea came to some form of conclusion at about 1652, that is, the drawings in the Albertina (Benesch 1373) and the Pierpont Morgan Library (Benesch 893).

In the Budapest drawing Rembrandt had regained, and even enormously increased, the dramatic concentration essential to his theme, but lacking in the etching B. 43, Hind 185 and, in the art of his maturity, achievements like this were always permanent ones, a *sine qua non* of all further renderings of the subject. Thus without forfeiting any of his expressive force, he could return to the narrative, horizontal shape of the etching and use it again to new advantage, though without the wealth of novelistic detail. The result is a change from narrative to epic and the monumental tranquility and balance of the new vertical composition are wholly consistent with the master's mature style. However, some inconsistency remains; the pictorial idea, an upsurge of pathos, seems to demand a vertical format and yet the composition is the monumental, horizontal shape of the late Rembrandt. In fact, such paradoxes are frequent in his later works and serve to heighten the inner stresses of his mighty conception.

As he had occasionally done before, Rembrandt next proceeded to instruct one of the pupils working under his direction, possibly Renesse, to try out the idea, and the result was the drawing Benesch 1373 (fig. 201) in the Albertina. The

general arrangement of the scene corresponds to the etching made in the same direction, but the figures are very different. Tobit and Tobias appear in solemn relief; the former sinking to his knees, the latter falling face forward to the ground like the man in the foreground in the Budapest drawing. The composition gains in internal compactness, and there are no further traces of the etching's baroque, spatial breakthrough. When the drawing was ready, Rembrandt went over the main group of figures with thick reed-penstrokes, reinforcing his pupil's soft sfumato with strong accents. The entire right half of the sheet displeased him and he placed a piece of paper over it, sparing only the outlines of Tobias and the opened coffer and between them he added the now familiar still-life of tilted, leaning dish and pitcher.

Rembrandt also covered the blank surface of the paper with sweeping brush-strokes; no novelistic detail, no angelic legs vanishing in the clouds, nothing but a broad shaft of celestial light streaming down on the kneeling figures below. He scarcely did more than hint at the edges of clouds, with the pen, and the form of the wall of the house with the brush, but on Tobit's right, partly with the pen, partly with the brush, he added a new figure, a kneeling man following the angel with his gaze—a fresh idea for the figure of Tobias.

The culmination of this preliminary sketch, the definitive, mature work, is the monumental reed-pen sheet in the Pierpont Morgan Library, Benesch 893 (fig. 200) where the group has been condensed into a high relief consisting purely of figures in profile and *en face*. These people are imbued with the same tension and passion as the group in the Budapest drawing, but show no feeling of unexpectedness or catastrophe; all are full of the inward calm and the devout, wondering resignation with which all the characters in Rembrandt's late works respond to a miracle. Indeed, the angel can now appear in concrete form in the composition, no longer as a grotesque verisimilitude, a pair of legs flying off in a Baroque whirl, but in the shape of a large, nude male figure with classical Renaissance proportions, who does not disturb the unearthly atmosphere as much as heighten it.

We do not know what Rembrandt intended with this series of drawings. Perhaps he was pursuing an idea for a painting which would have been an amended version of the painting in the Louvre, and of the etching B. 43, Hind 185. In either case the New York drawing brought the thought to a preliminary conclusion.

As I mentioned in the beginning, however, pictorial ideas never stagnated in Rembrandt's mind, but always drew renewed life from their progenitor's artistic strength and evolved on and on, related elements of content acting as vehicles and perpetuators of the formal theme, as in the development of a fugue. Towards the end of the 'thirties, Rembrandt was working on another Biblical subject which involves a heavenly messenger departing from awe-stricken mortals: the story of Samson's parents, Manoah and his wife, where the angel comes to announce the

birth of a son (Judges 13). There are two drawings relevant to this theme, one in the Berlin Print Room (Benesch 180), the other in the Louvre (Benesch 179), which can be dated to about the same period as the Tobias painting in the Louvre: they are full of baroque swing and daring, dynamic movement. Another drawing, done by Samuel van Hoogstraten while a pupil in Rembrandt's studio in the early 'forties, and corrected by the master (Benesch Addenda 20, Oxford, Ashmolean Museum), includes the figure of the angel from Rembrandt's painting of Tobias in the Louvre, but places it facing in the opposite direction. This itself is evidence of the close spiritual and formal links between the two themes in Rembrandt's immediate circle. A second drawing by a pupil in Aschaffenburg (Benesch 853), possibly Ferdinand Bol, shows the conversation between the angel and Manoah and his wife. Rembrandt also reworked this one, filling in a scenic background, taken from the famous Dresden painting (Bredius 509; fig. 202), with long pen-strokes. During the end of the 'thirties and the beginning of the 'forties, Rembrandt was evidently occupied with the idea of doing a painting on the Manoah theme (not, as was once supposed, primarily as thanksgiving for the birth of his son Titus), but nothing came of it. The immense task of painting *The Night Watch* (Bredius 410) obviously absorbed his mind. Indeed, even work on the *"Hundred Guilder Print"* (Hind 236) was interrupted for several years.

In about 1652, when the theme of *The Angel leaving Tobias and his Family* had been brought to some kind of conclusion, the Manoah motif reappeared in a drawing in the Gathorne-Hardy collection (Benesch 895). This sheet is closely connected to the New York *Tobias* (Benesch 893) by the figure of the nude ascending angle. Rembrandt now devoted himself to the subject with growing intensity, evidently aiming towards a large-scale painting and the drawings Benesch 980, 974 and 975 followed in about 1655. Both the latter show the thought behind the Tobias theme in the final stages of its development, in particular the Stockholm sheet (Benesch 975) which brings it to a monumental conclusion, and is undoubtedly the preliminary step towards a great painting. The flying angel is now an amended version of the celestial messenger in the Louvre painting of 1637, no longer influenced by Heemskerck, but by Tintoretto. But again these studies did not result in a painting, very possibly because of other commissions. In the period around 1655, Rembrandt was frequently occupied with subjects from Roman history, including the stupendous *Quintus Fabius Maximus* (Bredius 477), painted, perhaps, for the newly-built Amsterdam City Hall. In any case, he put the Manoah idea into the hands of one of his best pupils who executed a drawing in Dr. O. Reinhart's collection (fig. 203)[4] on the basis of Rembrandt's preparatory studies. Rembrandt later reworked this drawing extensively in reed-pen and white body colour in the upper left-hand corner and added the figure of the angel obviously omitted by the pupil; he represented it like an ascending Christ, visible only from the legs down,

framed in a bank of clouds. He also softened the blackness of the thick reed penstrokes with white brushwork so that the figure seems to be veiling itself in blazing light.

This drawing then provided the groundwork for a painting by the same anonymous pupil. W. Martin[5] excluded it from Rembrandt's oeuvre many years ago for stylistic reasons, and this conclusion is borne out by the evidence of the drawings. Nevertheless, Rembrandt must have considered the idea of this work as his own, for the pupil was instructed to sign it with the master's name and the date 1640— the year in which the original painting should have been, and obviously was not, carried out. However, Rembrandt continued to supervise the work, and even reworked it, a fact that was first recognized by F. Saxl[6]—although Saxl was mistaken in assuming that Rembrandt was reworking one of his own earlier works. There is no reason to believe that the painting itself originated in 1640, especially as the drawings, whether by Rembrandt or not, are unthinkable before the middle of the 'fifties.

I recently had the opportunity of studying the painting again, in good light, and was fully able to confirm Saxl's opinion. The substance of the work is undoubtedly by an alien hand—I get the impression that it might be the same pupil who painted the *"Rabbi"* (Bredius 257) in London, and the *Woman cutting her Nails* (Bode 477, HdG 308) in New York. However, we can definitely recognize Rembrandt's hand in the sacrificial flames, which shoot up in a web of fiery red, gold, salmon pink, ocre and pale yellow, especially as the same chromatic scale can be seen in the *Slaughtered Ox* (Bredius 457) in the Louvre, painted in 1655. Traces of Rembrandt's brushwork can also be found in the boulders in the lower right-hand corner, in the fire-light reflected by the copper-coloured hem of Manoah's mantle, and on the thick impasto of the ends of his girdle. Again, the broad, bold strokes used to paint the earth are characteristic of Rembrandt, and so is the angel, although it is hard to make this out when the painting is hanging in its accustomed place in the gallery. In fact, there can be no doubt that Saxl's deduction is correct, but we must make the reservation that it was not one of his own, but a pupil's work, to which Rembrandt was giving the final stamp.

Thus, one of Rembrandt's pictorial ideas came to a close, after having been rendered over and over again in two different iconographic garbs during more than a decade and a half, the affinity of subject-matter providing the link between the two Bible stories. This sequence of events gives us deep insight into Rembrandt's creative thinking. In his mind, one conception of a composition evolved out of the other, each one a complete work of art in itself, and yet never concluded, remaining somehow fragmentary even at the end. This sequence as a whole is an artistic revelation beyond compare, yet overshadowed by a secret tragedy, since it was apparently never to come to ultimate fulfilment. But it is the nature of Rembrandt's

art, with its inbuilt paradoxes, to achieve, in "incompleteness" a degree of inner fulfilment and completion denied to other artists, even when they are working in more favourable circumstances. For Rembrandt, each new step formed part of a steady advance, until the very last moment.

The stories of Tobias and Manoah are not the only themes which seem to hold up a mirror to Rembrandt's thought processes; there are many others. One of the most fascinating is the story of the woman taken in adultery which Rembrandt continued to develop right on into his last working years. In the first half of the 'forties, Rembrandt was already working on the theme, as is apparent from a series of drawings and studies of composition and models (Benesch 531–535), and the culmination of his preparatory work came in 1644, in a painting in London which is as solemn as it is moving (Bredius 566). The scene is set in the religious half-light of a church interior and, at first glance, the effect is of figures in a landscape, because the painting only reveals its true meaning to the spectator who approaches for a closer scrutiny of the event illuminated by a shaft of light from above. In fact, the picture has to be assimilated in two stages, and this always meant, for Rembrandt, that there was something still left unresolved.

At this period, Rembrandt's compositions were beginning to centre more and more around *man*, and in his later works, this theme dominated completely. Thus, when he returned to the drama of the adulteress at the end of the 'fifties, he concentrated exclusively on the silent group of figures waiting for Christ's answer, full of expectancy. For instance, the drawing in Stockholm (Benesch 1038), which is reduced to pure, strong outlines, merely shows the group standing round Christ reading, as He writes in the sand. This was a completely new compositional idea,[7] which has hardly anything in common with the London painting. But Rembrandt must also have felt that it provided no solution, as he started again, using the painting in London as a point of departure. The next attempt was a reed-pen drawing (Benesch 1046, Wallraf-Richartz Museum, Cologne; fig. 205) which is supremely powerful despite its small size, and which shows the group of figures from the London painting modified slightly. These changes are all the more significant, because they are characteristic of the late Rembrandt. In the painting, the group surrounding Christ is asymmetrical, and there are only upright male figures on the Saviour's left, while, on His right the sinner kneels alone. In his old age, however, Rembrandt endeavoured to create balance and equipoise throughout his compositions, and, in the reed-pen drawing, he placed a seated onlooker at Christ's left to act as counterweight to the figure of the adulteress. In so doing, he reawakened the memory of an etching done about 1652.

The story of the adulteress is part of the Teachings of Christ, and in the etching B. 67, Hind 256, known as *La Petite Tombe*, Rembrandt had created the most beautiful image of Christ the Teacher standing, raised up on a block of steps,

preaching to the crowd who listen to him with intense inward expectancy and devoutness. The standing and seated figures are divided to His left and right with calculated symmetry and the tranquility of the scene permits us to sense the mental tension all the more forcefully. This is the same aim that Rembrandt was pursuing in the Cologne drawing, which explains why he could refer back to *La Petite Tombe*, and indeed this harking back can be seen even more clearly in the Munich drawing on the theme of the adulteress (Benesch 1047; fig. 204).[8] In serene exchange with the adulteress and her accusers, Christ the Teacher pronounces His judgement: "He that is without sin among you, let him first cast a stone at her."

In all these versions of the adulteress theme, Christ and the sinner at His feet are the most strongly emphasized antagonists, while the rest of the crowd figures only as a chorus. This dialogue between the Saviour and the kneeling figure of a woman culminated in a last and supreme formulation, in a hitherto unknown drawing, once in E. V. Utterson's collection, which recently came to light in private hands in England [see pp. 244ff. and fig. 206], and is undoubtedly one of the rare pen studies surviving from Rembrandt's very last years. Like the *Raising of Tabitha* in Dresden (Benesch 1068; fig. 207), it can only be assigned the estimated date of 1662–65. The drawing measures 174 × 208 mm, is sketched with a broad, splaying reed-pen, and has been heavily corrected with white. It illustrates Christ's meeting with Martha and Mary after the death of Lazarus, as recounted in the Gospel according to St. John XI: 30–35, 40. Rembrandt has depicted the Christ's mourning for Lazarus, the lamenting of the Jews standing round and the fervour of the sisters' words with the utmost clarity; Martha is advancing to meet the Lord with an eloquent gesture of the hands and he gently admonishes her: "Said I not unto thee, that, if thou wouldest believe, thou shouldest see the glory of God ?" This reproof is as eloquently expressed as His words to the adulteress and her accusers, and in this way the thought behind the drawings in Cologne and Munich evolves a stage further. At the same time, Mary has sunk to the earth as deeply and humbly as Tobit in the drawings of the Angel's leave-taking. Thus, in this drawing, Rembrandt unites ideas of form with motifs of composition, transmitted by their content, both derived from various sequences of his creative activity in earlier decades, and combines them in a symphonic synthesis expressed with a power and intensity surpassing anything that preceded it.

"Über den Werdegang einer Komposition Rembrandts," *Bulletin du Musée Hongrois des Beaux-Arts*, 22, Budapest, 1963, pp. 71–87.

A Drawing by Rembrandt from his Last Years

D RAWINGS by Rembrandt from the 1660s are extremely rare. Then, the creative process developed entirely on the canvas, absorbing also the activity of the draughtsman and the etcher. Those few drawings, however, which Rembrandt made during the last years of his life and which survived the dissolution of the ménage of the lonely old man, belong to the most powerful revelations of the creative human spirit. The most outstanding ones among them are two compositional drawings, both preserved in the Print Room at Dresden: *Diana and Actaeon* (Benesch 1210),[1] and *St. Peter at the Death-Bed of Tabitha* (Benesch 1068; fig. 207),[2] the former being a paraphrase of an invention by A. Tempesta, the latter a genuine compositional idea of the master. Both are grandiose improvisations, produced with the solemn and sage *rubato* of a truly Homeric spirit.

These two extraordinary drawings are joined by a third one of the same time, *The Meeting of Christ with Martha and Mary after the Death of Lazarus* (fig. 206).[3] The drawing once belonged to the E. V. Utterson Collection, whose mark it shows (F. Lugt, *Les Marques de Collections*, no. 909). Having recently come to light in England from private property, it now enriches the collection of the Cleveland Museum of Art.

The subject-matter is taken from the Gospel according to St. John 11 : 30-36: "Now Jesus was not yet come into the town, but was in that place where Martha met Him. The Jews then which were with her in the house, and comforted her, when they saw Mary, that she rose up hastily and went out, followed her, saying, She goeth unto the grave to weep there. Then when Mary was come where Jesus was, and saw Him, she fell down at His feet, saying unto Him, Lord, if thou hadst been here, my brother had not died. When Jesus therefore saw her weeping, and the Jews also weeping which came with her, He groaned in the spirit, and was troubled. And said, Where have ye laid him ? They said unto Him, Lord, come and see. Jesus wept. Then said the Jews, Behold how He loved him!"

In the most simple and impressive way the master has literally described the scene according to the Bible. Mary, called by her sister, falls to the Lord's feet with the words: "Lord, if thou hadst been here, my brother had not died."

Martha's figure, kneeling in an upright position, is roughly drawn over that of her sister. The figures become diaphanous as if penetrated by X-rays. Martha's arguing with the Lord is vividly expressed. She objects to the opening of the tomb and warns Jesus of the putrefaction of the corpse. She accompanies her words with outstretched, "speaking" hands which are three times repeated in a wild

whirl of pentimenti. In their fourth position they are raised to the head, which on its part is drawn twice, the first version being slightly covered with white. Now they rise in prayer as if illustrating verse 27: "I believe that thou art the Christ, the Son of God, which should come into the world."

From the very beginning the figure of Christ appeared most simple and clear, rising like a column. Only the position of His left arm was somewhat corrected by the master and made more convincing. Christ's truthful and sublime face reveals His mourning for Lazarus. "Jesus wept." This the draughtsman caught with an incredible subtlety of the penwork, which otherwise is rough and impetuous. The gesture of the outstretched hands with interlaced fingers reveals the same expression of sorrow and compassion. They are drawn with a dry pen, not dipped anew into the liquid. So they become radiant and diaphanous, immensely subtle and tender. This mourning, however, is void of the despair of the other human beings; it is full of knowledge and divine consciousness: "Jesus saith unto her, Said I not unto thee, that, if thou wouldest believe, thou shouldest see the glory of God?"

The only tool used by Rembrandt for this drawing was the reed-pen; the only medium, dark brown bistre with some white body-colour. The paper is of that strong, white, grainy quality which the late Rembrandt preferred for his drawings. Measuring 174 × 208 mm, it was slightly cut down on all sides; otherwise the strongly applied liquid would have tinged the edge.

Above Martha, the figure of a standing man has been deleted with white body-colour which covers also the first version of Martha's head and tinges slightly its final version. No trace of white body-colour, however, can be found in the figure of Mary. A layer of diagonal penstrokes vibrates between Martha and Christ, as it was also used for shading in both late drawings at Dresden.

The combination of roughest power and sublimest tenderness of the penwork is indicative of Rembrandt's latest style of drawing. Bulky and heavy lines become floating and diaphanous, if drawn with a half-dry reed-pen. On the other hand, Rembrandt scratched with the sharp edge of the pen into bulky lines and blotches of bistre, making them radiant and diaphanous, like the quality of paint in his late canvases. This can be seen in the beard of Christ and also in His feet. The fingers of Martha's hands in the final, praying attitude and the features of the apostle between Martha and Christ are drawn in the same way.

Behind Christ appear the apostles who accompanied Him. They bow their heads in sorrow. To the right the composition is closed by the weeping Jews who followed the sisters. There we see a bearded old man in a high cap who dries his cheeks with a kerchief, another wearing a turban and a third one who is cut off by the narrow margin. The dark silhouette of the latter is made lighter by some scratching and white body-colour.

It may be ventured that Rembrandt intended first to place the scene in an interior. A kind of console appears at the right and above Christ's head; a vaulted arch sweeps out of it. Also the upper right corner is filled with architectural elements. Behind Martha a low, stone bench becomes visible like the frame of a tomb. It may be that Rembrandt wanted to indicate the grotto of Lazarus' burial place. Also the apostle in front seems to stand behind a low, stony parapet, on which he places his right hand. Yet, the outlines of his legs become visible through this parapet and aerial space extends beyond his figure. It seems as if a scenery would open there from whose depth another apostle climbs up to the elevated place. Thus, that ambient fluctuation between open and closed space is created, which is significant of Rembrandt's last works. One may be reminded of the *Jewish Bride* (Bredius 416) with an outlook onto a mysterious garden at the left and onto a bunch of flowers in a vase, placed on a kind of *guéridon* at the right.

It was Rembrandt's intention to emphasize in the present drawing also the activity of Jesus as a teacher. The dialogue between Him and Martha ends in the following words: "Said I not unto thee, that, if thou wouldest believe, thou shouldest see the glory of God?" (verse 40). It was the idea of content no less than the idea of form, which caused the interdependence of Rembrandt's compositional inventions. An outstanding event in Christ's activity as a teacher was the story of the woman taken in adultery. A first striking formulation of this narrative was given in the painting of 1644 (London, National Gallery, Bredius 566) which represented for Rembrandt not a final, but only a temporary solution. He continued to work on the idea of this painting, and towards 1660 originated two drawings—now in Munich (Benesch 1047; fig. 204) and Cologne (Benesch 1046; fig. 205)—which recast the London composition. The latter is particularly revealing, because it remodels the idea under the influence of the etching *La Petite Tombe* (B. 67, Hind 256) and brings about the solemn balance of form for which Rembrandt strove during his last years. In this way, a composition originated which anticipates in many respects the Cleveland drawing. Christ and the woman kneeling before Him as well as the groups of bystanders and the architectural framing of the Cleveland drawing seem to be foreshadowed in that of Cologne. At the same time, we realize that the Cleveland drawing represents still one step further into that realm of mystery and divination, in which the late Rembrandt's fantasy dwelt. We may date the Cologne and Munich drawings about 1659–1660 (according to the announcement of death dated May 14, 1659, on whose reverse the Munich sketch was drawn). We must allow, however, for a larger margin for the Cleveland drawing as well as for the related ones in Dresden: perhaps about 1662–65. There is no exact clue for the chronology. Time lost its importance for the old Rembrandt; and the art historian, eager to determine time, gropes in the dark when he enters this realm of mystery.

The Bulletin of the Cleveland Museum of Art L, March 1963, pp. 42–45.

Newly Discovered Drawings by Rembrandt

G REAT old masters who were also prolific draughtsmen frequently surprise art-lovers and collectors with newly discovered traces of their hand or new proofs of their genius and this may happen even when centuries have elapsed since they were active. Rembrandt was one of the most prolific of masters and scarcely a year passes without new examples of his incomparable talent being tracked down or chanced upon. The last two volumes of my corpus of Rembrandt's drawings,[1] in which I endeavoured to collect together all the material known to me, was published in 1957, and yet already a large number of new and important sheets have come to light.[2] The source of these hitherto unknown gems of Rembrandt's art has been, predominantly, England, that apparently inexhaustible treasure-house of diligent and enlightened art-collectors. In the following study, I should like to devote some thought to these new drawings in order to ascertain their stylistic and chronological position in the master's known œuvre. Some have already been published, some not. My thanks are due to the collectors concerned for making photographs available to me and for giving me permission to publish them.

Undisputed drawings from Rembrandt's Leiden days are rare. The few years the young painter spent in his native town were fully occupied with studying the techniques of oil-painting and etching, and he was not yet the productive draughtsman he was to become. Any early works are, therefore, all the more appealing, especially as they give evidence of an acute observation and a bold approach to rendering the visual world. At this period, Rembrandt spent much of his time studying beggars and paupers, the human flotsam of the rigours of warfare, who thronged the country roads. This range of themes was not entirely new. Jacques Callot had already devoted a series of etchings to it, the "Gueux et Mendiants",[3] and he was followed by Adriaen Pietersz van de Venne, who took it up in 1642 in a series of drawings, in the Albertina. The latter works, however, must have been influenced by Rembrandt who, as early as his Leiden years, was himself already an avowed disciple of Callot. His first beggar etchings follow the pattern set by the great French etcher. But, while Callot was concerned with strict organization of line and with rationalizing his method of expression, Rembrandt was aiming towards a complete graphic impression of pictorial, as well as human, unity. His sheets are more improvised, and yet much more comprehensive than those of Callot. They plumb depths beyond the scope of the didactic Gallic mind, they live and breathe in space and light and lay far more emphasis on the social and human aspects of life.

The most impressive of Rembrandt's beggar drawings are the magnificent black chalk studies dating from about 1629 (Benesch 12, 30, 31 and 32), and indeed, these sheets represent a culmination point in his work. But the brush (Benesch 24) and, more frequently, pen, were also welcome tools when he wanted to toss off a sketch of one of these pitiful creatures; I am thinking chiefly of nos. 22 and 23 in my catalogue, the wandering beggar couple and the blind man with the dog. In these instances, it is quite obvious that the character of the line has been derived from Callot. For instance, the pen has been applied to the paper with alternating heavy and light lines to obtain the same hair and shading lines as the etching-needle on Callot's copper plates. However, what Callot's rigid adherence to system turns into calligraphy and ornament developed, in Rembrandt's case, into a bold, free play of expression.

The superb exhibition of old master drawings organized by Vassar College Art Gallery in their jubilee year 1961 included a hitherto unpublished sheet ($4\frac{1}{2} \times 3\frac{1}{2}$ inches, Mr. and Mrs. E. Powis Jones collection, inscribed on the mount with the collector's mark of John Barnard, Lugt 1419; fig. 208).[4] This pen drawing is exceptionally closely related to the works mentioned above and may thus also be dated about 1628–29.[5] The subject is a beggar, standing in profile, turned to the left—a tall, bent figure leaning on a stick, his emaciated head, with its jutting chin, covered with a ragged, fur hat, and a flowing cloak with a tattered hem hanging from his shoulders. This figure has been tossed off with a splayed pen in a kind of *furioso*. The folds of the cloak, the legs, the stick and the shading of the ground between, flow from the pen in one vertical sweep, while, at the same moment, the artist lowered the original hemline of the cloak, on the right, with a vigorous flourish. Diagonal zigzag strokes indicate the shadows cast by the body on the legs and ground, and the varying thickness of the line throws the figure into striking, sharply-modelled relief.

Beside the sheets mentioned here, further material for comparison with this drawing can be found in the Berlin study (Benesch 10) for a disputing Pharisee in the *Tribute Money* of 1629 in Lady Beit's collection (Bredius 536),[6] the *Seated Man in a high Cap* in the Boymans–van Beuningen Museum (Benesch 29) and the *Young Worker leaning on a Spade* in the Van Regteren Altena Collection (Benesch 27) all of which give satisfacory proof of the accuracy of the dating.

The etchings of beggars leaning on sticks, B. 162, Hind 15 and B. 166, Hind 79 are also related to these drawings.

During the years 1629–31, Rembrandt made many studies of male models, dignified old men who appear as Biblical or holy figures in his paintings and etchings. Most of these drawings were executed in red or black chalk but, in 1962, there appeared on the London art market a *Study of an Old Man* (112×106 mm; fig. 218) which was obviously related to the above group, although a combination of pen and

brush had been used. The model for this drawing is already familiar from the red chalk studies Benesch 15, 16, 20, 37–42, and the pen drawing, Benesch 48. The head has been drawn mostly with the pen, but the brush begins to intrude in the modelling of the face and the hairs of head and beard, gradually taking over more and more, until it eventually dominates in the sweeping expanse of the breast. The difference between the two instruments used in the drawing brings about a difference in colour, because the pen worked in warm, brown bistre, and the brush in cool, dark-grey India ink. This chromatic duologue, set off by touches of red chalk on the beard, is strongly reminiscent of Rembrandt's two self-portraits, one in London (Benesch 53; fig. 103) and one in Amsterdam (Benesch 54; fig. 104), which are drawn in much the same way, the former about 1627/28, the latter about 1628/29. The vibrant modelling of the countenance in the newly discovered sheet, to be dated about 1629/30, also vividly recalls Benesch 54, which has the same dots and strokes of the pen. At the same time, the porous and airy construction of the old man's bust is magnificent; the ink does not completely hide the rough paper, but allows the graining to gleam palely through. This technique makes the whole form and movement of the figure, its setting in the atmosphere, incredibly life-like.

During the early Amsterdam years, Rembrandt's drawings often portrayed the theme of the Passion; it represented an inner need for him, an outlet for a creative imagination and narrative genius too hemmed in by the socially prescribed routines of portrait-painting; and the etchings he did at this period are monumental sheets, also dedicated to the life, teachings and sufferings of Christ. In fact, Rembrandt's mind must have been constantly preoccupied with such subjects, and thus the resulting sketches, though capable of furnishing material for other works, were primarily drawn for their own sake. *The Lamentation for Christ* in Dresden (Benesch 63) and *The Entombment* (Benesch 64) belong to this category, and the former owes its particular expressiveness to the brilliant "shorthand" of the figures, and the evocative way they are arranged in space. Similar characteristics can be detected in a hitherto unpublished small drawing in the collection of Dr. Robert Rudolf in London (pen and gallnut ink, 132 × 125 mm; fig. 209) which shows *Christ nailed to the Cross*. The figures on this sheet are so tiny that they look like figurines yet they reverberate—especially the group of soldiers on the left—with echoes of Callot. But how alive these figures are, how movingly they convey a sense of the drama of the sacrificial death! We cannot help but be impressed by the gestures of the man who is speaking to the two pensive soldiers on the left as he points to the Lord in His agony—so much so, in fact, that we almost feel pity for them. And how painfully Christ's body is stretched on the sacrificial tree! Two serving-men are kneeling beside His right hand, one holding it against the wood, the other hammering in the nail, and in the distance, one of the thieves' crosses is already rearing up against the sky.

In this small sketch, Rembrandt seems to be developing ideas by earlier artists; for instance, there is a similar crucifixion by one of his precursors which used to be in the Strœlin collection in Lausanne (pen, bistre and wash, 105 × 100 mm; fig. 211) and another version of the same theme by Jan Pynas, formerly in the Heseltine and Oppenheimer collections, and now in the collection of Mr. Bruce Flegg, Hampton-on-Thames (pen and bistre, 99 × 119 mm; fig. 210). In the first of these, the mounted officer towers up beside the cross as in Rembrandt's later *Raising of the Cross* (Bredius 548) in Munich, and, on the ground below, Christ's followers are busied round the swooning Mary, as they were to be in the *Descent from the Cross* in London (Bredius 565). Yet no one except Rembrandt could have summed *everything* up in such a lapidary form in so small a space.

Another, and larger, Biblical sheet that has turned up was in the B. Houthakker collection in Amsterdam in 1962 [and is now in the United States]. This drawing (pen and gallnut ink, 226 × 161 mm; fig. 212) shows *Christ with the Disciples before Emmaus* at the moment when the three men have just ascended the hill up to the town gate and are making a short halt. To the right, we look down into the depths of the valley where a tow-horse is pacing slowly up-river, and above this, the tree-covered slopes on the opposite side of the valley rise up to hilltops crowned with fortifications. The Saviour is just parting from his companions; His hand grips His stick purposefully, and He points along the road He has yet to travel—the pointing hand has been drawn twice—while turning to go. But the disciples hold Him back. One of them, the one seen from the back, standing in the extreme foreground, is gesturing towards the inn with his left hand, which has a walking stick in it, and with his right, he is trying to pull the Saviour there by the arm. The other, an older, bearded man wearing a skullcap, is also trying to persuade the Saviour to stop. His left hand indicates that the road is too long and night falling, while the rhetorical gesture of his right is an attempt to lend the words added persuasive power. The whole thing is tempestuously, almost crudely, drawn, but it is pervaded with the power of the inner eye. These three are men among themselves, conversing with one another in a companionable way, because they want to remain together, "Abide with us; for it is toward evening". The disciples are still unaware of the identity of their mysterious fellow-traveller, and they do not perceive the aura of light flaring up from the Saviour in a wild, fantastically jagged outline. But although Christ has not yet revealed Himself to them, the words they are to speak after the event already ring in our ears: "Did not our hearts burn within us, while He talked with us by the way, and while He opened to us the Scriptures?" (Luke 24: 32). The whole story is portrayed with a clarity and cogency of which only Rembrandt was capable.

The sheet has been drawn with a splayed quill-pen, and the gallnut ink has penetrated the paper over the course of the years, as has happened in so many of

Rembrandt's drawings from 1632/33. The line is wild and undisciplined, a completely new departure in technique and an expression of the fact that Rembrandt was now more interested in the emotion and human impact of his subject. In this regard, the sheet has affinities with other scenes from the Life of Jesus: the two drawings of *The Raising of the Daughter of Jairus* (Benesch 61 and 62) and *Christ conversing with Mary in the House of Lazarus* (Benesch 68). In all these, the Saviour's halo is represented as a jagged crown of flames. Finally, there is Benesch 69, a single figure of the Saviour preaching, very like the Christ of the Emmaus sheet; for instance, the pose and gesture are the same. These close similarities with other works give the newly discovered drawing a firm anchorage in Rembrandt's œuvre.

In addition to other similar ideas for paintings, Rembrandt did innumerable studies from life at this period, noting down people on the streets, or at home, and recording his sharp observations with a deft hand. In a small sketch, L. Franklyn Collection, London (114 × 48 mm [now private collection]; fig. 213), we see the rear view of a woman going to market, her shopping basket on her arm. Her head is hidden by a hood, and she is supporting herself against a balustrade or wall with her right hand. Her long, trailing gown does not completely cover her slippered feet, and we can quite clearly see her slow, shuffling footsteps. The lines are blurred in places because gallnut ink reacts chemically to paper and penetrates it. This drawing is typical of many sheets of studies of about 1633, such as Benesch 235, 242, 243, 246 and others.

Around 1633/34, the members of Rembrandt's immediate family circle begin to appear in his sheets of studies, especially Saskia, dressed for the house or the sick-bed in such simple and plain attire that, if it were not for the noble features of her face, we would think her to be a servant: Benesch 229, 250, 253, 254, 255.

We may also include here a still unknown sheet in the Pushkin Museum in Moscow, attributed there to "Rembrandt?" (pen and brush in gallnut ink, white body-colour on the shoulder, 59 × 59 mm, Massaloff collection no. 113 and J. C. Robinson, Lugt 1433; fig. 214). The drawing shows a young woman, half-length, wearing a full-sleeved house dress with a shawl round her shoulders. Her hair is tied back in a net, and there is a kerchief wound round her head to protect her against draughts. It is thus we see Saskia sitting up in bed in a drawing in the Dresden Print Room (Benesch 255). The delicate profile is undoubtedly hers. It appears in a similar form in a drawing in the Louvre (Benesch 254).

By 1635, the growing realism in Rembrandt's approach to the human face and form was giving him an unrivalled, and deeply disturbing power of divination, and the Biblical figures he spirits onto the page are as convincing as if the characters had sat for him themselves. The bust of St. Peter in the collection of Mr. and Mrs. Eugene V. Thaw, New York City (pen and bistre, 85 × 71 mm; fig. 217) is an

outstanding example of this period. The saint is starting up from a gloomy reverie and lifting up his hands in surprise. Both expression and gesture make it absolutely clear what moment this is. The angel has just come to him in prison, to free him.

By this time, Rembrandt had finally abandoned gallnut ink as a medium, preferring bistre, which gives a finer and more differentiated penline, and he was now able to put more emphasis on details. How St. Peter's countenance "speaks" in every tiny wrinkle, and how vividly his sudden start is depicted! The line splinters, frays and disintegrates, but has become immeasurably richer and easier to modulate. This new technique now made it possible for Rembrandt to portray dramatic moments, charged with strong emotion. He was approaching closer to the "realism" of Caravaggio, but in another, more direct sense than in his early Leiden works.[7]

Rembrandt's compositional studies dating from about 1635 often depict moments of supreme tension and dramatic peripeteia, and the lines crowd together in a wild swirl (Benesch 92, 95, 96, 104 and 106). When cataloguing the scene *Christ on the Mount of Olives* in Munich (Benesch 104), I omitted a reference to the fragmentary figure on the reverse, a man praying with upstretched arms (fig. 219). A recent opportunity to scrutinize this drawing more closely has convinced me that the core of the figure, drawn in powerful lines, is Rembrandt's original work, and that the rough, jabbing strokes which disfigure it so badly that it has been ignored hitherto, are a later addition by another hand. The figure has been cut because it was drawn on a larger scale than the sketch on the obverse, but there can be no doubt that the subject is the Saviour, wringing His hands in agonizing fear.

During the same year, Rembrandt was intensely occupied with the composition *Christ on the Mount of Olives*, and a further study has turned up to join the already familiar sketches for this work, Benesch 104 and 105. The study (pen and bistre, 43 × 65 mm, mark of the Grassi collection, Lugt 1171b, collection of [Schaeffer Galleries Inc.], New York; fig. 215) shows the kneeling figure of Christ we already know from the Munich drawings in the simplest form and is particularly important because it confirms the authenticity of a drawing which has long been mistakenly disputed, Benesch 105. This study must stem from the same source as the drawings in Munich, because the same clumsy line has been drawn to frame the drawing, occasionally even cutting across actual lines by Rembrandt.

Samson Sleeping (pen and bistre, 42 × 63 mm, mark of the Earl of Dalhousie's collection, Lugt 717a [Schaeffer Galleries Inc.], New York City; fig. 216) is a similar small sheet, equally modest, but also an important key to a known work, since it is a study for a detail of a complete composition which has been handed down to us in the form of a drawing in the Museum in Dijon (Benesch 127 recto; fig. 85). The style of both drawings indicates 1636, the year Rembrandt painted the large *Blinding of Samson* (Bredius 501). *Samson Sleeping* shows the preceding

moment in the Biblical story, Samson being shorn by the deceitful Delilah. Sunk in sleep, he is leaning against her knee with his head resting on his right arm; and the newly discovered drawing shows the detail of the head, part of the shoulders and right arm stretched out with the hand hanging loosely down. The cubic structure of the foreshortened body has been particularly emphasized.

During the first half, and around the middle of the 'thirties, Rembrandt painted many monumental half-length portraits of Orientals (e.g. Bredius 178, 179, 180, 206, 208, 210) and, as was to be expected, similar figures appear in his drawings (Benesch 272, 352, 353 and others). There is one such study, still unknown, but especially appealing in its lyrical wistfulness, in the Pushkin Museum in Moscow (110 × 104 mm, Massaloff Collection, Inv. 4662; fig. 220).[8] The drawing is light and elegant, executed with a sweeping pen, in the feathery lines typical of the year 1635. The young man's head and right hand stand out in light falling sharply from above, and his right cheek, underarm and breast are modelled with broad strokes and planes of brushwork. This combination of pen and brush is often found in portrait studies by Rembrandt in the 'thirties, such as Benesch 432, 434, 440, 441, and the result is a wonderful impression of richness and colour. The figure seems to sparkle in the light, and the shadows have many different intensities, although they are always lightened by reflection and flashes of light from the porous paper. In fig. 220, a layer of white body-colour on the right side of his turban makes it look as if it were illuminated by a shaft of reflected light, and the lines of the young man's face have a precision and depth of expressiveness only Rembrandt could have achieved. It should also be mentioned that the figure was sketched in first with delicate chalk lines, and that this technique can thus also be found, if rarely, in drawings which are unquestionably original Rembrandts.

With the year 1636, a certain atmosphere of calm begins to permeate Rembrandt's pen technique, a more deliberate attitude towards describing form and increased clarity and simplicity in the rendering. One good example of this is a sheet of studies (141 × 155 mm, pen and bistre, collections of H. S. Olivier, Lugt 1373, and Mrs. Siddall; fig. 221) acquired for the Ashmolean Museum in Oxford in 1960 by Sir Karl Parker.[9] Christopher White published a short note on this drawing.[10] The sheet shows various male figures, head, bust and half-length, who seem to have interested Rembrandt mainly by their bizarre headgear, that is, their broad-brimmed and high-crowned hats, one of which the artist noted down on the reverse, but crossed out again. White quite reasonably queried whether the hats came from Rembrandt's own studio wardrobe. He suggested that the studies had been drawn with a reed-pen, apparently because of the breadth of the line. Yet the flourishes in some of the passages could scarcely have been achieved with such a brittle instrument, so it is more likely to have been a blunt quill-pen, such as Rembrandt used in Benesch 300, among others. Similar types of figures

can be found among Rembrandt's sketches of actors (e.g. Benesch 295, 296, 296a, 297) and even more frequently among sheets of studies dating from 1636, like Benesch 329–334, 339 and 340.

The same clear, deliberate line persisted into the years 1637/38. Around the mid-century, Rembrandt often took up themes favoured by the Caravaggesque painters in the North and the South, such as groups of people playing cards and making music—the inspiration for all those banqueting, guard room and gaming scenes which figured in the paintings of the Southern and Northern Netherlandish painters. Rembrandt, however, paid tribute to these motifs mainly in drawings (e.g. Benesch 398, 399), although they also appear in a few paintings with large-scale figures, such as his famous *Self-portrait with Saskia* (Bredius 30) in Dresden. I found the negative of one of these drawings (the original has disappeared and is unknown to me) in the Rijksbureau voor Kunsthistorische Documentatie in The Hague.[11] This pen and bistre sketch (110 × 142 mm; fig. 223) shows soldiers playing cards in a guard room. There is a group of three in the foreground on the left, sitting round a barrel serving as a table, and a fourth is on the right in the background, sitting by an open fire, with his lance propped against the wall beside him. From the point of view of the draughtsmanship, the composition is very like the *Winged Man on Horseback* (Benesch 364) and thus probably dates from about 1637, and the strong geometric quality of the abstraction of the minor figures would tend to confirm this.

The protagonist of the scene is a young officer with a plumed cap and a sword. It is his turn to play, and there is supreme sensitivity in Rembrandt's rendering of his concentration and the gloomy expression with which he is mustering his obviously bad hand, while his opponent gleefully lays the trump cards on the table. The third man who has been given, as an afterthought, a hat, is sitting in a melancholy pose, and has obviously abandoned the game. All this is set out in a few strokes with the kind of Shakespearean humour only Rembrandt could express, and, indeed, the enormous gulf between his, and his pupils' work, is well illustrated by a drawing on a similar theme which was formerly in the collection of Victor Koch in London (Valentiner 768). This latter drawing seems to have such a weak and inconsequential linear framework, when we compare it with Rembrandt's masterpiece, and the faces of the group of players seem completely empty, however much the artist has tried to achieve the same vivacity. There is another drawing, also by a pupil and based on Rembrandt's drawing, formerly in the collections of Joseph Baer, Frankfort, and Victor Koch, London (139 × 158 mm).

Another drawing which has come to light is a preliminary study for *St. John the Baptist preaching* in Berlin (Bredius 555), painted about 1637. Executed in red chalk, it is in the collection of Count Antoine Seilern (176 × 186 mm, collection of E. G. Spencer-Churchill, watermark Baselstab; *Paintings and Drawings of*

Continental Schools other than Flemish and Italian at 56 Princes Gate, London, S.W.7, London 1961, Cat. III, no. 182; fig. 228) and shows two versions of the saint preaching. On the reverse is a head of Christ. This drawing was recognized as a preparatory study for the main figure by J. Wilde and J. G. van Gelder. The straggling, red chalk line and the emphasis on abstraction of the figure link it with a series of Rembrandt's drawings which can be dated roughly to 1637. The sketch for the whole composition (Benesch Addenda 10) was also drawn on paper with a Basel mark. There is another study on paper with the Baselstab watermark (Louvre; Lugt, Inventaire Général 1266, Benesch 533) for the painting in the National Gallery, *The Woman taken in Adultery* (Bredius 566), dating from the beginning of the 'forties.

I have repeatedly stressed that the Rembrandt collection in Munich is a rich fund of material for research, although, owing to the eighteenth-century scare of the "Krahe forgeries", a large part of the collection was rejected, lock, stock and barrel. Now, however, owing to a recent, detailed historical study by W. Wegner,[12] which revealed the myth as such, there is no reason to doubt the nature of its provenance. Large portions of the drawings must have come straight from Rembrandt's studio estate, particularly items regarded as of no commercial value which were sold at the auction in 1657. This applies particularly to numerous "scribbles" which were presumably touched up and falsified by later additions intended to enhance their value, but which still have a nucleus of genuine lines from the master's hand, for example, the sheet Inv. no. 1631, excluded from the œuvre by both Hofstede de Groot and myself. This drawing shows two richly dressed women in a landscape drawn by an apocryphal hand, and on the reverse there is another landscape with a group of farmhouses under a clump of trees, drawn richly and delicately in pen and bistre (139 × 123 mm; fig. 222). This motif, the focus of the study, has been surrounded by penlines in a darker tone—as undisciplined as they are artistically meaningless. In fact, they have obviously been added by another artist to "round off" the humble, flat Netherlands countryside and make it into a mountainous, coastal landscape. However, when we compare it with the *Farmhouse amid a Copse* (Benesch 471) and the *Row of Trees in an Open Field* (Benesch 472) in the Vienna Akademie der Bildenden Künste, the original nucleus can be recognized unhesitatingly as Rembrandt's work. There is also a sheet by Lastman in the Rembrandthuis in Amsterdam, *Tobit and Tobias kneeling before the Angel* (Benesch 474), where Rembrandt has drawn in, in black chalk, the fringe of a wood with exactly the same structure as the Munich sheet.

An important study for the "*Hundred Guilder Print*" also reappeared recently in the Blanc and Deschamps collections (Palais Galliera, Paris; Sale Tuesday, 23rd June, 1964, no. 12, now in the Print Room in Amsterdam). My thanks are due to M. Alexandre Ananoff for bringing it, and the following sheet, to my attention.

The drawing (100 × 125 mm; fig. 225), which had previously only been known from the (incomplete) etched reproduction in Charles Blanc's Rembrandt catalogue (Benesch 183), has been executed in pen, bistre and wash, and shows two versions of the sick woman lying at the Saviour's feet. In the first version, on the left, she is holding her injured, bandaged leg with her right hand and gesturing towards it with the left, and there is a soft cap on her head; the right hand and leg have been redrawn in two detail studies (thus the drawing Benesch 388 is obviously an earlier attempt at this figure). In the second version, which is larger, the gesture of the woman's hands was first repeated identically, and then the left was raised to conform with the final form in the drawing (Benesch 188) in Berlin and the etching (B. 74, Hind 236). In this latter drawing, the woman's head is covered with a cloth.

A further sheet from the Blanc and Deschamps collections (Palais Galliera, Paris, Sale Tuesday, 23rd June, 1964, no. 13, now in the collection of B. Houthakker, Amsterdam [now private collection, New York], reed-pen and bistre 145 × 125 mm; fig. 224) shows a group of men in conversation, some of whom are sitting in the foreground on a bench, with their backs to the spectator. Rembrandt was drawing broad, reed-pen sheets of this type at the beginning of both the 'thirties (Benesch 207–215) and the 'forties (Benesch 667, 732a, 736) but, in this case, the later date is the more probable because of the strong spatial effect of the composition. The men are presumably a group of Jews in a synagogue (cf. Benesch 656).

Around 1642/43, Rembrandt returned to a theme he had already handled in an etching (B. 30, Hind 149) in 1637, giving it new depths of human feeling, *The Dismissal of Hagar*, and one of the results of his endeavours is the important and powerful drawing in London, Benesch 524. During the first half of the 'forties, Rembrandt often did several versions of pictorial ideas he found particularly absorbing, one of the most famous examples of this being his illustrations of scenes from the life of Joseph,[13] and he developed and recast *The Dismissal of Hagar* over and over again in just the same way. One of these versions was copied by a pupil, and is now in the Louvre (Lugt 1208); it has been fully discussed by R. Hamann.[14] In this drawing, the group of figures in front of Abraham's house has been transferred into a luxuriant landscape (Lugt has correctly pointed out that the apocryphal date of 1650 is too late). In fact, it is evident that the group is a slightly altered version of the group in the London drawing, where Abraham is laying his right hand on the departing Ishmael's head in blessing, and is lifting his left, appeasingly, to grasp Hagar's hand. In the Paris copy, the boy is standing still and the patriarch has already grasped Hagar's hand. The prototype of this copy, or rather, a fragment of it, representing only the group of figures, turned up in Vienna in 1937, and is now in the Schocken Library in Jerusalem (pen and bistre, wash,

152 × 122 mm [Sale Sotheby's, July 7, 1966, lot 14]; fig. 226). The sheet has
been impaired by wash, and the stairway behind Hagar and the landscape have
been obliterated, yet the delicate, tender lines of the figure's features have remained
intact, and their tranquil, gliding flow and tendency to flourishes are typical of
Rembrandt's figure drawings of 1642/43.

There is also another drawing with the same linear characteristics, showing
Abraham and Isaac on the Way to the Sacrifice (pen and bistre, wash, 104 × 187
mm, collection of I. Silberstein, Moscow; fig. 227) which has suffered even more
severely from wash, but where the wandering, tentative lines of Rembrandt's
pen of 1643 are equally unmistakable. Much is said with mickle: the heavy tread of
Isaac, who is laden with a bundle of faggots and a hod of coals, Abraham's words to
the servants he is ordering to wait with the mules, the mountain landscape with the
path winding upwards.

When he was sketching single figures or groups from life during the 'forties,
Rembrandt was as quick to take up black chalk as a pen, and his chalk line is airy,
atmospheric and permits delicate shading and a hint of colour values. One of the
characteristics of these chalk sheets is their light, silvery tone, and because they are
often pages cut out of sketchbooks, many are small. There are two hitherto
unknown drawings of this type in the collection of the Museum of Art of the
Roumanian People's Republic of Bucharest, whose director, M. H. Maxy, brought
them to my notice. The first shows the bust of a woman, full face, wearing a head-
cloth or hood (48 × 38 mm, collection no. 43, collectors' marks of V. H. J. van
Haecken, Lugt 2516, and Sir Joshua Reynolds; fig. 229), and is closely related to
two other sketches (British Museum, Benesch 671 and 672) also bearing Reynolds'
mark, and evidently originating in the same sketchbook of about 1642. The other
little sheet (48 × 35 mm, coll. no. 45; fig. 230) shows the half-length figure of a
young man, in profile, with folded arms and a peaked cap. The clarity of the struc-
ture of this drawing would best be compared with sheets dated about 1647/48, such
as Benesch 720, 721, 724, 725 and 749 recto.

The two rustic figures, shrouded in cloaks to protect themselves from the rain
(115 × 102 mm, formerly in the Koenigs collection, Haarlem; Cat. Sotheby
May 10th, 1961, lot 35; fig. 231), on the other hand, are typical of Rembrandt's
drawings of about 1644/45 (e.g. Benesch 693, 693a) where the flourishes from the
penned sheets had begun to influence the movement of the chalk. The way the
two men confront one another in the misty, autumnal atmosphere gives an enchant-
ing feeling of intimacy, something frequently found in Rembrandt's works of
the 'forties. The chalk glides over the paper with the utmost circumspection, only
rarely marking a dark accent.

Christopher White has recently published[15] an entrancing life study from the
late 'forties (pen and bistre, 63 × 60 mm, formerly in the collections of Walpole

and Delany, now private collection, London; fig. 232) showing the half-length figure of a mother suckling her child. This drawing, which I had only previously known from a more elaborate copy in the National Gallery in Washington,[16] gives an excellent example of the economy of line Rembrandt developed with increasing maturity, and the way he used it to grasp such studies from life in their entirety. The movement and pose of the child have been borrowed from life with an unequalled naturalness. White is correct in giving this study a late date; I should put it between two drawings on the same theme in Stockholm, Benesch 707 recto, about 1646, and Benesch 1073, about 1650.

In the religious paintings of his Leiden period, Rembrandt conjured up a superb sensation of space, and although this was repressed by the condensed, baroque, figure style he adopted in the 'thirties, it re-emerged in the 'forties in a lavish way. Now Rembrandt's Biblical scenes and parables were set in lofty, vaulted, temple aisles and the figures appear dwarfed by their vast surroundings, like a *staffage*. Not, however, that they lose significance thereby. On the contrary, the gigantic "sounding-board" of the architecture heightens the sanctity and solemnity of the action taking place.

Among the most famous examples of this period are the London painting of 1644 *Christ and the Woman taken in Adultery* (Bredius 566) and the *Circumcision*, from the Oranian series, now destroyed, and known only from the copy in Braunschweig, a study in Munich (Benesch 581), an etching *The Marriage of Jason and Creusa* (B. 112, Hind 235) and, last but not least, the *Julius Claudius Civilis* in its original form. There are also several drawings which make it obvious that Rembrandt was mulling over further pictorial ideas of this kind about 1647, particularly the two drawings of *The Presentation in the Temple*, one in Berlin (Benesch 588) and the other in the Rothschild Bequest in the Louvre (Benesch 589). A *Publican and the Pharisee* belonging to the same group was recently auctioned at Sotheby's (pen and bistre, wash, 206 × 187 mm, collections of Thomas Hudson, Jonathan Richardson Sr., and Mrs. Symonds; Sale 12 March, 1963, lot 66 [now private collection, New York]; fig. 233). We are looking into the nave of an enormous church, divided in half by a foreshortened row of columns linked by arches. In the background, an immense exedra opens out, the size of which can be gauged by the height of the tiny figures moving along the gallery. The vastness of the depths of the interior is also emphasized by the varying dimensions of the rest of the visitors to the temple. There are also many similarities to the *Marriage*. For instance, the capitals of the columns are identical, and the interior throws as little shadow and is just as full of light. It has even been modelled with the same airy, floating wash. Again, just as in the *Marriage*, there is a "wing" of shadow, in the form of a column, in the foreground, where Medea is brooding in the dark, so, here, there is a column throwing a shadow over the proscenium, with the publican kneeling half in, half out

of it. And what a profound expression of repentance and humility there is on the face of the man beating himself on the breast! And how haughtily the Pharisee stalks up the steps in the middle ground, to the sound of a guitar played by one of the temple musicians! The gesture of his hands is eloquent; "God I thank thee, that I am not . . . as this publican" (St. Luke 18:11). The simplicity, straight-forwardness and human conviction of this tale alone would point to Rembrandt as the author, even without the extremely close structural relationships with Benesch 588, 589 and 593, particularly in the hatched modelling of the figures.

At this point, I should like to interpose an addition to my corpus. When I was discussing Benesch 516, *The Holy Family in the Carpenter's Workshop* (London, British Museum), I mentioned a drawing on this theme which had been brought to my attention by A. E. Popham after it had come to light on the London art market, and had been purchased by Count Seilern. Since Count Seilern refused my request for a photograph of the sheet, I was unable to include it in my corpus, and could only reiterate Popham's opinion that it was connected with Benesch 516, a drawing I date at about 1640 to 1642. In the meanwhile, however, the drawing has been published,[17] and, judging from the collotype reproduction, should be dated considerably later. The catalogue of Princes Gate has already advanced the date to 1646, but I would put it even later, at about 1648/49, the same period as the *Holy Family* (Benesch 620) in Rotterdam. The idea behind Benesch 516 can be seen in the process of further evolution in the Seilern drawing, and fully developed in the etching (B. 63, Hind 275) of 1654.

Some of the most revealing evidence about Rembrandt's creative work can be gathered from his corrections to drawings by pupils. Most of these drawings, as G. Falck[18] has shown, come from the hand of Constantijn van Renesse, who spent two periods in Rembrandt's studio, once in 1649, and again in 1652, and remained in constant touch with his master, who corrected his sheets from time to time (see the note to Benesch 1378). *The Crucifixion of Christ* in the Boymans-van Beuningen Museum (170 × 194 mm, Inv. no. R. 91, formerly Koenigs Collection; fig. 235) is easily recognizable as Renesse's work because of the tonal wash, but Rembrandt's strong penstrokes are evident, not only in the chief figures, but also in the Pharisee on the right, the rider on the left edge of the drawing and the group of dice-throwers. We can also see traces of Rembrandt's imaginative powers in the deli-cately drawn buildings in the background. At the same time as these amendments were being carried out, the horizontal beam of the cross was brought further down. To judge from the evidence of the style, Renesse must have done this drawing during his first period in Rembrandt's studio (1649), a conclusion which is con-firmed by comparison with the crucifixions, Benesch 652 and 653. Another drawing by Renesse, with corrections by Rembrandt, was recently auctioned by Kornfeld and Klipstein, Berne (III. Sale 27 May 1964, cat. no. 266; pen and brush in bistre

and India ink, 178 × 198 mm, collection of C.J.F.J. Maassen, Amsterdam, Lugt 1774b [now Coll. Dr. H. Bünemann, Munich];[19] fig. 236). It shows Lot and his daughters grouped together in an archway, with tonal shading in chalk and bistre in diagonal lines, and is strongly reminiscent of the setting of *The Annunciation* (Benesch 1372) in Berlin. Rembrandt has worked over the softly modelled group with a reed-pen in powerful, firm lines, and his corrections are clear and logical. For instance, the pose of the daughter standing with her head bent is more clearly foreshortened, the undifferentiated, shadowy mass of the seated daughter has been articulated better and thus transformed into a pose full of tension as the theme demands, and the figure of the father has been given added solidity.

David commanding Zadok and his Sons to return into the City (2 Samuel 15 : 27) is the theme of a hitherto unpublished drawing in a private collection, brought to my notice by the kind offices of my friend J. Q. van Regteren Altena (pen and bistre, 180 × 250 mm; fig. 234). This is one of several sheets dating from the turn of the decade, about 1650, a time when Rembrandt's tectonic, late style is already detectable in the total lay-out, although the details do not yet manifest the crystalline forms that were to come. *The Good Samaritan* in Lord Faringdon's collection[20] is an example of these sheets, and also *The Ascension of Christ* in Munich (Benesch 864). The solid column structure framing the two men, David and Zadok, anticipates works of 1653—in true Rembrandt fashion, the head of Zadok has been drawn twice—and the zigzag shading on the column, marking the shadow between direct light and reflected light in the curve, can be seen again, for example, in the *Ecce Homo* (Benesch 927) and *Susanna* (Benesch 928). On the other hand, the sharp accents, particularly on the extremities (cf. *David prevents Abisai from killing Saul*, Benesch 650a) and the foliage in the landscape, are typical of the close of the 'forties. The insight with which this little-known episode from the Bible is being related could, of course, be exercised by no one but Rembrandt.

According to the evidence of its style and developmental history, the important drawing from the Museum of Fine Arts in Budapest must have been executed in 1651. Dr. Ivan Fenyö brought it to my attention. It was among the works of art that came to the museum from the collection of István Delhaes (Lugt 1761). Since it had never been seriously considered as a work of Rembrandt, it had never been included in any of the publications devoted to the Rembrandt drawings in Budapest, but as soon as I compared it with incontestable sheets from the beginning of the 'fifties, I realized that it was not only authentic, but also extremely important (pen and bistre, 137 × 183 mm, Inv. no. 58.26 K; fig. 195). As I have already made a detailed study of the drawing's chronological position in Rembrandt's œuvre,[21] I will confine myself here to a few brief indications.

The subject of the sheet is *The Angel leaving Tobias and his Family*. In spite of the extreme delicacy of the penlines, the drawing conveys a strong and dramatic

sense of agitation. The old Tobit has thrown himself forward, the rest start back, dazzled by the shining vision. The composition is a direct development of another drawing on the same theme, in Oxford, dating from about 1649/50 (Benesch 638a; fig. 196), but has been considerably heightened and intensified in the process. In fact, the theme was by no means new to Rembrandt, since he had already handled it twice before, once in 1637, in a painting in the Louvre (Bredius 503; fig. 194) and once in 1641, in an etching (B. 43, Hind 185; fig. 75). Thus the Budapest drawing is a recasting of the theme in Rembrandt's mature style, the classical culmination being the drawing in the Pierpont Morgan Library in New York (Benesch 893; fig. 200). The date of the sheet can be confirmed with reasonable exactitude because of stylistic affinities with *Isaac blessing Jacob* (Benesch 891; fig. 198), about 1651/52, and similarities in content with the etching (B. 42, Hind 252; fig. 197) *The Blind Tobit* done in 1651.

Another small sheet in the Museum of the Roumanian People's Republic in Bucharest (pen and bistre, 47 × 35 mm; fig. 239, enlarged) shows the half-length figure of an oriental, in profile, looking to the left, and has undoubtedly been cut from a larger, Biblical composition. It is one of a group of sheets of about 1652 which are drawn very clearly with a reed-pen, and hair lines and shadow lines alternate according to whether the line is being drawn with a sharp edge of the cropped nib, or with the flat. *The Angel appearing to St. Joseph in his Dream* (Benesch 915) in Amsterdam is a typical example of this technique.

A hitherto unrecognized example of Rembrandt's landscape art has recently been restored to its rightful position by Christopher White:[22] *Farm Buildings by a Canal* (black chalk, 104 × 183 mm, collection of R. Payne Knight, British Museum; fig. 237). In his catalogue,[23] A. M. Hind described the drawing as "attributed to Rembrandt, but doubtful", and we can only assume that his misgivings were caused by a later sepia wash which has given the sheet an alien note, and impaired its silvery tonality. White, however, relied not only on the internal evidence of the high quality of the drawing, but also showed, from its outward appearance, that, in accordance with its format, it came from the same sketchbook of about 1652 as the superb sheets in the Albertina, *View over Het Ij* (Benesch 1280) and the *Bulwark of the Fortifications of Amsterdam* (Benesch 1281). There is also a view over the Amstel in Berlin (Benesch 1279) which belongs to the same group. In his later landscape drawings Rembrandt preferred peaceful, low-lying cubic forms, bulwarks and cottages with broad, low roofs.

Towards the middle of this decade, Rembrandt reached his apogee as a landscape draughtsman. About 1654 he was drawing sheets with a broad reed-pen, clumps of trees in undulating countryside, crossed by dykes, where the wind sets their tops swaying (Benesch 1331, 1332). He also used to apply wash thinned out with water, using a broad brush, to lend his work a strong sense of atmosphere,

so that the spectator feels as if he were really breathing the damp, sea air. At this time, Rembrandt was using his media to produce supreme heights of monumentality, and even the humblest motif or fragment of reality becomes monumental in mass and scale. A superb, unrecognized sheet of this type (pen and bistre, wash, 130 × 197 mm; fig. 238) was recently acquired on the English art market by a private collector in America.[24] The drawing shows a bend in a road fringed by trees, beside a canal closed by a weir in the background. Also in the background, there is a low, block-shaped house with a wide chimney. The vigorous penstrokes that transform the paper into sweeps of light and atmosphere are sparse, with wide spaces between them.

About 1654 to 1656, Rembrandt devoted much careful study to the Indian miniatures of the Mogul school, even making copies which are really works of art in their own right: attentive, but free adaptations drawn on the Japanese paper he usually reserved for the most precious early pulls of his etchings. It is possible that Rembrandt may have owned the Indian miniatures, and, indeed, it used to be thought that he copied them when he was forced to part with them at the liquidation of his property, but this is ruled out by the fact that he began to study them years before he went bankrupt. Twenty-five of these copies were listed at the auction of the collection of J. Richardson Sr. on 22nd January 1747; Lugt refers to eighteen known examples bearing Richardson's collector's mark, and yet another turned up in the London salerooms in 1961 (pen and bistre, wash, on Japanese paper, 213 × 178 mm, collections of T. Hudson, J. Richardson Sr. and R. F. Symonds; fig. 240).[25] This genre scene, which is a free combination by Rembrandt himself purports to show Shah Jahan in conversation with his falconer, although, in reality, the figures are anonymous and have been taken from different contexts. Rembrandt's prototypes are now part of the decoration of a Rococo interior in Schönbrunn Palace.[26] The prototypes of almost all the drawings are to be found there. The "Shah" is really the dignitary on the left in the garden house of the section numbered 39 in Strzygowski's volume of plates and the falconer stands on the right of the rider in section no. 24.

Copies of unknown original drawings by Rembrandt belong to the most revealing documents of his œuvre, although it is not always easy to recognize them as such, and even less easy to determine the chronological position of the original. Thus, it is always a happy day for the art historian when a lost original appears and confirms his guess.

This piece of good fortune happened to me in the case of a superb Biblical drawing (pen and bistre, wash, 165 × 216 mm; fig. 241). My judgement had been pronounced entirely on the basis of a copy in Dresden (Benesch C 75), but now Christopher White has discovered the original and acquired it for the British Museum.[27] The drawing shows a bearded man in royal robes, seated on a throne

(Rembrandt always used ermine and a turban with a heron clasp to indicate royal rank, even when omitting the crown) with an armed man kneeling before him in deep humility. Rembrandt has corrected the pose of this figure, and, in the second version, the man is kissing the ground. White suggests that the drawing shows "Jonathan begging for David's Forgiveness", and in view of the themes of the sheets most closely related in style, this idea has much to recommend it. Rembrandt frequently portrayed King David in this pose, and White was fully justified in pointing to Benesch 947 and 948, *Nathan admonishing David*, as the drawings most closely connected to it. Indeed, the latter, especially, has such close affinities with the newly-discovered sheet that it might even have been executed in the same moment of inspiration. Here, too, the figure of the King has echoes of the Indian miniatures Rembrandt was copying at much the same time, although the figure of the kneeling man is so massive in its sculptural structure that it foreshadows his style of drawing at the end of the 'fifties.

A fragment of one of Rembrandt's late drawings was recently recognized in the Print Room of the Veste Coburg by Werner Sumowski[28] (broad reed-pen in bistre, white body-colour, 121 × 53 mm, Boehm collection, Inv. no. Z 2703; fig. 242).[29] This drawing shows a full-length, male figure, seen from the back (originally placed higher, but covered with white), with three more figures on a deeper level, on the left. One of these figures is gesticulating with a stick or sword, like David cutting off the skirt of Saul's robe. Judging by the way the thick penlines run, the drawing must have continued for some way in both directions. The two sheets most closely connected with this drawing were done about 1660, the Madrid sketch for *The Denial of St. Peter* in Amsterdam (Benesch 1050) and the (reworked) *Lamentation* in Munich (Benesch 1049; fig. 73). Like the latter, the sheet in Coburg is only a working sketch the artist made for himself, reduced to the most lapidary form and it is not possible to interpret all the broad, reed-penlines such as, for example, those on the upper left. A similar line, drawn broadly with a split pen, also runs across the figures at the left edge of the *Lamentation*.

The most magnificent Rembrandt drawing that has come to light in recent years is *The Meeting of Christ with Martha and Mary after the Death of Lazarus* (reed-pen in bistre, white body-colour, 174 × 208 mm, E. V. Utterson collection; fig. 206), which turned up in a private collection in England, and is now in the possession of the Cleveland Museum of Art. I have already discussed it twice in detail[30] and will thus restrict myself here to a synopsis of the essential facts. The drawing illustrates St. John 11, verses 30 to 36, the moment when Jesus comes to the grave of Lazarus with his disciples and meets Martha. Summoned by Martha, Mary hastens out of the house, followed by mourning Jews, and the sisters kneel before Jesus. Martha resists the idea of having the grave opened, while Mary moans: "Lord, if thou hadst been here, my brother had not died!" Extremely broad

reed-penlines alternate with filmy penstrokes and radiating scratches from a dry pen with layers of white body-colour to give this drawing a rhapsodical eloquence. It possesses all the extremes of fluctuation and vibration characteristic of Rembrandt's drawings of the 'sixties, particularly the two sheets in Dresden, *St. Peter at the Death-bed of Tabitha* (Benesch 1068; fig. 207) and *Diana and Actaeon* (Benesch 1210),[31] and like the latter, can only be given a conjectural dating, that is, about 1662 to 1665, since there are no points of reference for real accuracy. The technique of these drawings has the same mysterious, radiant quality as Rembrandt's last paintings; however monumentally the figures are drawn, they seem diaphanous and floating. One seems to grow out of another, it is hard to say whether Martha or Mary's figure reached the paper first, though it was probably the former, and the pentimenti in the middle near them gather in a wild swirl. But each version clearly expresses what it is meant to say. At first, Mary is seen falling with her hands on the ground, and in the second attempt, she is touching the Lord's left foot. Martha's hands are drawn in four (!) different positions; she starts by expressing practical misgivings, wanting to persuade him that the tomb can no longer be opened because of advanced putrefaction. Then her head is thrown back and her hands raised up in worship: "Yea, Lord; I believe that thou art the Christ, the Son of God, which should come into the world." The expressive manner in which Rembrandt sets out this story, Christ's emotion at His friend's tomb, the weeping of the Jews and the mourning of the apostles, the vigour and impact coupled with tenderness and feeling, prove how even his draughtsmanship continued to develop and progress until the end of his days.

In addition to the above group of newly discovered drawings, I should like to discuss two sheets from the collection in the Hermitage in Leningrad. Both of these were included in Hofstede de Groot's catalogue, but were gradually forgotten because they were seen by so few people, and never reproduced.

The first sheet is a sketch of about 1635 showing a young woman sitting in an armchair (pen and bistre, wash, 138 × 108 mm, Inv. 5305, Cobenzl and Paul III collections, HdG 1525; fig. 243). She is seen in profile, looking to the left, with her arms, in the first version, supported on the arms of the chair. In the second version, she is lifting her right hand, which holds a sheet of rolled-up paper. The young woman's hair is covered with a thin veil which tumbles down over her shoulders and seems to trail on the floor, at the right. The penline is rich, and frayed into several strands, the line of the year 1635, and there is a bistre shadow, which has been spread with a finger, falling on the armchair. The pose and arrangement of the composition are startlingly reminiscent of the etching *The Great Jewish Bride* (Hind 127) of 1635, and it is possible that we are dealing with an early, preliminary attempt, such as a study from a model—perhaps even Saskia.

This sheet has been reproduced once by Professor M. Dobroklonsky,[32] a meticulous scholar, who quotes Gustav Falck's (oral) opinion on the drawing, which was completely negative. Dobroklonsky himself, however, is correct in emphasizing the drawing's affinity with the studies of Saskia (Benesch 281 and 282, about 1634/35) and states the case for Rembrandt's authorship of this drawing.

The second of these sheets from the Hermitage is one of Hofstede de Groot's most important discoveries in that museum. He found it among the drawings of the Italian School (Inv. 8028) and included it in his catalogue as no. 1524, "*Head with Helmet, in profile to the left* . . . sketchy pen drawing". It comes from the collection of Count Brühl, and has been drawn with a reed-pen on a small scrap of paper (49 × 40 mm) and the penstrokes have the broad "optical" quality of the mid-fifties; the edges, however, have been drawn by another hand. In spite of its small size, the sheet has a tremendous radiant quality and is, as Mme. Xenia Agafonowa was the first to recognize,[33] obviously a study for a painting, namely, the classical armed figure with an Athene helmet Rembrandt painted twice in 1655, the version in the Gulbenkian collection being called *Pallas* (Bredius 479) and the other, in Glasgow, *Alexander* or *Mars* (Bredius 480). The Pallas theme had been in Rembrandt's mind since the 'thirties, and in 1652 he used it in a sketch for an interior full of atmosphere, which he drew in the *album amicorum*, "Pandora", belonging to his friend Jan Six (Benesch 914). The eminent archaeologist, Professor Jan Six, considers the deity in the Album to be a tribute to his ancestor's mother, Anna Wijmer,[34] but E. Haverkamp–Begemann rejects this, identifying the figure quite simply as Pallas.[35] On the other hand, Professor Six has not unjustifiably pointed out that the woman seated behind the books has somewhat aging features which would hardly correspond with Rembrandt's ideal image of Pallas, as fitting here as his ideal image of Homer (Benesch 913). Indeed, he devoted considerable space to this ideal image in paintings, not to mention the drawing in Leningrad. But how could it make sense to see an aging Pallas seated beside a bust of herself in youthful beauty? Professor Six' idea that this figure has contemporary significance as a portrait cannot, thus, be lightly dismissed. Perhaps the antique Pallas is being deliberately contrasted to the modern one. For instance, it is striking how the curtain over the head on the "antique" Pallas is drawn so as to veil it in shadow, while the light illuminating the "modern" Pallas is so much brighter, as if, as E. Haverkamp-Begemann suggests, the light of wisdom were shining forth from her. It seems as if the modern Pallas were overshadowing the antique.

The opportunity of looking at a work of art in the original can often teach us a new way of seeing. A drawing which has been a riddle, resisting all attempts at classification, may suddenly begin to "speak" when we confront, for the first time in the original, the work of art to which it has been preparatory. Although, of course, such experiences are purely subjective, they may pave the way for

ascertaining objective facts. It is for this reason that I propose to relate the following story in the first person—the story of a drawing I recognized to be a study for *The Prodigal Son* (Bredius 598; fig. 244) in the Hermitage.

The drawing, which shows an *Oriental walking to the left* (HdG 1286; fig. 245), is in the Print Room in Amsterdam, and has had various dates attributed to it, all within the 'fifties. Henkel (catalogue no. 33), for instance, opted for the compromise solution of 1655, but Schmidt-Degener was the first to discern the hallmarks of Rembrandt's late style, and linked the sheet with *The Adoration of the Magi* in Buckingham Palace, painted in 1657 (Bredius 592; fig. 68). When I myself came to catalogue it, I did not feel that it fit satisfactorily into any of the groups of drawings that could be dated around these periods, and I thus excluded it as doubtful.

However, when I first caught sight of *The Prodigal Son* in Leningrad, the answer came in a flash of inspiration. This painting is a major work of Rembrandt's later years, as majestic as it is enigmatic, and I realized, at once, that the drawing was connected with the gigantic figure at the right edge of the canvas. When the painting is photographed or reproduced, the light is always focused on the main group, leaving the rest engulfed in shadow, but anyone who has seen the picture in bright sunlight will remember those silent onlookers and the strange spell they cast, and the way the parable becomes a scene from a dream, a reflection of the dark mirror of their souls. The mighty figure on the right is the elder son, approaching with a solemn, reproachful mien. He is wearing a tall hat, and his hands are clasped, holding a thin cane in such a way that it hangs down like a pendulum. This cane was one of Rembrandt's studio props, and it appears again in the models' hands in his portraits of Jacob Trip and Dirk van Os (Bredius 314 and 315). The elder son is also wearing a long coat, tossed over his shoulders like a cloak, with the sleeves hanging loosely down and, like his seated neighbour, shoes with broad soles, the curved uppers fitting snugly to the foot. These shoes, shaped like heavy, squat wedges, are reminiscent of those worn by southern Slavic and Greek peasants and appear exclusively in the present painting and the Amsterdam drawing, which also corresponds to the former in all other details of costume.

The lines of the drawing are the broad, spreading lines of the reed-pen we so often encounter in drawings from Rembrandt's later period, such as the *Lady Hawking* in Dresden (Benesch 1183; fig. 10), and the mask-like expression of the face, which lacks the profundity of the countenance in the painting, also indicates a late date. In fact, this blankness is probably due to the fact that Rembrandt's drawings in the 'sixties were not intended to be more than working studies for his own use when preparing a painting. The last drawings he did for their own sake are the late nude studies. Thus, the drawing of the *Oriental* itself provides sufficient internal evidence to place it in its correct genetical position in Rembrandt's œuvre.

A reasonably faithful copy, by a pupil, of an important lost drawing by Rembrandt has recently turned up in a private collection in England, and was brought to my attention by Neil MacLaren (pen and bistre; fig. 246). The subject recalls the parable of the Tribute Money, but that the gesture of the man approaching Christ is not that of someone handing over a coin. Perhaps it is *The Healing of the Withered Hand* (St. Matthew 12 : 13). The figures have been drawn tectonically in the cubic style of the years 1654 to 1656, and this feature is particularly evident in the man stretching out his hand to Christ, and in the group of Pharisees on the right. The composition is envisaged on a large scale and is classically balanced, the figures being arranged as in a frieze. It should be compared with *Tobias and Sarah guided by the Angel* (Benesch 985) and *Christ and the two Disciples on their Way to Emmaus* (Benesch 987).

Another drawing which has emerged—a copy of one of Rembrandt's most enchanting creations, of about 1637—is obviously an accurate facsimile of the lost prototype, but too poor in quality to be attributable to the immediate teaching activities in his studio (pen and bistre, 163 × 163 mm, private collection, U.S.A.; fig. 247). The drawing shows a *Pastoral Scene*, with a shepherdess crowning her swain with a garland of flowers in the shade of the trunk of an old willow tree, very much like the figures in Jacob Cats' *Trouringh*, published in 1637. Hans Kauffmann was the first to point out that this book was the source of Rembrandt's bucolic themes. The little dog in the lower right hand corner gives a clue to the dating because it appears, in mirror-image, in the etching of 1638, *Jacob telling his Dreams* (B. 37, Hind 160). This appealing scene is a precursor of the *Eulenspiegel* of 1642 (B. 188, Hind 200), though more naive and child-like, with less latent sensuality.

Finally, I should like to discuss some drawings I would have included in the "Attributions" section of my corpus.

The beginning of the 'forties was a problematic period for Rembrandt's draughtsmanship. The 'thirties had ended with a grand, baroque flourish which even affected the first studies for the *"Hundred Guilder Print"*, but with *The Night Watch*, a supreme, painterly mission became apparent in his work leading him to put off, or even abandon, other projects, such as, for instance, *Manoah's Offering*. At the same time, anxiety for his family and, at last, death itself darkened his days. Gradually the confident systematic draughtsmanship of his baroque manner of the 'thirties collapsed, and his "handwriting" grew restless and unruly, reared up, then fumbled again, becoming helpless and searching out new paths with the step of a sleepwalker. Thus the development of his draughtsmanship at the beginning of the 'forties is vague, vacillating, and extremely difficult for the researcher to pin down, and many sheets from this period have been unjustly

judged, although they are very much an integral part of his personality as a whole: for example, the studies for an *Entombment,* for the *Adulteress* and others. A further consequence of these problems is that the "Attributions" category is swelled by sheets which have many features that tell of Rembrandt, because no one is bold enough to make a definite decision.

There are two sketches for a composition *Sarah presenting Hagar to Abraham* (Benesch A 35 and A 51) which belong to this category and a *Return of the Prodigal Son* (pen and bistre, later line drawn round in chalk, 140 × 180 mm, Dr. Robert Rudolf collection, London; fig. 248) which is very closely related in style. The line at first seems jerky and confused, but it has the right, objective significance, impact and expressiveness, and the sketch has numerous connections with fully authenticated drawings. For instance, the door-frame on the right, hatched with a short, horizontal zigzag, appears in Benesch 499 and the thin, sharply-drawn nose of the old serving-woman can be paralleled in Benesch 492, 512 and 513. For the drawing of the feet and the use of dense zigzag hatching, we could point to Benesch 500, 512, 515 and A 51 and the trees remind us of Benesch 488, 498, 499, 513, 515 and 551. Thus the sheet seems to have a firm foothold among the drawings from the beginning of the 'forties, quite apart from a certain human directness and sharpness of observation which are not found in the work of any other artist. For instance, the way the old serving-woman pauses in the midst of her sweeping and looks suspiciously at the group and the way the dog snuffles at the heel of the returning youth. In other words, there is plenty of evidence to be put in the positive scale of the "Attribution".

Towards the end of the 'forties, Rembrandt was occupied with a theme from classical mythology, *Mercury, Argus and Io,* and the result was a drawing in the University Library of Warsaw (Benesch 627) which shows the moment when Mercury is furtively drawing his sword to slay the sleeping guard. There is also a second drawing (formerly de Burlet, Basel, Benesch Vol. III, pp. 175, ad 627; fig. 249) representing the same instant, and now a third version has appeared, and is in the possession of the East Berlin Print Room (pen and bistre, 185 × 222 mm; fig. 250). The drawing, which was brought to my attention by Dr. Werner Timm, shows the next phase of the myth, Mercury raising his sword for the death-blow, and if ever, this is the moment when two originals need to be put side by side for comparison. The Berlin sheet is a beautiful, strong drawing, superior to the de Burlet sketch (perhaps a pupil's copy), yet not quite reaching the quality of the Warsaw version, which has, in the articulation of the figures, a tranquil completeness already anticipating Rembrandt's work in the 'fifties. The Berlin sheet, on the other hand, with its vigorous hatching stroke, has a more restless, flickering effect. Not that there were no drawings like this at the end of the 'forties; we should compare, for example Benesch 598 here, which shows the early stages of the myth,

Argus examining Mercury's flute, and we could also point to Benesch 606, 613 and 638. At the same time, the drawing of the tree is related to Benesch 637 and 640. Nevertheless, although it has many features and qualities which might indicate Rembrandt's authorship, the sheet lacks the ultimate power to convince, and there is a clear case for retaining the status quo: a place among the "Attributions".

"Neuentdeckte Zeichnungen von Rembrandt," *Jahrbuch der Berliner Museen* 6 (1964), pp. 105–150.

Related Publications by the Author

BOOKS

Rembrandt, Werk und Forschung, Gilhofer and Ranschburg, Vienna, 1935.

See: *Artistic and Intellectual Trends from Rubens to Daumier as shown in Book Illustration*, Cambridge, Massachusetts, 1943.

Rembrandt, Selected Drawings, Phaidon Press, London—Oxford University Press, New York, 1947 (also editions in German, French, Dutch, Swedish).

A Catalogue of Rembrandt's Selected Drawings, Phaidon Press, London—Oxford University Press, New York, 1947 (also editions in German, French, Dutch, Swedish).

The Drawings of Rembrandt, A Critical and Chronological Catalogue, Phaidon Press Ltd., London, volumes I–VI, 1954–57.

Rembrandt, Biographisch-kritische Studie, Éditions d'Art Albert Skira, Geneva, 1957 (also editions in English, French and Spanish).

Rembrandt as a Draughtsman, Phaidon Press Ltd., London, 1960.

Rembrandt als Zeichner, Phaidon Press Ltd., London–Cologne, 1963.

See: *Meisterzeichnungen der Albertina*, Galerie Welz Verlag, Salzburg, 1964.

See: *Master Drawings in the Albertina*, Greenwich, Connecticut–London–Salzburg, 1967.

ESSAYS

"Rembrandt Harmensz. van Rijn," Thieme und Becker XXIX, Leipzig, 1935, pp. 259–271.

"Titus Rembrandtsz. van Rijn," ibid., p. 271.

"Rembrandt–Feier in Amsterdam," *Neue Freie Presse* no. 25468, Vienna, 7 August, 1935, p. 8.

"Rembrandt als Zeichner," *Mitt. d. Ges. f. vergl. Kunstforschung in Wien*, I. Jg., no. 2, Vienna, 1948, pp. 7, 8. [This essay is not reprinted here as it is a summary of previous writings on Rembrandt and was later published fully developed in the author's introductory essay to his book *Rembrandt as a Draughtsman* with the title "Some words on Rembrandt's Development as a Draughtsman". See p. 171.]

"Rembrandts Bild bei Picasso," *Pour Daniel-Henry Kahnweiler*, Stuttgart, 1965, pp. 44–54 [will be reprinted in vol. IV].

CATALOGUES OF EXHIBITIONS (arranged and presented on the author's initiative in or by the Albertina)

"Ausstellung ausgewählter Radierungen Rembrandts," Albertina, Vienna, Krystallverlag, 1925, pp. 1–8 (Die Neuaufstellung des Rembrandtwerkes der Albertina).

"Rembrandt, Ausstellung im 350. Geburtsjahr des Meisters," Albertina, Vienna, Autumn 1956, pp. 3–50.

"Die holländische Landschaft im Zeitalter Rembrandts," Albertina, Vienna, Summer 1936, pp. 4–23 [see pp. 130–131].

See: *The Albertina Collection of Old Master Drawings, A Short History of the Albertina Collection*, The Arts Council of Great Britain, Victoria and Albert Museum, London, 1948.

"Die schönsten Meisterzeichnungen," Albertina, Vienna, 1949, pp. 2–4.

"Von der Gotik bis zur Gegenwart, Neuerwerbungen, 1947–49," Albertina, Vienna, 1949–50, pp. 2–43 (nos. 11, 12).

"Die Musik in den Graphischen Künsten," Albertina, Vienna, 1951, pp. 3–6.

"Neuerwerbungen alter Meister 1950–58," Albertina, Vienna, 1958, pp. 3–64 (nos. 31, 32).

BOOK REVIEWS

Rembrandt-Bibel by E. W. Bredt, *Graph. Künste* XLV (1922), Vienna, Mitteilungen pp. 35, 36.

Rembrandt und der holländische Barock by F. Schmidt-Degener, *Graph. Künste* LII (1929), Vienna, Mitteilungen pp. 58, 59.

Notes to the Text

REMBRANDT AND THE PROBLEMS OF RECENT RESEARCH

1. "Aus der Werkstatt Rembrandts" *Heidelberger kunstgeschichtliche Abhandlungen* vol. 3, Heidelberg, 1918.

2. *Beiträge zur Geschichte und Methode der Kunstgeschichte*, Basel, 1917.

3. "Die Theorie des Romans", *Zeitschrift für Aesthetik* XI (1916), Stuttgart, pp. 225 ff.

4. "Das holländische Gruppenporträt" *Jb. d. Kh. Slgen des Allerh. Kaiserhauses* XXIII (1902), pp. 71 ff.

5. [For further details, see, Thieme-Becker XXIX, p. 267 (O. Benesch).]

6. Rembrandt's strange reluctance, in his late style, to make a single figure the centre point of the linear composition, and thus to subordinate it, is connected, in some way, with his desire for co-ordination and equal weighting for all the figures. Possibly the most striking example of this is the late *Ecce Homo* (B. 76, Hind 271) where the figures of Christ and Pilate stand flanking a gap in space—the goal of all the corresponding compositional lines in the pictorial plane—from whose depths Barrabas emerges.

It is characteristic that at the point where we would expect to find the focus of the centripetality, and the symmetry of corresponding lines, there is often, paradoxically enough, a yawning gap in space. Everything the old Rembrandt kept in the linear, and on the plane, is, in the last resort, pointing to the space he reveals to us by concealment.

7. *Jb. d. Preuss. Kstsglen* 38, pp. 107 ff.

8. Lecture in the Kunstgeschichtliche Gesellschaft, Berlin, Sitzungsbericht 10th October 1919. The following discussion of Kauffmann's opinion was added to the finished MS, because it was not until then that I became aware of his exhaustive review of Neumann's book in the *Rep. f. Kw.* XLIII (1921), pp. 115 ff.

9. [See pp. 223 and 286, note 13.]

10. [Cf. also the comments to Benesch 1058–1061.—L. Münz, *Konsthistorisk Tidskrift* XXV (1956), Stockholm, p. 60, and other treatises on the *Julius Civilis* in the same volume of the journal; P. Halm, B. Degenhart, W. Wegner, *Hundert Zeichnungen aus der Staatlichen Graphischen Sammlung*, Munich, 1958, no. 84; O. Benesch, *Rembrandt as a Draughtsman*, London, 1962, cat. no. 100. W. Wegner, "Rembrandt und sein Kreis", Staatl. Graph. Sammlung, Munich, Exhibition 1966/67, cat. 28.]

11. The same principle is at the heart of Rembrandt's technique as a draughtsman and painter in his late period. Using only straight lines, forming right angles wherever they touch, he spirited magical visions of space onto paper, without the help of wash, by dividing the surface into reciprocal compartments. The same is true of his canvases of this period, where he applied broad spots of colour with a spatula, setting them one beside the other like pieces of mosaic, spots which alternately push each other in and out of the depths.

12. [See p. 240.]

13. This reversion to co-ordination in his classical phase, though admittedly in a different key, enabled Rembrandt to resume a former task, the group portrait.

14. Neumann would prefer to speak of "stimuli".

15. [Two drawings attributed to Perino del Vaga, see Benesch 1208, 1209; a third drawing in Madrid, Real Academia de San Fernando, *Catalogo de Los Dibujos*, 1967, pp. 148, 149 (A. E. Pérez-Sánchez).]

16. [See p. 212.]

17. [Benesch 445, cf. also 443 and 444.]

REMBRANDT'S DEVELOPMENT AS A DRAUGHTSMAN

1. This study is the first chapter of a treatise on Rembrandt's development as a draughtsman up to the year 1634, submitted to the Faculty of Philosophy, University of Vienna, as an inaugural thesis in 1921. The MS is in the Warburg Institute, Hamburg [now London]. The fact that this is published some time before the proposed ex-

pansion of the work (spanning the years until the inception of the *"Hundred Guilder Print"*, that is, the turn of the 'thirties and 'forties) is due mainly to the constant discovery of unknown works which made it seem advisable to wait with the conclusion. On the other hand, the questions touched upon here are vitally relevant, not only to art history, but also to the study of history as a whole. I have tried to give a concrete instance of the application of these methods to an individual case in my essay "Rembrandt und die Fragen der neueren Forschung" [see pp. 1–24], a study of *Julius Civilis* (Bredius 482). [See also the author's introduction to *The Drawings of Rembrandt*, vol. I, also *Rembrandt as a Draughtsman*, pp. 5 ff.]

2. *Jb. d. Kh. Slgen d. Ah. Kh.* XXIII (1902), Vienna, pp. 71 ff.

3. "The problem of Rembrandt is none other than the artistic problem of his nation, at a certain stage in its development; but, in his urge to find the most perfect solution, Rembrandt remained involved in it long after his fellow countrymen had mostly passed beyond. When Rembrandt eventually found his most satisfactory solution, his fellow Dutchmen had lost all comprehension of it; and the recognition he was denied at the time was only vouchsafed to him in art-historical researches and studies of the end of the XIX century" (Riegl, op. cit., p. 245).

4. On Rubens' traditionalism and the Italianate, retrospective tendency of his art, particularly in his early Antwerp period, cf. Oldenbourg, "Die Nachwirkung Italiens auf Rubens und die Gründung seiner Werkstatt" *Jb. d. Kh. Slgen d. Ah. Kh.* XXXIV (1917), Vienna, pp. 159 ff.

5. Oldenbourg (op. cit., p. 215) stresses the basic "classical" theme in Rubens' work. But in this case, "classical" refers to the fundamentally Mannerist mood of Rubens' art, which appears most clearly during the years 1611–1615. This classicism is thus not identical with the baroque classicism referred to here, which evolved about mid-century. Rubens' classicism has as little in common with the latter as does that of the Carracci and Abraham Janssens.

6. I am leaving aside here earlier cases of Rembrandt's direct influence on artists who belonged to other schools of style and content, such as the Haarlem painters,

Frans Hals and Adriaen van Ostade.

7. Rembrandt's role as the instigator of a great, general transformation in artistic style should not be seen as the creation of something new out of nothing or as an obstacle thrown across the mainstream of Dutch art. He undoubtedly fulfilled those tendencies latent in Dutch art which can be traced as far back as the late middle ages. Even Geertgen's works exhibit a sort of "classicism" in their formal and conceptual approach, and a method of composition which uses large, calm, monumentally-compact forms and optical chromatic planes. This latent trait in Netherlandish art spread during the period of Romanism in the early seventeenth century until it eventually manifested itself in artistic phenomena which seem to anticipate something of late Baroque Classicism (W. van den Valckert, Mierevelt). A similar tendency can be observed in the architecture of the period, which developed steadily towards the architectonic classicism that was to come, and in this instance there can be no question of Rembrandt being involved (cf. A. Riegl, "Die Barockdekoration und die moderne Kunst", *Mitt. d. Oesterr. Museums*, N.F. XII, pp. 261 and 295).

Classical tendencies were thus present in every field, but Rembrandt was the first to weld them into a great stylistic trend, a new creative concept of universal importance, and this concept is quite different from that of Rubens. For it was due entirely to Rembrandt that the problem grew beyond the bounds of Dutch art alone, and became international. He was also the first to raise a specifically Dutch phenomenon to the level of a movement capable of sweeping through Europe, that is the Baroque Classicism of the second half of the century. Indeed, only an artist with such wide spiritual horizons could have achieved such a feat, and Dutch Baroque never produced a second. Thus, to show that there were classical tendencies already latent in Dutch art does not detract from the importance of Baroque Classicism as a new creation of Rembrandt's genius.

8. Riegl interpreted the strong "re-objectivizing" implicit in the link with French Classicism as an advance in the direction of increased subjectivity. But, in fact, the objective elements in this late classicism

are so fractured, so glitteringly transformed and so full of fragmentary nuances that they are given a new meaning, and we can sense the gradual progress of the development of art towards modern times, where subjectivism rules unchallenged. But this increased subjectivity is something taking place on the surface and easing the developmental and historical transition into the eighteenth century; at the same time, it also indicates a minimizing of the problems, and a restriction of what once streamed forth, free and mighty.

Late Dutch Classicism is characterized by a certain narrowness of horizon, a touch of mediocrity, and a plethora of minor masters. Admittedly, it also represented the full rationalization of the achievements of the classical age, and to a certain degree this implies an advance in subjectivity. But the petty intellectualism of this art is something essentially, not relatively, different from the classical power of Rembrandt's subjectivism. The former has all the restrictedness and narrowness of meaning that give the appearance of more intense subjectivity, whereas Rembrandt's art exhibits the free outpouring and limitless breadth of a world that seems objective in its transfigured calm and self-composure, the fabric of an incredibly deep, super-individual and universally valid subjectivity. The acid test of the art of the late classicists is the limited subject-matter which reflects itself, and makes itself into the object; in this way it regresses back to the narrow confines of precisely that objectivity it was attempting to surmount by isolationary individualism.

9. Rembrandt's adherence to classical form is a principle to be taken with some reservations. For instance, the simplification involved was not a matter of ever-increasing, rigid circumspection, but a simplification which, in its last phase, seemed to be decomposed, as if by an inner fluid, and broken up into lapidary fragments. This is a form of simplification which stands at the outermost edge of what is expressible in formal terms, and which has dissolved into an immaterial, cosmic, haunting fluidity to such an extent that it would only have to go one step further to disintegrate into formlessness. This is a classicism whose inherent, subjective meaning almost turns it into the opposite, that is, into complete disintegration. It is all too easy to forget that Rembrandt's late classical period should not be considered as a homogeneous whole, since there is an enormous difference between the work of the 'fifties and that of the 'sixties—a difference which is completely obscured by the usual division of his career into three parts. Indeed, Rembrandt's classicism of the 'sixties almost seems to merge into the flickering of a new Baroque: but this is only illusion. In fact, what we have here is the final consequence of classicism. The problem of the late Rembrandt is closely related to the classicism of the late Beethoven, whose last string quartets show the classical discipline of his late style dissolving into an ethereal vibrancy, a fugue-like, fugitive probing, which suddenly escapes, for a few bars of soaring harmony, and explores the infinite, and which is almost the negation of classicism. Yet this music is not Romantic, but profoundly and essentially classical, although it is, admittedly, a classicism raised to the ultimate degree, to the outermost limits of artistic portrayal. The late Beethoven may have shaped the destiny of Romantic music but he was separated from it by a deep, essential incompatibility.

10. In "Rembrandt und die Humanisten vom Muiderkring", *Jb. d. Preuss. Kstslgen* 41 (1920), pp. 46 ff., Kauffmann traces the sources of Rembrandt's literary themes (particularly in his early period). He produces many valuable conclusions, but goes too far in his endeavour to trace Rembrandt's intellectually complex pictorial content back to the Dutch literati of the period. The intellectual world of the young Rembrandt was so very different from that of his circle of humanist friends, and similarities in literary content do not necessarily indicate similarities in intellectual nature. Here, too, it is not the immediate and closest historical links which give us the deepest answers, since the deepest historical connections follow hidden pathways.

11. Review of Neumann's "Rembrandt" (*Mitt. d. Ges. f. verv. Kunst*, Vienna, 1903, pp. 51–53).

12. M. Dvořák, "Wickhoff's letzte literarische Projekte" (*Bericht über die Verhandlungen des 9. Internationalen Kunsthistorischen Kongresses in München*).

13. It is characteristic of the subjective nature of Rembrandt's art that even true, genetic sequences of designs for a definite work, which have come into being within a short period, are linked by the same underlying spiritual connection. This is particularly evident in the *Julius Civilis* and its strange history [see pp. 1–24].

14. It is often—erroneously—concluded that works with identical iconographical content were executed at identical times. In fact, the iconography can serve, at the most, as a support for a theory based on other considerations. It often happens that Rembrandt was particularly engrossed with certain themes at certain periods, but this means only that we can formulate tentative conclusions about the stretches of time over which Rembrandt was particularly concerned with the ideas inspired by any one theme. It could never be stated categorically that any one sheet was an immediate design or preliminary study for a certain work, however close the thematic link. After all, the related drawing might just as well have been executed after, rather than before, the painting or etching.

15. The fact that this possibility had not even been considered before, proves how little we still know about Rembrandt's development as a graphic artist, in spite of all the dated works. The incorrect datings of the "*Hundred Guilder Print*" (B. 74, Hind 236), which was beginning to form about 1640, and *The Artist drawing from a Model* (B. 192, Hind 231) which was executed at the end of the 'thirties, are excellent examples. [See Benesch 183–185, and the comment to 423.]

16. This does not mean that every painting and etching in Rembrandt's oeuvre must have an equally important and contemporary partner among his drawings. Naturally the emphases vary with the problems and the phases of development. The draughtsman Rembrandt occasionally precedes the painter and etcher, just as Beethoven's string quartets and piano sonatas are often a jump ahead of the rest of his work.

17. The system of interpretative historical analysis introduced by Riegl in the "Group Portrait" was defined by E. Panofsky ("Der Begriff des Kunstwollens", *Zeitschrift für Aesthetik*, XIV (1919), Stuttgart, pp. 335 ff.) as follows: "A method such as that inaugurated by Riegl, is—if correctly understood—as far removed from the purely historical method of writing about art history, which is concerned with the recognition and analysis of important single phenomena and their connections, as, for instance, the theory of cognition is from the history of philosophy. The 'necessity' this method discerns in certain historical processes does not consist—assuming that the concept of 'Kunstwollen' is applicable—in ascertaining whether there is a causal relationship or interdependency between several individual events following one another in time, but in discovering whether they have a unifying principle, when taken as a total artistic phenomenon. The aim is not to discover the genetic grounds for stating that a series of facts is a necessary sequence of a certain number of single events, but to undertake an interpretative historical analysis of them as an ideal entity."

This definition is a first step towards a sympathetic understanding of the interpretative system, although it commits a fundamental error in the distinction between the historical and interpretative systems. The latter is not something apart from historical reality and that reality's concrete causality, as Panofsky believes. In construction, it corresponds with historical reality and the relationships it uncovers are concrete, historical facts, although they are viewed in the light of an illuminating interpretation which brings out the essentials. The impressionistic image given by a historical complex with its bewildering network of illusory connections bears no resemblance to historical reality, because this usually lies below the surface, and to seek it is the true object of the interpretative method of analysis. Riegl probably did not doubt for one moment that his interpretation was "pure, historical art history", with a significant, genetic structure corresponding to an equally significant reality, even though the former was not revealed to every casual glance.

REMBRANDT'S *THE FALCONER*

1. The painting was acquired for the Gothenburg Museum by Professor Axel L. Romdahl, who published it for the first time in his essay "Riddaren med falken", Gothenburg, 1922.

2. Valentiner, "Rembrandt, Wiedergefundene Gemälde", Kl. d. K. XXII (1921), pl. 94.
3. Copenhagen, Royal Picture Gallery, op. cit., pl. 97.

REMBRANDT DRAWINGS IN THE MUSEUM OF FINE ARTS, BUDAPEST

1. [G. von Térey, *Zeichnungen von Rembrandt Harmensz van Rhijn im Budapester Museum der Bildenden Künste, Leipzig, 1909.*]
2. I have described the method and principles of critical analysis in the essay "Rembrandts zeichnerische Entwicklung" [see pp. 26–40].
3. [Catalogued as 1630/31, see Benesch 47.]
4. [Now in the Boymans–Van Beuningen Museum, formerly F. Kœnigs collection.]
5. [Now in the Rijksprentenkabinet, Amsterdam.]
6. This sheet was retouched at some later date. There is a splash of bistre between the fullest part of the bundle of clothing, and the left contour of the body. The background of shadow around the head and along the right contour of the body has been smudged and has become opaque. The delicate white highlights, however, are undoubtedly original.
7. [*The Preacher Jan Cornelisz Sylvius*, now in the National Gallery of Art, Washington, D.C.]
8. The artist covered some of the vertical and horizontal lines crossing the drawing with white body-colour, but with time they have broken through again and become visible.
9. [Benesch 1187–1204 and others.]
10. The lines on the reverse are in [a seventeenth-century] handwriting.
11. [See p. 244.]

REMBRANDT'S ARTISTIC HERITAGE

1. This study is based upon a lecture which I gave in March 1924, and has been very little altered because, in any case, it could never be considered "complete". In fact, I would be glad to preserve the spontaneity of the spoken word, perhaps the best method of conveying the sense of a whole from a few selected examples. I should only like to add here that I have laid more emphasis on the deep-lying, essential effect Rembrandt had in his own time and later rather than on obvious examples of his "influence".

2. The red chalk drawing *The Entombment of Christ* (HdG 891, Benesch 17), 1630, in London.

3. The *Portrait of Elisabeth Jacobsdr. Bas* was attributed to Backer because of the close stylistic relationship with his 1635 portrait of the preacher Jan Uijtenbogaert in the Remonstranten Church in Amsterdam [Bauch, *Backer*, no. 159; now on loan to the Rijksmuseum] and his portrait of a woman in the gallery in Antwerp (attributed by Dr. Buschmann) [Bauch, *Backer* 193]. The specific point of similarity between the Bas portrait and the painting in Antwerp is, apart from the conception of the portrait in general, the mental attitude and the psychic characterization (although they are, of course, two quite different personalities) and the modelling of the head and hands. For instance, the relief of the face is in full light, so that deep furrows of shadow form in the wrinkles around the eyes and at the corners of the mouth and the material substance, though firm and palpable, and despite all its clarity, seems to be brittle and crumbling, very unlike Rembrandt's forms which swell out, full of life. The hands, too, for all their rounded, painterly plasticity, have hard contours, and look rather like crumpled parchment. On the chromatic plane, the paintings are connected by a certain olive-green in the undercoat, which Backer affected, and the gleaming substantiality of the heavy silk dress encasing Elisabeth Bas' body like a suit of armour, reminds us of the same feature in the Uijtenbogaert portrait. At

the same time, the Uijtenbogaert portrait is very similar to Rembrandt's etching B. 279, Hind 128, of 1635, though in mirror-image; indeed, the head and torso look as if they had been translated into paint from the etching. Which work was earlier, that of the master or that of the pupil? It is easy to suggest that Rembrandt had already made a preparatory drawing for the etching and that Backer's portrait was painted under the simultaneous influence of Rembrandt's study and the model. Bredius was the first to attribute the Bas portrait to Backer, but today, as far as I know, only F. Schmidt-Degener still holds the same opinion (I have this from Dr. Roëll). K. Bauch, who is about to write a monograph on the artist, and who also considered Backer, has told me that he has changed his opinion, although to what extent I do not know. In any case, his forthcoming publication will give us some important aspects of the problem [*Jakob Adriaensz Backer*, Berlin, 1926, no. 137 as "completed by Rembrandt". Rijksmuseum as F. Bol. See also p. 209.]

[This note has been rectified by the editor. The date 1634 in the original essay had been taken from Tidemann, *Oud H.* XXI (1903), p. 125, as well as from Thieme-Becker II, p. 323. In the present condition of the painting, the date is difficult to decipher. It was read by the editor as "1635"; Professor van Regteren Altena is inclined to agree with this.]

4. I shall give the reasons for my attribution of this painting and its companion-piece (Bode 184, Bredius 352; [now Vaduz, Prince of Liechtenstein]) in another publication [see p. 209]. [See Moltke p. 254, No. 142.]

5. [See p. 208.]

6. ["De Potter"; Schuurmann, p. 43; Rijksmuseum, Cat. of Paintings, 1966, Inv. 920.]

7. Schwerin, Gemäldegalerie. [Schuurmann, op. cit., p. 53, fig. p. 57.]

8. *Rembrandt K.d.K.*, 3rd edition, 1908, p. 385 [erroneously identified as St. Bartholomew, since the set-square is an attribute of St. Thomas. The convincing attribution of the painting to Maes comes from Georg Gronau.

9. [D. Pont, *Barent Fabritius*, Utrecht, 1958, p. 111, cat. no. 20. Schuurmann, op. cit., pp. 46, 47. See also Coll. Writings II, "Zu Barent Fabritius", where Barent and

Carel are already described as brothers by the author.]

10. The immediate source of Weyer's inspiration is a skirmish between cavalrymen by Ph. Wouvermans, shown at the Dutch exhibition "Maîtres Hollandais du XVIIe siècle", Muller, Amsterdam 1906, cat. 129, repr. in the Album. It is characteristic of Weyer not to have taken one iota of Wouvermans' "petit maître" qualities, but to have worked right through to the full dramatic power of early Dutch Baroque.

11. Formerly in the J. Brass collection in Venice, [now in Cleveland, Ohio, Museum of Art, Handbook 1958, cat. no. 424. R. Pallucchini, *Piazzetta*, Milan 1956, p. 26.]

12. [T. Pignatti, *Le acqueforti dei Tiepolo*, Florence, 1965, XXXII.]

13. Both paintings in the Oesterreichische Galerie, Vienna [Coll. Writings IV, "Franz Anton Maulbertsch". See also K. Garas, *Franz Anton Maulbertsch*, Budapest, 1960, cat. 185, 67.]

14. [Garas, cat. 344, 345; formerly St. v. Auspitz Collection.]

15. [F. Dworschak, R. Feuchtmüller, u.a., *Der Maler Martin Johann Schmidt*, Vienna 1955, pl. 50, Göttweig; on loan to the Niederösterreichisches Landesmuseum, Vienna.]

16. A. Feulner, *Die Zick*, Munich 1920, p. 42. [See p. 252. Zick actually made a copy of Rembrandt's *Blinding of Samson* (Bredius 501), Wallraf-Richartz Museum, Cologne. See A. Feulner, *Wallraf-Richartz-Jb.* 9 (1936), p. 174, fig. 119.]

17. Academia de San Fernando, Madrid, [*Cat. de las Pinturas*, 1965, 669 (F. Labrada)].

18. Academia de San Fernando, Madrid [now Prado, *Cat. de las Pinturas*, 1963, 749 (F. J. Sánchez-Cantón)].

19. ["Exposition E. Delacroix," Louvre 1963, no. 134, M. Sérullaz.]

20. A. Robaut, *L'Oeuvre complet d'Eugène Delacroix*, Paris, 1885, 788; [Exposition E. Delacroix, Louvre 1930, cat. 164; now on loan to the Philadelphia Museum of Art from a private collection (see Lee Johnson, *Revue du Louvre*, 16e année, Paris, 1966, nos. 4/5, p. 218, fig. 1, to whom the editor owes special thanks for information about Delacroix).]

21. [J. Meier-Graefe, *Corot*, Berlin, 1930, p. XLVI. Also A. Robaut, *L'Oeuvre de Corot*, Paris 1904/6, 1035.]

22. [V. W. van Gogh Collection, Stedelijk Museum, Amsterdam; J.-B. de la Faille, *L'Oeuvre de Vincent van Gogh*, Paris, 1928, no. 677.]

23. [K. Schwarz, *Das Graphische Werk von Lovis Corinth*, Berlin, 1917, L. 245.]

REMBRANDT DRAWINGS IN THE GRAPHISCHE SAMMLUNG, MUNICH

1. HdG p. 117.
2. There is a version at M. Pennington, Glendale, California, and several copies of this painting also exist.
3. [K. Freise, *Pieter Lastman*, Leipzig, 1911, no. 84; Staatliche Museen, Gemäldegalerie, Berlin–Dahlem, Catalogue 1966, no. 677.]
4. According to O. Weigmann, they come from the Mannheim workshop. [cf. P. Halm, B. Degenhart, W. Wegner, *Hundert Meisterzeichnungen aus der Staatlichen Graphischen Sammlung München*, Munich, 1958, p. 68; also W. Wegner, *Kurfürst Karl Theodor von der Pfalz als Kunstsammler*, Mannheim, 1960; idem, *Rembrandt und sein Kreis*, Exhibition, Munich 1966/67.]
5. [Concerning the representations of Rumbartus, see I. H. van Eeghen, *Jaarboek Amstelodamum* 43, Amsterdam, 1956, pp. 144 ff., and O. Benesch, *Rembrandt as a Draughtsman*, comment to cat. 21.]
6. Valentiner, op. cit., plate 37.
7. "Über einige von Rembrandt übergangene Schülerzeichnungen," *Jb. d. Preuss.*

Kstslgen 45, 1924, pp. 191 ff., Benesch 1019. Quite apart from the magnificence of the idea, the superb quality of the drawing compels us to disagree with Falck and attribute it to Rembrandt. It is also not difficult to show the connection with undoubtedly authentic drawings of the 'fifties, for instance, two women recently acquired by the Albertina (Benesch 1167). The fact that it appears on the reverse of a drawing by Renesse does not alter our opinion any more than in the case of Munich, Inv. 1763 verso, Benesch 288.

8. [See the comment to Benesch 958 written after a close examination of the drawing. See also Mitt. 1927, p. 22, footnote, with the quotation of a letter from J. Rosenberg in reference to Bredius 523.]
9. *Vasari Society* VIII, 26.
10. *Vasari Society* X, 16.
11. S. Meller has justifiably reinstated this sheet among Rembrandt's finest works. I published it in the Hungarian journal *Ars una* 1, 7 April, 1924, pp. 25 ff. [See pp. 54–6.]

NEW STATES IN ETCHINGS BY MOCETTO, NICOLETTO DA MODENA, LUCAS VAN LEYDEN AND REMBRANDT

1. [This essay has been abbreviated by the editor, but all passages concerning first statements by the author have been included.]
2. *Catalogue of Early Italian Engravings*, British Museum, 1910.
3. [A. M. Hind, *Early Italian Engraving* V, London, 1948, p. 164, no. 9 (accepts I and II).]
4. Established by A. Stix. Hind, ibid., p. 127, no. 63, Pl. 676 indicates three states: I, II, and III (?).
5. [F. W. H. Hollstein, *The Graphic Art of Lucas van Leyden*, Amsterdam, n.d., p. 94; erroneous quotation. See p. 107.]

6. D. A. Rovinski, *L'Oeuvre gravé de Rembrandt*, St. Pétersbourg, 1890, vol. I ff.
7. New edition by H. W. Singer, Leipzig, 1922.
8. *Die Neuaufstellung des Rembrandtwerkes der Albertina* (O. Benesch), Vienna, Krystallverlag, 1925 (Ausstellung ausgewählter Radierungen Rembrandts, Albertina); [quoted on p. 272.]
9. [Cf. the arrangement of states BB 41-G in *Rembrandt's Etchings, True and False* by G. Biörklund—O. H. Barnard, Stockholm–London–New York, 1955.]
10. [Overlooked by Münz and others.]

(ON THE PROBLEM OF NEW STATES IN PRINTS BY LUCAS VAN LEYDEN AND REMBRANDT)

1. [In some places this essay has been abbreviated by the editor.]
2. *Oud Holland* XLIII (1926), pp. 243, 244.
3. In the case of a suspected copy, the procedure would be as follows: to reject without demur an impression of the later editions which improves upon the earlier ones only by having the numbering or the inscription, but under no circumstances to regard an impression with an *old* alteration as a duplicate.
4. A.-C. Coppier, *Les Eaux-Fortes de Rembrandt*, p. 32. The author strangely enough describes the surviving plate as "en bon état", although the wear and Basan's reworking can be observed even in the reproduction.
5. [The reference to this note has been transferred to p. 279 middle, note 8, where it actually belongs.]

A COPY OF REMBRANDT'S *PETITE TOMBE*

1. If we ignore J. P. Norblin's reworking. B.67, Hind 256 [Münz 236.]
2. [L. Münz assumes that the copy was made by James Bretherton. There is a print of it in the Rijksprentenkabinet in Amsterdam, which is reproduced here.]

REMBRANDT'S LAST DRAWING OF HIMSELF

1. I made a brief announcement of this in *Pantheon* I, Munich, 1928, p. 226.
2. To make it easier to distinguish the original structure, the sheet has been reproduced enlarged.
3. By being connected with *The Descent from the Cross* (B.83, Hind 280) of 1654, and *The Entombment* (B.86, Hind 281), the etching B.50, Hind 279 has usually been dated "around 1654", and thus too early. On the basis of the drawing in Dr. Beets' collection, [now in the F. Koenigs Collection, the Boymans–Van Beuningen Museum, Rotterdam], I have been able to show, for the first time, that this dating is incorrect and to suggest that it was executed about the end of the 'fifties (*Mitt. d. Ges. für verv. Kunst* XLV, 1922, p. 35 [See p. 272].
4. [Now Rotterdam, Boymans–Van Beuningen Museum.]
5. cf. my comments in the *Wiener Jahrbuch für Kunstgeschichte* III, p. 118 [see p. 44].

UNKNOWN AND WRONGLY ATTRIBUTED DRAWINGS BY REMBRANDT

1. As he has kindly pointed out to me, this has been the view of F. Saxl for some time.
2. I have discussed the group in detail in my thesis "Rembrandts zeichnerische Entwicklung bis 1634". [See p. 26.]
3. The use of some white chalk is peculiar to these two sheets: it does not cover but merely veils a little here and there, giving a "floating" effect.
4. There is another sheet I also consider to be a work by Rembrandt that has strayed into the Bol oeuvre. It shows a bearded scholar seated at a table (Bock-Rosenberg, p. 87, pl. 69, Benesch 729, Berlin Print Room). The superb clarity, firmness and confidence of the spatial form is something fundamentally different from the confusion of intersecting lines in Bol's pen drawings. It is most closely related to the study for a *Portrait of a Scholar* dating from about 1647, in Budapest (HdG 1373, Benesch 766) and the study from life, *The Preacher Jan Cornelisz Sylvius* (HdG 304, Benesch 762) for the portrait, Bredius 237 (1644), from the Carstanjen Collection [Cologne, Wallraf-Richartz Museum].
5. Photograph by courtesy of M. le Conservateur, F. Mercier; verso: *Sketch of Tobias' Wife*.
6. Since recto and verso were executed at the same time, the etching, as I have already stated, should also be dated to the end of the thirties. [See p. 50.]

7. [Sale, Gilhofer and Ranschburg, Lucerne, 28th June, 1934, no. 223.]

8. ["In ongenaden synden de worden niet geschooren".]

9. [See p. 240.]

10. Pen and bistre on granulated paper (167 × 135 mm.); the lines in sepia were added later, Colls. Artaria and Wurzbach. [Sale, Gilhofer and Ranschburg, Lucerne, 28th June 1934, no. 225. E. Perman, Stockholm; P. de Boer (1966), exhibited, Oude Tekeningen, P. en N. de Boer, Singer Museum, Laren N.H., 1966, cat. 191.]

11. When looking through the de Grez collection, apart from the above-mentioned sheets, I noted down the following works by Rembrandt:
Listed under Eeckhout:
1205, *Little child in lost profile to the left* (Benesch 227). About 1632/33 (belonging to the group HdG 141, 157, 159, Benesch 223, 218, 219). According to a note on the mount, Hofstede de Groot also attributed it to Rembrandt.

1199, *Girl asleep* (Benesch 287, "Saskia"). About 1634, Ploos van Amstel collection (group of HdG 995, 934, 255, 706, 773, Benesch 281, 286, 255, 284, 283).

1204, *Young Boy looking upward* (Benesch 1098, "Girl or Boy"). About 1652.

1899, "Inconnu", *Bust of a girl* (Benesch 699), about 1647.

Listed under Rembrandt:

3019, *Oriental in a wide-brimmed hat* (Benesch 231). About 1632.

3020, *Man in a plumed hat* (Benesch 695), 1645/47.

3021, *Man in a helmet* (Benesch 694, "bust"). 1645/47.

12. .[See p. 262.]

13. *Jb. d. Preuss. Kstslgen* XXV.

14. It is the reverse of a drawing by Renesse, published by G. Falck, *Jb. d. Preuss. Kstslgen* XLV (1924), p. 196. Falck assumes that the drawings on both sides of the sheet are by Renesse.

PORTRAIT OF A WOMAN FROM REMBRANDT'S EARLY PERIOD IN AMSTERDAM

1. [See Benesch, *Werk und Forschung*, p. 17. According to tradition—the relevant documents were lost after 1938—this painting came originally from an aristocratic Russian collection. After 1934 it was acquired by Ernst Adler, an industrialist from Asch, Czechoslovakia, and appeared in 1940 at the Kunstsalon Franke, Leipzig.]

2. [Independently, M. J. Friedländer, in a certificate dated 28 May 1930, described the painting as an "excellent, well-preserved work by Rembrandt of about 1632". A copy of the certificate recently came to the editor's knowledge in the Rijksbureau voor Kunsthistorische Documentatie, The Hague.]

THE DUTCH LANDSCAPE IN REMBRANDT'S PERIOD

1. Cat. no. 42, Benesch 1354, *Het Molentje* (fig. 97).

AN EARLY GROUP PORTRAIT DRAWING BY REMBRANDT

1. First presented as a communication at the International Congress of the History of Art, London, 1939. When it was published the essay was prefaced by W. R. Valentiner:
Editor's Note. If the Rembrandt drawing from the Bonnat collection mentioned in Dr. Benesch's illuminating article has not been published as yet in Rembrandt's Handzeichnungen, Klassiker der Kunst, it is for the sole reason that it was to be reproduced in the third volume with other genre drawings of difficult interpretation. I quite agree with the author that it is a fascinating original from Rembrandt's hand. . . .

In connection with the candle-light scene from the Van Aalst collection reproduced by Dr. Benesch, another hitherto unpublished painting belonging to the same series is here reproduced for the first

time [Bredius, third edition, 421A]. The painting turned up recently on the English art market and has been acquired by the collector who owns the companionpiece.

W. R. Valentiner.

2. [Later in the Estate of the late Dr. N. J. Van Aalst; now G. Cramer, The Hague.

Cat. XIII, 1966/67. The photographs reproduced here were taken after restoration of the paintings.]

3. Dutch art market. [Sale N(athan) K(atz), Paris, April 25, 1951; now Paris, Georges Lehman Collection.]

THE REMBRANDT PAINTINGS IN THE NATIONAL GALLERY OF ART

1. [Many more Rembrandt paintings have come to the National Gallery since, mainly from the Widener Collection. Among them there are portraits, Biblical and mythological subjects and others. *National Gallery of Art, Washington, D.C.*, by John Walker, New York, 1963; and Summary Catalogue of European Paintings and Sculpture, Washington, D.C. 1965, pp. 109–111; Illustrations 1968.]

2. I had the opportunity of examining the date in full sunlight when the painting came to Amsterdam for the Rembrandt Exhibition of 1932. It is unmistakably 1633.

3. Signed and dated, but the date is no longer

clearly visible.

4. Cf. W. R. Valentiner, *Rembrandt und seine Umgebung*, Strasbourg, 1905.

5. A rough pen sketch by Rembrandt in the Munich Print Room (Benesch 958 recto) also helps to clarify the relation between the two versions. It shows the Washington version. The posture of the woman with her legs crossed, as we see it in the Berlin version, is a correction superimposed afterwards. The signature of this drawing is false, and its falsifier worked with the same pen into the drawing itself. This is the reason why it was regarded as doubtful though its nucleus is a genuine work by Rembrandt. [See p. 93.]

REMBRANDT AND THE GOTHIC TRADITION

1. This essay contains results of research work on Rembrandt's drawings done at the Fogg Museum of Art. They were first presented in a public lecture (27 November, 1944) at the Dumbarton Oaks Research Library and Collection, Harvard University, Washington, D.C., with whose permission they appear here in print. I am indebted to Professor Arthur Burkhard, who kindly revised the English of the manuscript.

2. Formerly C. Hofstede de Groot Collection. [Later] Charles P. Curtis Collection, Boston. F. Becker, *Holländische Meister aus der Sammlung C. Hofstede de Groot*, Leipzig, 1923, no. 38.

3. "Rembrandt und der holländische Barock," *Studien der Bibliothek Warburg*, 9, Leipzig, 1928, p. 43.

4. [See O. Benesch, *Rembrandt*, Geneva, 1957, pp. 105 ff.]

5. "Rembrandt Imitateur de Claus Sluter et de Jean van Eyck", *Gazette des Beaux-Arts*, vol. 36, 1906, pp. 89 ff.

6. M.-J. Six, "Les Bronzes de Jacques de Gerines", *Gazette des Beaux-Arts*, vol. 15, 1896, p. 388. Marguerite Devigne, "Un

Nouveau Document pour Servir à l'Histoire des Statuettes de Jacques de Gérines au Musée d'Amsterdam", *Revue d'Art*, Antwerp, 1922.

7. J. L. A. A. M. van Rijckevorsel, *Rembrandt en de Traditie*, Rotterdam, 1932, p. 53; Valentiner 454.

8. Valentiner 552 [now Amsterdam, Rijksprentenkabinet].

9. [See the comment to Benesch 152.]

10. M. J. Friedländer, *Die Altniederländische Malerei*, vol. 4, no. 7. [F. Winkler, *Hugo van der Goes*, Berlin, 1964, pp. 45, 46, fig. 29; *Verzeichnis d. Gemälde*, Berlin, 1966, Catalogue p. 53, no. 1622.]

11. M. J. Friedländer, op. cit., vol. 7, no. 12; [now National Gallery of Canada, *Cat. of Paintings* I, Ottawa–Toronto, 1957, p. 63. (R. H. Hubbard)]

12. HdG 1218. Kleinmann, *Handzeichnungen holländischer Meister*, vol. 3, pl. 10.

13. M. J. Friedländer, op. cit., vol. 2, no. 46.

14. Sale Erhardt, Schiltigheim, Drouot, 16 February, 1939, Catalogue, no. 8. *The Man of Sorrows* appears in a copy with the monogram GL in the Episcopal Museum

in Utrecht. A third copy was recently in a dealer's hands in New York.

15. P. Vitry et G. Brière, *Documents de Sculpture Française du Moyen-Age*, vol. I, pl. 112, 4.

16. Henri David, *De Sluter à Sambin*, Paris, 1933, vol. I, p. 16.

17. Willem Vogelsang, *Die Holzskulptur in den Niederlanden*, vol. I, Utrecht, 1911, no. 40, pl. xxiv.

18. Marguerite Devigne, *La Sculpture Mosane du XII au XVI Siècle*, Paris and Brussels, 1932, figs. 194 and 197.

19. Valentiner 494.

20. M. J. Friedländer, op. cit., vol. 2, no. 1; [reproduced in J. Destrée, *Roger de la Pasture*, Paris–Brussels, 1930, vol. II, pl. 13.]

21. [J. Destrée, op. cit., pl. 16.]

22. Valentiner 496.

23. M. J. Friedländer, op. cit., vol. 2, no. 20, pl. xvii; [now National Gallery, Acquisitions 1953–62, cat. p. 87, no. 6265.]

24. [Sale Klipstein and Kornfeld, Berne, 7 June, 1961, cat. 101, no. 177; now Queens College, New York; donated by Mr. Norbert Schimmel.]

25. W. Nijhoff, *Nederlandsche Houtsneden 1500–1550*, vol. I, S-Gravenhage, 1931, pl. 79.

26. M. J. Friedländer, op. cit., vol. 10, no. 82.

27. [See p. 124.]

28. Valentiner 284.

29. Rijckevorsel, op. cit., pp. 200–201.

30. F. Lugt, Inv. Gén. III, 1305 verso.

31. M. J. Friedländer, op. cit., vol. 5, no. 42.

32. Staedelsches Kunstinstitut, Frankfurt am Main. M. J. Friedländer, op. cit., vol. I, p. 124, pl. xlviii.

33. Gothenburg Museum, Bredius 319. [See p. 42.]

34. Valentiner 748 A; Benesch 1183 recto.

35. J. G. Johnson Collection, *Catalogue of Paintings*, Philadelphia, 1941, p. 27, no. 346 [now Philadelphia Museum of Art]. M. J. Friedländer, op. cit., vol. 5, no. 43.

36. Valentiner 565.

37. [The Metropolitan Museum of Art, *A Catalogue of Early Flemish, Dutch and German Paintings*, H. B. Wehle, New York, 1947, p. 2, No. 3392 A.]

38. M. J. Friedländer, op. cit., vol. 5, no. 3; [*Ausstellung*, Kunstmuseum Winterthur, 1955, no. 67].

39. C. Hofstede de Groot, "Rembrandts reizen naar Engeland", *Oud Holland*, 1921, pp. 1 and 59.

REMBRANDT'S ARTISTIC HERITAGE—FROM GOYA TO CÉZANNE

1. [A. L. Mayer, *Francisco de Goya*, Munich, 1923, cat. 21, fig. 63.]

2. [Rome, Villa Albani.]

3. [See p. 1 ff.]

4. We have to keep in mind the fact that Goya, before his emigration to France and his first visit to the Louvre, had no opportunity whatsoever to see late paintings by Rembrandt. Also, the Spanish property of Rembrandt paintings was extremely modest in Goya's time. An early painting like the *Sophonisba* of the Prado (fig. 177) was not apt to foster tendencies in Goya's art, which came close to the *late* phase of Rembrandt. There existed no large stock of original drawings, which Goya could have seen in the portfolios of collectors and dealers in Spain. Rembrandt's prints, however, were accessible in excellent impressions, as we may derive from the oeuvre in the Biblioteca Nacional in Madrid, and *they* must have been the main source of inspiration for Goya. Goya's *Self-Portrait* in eighteenth-century costume, a pen drawing in the Robert Lehmann Collection, New York, clearly shows the impression which Rembrandt's etched self-portraits made upon him, even in the details of technique like the "dotted manner." It is all the more understandable in the case of an independently creative artist like Goya, that the unlimited gamut of tones in the black and white of Rembrandt's mature etchings could teach him as *painter* a decisive lesson. This may account for the approach of Goya's late style to Rembrandt's. Furthermore, we must not forget that the pictorial realism of Caravaggio was the basis of Rembrandt's art as well as of that of the Spanish painters of the seventeenth century. It is natural that two artists genuinely linked in their idiosyncrasy, may draw related conclusions from the same suppositions.

5. [A. L. Mayer, *Francisco de Goya*, cat. 89.]

6. With regard to the influence of Rembrandt

and his circle upon Fragonard, an addition to Part I (1948) may be permitted here. I discussed a drawing in the Musée Cognacq-Jay, Paris, ascribed there to Fragonard. It represents a young man in Dutch seventeenth-century costume, who is looking at a print or drawing. I ventured the possibility that it might be a copy by Fragonard after Gerbrand van den Eeckhout. The exhibitions of French masterworks, arranged by myself in the Albertina in 1950, gave me the opportunity to investigate that drawing closely. I came to the conclusion that it is not a copy by Fragonard, but an original by Eeckhout himself (fig. 147). I found two proofs for the accuracy of this assumption. Jurian Cootwyck has reproduced the drawing in one of his prints (Wurzbach no. 1). Furthermore, in a free copy after Vermeer's *Milkmaid* he nailed the drawing to the wall as a decoration. This he would never have done with a work of his contemporary Fragonard, but only with one which he correctly considered to belong to Vermeer's period. This correction may serve to clarify the drawn oeuvre of Fragonard, whose relation to Rembrandt is proved by many other cases.

7. [Version of the painting: A. L. Mayer, op. cit., cat. 693 (Madrid, Academia de San Fernando).]

8. [For etchings, see J. Hofmann, *Francisco de Goya*, Vienna, 1907.]

9. [T. Pignatti, *Le acqueforti dei Tiepolo*, Florence, 1965 (XXXII).]

10. [A. L. Mayer, op. cit., cat. 53 (Madrid, S. Anton Abád).]

11. [A. L. Mayer, op. cit., cat. 65, 66.]

12. [M. Davies, *The British School*, London, 1936, Illustrations p. 27, Inv. 2657 (now Tate Gallery).]

13. [Sale, Christie's, 19th March, 1965, lot 102.]

14. [National Gallery of Art, Washington, D.C., New York, 1963, p. 180 (John Walker).]

15. The etching B. 72, Hind 198 (1642) was undoubtedly the model which inspired Delacroix to create the general setting of his painting, done in 1850, and which was exhibited in the Salon in 1850–1851 (Robaut no. 1163). There we see the tomb in the foreground, Christ standing behind it with a cluster of figures clinging to Him, and a grotto of rocks with a view into the distance. Christ with a quiet gesture of His hand evokes the dead to new life. The etching is from that period in which Rembrandt began to calm down the "Barocco" of the 1630's. In this respect, Delacroix' painting shows much more baroque, flamboyant movement which is due not only to the influence exerted upon him by the Flemish masters, but also to the circumstance that apparently Rembrandt's earlier etching of the same subject (B. 73, Hind 96) contributed elements to the genesis of Delacroix' invention. This is proved by the arms and trophees of the dead hung up in the upper left corner, which Delacroix took over from Rembrandt and by the energetic diagonal closure of the lower left corner by a slab from the cover of the sarcophagus. The attitudes of the two sisters and of the man joining his hands in amazement hark back, indeed, to gestures in Rembrandt's earlier etching.

An error may be corrected here which occured in Part I of this essay. Due to the fact that I had no opportunity to correct the proofs of the illustrations, a photograph of the copy (Bredius 537) after Rembrandt's original in the Rijksmuseum (Bredius 538) was mistakenly reproduced as Lievens' painting *The Raising of Lazarus* in the Museum of Brighton (Schneider 31). This important painting which Lievens himself rendered in his etching Rovinski 3, has meanwhile become generally known due to its exhibition in the Lakenhal at Leiden during the Rembrandt Anniversary 1956 (Tentoonstelling "Rembrandt als Leermeester" cat. no. 65).

16. [Eugène Delacroix, Louvre Exhibition 1963, under cat. no. 89.]

17. [New York, The Brooklyn Museum. M. Sérullaz, *Mémorial de l'Exposition Eugène Delacroix*, Musée du Louvre, Paris, 1963, no. 439.]

18. [J. Adhémar, *Honoré Daumier*, Paris, 1954, no. 41.]

19. [J. Adhémar, op. cit., no. 49.]

20. [De la Faille 624 (Delft, H. Tutein Nolthenius); now W. Weinberg, Scarsdale, N.Y.; Vincent van Gogh Exhibition, Munich, 1956, cat. 147.]

21. Rembrandt, *Kl. d. K.*, 3, 1908, no. 543 (Paris, Collection A. Schloss).

22. Solothurn, J. Mueller Collection.

AN UNKNOWN REMBRANDT PAINTING OF THE LEIDEN PERIOD

1. I am most obliged to Monsieur Lossky for having kindly provided an excellent photograph of the painting and for having given me the permission to publish it. [Rembrandt and his Pupils, a loan exhibition of Paintings commemorating the 300th anniversary of Rembrandt, Montreal, Museum of Fine Arts, January–February 1969, cat. no. 4 (David G. Carter).]

2. [See pp. 83 ff.]

3. *The Burlington Magazine* XCV, 1953, p. 36, fig. 9 and p. 37.

4. We notice unmistakably his influence in another painting of 1627, *David showing the head of Goliath* (Bredius 488).

"CARAVAGGISM" IN THE DRAWINGS OF REMBRANDT

1. [Now Estate of the late Dr. N. J. van Aalst; G. Cramer, The Hague. See p. 137.]

2. [See pp. 138 ff.]

3. [See pp. 134–139.]

4. [See p. 135.]

5. [A. de Vesme, *Le Peintre-Graveur Italien*, Milan, 1906, p. 1, no. 1.]

6. "Mostra del Caravaggio", Catalogue, Milan, Palazzo Reale, April/June 1951.

7. [See O. Benesch, *Rembrandt as a Draughtsman*, cat. 12 and fig. 12.]

8. [See p. 216].

WORLDLY AND RELIGIOUS PORTRAITS IN REMBRANDT'S LATE ART

1. [The present essay is the revised version of a lecture given in 1942 at the National Gallery of Art, Washington, D.C. For "*The Night Watch*" and other paintings discussed here, see O. Benesch, *Rembrandt*, Geneva, 1957. See also p. 3.]

2. [See p. 96.]

3. [According to information received from Dr. C. Virch, the Metropolitan Museum, the painting belongs to the heirs of Stephen C. Clark.]

4. [Sale Sotheby's, 24 June 1964, no. 5. Now Cleveland, Ohio, the Cleveland Museum of Art (Bulletin, December, 1967, pp. 295 ff., Sherman E. Lee).]

5. Dated 1661. [L. Münz, *Burlington Magazine* XC, 1948, p. 64. *Gemälde der Ruzicka-Stiftung*, Exh. Zürcher Kunsthaus 1949–50, cat. 26.] Bredius, third edition, 616A.

6. J. Rosenberg (*Rembrandt*, Cambridge, 1948, p. 68; [also London, 1964, pp. 125 ff.]) has pointed out the close relation between the painting and traditional representations of Jacob and Rachel.

THE REMBRANDT EXHIBITION IN WARSAW

1. *Rembrandt i Jego Krag*, Muzeum Narodowe, Warsaw, 1956, 2 vols. Quoted here as "cat. no".

2. [See J. Białostocki and M. Walicki, *Europäische Malerei in Polnischen Sammlungen*, Warsaw, 1957, nos. 236, 234, 235, 232, 233, 186, 277, 240, 245, 238, 244, 239, 282, 252, 251, 249, 254. These numbers appear in the sequence in which they are quoted by the authors with reference to this essay. See also ibid, Addenda 186, 232–244, and 246.]

3. [Later inscription by the author on photograph in his archives: Staveren.]

4. [See p. 60.]

5. K. Bauch, *J. A. Backer*, Berlin, 1926. [See p. 58.]

6. [See p. 59.]

7. [See p. 64 f.]

8. [See p. 216.]

REMBRANDT AND ANCIENT HISTORY

1. The present essay is the revised and enlarged version of a lecture given in 1945 in the Dumbarton Oaks Research Library, Harvard University, Washington, D.C.

2. W. R. Valentiner, "Rembrandt auf der Lateinschule", *Jb. d. Preuss. Kstslgen*, 27 (1906), p. 18; also in *Aus der Niederländischen Kunst*, Berlin, 1914, chapter 5.

3. [Since 1945 property of the Government of the Netherlands; as a state loan in the Lakenhal Museum, Leiden.]

4. Credit for the correct identification of the subject goes to W. C. Schuylenburg. See W. Stechow, "Römische Gerichtsdarstellungen von Rembrandt und Bol", *Oud Holland*, 1929, pp. 134 ff. A different subject was proposed by Fr. Schmidt-Degener in an ingenious essay (*Oud Holland* LVIII [1941], pp. 106 ff): "The Clemency of Titus" as recounted by Suetonius. Rembrandt's representation could, indeed, be interpreted this way, were it not for the heap of pillaged weapons in the foreground, which follows Livy's text closely. Titus' Clemency was more a scene of justice than an act in a war-like drama. When reading Livy's text and comparing Rembrandt's painting, one becomes aware of how intent Rembrandt always was upon depicting literary texts in a dramatic way. Furthermore, Rembrandt dealt with the story of the Tarquinian conspirators again in drawings of a later date.

5. For the illustrations to Herckmans' *Der Zee-Vaert Lof* see my book, *Artistic and Intellectual Trends from Rubens to Daumier as shown in Book Illustration*, Cambridge, 1943, pp. 21, 22. Jan Veth, following closely the printed text in his essay (*Onze Kunst*, Jg. 9, Dl. XVIII, pp. 73–82), ventured the possibility that the man dismounting from his horse may have represented Augustus. The extensive allegorical interpretation of the etching by J. D. M. Cornelissen, however, returns to the old error of seeing Antonius as the protagonist ("Het Schepje van Fortuyn", *Oud Holland* LVIII [1941], p. 111 ff.)

6. [A similar bust, Benesch 770a, was acquired by the author for the Albertina in 1949.]

7. "Komödiantendarstellungen Rembrandts", *Zeitschrift f. Bild. Kst.* LIX (1925/26), pp. 265, 266.

8. [R. Cantinelli, *Jacques-Louis David*, Paris-Brussels, 1930, Pl. VI.]

9. F. Schmidt-Degener, *Rembrandt en Vondel*, Amsterdam, 1950, pp. 57–59.

10. [M. Rooses, *L'Oeuvre de P. P. Rubens*, Antwerp, 1890, no. 707; *KdK*, p. 154.]

11. Arnoldus Noach, "De Maaltijd in het Schakerbosch en de Versiering van het Stadhuis", *Oud Holland* LVI (1939), pp. 145 ff. During the Rembrandt Jubilee of 1956 a special issue of the *Konsthistorisk Tidskrift* (XXV, 1–2) was devoted to the painting.

12. [J. W. v. Moltke, *Govaert Flinck*, Amsterdam, 1965.]

13. Since Hofstede de Groot's *Catalogue* (1906) and Carl Neumann's book, *Aus der Werkstatt Rembrandts* (1918), the opinion of scholars dealing with the drawings (Neumann, Kauffmann, Benesch, Saxl, Bauch, Valentiner, Lugt, Helle, Noach, Cornelius Müller) has passed through all variations from total acceptance to total rejection. It would be of little avail and exceed our limits to renew the discussion of their authenticity. In vols. III, IV and V of my corpus of the drawings of Rembrandt, I have published and proposed for discussion the considerable number of cursory sketches by the master for well-known paintings of his which are preserved in the Graphische Sammlung at Munich. The nucleus of the Munich drawings is recognizable as a stock which goes back to Rembrandt's studio itself. Hence my positive attitude towards them. [See p. 7 ff.]

14. It is drawn on the reverse side of a funeral announcement of 25 October, 1661. I. H. van Eeghen, "Rembrandt's Claudius Civilis and the Funeral Ticket", *Konsthistorisk Tidskrift* XXV (1956), pp. 55–57.

15. [See p. 194.]

16. [See p. 146.]

17. [See p. 146.]

18. [See p. 146.]

19. [Many of the examples of Rembrandt's works mentioned and discussed here as well as in other essays by the author appear in the recently published book by Kenneth Clark, *Rembrandt and the Italian Renaissance*, London, 1966.]

SCHÜTZ AND REMBRANDT

1. The biographical and historical dates mentioned in this essay are based on the extensive monograph by Hans Joachim Moser, *Heinrich Schütz, Sein Leben und Werk*, Kassel und Basel 2/1954.

2. Georg Schünemann, "Ein neues Bildnis

des Heinrich Schütz", in *Deutsche Musik-kultur* I, 1936/37, p. 47–48.

3. Moser, ibid., plate XXXIII.

4. It cannot be the one his first patron Landgraf Moritz "the learned" of Hessen gave him as a keepsake when he left Dresden in 1617, as Moser, ibid., p. 82, assumes, since it portrays a prince with long, flowing hair (perhaps Johann Georg II of Saxony?).

5. *The Burlington Magazine*, LXIX, 1936, p. 153.

6. In a postscript to Hevesy's suggested identification (*Burlington Magazine*, LXIX, 1936, p. 286) Julius S. Held advanced the view that the hand holding the roll of notes in the Washington portrait was a later addition by another artist. He claimed that close scrutiny of the original had led him to this opinion and that it was further substantiated by the mezzotint by the Amsterdam graphic artist, Jan Stolker (1724–85)—a previous owner of the painting. The mezzotint shows the model simply as a bust, without the hand (Wurzbach, *Niederländisches Kunstlerlexikon*, no. 10). However Held overlooked the fact that Stolker also made an etching after the portrait (Wurzbach, no. 4) which shows the sitter and the hand holding the music MS. It was only omitted from the mezzotint because of the narrow shape of the detail chosen. This seems to destroy much of the force of Held's doubts about identifying the sitter as a musician. In fact, the hand is an integral part of the whole composition. I have also had an opportunity of examining the original closely, and it was my impression that both hand and head show the same artistic stamp. If Rembrandt is to be deprived of one, he must be deprived of the whole painting. In any case the gesture of the hand holding the rolled-up music MS, which appears again in the Spetner portrait is a typical one for a choir conductor of the Baroque period,

who would have been using his part of the score as a baton.

7. It is surprising that Maerker has not mentioned one cogent objection that really could be levelled against his identification of the portrait with Schütz: the hair-style. The three portraits of Schütz in old age show him with medium length hair, combed back smoothly, waving slightly behind the ears and at the temples, whereas the Washington portrait shows us a man wearing his hair long and curled, falling onto his collar, the fashion of the 'thirties. When we examine the male portraits painted by Rembrandt in the early 'thirties, it is evident that older persons, with dates of birth before 1600, usually wear cropped hair (as, for instance, most of the officers in Hals' *Jorisdoelen* of 1616), while those born in the new century, like Rembrandt himself, are all adherents of the new fashion. However, this is no real obstacle, since we have met people wearing long, flowing curls even earlier as, for example, the woodcut portrait of Praetorius of 1606 and various self-portraits by Rubens. Frans Hals, who was the same age as Schütz, followed the new fashion. It would be natural that Schütz could no longer keep to it as his hair grew greyer and thinner.

8. The text of the title is as follows: "Angst der Hellen unnd Friede der Seelen/Das ist/Der CXVI Psalm Davids durch etzliche vornehme Musicos im Chur: und Fürstenthumb Sachsen sehr künstlich und ahmutig uff den Text gerichtet. Mit V, IV, III Stimmen componiret, von Ihnen durch freundlich schriftliches suchen und bitten impetrirt, colligiert unnd zuförderst zu GOTTES lob Ehr und preiss, denen Authoribus aber selber zu grossem danck, unsterblichem ruhm und erweckung mehr derogleichen nützlicher und heiliger Kirchenarbeit publicirt und auch bestendiger Ehr und lieb zur Music zum Druck verlegt."

ON THE DEVELOPMENT OF A COMPOSITION BY REMBRANDT

1. Inv. No. 58.26.K.—from the István Delhaes Collection (Lugt 761).

2. [See p. 261.]

3. This was done with close reference to the figure of Tobit in the woodcut of *The Angel's leave-taking* by Heemskerck (Holl-

stein 6), which had already provided a model for the figure of the angel in the Louvre painting.

4. I have included it as an original as no. 976 in volume V of my corpus. Obviously it should be relegated, together with the

sheets Benesch 1007 and 1008 by the same hand, to the "Attributions", following no. A94. I have already stressed the difficulty of distinguishing master from pupil in the text to Benesch 1007, 1008 and A96a. My present negative judgment of Benesch 976 follows the opinion of W. Sumowski (see: Bemerkungen zu Otto Beneschs Corpus der Rembrandtzeichnungen II, Bad Pyrmont, 1961, p. 18). Compare also the same author's remarks on the connection between the Tobias and Manoah compositions in "Nachträge zum Rembrandtjahr 1956", *Wissenschaftl. Zeitschrift der Humboldt-Universität in Berlin, Gesellschafts- und*

sprachwissenschaftl. Reihe Jg. VII (1957/58) no. 2.

5. *De Hollandsche Schilderkunst in de zeventiende Eeuw*, Vol. 2. *Rembrandt en zijn Tijd*, Amsterdam 1936 p. 505.

6. "Rembrandt's Sacrifice of Manoah", *Studies of the Warburg Institute*, Vol. 9, London, 1939.

7. Bruegel once handled this episode in grisaille; [see G. Glück, *Das grosse Bruegel–Werk*, Vienna–Munich, 3rd edition, no. 25. London, Count Antoine Seilern.]

8. It has been drawn on the back of a funeral announcement dated 14th May 1659.

A DRAWING BY REMBRANDT FROM HIS LAST YEARS

1. [See pp. 55, 264.]
2. [See pp. 55, 264.]

3. The Cleveland Museum of Art, Purchase Leonard C. Hanna Jr., Bequest, Inv. 62. 116. [See p. 243 and p. 263.]

NEWLY DISCOVERED DRAWINGS BY REMBRANDT

1. *The Drawings of Rembrandt, A Critical and Chronological Catalogue*, vols. I–VI, Phaidon Press, London, 1954–57.

 [Because of the complexity of works of Rembrandt and of other artists referred to in reviews of O. Benesch, *The Drawings of Rembrandt*, vols. I–VI, we have not been quoting single cases in the footnotes, but are quoting here once and for all as follows:

 J. Q. Van Regteren Altena, *Oud. H.* LXX (1955), pp. 118 ff.; J. G. van Gelder, *Burl. Mag.* 97 (1955), pp. 395 ff., 103 (1961), pp. 149 ff.; J. Rosenberg, *The Art Bulletin* 38 (1956), pp. 63 ff., 41 (1959), pp. 108 ff.; W. Sumowski, *Wissenschaftliche Zeitschrift der Humboldt-Universität zu Berlin* VI (1956/57), no. 4, pp. 255 ff. and *Bad Pyrmont*, 1961, pp. 3 ff.; E. Haverkamp–Begemann, *Kunstchronik* 14 (1961), pp. 10 ff., 50 ff., 85 ff.]

2. Some of them have been published in my book *Rembrandt as a Draughtsman*, Phaidon Press, London, 1960.

3. J. Lieure, *Jacques Callot*, III, Paris 1927, 479–503.

4. Centennial Loan Exhibition Drawings and Watercolours, fig. 39.

5. Thus, in spite of the date given in the exhibition catalogue, it had already been

correctly dated by Werner Sumowski, *Kunstchronik* XV (1962), pp. 274/5.

6. [Bauch 48]. Now Ottawa, National Gallery of Canada.

7. [See p. 175.]

8. The sheet used to be in the Hermitage in Leningrad; it was catalogued as "Eeckhout" in a Rembrandt Exhibition.

9. *Ashmolean Museum Annual Report* 1960, pp. 56–7, pl. XIV.

10. "Rembrandt: Two recently discovered drawings", *Burlington Magazine* CIII (1961), p. 278.

11. Negative RKD no. 11862 Ph. Koninck (attributed). Collection of S. de Clercq, Den Haag (1941) as "Teniers".

12. Wolfgang Wegner, *Kurfürst Carl Theodor von der Pfalz als Kunstsammler*, Mannheim, 1960.

13. Benesch 526, 527, 528: *Joseph telling his Dreams*, 541 and 542: *The Brethren of Joseph requesting Benjamin from their Father*. As regards the three sheets of *Joseph telling his Dreams*, I should like to point out that in my catalogue the numerical order is also intended to indicate the chronological order of the drawings as I see it. As in the case of the departure of Hagar, which was a further development of an etching of 1637, Rembrandt was developing, in *Joseph*

telling his Dreams an etching he had done in 1638 (B. 37, Hind 160) which was itself based upon the grisaille in the Rijksmuseum (Bredius 504). The sheet in the Albertina (Benesch 526) is probably the earliest, since it follows the grisaille in the arrangement of the chief figures. Benesch 527 shows the group reversed with the brothers' numerous entourage rounded off as for a painting. I cannot agree with E. Haverkamp-Begemann that the sequence should be reversed (*Kunstchronik*, 14. *Jg.*, *Heft* 2, 1961, p. 51), and indeed, even an experienced reader would have difficulty in following his train of thought since he confuses the catalogue numbers of the sheets. However, in his dating of the drawing in London (Benesch 528), which he puts as the latest, I completely agree with him. The costumes of Jacob and Rachel are as much changed as their poses. The signature in Benesch 526, which Haverkamp-Begemann gives as authentic, must be apocryphal, although he firmly regards it as genuine. I know of no other case when Rembrandt signed himself "Rembrant".

14. Richard Hamann, "Hagars Abschied bei Rembrandt und im Rembrandt–Kreise", *Marburger Jahrbuch für Kunstwissenschaft* VIII/IX (1936), p. 523, fig. 78.

15. "Three Drawings by Rembrandt", *Master Drawings* I, 2 (1963), New York, pp. 38/39.

16. A closely related copy after an unknown study by Rembrandt of the same motif is in the collection of Dr. W. Wydler, Baden nr. Zürich.

17. *Paintings and Drawings of Continental Schools other than Flemish and Italian*, at 56 *Princes Gate*, London S.W.7, London, 1961, no. 193.

18. *Jahrbuch der Preussischen Kunstsammlungen* 45, 1924, pp. 191 ff.

19. [W. Sumowski, *Pantheon* 23 (1965), pp. 246 ff., later published this drawing.]

20. O. Benesch, *Rembrandt as a Draughtsman*, London, 1960, no. 59.

21. [See p. 235.]

22. *Master Drawings* I, 2, (1963), Plate 33.

23. *Catalogue of Drawings by Dutch and Flemish Artists*, vol. I, London, 1915, no. 126.

24. Sale Sotheby's, 21 February, 1962, lot 274 "attributed to Rembrandt". Bought by R. W. Hompe, U.S.A.

25. Sale Sotheby's, 10 April, 1961, lot 33.

26. This was established by J. Strzygowski-H. Glück, *Asiatische Miniaturenmalerei*, Klagenfurt, 1933, p. 22. See also J. Strzygowski, *Die Indischen Miniaturen im Schlosse Scḧnbrunn*, Wiener Drucke, 1923.

27. Burlington Magazine CIII (1961), pp. 278/79.

28. "Die Zeichnungen Rembrandts und seines Kreises im Kupferstichkabinett der Veste Coburg", *Jahrbuch der Coburger Landesstiftung*, 1963, p. 89 ff.

29. I am much indebted to Dr. Heino Maedebach for kind permission to reproduce the photograph of this drawing.

30. [See p. 243 and p. 244.]

31. [See p. 55 and p. 244.]

32. "Rembrandt's Drawings at the Hermitage" (Travaux du Département de l'Art Européen, Leningrad 1940, Tome I), pp. 1–16, fig. 7.

33. Mme. Agafonowa is preparing an essay on this drawing, so I was not permitted to publish a photograph. [*Burl. Mag.* CVII (1965), pp. 402–404, fig. 5.]

34. J. Six, *Oud Holland* 11 (1893) p. 157; id., "De Pandora van Jan Six", *Haagsch Maandblad*, April 1924, pp. 380, 381.

35. Rembrandt's so-called Portrait of Anna Wijmer as Minerva, Studies in Western Art III, Princeton, 1963, pp. 59 ff.

ILLUSTRATIONS

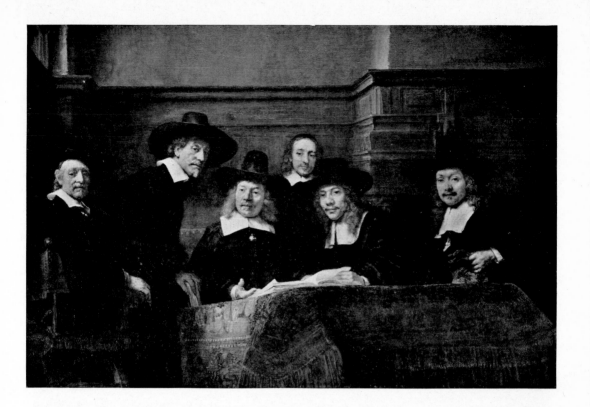

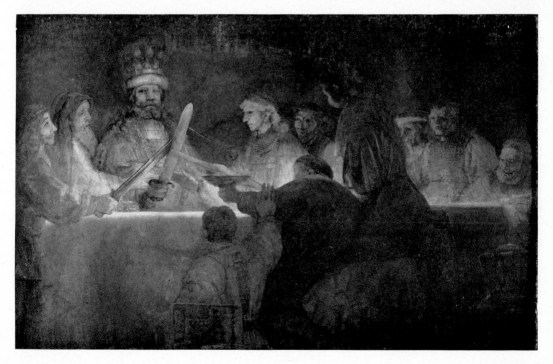

REMBRANDT AND THE PROBLEMS OF RECENT RESEARCH (Figs. 1–6)

1. *The Syndics*. Amsterdam, Rijksmuseum.
2. *The Conspiracy of Julius Civilis*. Stockholm, National Museum.

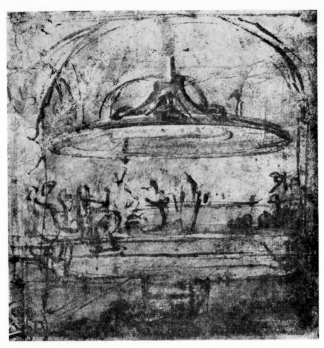

3. *The Conspiracy of Julius Civilis*. Pen and wash drawing. Munich, Print Room.

4. *The Conspiracy of Julius Civilis*. Pen and wash drawing. Munich, Print Room.

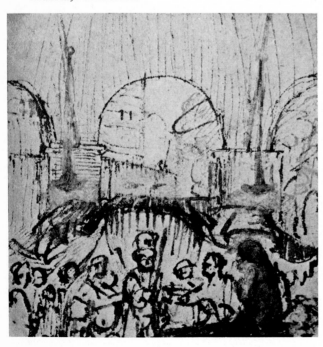

5. *The Conspiracy of Julius Civilis*. Pen drawing. Munich, Print Room.

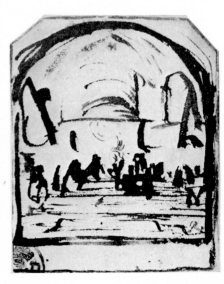

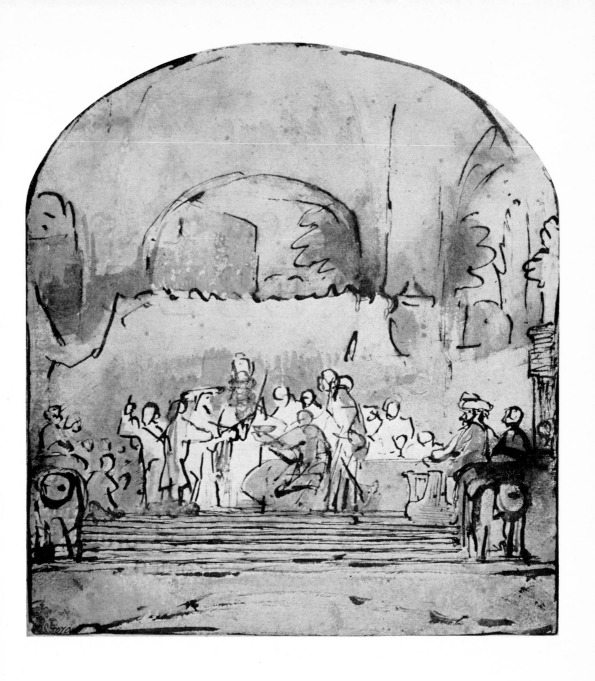

6. *The Conspiracy of Julius Civilis*. Pen and wash drawing. Munich, Print Room.

8. Aert de Gelder, *Maria Annuntiata*. Stockholm, Count Hallwyl Collection.

7. Previously attributed to Aert de Gelder, *David on his Death-Bed*. Pen drawing. Chatsworth, Devonshire Collection (Trustees of the Chatsworth Settlement).

A DRAWING BY AERT DE GELDER

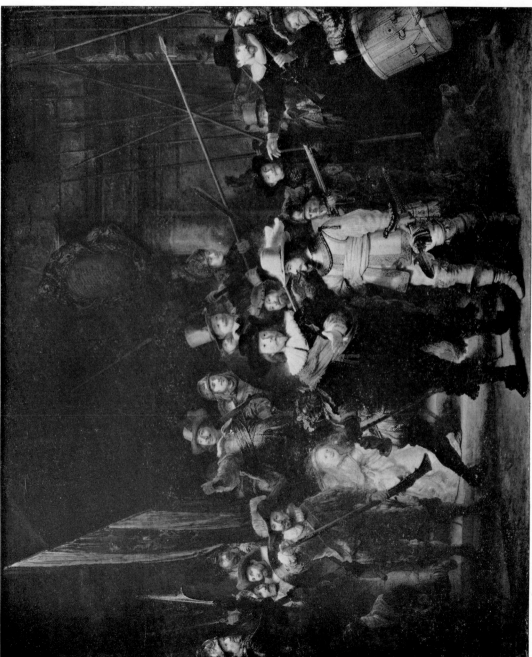

9. *The Night Watch.*
Amsterdam, Rijksmuseum.

10. *A Lady Hawking*. Pen drawing. Dresden, Print Room.

REMBRANDT'S *THE FALCONER* (Figs. 10 & 11)

11. *The Falconer*. Gothenburg, Museum.

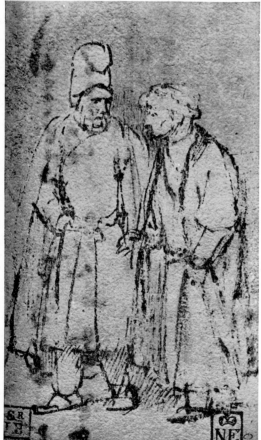

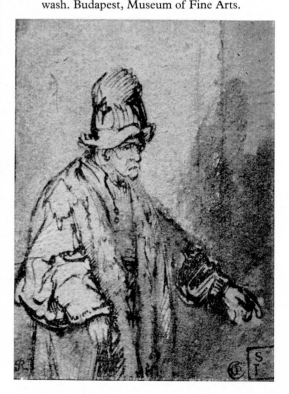

12. *Sheet of Studies*. Pen and bistre,
 faded. Budapest, Museum of
 Fine Arts.

13. *Two Men in Discussion*. Pen and bistre, wash.
 Budapest, Museum of Fine Arts.

14. *An Old Jew in a High Hat*. Pen and bistre,
 wash. Budapest, Museum of Fine Arts.

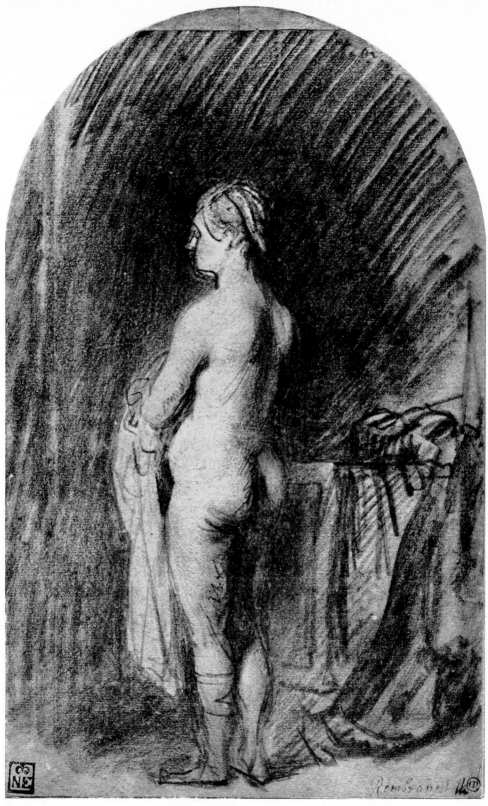

15. *A Standing Female Nude*. Chalk drawing. Budapest, Museum of Fine Arts.

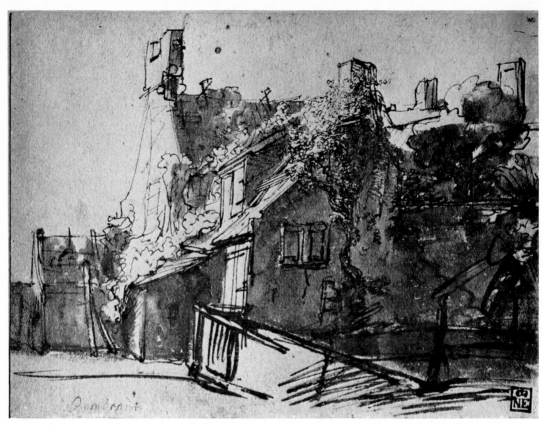

16. *Farmhouse*. Pen and wash drawing. Budapest, Museum of Fine Arts.

17. *Farmhouses among Trees*. Pen and wash drawing. Budapest, Museum of Fine Arts.

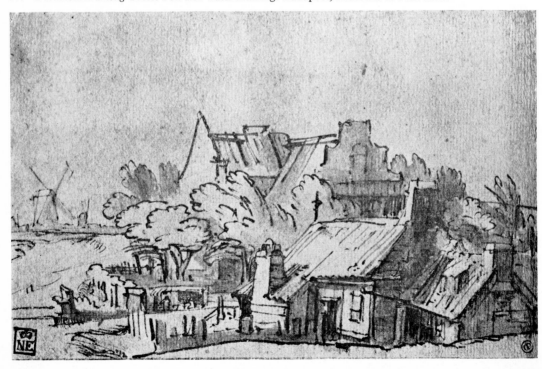

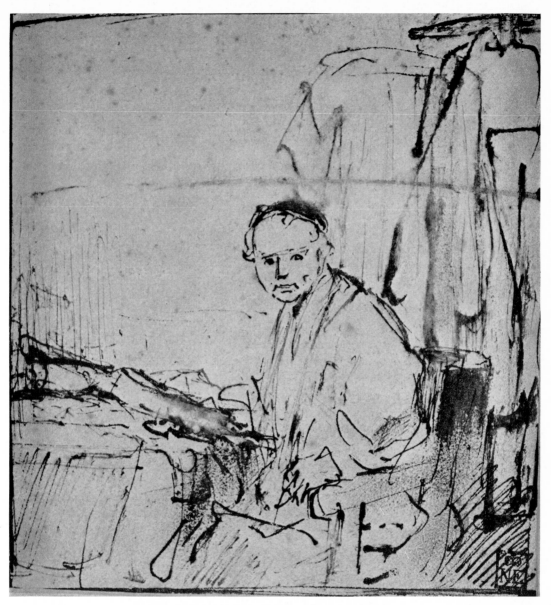

18. *A Scholar at his Desk*. Pen drawing. Budapest, Museum of Fine Arts.

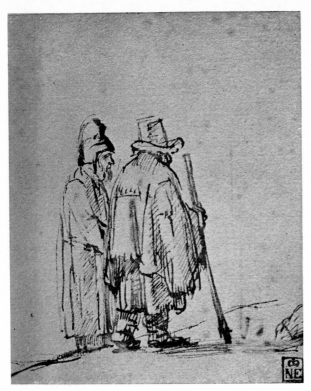

20. *Two Rowing Oarsmen*. Pen drawing.
Budapest, Museum of Fine Arts.

19. *Two Old Shepherds*. Pen drawing.
Budapest, Museum of Fine Arts.

21. *Haman in disgrace before Ahasuerus and Esther*. Pen drawing. Budapest, Museum of Fine Arts.

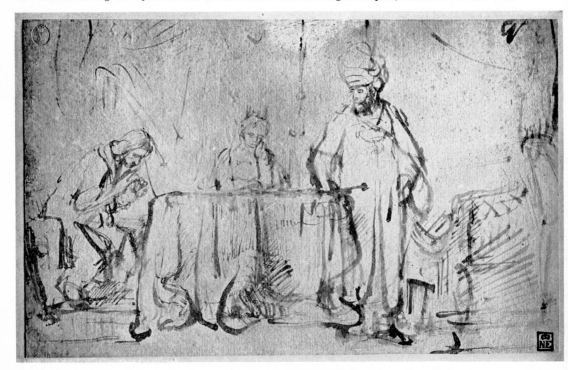

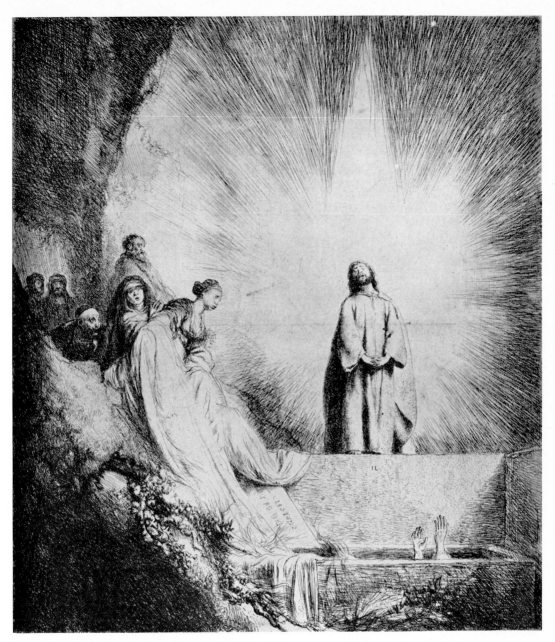

22. Jan Lievens, *The Raising of Lazarus*. Etching.

REMBRANDT'S ARTISTIC HERITAGE (Figs. 22–55)

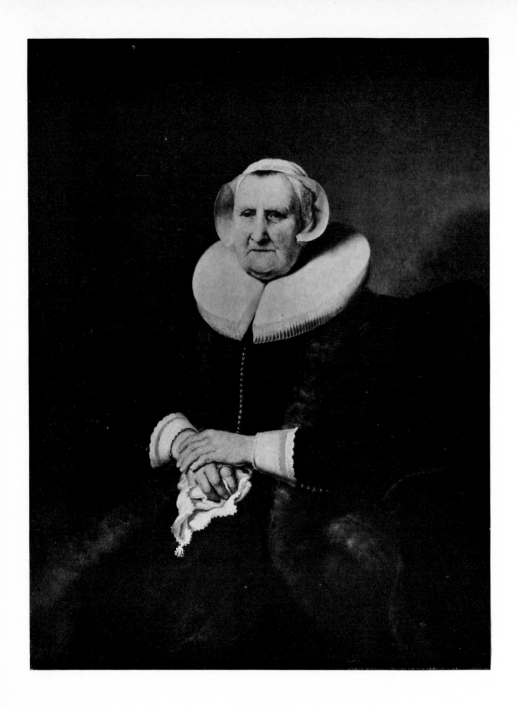

23. J. A. Backer [later attributed to F. Bol], *Elizabeth Jacobsdr. Bas*.
Amsterdam, Rijksmuseum.

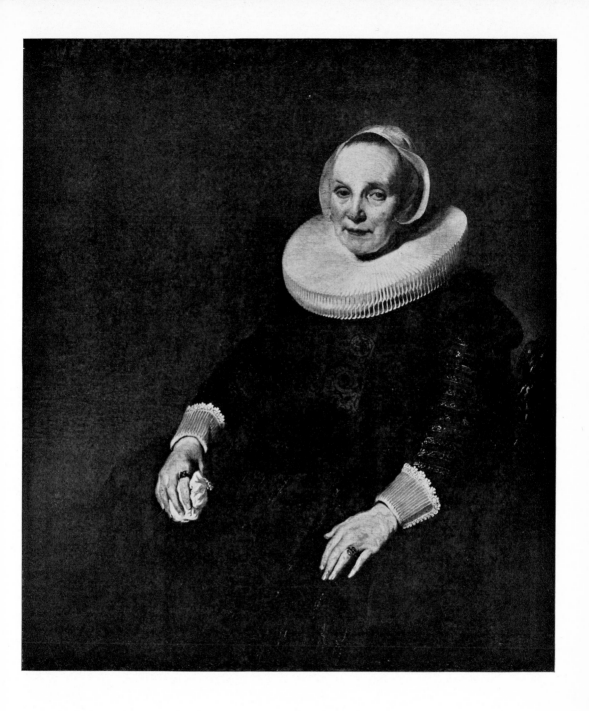

24. J. A. Backer, *Portrait of a Woman*. Antwerp, Museum.

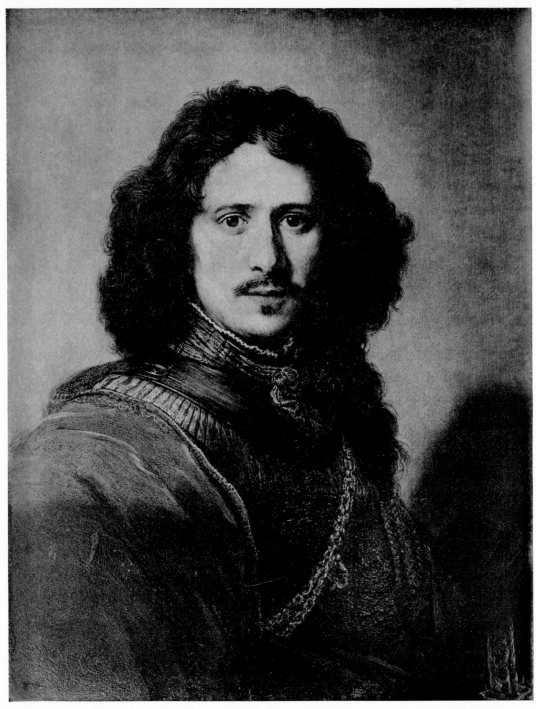

25. G. Flinck, *Portrait of an Officer*. Zurich, Mrs. H. Anda-Bührle.

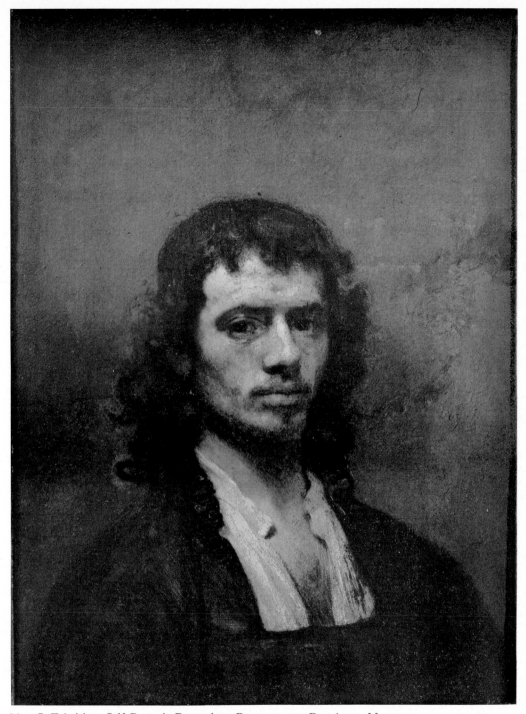

26. C. Fabritius, *Self-Portrait*. Rotterdam, Boymans-van Beuningen Museum.

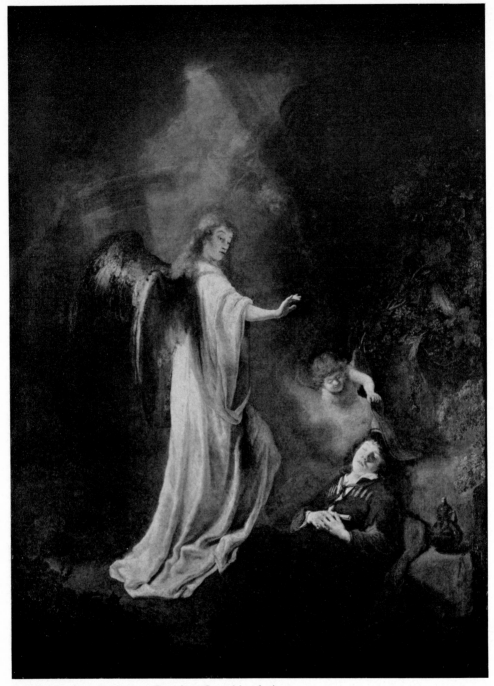

27. F. Bol, *Jacob's Dream*. Dresden, Gemäldegalerie.

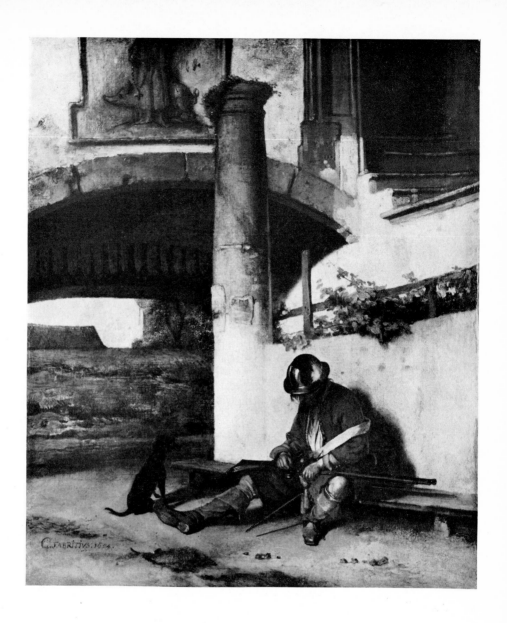

28. C. Fabritius, *The Watch*. Schwerin, Staatliches Museum.

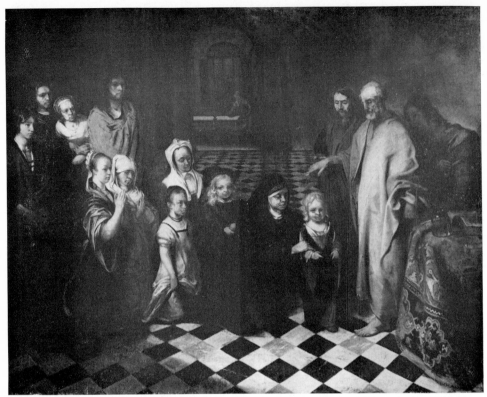

29. B. Fabritius, *St. Peter in the House of Cornelius*. Braunschweig, Herzog Anton-Ulrich Museum.

30. Aert de Gelder, *Judah and Thamar*. Vienna, Akademie der Bildenden Künste, Gemäldegalerie.

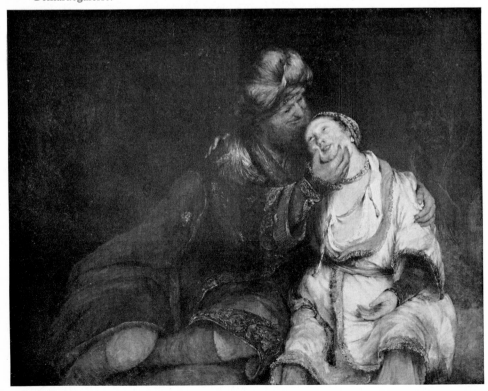

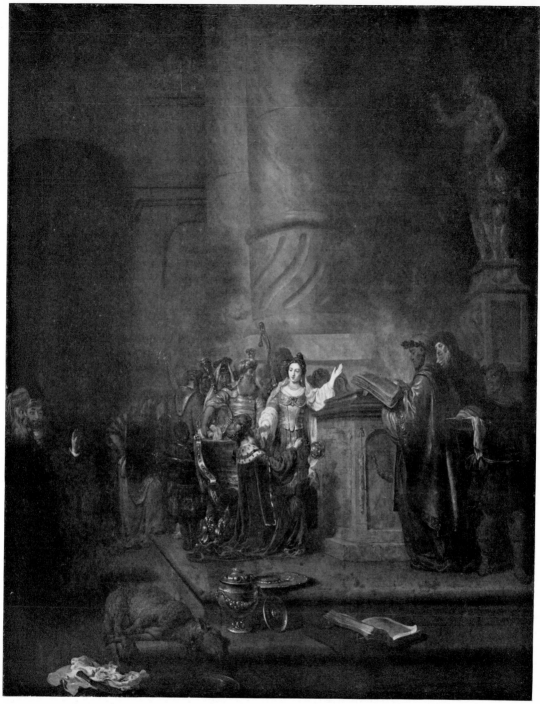

31. G. van den Eeckhout, *Solomon's Idolatry*. Braunschweig, Herzog Anton-Ulrich Museum.

32. Christoph Paudiss, *Portrait of a Young Man*. Prague, National Gallery.

33. Johann Matthias Weyer, *The Conversion of Saul*. Braunschweig, Herzog Anton-Ulrich Museum.

34. G. B. Tiepolo, *The Philosopher from 'Scherzi di Fantasia'*. Etching.

35. G. Benedetto Castiglione, *'Rembrandt' and the Head of an Oriental*.
 Etching. Vienna, Albertina.

36. J. Zick, *Saul with the Witch of Endor*. Wurzburg University, Museum.

37. Christian W. E. Dietrich, *The Presentation in the Temple*. Etching by
G. F. Schmidt.

38. Giuseppe Crespi, *The Last Sacrament*. Dresden, Gemäldegalerie.

39. G. B. Piazzetta, *The Supper at Emmaus*. Cleveland, The Cleveland Museum of Art.

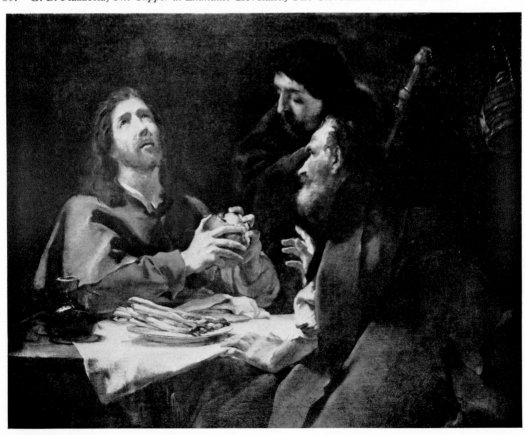

40. J. B. S. Chardin, *A Man Pulling a Chariot ('la Vinaigrette')*. Stockholm, National Museum.
41. J.-H. Fragonard, *The Pasha*. Paris, Private Collection.

42. M. J. Schmidt, *The Marriage of the Vir*
Vienna, Niederösterreichisches
Landesmuseum (on loan).

43. F. A. Maulbertsch, *Joseph telling his Dreams*.
Formerly Vienna, Stephan v. Auspitz
Collection.

F. A. Maulbertsch, *The Raising of the Cross*.
Etching by P. K. Fellner. Vienna, Albertina.

M. J. Schmidt, *Christ Healing the Sick*.
Etching by F. Landerer. Vienna, Albertina.

46. J. B. S. Chardin, *Self-Portrait*. Paris, Louvre.

47. F. de Goya, *Self-Portrait*. Madrid, Academia de San Fernando.

48. F. de Goya, *The Disasters of War*: 'Nothing'. Etching.

49. E. Delacroix, *The Assassination of the Bishop of Liège*. Paris, Louvre.

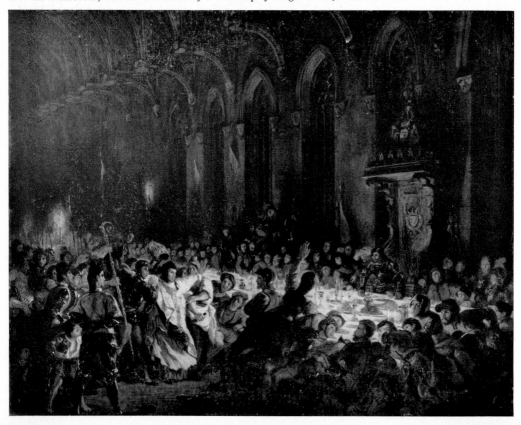

50. J. B. C. Corot, *St. Sebastian*. Paris, Louvre.

51. P. Cézanne, *Self-Portrait*. Moscow, Museum of Western Art.

52. V. van Gogh, *The Raising of Lazarus*. Amsterdam, Stedelijk Museum (on loan).

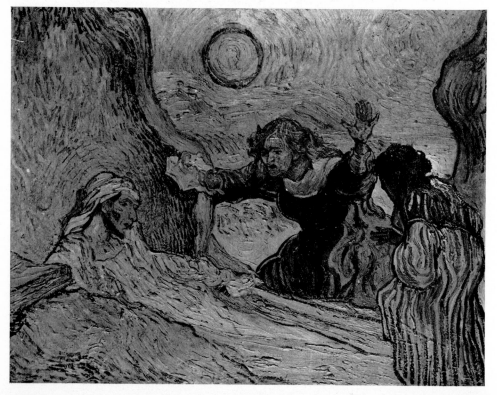

53. Herbert Boeckl, *Self-Portrait*. Vienna, Österreichische Galerie.

54. Lovis Corinth, *Christ carrying the Cross*. Lithograph.

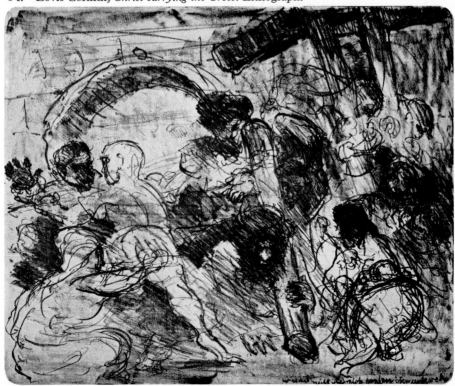

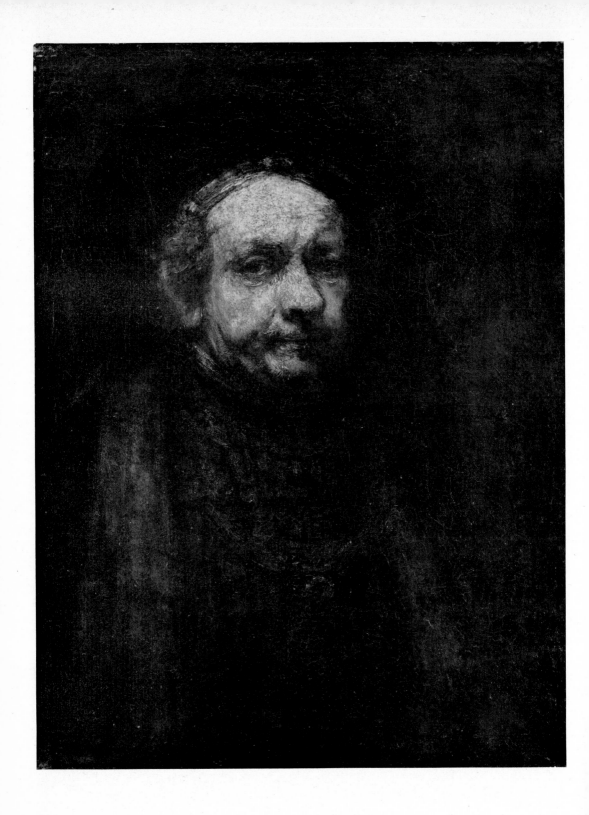

55. *Self-Portrait*. Florence, Uffizi.

56. *Head of an Old Man*. Etching.

57. *Bust of an Old Man*. Red Chalk drawing. Stockholm, National Museum.

58. *Study of a Recumbent Woman and a Sleeping Woman*. Pen drawing. Munich, Print Room.

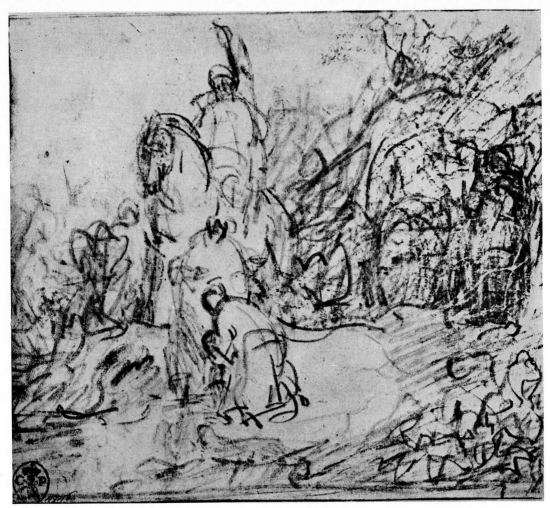

59. *The Baptism of the Eunuch*. Chalk drawing. Munich, Print Room.

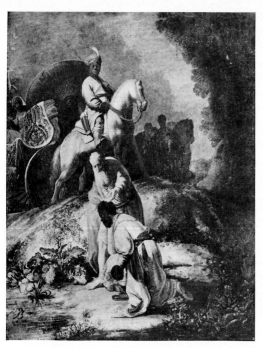

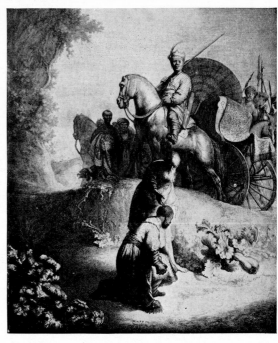

60. Rembrandt School, *The Baptism of the Eunuch*. Formerly Oldenburg, Landesmuseum.

61. J. G. van Vliet after Rembrandt, *The Baptism of the Eunuch*. Etching.

62. *Judas returning the Pieces of Silver*. Mulgrave Castle, Yorks., Normanby Collection.

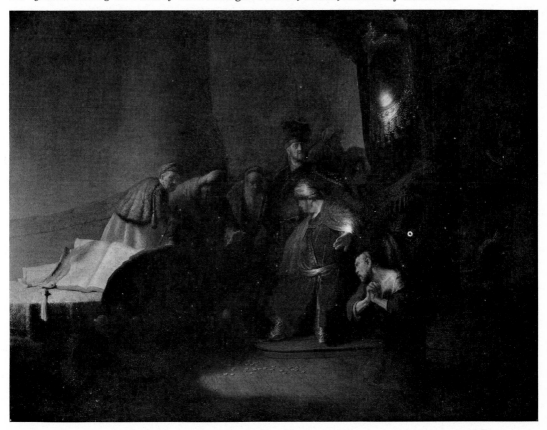

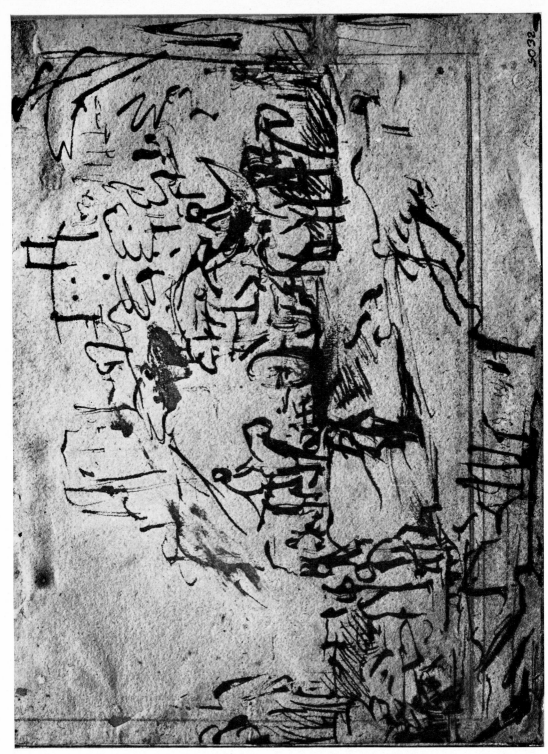

63. *The Baptism of the Eunuch.* Pen drawing. Munich, Print Room.

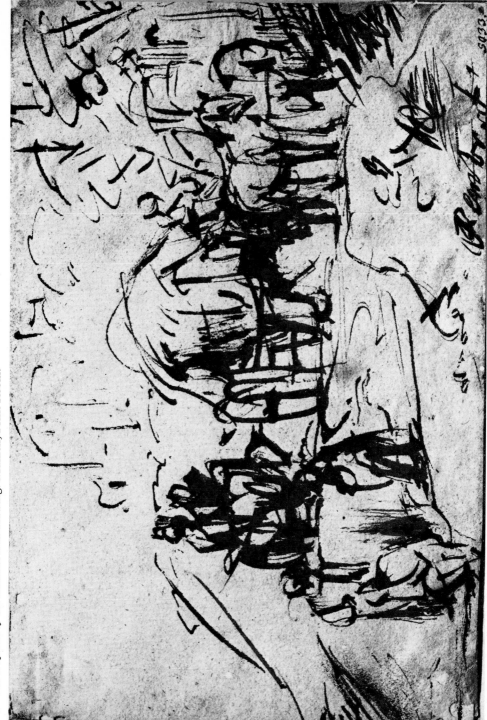

64. *The Baptism of the Eunuch.* Pen drawing. Munich, Print Room.

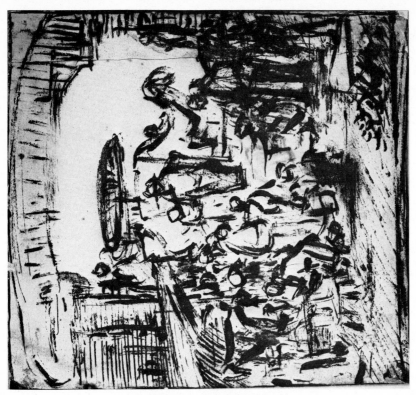

66. *The Adoration of the Magi.* Pen drawing. Munich, Print Room.

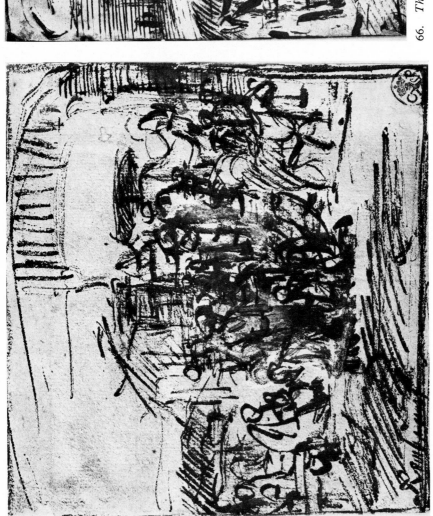

65. *The Adoration of the Magi.* Pen drawing. Munich, Print Room.

68. *The Adoration of the Magi.* London, Buckingham Palace.

67. *The Adoration of the Magi.* Pen drawing. Munich, Print Room.

69. *Potiphar's Wife accusing Joseph*. Washington, D.C., National Gallery of Art, Mellon Collection.

70. *Potiphar's Wife accusing Joseph*. Berlin, Staatliche Museen, Gemälde

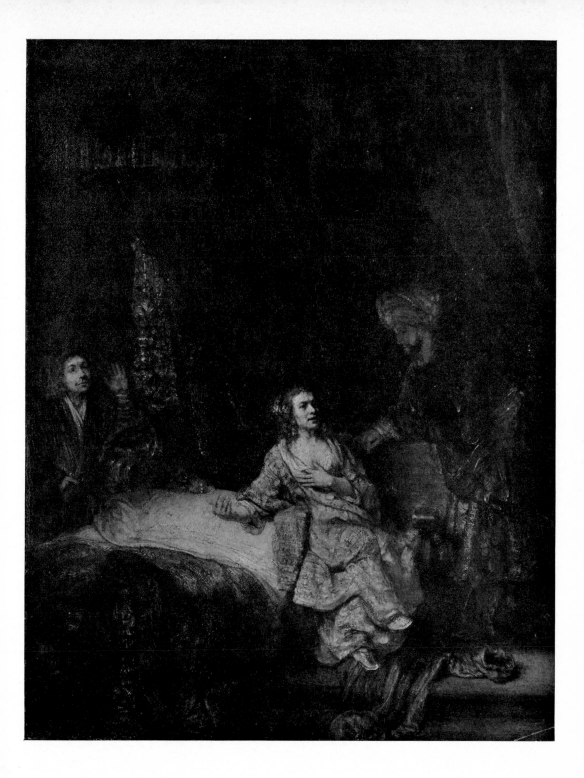

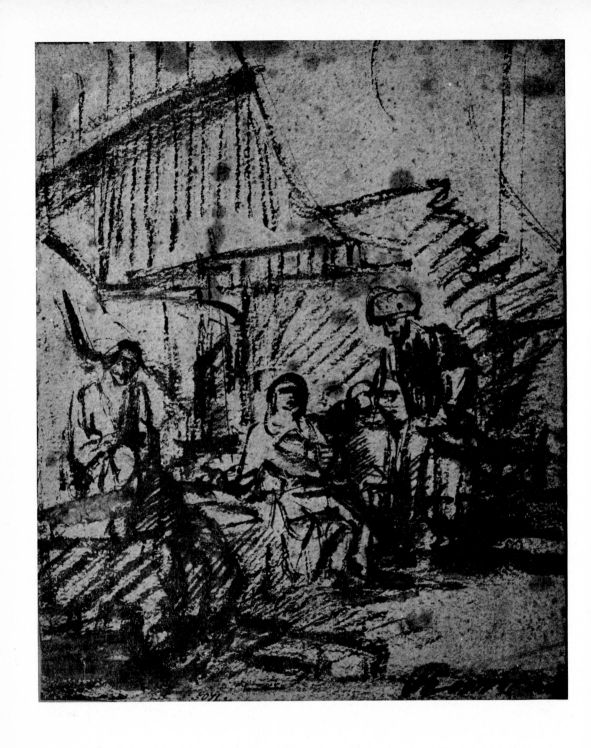

71. *Sketch for Potiphar's Wife accusing Joseph.* Pen drawing. Munich, Print Room.

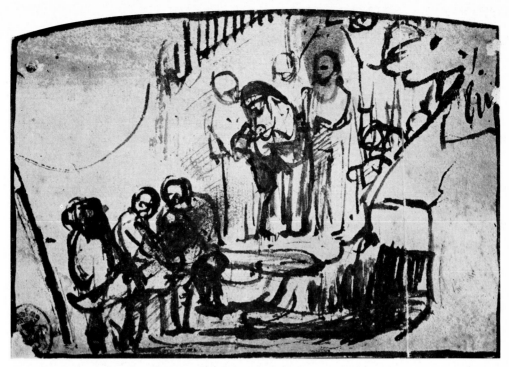

72. *The Entombment*. Pen drawing. Munich, Print Room.

73. *The Lamentation for Christ*. Pen drawing. Munich, Print Room.

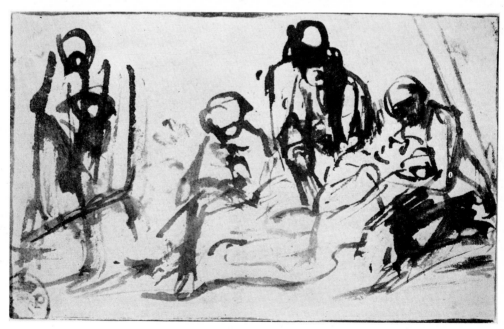

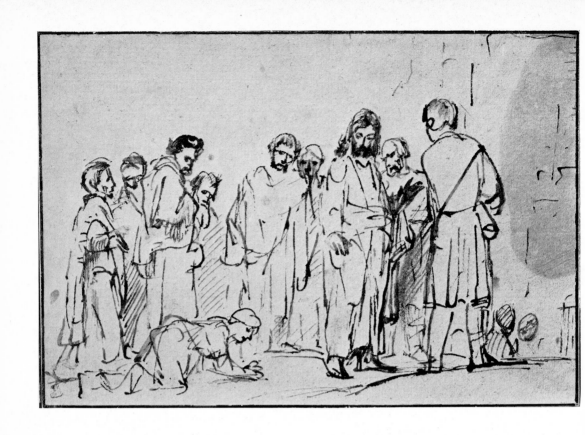

74. *Christ with His Apostles and the Woman who had an Issue of Blood*. Pen drawing. Vienna, Albertina.

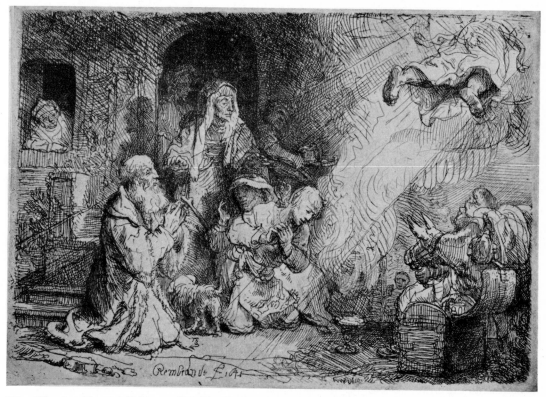

75. *The Angel leaving Tobias and his Family*. Etching. Vienna, Albertina.

77. *Christ driving the Money-Changers from the Temple*. Etching. Vienna, Albertina.

76. *The Raising of Lazarus* (detail). Etching. Vienna, Albertina.

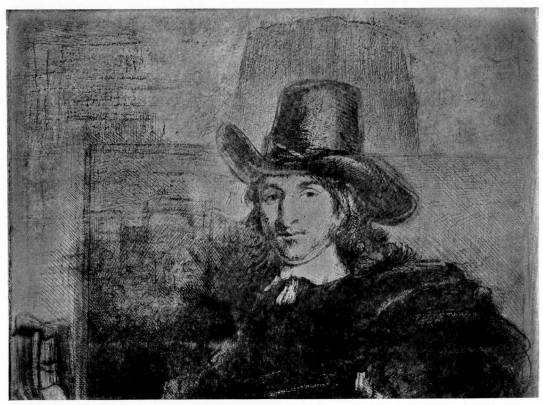

78. *Jan Asselyn* (copy). Etching. Berlin, Print Room.

79. *Jan Asselyn* (detail). Etching. Berlin, Print Roo

80. *Jan Asselyn* (detail). Etching. Vienna, Albertin

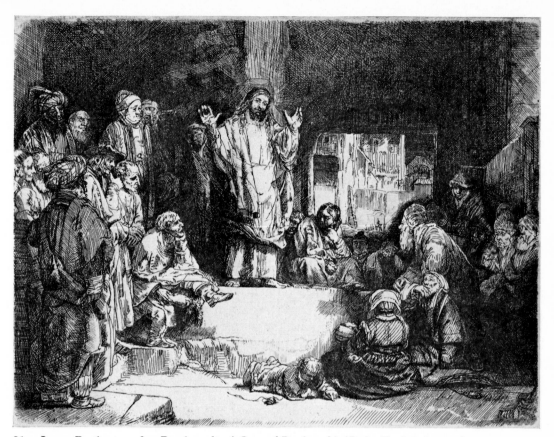

81. James Bretherton after Rembrandt, *A Copy of Rembrandt's 'Petite Tombe'*. Amsterdam,
Rijksmuseum, Print Room.

82. *Self-Portrait*. Pen drawing (enlarged). Vienna, Albertina. Cf. frontispiece.

REMBRANDT'S LAST DRAWING OF HIMSELF (Figs. 82 & 83)

83. *Self-Portrait*. Aix, Museum.

84. *Saskia seated in an Armchair*. Chalk drawing. Hamburg, Kunsthalle.

UNKNOWN AND WRONGLY ATTRIBUTED DRAWINGS BY REMBRANDT (Figs. 84–95)

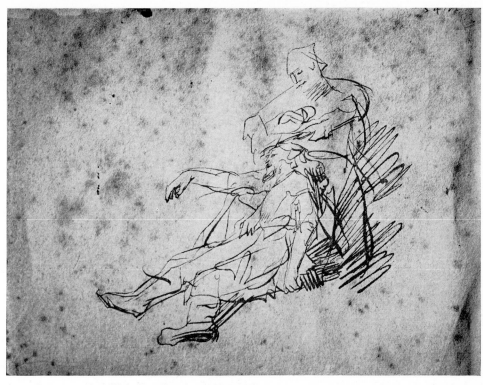

85. *Samson and Delilah*. Pen drawing. Dijon, Museum.

86. *Joseph expounding the Prisoners'*
Dreams. Pen drawing. London.
British Museum.

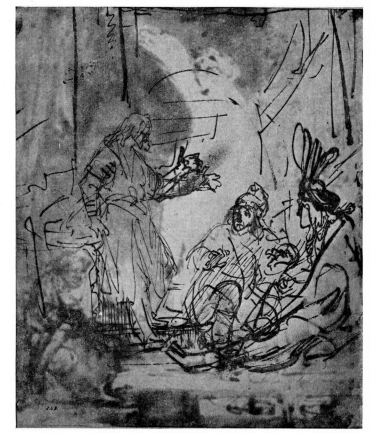

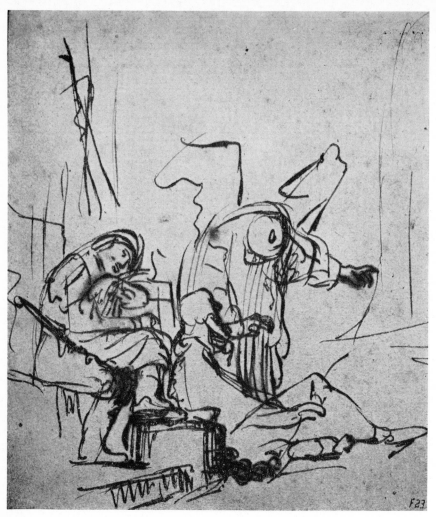

87. *The Liberation of St. Peter*. Pen drawing. Formerly Brno, Czechoslovakia, Dr. A. Feldmann.

88. *Joseph lifted from the Pit by his
 Brethren.* Pen drawing. Amsterdam,
 P. de Boer.

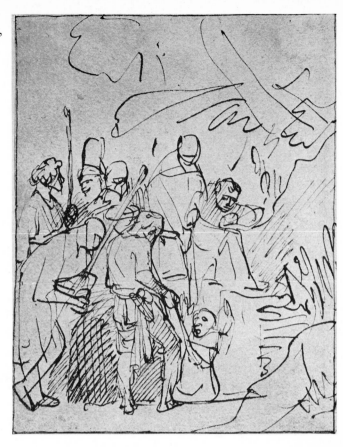

89. *Sheet of Studies.* Pen drawing. New York, The Pierpont Morgan Library.

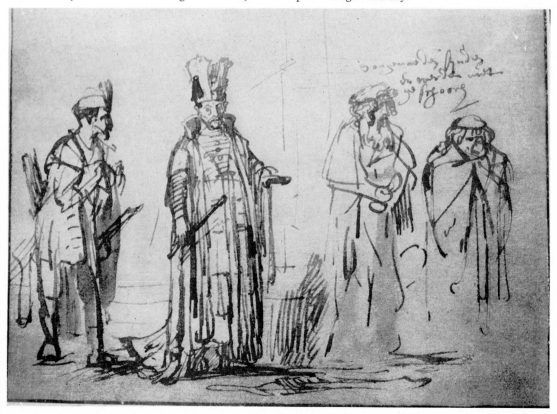

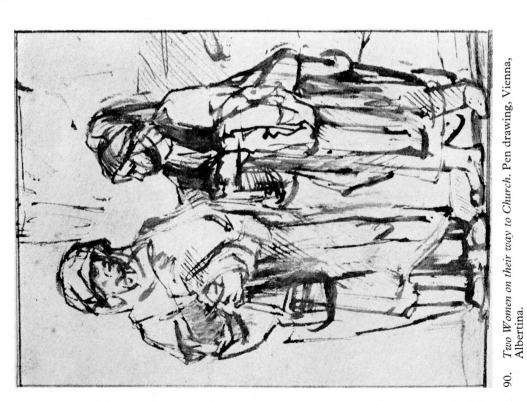

90. *Two Women on their way to Church.* Pen drawing, Vienna, Albertina.

91. *The Emperor Akbar.* Pen, brush and wash drawing. Vienna, Albertina.

93. *Preciosa.* Chalk drawing. Brussels, Musée des Beaux-Arts.

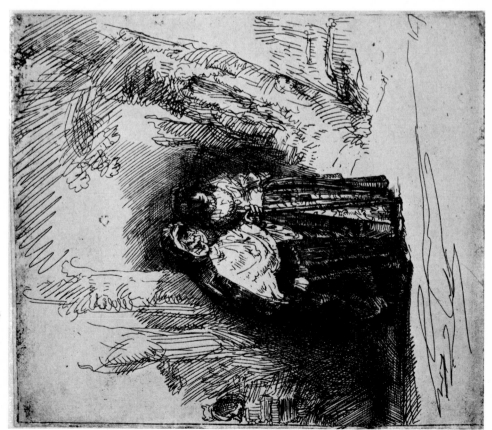

92. *Preciosa.* Etching.

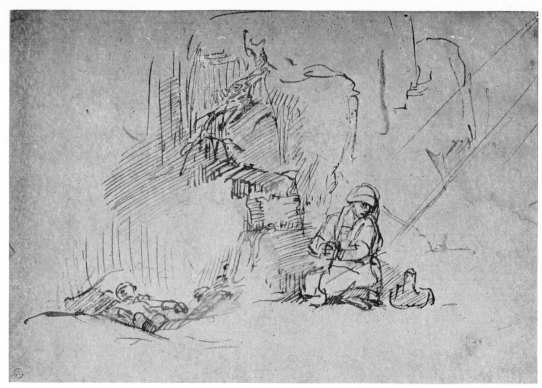

94. *Hager and Ishmael in the Desert*. Pen drawing. Berlin, Print Room.

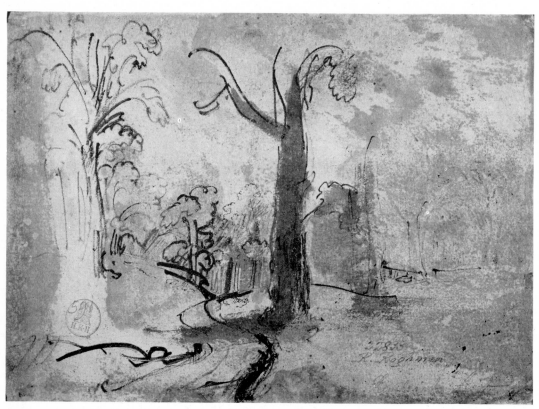

95. Attributed to Rembrandt, *A Road in a Forest*. Pen and wash drawing. Hamburg, Kunsthalle.

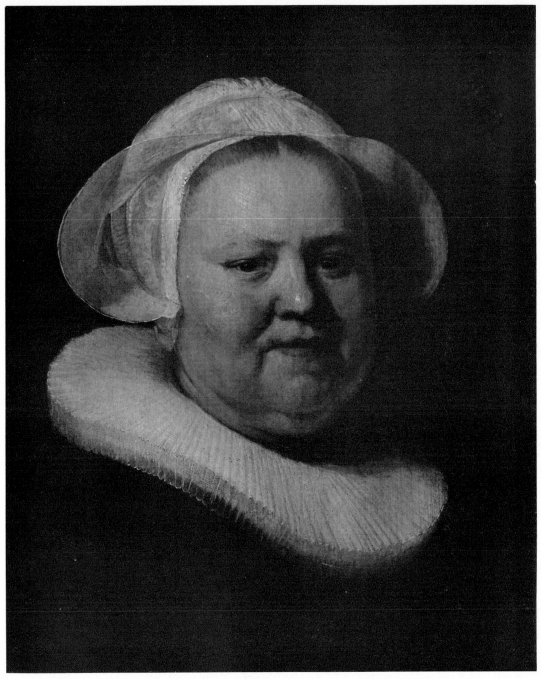

96. *Portrait of a Woman*. Leipzig, Art Trade.

PORTRAIT OF A WOMAN FROM REMBRANDT'S EARLY PERIOD IN AMSTERDAM

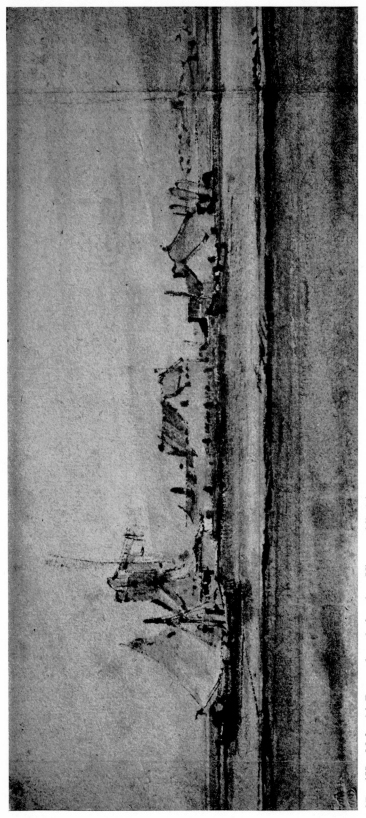

97. '*Het Molentje*'. Pen and wash drawing. Vienna, Albertina.

THE DUTCH LANDSCAPE IN REMBRANDT'S PERIOD

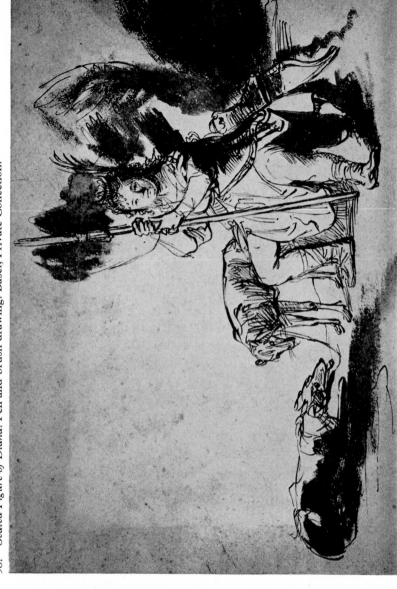

98. *Seated Figure of Diana*. Pen and brush drawing. Basel, Private Collection.

99. *The Reading*. Pen and brush drawing. Bayonne, Musée Bonnat.

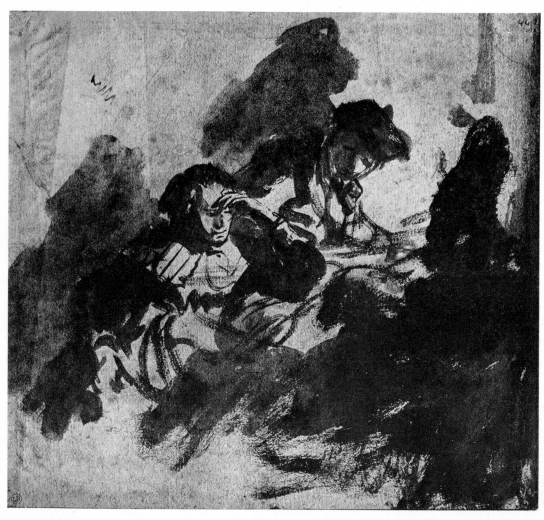

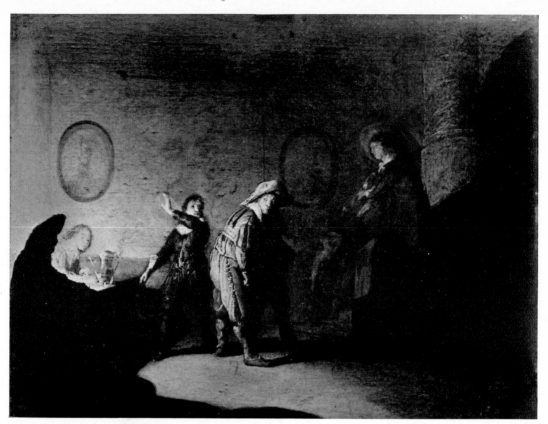

100. *'La Main Chaude.'* Dublin, National Gallery.

101. *Two Figures seated in Armchairs.*
Chalk drawing. Rotterdam, Boymans-
van Beuningen Museum.

102. *Portrait of Rembrandt's Mother.* Pen and brush
drawing. Paris, Private Collection.

104. *Self-Portrait.* Pen and brush drawing. Amsterdam, Rijksmuseum, Print Room (de Bruyn Collection).

103. *Self-Portrait.* Pen and brush drawing. London, British Museum.

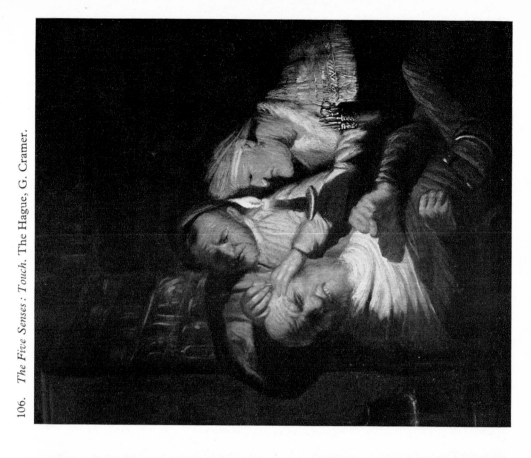

106. *The Five Senses: Touch.* The Hague, G. Cramer.

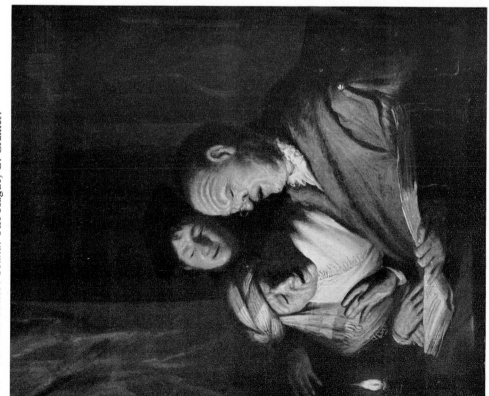

105. *The Five Senses: Sound.* The Hague, G. Cramer.

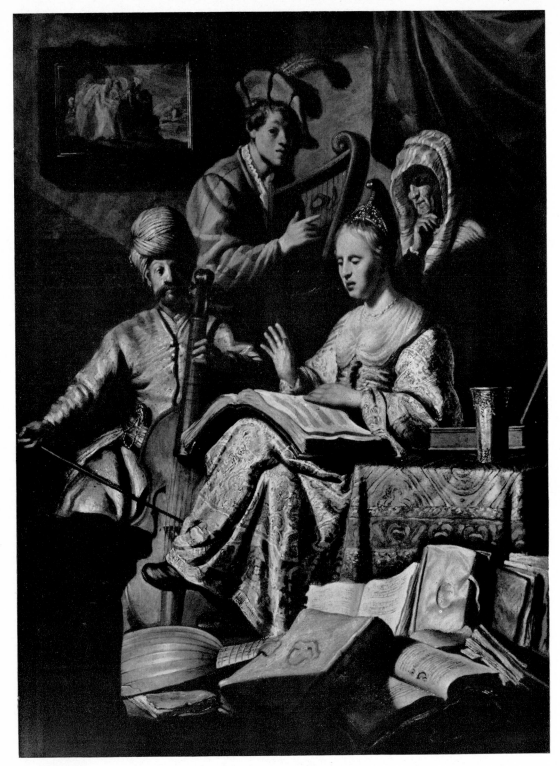

107. *The Rembrandt Family*. Paris, G. Lehman Collection.

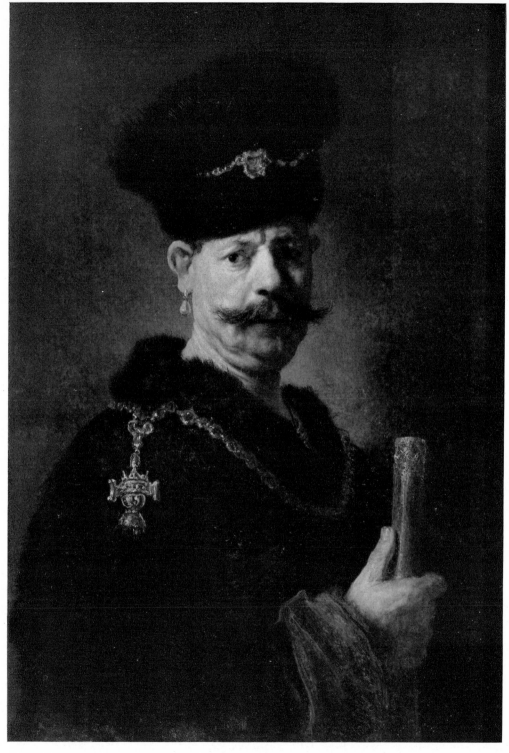

108. *A Polish Nobleman*. Washington, D.C., National Gallery of Art, Mellon Collection.

THE REMBRANDT PAINTINGS IN THE NATIONAL GALLERY OF ART
(Figs. 108–119)

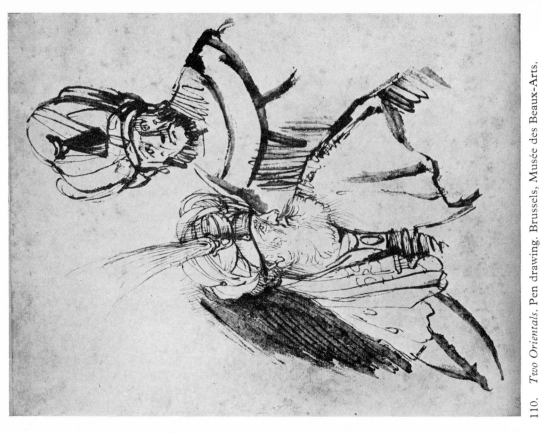

110. *Two Orientals*. Pen drawing. Brussels, Musée des Beaux-Arts,

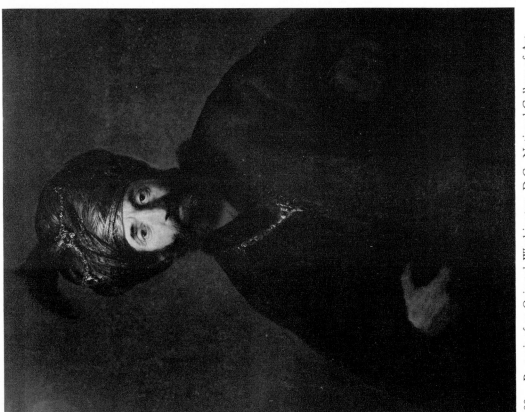

109. *Portrait of an Oriental*. Washington, D.C., National Gallery of Art.

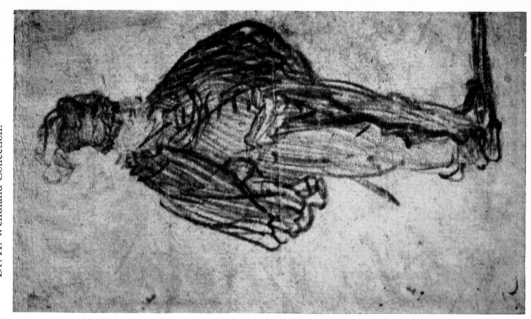

112. *Figure of an Old Pole.* Chalk drawing. Lugano, Dr. H. Wendland Collection.

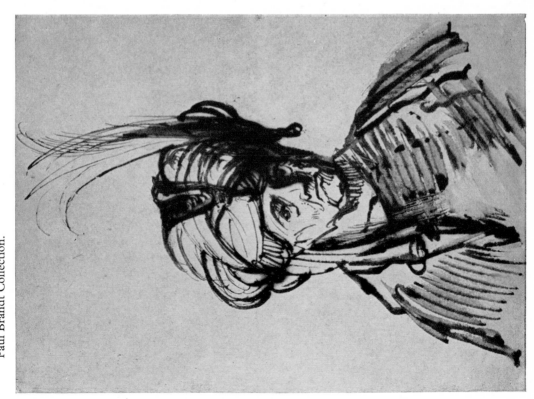

111. *Bust of an Oriental wearing a Turban.* Pen drawing. Amsterdam, Paul Brandt Collection.

114. *Bust of a Little Girl.* Pen drawing. Dresden, Print Room.

113. *A Girl with a Broom.* Washington, D.C., National Gallery of Art, Mellon Collection.

116. *An Old Lady with a Prayer-Book*. Washington, D.C., National Gallery of Art, Mellon Collection.

115. *A Woman holding a Pink*. Washington, D.C., National Gallery of Art, Mellon Collection.

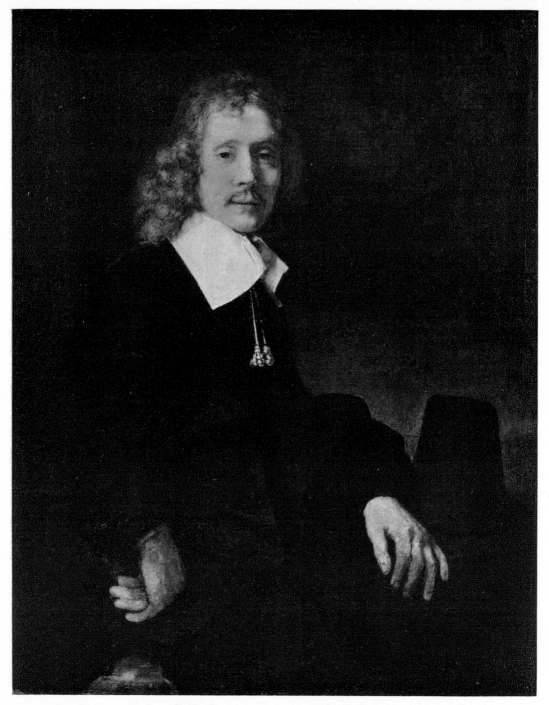

117. *A Young Man seated at a Table.* Washington, D.C., National Gallery of Art, Mellon Collection.

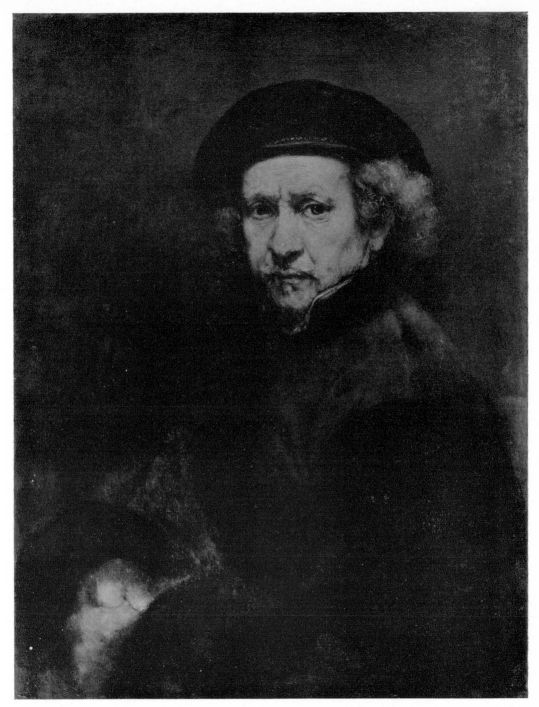

118. *Self-Portrait*. Washington, D.C., National Gallery of Art, Mellon Collection.

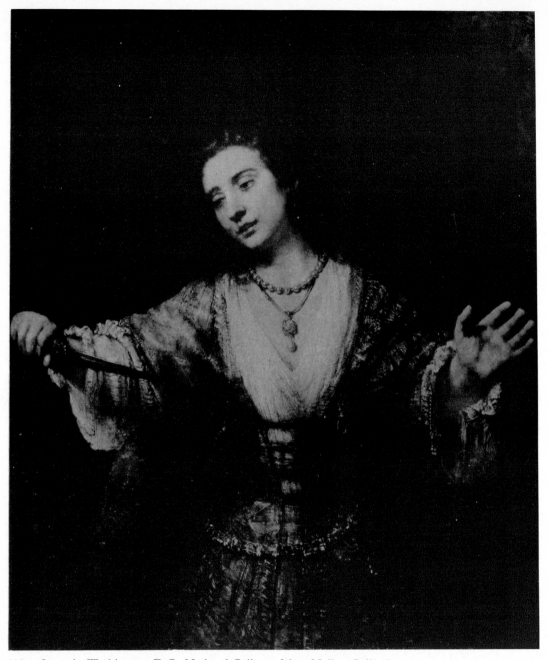

119. *Lucretia*. Washington, D.C., National Gallery of Art, Mellon Collection.

REMBRANDT AND THE GOTHIC TRADITION (Figs. 120–136)

120. *Jacob blessing his Grandchildren*. Cassel, Gemäldegalerie.
121. Jan van Eyck, *The Dukes and Duchesses of Burgundy*.
 Bronzes. Amsterdam, Rijksmuseum.

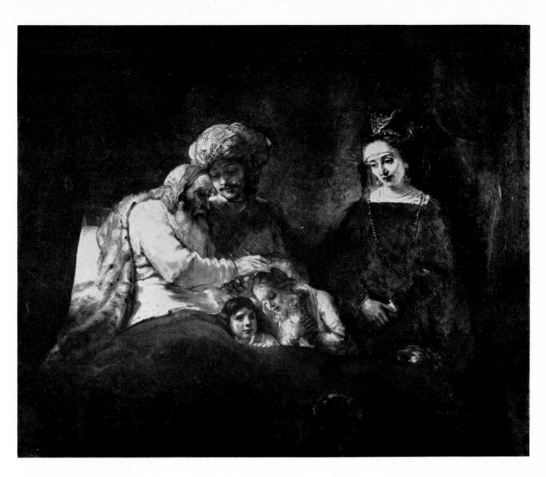

122. *Mary Mourning beneath the Cross and
Several Mourners.* Pen drawing.
Amsterdam, Rijksmuseum, Print Room

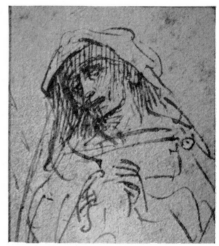

123. *The Mourning Mary.* Pen drawing.
Amsterdam, Museum Fodor.

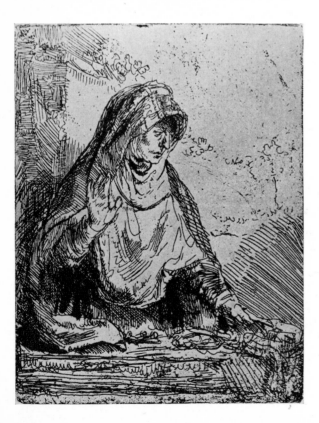

124. *The Holy Virgin.* Etching.

125. Burgundian School, *The Entombment of Christ*. Dijon, St. Michel.

126. *The Mourning Virgin*. Epinal, Musée des Vosges.

127. School of Utrecht,
The Holy Virgin. Utrecht,
Archiepiscopal Museum.

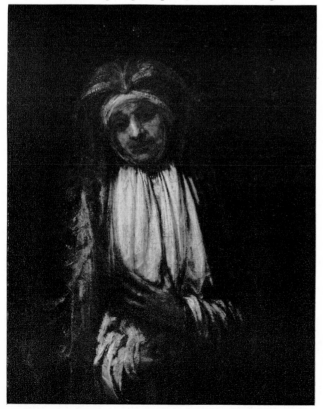

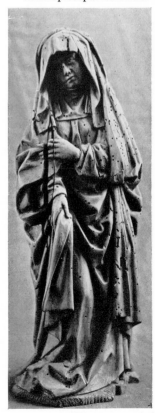

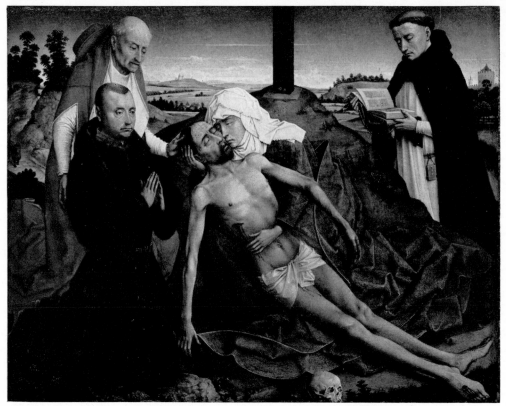

128. Rogier van der Weyden, *Pietà*. London, National Gallery.

129. *The Lamentation for Christ*. Pen drawing. Constance, Wessenberg Gallery.

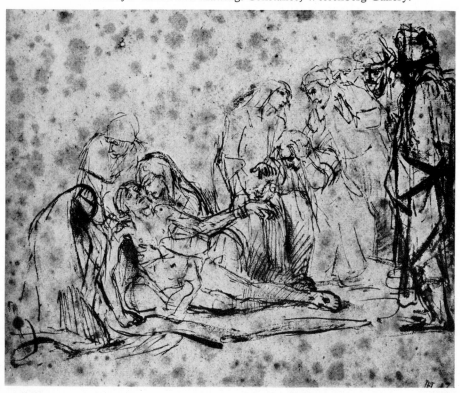

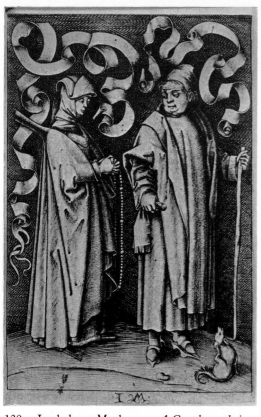

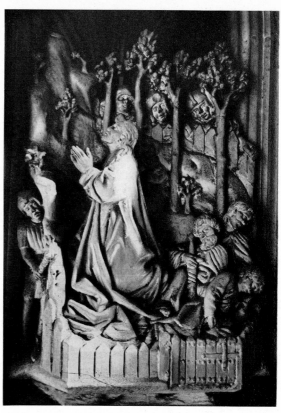

130.	Israhel van Meckenem, *A Couple on their Way to Church*. Engraving.

131.	Flemish XV century, *The Agony in the Garden*. Louvain, St. Peter's.

132.	*The Agony in the Garden*. Pen drawing. Queens, New York, Queens College.

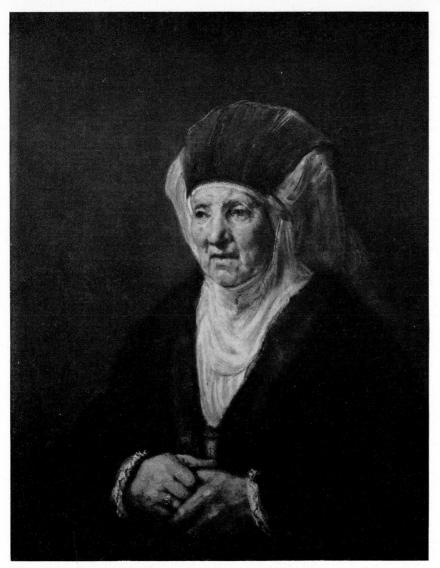

133. *Portrait of an Old Lady*. Stockholm, National Museum.

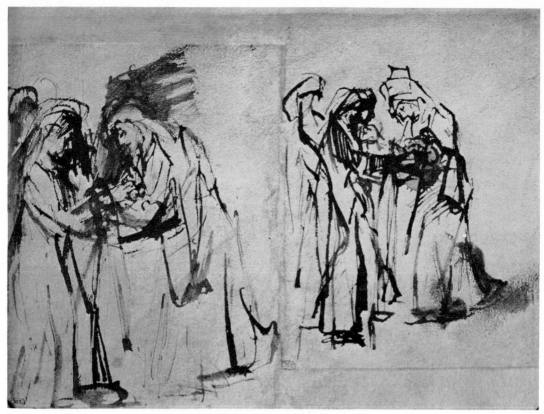

134. *Two Studies for a Visitation*. Pen drawing. Paris, Louvre.

135. *The Visitation*. Pen and wash drawing. Paris, Louvre (W. Gay Bequest).

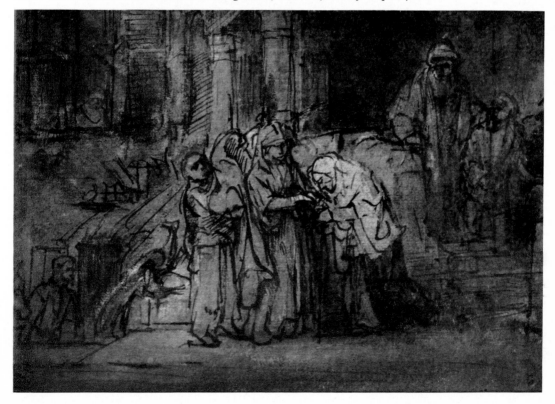

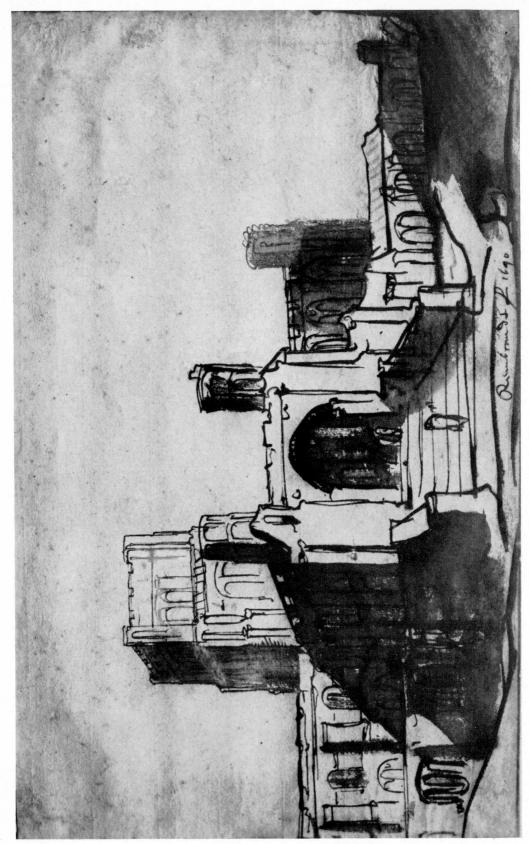

136. *The Cathedral of St. Albans.* Pen and wash drawing. Haarlem, Teyler Museum.

138. F. de Goya, *The Last Communion of St. Joseph of Calasanz.* Madrid, Church of St. Anthony.

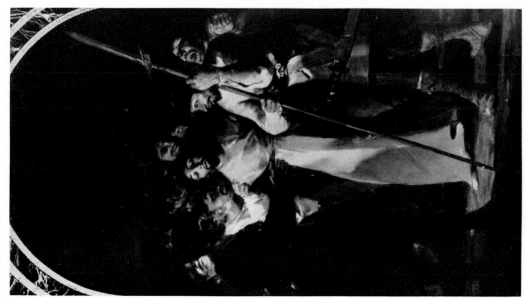

137. F. de Goya, *The Seizure of Christ.* Toledo, Cathedral.

139. F. de Goya, *St. Paul*. New York, Lilienfield Galleries.

140. F. de Goya, *Disasters of War Sad presentiments of what is going to happen*. Etching.

141. F. de Goya, *Two Old Witches*. Madrid, Prado.

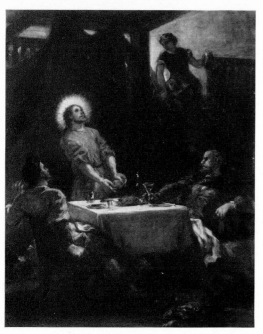

142. E. Delacroix, *The Supper at Emmaus.*
New York, The Brooklyn Museum.

143. E. Delacroix, *The Raising of Lazarus.* Basel,
Kunstmuseum.

144. H. Daumier, '*Ecce homo*'. Essen, Museum.

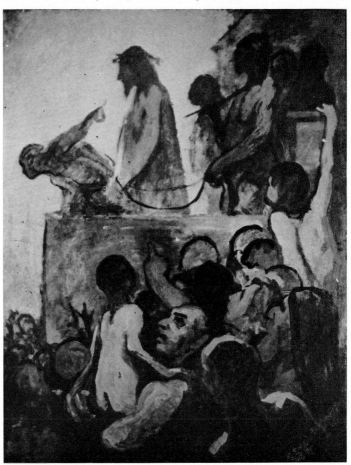

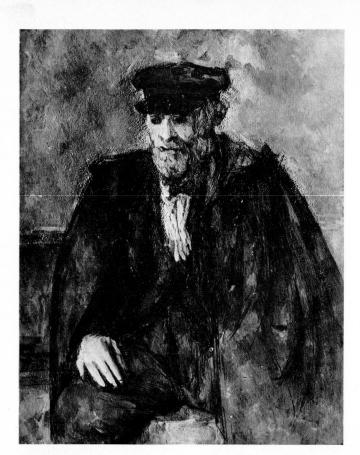

145. P. Cézanne, *Vieux à la Casquette*.
Solothurn, J. Mueller Collection.

146. V. van Gogh, *Vision of an Angel*.
Scarsdale, New York, W. Weinber

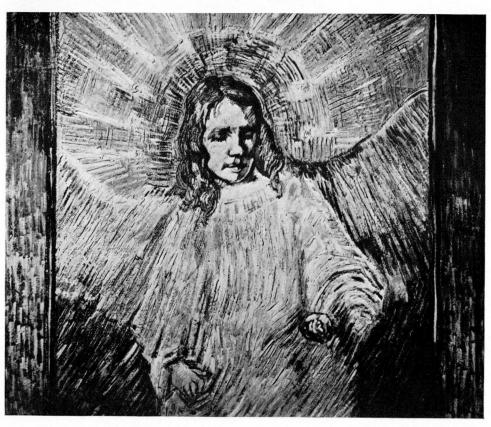

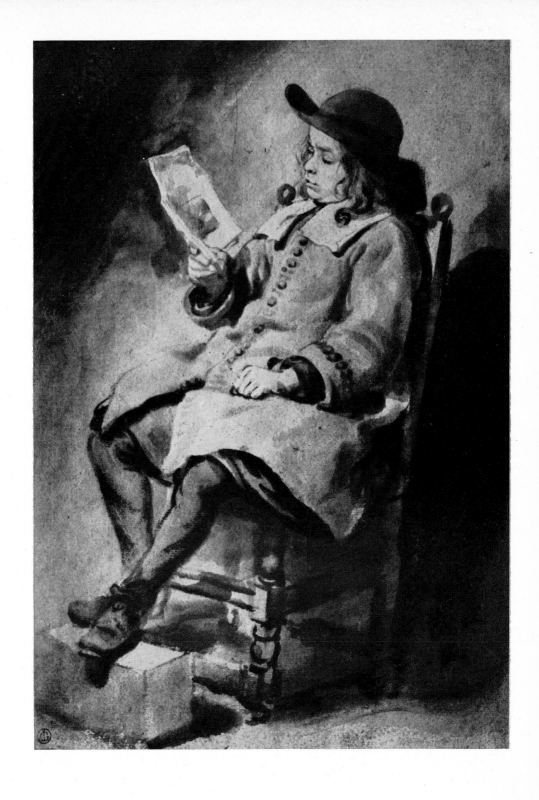

147. G. van den Eeckhout, *Boy looking at a Print*. Brush drawing. Paris, Musée Cognacq-Jay.

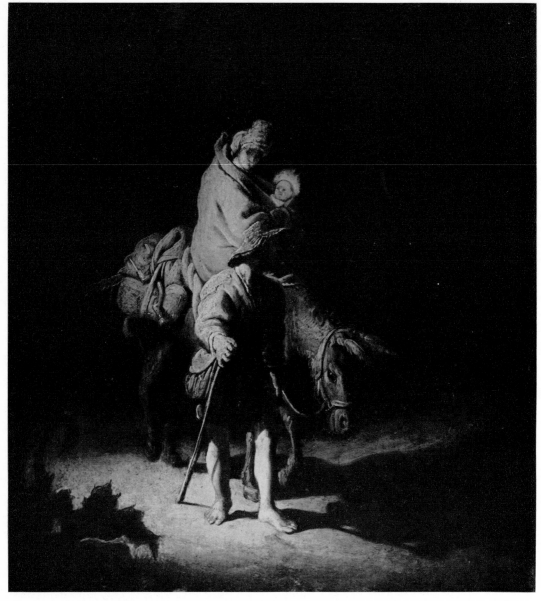

148. *The Flight into Egypt.* Tours, Musée des Beaux-Arts.

AN UNKNOWN REMBRANDT PAINTING OF THE LEIDEN PERIOD (Figs. 148 & 149)

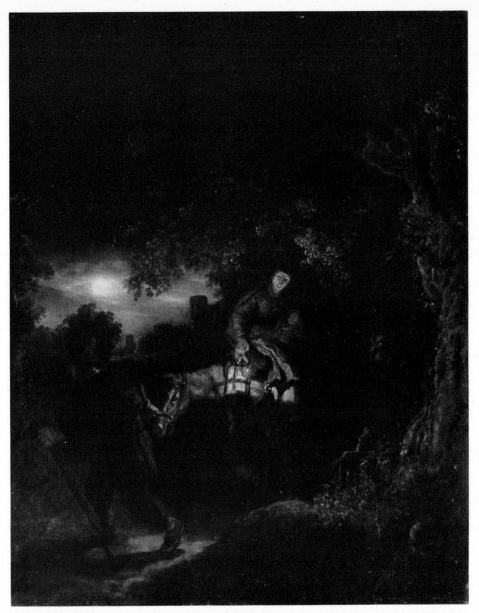

149. *The Flight into Egypt*. London, Lord Wharton.

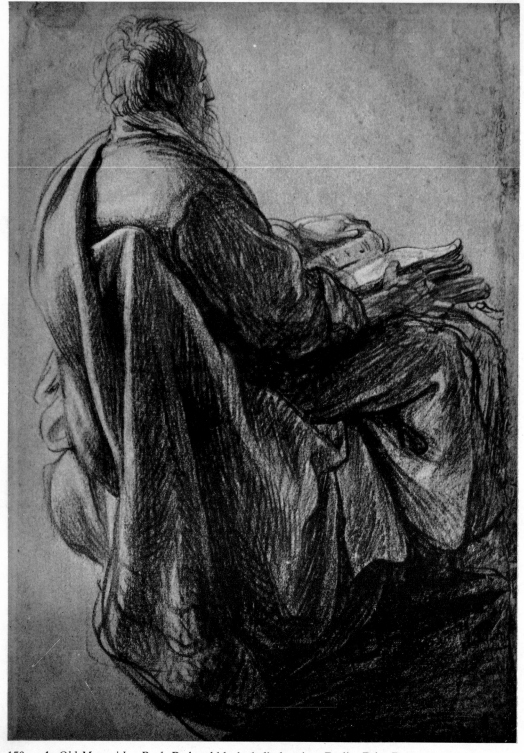

150. *An Old Man with a Book.* Red and black chalk drawing. Berlin, Print Room.

'CARAVAGGISM' IN THE DRAWINGS OF REMBRANDT (Figs. 150–155)

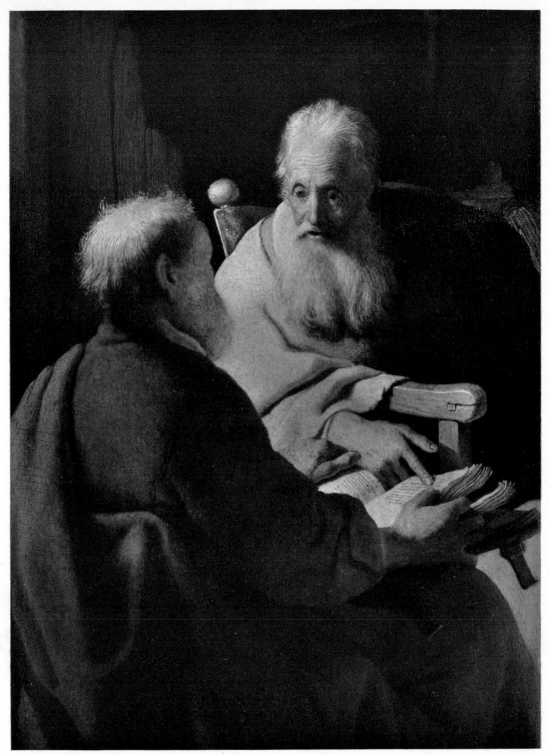

151. *Two Philosophers disputing (detail)*. Melbourne, National Gallery of Victoria.

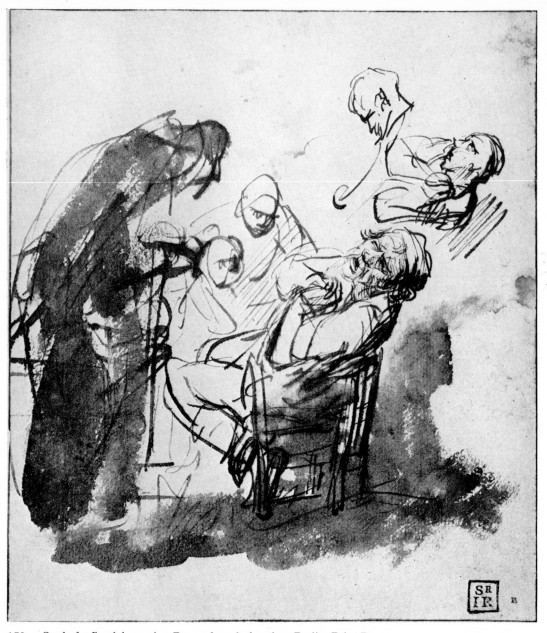

152. *Study for Jacob lamenting*. Pen and wash drawing. Berlin, Print Room.

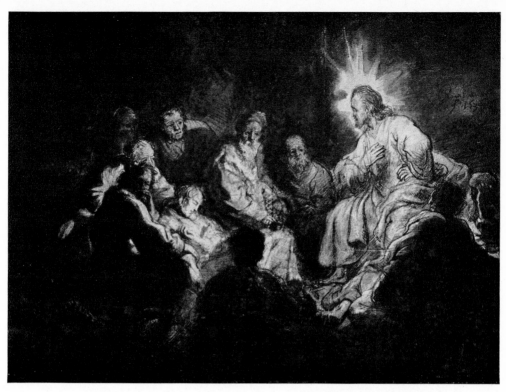

153. *Jesus and His Disciples*. Chalk, pen and gouache drawing. Haarlem, Teyler Museum.

154. *The Presentation in the Temple.*
Pen and brush drawing.
The Hague, Royal Library.

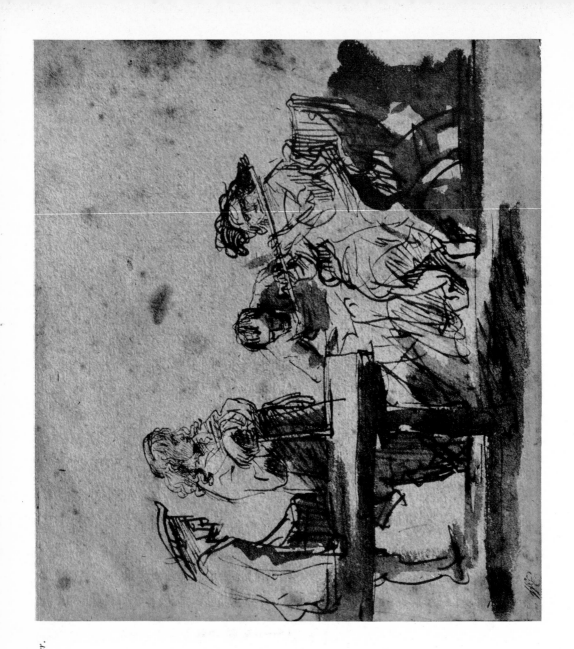

155. *A Group of Musicians listening to a Flute Player.*
Pen and wash drawing. Donnington Priory,
Newbury, Berks., Capt. G. Gathorne-Hardy
Collection.

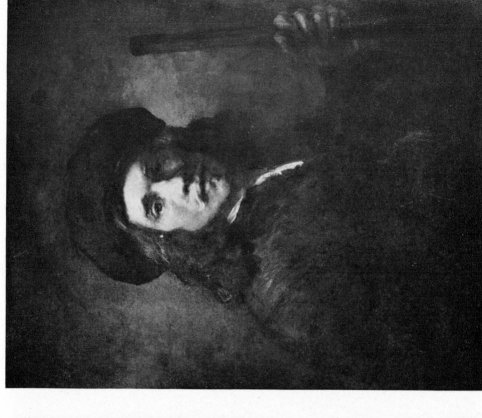

157. *Portrait of a Man with a Stick*. Paris, Louvre.

156. *A Bearded Man in a Cap, The so-called Rabbi*. London, National Gallery.

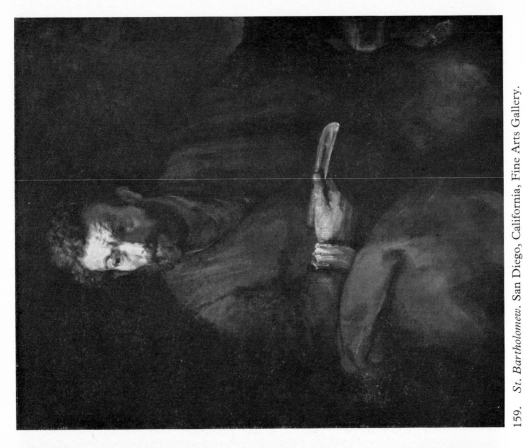

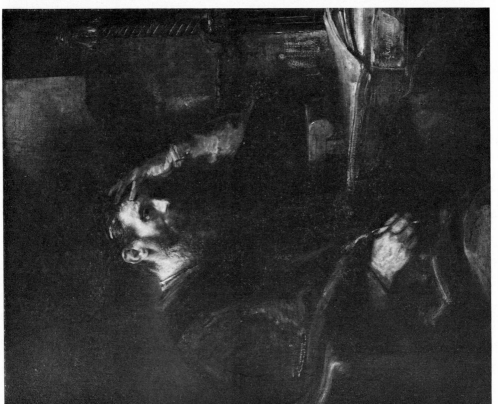

158. *The Apostle Paul.* Washington, D.C., National Gallery of Art, Widener Collection.

159. *St. Bartholomew.* San Diego, California, Fine Arts Gallery.

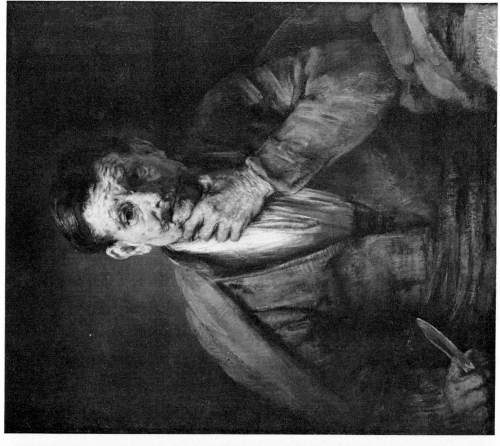

161. *St. Bartholomew*. Sutton Place, Surrey, The J. Paul Getty Collection (Art Properties Inc.).

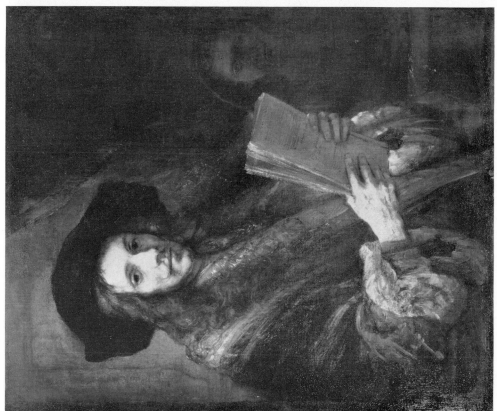

160. *'The Auctioneer'*. New York, Metropolitan Museum of Art.

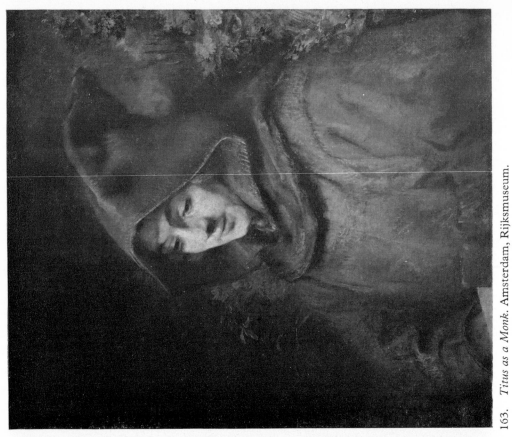

163. *Titus as a Monk.* Amsterdam, Rijksmuseum.

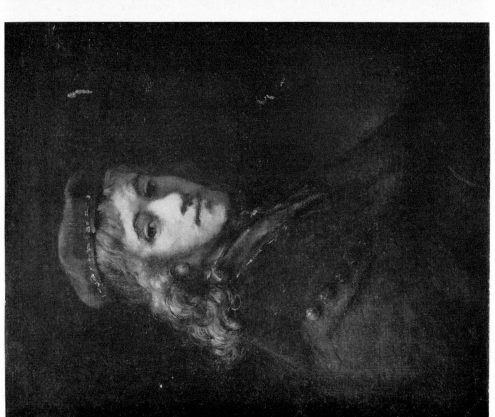

162. *Titus.* Paris, Louvre.

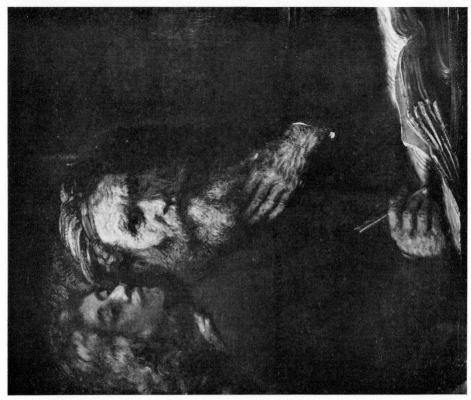

165. *St. Matthew writing*. Paris, Louvre.

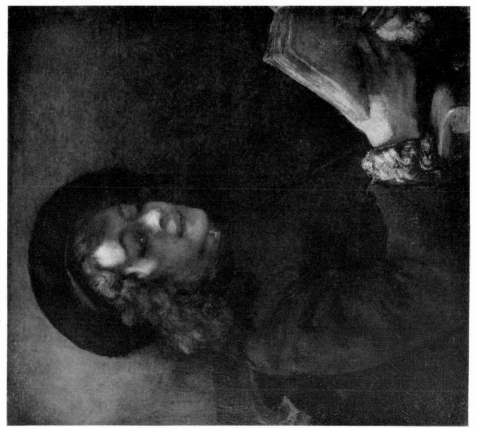

164. *Titus*. Vienna, Kunsthistorisches Museum.

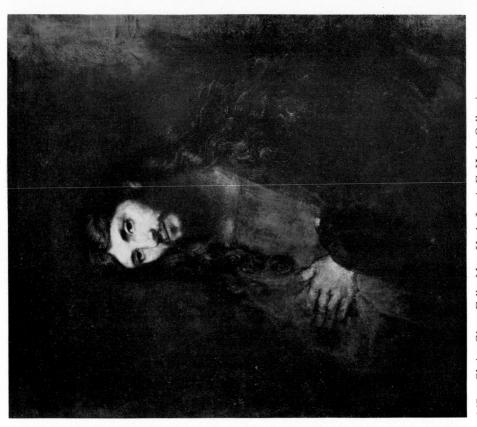

167. *Christ.* Glens Falls, New York, Louis F. Hyde Collection.

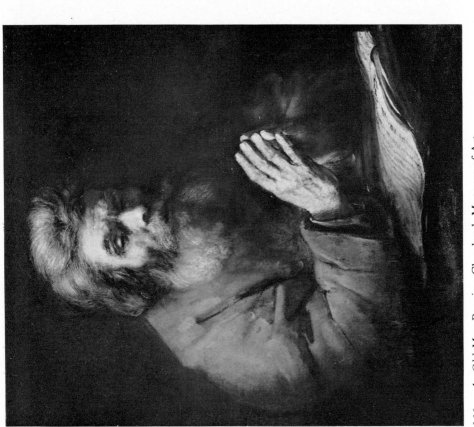

166. *An Old Man Praying.* Cleveland, Museum of Art.

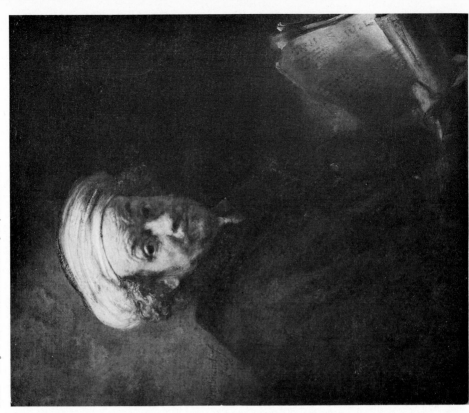

169. *Self-Portrait.* Amsterdam, Rijksmuseum.

168. *A Portrait of a Young Jew.* Montreal, Van Horne Collection.

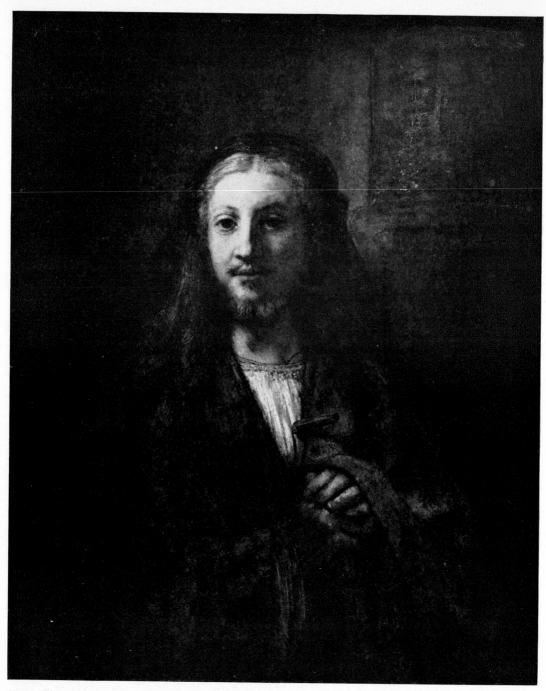

170. *Christ*. New York, Metropolitan Museum of Art.

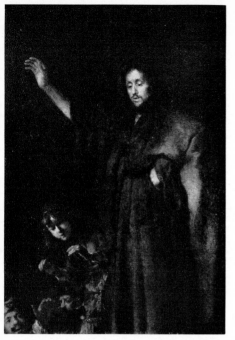

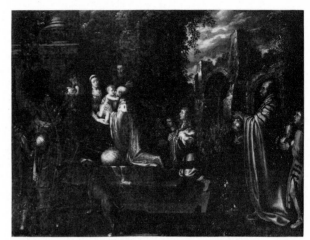

171. C. Fabritius, *The Raising of Lazarus* (detail). Warsaw, National Museum.

172. Pieter Lastman, *The Adoration of the Magi*. Prague, National Gallery.

3. *The Virgin of an Annunciation* (fragment). Prague, National Gallery.

174. Constantijn van Renesse, *Satyr with Peasants*. Warsaw, National Museum.

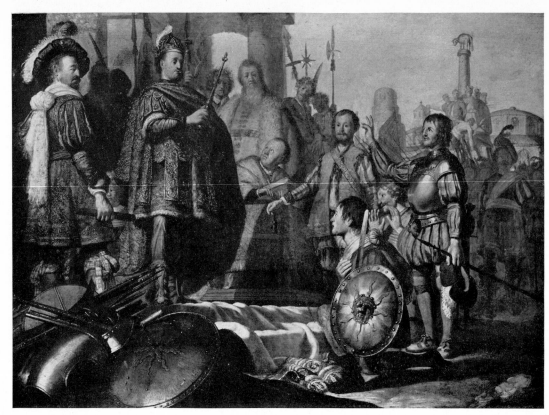

175. *The Justice of Brutus*. Leiden, Lakenhal.

176. *The Beheading of the Tarquinian Conspirators*. Pen drawing. London, The British Museum.

177. *Sophonisba receiving the Cup*. Madrid, Prado.

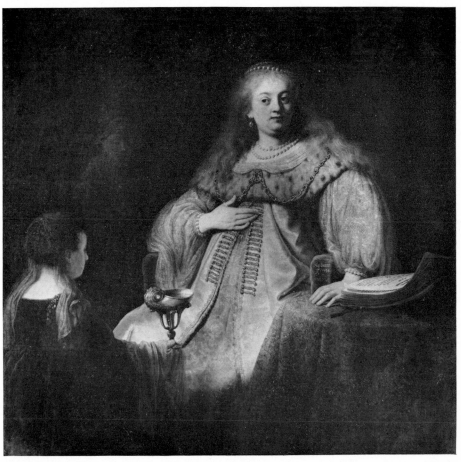

178. *Study from the Bust of the Emperor Galba.*
Pen drawing. Berlin, Print Room.

179. *Manius Curius Dentatus refuses the Gifts of the Samnites.* Pen drawing. Warsaw, University Library.

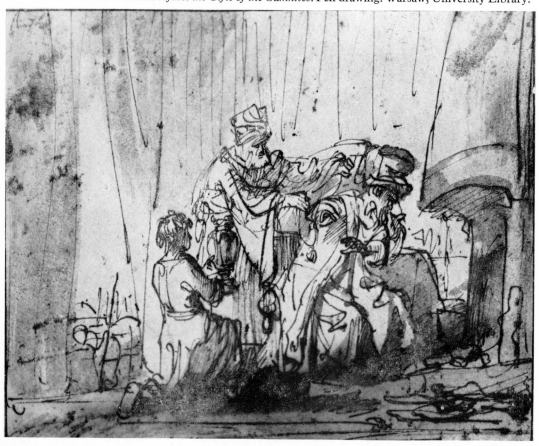

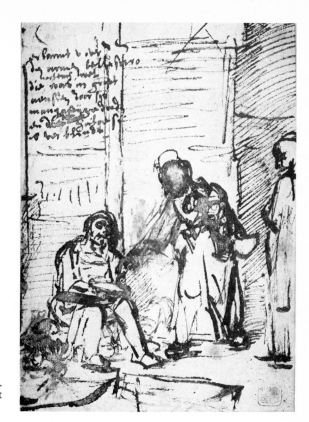

180. *The Blind Belisarius receiving Alms.*
Pen drawing. Berlin-Dahlem, Print
Room.

181. *The Roman Women before Coriolanus.* Pen drawing. Groningen, Museum.

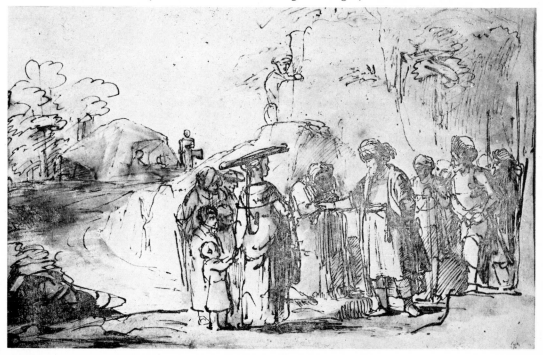

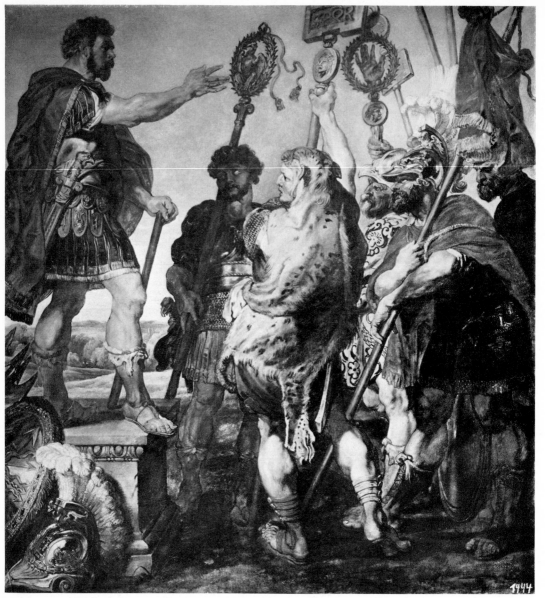

182. Rubens, *The Story of the Death of the Consul Decius Mus (Decius telling his Dreams)*. Vaduz, Prince of Liechtenstein.

183. *Quintus Fabius Maximus* (study for the painting of 1655). Pen drawing. Berlin-Dahlem, Print Room.

184. *Coriolanus receiving the Deputies of the Roman Senate*. Pen drawing. Rotterdam, Boymans-van Beuningen Museum.

185. *Scene from the Life of Pyrrhus*. Pen drawing. London, British Museum.

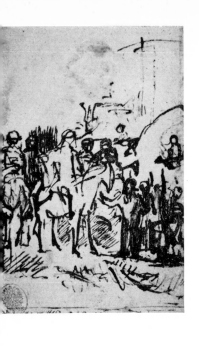
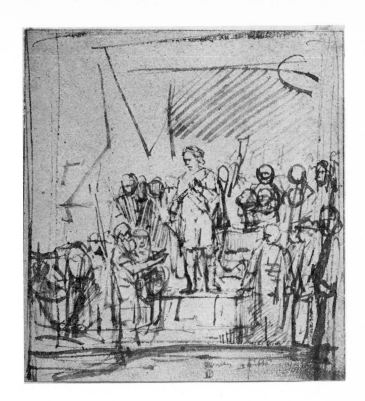
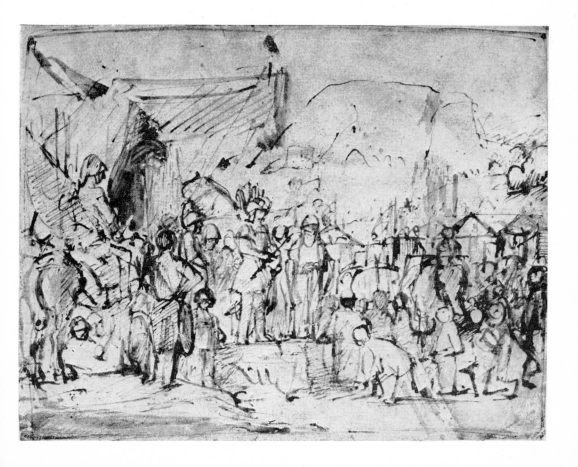

186. *Homer dictating to a Scribe* (study for the painting of 1663). Pen and wash drawing. Stockholm, National Museum.

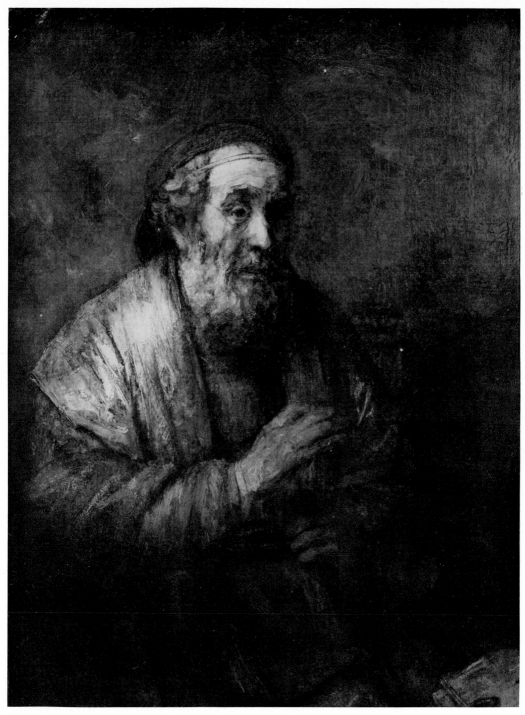

187. *Homer*. The Hague, Mauritshuis.

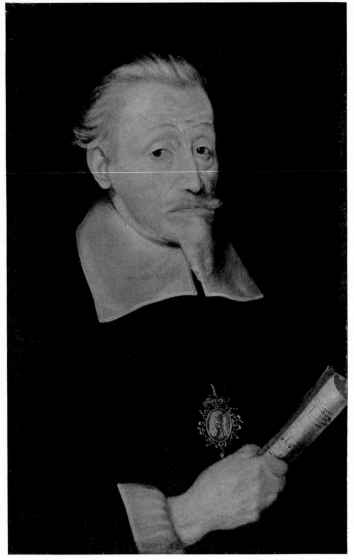

188. Christoph Spetner, *Heinrich Schütz*. Leipzig, University Library.

189. Christian Romstet, *Heinrich Schütz*. Engraving.

190. Unknown German artist, *Heinrich Schütz*. Berlin, National Library.

SCHÜTZ AND REMBRANDT (Figs. 188–193)

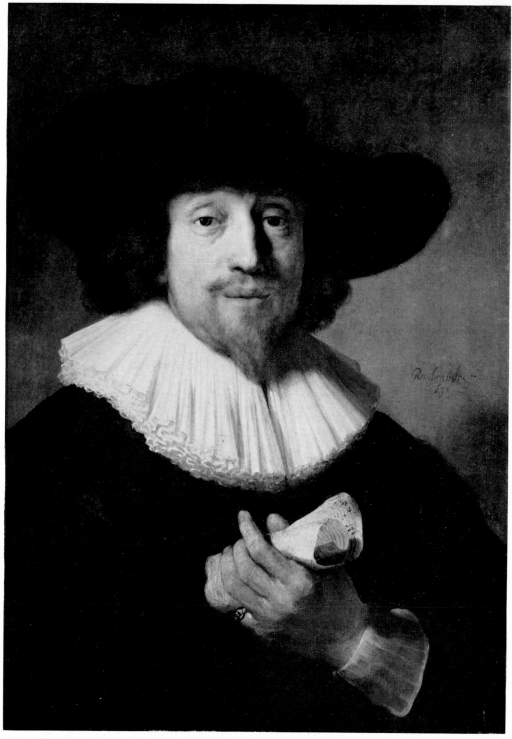

191. *Portrait of a Musician (Heinrich Schütz)*. Washington, D.C., The Corcoran Gallery of Art.

192. Unknown artist, *Title-page of the tenor part on Burchard Grossmann's edition of Psalm 116 which Schütz set to music.* Engraving. Berlin, National Library.

193. *An Old Scholar.* Pen and wash drawing. The Hague, Royal Library.

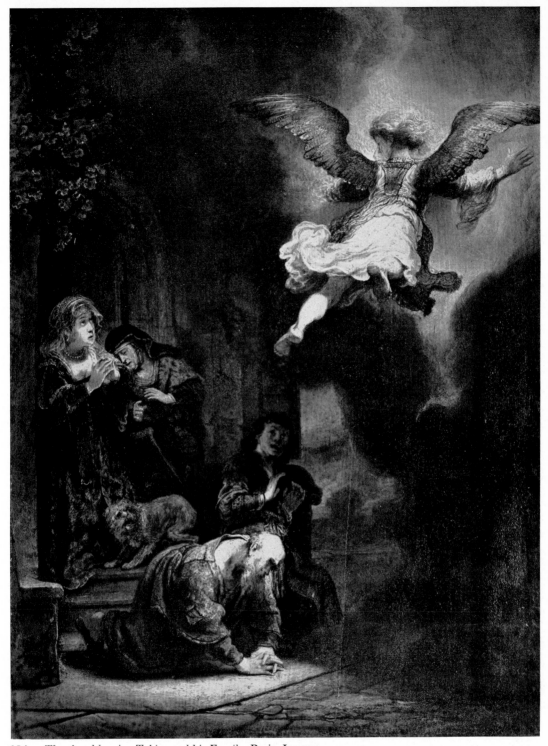

194. *The Angel leaving Tobias and his Family*. Paris, Louvre.

ON THE DEVELOPMENT OF A COMPOSITION BY REMBRANDT (Figs. 194–205)

195. *The Angel leaving Tobias and his Family*. Pen drawing. Budapest, Museum of Fine Arts.

196. *The Angel leaving Tobias and his Family*. Pen drawing. Oxford, Ashmolean Museum.

197. *The Blind Tobit*. Etching.

198. *Isaac blessing Jacob*. Pen drawing. Chatsworth, Devonshire Collection (Trustees of the Chatsworth Settlement).

199. *Hagar and Ishmael in the Desert*. Pen drawing. Munich, Print Room.

200. *The Angel leaving Tobias and his Family.* Pen drawing. New York, Pierpont Morgan Library.

201. Pupil of Rembrandt, corrected by the Master, *The Angel leaving Tobias and his Family.* Pen and wash drawing. Vienna, Albertina.

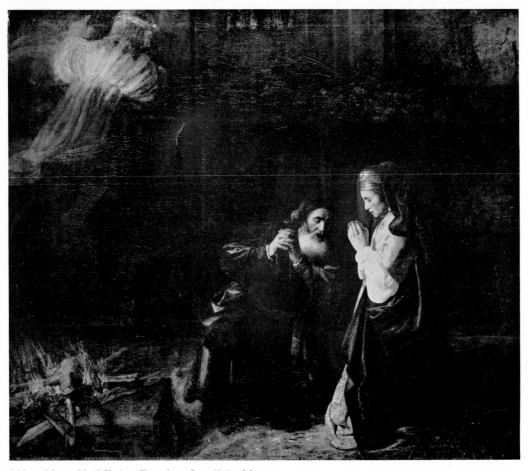

202. *Manoah's Offering*. Dresden, Staatliche Museen.
203. Pupil of Rembrandt, corrected by the Master, *Manoah's Offering*. Pen drawing. Winterthur,
Dr. Oskar Reinhart Collection.

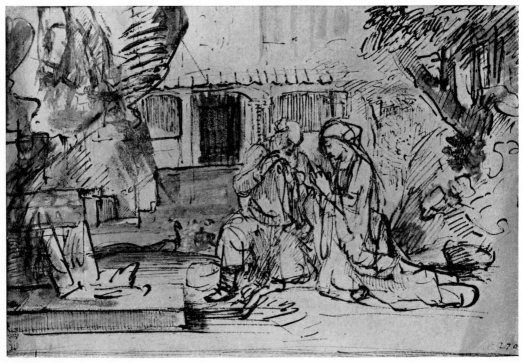

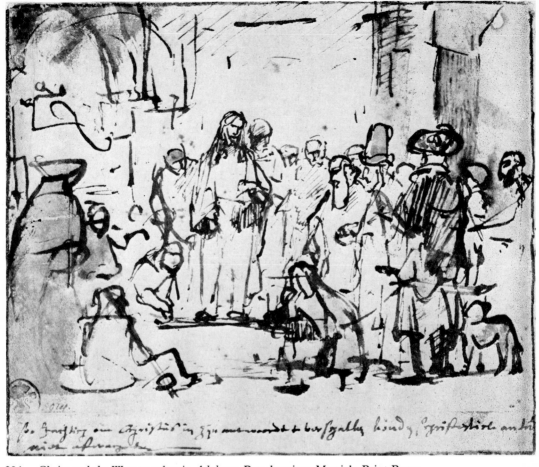

204. *Christ and the Woman taken in Adultery*. Pen drawing. Munich, Print Room.

205. *Christ and the Woman taken in Adultery*. Pen drawing. Cologne, Wallraf-Richartz Museum.

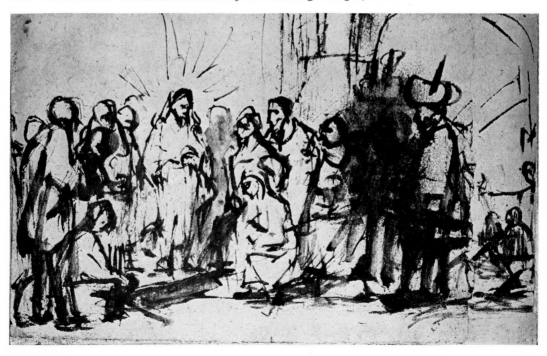

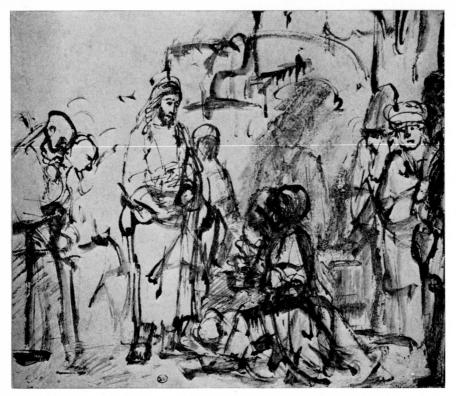

206. *The Meeting of Christ with Martha and Mary after the Death of Lazarus.*
Pen drawing. Cleveland, Museum of Art.

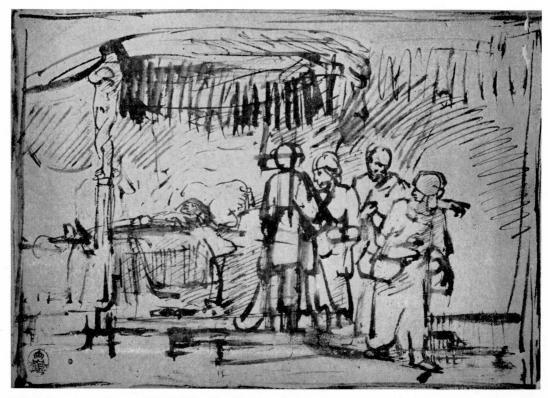

207. *St. Peter at the Death-bed of Tabitha.* Dresden, Print Room.

208. *Beggar* (enlarged). Pen drawing. New York, Mr. and Mrs. E. Powis Jones
Collection.

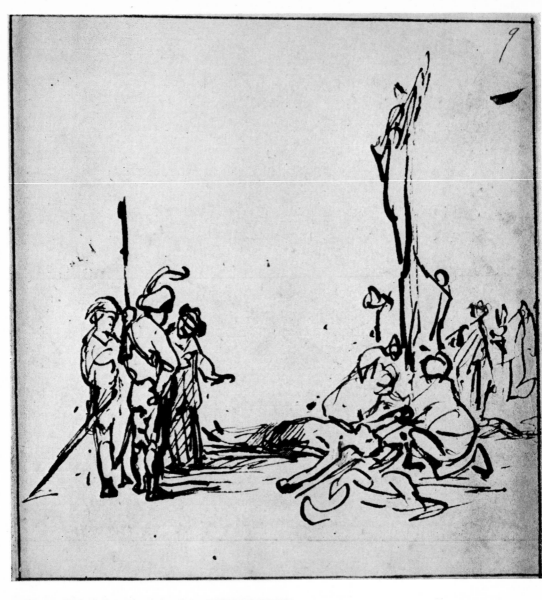

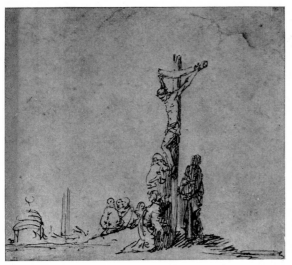

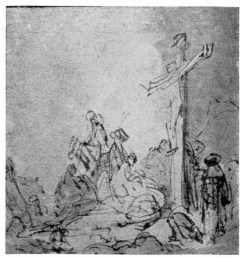

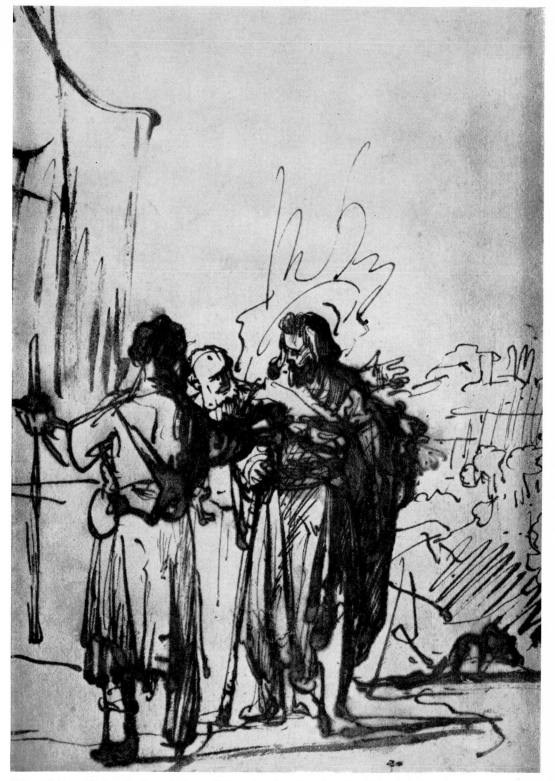

209. *Christ nailed to the Cross* (enlarged). Pen drawing. London, Dr. Robert Rudolf Collection.
210. Jan Pynas, *The Crucifixion*. Pen drawing. Hampton-on-Thames, Mr. Bruce Flegg.
211. Precursor of Rembrandt, *The Crucifixion*. Pen drawing. Formerly Lausanne, Stroelin Collection.
212. *Christ with the Disciples before Emmaus*. Pen drawing. Formerly Amsterdam, B. Houthakker, now U.S.

214. *Saskia in profile to the right*. Pen
drawing. Moscow, Pushkin Museum.

213. *Woman with a Shopping Basket*. Pen drawing.
London, Private Collection.

215. *Christ on the Mount of Olives*. Pen drawing.
New York, Schaeffer Galleries Inc.

216. *Samson Sleeping*. Pen drawing. New York,
Schaeffer Galleries Inc.

217. *St. Peter*. Pen drawing. New York, Mr. and
Mrs. Eugene V. Thaw.

218. *Bust of an Old Man*. Pen and brush drawing, red chalk. London, Mr. Leo Franklyn.

219. *Christ on the Mount of Olives*. Pen drawing, fragment. Munich, Print Room.

220. *Bust of a Young Oriental.*
Pen and brush drawing.
Moscow, Pushkin Museum.

221. *Sheet of Studies.* Pen and wash
drawing. Oxford, Ashmolean
Museum.

222.	*Farmhouses under a Group of Trees*. Pen drawing. Munich, Print Room.

223.	*Soldiers playing Cards in a Guard Room*. Pen drawing. The Hague, formerly S. de Clercq Collection.

224. *Group of Men in Conversation*. Pen drawing. Amsterdam. Formerly L. A. Houthakker.

225. *Sick Women, Study for the 'Hundred Guilder Print'*. Pen drawing. Amsterdam, Rijksmuseum, Print Room.

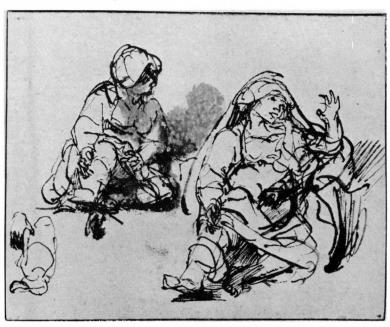

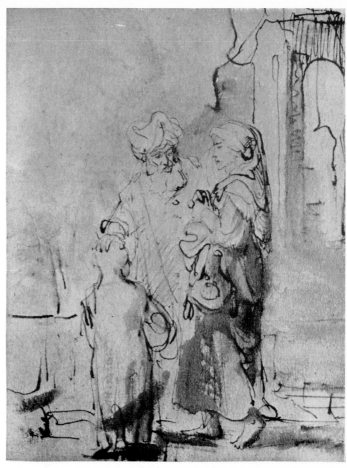

226. *The Dismissal of Hagar*. Pen drawing. Jerusalem, Schocken Library.

227. *Abraham and Isaac on the Way to the Sacrifice*. Pen and wash drawing. Moscow, I. Silberstein Collection.

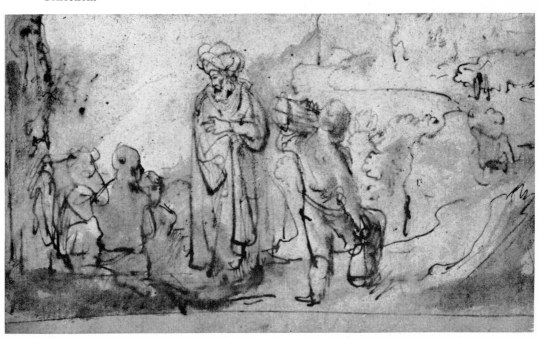

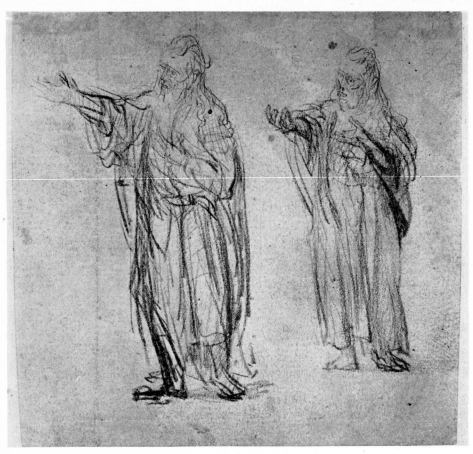

228. *St. John the Baptist preaching.* Red chalk. London, Count Antoine Seilern
Collection.

231. *Two Peasants in Discussion*. Chalk drawing. Formerly Haarlem, F. Koenigs Collection.

232. *Mother suckling a Child.* Pen drawing. London, Private Collection.

229. *Bust of a Woman* (enlarged). Chalk drawing. Bucharest, Museum.

230. *Half-Length Figure of a Young Man* (enlarged). Chalk drawing, Bucharest, Museum.

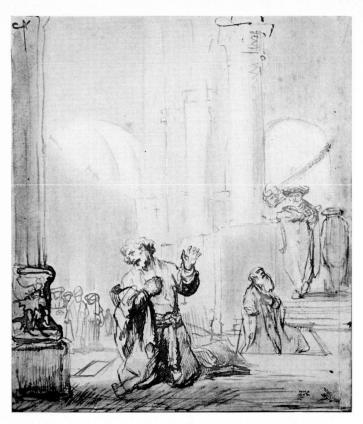

233. *The Publican and the Pharisee.*
Pen drawing. London, Sale
Sotheby's, 12 March 1963.

234. *David commanding Zadok and his Sons to return into the City.* Pen drawing. Private Collection.

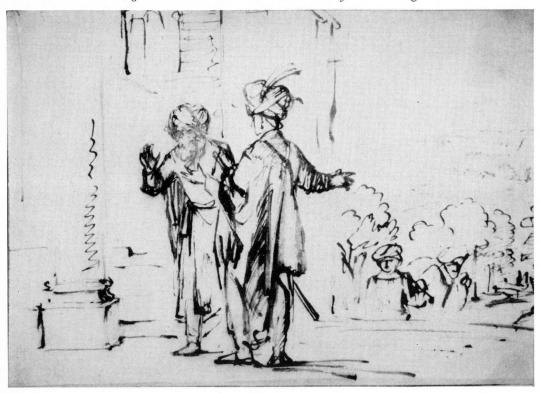

235, 236. C. van Renesse, with corrections by Rembrandt. Pen and brush drawings.
The Crucifixion. Rotterdam, Boymans-van Beuningen Museum.
Lot and his Daughters. Munich, Dr. H. Bünemann Collection.

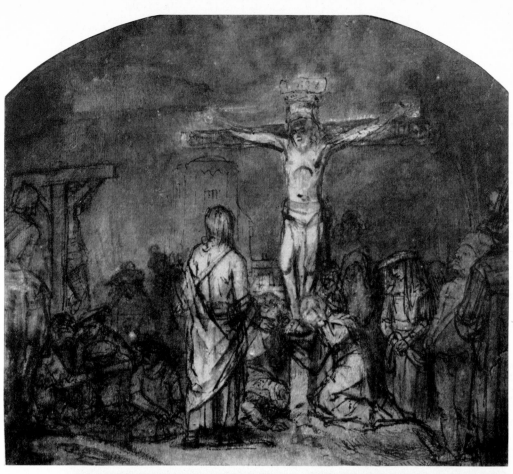

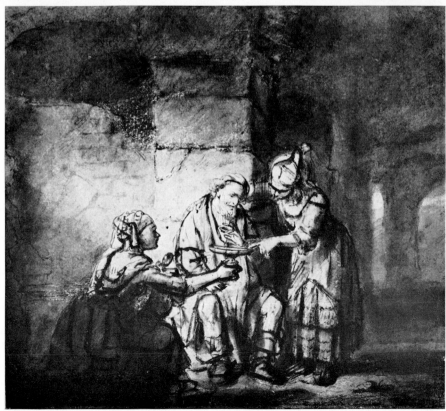

237. *Farm Buildings by a Canal*. Chalk drawing. London, British Museum.

238. *Curved Road fringed by Trees*. Pen and wash drawing. U.S., Mr. R. W. Hompe.

241. *Jonathan begging David's Forgiveness*. Pen and wash drawing. London, British Museum.

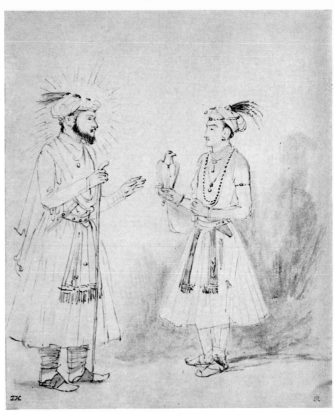

239. *Bust of an Oriental* (enlarged). Pen drawing. Bucharest, Museum.

240. *Shah Jahan in Conversation with his Falconer*. Pen and brush drawing. Sale Sotheby's, 10 May 1961.

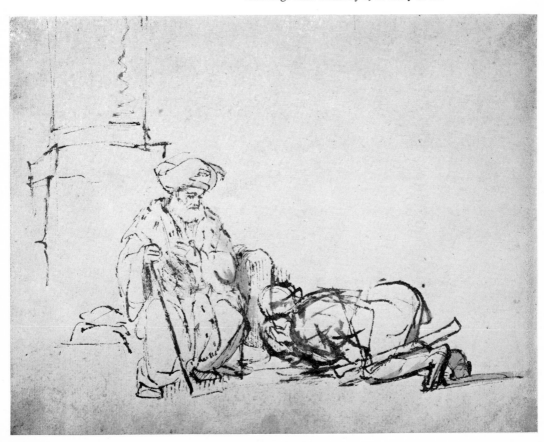

243. *Young Woman seated in an Armchair.* Pen and wash drawing. Leningrad, Hermitage.

242. *Fragment.* Pen drawing. Veste Coburg, Print Room.

245. *An Oriental.* Pen drawing. Amsterdam, Rijksmuseum, Print Room.

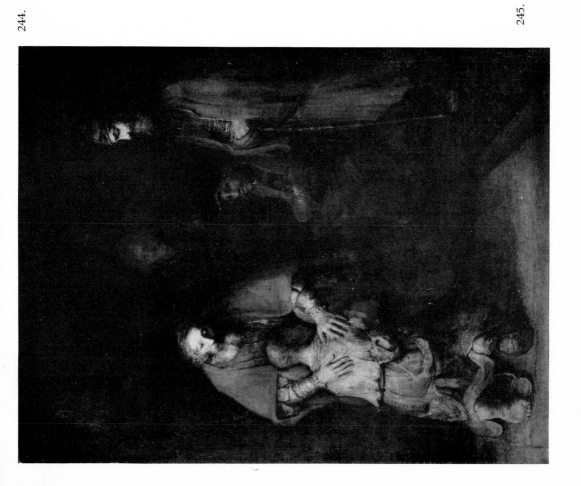

244. *The Return of the Prodigal Son.* Leningrad, Hermitage.

246. Copy by a pupil after Rembrandt, *The Healing of the Withered Hand*(?). Pen drawing. England, Private Collection.

248. Attributed to Rembrandt, *The Return of the Prodigal Son.*
London, Dr. Robert Rudolf.

247. Copy after Rembrandt, *Pastoral Scene.* Pen drawing.
U.S., Private Collection.

249. Attributed to Rembrandt (copy of a pupil?), *Mercury, Argus and Io*. Pen drawing. Formerly Basel, de Burlet.

250. Attributed to Rembrandt, *Mercury, Argus and Io*. Pen drawing. East Berlin, Print Room.

General Index

Index of Rembrandt Drawings

Index of Rembrandt Paintings

Index of Rembrandt Etchings

General Index

Aachen, Hans von, 233
Altdorfer, Albrecht, 67, 174, 205
 Birth of the Virgin Mary in the Church, 8;
 Holy Family round the Font, 8; *Pilate*
 washing his Hands, 8
Amalia of Solms, 222–3
Amsterdam,
 City Hall, 4, 13, 16, 145, 148, 218, 222
 Rembrandt in, 128
Arpino, Cavaliere d', 177
Avercamp, Hendrik, 130

Backer, Jacob Adriaensz, 58
 Portrait of Elizabeth Jacobsdr. Bas (Amster-
 dam), 58–9, 209, fig. 23; *Portrait of a*
 Woman (Antwerp), 58, fig. 24
Baudelaire, Charles, 167
Baudouin, Pierre Antoine, 72
Bassani, the, 65
Bassano, 179
Beethoven, 75, 77, 78, 79, 160
Bernhard, Christoph
 Dresden Song Book, 229
Berry, Duc de, Jean
 Prayer Book, 156
Blake, William, 160
Blomaert, Abraham, 172, 174, 175
Bloemaerts, the, 178
Boeckl, Herbert, 81–2
 Self-Portrait (Vienna), fig. 53
Bol, Ferdinand, 59, 115–16, 219
 Jacob's Dream (Dresden), 59, fig. 27;
 Portrait of a Woman (Palais Lazienki),
 209; *Annunciation* (drawing), 211
Bosch, Hieronymus, 162
Boucher, François, 72
Bramer, Leonard, 65
 The Raising of Lazarus (Prague National
 Gallery), 207
Bretherton, James, 280, footnote 2
 Copy of Rembrandt's "Petite Tombe", fig. 81
Bronckhorst, Jan Gerritsz. van, 219
Brouwer, Adriaen, 147
Bruegel, Pieter, the Elder, 6, 29
Burgundian School (Dijon)
 The Entombment of Christ, 151, fig. 125
Buytewech, Willem, 130

Callot, Jacques, 28–9, 47, 50, 64, 71, 72, 77, 78,
 84, 87, 118, 136, 147, 174, 178, 247, 248
 Misères de la Guerre, 77; *Gueux et Mendiants*
 (etchings), 247

Campen, Jacob van, 218 *see also* Amsterdam,
 City Hall
Canova, Antonio, 75
Cappelle, Jan van de, 31, 63
Caravaggio, 27, 128, 175–89, 214, 215, 252
 The Calling of St. Matthew (Rome), 176,
 186; *The Denial of St. Peter* (etching),
 181; *The Martyrdom of St. Matthew*, 183;
 The Conversion of Saul (Genoa), 183, 184
Castiglione, Giovanni Benedetto, 65–6
 Rembrandt and the Head of an Oriental,
 (etching), fig. 35
Cats, Jacob,
 Trouringh, 267
Cervantes, 6
Cézanne, Paul, 32, 74, 80–1, 169
 Self-Portrait 1864, fig. 51; *Vieux à la*
 Casquette (Solothurn), fig. 145
Chantreau, Jerôme François, 72
Chardin, Jean Baptiste Siméon, 73–5, 80
 Pierrot catching Goldfish (Glasgow), 74;
 Portrait of *Painter Aved*, 73; Self-
 Portrait (Paris), 74, fig. 46; *A Man*
 pulling a Chariot (La Vinaigrette), (draw-
 ing), 74–5, fig. 40; *Portrait of the Poet*
 Sedaine, 74
Christian IV of Denmark, King, 231
Christoph, Bernhard
 The Dresden Song Book, 229
Conrad, David
 Heinrich Schütz. (Engraving in *Dresden*
 Song Book), 229
Constable, John, 79, 164–5
 The Windmill (London), 165
Copenhagen, Schütz in, 231–2
Corinth, Lovis
 Christ carrying the Cross (lithograph), 81,
 fig. 54
Cornelisz, Jacob, van Amsterdam, 153
 Large Passion: The Agony in the Garden
 (woodcut), 153
Corot, Jean Baptiste Camille, 80
 St. Sebastian (Paris, Louvre), 80, fig. 50
Correggio, 182, 183
Crespi, Giuseppe Maria, 66, 159
 The Last Sacrament (Dresden, Gemälde-
 galerie) 66, fig. 38
Cuyp, Aelbert, 63
Cuyp, Benjamin, 65
Cuyp, Jacob Gerritsz
 Portraits of Jan and Margareta Trip, 201

Index of Rembrandt Drawings

Index of Rembrandt Paintings

Index of Rembrandt Etchings